INTERIOR DESIGN REVIEW
Best Interior Design on the Planet

INTERIOR DESIGN REVIEW
Best Interior Design on the Planet

EDITED BY

Cindi Cook

CONTRIBUTING EDITOR

Marc Steinhauer

TEXTS BY

Tatjana Seel

ADVISORY BOARD

Matteo Thun

Delia Fischer

Stephanie von Pfuel

Caroline Sarkozy

Leslie von Wangenheim

Barbara Bergman

Oliver Jahn

Ignace Meuwissen

teNeues

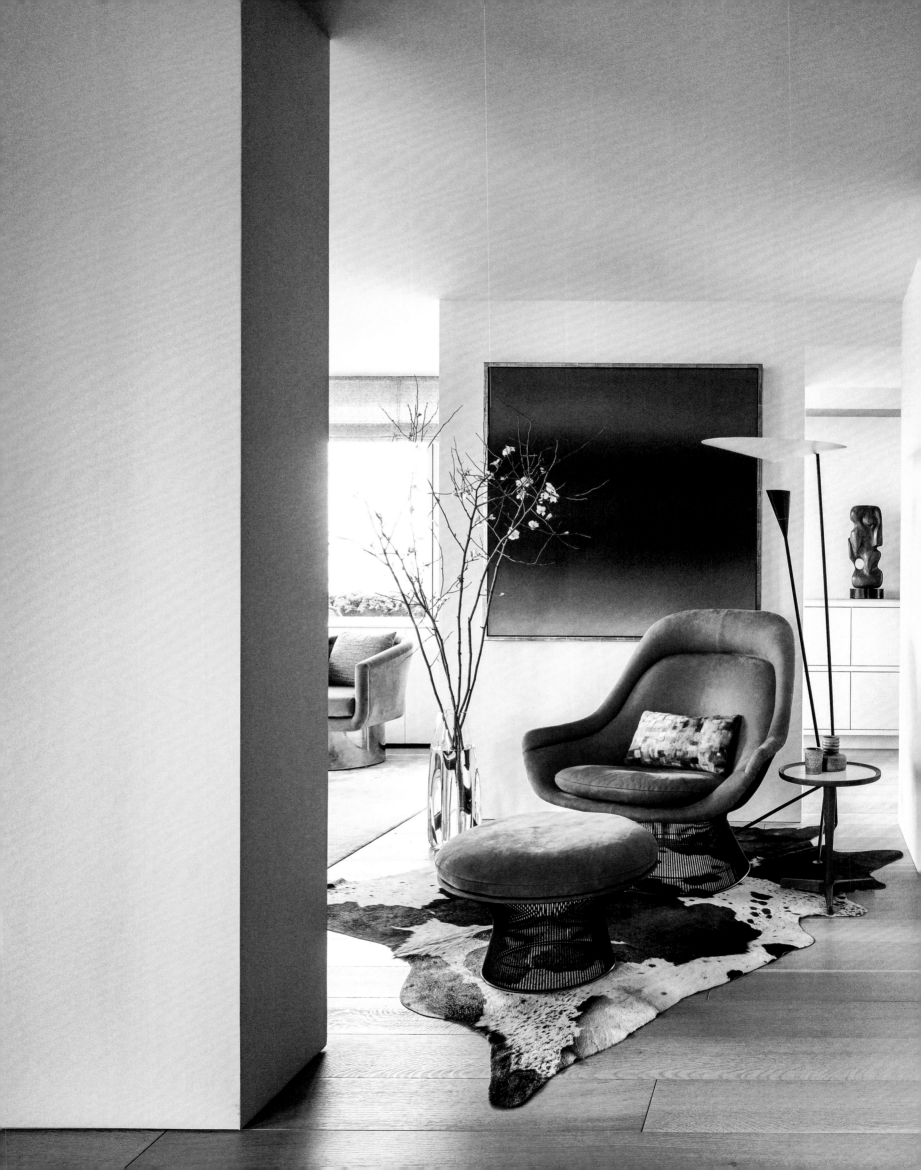

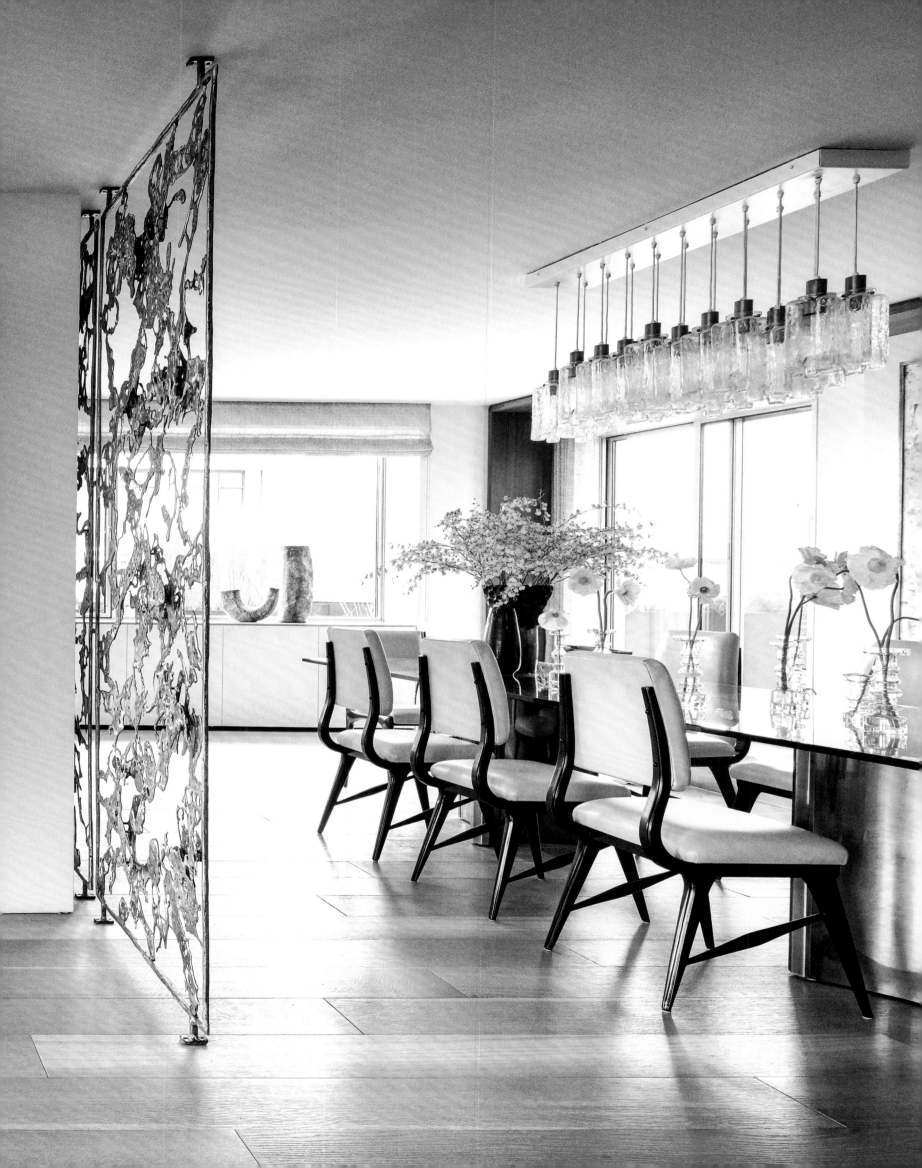

Contents

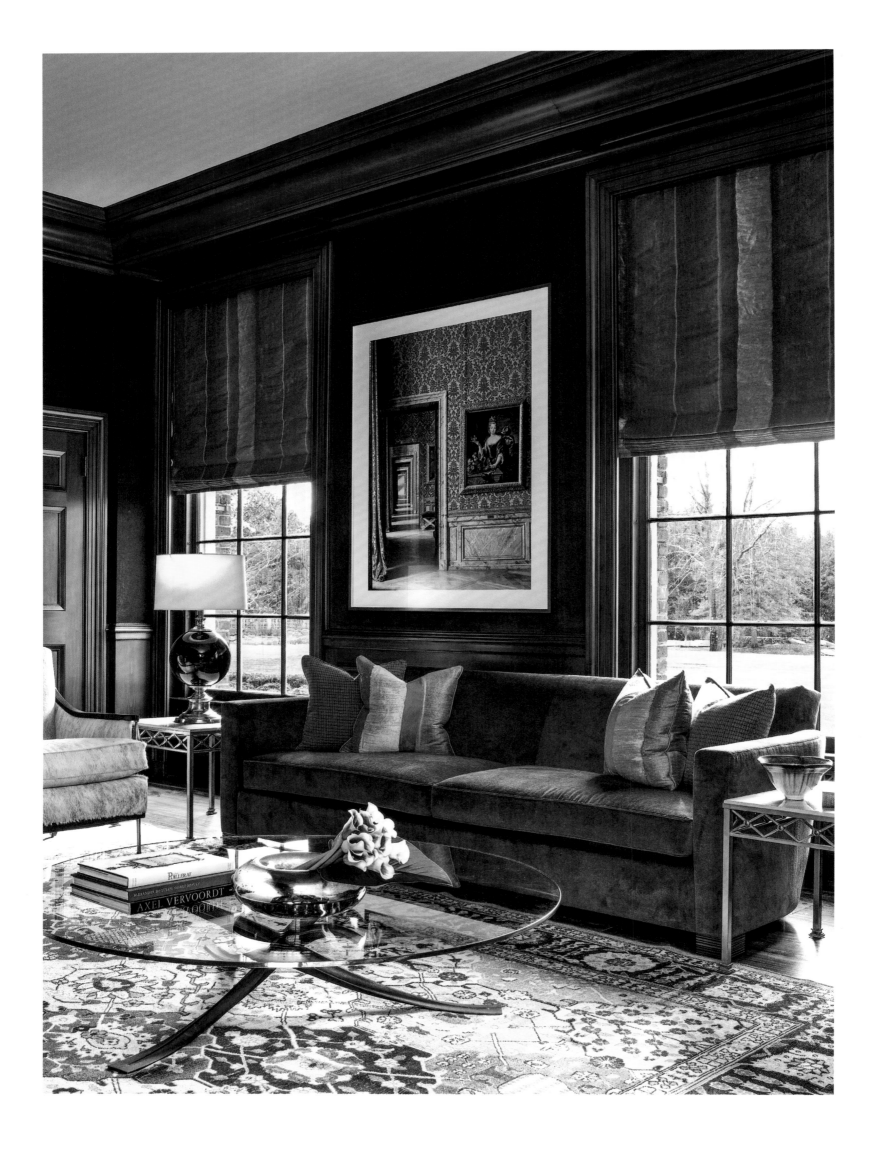

FOREWORD

Interior Design Review—The book that you are holding in your hands is dedicated to anyone who wants to create something unique. Who understands how to visualize yearnings; whose designs go straight to the heart, making life richer. Without exception, the interior designers showcased in this book love what they do. Know the most exquisite fabric manufacturers. Create color concepts that link rooms with one another. Attend art auctions—and are only able to acquire valuable objects or antiques thanks to their in-depth knowledge. To quote Margit J. Mayer, editor-in-chief of *AD* Germany for many years, "When taken seriously, interior design is not a walk in the park. It is a military campaign. Because glamour is a hell of a lot of work." Each designer, each architect, each decorator has their own methods; their own outlook; their own personal motivation for choosing the profession. For example Philip Gorrivan—his mother had French-Moroccan origins, always remaining an exotic foreigner in the conservative environment of Maine. And this was exactly why she influenced his taste from an early age. It was from her that he inherited his preference for an eclectic style combined with a boundless freedom to dare to do something new without worrying about others. Or Munich-based interior designer Peter Buchberger, who compares his work to that of an opera composer. His signature style reveals his link to unusual textiles, authentic materials that will stand the test of time. He is a master of the accent, capable of creating dramatic schemes, but always remains observant and intelligent. Internationally respected architect and designer Matteo Thun, who transformed a landmarked hospital on an island off Venice into an airy and elegant five-star hotel, can teach us lots about sustainable building and interior design. He is one of the key influencers in our wasteful world. Careful use of resources is also a central issue for Pamela Shamshiri, who runs a Los Angeles-based design firm together with her brother Ramin. She herself lives with her family in an iconic property, built in the late 1940s by Viennese architect Rudolph Michael Schindler, and has been working for over nine years to painstakingly and sensitively restore all its details. A visit to her website, that includes an article published in the *New York Times Magazine*, is well worthwhile, if only to see the dramatic, impressive location of the house. Positioned amongst swaying treetops above Laurel Canyon it appears to float in the air. Embark on a voyage of discovery. Enjoy the flamboyant style of Texan Lucinda Loya or the elegant interiors of Robert Stilin, who chose the title "Roll the Dice" for an exhibition at New York's annual Kips Bay Show House. Follow his example—stay curious!

Cover image:
Carmiña Roth Interiors (pp. 114-117)

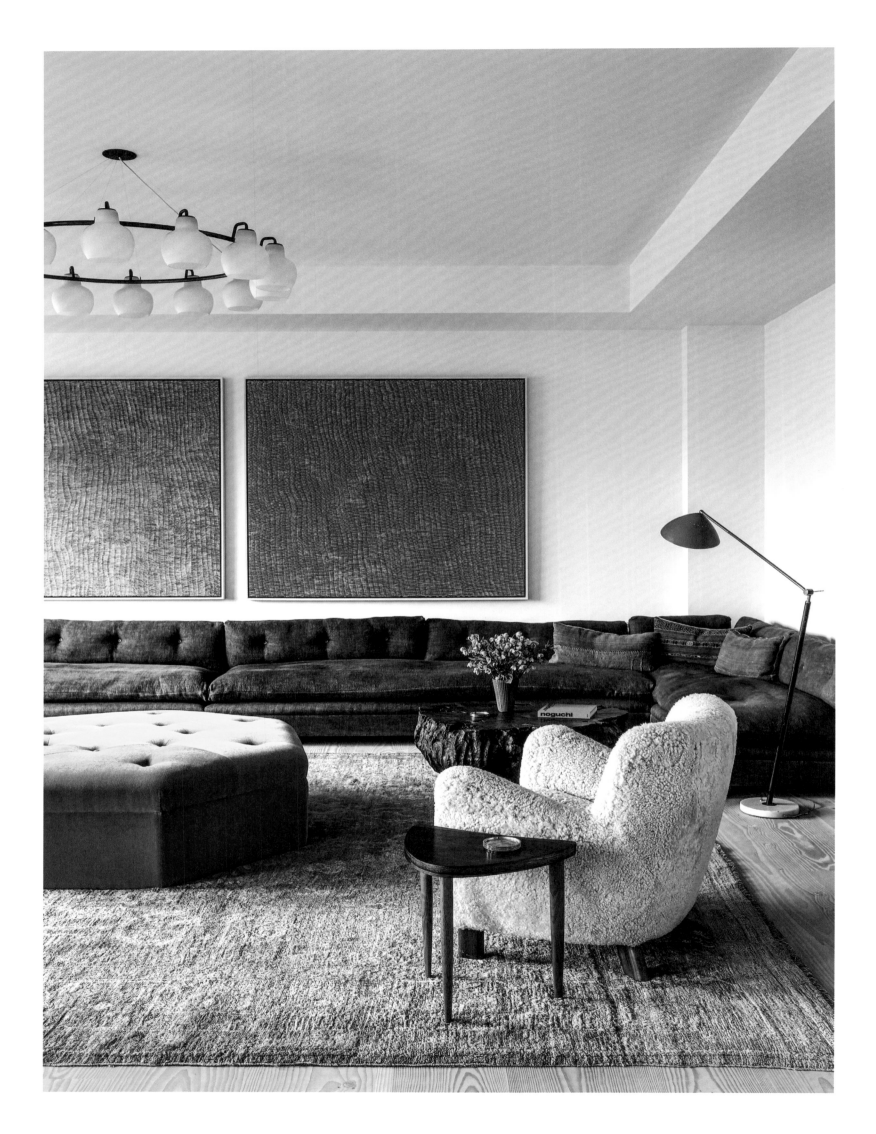

VORWORT

Interior Design Review – das Buch, das Sie in Händen halten, ist jenen gewidmet, die Einzigartiges schaffen. Die es verstehen, Sehnsüchte zu visualisieren, die mit ihren Entwürfen direkt ins Herz treffen und das Leben reicher machen. Die Interior Designer, die hier vorgestellt werden, lieben ausnahmslos, was sie tun. Kennen die exquisitesten Stoffmanufakturen. Erstellen Farbkonzepte, die Räume miteinander verbinden. Besuchen Kunstauktionen – und bringen nur deshalb wertvolle Objekte oder Antiquitäten mit, weil sie über herausragenden Sachverstand verfügen. „Wenn es ernsthaft betrieben wird, ist Interior Design kein Spaziergang. Sondern ein Feldzug. Weil Glamour verdammt viel Arbeit macht", hat Margit J. Mayer, die langjährige Chefredakteurin von *AD* Deutschland, einmal gesagt. Jeder Designer, jeder Architekt oder Gestalter hat seine eigene Herangehensweise, seinen eigenen Blickwinkel, seinen individuellen Beweggrund, weshalb er sich für diesen Beruf entschieden hat. Beispielsweise Philip Gorrivan: seine Mutter blieb mit ihren französisch-marokkanischen Wurzeln in der konservativen Umgebung Maines stets Exotin und schulte gerade deswegen früh seinen Geschmack. Von ihr erbte er die Vorliebe für ein offenes Stilempfinden, verbunden mit der grenzenlosen Freiheit im Kopf, unbeirrt Neues zu wagen. Oder der Münchener Interior Designer Peter Buchberger, der seine Arbeit mit der eines Opernkomponisten vergleicht. Seine Handschrift verrät den Bezug zu besonderen Textilien, echten Materialien, die die Zeit überdauern. Virtuos setzt er Akzente, inszeniert schon einmal Drama, aber stets achtsam und klug. Von dem international bekannten Architekten und Designer Matteo Thun, der ein denkmalgeschütztes Sanatorium auf einer Insel vor Venedig in ein lichtes und zugleich elegantes Fünf-Sterne-Hotel verwandelte, lernen wir eine Menge über nachhaltiges Bauen und Einrichten. Thun ist einer der wichtigsten Impulsgeber in unserer verschwenderischen Welt. Der sorgsame Umgang mit Ressourcen steht auch für Pamela Shamshiri im Mittelpunkt, die in Los Angeles zusammen mit ihrem Bruder Ramin ein Designbüro betreibt. Sie selbst lebt mit ihrer Familie in einer Ikone, Ende der Vierzigerjahre von dem Wiener Architekten Rudolph Michael Schindler erbaut. Über neun Jahre hat sie akribisch an deren behutsamer Restaurierung gefeilt. Ein Blick auf ihre Website, die eine Veröffentlichung im *New York Times Magazine* zeigt, lohnt: allein wegen der dramatisch beeindruckenden Lage des Hauses, das inmitten wogender Baumwipfel über dem Laurel Canyon zu schweben scheint. Gehen Sie auf Entdeckungstour. Erfreuen Sie sich am flamboyanten Stil der Texanerin Lucinda Loya ebenso wie an den eleganten Interiors von Robert Stilin, der für eine Ausstellung im jährlich stattfindenden New Yorker Kips Bay Show House den Titel „Roll the Dice" wählte. Machen Sie es wie er: Bleiben Sie neugierig!

Studio Shamshiri (pp. 76-79)

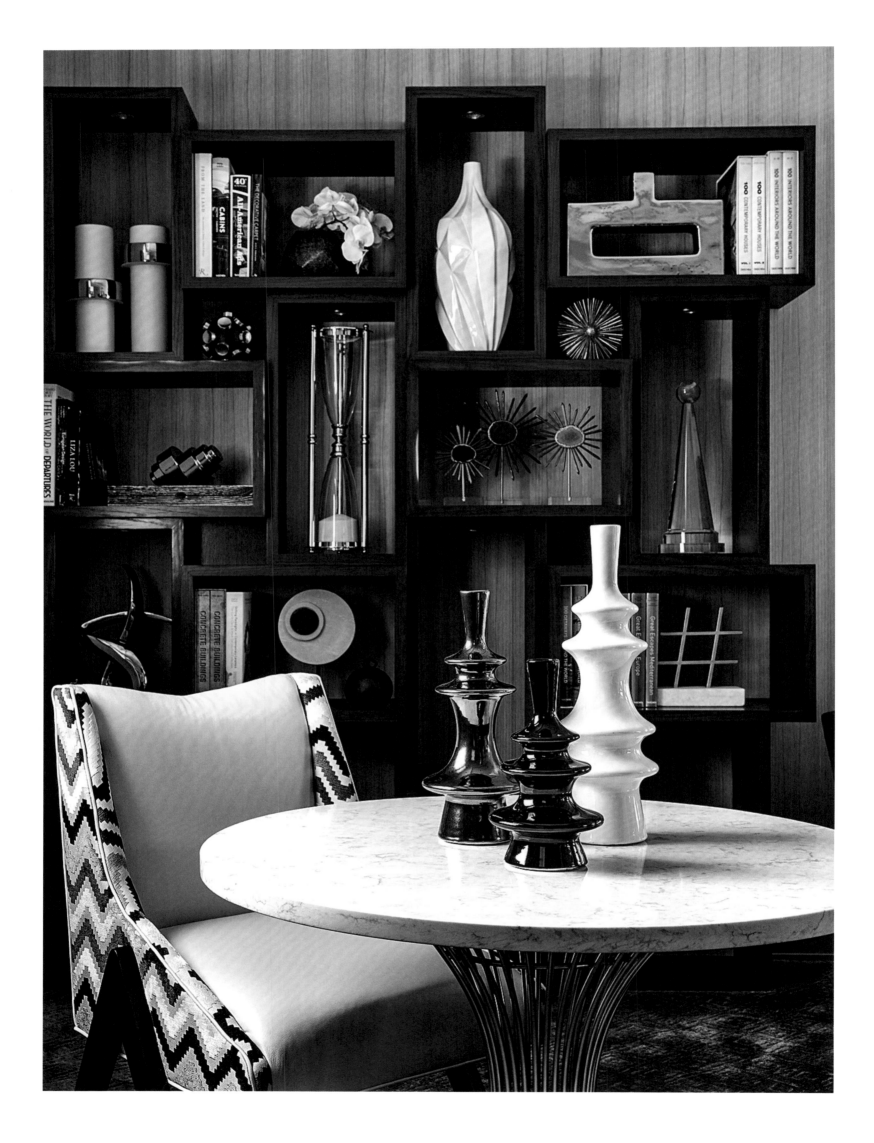

PRÉFACE

Interior Design Review – le livre que vous avez entre les mains est consacré aux personnes souhaitant créer quelque chose d'unique. Aux personnes qui savent visualiser les nostalgies, qui touchent les cœurs avec leurs réalisations et rendent la vie plus riche. Les décorateurs d'intérieur, ou *interior designer*, présentés ici aiment tous ce qu'ils font, sans exception. Ils connaissent les manufactures de tissu les plus exquises. Ils créent des concepts de couleurs qui connectent les espaces entre eux. Ils se rendent à des ventes aux enchères d'art et ne proposent ainsi que des objets précieux ou des antiquités parce qu'ils possèdent un sens créatif hors de la moyenne. « Si elle est réalisée avec sérieux, la décoration d'intérieur n'est pas une partie de plaisir. C'est une campagne militaire. Parce que le glamour donne beaucoup de travail », a déclaré une fois Margit J. Mayer, la rédactrice en chef de longue date d'*AD* Allemagne. Chaque designer, chaque architecte ou décorateur possède ses propres approches, sa propre perspective, ses motivations individuelles qui l'ont poussé à exercer ce métier. Si l'on prend Philip Gorrivan pour exemple : sa mère, avec ses racines franco-marocaines est toujours restée « exotique » dans la région conservatrice du Maine. Pour cette raison, elle lui a transmis très tôt son goût du style. Il tient d'être une approche créatrice ouverte alliée à une liberté d'esprit infinie, sans peur de la nouveauté. Ou encore l'interior designer de Munich, Peter Buchberger, qui compare son travail à celui d'un compositeur d'opéra. Sa signature trahit son goût pour les textiles originaux, les matériaux authentiques qui durent avec le temps. Avec brio, il place des contrastes, met en scène un côté dramatique, toujours avec prudence et intelligence. L'architecte et design de renommée internationale Matteo Thun, qui a transformé un sanatorium classé monument historiques sur une île devant Venise en un hôtel cinq étoiles simple et élégant à la fois, nous a beaucoup appris sur la construction et la décoration durables. Thun est l'un des pionniers essentiels dans notre monde voué au gaspillage. La gestion respectueuse des ressources est également la priorité pour Pamela Shamshiri qui possède une agence de design à Los Angeles avec son frère Ramin. Elle vit elle-même avec sa famille dans une maison iconique qui a été construite à la fin des années 40 par l'architecte viennois Rudolph Michael Schindler. Elle a travaillé à sa restauration respectueuse et soignée pendant plus de neuf ans. Il vaut la peine d'aller consulter son site Internet qui affiche une publication dans le *New York Times* : notamment en raison de l'emplacement impressionnant de la maison qui semble flotter au-dessus du Laurel Canyon au milieu des cimes des arbres Partez en exploration. Découvrez le style flamboyant de la Texane Lucinda Loya ainsi que les intérieurs élégants de Robert Stilin qui a choisi pour une exposition du Kips Bay Show House annuel de New York le titre « Roll the Dice ». Faites comme lui : Restez curieux !

Ovadia Design Group (pp. 22-25)

AMY LAU
New York City, United States

"I design rooms as if they were pieces of art. Every element plays an important role."
„Ich konzipiere Räume wie ein Gesamtkunstwerk. Jedes Detail nimmt eine wichtige Rolle ein."
« Je conçois les espaces comme une œuvre d'art. Chaque détail joue un rôle important. »

Amy Lau grew up in Paradise Valley, Arizona, surrounded by majestic canyons in blazing earthy reds. As a child she collected minerals with her grandmother, an artist, and is sure that she has inherited her creativity from her. After studying art history and receiving a master's in fine and decorative arts from the prestigious Sotheby's graduate program, Lau worked for Thomas O'Brien, the founder of Aero, a top New York design studio. As one of the city's top interior designers, she is in high demand as a consultant to collectors of 20th century decorative arts. Lau is the founder of the Design Miami show, and recently designed the Prisma line and an array of patterned cowhide rugs and pillows for Kyle Bunting. Amy's singular, successful approach has earned her firm many accolades, including *Architectural Digest's AD 100* Award for 2018. Lau's feminine and expressive style embraces both art and design, with spaces enlivened with dynamic mixes of vintage and contemporary pieces. That done for the 800-square-meter (8,600-square-foot) residence of a New York businessman and his wife creates a warm atmosphere with breathtaking views, despite the huge size (right). In the living room, with a ceiling height of almost six meters (20 feet), two silk rugs function as visual islands for the sofas that Lau commissioned from design legend Vladimir Kagan. Majestic lights by Lindsey Adelman float above them.

Aufgewachsen ist Amy Lau in Paradise Valley, Arizona – umgeben von eindrucksvollen Canyons in erdigem Feuerrot. Als Kind hat sie zusammen mit ihrer Großmutter, einer Künstlerin, Mineralien gesammelt. Ihre Kreativität, ist sie sicher, hat sie von ihr geerbt. Nach dem Studium der Kunstgeschichte und einem Master in bildender und dekorativer Kunst beim renommierten Sotheby's-Graduiertenprogramm arbeitete die Amerikanerin bei Thomas O'Brien, dem Gründer von Aero, das zu New Yorks führenden Designstudios gehört. Amy Lau ist nicht nur eine gefragte Beraterin für Sammler dekorativer Kunst des 20. Jahrhunderts, sondern hat auch die Messe „Design Miami" initiiert. Als Interior Designerin gehört sie zweifellos zu New Yorks Elite. Ihr Stil ist feminin und expressiv gleichermaßen. Sie verehrt Landschaften, liebt natürliche Materialien, die in ihren Projekten zum Einsatz kommen. In ihrer Arbeit kombiniert Amy Lau Kunst und Design, legt Wert auf eine dynamische Mixtur aus Vintage-Objekten und zeitgenössischen Stücken. Für einen New Yorker Geschäftsmann und dessen Frau schuf sie auf 800 Quadratmetern ein trotz der enormen Größe warm anmutendes Ambiente mit atemberaubender Aussicht (rechts). Im Wohnzimmer mit fast sechs Metern Deckenhöhe bilden zwei Seidenteppiche optische Lounge-Inseln mit Sofas, die Amy Lau von Designlegende Vladimir Kagan anfertigen ließ. Darüber schweben majestätisch anmutende Leuchten von Lindsey Adelman.

Amy Lau a grandi à Paradise Valley, Arizona, entourée d'impressionnants canyons rouge feu. Enfant, elle collectait les minéraux avec sa grand-mère, une artiste. Elle a certainement hérité de sa créativité. Après des études d'Histoire de l'art et un Master en art plastique et art décoratif du célèbre programme Sotheby, l'Américaine a travaillé chez Thomas O'Brien, le fondateur d'Aero, qui fait partie des plus grands studios de design de New York. Amy Laud n'est pas seulement conseillère pour les collectionneurs d'art décoratif du XXe siècle, elle a également lancé le salon « Design Miami ». En tant que décoratrice d'intérieur, elle fait sans aucun doute partie de l'élite de New York. Son style est féminin et expressif à la fois. Elle adore les paysages, aime les matériaux naturels qui sont utilisés dans ses projets. Dans son travail, Amy Lau combine l'art et le design, elle accorde de l'importance au mélange dynamique d'objets vintage et de pièces contemporaines. Pour un homme d'affaires new-yorkais et sa femme, elle a créé sur 800 m² une ambiance chaleureuse avec une vue à couper le souffle, malgré la surface énorme (à droite). Dans le séjour avec près de six mètres de hauteur sous plafond, deux tapis de soie forment des îlots lounge avec des canapés qu'Amy Lau a fait réaliser par la légende du design Vladimir Kagan. Au-dessus, des lampes majestueuses de Lindsey Adelman flottent.

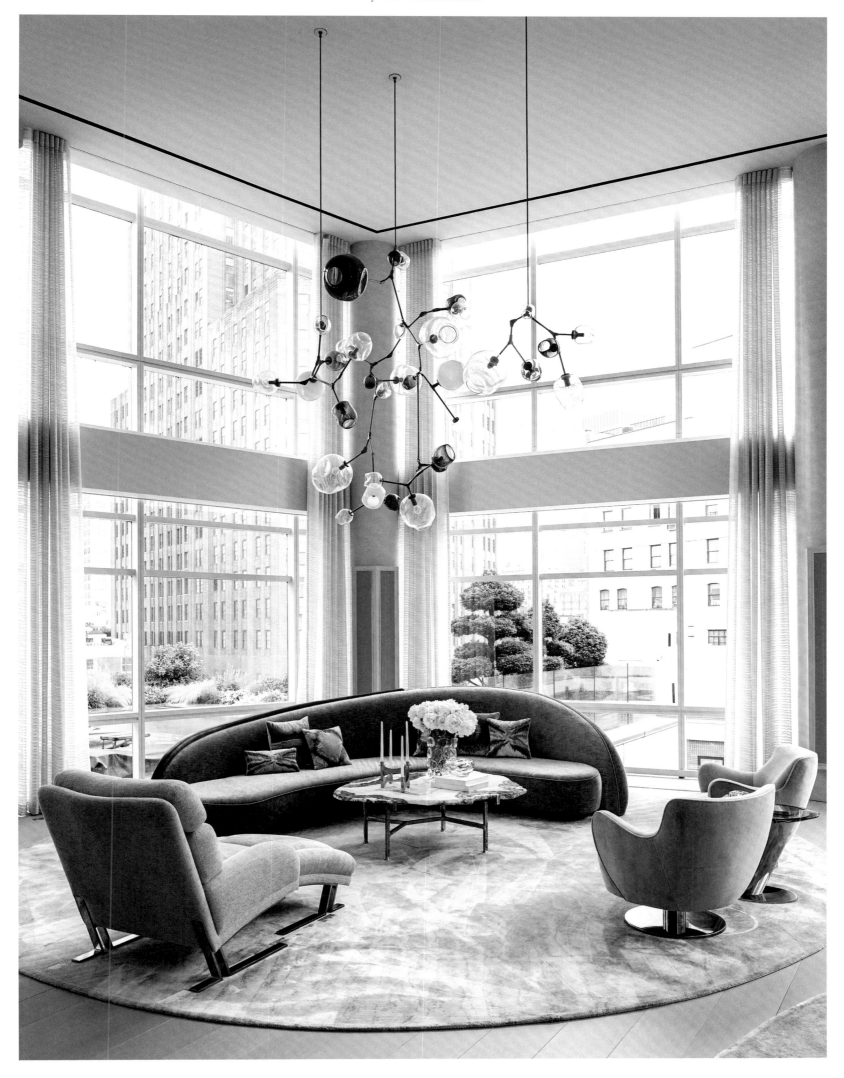

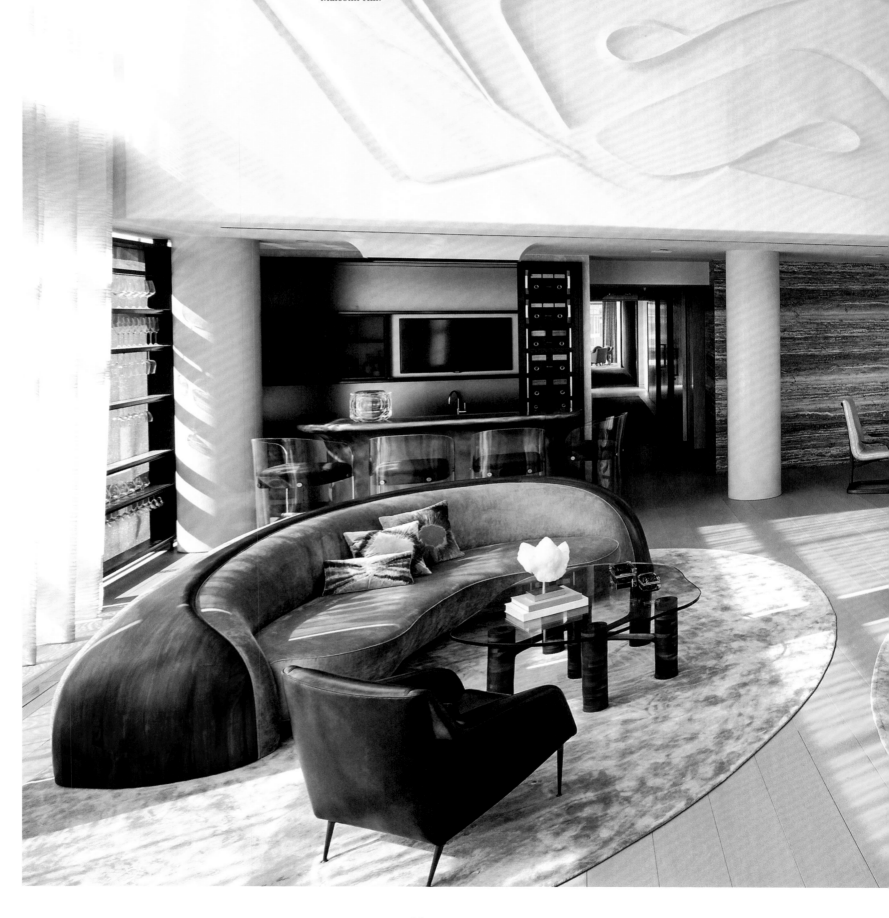

The "Tribeca Triplex" with 800 square meters (8,600 square feet) living space was created from five apartments. Amy Lau had artist Malcolm Hill sculpt a plaster relief above the bar and dining area.

Aus fünf Apartments entstand ein „Tribeca Triplex" mit 800 Quadratmetern Wohnraum. Über der Bar und dem Essbereich ließ Amy Lau von dem Künstler Malcolm Hill ein Gipsrelief modellieren.

À partir de cinq appartements, un « Tribeca Triplex » a vu le jour avec une surface habitable de 800 m². Au-dessus du bar et de l'espace repas, Amy Lau a fait réaliser un relief en plâtre par l'artiste Malcolm Hill.

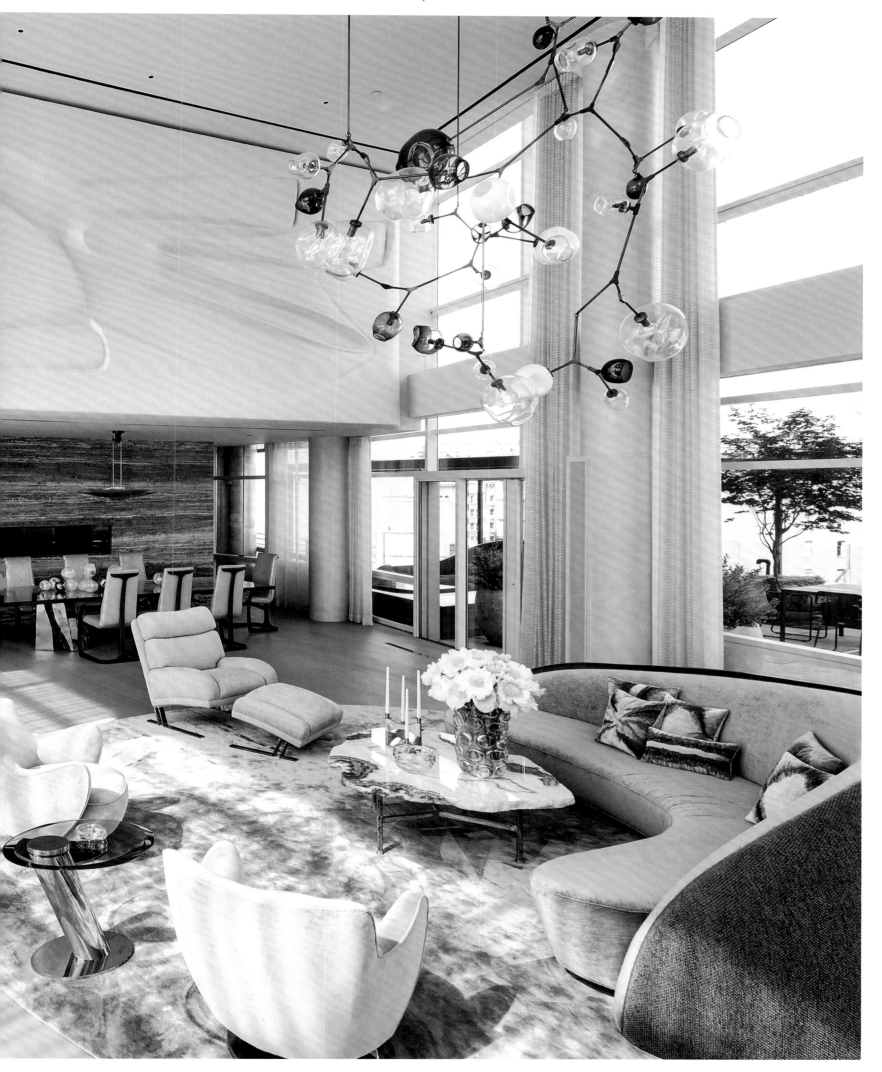

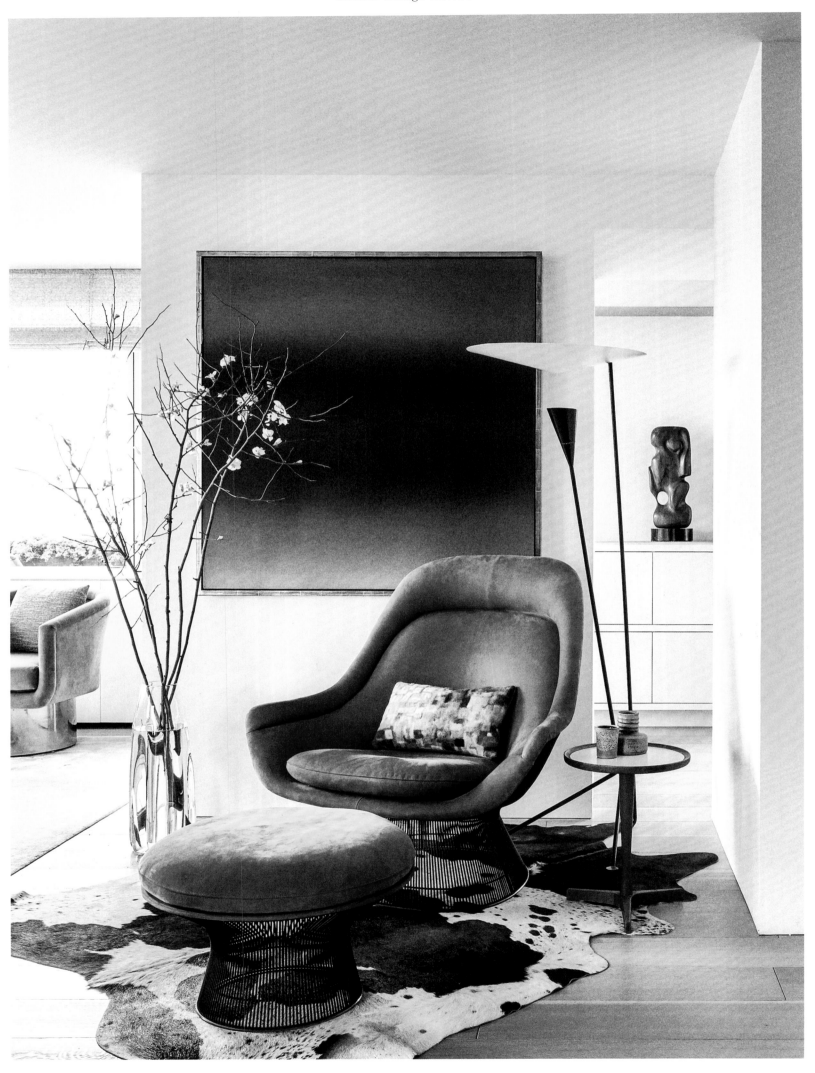

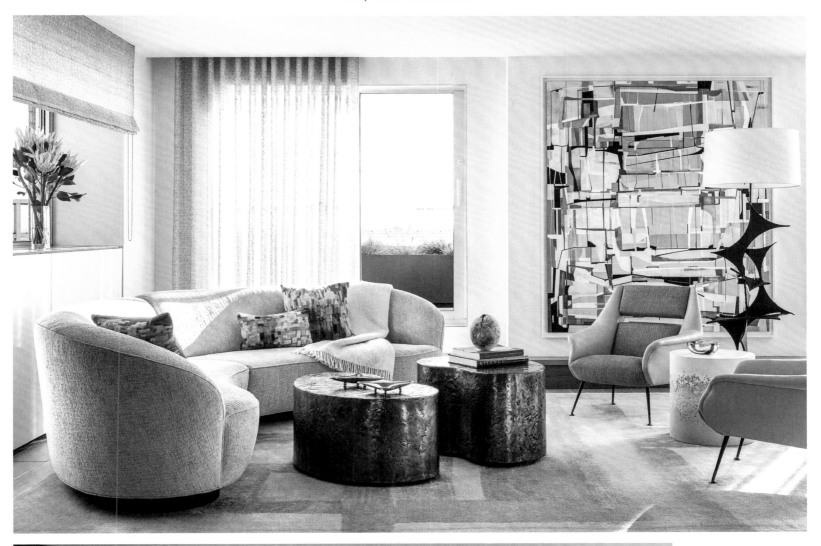

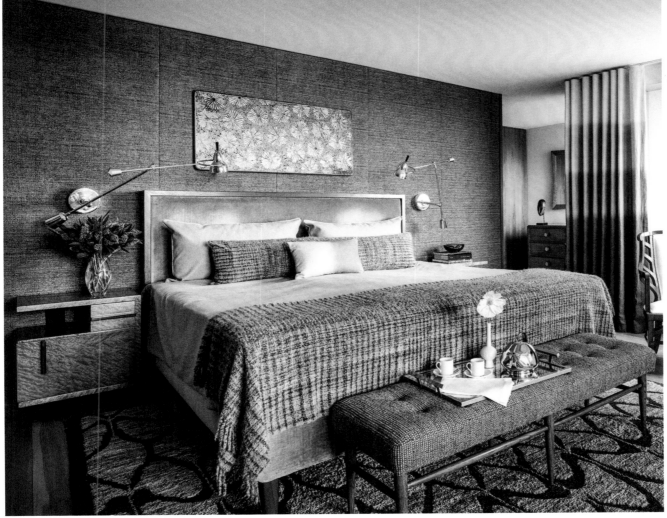

At East End Avenue, Amy Lau created a city oasis for a pair of art collectors that reflects the colors of the East River. The living room (above) features a painting by James Kennedy.

Für ein Kunstsammler-Ehepaar schuf Amy Lau an der East End Avenue eine Stadtoase, die mit den Farbnuancen des East Rivers korrespondiert. Im Wohnraum (oben) ein Gemälde von James Kennedy.

Pour un couple de collectionneurs d'art, Amy Lau a créé sur l'East End Avenue une oasis urbaine qui est assortie aux nuances de couleurs de l'East River. Dans le séjour (en haut), un tableau de James Kennedy.

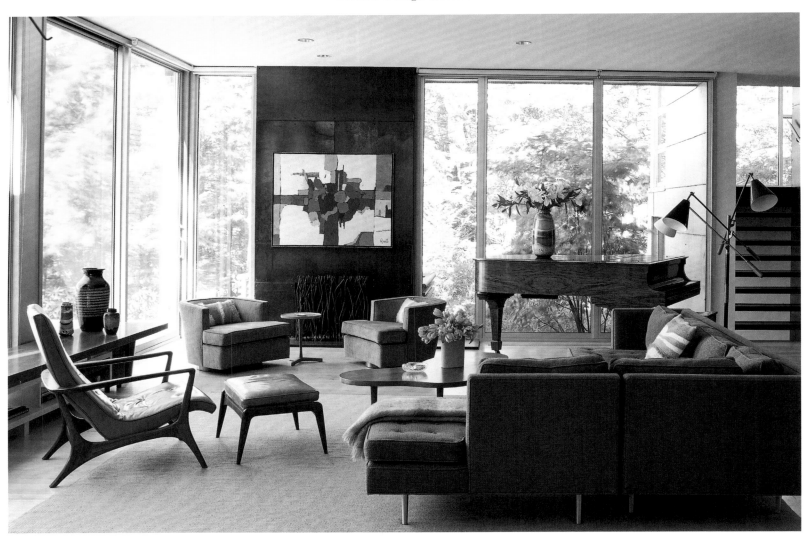

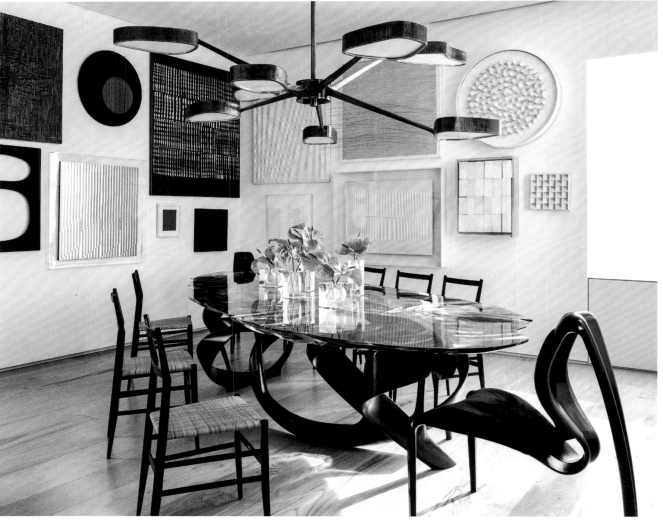

Fall leaves provided Amy Lau with the inspiration for a house on Kent Lake, New York that is decorated in warm copper tones (above). Light sofas by Jean-Michel Frank and Ico Parisi chairs in the living room (above right).

Inspiriert vom Herbstlaub wählte Amy Lau warme Kupfertöne für ein Haus am Kent Lake, New York (oben). Helle Sofas von Jean-Michel Frank und Ico-Parisi-Stühle im Wohnzimmer (oben rechts).

Inspirée par les feuillages d'automne, Amy Lau a choisi des tons cuivre chauds pour une maison au bord du Kent Lake, New York (haut). Des canapés clairs de Jean-Michel Frank et des chaises d'Ico Parisi dans le séjour (en haut à droite).

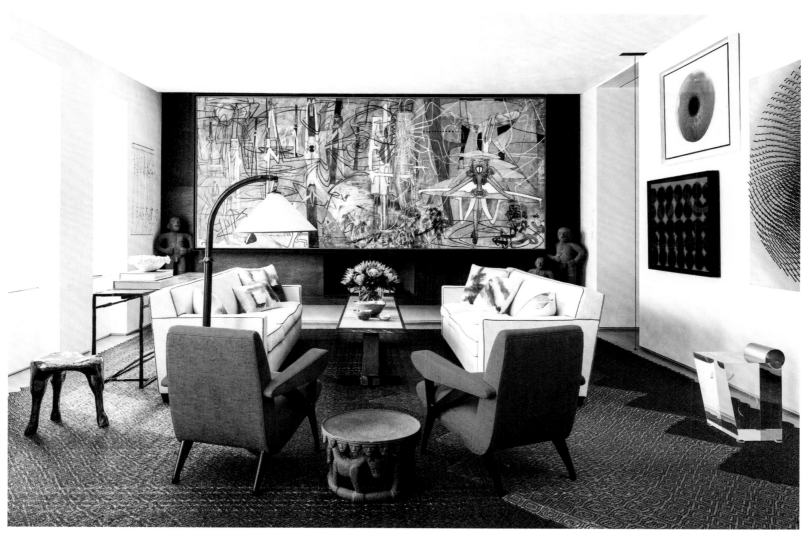

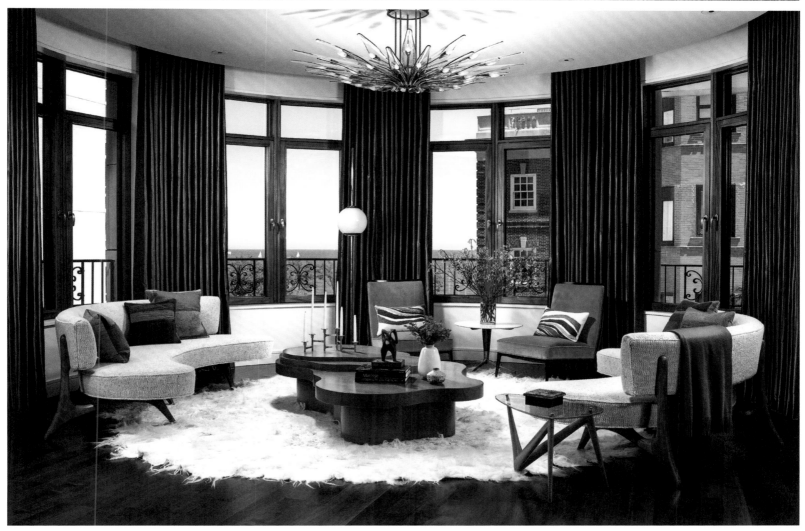

OVADIA DESIGN GROUP
New York City, United States

"We see a design process as being expressive, innovative and without constraints."
„Unter einem Designprozess verstehen wir, dass er ausdrucksstark, innovativ und ohne Zwänge ist."
« Selon nous, un processus de design est expressif, innovant et sans contrainte. »

What makes an architect switch to interior design? There can be only one answer: passion. That was certainly the case with Jack Ovadia. Born in Brooklyn, he studied at the New York Institute of Technology before going on to plan a variety of houses and residences all over America for a number of prestigious architects' offices. "During that time, I developed the ability to approach a project strategically from the very onset and consistently supervise it right through to completion." While working with Stephan Yablon Architecture, Jack Ovadia was intensively confronted with interior design and discovered that it was exactly what he wanted to do in future. "I felt that I didn't just want to create spaces for people to simply live in, I wanted them to feel at home in those spaces." Ovadia Design Group works diligently on every detail. Colors, materials, fabrics, furniture and light are meticulously coordinated with one another. Jack himself has a penchant for sumptuous fabrics such as silk and velour. "In addition to that," he stressed, "my work is consistently marked by the use of various metals such as silver, bronze and copper." In Great Neck, New York, he designed an absolutely awe-inspiring residence (right). The floor tiles in the entrance hall correspond to the glass mosaic designed by artist Allison Eden. "There is a cheerful, colorful and simultaneously sophisticated ambience," said Jack Ovadia, describing the overall concept—just the ticket for the occupants, an entertaining young family with kids.

Warum entschließt sich ein Architekt zum Interior Design zu wechseln? Die Antwort kann nur lauten: aus Passion. Genau so war es bei Jack Ovadia. Geboren in Brooklyn studierte er am New Yorker Institute of Technology bevor er für verschiedene namhafte Architekturbüros Häuser und Residenzen in ganz Amerika plante: „Während dieser Zeit habe ich die Fähigkeit entwickelt, ein Projekt von Beginn an strategisch anzugehen und konsequent bis zur Fertigstellung zu begleiten." Bei Stephan Yablon Architecture kam Jack Ovadia intensiv mit Interior Design in Berührung und entdeckte, dass es genau das war, was er künftig machen wollte: „Es berührt mich, nicht einfach nur Räume zu gestalten, in denen Menschen gut leben können. Ich wünsche mir, dass sie in diesen Räumen ein Zuhause finden." Die Ovadia Design Group feilt an jedem Detail. Farben, Materialien, Stoffe, Möbel und Licht werden akribisch aufeinander abgestimmt. Jack selbst hat eine Schwäche für luxuriöse Textilien, beispielsweise Seide und Velours: „Außerdem", betont er, „wird man bei mir immer verschiedene Metalle wie Silber, Bronze oder Kupfer finden."

In Great Neck, New York schuf er ein atemberaubendes Domizil (rechts). Im Entree korrespondieren die Bodenfliesen mit dem Glasmosaik der Künstlerin Allison Eden. „Die Stimmung sollte heiter, farbenfroh und gleichzeitig anspruchsvoll sein", beschreibt Jack Ovadia das Gesamtkonzept. Passend zu den Bewohnern, einer humorvollen jungen Familie mit Kindern.

Pourquoi un architecte décide de passer à l'*interior design* ? Une seule réponse possible : par passion. C'est précisément ce qu'il s'est passé pour Jack Ovadia. Né à Brooklyn, il a étudié à l'Institute of Technologie de New York avant de planifier des maisons et résidences dans toute l'Amérique pour diverses agences d'architectes de renom : « Pendant cette période, j'ai développé la capacité d'appréhender un projet dès le début et de l'accompagner jusqu'à sa finalisation ». Chez Stephan Yablon Architecture, Jack Ovadia s'est penché intensivement sur l'*interior design* et a découvert que c'est ce qu'il voulait désormais faire. « Ce qui me touche est de ne pas seulement aménager des pièces dans lesquelles les gens peuvent bien vivre. Je souhaite qu'ils s'y sentent chez eux ». Les couleurs, les matériaux, les tissus, les meubles et l'éclairage sont minutieusement harmonisés entre eux. Jack a un penchant pour les textiles luxueux, comme la soie et le velours : « De plus », souligne-t-il, « on ne cesse de trouver chez moi divers métaux comme l'argent, le bronze ou le cuivre ». Il a aménagé un domicile à couper le souffle à Great Neck, New York (à droite). Dans l'entrée, les carrelages sont assortis à la mosaïque en verre de l'artiste Allison Eden. « L'ambiance devait être gaie, haute en couleurs et sophistiquée à la fois », décrit Jack Ovadia à propos du concept général. Comme les résidents, une jeune famille pleine d'humour avec des enfants.

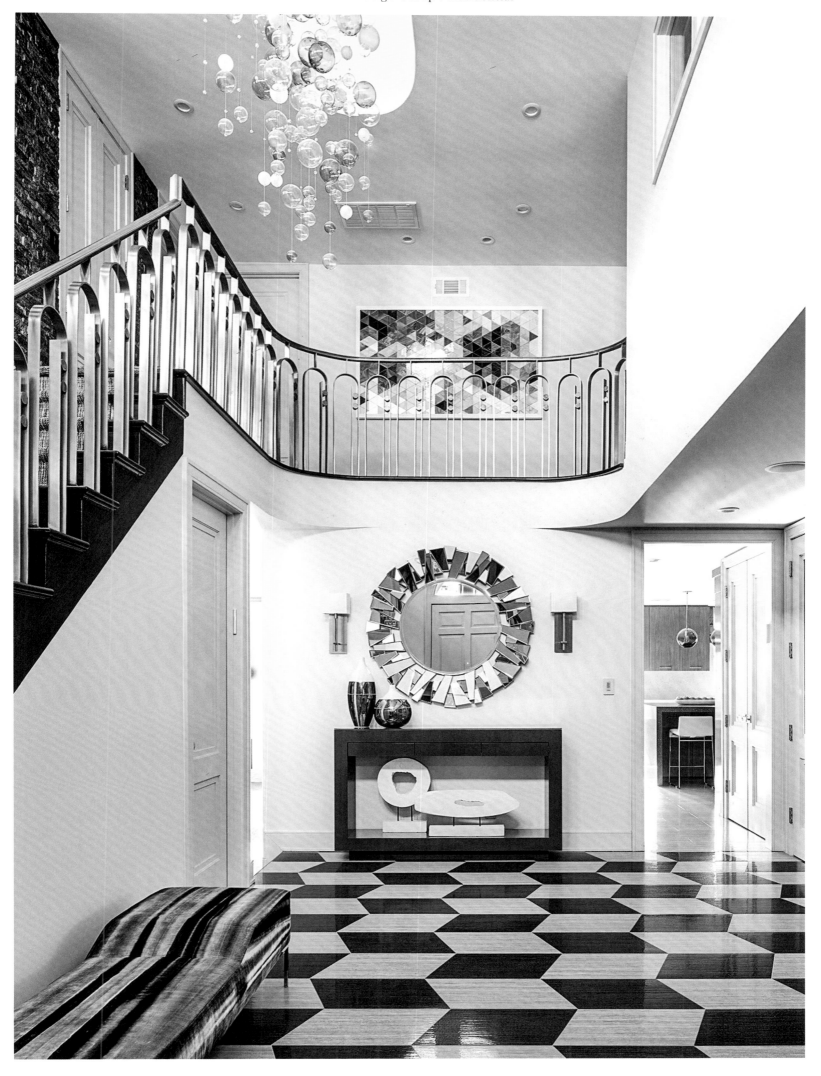

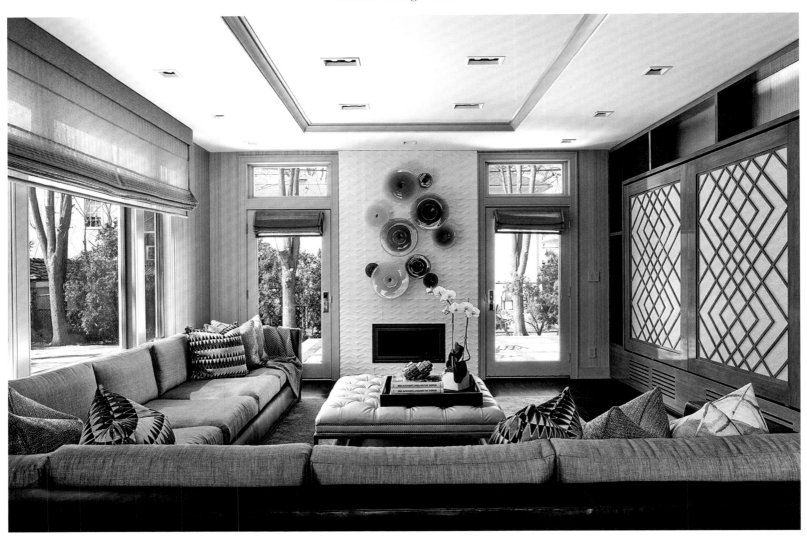

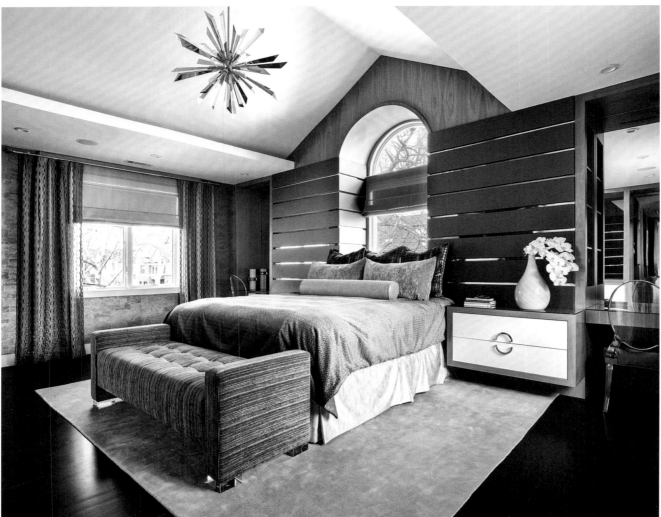

The villa belonging to a young family in Great Neck, New York, is full of surprises. For example, the partitioning in the living room with integrated TV, sound system and generous storage areas (above).

Die Villa einer jungen Familie in Great Neck, New York birgt viel Überraschendes. Beispielsweise einen Raumteiler im Wohnzimmer, in den TV, Soundsystem und viel Stauraum integriert wurden (oben).

La villa d'une jeune famille à Great Neck, New York regorge de surprises. Par exemple, un séparateur d'espace dans le séjour dans lequel le système audio de la télévision et de nombreux rangements ont été intégrés (en haut).

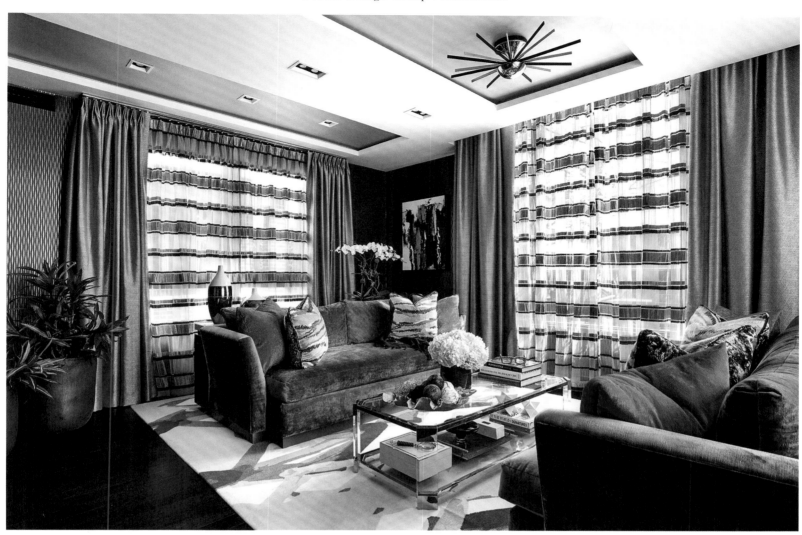

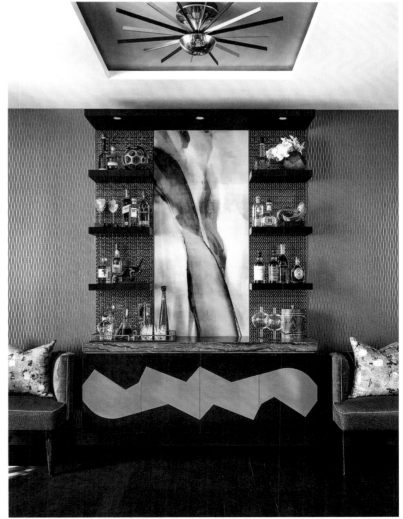

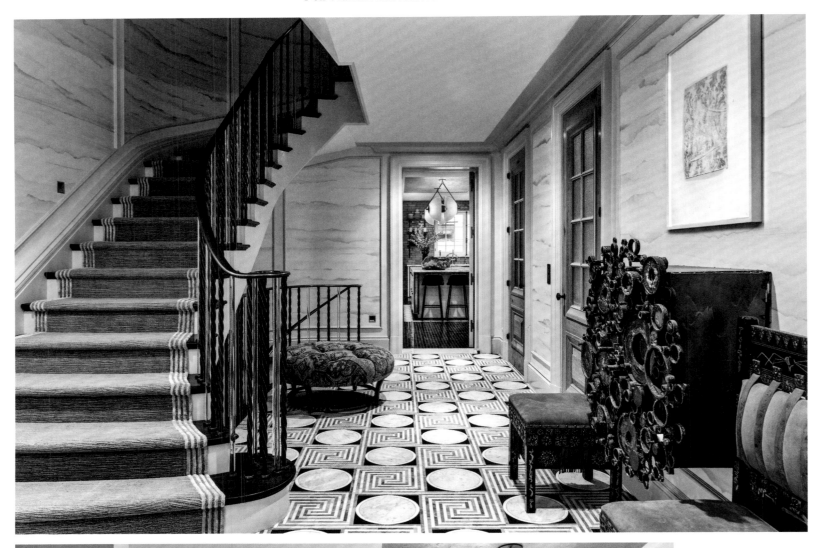

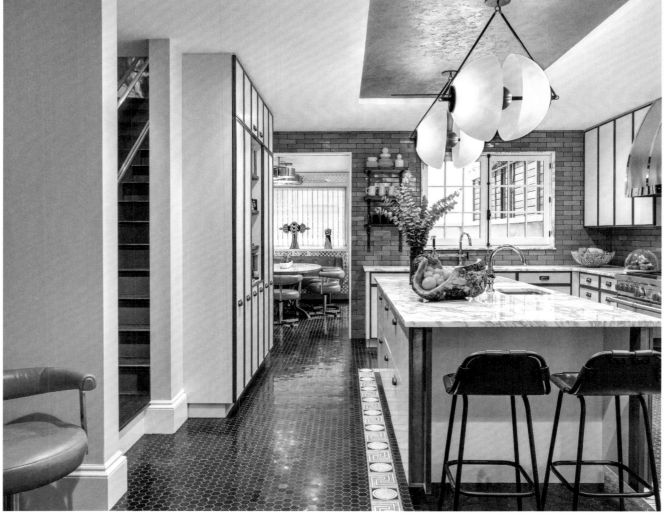

In a Neo-Grecian New York residence, Joe Nahem designed the stairwell balustrade, comprised of matte bronze and glass, to function as a central element. Two Bugatti chairs give the space the requisite drama.

In einem neo-griechischen New Yorker Gebäude gestaltete Joe Nahem das Treppengeländer als zentrales Element aus matter Bronze und Glas. Zwei Bugatti-Chairs sorgen für die nötige Dramatik.

Dans un bâtiment new-yorkais néo-grec, Joe Nahem a conçu la rampe de l'escalier comme un élément centre fait de bronze mat et de verre. Deux chaises Bugatti apportent le côté dramatique nécessaire.

FOX-NAHEM ASSOCIATES

New York City, United States

"Sometimes our clients themselves provide us with the best sources of inspiration."
„Manchmal sind es unsere Kunden selbst, die uns die besten Inspirationsquellen liefern."
« Parfois, nos clients sont nos meilleures sources d'inspiration. »

Joe Nahem describes his creative process as intimate and very personal. He believes that young designers in particular have to be able to let go of their egos and engage with their clients' needs. His view comes from over 30 years' experience. At 22 years old and still at Parsons School of Design in New York City, Nahem founded his firm Fox-Nahem Associates with his now-late partner Tom Fox. Today, more than three decades later, Nahem works with his highly trained team of 10 designers. The firm has completed projects in New York City, Beverly Hills, Miami, Aspen, and Malibu. Joe has collaborated on these projects with such architectural legends as Robert A.M. Stern, Annabelle Selldorf and Steven Harris. Nahem's aesthetic includes a combination of hand-picked antiques, eclectic vintage objects and sumptuous materials that he integrates into the design scheme in a way that is both stylish and surprising. He is also passionate about art and fine crafts. Unusual ceramics, woven leather, metallic upholstery fabrics, and custom woven rugs made by artisans with whom he works give his rooms a look that is always one-of-a-kind. To respect the original historic neo-Grecian grandeur of a Manhattan townhouse that he gut-renovated (left), he didn't try to reproduce the past but created an interior that is reminiscent of that bygone era by using materials such as bronze, hand-painted wallpaper, and vintage furniture. The result is vibrant and chic yet in keeping with the historic dignity of the building.

Den kreativen Prozess seiner Arbeit bezeichnet er als intim und sehr persönlich. Vor allem junge Designer, glaubt Joe Nahem, sollten in der Lage sein, ihr Selbstbewusstsein nicht in den Vordergrund zu stellen, sondern lernen, sich auf die Bedürfnisse ihrer Auftraggeber einzulassen. Nahem spricht aus seiner 30-jährigen Erfahrung: Bereits im Alter von 22 gründete er Fox-Nahem Associates mit seinem inzwischen verstorbenen Partner Tom Fox, während beide noch an der Parsons School of Design in New York studierten. Drei Jahrzehnte später realisiert Joe zusammen mit einem versierten zehnköpfigen Designteam Projekte in New York City, Beverly Hills, Miami, Aspen oder Malibu, darunter Häuser von Architekturlegenden wie Robert A.M. Stern, Annabelle Selldorf oder Steven Harris. Ausgesuchte

Antiquitäten, eklektische Vintage-Objekte, prachtvolle Materialien – Joe Nahem kombiniert sie stilsicher und überraschend zugleich. Besonders am Herzen liegen ihm Kunst und feines Handwerk: eine Leidenschaft, die Nahem über die Jahre kultiviert hat. Außergewöhnliche Keramik, Flechtleder, metallische Polsterstoffe und handgewebte Teppichunikate von Kunsthandwerkern, mit denen er eng verbunden ist, geben seinen Räumen stets einen individuellen Look. Einem grundsanierten Stadthaus in Manhattan, erbaut im neo-griechischen Stil (links), gab Joe Nahem seine Grandezza zurück, indem er, anstatt die Vergangenheit zu reproduzieren, Materialien wie Bronze, handbemalte Tapeten und Vintage-Möbel zusammenbrachte. Das Ergebnis ist so lebendig wie elegant und wird dem ehrwürdigen Gebäude gerecht.

Il décrit son processus créatif comme intime et très personnel. Selon Joe Nahem, les jeunes designers, notamment, devraient être en mesure de ne pas mettre leur assurance au premier plan et plutôt apprendre à se fier aux besoins de leurs donneurs d'ordres. Nahem parle du haut de ses 30 ans d'expérience : à l'âge de 22 ans déjà, il a fondé Fox-Nahem Associates avec son partenaire maintenant décédé Tom Fox alors qu'ils étudiaient tous les deux encore à la Parsons School of Design à New York. Trois décennies plus tard, Joe réalise avec une équipe de dix designers avertis des projets à New York City, Beverly Hills, Miami, Aspen ou Malibu, dont des maisons des légendes de l'architecture comme Robert A.M. Stern, Annabelle Selldorf ou Steven Harris. Antiquités sélectionnées, objets vintages éclectiques, matières prestigieuses – Joe Nahem les combine de manière assurée et surprenante à la fois. L'art et l'artisanat raffiné lui tiennent particulièrement à cœur : une passion que Nahem a cultivée avec les années. Une céramique exceptionnelle, du cuir tressé, des tissus matelassés métallisés et des tapis uniques tissés à la main par des artisans créateurs avec lesquels il entretient d'étroites relations donnent toujours à ses pièces un look individuel. Joe Nahem a redonné toute sa prestance à une maison de ville entièrement rénovée à Manhattan, construite dans le style néo-grec (à gauche) en alliant des matériaux comme le bronze, des tapisseries peintes à la main et des meubles vintage plutôt que de reproduire le passé. Le résultat est aussi vivant qu'élégant et fait honneur au magnifique bâtiment.

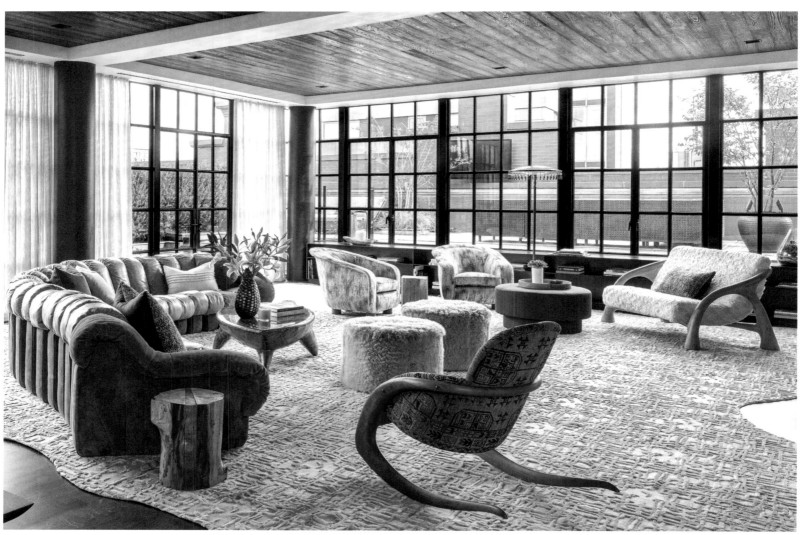

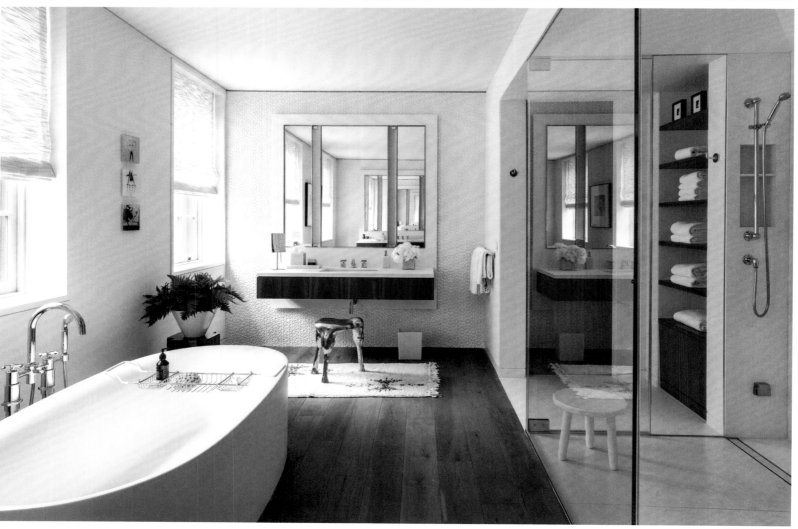

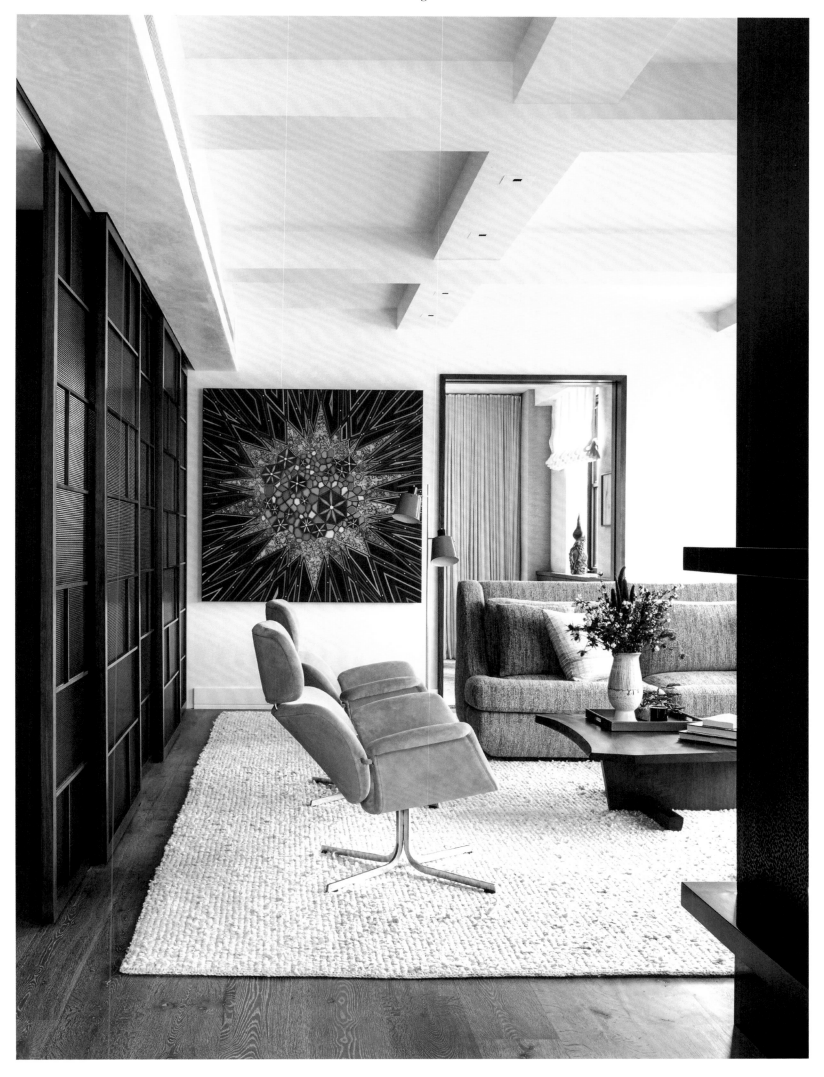

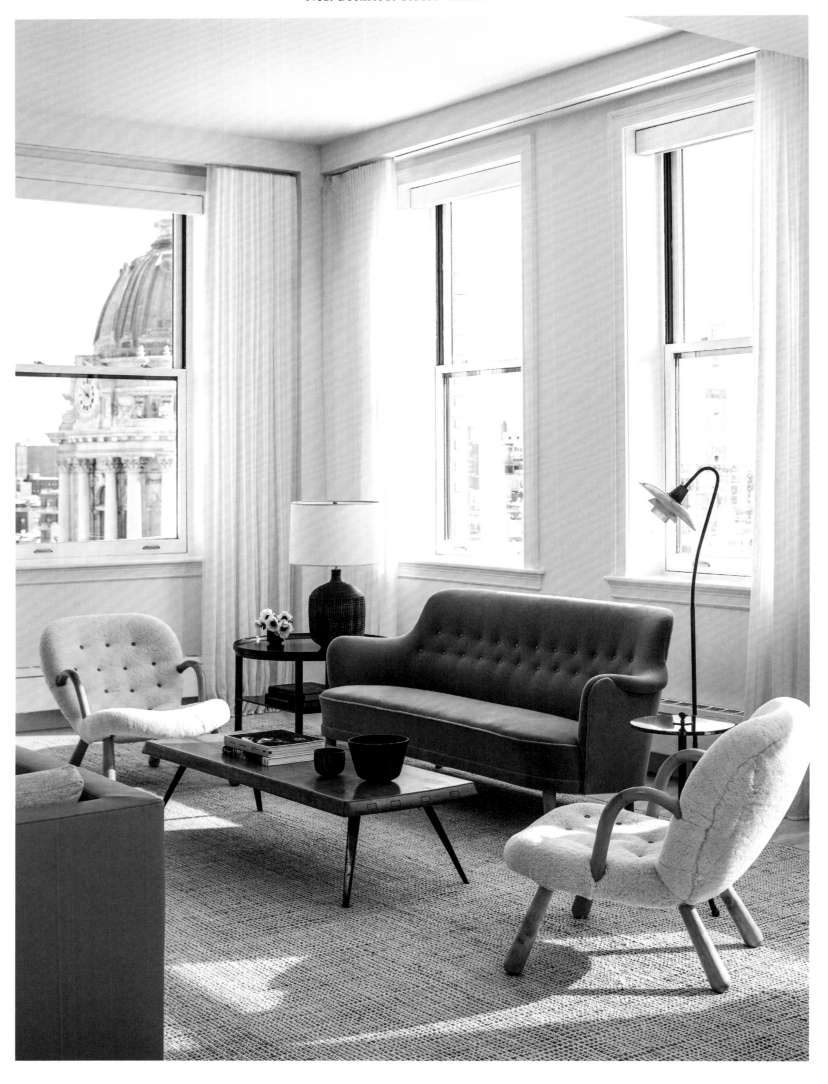

NEAL BECKSTEDT STUDIO

New York City, United States

"When I design a space, I like to start with the appropriate chair."
„Wenn ich einen Raum entwerfe, fange ich am liebsten mit einem passenden Stuhl an."
« Lorsque j'aménage un espace, j'aime commencer avec une chaise adaptée ».

For fashion designer Derek Lam and his partner Jan-Hendrik Schlottmann, he outfitted a beach house on Fire Island and an apartment at Gramercy Park. When asked about working with the international fashion designer, New York interior designer and architect Neal Beckstedt primarily emphasizes the freedom he was given and the immense trust placed in him: "My clients are always a great source of inspiration for me. I naturally try to ascertain who they are, how they live and what interests them. This is precisely the process that inspires me and I try to transfer the respective results into spaces." Neal Beckstedt grew up in rural Ohio and is in no doubt that his roots have a major impact on his work today as an interior designer. Surrounded by barns and modest farmhouse architecture, he spent his childhood doing creative woodwork, drawing, cooking and gardening: "My parents," extols Beckstedt, "have always been supportive and fostered my interests." In SoHo, the architect designed a light-drenched penthouse in concordance with its generous floor plan. To provide plenty of room for his client's vast contemporary art collection, he kept the outfitting distinct and minimal in a move that additionally showcased the vintage French and Scandinavian furniture.

Für den Fashiondesigner Derek Lam und seinen Partner Jan-Hendrik Schlottmann hat er auf Fire Island ein Beachhouse und ein Apartment am Gramercy Park eingerichtet. Fragt man den New Yorker Interior Designer und Architekten Neal Beckstedt nach der Zusammenarbeit mit dem internationalen Modedesigner, betont er in erster Linie die Freiheit und das immense Vertrauen, das ihm entgegengebracht wurde: „Meine Klienten sind für mich immer auch große Inspirationsquellen. Natürlich probiere ich herauszufinden, wer sie sind, wie sie leben und für was sie sich interessieren. Es ist genau dieser Prozess, der mich begeistert und dessen Ergebnis ich versuche, in Räume zu übersetzen." Neal Beckstedt wuchs in der ländlichen Umgebung Ohios auf. Er ist davon überzeugt, dass seine Wurzeln großen Einfluss

auf seine heutige Arbeit als Interior Designer haben. Umgeben von Scheunen und der einfachen Architektur der Farmhäuser hat er seine Kindheit mit kreativen Holzarbeiten, Zeichnen, Kochen und Gartenarbeit verbracht: „Meine Eltern", schwärmt Beckstedt, „haben mich stets in allem unterstützt und meine Interessen gefördert." Ein lichtdurchflutetes Penthouse in SoHo gestaltete der Architekt entsprechend seines großzügigen Grundrisses. Um der immensen zeitgenössischen Kunstsammlung seines Auftraggebers Raum zu geben, hielt er die Einrichtung minimalistisch und klar. Auf diese Weise kommen auch die französischen und skandinavischen Vintage-Möbel zur Geltung.

Pour le designer de mode Derek Lam et son partenaire Jan-Hendrik Schlottmann, il a aménagé sur Fire Island une beachhouse et un appartement près du Gramercy Park. Si l'on interroge l'*interior designer* et architecte newyorkais Neal Beckstedt sur sa collaboration avec le designer de mode international, il souligne en premier lieu la liberté et la confiance immense qu'il lui a témoigné. « Mes clients sont toujours de grandes sources d'information pour moi. Bien évidemment, j'essaie de découvrir qui ils sont, comment ils vivent et quels sont leurs centres d'intérêts. C'est précisément ce processus qui m'enthousiaste et son résultat que j'essaie de transposer dans les espaces. » Neal Beckstedt a grandi dans l'environnement rural de l'Ohio. Il est convaincu que ses racines ont une grande influence sur son travail actuel d'*interior designer*. Entouré de granges et de l'architecture simple des bâtiments fermiers, il a passé son enfance à réaliser des travaux créatifs avec le bois, à dessiner, cuisiner et jardiner : « Mes parents », s'enthousiaste Beckstedt, « m'ont toujours aidé et m'ont soutenu dans mes centres d'intérêt. » L'architecte a aménagé un penthouse baigné de lumière à SoHo en respect de ses dimensions généreuses. Afin de laisser de la place à l'immense collection d'art contemporain de son donneur d'ordres, il a laissé l'aménagement minimaliste et clair. De cette manière, les meubles vintage français et scandinave sont mis en valeur.

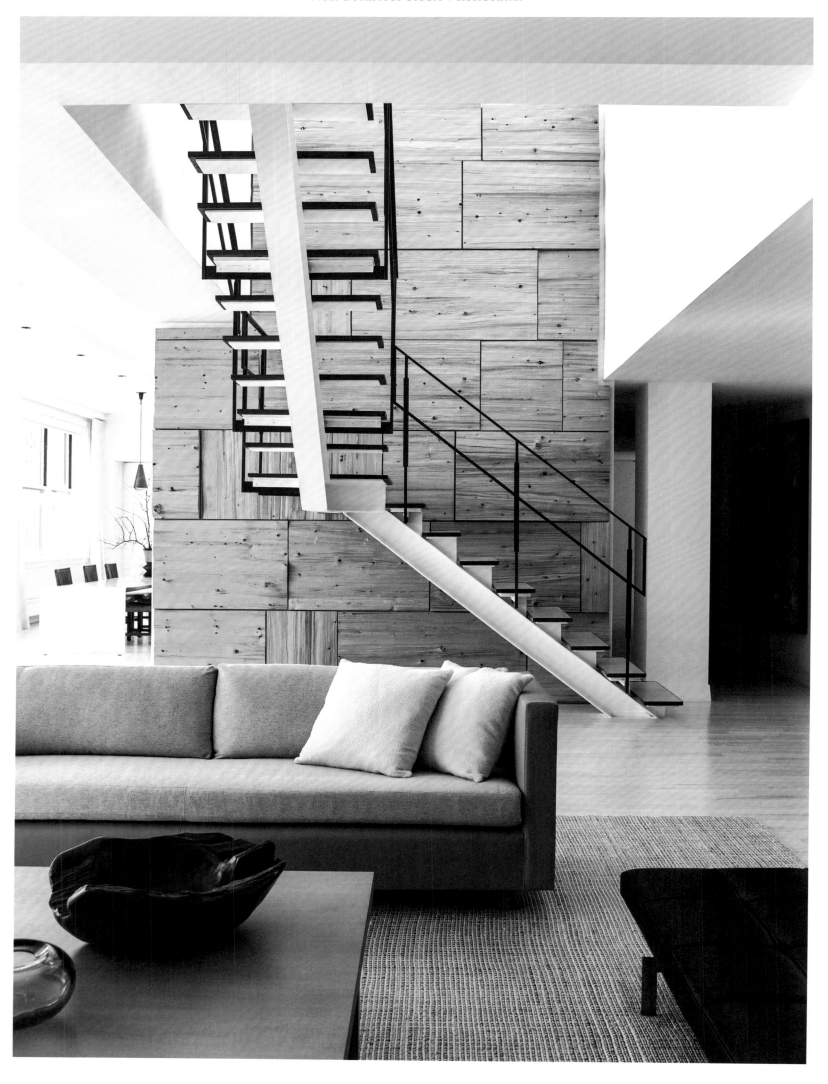

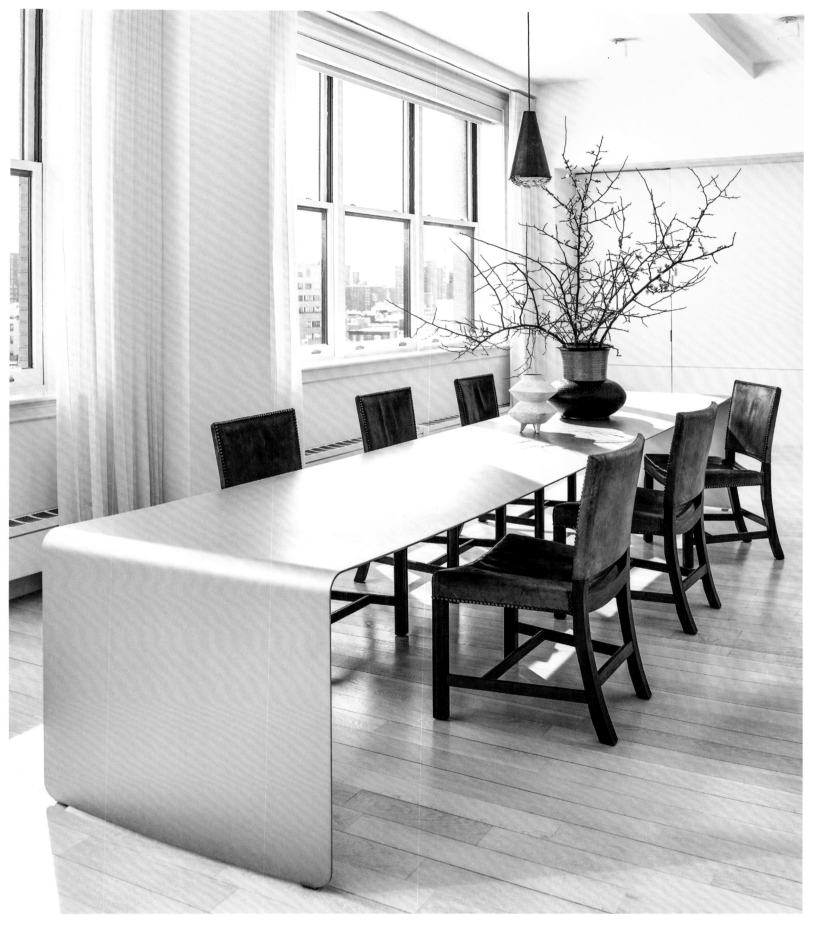

A New York loft with a stunning panorama: Neal Beckstedt created subtle accents and decked the wall with kiln-dried cypress wood running all the way up to the skylight.

Ein New Yorker Loft mit grandiosem Rundumblick: Neal Beckstedt setzt auf feine Akzente und verkleidete die Wand mit ofengetrocknetem Zypressenholz, das sich bis zum Dachfenster erstreckt.

Un loft newyorkais avec une vue panoramique grandiose : Neal Beckstedt mise sur les contrastes raffinés et a recouvert le mur d'un bois de cyprès séché au four qui s'étend jusqu'à la lucarne.

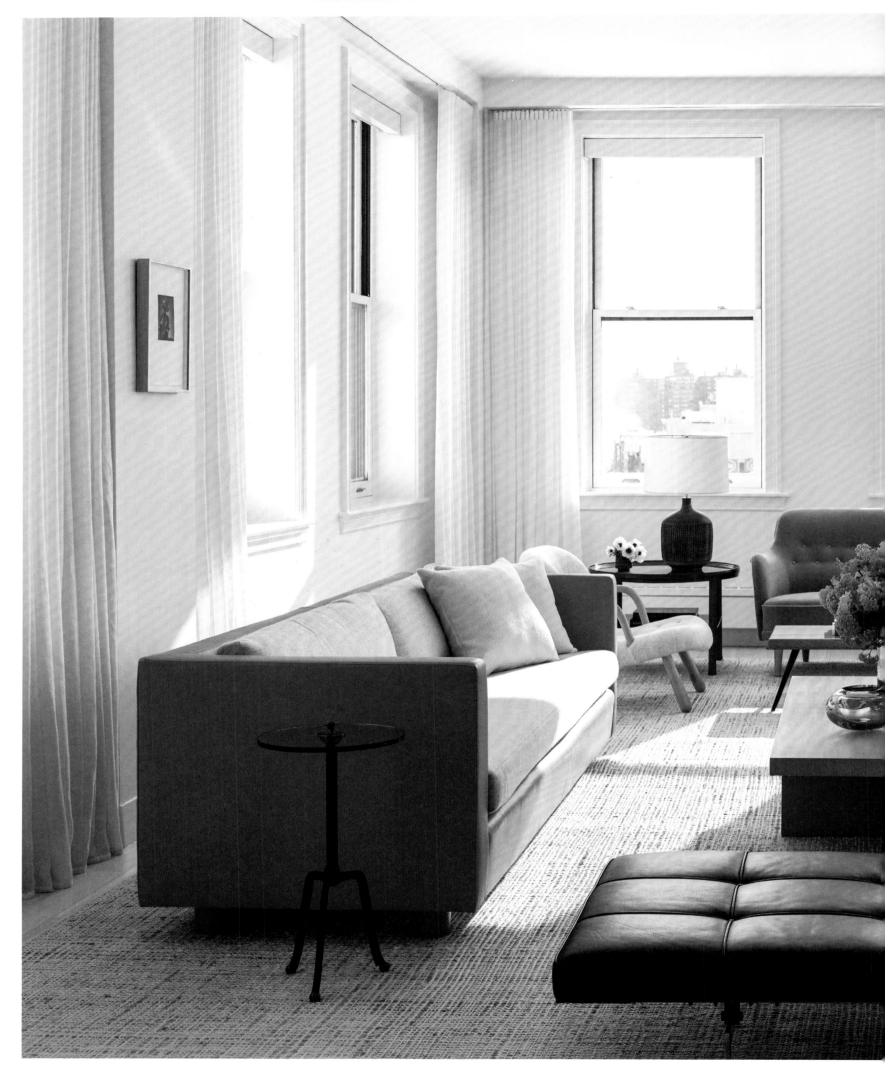

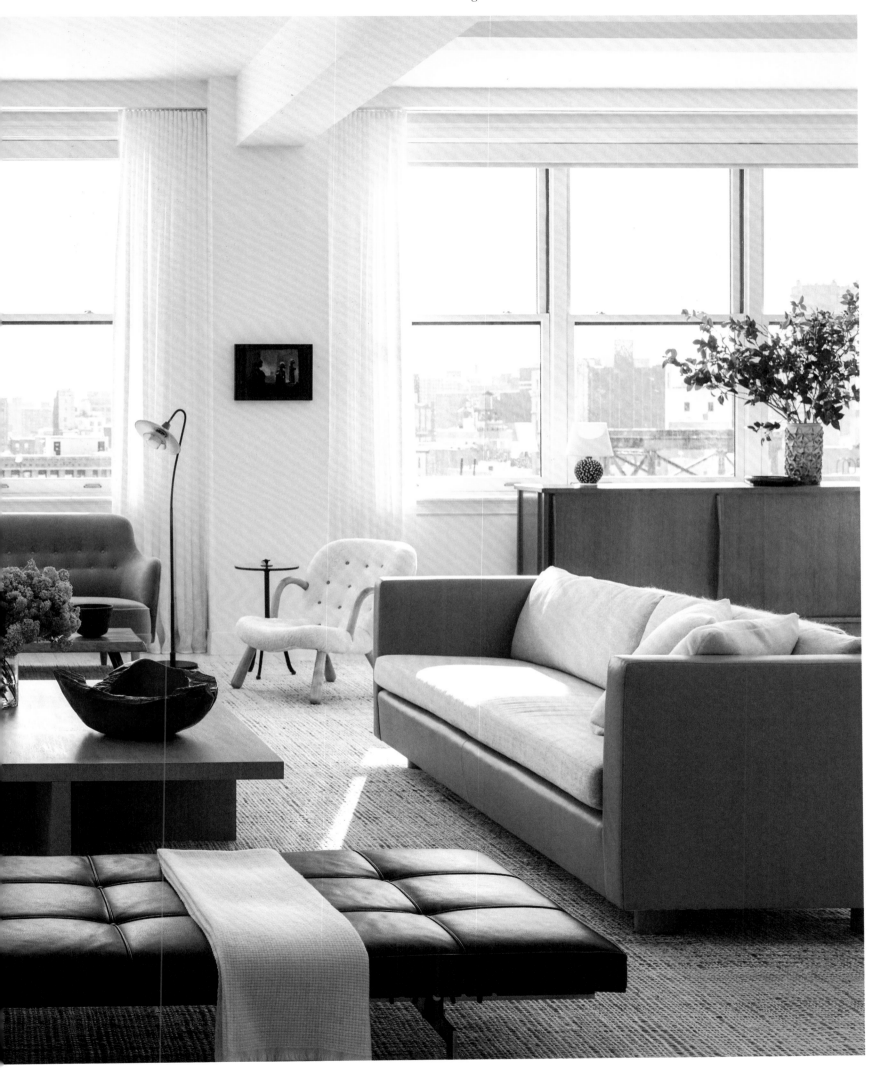

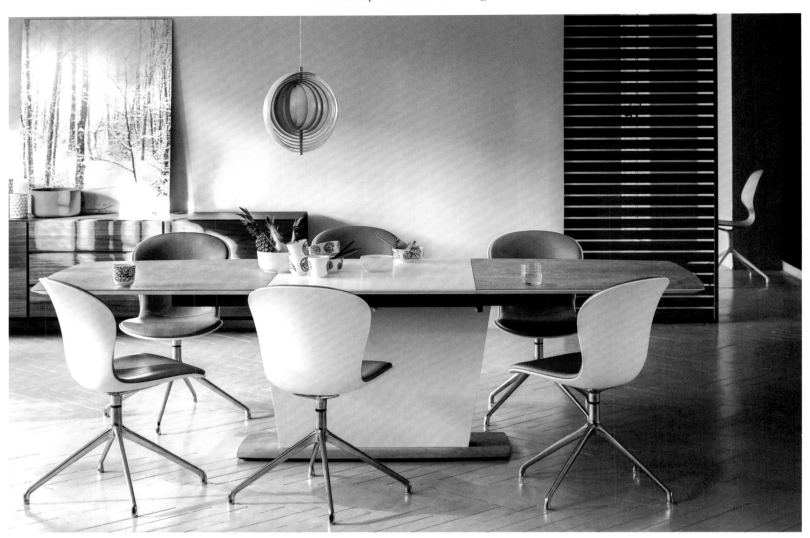

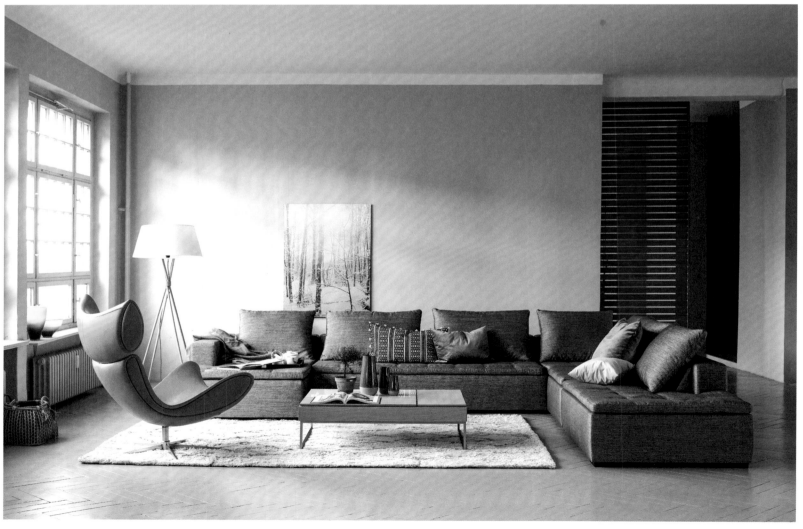

BOCONCEPT

Herning, Denmark

"Our style is simple without feeling cold and has been influencing interior design trends for years now."
„Unser Stil ist schlicht, ohne kühl zu wirken und prägt seit Jahrzehnten Einrichtungstrends."
« Notre style est simple sans être froid et marque depuis des décennies les tendances de la déco d'intérieur. »

In the beginning craftsmanship and youthful determination were all that Danish cabinet makers Jens Ærthøj and Tage Mølholm had. Their goal? To create furniture that was carefully crafted but had a simple, attractive design. That was back in 1952, in the Danish town of Herning, and the beginning of an unparalleled success story. Today BoConcept has almost 300 stores in more than 60 countries worldwide. Over the years the original items have been joined by tables, armchairs, chairs, shelving units, beds, and home accessories. A highlight of the range is the "Imola" statement armchair, celebrating its tenth anniversary this year. The fundamental idea behind the brand remains unchanged, with today's BoConcept range still comprising contemporary, high-end pieces that can easily be combined. Qualities that are typically Danish. The company regularly collaborates with international designers, including Karim Rashid who in 2012 created the leaf-shape "Ottawa" dining series to mark the 60th anniversary of the brand, winning the Red Dot Design Award in the process. "Adelaide" chairs, created for BoConcept by Danish designer Henrik Pedersen, are also iconic products, as is the "Mezzo" corner sofa (below left) supplied as various modular elements. The name "BoConcept", translating as "living concept", says it all.

Am Anfang waren ihre Handwerkskünste und jugendliche Entschlossenheit die einzigen Begleiter der beiden dänischen Tischler Jens Ærthøj und Tage Mølholm. Ihr Credo: Sie wollten Möbel bauen, die handwerklich hochwertig waren, gleichzeitig schnörkellos und formschön im Design. Das war 1952 in der dänischen Stadt Herning und der Start für eine beispiellose Erfolgsgeschichte. Heute ist BoConcept mit fast 300 Stores in mehr als 60 Ländern der Welt vertreten. Im Laufe der Jahre kamen zu den Möbeln der Anfangsjahre Tische, Sessel, Stühle, Regale, Betten und Wohnaccessoires hinzu. Ein Highlight der Kollektion ist der Statement-Sessel „Imola", der in diesem Jahr sein 10-jähriges Jubiläum feiert. Die Grundidee ist geblieben: Das BoConcept-Programm umfasst bis heute zeitgemäße, hochwertige Möbel, die sich untereinander gut kombinieren lassen – Eigenschaften, die

typisch dänisch sind. Regelmäßig arbeitet das Unternehmen mit internationalen Designern, beispielsweise Karim Rashid, der 2012 zum 60. Jubiläum das „Ottawa"-Esszimmer mit blattförmigen Stühlen entwarf und dafür den Red Dot Design Award gewann. Als moderne Klassiker gelten auch die „Adelaide"-Stühle (links oben), die der dänische Designer Henrik Pedersen für BoConcept entwarf, sowie das Ecksofa „Mezzo" (links unten), welches variabel kombinierbar ist. Übersetzt bedeutet „BoConcept" Wohnkonzept: der Name ist hier Programm.

Au début, leurs artisanats et leur détermination juvénile étaient le seul bagage des deux menuisiers danois Jens Ærthøj et Tage Mølholm. Leur crédo : ils voulaient construire des meubles d'une grande qualité artisanale, à la fois sans fioriture et esthétique. L'histoire de leur succès exemplaire a commencé en 1952 dans la ville danoise de Herning. Aujourd'hui, BoConcept est présent avec près de 300 magasins dans plus de 60 pays du monde entier. Au fil des années, des tables, des fauteuils, des chaises, des étagères, des lits et des accessoires de décoration ont rejoint les meubles des débuts. L'un des articles-phares de la collection est le fauteuil emblématique « Imola » qui fête cette année son 10ème anniversaire L'idée de base est restée : le programme BoConcept comprend aujourd'hui encore des meubles contemporains de qualité qui peuvent se combiner bien ensemble – des qualités typiquement danoises. Régulièrement, l'entreprise travaille avec des designers internationaux, par ex. Karim Rashid qui a dessiné en 2012, pour le 60ème Anniversaire la salle à manger « Ottawa » avec des chaises en forme de feuille et a gagné pour cela le Red Dot Design Award. Les chaises « Adelaide » (en haut à gauche) que le designer danois Henrik Pedersen a dessiné pour BoConcept et le canapé d'angle « Mezzo » (en bas à gauche) qui peut être combiné de multiples façons sont également considérés comme des classiques modernes. Si l'on traduit « BoConcept », cela signifie concept d'intérieur : le nom ici parle de lui-même.

MATTEO THUN
& PARTNERS

Milano, Italy

"Only if you dare to do something new, to cross borders, you can experience new knowledge."
„Nur wer wagt, etwas Neues zu machen, Grenzen zu überschreiten, kann neues Wissen erlangen."
« Seul celui qui ose faire quelque chose de nouveau, dépasser les frontières peut acquérir
de nouvelles connaissances. »

He has devised espresso cups; created lamps, designed sofas, and realized numerous hotels throughout Europe. Despite this, Matteo Thun, co-founder of the Memphis design group, does not like to be called a star. Working together with Antonio Rodriguez and a team of 70 architects and interior and product designers, his primary focus is on sustainability. The architect uses local materials and craftsmen, following what he describes as the "three zeros" principle—"This means using locally sourced materials that can be delivered to the construction site in 24 hours or less; have zero CO2 emissions; and generate zero waste," explains Thun, who operates an architecture and design studio with offices in Milan and Shanghai. In Italy Matteo Thun transformed the landmarked ruins of an old lung clinic on a private island off Venice into the elegant, light-filled 5-star JW Marriott Venice Resort + Spa Hotel. Inside the old walls the architect installed box-like rooms with glass façades that provide views of the original structure. It was possible to leave the layout of the former hospital with its wide corridors and glass doors largely untouched. The only architectural change to the building is the rooftop terrace with its infinity pool and panoramic restaurant with a view across the lagoon to St. Mark's Square.

Er hat Espressotassen entworfen, Lampen kreiert, Polstermöbel designt und zahlreiche Hotels in ganz Europa realisiert. Trotzdem will Matteo Thun, Mitbegründer der Designgruppe Memphis, sich nicht als Star verstanden wissen. Zusammen mit Antonio Rodriguez und einem Team aus 70 Architekten, Interior- und Produktdesignern fühlt er sich vor allem dem Thema Nachhaltigkeit verpflichtet. Der Architekt arbeitet mit lokalen Materialien und Handwerksbetrieben und folgt dem Prinzip der „three zeros": „Dies bedeutet den Einsatz lokal gewonnener Materialien, deren Anlieferung zur Baustelle nicht länger als 24 Stunden dauert und die null CO2 sowie null Abfall generieren", erklärt Thun, der in Mailand und Shanghai ein Architektur- und Designstudio betreibt. In Italien verwandelte Matteo Thun die denkmalgeschützten Ruinen eines ehemaligen Lungensanatoriums auf einer Privatinsel vor Venedig in das elegante und lichtdurchflutete Fünf-Sterne-Hotel JW Marriott Venice Resort + Spa. Der Architekt setzte in vorhandene Gebäudestrukturen kubische Räume mit Glasfassaden, die den Blick auf die ursprüngliche Bausubstanz freigeben. Das ehemalige Krankenhaus mit seinen großzügigen Gängen und Glastüren konnte von der Aufteilung weitestgehend belassen werden – nur die Rooftop-Terrasse mit Infinity-Pool und Panorama-Restaurant sind architektonischer Neueingriff. Von hier oben aus zoomt sich der Blick der Gäste direkt auf die Lagune und den Markusplatz.

Il a dessiné des tasses à expresso, créé des lampes, conçu des meubles capitonnés et a réalisé de nombreux hôtels dans toute l'Europe. Cependant, Matteo Thun, cofondateur du groupe de design Memphis, ne se considère pas comme une star. En collaboration avec Antonio Rodriguez et une équipe de 70 architectes, d'architectes d'intérieurs et de designers de produits, il ressent notamment une forte responsabilisé dans le domaine de la durabilité. L'architecte travaille avec des matériaux locaux et des entreprises d'artisans et respecte le principe des « three zeros ». « Cela signifie utiliser des matériaux locaux dont la livraison jusqu'au chantier ne dure pas plus de 24 heures et qui génèrent zéro CO2 et zéro déchets », a déclaré Thun qui possède un studio d'architecture et de design à Milan et Shanghai. En Italie, Matteo Thun a transformé les ruines classées monument historique d'un ancien sanatorium pulmonaire sur une île privée devant Venise en l'élégant hôtel cinq étoiles baigné de lumière JW Marriott Venice Resort + Spa. L'architecte a utilisé dans les structures du bâtiment des espaces cubiques avec des façades en verre qui donnent sur la substance originale des ouvrages. La disposition de l'ancien hôpital avec ses couloirs imposants et ses portes en verre a été largement conservée – les seules innovations architecturales sont la terrasse rooftop avec piscine Infinity et le restaurant panoramique. Vu d'en haut, le regard des clients s'étend sur la lagune et la place Saint-Marc.

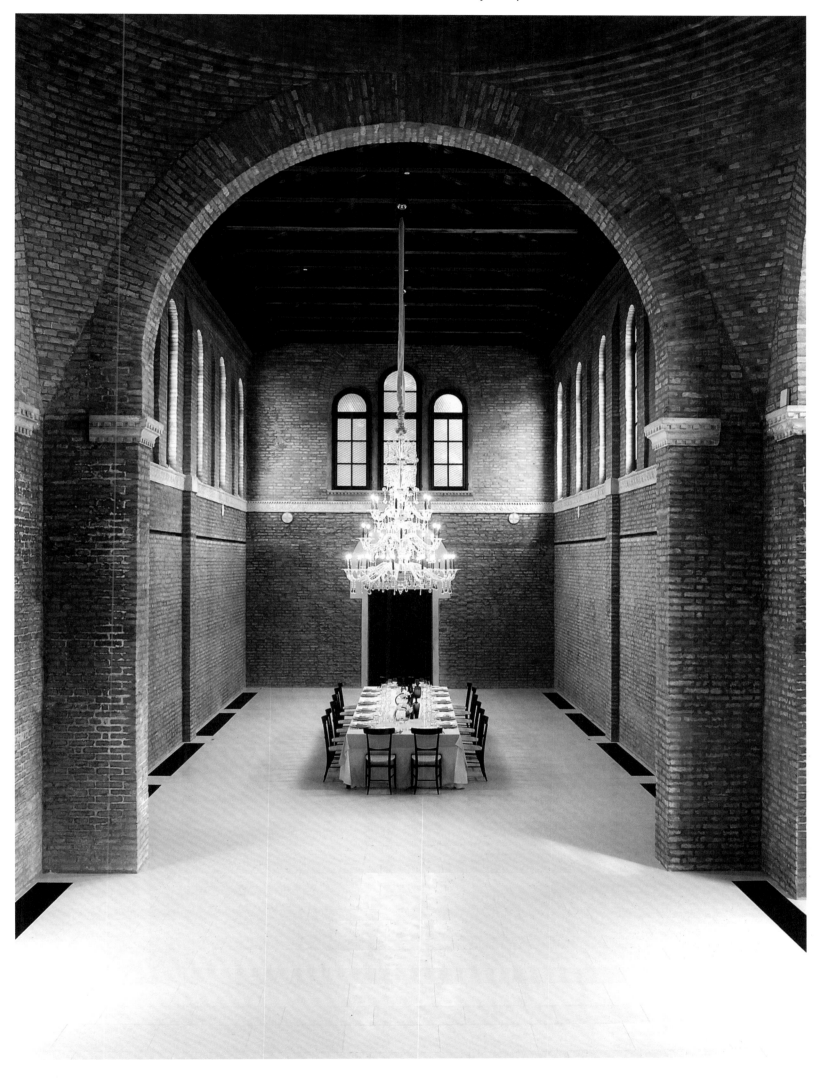

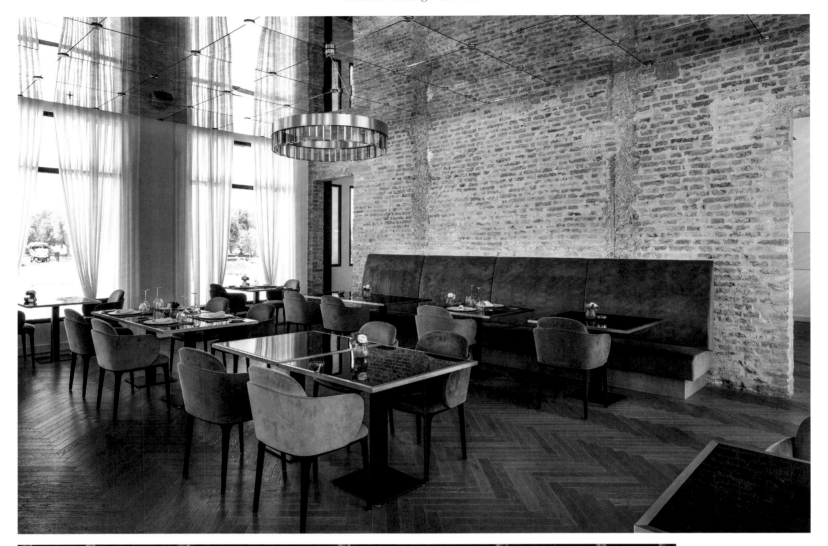

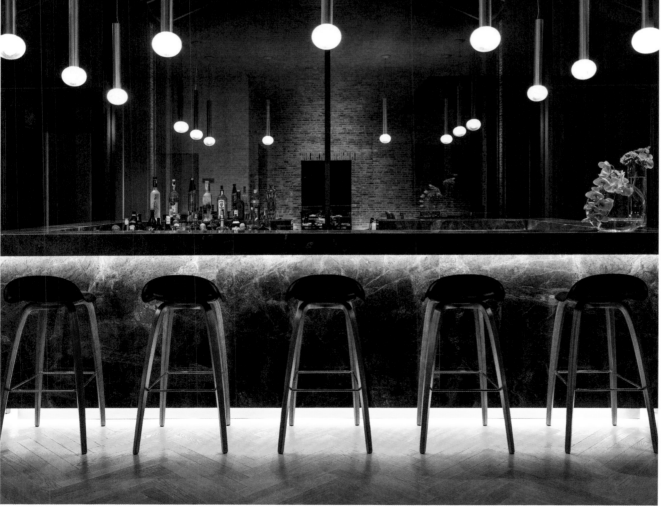

Italy's coastal area provided the inspiration for the design scheme at the JW Marriott Venice Resort + Spa—aqua, beige, and white are the dominant colors. Only local materials were used for the project.

Die Küstenregion Italiens als optisches Vorbild: im JW Marriott Venice Resort + Spa dominieren Aqua-, Beige- und Weißtöne. Verbaut wurden ausschließlich Materialien aus dem Umland.

La région côtière de l'Italie comme modèle visuel : au JW Marriott Venice Resort + Spa, les tons aqua, beige et blanc dominent. On a exclusivement utilisé des matériaux des environs.

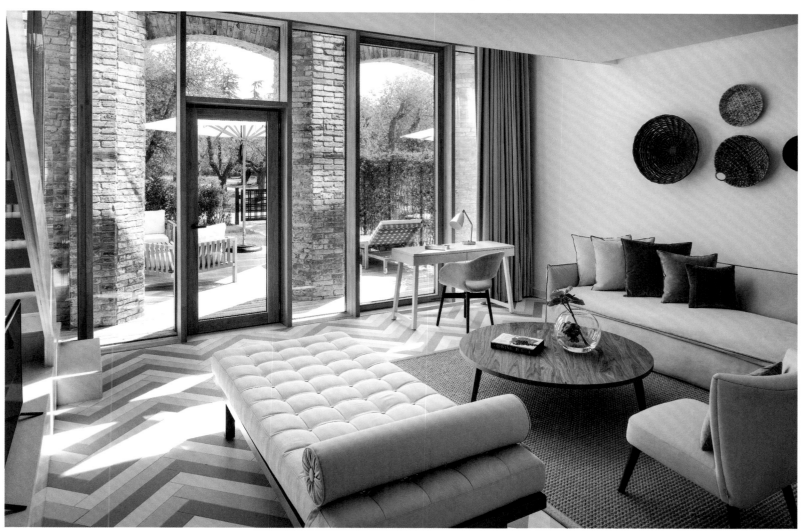

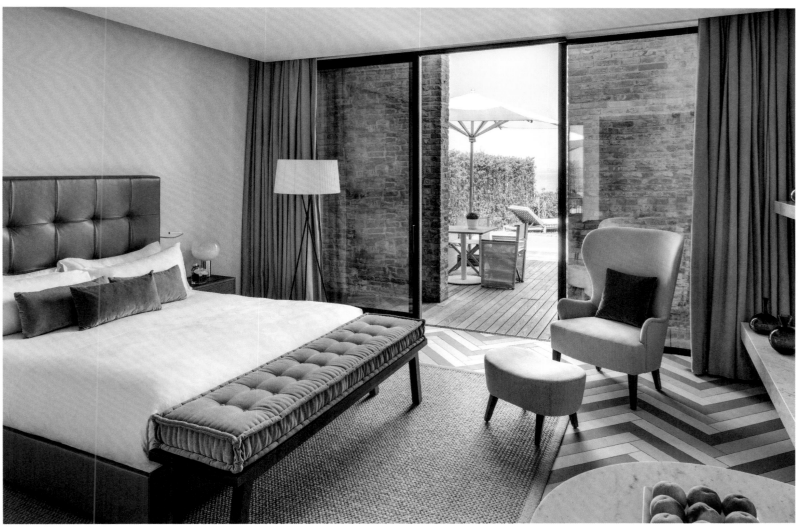

ARNOLD / WERNER
Munich, Germany

"We plan projects down to the last detail but without losing sight of the bigger picture."
„Wir durchdenken ein Projekt bis ins Detail, ohne das große Ganze aus den Augen zu verlieren."
« Nous réfléchissons aux moindres détails d'un projet sans perdre de vue l'ensemble. »

They have designed soccer team FC Bayern's Munich training center; renovated villas on Lake Starnberg; and provide prominent bar owner Charles Schumann with interior design advice. Sascha Arnold, Steffen Werner, and their eponymous Munich-based architectural office take a holistic approach. "We strive to achieve harmony; combining color with design and interpreting each project's context, surroundings, and individual preferences as if it were our first!" In just three months they transformed a run-of-the-mill store in downtown Munich into an atmospheric gourmet gelateria. The existing spaces were reconfigured to include warm materials such as brass; coral color blocks; and textured fabrics from Kvadrat. The architectural office used triangular-profile strips of ash wood painted on one side to clad the walls and counter. This creates an interesting effect that combines coral color and light ash wood, depending on which angle the cladding is viewed from. The architects' concept for the offices of the Munich design agency Fantomas incorporated the existing features, supplementing them with contemporary furnishings. The building, located in a complex built by Leo von Klenze, is directly adjacent to the Hofgarten Park. In the main room, fabric-covered panels provide visual warmth and good acoustics, while projecting wall lights emphasize the 4-meter (13-foot) high ceilings and are aligned to the large historic windows. The design won Sascha Arnold and Steffen Werner an Iconic Award and a German Design Award.

Sie haben für den FC Bayern das Münchener Leistungszentrum gestaltet, Villen am Starnberger See umgebaut, beraten Münchens prominenten Barbesitzer Charles Schumann als Interior Designer: Sascha Arnold und Steffen Werner stehen zusammen mit ihrem gleichnamigen Münchener Architekturbüro für einen ganzheitlichen Denkansatz: „Wir streben nach Harmonie, kombinieren Farben mit Design und interpretieren Kontext, Umgebung und individuelle Vorlieben jedes Mal neu!" Ein nüchtern wirkendes Ladengeschäft in der Münchener Innenstadt wandelten sie in nur drei Monaten in eine stimmungsvolle Gourmet-Gelateria um. Die Bestandsräume wurden neu gegliedert, warme Materialien wie Messing, korallfarbene, lackierte Flächen und strukturierte Stoffe von Kvadrat zogen ein. Wände und Theke verkleidete das Architekturbüro mit Eschenholzleisten, die einen dreieckigen Querschnitt aufweisen und einseitig farbig lackiert wurden. Je nach Betrachtungswinkel entsteht so ein interessanter Effekt aus einem Koralleton und hellem Eschenholz. Für die Büroräume der Münchener Designagentur Fantomas bezogen die Architekten den Bestand mit ein und ergänzten diesen durch eine moderne Einrichtung. Das Gebäude der Münchener Residenz wurde von Leo von Klenze erbaut und befindet sich direkt am Münchener Hofgarten. Im Hauptraum sorgen stoffbezogene Wandpaneele für optische Wärme und gute Akustik. Auskragende Wandleuchten betonen die Raumhöhe von knapp vier Metern und orientieren sich an den großen Bestandsfenstern. Sascha Arnold und Steffen Werner haben dafür den Iconic Award sowie den German Design Award bekommen.

Ils ont aménagé le centre de performance munichois du FC Bayern, des villas au bord du lac de Starnberger, ils ont également conseillé le célèbre propriétaire de bar de Munich Charles Schumann en tant que décorateurs d'intérieur : avec leur cabinet d'architectes éponyme à Munich, Sascha Arnold et Steffen Werner revendiquent ensemble une approche conceptuelle globale : « Nous recherchons l'harmonie, combinons les couleurs au design et réinterprétons à chaque fois le contexte, l'environnement et les préférences individuelles ! » En seulement trois mois, ils ont réussi à transformer une boutique d'aspect austère au centre-ville de Munich en une gelateria haut de gamme chaleureuse. Ils ont restructuré les espaces existants et y ont placé des matériaux chauds comme le laiton, des peintures corail et des tissus structurés de Kvadrat. Le cabinet d'architectes a recouvert les murs et le comptoir de planches en bois de frêne présentant une coupe triangulaire et peintes sur un côté. Selon l'angle de vue, la couleur rouille et le bois de frêne clair forment ainsi un effet intéressant. Dans les bureaux de l'agence de design Fantomas, les architectes ont conservé l'aménagement existant et l'ont agrémenté d'éléments modernes. Le bâtiment de la Résidence de Munich a été construit par Leo von Klenze et se trouve juste à côté du Hofgarten (jardin de la cour). Dans la salle principale, des panneaux muraux recouverts de bois apportent une chaleur visuelle et confèrent une bonne acoustique. Des lampes murales en saillie soulignent les quatre mètres de hauteur de la pièce et s'orientent sur les grandes fenêtres d'origine. Sascha Arnold et Steffen Werner ont reçu pour cela l'Iconic Award et le German Design Award.

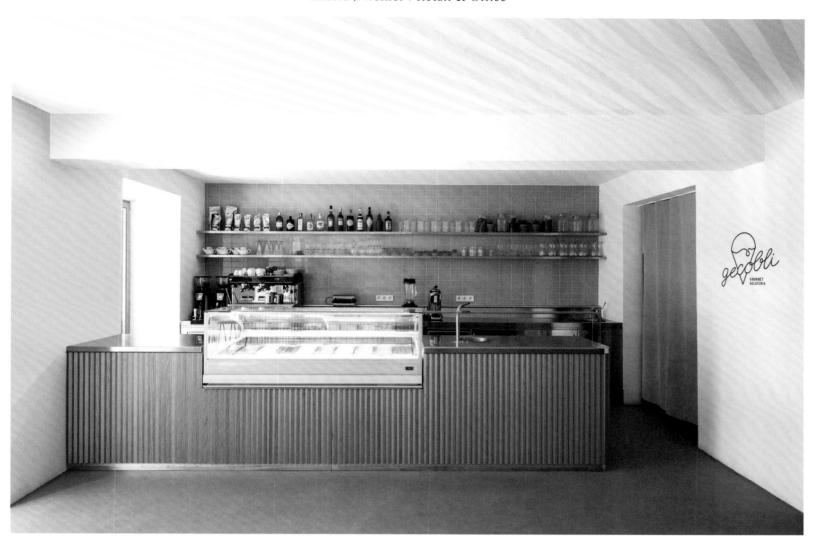

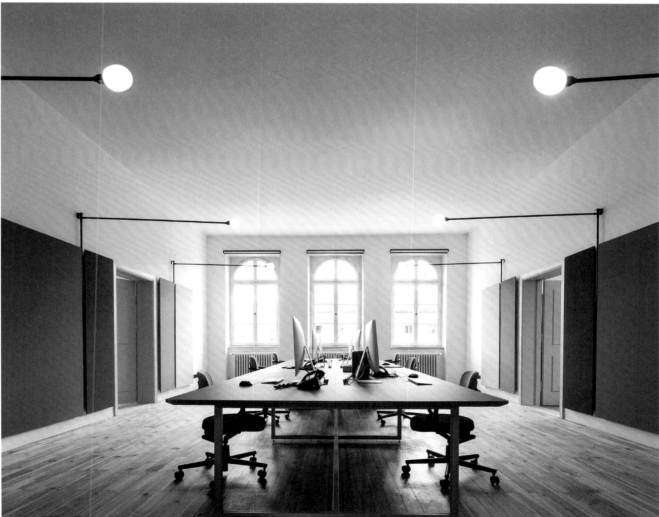

A light gray polished concrete floor contrasts with yellow stripes on the ceiling—the Munich ice cream parlor in a new look. Arnold / Werner handled the design, planning and conversion of a design agency's office.

Hellgrauer Spachtelboden kontrastiert von gelben Streifen an der Decke: die Münchener Eisdiele im neuen Look. Für das Büro einer Designagentur übernahm Arnold / Werner Entwurf, Planung sowie Umbau.

Le sol en béton ciré contraste avec les bandes jaunes du plafond : voici le nouveau look du glacier munichois. Arnold / Werner se sont chargés de l'ébauche, de la planification et de la transformation du bureau d'une agence de design.

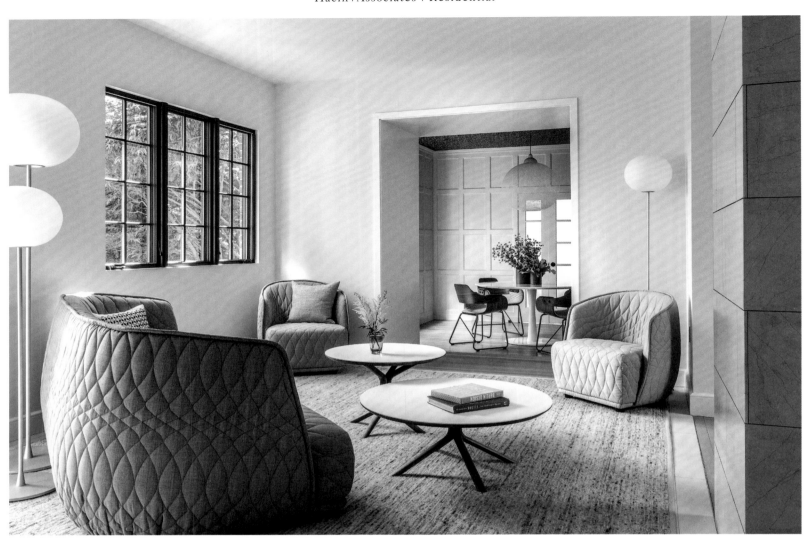

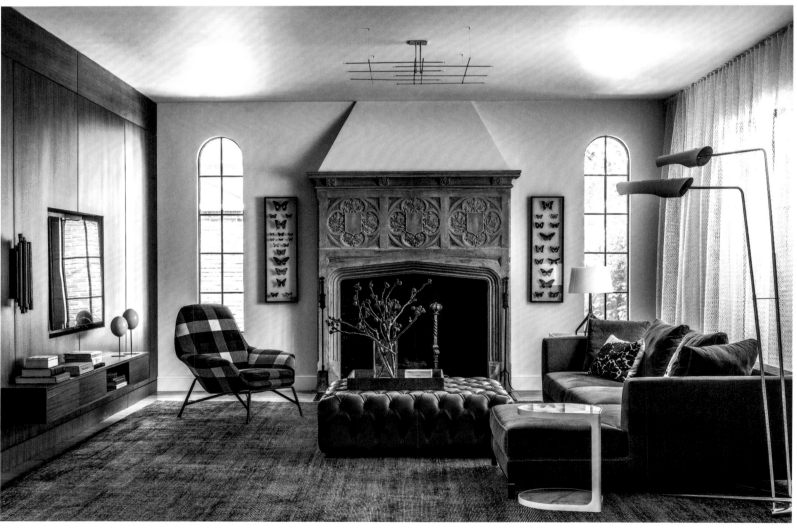

HACIN+ASSOCIATES
Boston, United States

"We believe that the best designed spaces have stories to tell."
„Wir glauben, dass Räume mit einem durchdachten Design Geschichten zu erzählen haben."
« Nous pensons que grâce à un design bien conçu, les espaces peuvent raconter des histoires. »

Landmark neighborhoods such as Beacon Hill; modern glass architecture; historic mills and warehouses—Boston is as diverse as it is exciting. David Hacin of the eponymous architecture and interior design firm, graduated from Princeton University and gained a Master of Architecture from the Harvard Graduate School of Design in Cambridge. Born in Switzerland, David says, "I feel as if New England's largest city has adopted me." Hacin+Associates, headquartered in the trendy SoWa Arts District, sees itself as an architectural practice rooted in Boston's historic traditions, but with a mission to be timeless, authentic, and courageous. "Architecture and interior design must work hand in hand," believes David, who has built up a team of more than 25 designers since founding the company in 1993. He defines his role as a creative director, orchestrating the best possible collaboration and balance between the architecture and interior design disciplines. H+A's focuses are many and varied. Whether single-family houses, lofts, offices, restaurants, hotels, or urban development concepts, David approaches every project with respect to telling meaningful stories about people and place. For example, together with his interior design team, he transformed a historic-revival 1930s Tudor-style home in

Newton, Massachusetts (left) from the original cramped and compartmentalized layout into an open and livable family home. Visual connections lead the eye from one room to the next, while seating areas with comfortable sofas and armchairs plus high-quality carpet and textiles create a warm and inviting atmosphere. Classic materials and hand-made features inform the successful design concept which maintains and updates the spirit of the home's Tudor identity.

Denkmalgeschützte Stadtteile wie Beacon Hill, moderne Glasarchitektur, historische Mühlen und Lagerhäuser am Wasser – Bostons Erscheinungsbild ist so vielseitig wie spannend. David Hacin vom gleichnamigen Architektur- und Designbüro ist ein Princeton-Absolvent und machte seinen Master of Architecture an der Harvard Graduate School of Design in Cambridge. Der gebürtige Schweizer sagt: „Ich fühle mich von der Metropole Neuenglands wie adoptiert." Hacin+Associates, dessen Räume im angesagten SoWa Arts District liegen, sieht sich in Bostons historischer Tradition verwurzelt und möchte als Architekturbüro zeitlos, authentisch und mutig sein. „Architektur und Innenarchitektur müssen Hand in Hand arbeiten", findet David und hat seit der

Gründung 1993 ein Team von über 25 Mitarbeitern aufgebaut. Sich selbst sieht er als Creative Director, der für die Zusammenarbeit und Balance zwischen den Disziplinen Architektur und Interior Design zuständig ist. Hacin+Associates Facetten sind vielseitig. Ob Einfamilienhäuser, Lofts, Büros, Restaurants, Hotels oder städtebauliche Konzepte: David geht an alle Projekte mit großem Respekt heran. Ein Tudorgebäude von 1930 in Newton, Massachusetts (links), das mit seinen unterteilten Zimmern streng und kleinteilig wirkte, verwandelten David und sein Team in ein informelles, offenes Familiendomizil. Blickachsen führen von einem Raum zum nächsten, Sitzinseln mit Sofas und Sesseln sowie hochwertige Teppiche und Textilien sorgen für Behaglichkeit. Klassische Materialien und gutes Handwerk gehen einen gelungenen Dialog ein.

Des quartiers classés monument historique tels que Beacon Hill, une architecture moderne en verre, des moulins historiques et des entrepôts au bord de l'eau – Boston est aussi diversifiée que captivante. David Hacin, du cabinet d'architecture et de design du même nom, a obtenu un diplôme à Princeton et son Master of Architecture à la Harvard Graduate School of Design à Cambridge. Le designer originaire de Suisse a déclaré : « Je me sens adopté par la métropole de Nouvelle-Angleterre. » Hacin+Associates dont les locaux se trouvent dans le célèbre SoWa Arts District se sent ancré dans la tradition historique de Boston et se veut un cabinet d'architecture atemporel, authentique et audacieux. « L'architecture et l'architecture d'intérieur doivent travailler main dans la main », considère David. Depuis la fondation du cabinet en 1993, il a rassemblé une équipe de plus de 25 collaborateurs. Il se considère lui-même comme un creative director qui est chargé de trouver la cohésion parfaite entre les disciplines d'architecture et d'*interior design*. Les facettes de Hacin+Associates sont variées. Qu'il s'agisse de maisons individuelles, de lofts, de bureaux, de restaurants, d'hôtels ou de concepts d'urbanisme : David aborde tous les projets avec un grand respect. David et son équipe ont transformé un bâtiment Tudor de 1930 à Newton, Massachusetts (à gauche) d'apparence stricte et morcelée avec ses pièces divisées en un domicile familial informé et ouvert. Des perspectives conduisent d'une pièce à l'autre, des îlots avec des canapés et fauteuils ainsi que des tapis et textiles de qualité apportent un grand confort. Des matériaux classiques et un artisanat de qualité entretiennent un dialogue réussi.

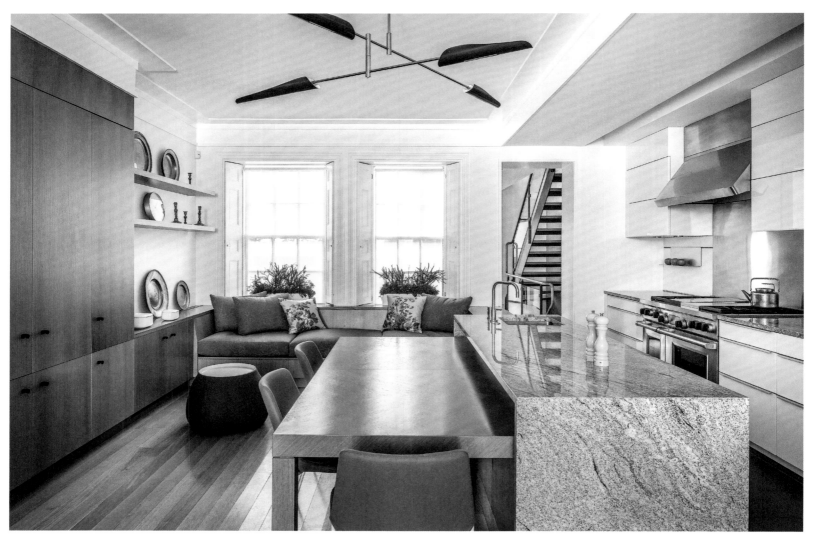

In Boston's Beacon Hill neighborhood, David Hacin renovated a 19th-century townhouse. The entry foyer introduces a steel and glass partition complementing the restored front door as a separation from the family room; in the kitchen the oak table has been integrated into the granite island.

In Bostons Viertel Beacon Hill sanierte David Hacin ein Townhouse aus dem 19. Jahrhundert. Im Foyer befindet sich ein Raumtrenner aus Glas und Stahl, in der Küche wurde der Eichentisch in einen Granitblock integriert.

Dans le quartier Beacon Hill de Boston, David Hacin a rénové une villa urbaine du XIXe siècle. Dans le foyer, un séparateur fait de verre et d'acier a été placé, dans la cuisine, la table en chêne a été intégrée dans un bloc de granit.

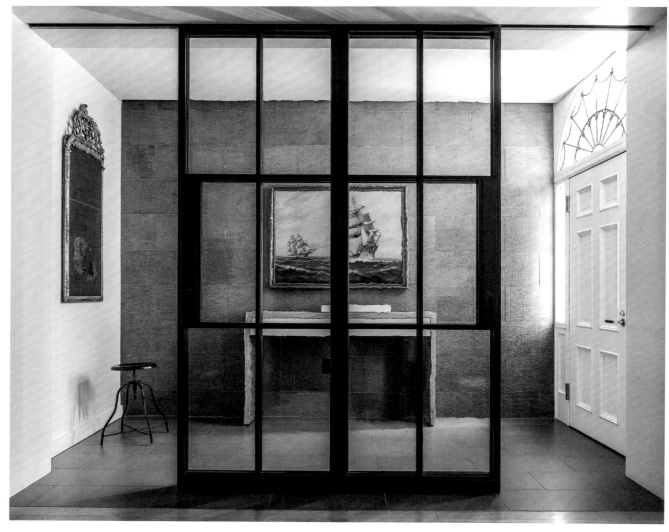

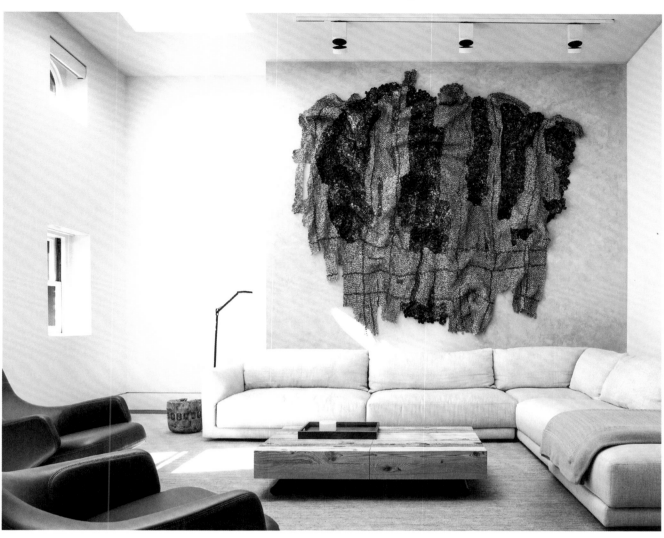

At the Public Garden Townhouse, built in 1848, the architects created a contemporary backdrop for the clients' art collection, including watercolors by American artist Wendy Artin and a John Koga bronze sculpture in the salon.

Im Public Garden Townhouse von 1848 schufen die Architekten einen modernen Rahmen für die Kunstsammlung, zu der Aquarelle der Amerikanerin Wendy Artin und eine Bronzeskulptur von John Koga gehören.

Dans la Public Garden Townhouse de 1848, les architectes ont créé un espace moderne pour la collection d'art qui compte des aquarelles de l'Américaine Wendy Artin et une sculpture en bronze de John Koga.

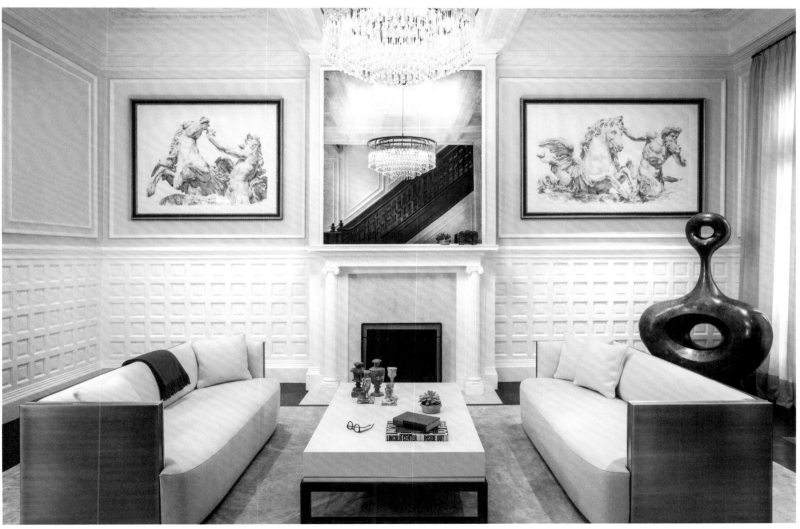

PARIS FORINO
New York City, United States

"I like to infuse my work with the grace and musicality of a ballet performance."
„Meine Arbeit vergleiche ich gerne mit der Anmut und Musikalität einer Ballettinszenierung."
« Je compare toujours mon travail à l'élégance et la musicalité d'une mise en scène de ballet. »

To speak of design and ballet in one breath may sound a little surprising given that the two are quite different. Yet to Paris Forino the relationship is clear, not only because she dreamt of being a ballet dancer as a child—and, indeed, was well on her way to being one—but also because she believes both disciplines express elegance, lightness and grandeur. Forino was born in Sydney, Australia. A trip to Paris shortly after finishing high school was destined to shape her future, "I was so inspired by its beauty and fabulous spaces. I knew there and then that I was going to be a designer," she says passionately. After graduating from the University of Technology in Sydney, Paris set off to Manhattan and gained experience at Tihany Design and Cetra Ruddy before opening her own design firm in 2012. She describes her aesthetic as being elegant, feminine and full of esprit, "Interior design is developing in a direction where the composition as a whole is understated and unpretentious—creating space for gorgeous details." A couple moving back to New York took an apartment in the historic Flatiron District and wanted that "wow" factor to complement the expansive vista (right). Paris thoughtfully crafted a luxurious interior with beautiful materials full of bespoke features.

Design mit Ballett zusammenzubringen – das mag auf den ersten Blick verwundern, handelt es sich doch um zwei sehr unterschiedliche Themenbereiche. Für Paris Forino ist die Verbindung dennoch offensichtlich. Nicht nur, weil sie während ihrer Kindheit davon träumte, Ballerina zu werden (und auch auf dem besten Weg dahin war) –, sondern weil beide Disziplinen für sie mit Eleganz, Leichtigkeit und Grandezza einhergehen. Paris Forino wurde in Sydney, Australien geboren. Eine Reise nach Paris, sie hatte gerade die Highschool beendet, drehte ihre Zukunft in die entscheidende Richtung: „Ich war so inspiriert von der Schönheit dieser Stadt und ihren großartigen Plätzen, dass ich noch dort beschloss, Designerin zu werden", schwärmt sie. Nach ihrem Studium an der University of Technology in Sydney ging Forino nach Manhattan, um bei Tihany Design und Cetra Ruddy Erfahrungen zu sammeln, bevor sie 2012 ihr eigenes Studio eröffnete. Ihren Stil beschreibt sie als elegant, feminin und voller Esprit: „Ich denke, Interior Design entwickelt sich in eine Richtung, die in der Gesamtkomposition leicht und unprätentiös wirkt, um prächtigen Details Raum zu geben!" Ein Paar, das zurück in die Stadt wollte und ein Apartment in New Yorks historischem Flatiron District bezog, wünschte sich einen Wow-Effekt entsprechend der gigantischen Aussicht (rechts). Paris Forino schuf ein luxuriöses Interior mit maßgefertigten Details.

Comparer le design et le ballet, cela peut sembler étranger au premier regard, il s'agit en effet de deux domaines très différents. Cependant, leur lien est évident pour Paris Forino. Non seulement parce qu'elle rêvait de devenir ballerine lorsqu'elle était enfant (et était sur le point de le devenir) mais également parce que les deux disciplines impliquent pour elle élégance, légèreté et grandezza. Paris est née à Sydney, Australie. Un voyage à Paris, juste après la fin du lycée, lui a montré la voie de son avenir : « J'ai été tellement inspirée par la beauté de cette ville et ses places magnifiques que c'est là-bas que j'ai décidé que j'allais devenir designeuse », s'enthousiasme-t-elle. Après des études à l'University of Technology à Sydney, Paris Forino a déménagé à Manhattan pour travailler chez Tihany Design et Cetra Ruddy avant d'ouvrir sa propre agence en 2012. Elle décrit son style comme élégante, féminine et malin : « Je pense que l'*interior design* évolue dans une direction lui permettant de paraître simple et discret dans l'ensemble de la composition afin de laisser de la place aux détails majestueux ! » Un couple qui voulait retourner en ville et a acheté un appartement dans Flatiron, un quartier historique de New York, voulait un effet marquant en harmonie avec la vue gigantesque (à droite). Paris Forino a crée un intérieur luxueux avec des détails sur mesure.

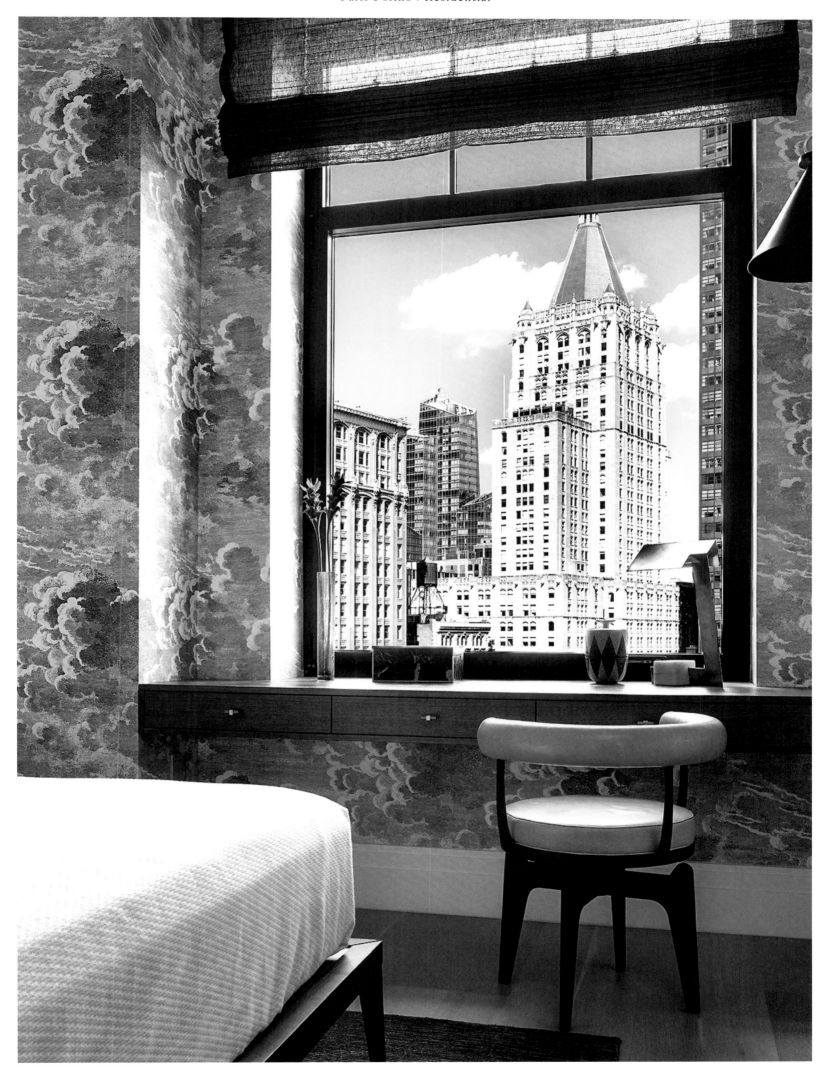

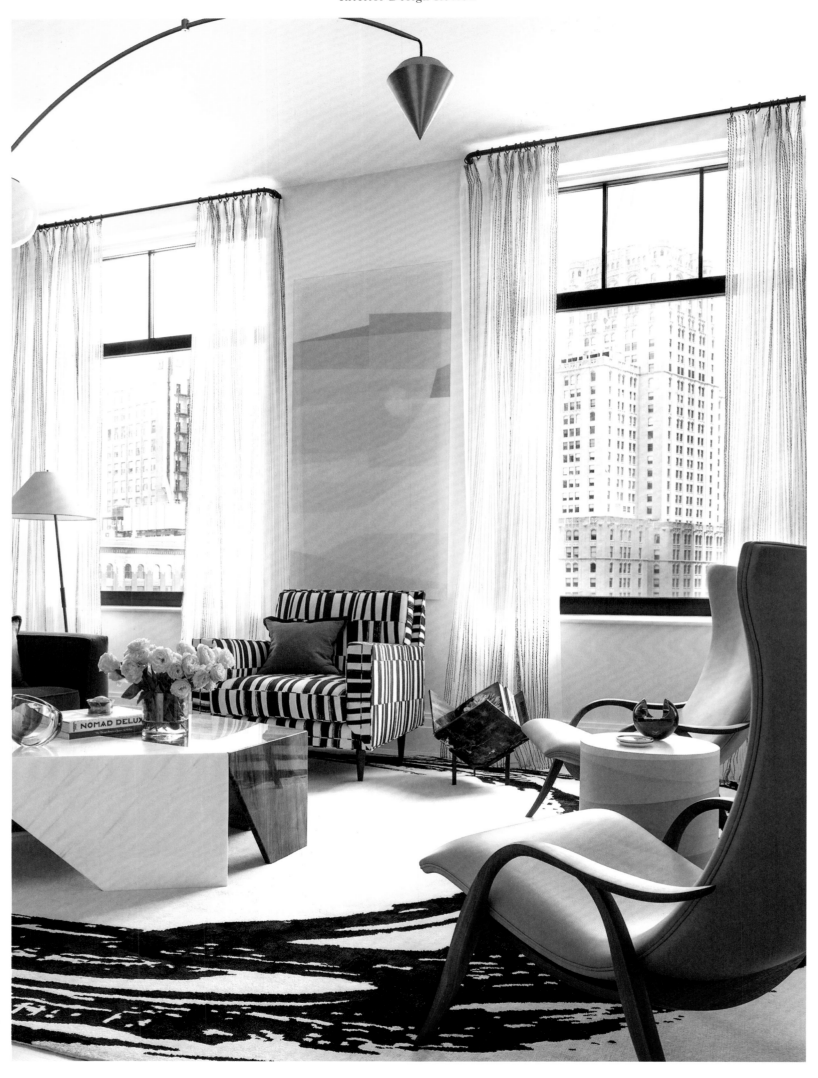

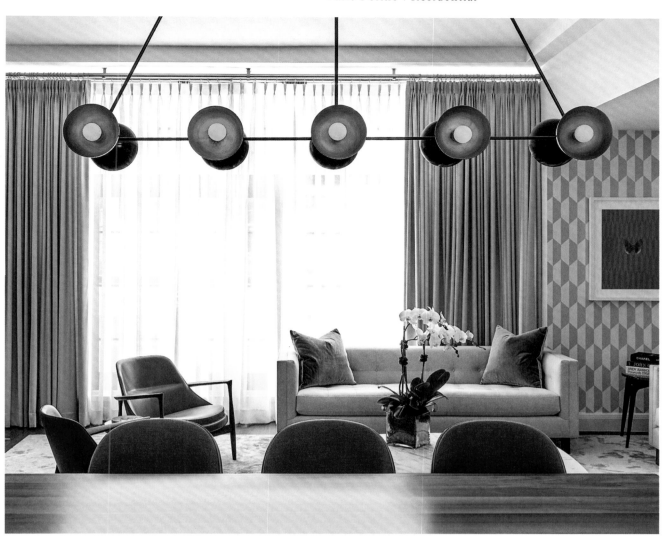

Paris Forino selected Fornasetti wallpapers, cashmere cover fabrics and hand-knotted silk carpets for a newly married couple with a desire for luxurious textures (left and bottom left).

Für ein frisch vermähltes Paar, das sich feine Texturen wünschte, wählte Paris Forino Tapeten von Fornasetti, Bezugsstoffe aus Kaschmir und handgeknüpfte Seidenteppiche (links und links unten).

Pour un couple de jeunes mariés qui souhaitaient des textures fines, Paris Forino a choisi des tapisseries de Fornasetti, des tissus de revêtement en cashmere et des tapis de soie noués à la main (à gauche et en bas à gauche).

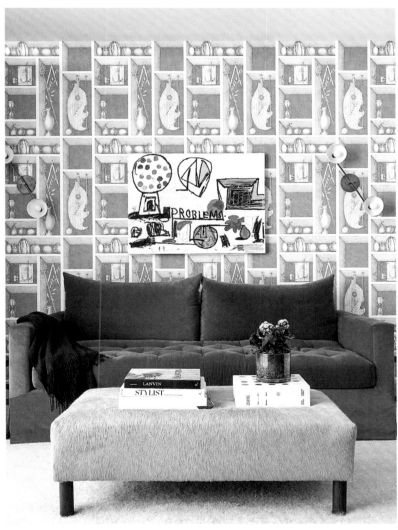

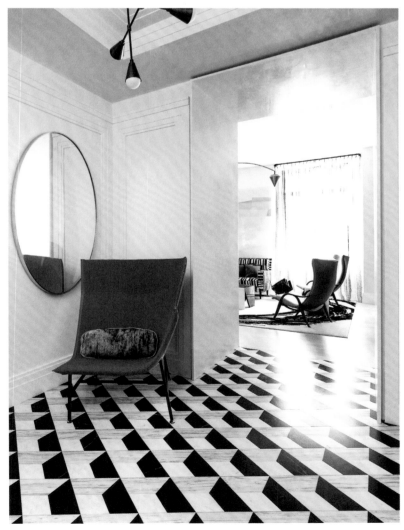

ELKUS MANFREDI
Architects
Boston, United States

"Our work is like a guided voyage of discovery—always personal and focused on the client."
„Unsere Arbeit ist wie eine geführte Entdeckungsreise: stets individuell, dem Kunden zugewandt."
« Notre travail ressemble à un voyage organisé de découverte : il est toujours personnalisé, axé sur le client. »

Diversity as a leitmotif, clients located around the globe: Boston-based design firm Elkus Manfredi Architects plans hotels, corporate headquarters, and residential towers for new communities. David Manfredi and Howard Elkus founded the firm in 1988 with the view that architecture and interiors are team players that generate important synergies. With that in mind, their first employee was Elizabeth Lowrey, a designer who became one of the firm's Principals. "Although it takes courage to throw preconceived ideas overboard, it makes the final outcome more authentic," she explains. In Quincy, south of Boston, the team designed Meriel Marina Bay, an apartment complex (right page, top and bottom left) inspired by the light and water, where carefully curated spaces serve as functional vignettes, and where island-like seating provides salient views of the marina beyond. For Sepia, a condominium development in Boston (right page, top), Elkus Manfredi partners the industrial heritage of the neighborhood with an upscale, contemporary, hospitality-inspired experience. A sense of ease and understated sophistication exists for the headquarters of retail developer WS Development (right page, bottom), by combining an urban aesthetic with the use of reclaimed and artisanal woods.

Vielseitigkeit als Leitmotiv, Auftraggeber, die über die ganze Welt verteilt sind: Das in Boston ansässige Büro Elkus Manfredi Architects plant Hotels, Firmenzentralen und Wohnhochhäuser für neue Communitys. Dass Architektur und Innenarchitektur entscheidende Teamplayer sind und wichtige Synergien bilden, war für David Manfredi und Howard Elkus, die ihr Büro 1988 gründeten, immer selbstverständlich. Im einst jungen Unternehmen nahmen sie deshalb Elizabeth Lowrey als erste Angestellte mit ins Boot. Die Innenarchitektin ist inzwischen Teilhaberin und für den Bereich Interior Design zuständig. Ihr Ansatz: alle Beteiligten eines Projektes sollen neugierig sein. „Es benötigt zwar Mut, vorgefertigte Bilder über Bord zu werfen, aber das Ergebnis ist am Ende wesentlich authentischer", erklärt die Kreative. In Quincy, südlich von Boston, realisierte das Team die Meriel Marina Bay, einen Jachthafen mit Apartments (rechte Seite, links

oben und unten). Licht und Wasser standen Pate für das zurückhaltende Interior. Loungemöbel wurden als Inseln im Raum mit Blick auf die Marina installiert. Für das Sepia, einen Komplex mit Eigentumswohnungen im South End in Boston (rechte Seite oben), wurde das industrielle Erbe des Stadtteils mit einem exklusiven, zeitgenössischen Ambiente kombiniert. In der Zentrale von WS Development (rechte Seite, unten) brachten Elkus Manfredi Architects ein Gefühl der Ruhe und schlichte Eleganz zum Ausdruck: Eine urbane Formensprache, gepaart mit aufgearbeitetem Altholz, bestimmten hier das Design.

La diversité pour leitmotiv, des donneurs d'ordres dans le monde entier : le bureau Elkus Manfredi Architects, installé à Boston, planifie des hôtels, des centrales d'entreprise et des immeubles résidentiels pour des nouvelles communautés. Pour David Manfredi et Howard Elkus, qui ont fondé leur bureau en 1988, il a toujours été évident que l'architecture et l'architecture intérieure forment une équipe et créent des synergies importantes. Pour cette raison, ils ont pris à bord Elizabeth Lowrey en tant que première salariée de l'entreprise alors tout juste fondée. L'architecte d'intérieur est depuis actionnaire et responsable du département d'*interior design*. Leur approche : tous les personnes impliquées dans un projet doivent être curieuses. « Certes, du courage est nécessaire pour jeter par dessus bord les images préconçus mais le résultat est bien plus authentique au final », explique la créatrice. À Quincy, au sud de Boston, l'équipe a réalisé la Meriel Marina Bay, un port de plaisance avec des appartements (page de droite, en haut et en bas à gauche). La lumière et l'eau s'imposent face à l'intérieur discret. Les meubles lounge ont été installés sous forme d'îlots avec vue sur la marina. Pour le complexe Sepia avec des appartements en propriété au sud de Boston (page de droite, en haut), l'héritage industriel du quartier a été combiné à une ambiance contemporaine exclusive. Dans la centrale de WS Development (page de droite en bas), Elkus Manfredi Architects a exprimé un sentiment de calme et une élégance simple : un langage formel urbain, allié à du bois ancien travaillé, déterminent ici le design.

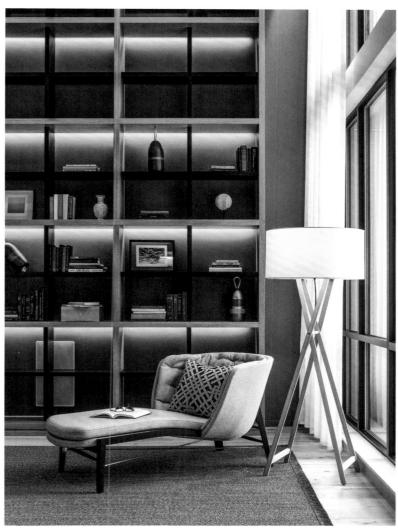

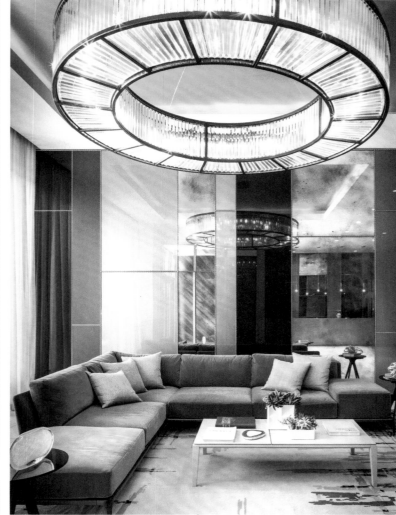

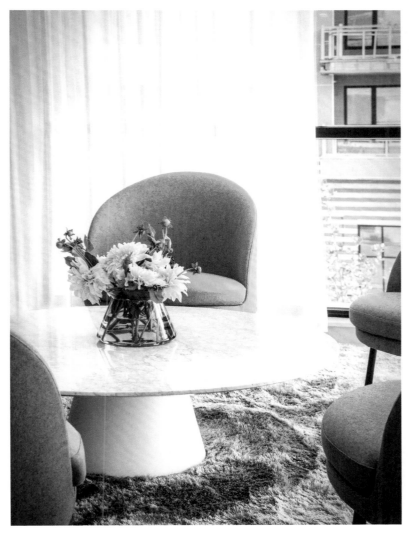

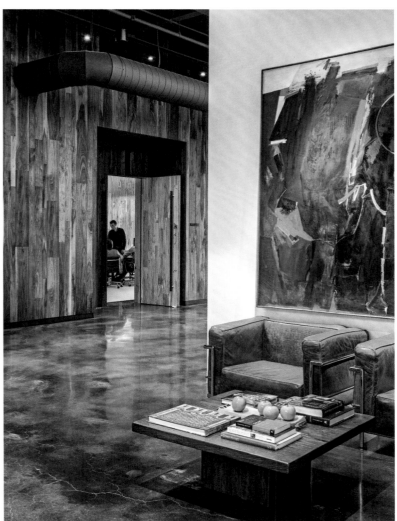

WESTWING
Munich, Germany

"We have a creative soul and aim to offer both classics and trend pieces."
„Wir haben eine kreative Seele und möchten Klassiker ebenso anbieten wie Trendpieces."
« Nous avons une âme créative et souhaitons proposer aussi bien des articles classiques que tendance. »

With its elegant armchairs the meeting room is reminiscent of the simple chic of a Parisian hotel; the cafeteria wouldn't look out of place in a Scandinavian design house—but both are actually located on shopping club Westwing's business premises and reflect founder Delia Fischer's personal style. In 2011 the native of Munich, who has an excellent instinct for eclectic materials and styles, quit her job as a fashion and interiors editor to embark on the adventure of setting up her own company. She has been sharing her love of contemporary style mixes with the world ever since. The business entrepreneur's philosophy is that "With the right home accessories, anyone can transform their home without having to spend a fortune!". Her shopping community website not only offers furniture and accessories at attractive prices but also provides a wide range of interior design ideas and inspiration. So what is Delia's personal preference? She loves a mix of "eclectic, cozy, and experimental". Her historic Munich apartment has super-high ceilings and is painted in a soft gray shade from the Anna von Mangoldt collection. The dining room is dominated by a large, marble-top table—Delia loves to entertain lots of guests. The living room, in contrast, has a cozy vibe with a Beni Ourain-look Moroccan rug combined with a generous sofa and a pair of 1960's inspired cocktail chairs. She particularly likes their green velvet upholstery, saying "There is no other fabric like it—it's elegant but cozy at the same time!"

Der Meeting-Raum mit seinen eleganten Fauteuils erinnert an den unkomplizierten Chic eines Pariser Hotels, die Kantine könnte ebenso in einer skandinavischen Designschmiede untergebracht sein: beide gehören zu den Geschäftsräumen des Shopping-Clubs Westwing und tragen die Handschrift von Gründerin Delia Fischer. Die Münchnerin hat mit ihrem feinen Gespür für Material- und Stilmix 2011 ihren Job als Mode- und Wohnredakteurin gegen das Abenteuer eines Start-ups getauscht und den Spaß am modernen Stilmix seither in die Welt getragen. „Jeder kann mit den richtigen Wohnaccessoires den Look verändern, ohne sich dabei in Unkosten stürzen zu müssen!", lautet das Credo der Unternehmerin. Auf ihrer Shopping-Community bietet sie nicht nur Möbel und Accessoires zu attraktiven Preisen an, sondern zeigt vielfältige Ideen und Inspirationen rund ums Wohnen. Und privat? Liebt sie die Mischung „eklektisch, gemütlich und experimentell". Ihre Münchener Altbauwohnung mit extra hohen Decken hat Delia in einem zarten Grauton aus der Kollektion Anna von Mangoldts gestrichen. Im Esszimmer dominiert ein großer Tisch mit Marmorplatte – die Kreative bewirtet gerne viele Gäste. Im Wohnzimmer hingegen sorgt ein Teppich im Beni-Ourain-Look für Behaglichkeit zusammen mit dem üppigen Sofa und den beiden Cocktailsesseln im 60s-Look. Delia Fischer mag vor allem deren grünen Veloursbezug: „Es gibt keinen Stoff, der gleichermaßen elegant und gemütlich ist!"

Avec ses fauteuils élégants, la salle de réunion rappelle l'élégance simple d'un hôtel parisien, la cantine semble sortir tout droit d'un studio de design scandinave : elles font partie toutes les deux des bureaux du club de shopping Westwing et portent la signature de la fondatrice, Delia Fischer. Grâce à son sens inné pour le mélange de matières et de styles, la Munichoise a troqué en 2011 son poste de rédactrice de mode et d'habitat contre l'aventure start-up et transmet depuis au public le plaisir d'un mélange moderne de styles. « Avec les bons accessoires, nous pouvons tous changer de style sans dépenses inconsidérées ! », tel est le crédo de l'entrepreneuse. Dans sa communauté de shopping, elle propose non seulement des meubles et des accessoires à des prix attrayants mais également des idées variées et inspirantes pour l'aménagement d'intérieur. Et dans le privé ? Elle aime les mélanges « éclectiques, confortables et expérimentaux ». À Munich, Delia a repeint son appartement ancien aux plafonds très hauts dans un ton gris pastel de la collection d'Anna von Mangoldt. Dans la salle à manger, une grande table avec plateau en marbre domine – la créatrice aime recevoir des grandes assemblées d'invités. Dans le séjour, en revanche, un tapis dans le look Beni Ourain apporte un grand confort, allié au généreux canapé et aux deux fauteuils cocktail dans le look des années 60. Delia Fischer aime notamment leur revêtement en velours vert :« Il n'y a pas de tissu à la fois aussi élégant que confortable ! »

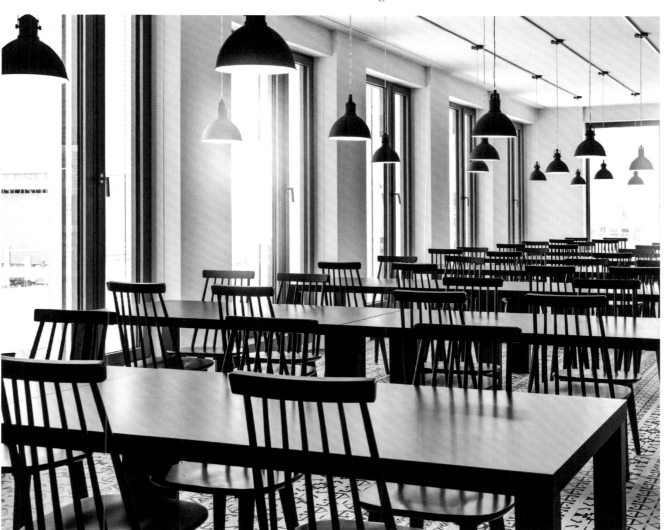

Westwing's Munich cafeteria has a light, pared-back look, while every meeting room has its own unique interior design concept designed to reflect the wide range of styles offered by the successful shopping club.

Die Kantine bei Westwing in München wirkt licht und reduziert, die unterschiedlich dekorierten Meeting-Räume spiegeln die Wohnwelten des erfolgreichen Shopping-Clubs in seiner ganzen Bandbreite.

La cantine de Westwing semble simple et minimaliste, les salles de réunion aux décors variés reflètent toute la palette d'univers d'aménagement du club de shopping à succès.

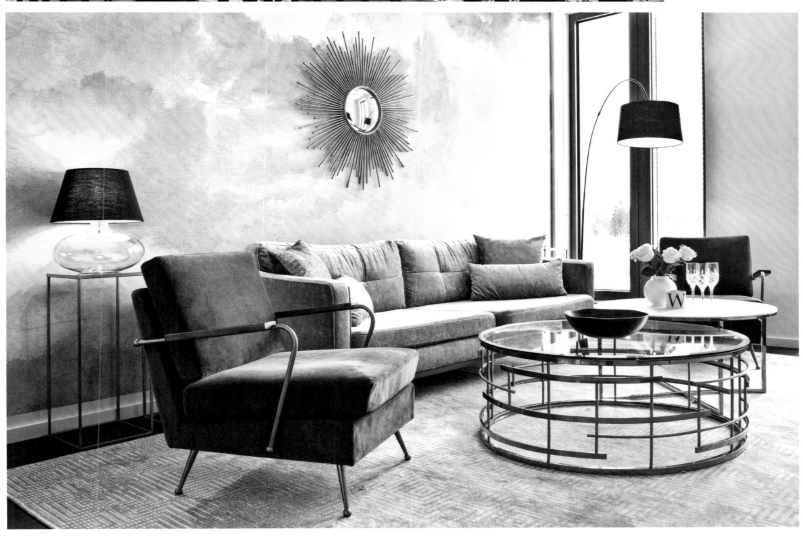

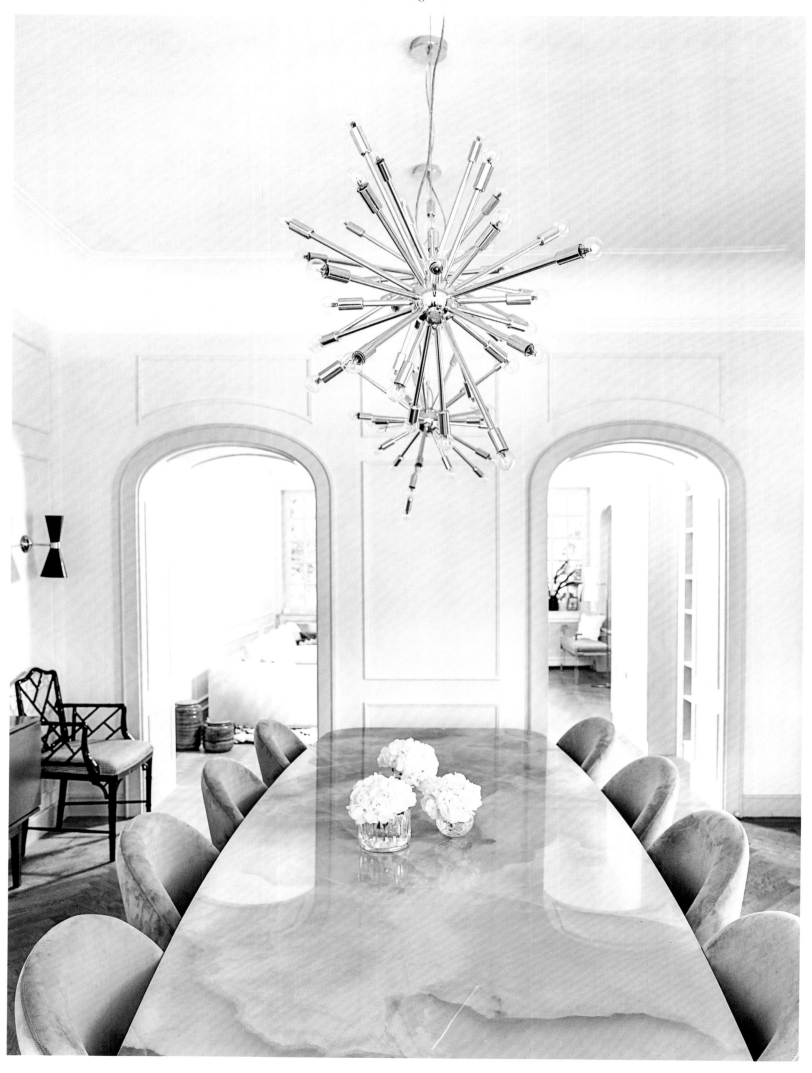

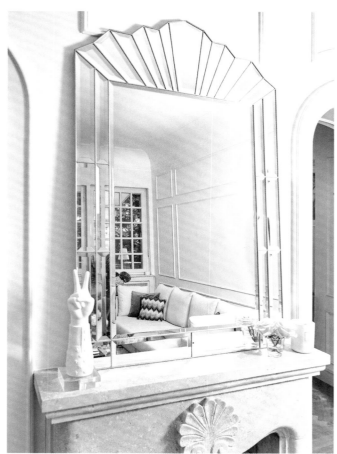

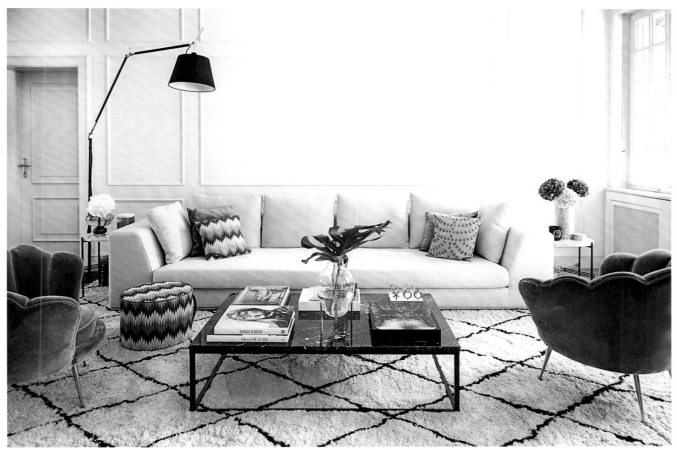

The décor in Delia Fischer's private home incorporates an interesting mix of cool and warm elements. The dining room accents are brass and marble; the living room's wool and velvet.

In Delia Fischers Privatwohnung gehen kühle und warme Elemente eine interessante Verbindung ein. Im Esszimmer mag sie Messing und Marmor, im Wohnraum Wolle und Velours.

Dans l'appartement privé de Delia, des éléments froids et chauds forment une alliance intéressante. Dans la salle à manger, elle aime le laiton et le marbre, dans le séjour, la laine et le velours.

6 Questions for ...
DELIA FISCHER

Can you reveal your sources of inspiration to us?
"I like to read design magazines. And I love coffee table books on interiors and architecture. But the most important thing is to go through life with your eyes open! Traveling provides me with masses of input—there are so many beautifully furnished hotels and restaurants around these days. I take photos of everything I like to create a personal inspiration portfolio."

How would you describe your design style?
"Cozy chic. Simple basics mixed with wow accent pieces."

What does a piece of furniture or home accessory have to be like to get selected for Westwing?
"First and foremost, it should be stylish. That's always been important to me. And, of course, diversity plays a big part in the decision. The product mix needs to be exciting and inspirational, so newcomer labels are just as important as design classics. We draw on our experience and are currently developing our own product line."

What interior design tips can you give us?
"It's super important to base the design on your personality! If your apartment or house reflects your character, then you'll feel at home. And if you love your home, it will love you back. Take a look in your closet—the colors you like to wear are the ones you'll enjoy having around you. I would keep big ticket pieces such as sofas and carpets neutral, while accessories and a small number of statement pieces can be more eye-catching."

"If you love your home, it will love you back. My favorite place? The lounge chair in the reading corner."

Do you have a favorite designer?
"Lots. Even now I still find Dorothy Draper, the American interior design pioneer, and her fantastically flamboyant style inspiring. I also like Kelly Hoppen from South Africa and Ryan Korban, the New York interior design scene's hottest property right now."

Is New York your favorite city?
"What's not to like about NYC? But the city I love most is Miami! It's such a melting pot of art, culture, and design."

Verraten Sie uns Ihre Inspirationsquellen?
„Ich lese gerne Design-Zeitschriften. Und ich liebe Bildbände zum Thema Interior und Architektur. Doch wichtig ist es, mit offenen Augen durchs Leben zu gehen! Meine Reisen geben mir viele Inputs. Es gibt mittlerweile unzählig schön eingerichtete Hotels und Restaurants. Alles, was mir gefällt, fotografiere ich – so entsteht ein ganz persönliches Inspirations-Portfolio."

Wie würden Sie Ihre Designästhetik beschreiben?
„Cozy Chic. Schlichte Basics gemischt mit tollen Akzenten."

Wie muss ein Möbel oder ein Wohnaccessoire aussehen, um Teil von Westwing zu werden?
„In erster Linie sollte es stilvoll sein, das war mir von Anfang an wichtig. Außerdem spielt natürlich die Mischung eine große Rolle. Es muss spannend und inspirierend sein, Designklassiker gehören ebenso dazu wie kleine Newcomer-Labels. Wir schöpfen aus unseren Erfahrungen und arbeiten inzwischen an einer eigenen Produktlinie."

„Wer sein Zuhause liebt, den liebt es zurück. Mein Lieblingsplatz: die Chaiselongue in der Bücherecke."

Welche Tipps geben Sie beim Einrichten?
„Unbedingt die eigene Persönlichkeit mit einfließen lassen! Wenn die Wohnung den eigenen Charakter spiegelt, fühlt man sich zu Hause. Und wer sein Zuhause liebt, den liebt es zurück. Schauen Sie in Ihren Kleiderschrank: Farben, die man gerne trägt, hat man auch gerne um sich. Große Elemente wie Sofas und Teppiche würde ich eher schlicht halten, Accessoires und das ein oder andere Statement-Stück dürfen Hingucker sein."

Haben Sie einen Lieblingsdesigner?
„Viele. Bis heute inspirierend finde ich die amerikanische Pionierin des Interior Designs Dorothy Draper und ihren großartigen farbenprächtigen Stil. Aber auch die Südafrikanerin Kelly Hoppen finde ich toll oder Ryan Korban, den derzeitigen New Yorker Shootingstar der Einrichtungsszene."

Ist New York Ihre Lieblingsstadt?
„Natürlich mag ich NYC. Aber meine Lieblingsmetropole ist Miami! Sie ist ein absoluter Melting Pot aus Kunst, Kultur und Design."

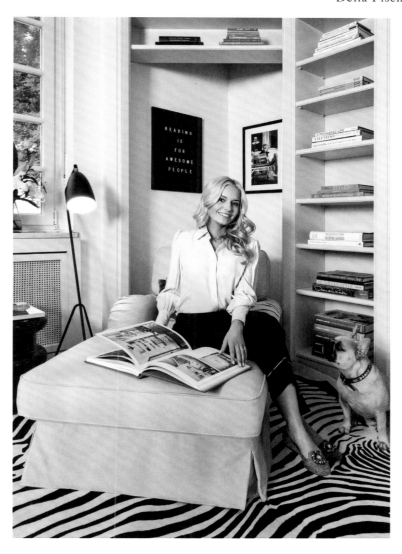

Business entrepreneur Delia Fischer swears by the impact that can be achieved using accessories. Her shopping club offers everything from scented candles through decorative mirrors, such as the "Butterfly" with gold butterfly design elements.

Die Unternehmerin Delia Fischer setzt auf die Wirkung von Accessoires. In ihrem Shopping-Club finden sich Duftkerzen ebenso wie dekorative Spiegel, beispielsweise „Butterfly" mit goldenen Schmetterlingen.

L'entrepreneuse Delia mise sur l'effet des accessoires. Dans son club de shopping, on retrouve aussi bien des bougies parfumées que des miroirs décoratifs, par exemple « Butterfly » avec des papillons dorés.

Pouvez-vous nous parler de vos sources d'inspiration ?

« Je lis beaucoup de magazines de design. J'aime également les ouvrages illustrés consacrés à la décoration d'intérieur et à l'architecture. Entretenir son sens de l'observation est également essentiel ! Mes voyages m'inspirent beaucoup. De nos jours, il existe tellement d'hôtels et de restaurants bien aménagés. Je prends en photo tout ce qui me plaît – j'obtiens ainsi un portfolio d'inspiration à mon image. »

Comment décririez-vous votre style d'aménagement ?

« Cosy chic. Des basics simples combinés à de beaux contrastes. »

Quel critère esthétique doit remplir un meuble ou un accessoire d'intérieur pour rejoindre l'assortiment de Westwing ?

« En premier lieu, il doit être stylé. Cela a toujours été essentiel à mes yeux. Bien évidemment, les mélanges jouent également un grand rôle. Il doit être passionnant et inspirant, cela vaut aussi bien pour les classiques du design que pour les jeunes marques plus modestes. Nous puisons dans nos expériences et travaillons actuellement à notre propre ligne de produits. »

Quels conseils d'aménagement donneriez-vous ?

« Tenir impérativement compte de sa personnalité ! On se sent chez soi lorsque notre intérieur reflète notre caractère. Si vous aimez votre intérieur, vous serez choyé en retour. Regardez dans votre penderie : on aime avoir autour de soi les couleurs que l'on porte avec plaisir. Je conseille de choisir la simplicité pour les grands éléments, comme les canapés ou les tapis. Les accessoires ou les quelques pièces maîtresses peuvent volontiers passer au premier plan. »

> ## « Si vous aimez votre intérieur, vous serez choyé en retour. Mon endroit préféré : la chaise longue de mon coin lecture. »

Avez-vous un designer favori ?

« J'en ai beaucoup. La pionnière américaine de la décoration d'intérieur, Dorothy Draper et son style magnifique, haut en couleurs m'inspirent aujourd'hui encore. J'aime également l'architecte d'intérieur d'Afrique du Sud Kelly Hoppen ou encore Ryan Korban, l'étoile montante new-yorkaise de l'aménagement d'intérieur. »

Est-ce que New York est votre ville préférée ?

« Bien évidemment, j'adore NYC. Mais ma ville préférée, c'est Miami ! C'est un melting pot absolu d'art, de culture et de design. »

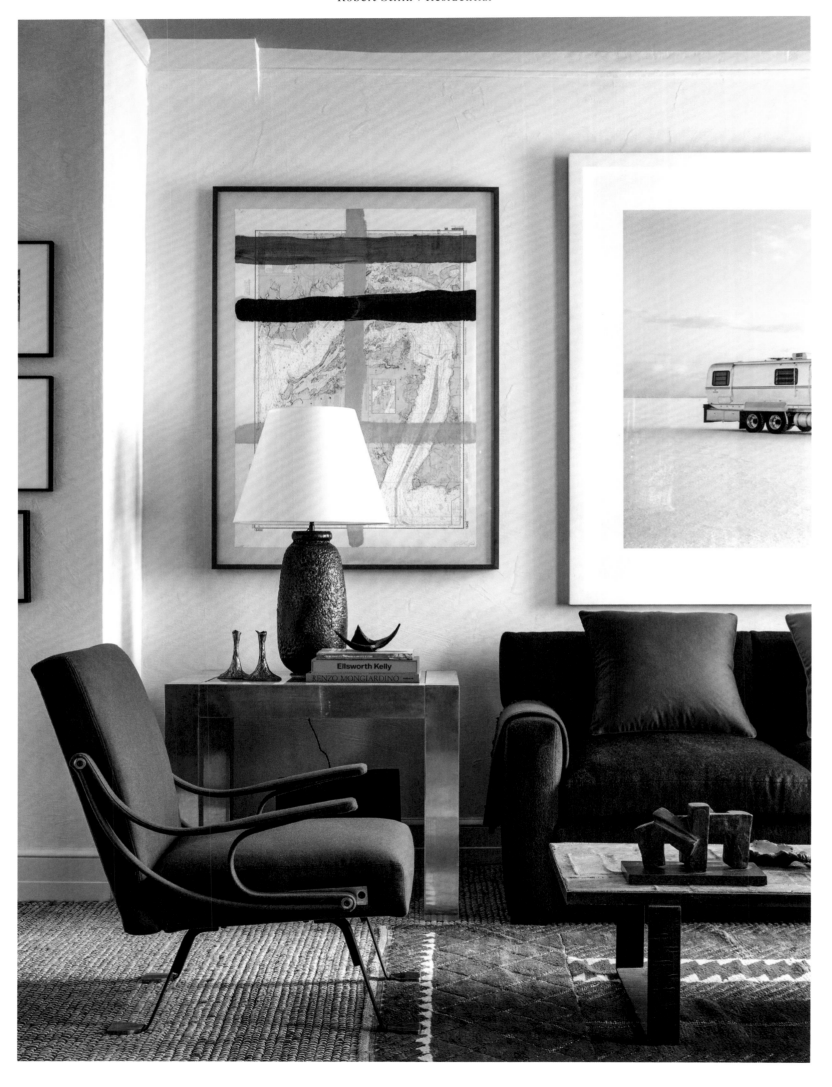

ROBERT STILIN

New York City, United States

"I'm not interested in creating showplaces, but homes that feel very real."
„Ich bin nicht daran interessiert, Schauplätze einzurichten, sondern Räume, die sich echt anfühlen."
« Je ne suis pas intéressé par l'aménagement de vitrines mais plutôt de pièces à l'ambiance authentique. »

Optimism and self-confidence—attributes that the New York interior designer Robert Stilin believes are imperative. "Fearless people have always been my role models. I've followed their careers and tried to learn from them." His own vita reveals grit and flexibility. Heeding the advice of his father, Stilin initially studied business management, but then his passion and ambition prevailed. Instead of Wall Street, he was drawn to Palm Beach, where in 1989 Stilin opened an elegant design store offering vintage furniture, objects and art. One day, a couple visited the shop and found they wanted to buy everything. That visit led the couple to enlist Robert to lend his expertise to designing the rest of their home. That's where it all kicked off. He ensured from the very beginning that he only worked with the best dealers and craftsmen, a principle that he has lived by his entire career. In 2003, he opened two design studios: first in East Hampton, followed by another in New York City. Being an avid collector and connoisseur himself, art and antiques play a central role for Stilin. He creates living spaces that accentuate art without being sterile and believes good interior design should be sophisticated, warm and distinctively livable. For the 2017 Kips Bay Decorator Show House the designer created a European salon entitled "Roll the Dice" (left)—a term very well-suited to Stilin and his past.

Zuversicht und Selbstvertrauen – Eigenschaften, die der New Yorker Interior Designer Robert Stilin unerlässlich findet: „Menschen, die nicht ängstlich sind, waren mir stets Vorbild. Ich habe ihren Werdegang verfolgt und versucht, von ihnen zu lernen." Seine eigene Vita beweist Mut und Flexibilität. Ursprünglich hatte er auf Anraten seines Vaters Betriebswirtschaft studiert. Doch dann siegten Leidenschaft und Tatendrang. Anstatt an die Wall Street zog es ihn nach Palm Beach, wo er 1989 einen eleganten Designerladen mit Vintage-Möbeln, Objekten und Kunst eröffnete: „Eines Tages kam ein Paar und wollte alles aufkaufen. Ich fragte sie, ob ich ihnen beim Einrichten helfen könnte", erzählt er schmunzelnd. Das war der Startschuss. Von Anfang an habe er darauf geachtet, nur mit den besten Lieferanten und

Handwerkern zu arbeiten – ein Anspruch, der Anklang fand. 2003 packte der Amerikaner seine Taschen und eröffnete zwei Designstudios: eines in New York, das andere in East Hampton. Kunst und Antiquitäten spielen eine große Rolle – er selbst gilt als passionierter Kenner und Sammler. Stilin kreiert Wohnräume, die der Kunst gerecht werden, ohne steril zu sein. Gutes Interior Design, findet er, sollte raffiniert, warm und vor allem lebenswert sein. Für das Kips Bay Decorator Show House 2017 inszenierte der Designer einen europäischen Salon und gab ihm den Titel „Roll the Dice" (links). „Die Würfel rollen lassen" – ein Motto, das gut zu ihm und seiner Vergangenheit passt.

Assurance et confiance en soi, des qualités que l'*interior designer* new-yorkais Robert Stilin considère indispensables : « J'ai toujours pris pour modèle des personnes qui n'ont pas peur. J'ai suivi leur carrière et essayé d'apprendre d'elles ». Son propre CV témoigne de son courage et de sa flexibilité. À l'origine, il avait étudié la gestion d'entreprise sur conseil de son père. Cependant, la passion et l'entrain ont fini par gagner. Plutôt que Wall Street, il s'est rendu à Palm Beach où il a ouvert en 1989 une élégante boutique de designers avec des meubles vintages, des objets et de l'art : « Un jour, un couple est venu et voulait tout acheter. Je leur ai demandé si je pouvais aménager leur intérieur », raconte-t-il en souriant. C'était le coup d'envoi. Dès le départ, j'ai veillé à travailler uniquement avec les meilleurs fournisseurs et artisans, une exigence qui a été saluée. En 2003, l'Américain a fait ses valises et a ouvert deux agences de design : une à New York et l'autre à East Hampton. L'art et les antiquités jouent un grand rôle, il se considère lui-même comme un connaisseur et un collectionneur passionné. Stilin crée des espaces de vie qui rendent hommage à l'art sans être stériles. Selon lui, un bon *interior design* doit être raffiné et agréable à vivre. Pour le Kips Bay Decorator Show House en 2017, le designer a mis en scène un salon européen et lui a donné le titre de « Roll the Dice » (à gauche). « Laisser rouler les dés », un mot d'ordre qui lui convient bien à lui et à son passé.

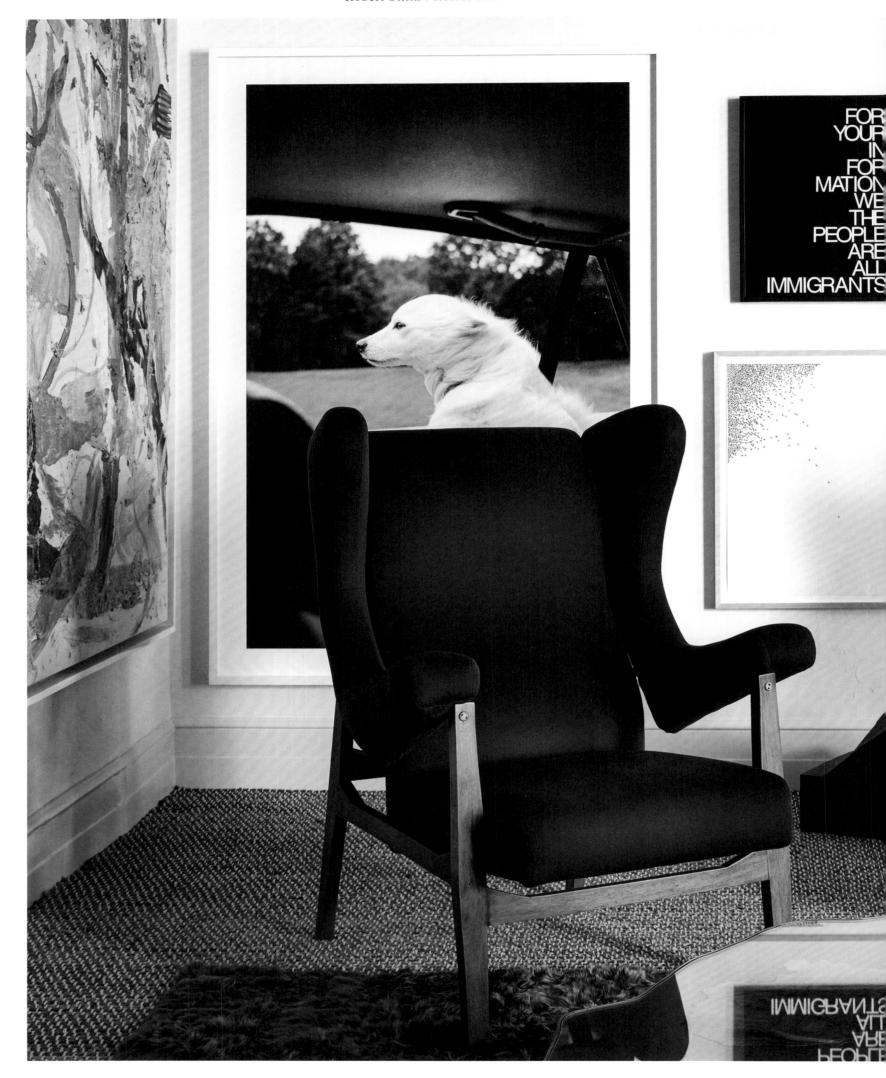

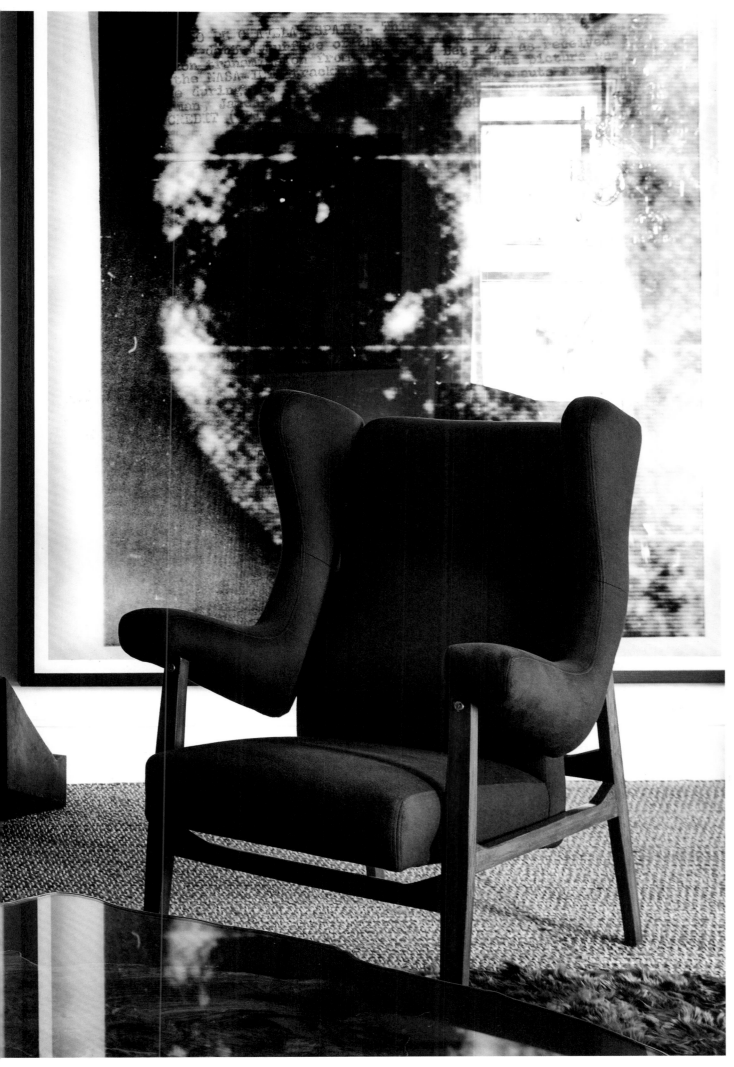

In 2017, Robert Stilin designed a salon featuring Franco Albini armchairs for the Kips Bay Decorator Show House, an annual event in New York for interior designers.

Robert Stilin gestaltete 2017 für das Kips Bay Decorator Show House, ein jährlich in New York stattfindender Showroom für Interior Designer, einen Salon mit Armchairs von Franco Albini.

En 2017, pour le Kips Bay Decorator Show House, un showroom ayant lieu chaque année à New York pour les *interior designers*, Robert Stilin a aménagé un salon avec des armchairs de Franco Albini.

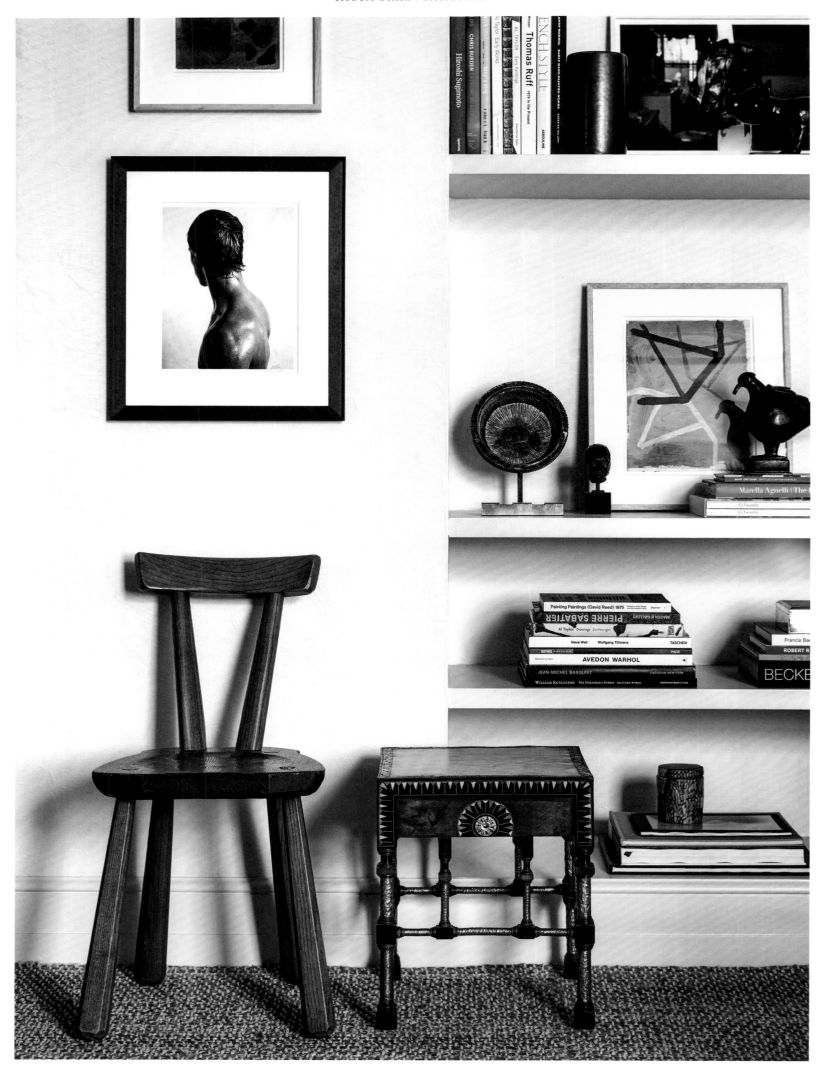

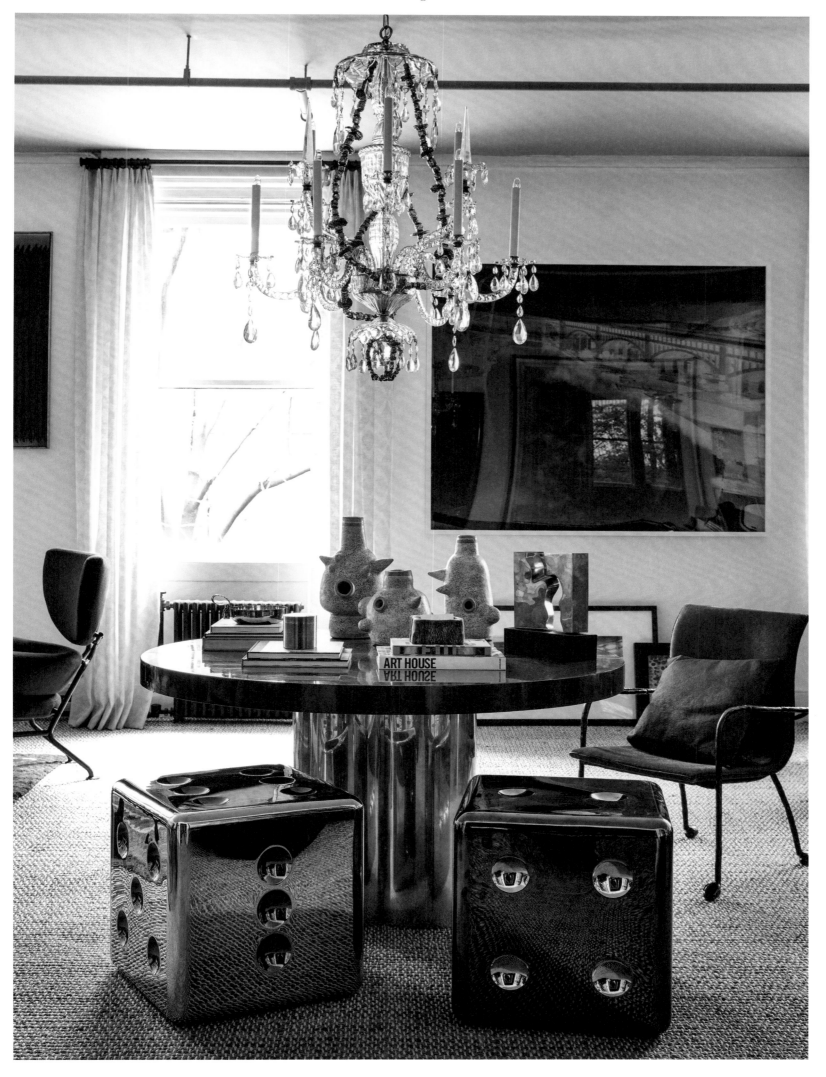

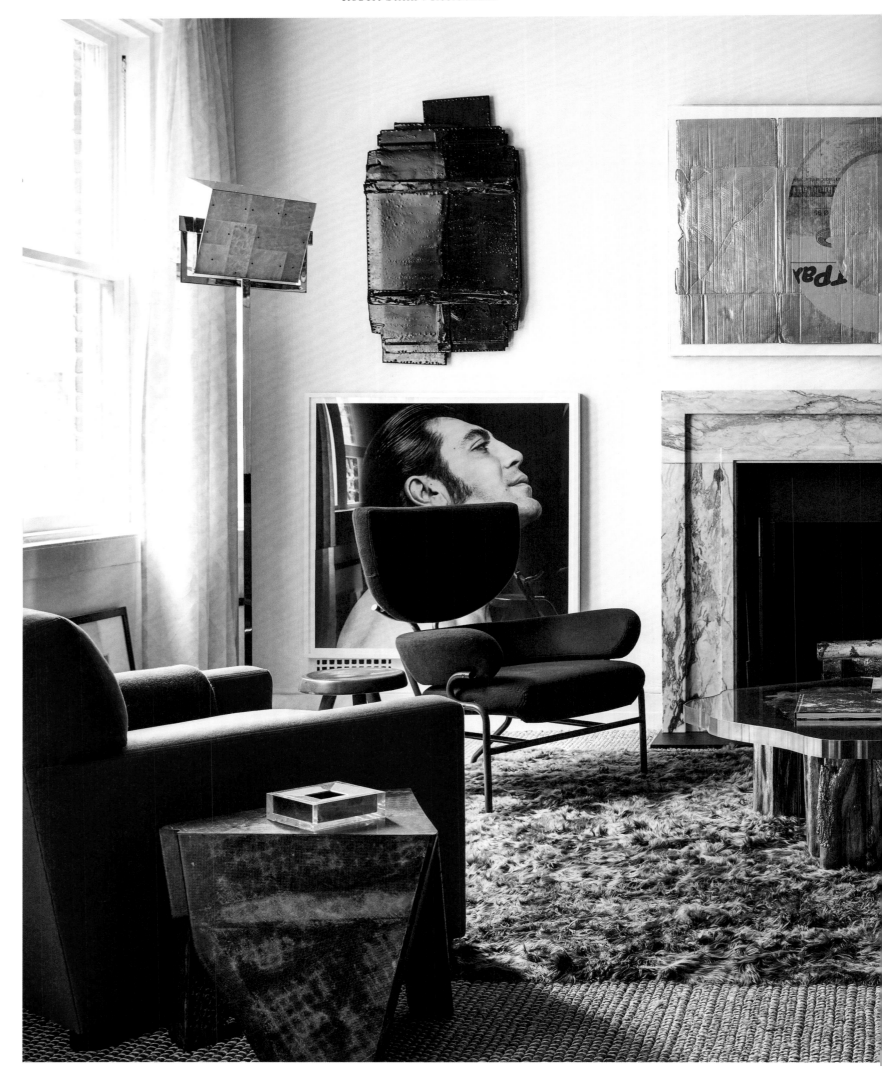

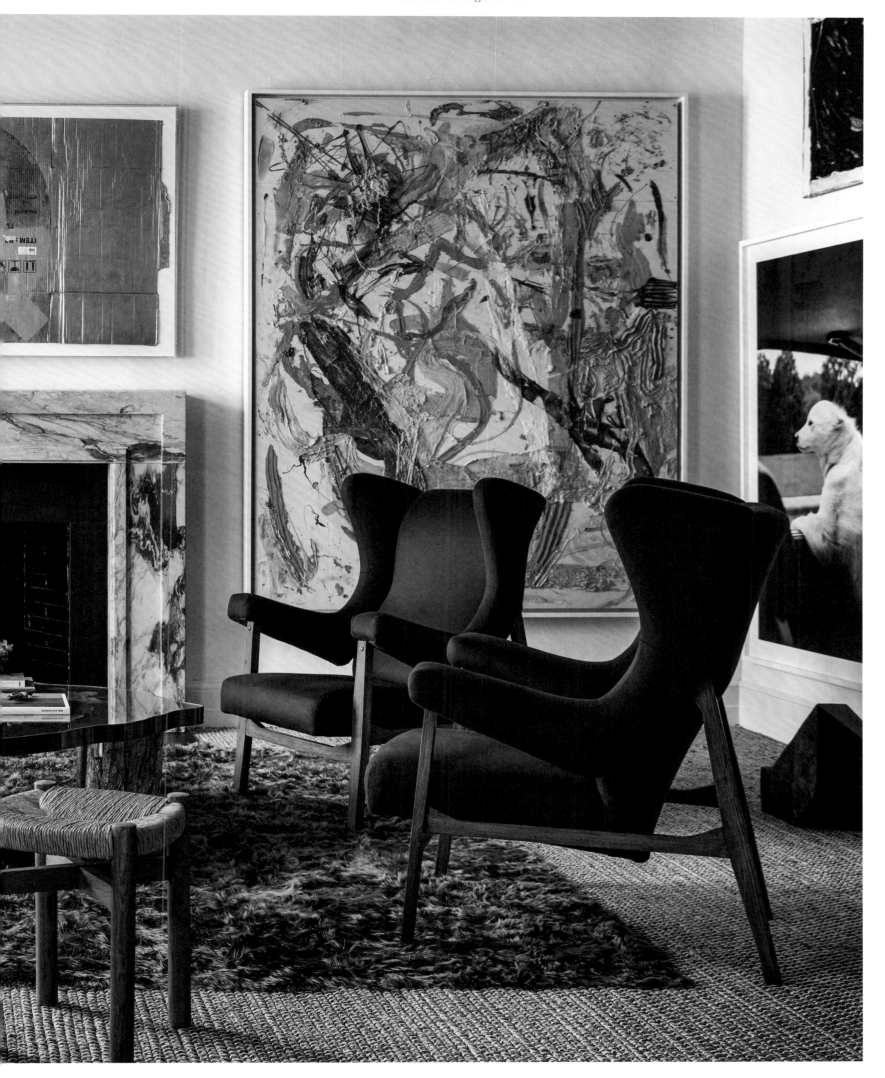

DAVID DREBIN
New York City, United States

"I take my inspiration from my imagination. Nothing is deliberate or planned—it simply happens."
„Meine Inspiration ist die Fantasie. Nichts ist gewollt oder geplant – es passiert einfach."
« L'imagination est mon inspiration. Rien n'est voulu ou planifié, cela se passe, tout simplement. »

What would interior design be without art? Merely a beautiful but empty shell. Its vitality comes from the impressive sculptures and striking photographs or paintings that we can lose ourselves in. Internationally-renowned, New York City-based photographer and artist David Drebin is celebrated for his neon light installations and their provocative messages. He is known for his photographs, that focus on women and their desires; phantasies; and erotic charisma. The subjects appear unapproachable but simultaneously irresistible, placing the viewer in the role of an involuntary voyeur who shares the desires, dreams, and hopes while experiencing feelings of intimacy, eroticism, melancholy, or loneliness. Drebin's neon light installations provide a counterpoint to this. "Shut up and kiss me", "Don't Ever Call Me Again", "It's All Lies Darling"—if Drebin's photographs show women's desires, the installations give the answers. Born in Canada in 1970, David Drebin grew up in Toronto. After completing his studies at the Parsons School of Design in 1996 he quickly made a name for himself as a photographer. His first solo show was at Berlin gallery "Camera Work" in 2005; the publishing company teNeues has released 5 coffee table book collections of his work—"Dreamscapes", "The Morning After", "Beautiful Disasters", "Chasing Paradise", and "Love & Lights". David Drebin is a storyteller whose narrative uses words and images.

Was wäre Interior Design ohne Kunst? Nicht mehr als eine schöne Hülle. Denn sind es nicht beeindruckende Skulpturen, imposante Fotografien oder Gemälde, in denen wir uns verlieren können, die Lebendigkeit schaffen? Die Neonlichtarbeiten des international bekannten New Yorker Fotografen und Künstlers David Drebin faszinieren allein wegen ihrer provokanten Botschaften. Drebin ist bekannt für seine Fotografien, die Frauen und ihre Sehnsüchte, Fantasien sowie erotische Ausstrahlung thematisieren. Unnahbar und gleichzeitig unwiderstehlich wirken sie darauf und machen den Betrachter unwillkürlich zum Voyeur. Er wird Teil ihrer Sehnsüchte, Träume und Hoffnungen – empfindet dabei Nähe, Erotik, Melancholie oder Einsamkeit.

Seine Neon-Installationen sind so etwas wie die Antwort darauf. „Shut up and kiss me", „Don't Ever Call Me Again", „It's All Lies Darling" – während die Fotografien die Sehnsüchte der Frauen visualisieren, liefern die Schriftzüge die entsprechende Antwort. Drebin wurde 1970 in Kanada geboren und wuchs in Toronto auf. Nach seinem Studium an der Parsons School of Design 1996 wurde die Kunstwelt schnell auf seine Fotografien aufmerksam. Seine erste Einzelausstellung fand 2005 in der Berliner Galerie „Camera Work" statt. Bei teNeues sind seine Bildbände „Dreamscapes", „The Morning After", „Beautiful Disasters", „Chasing Paradise" sowie „Love & Lights" erschienen. Drebin ist ein Storyteller – in Wort und Bild.

Que serait *l'interior design* sans art ? Rien de plus qu'une belle enveloppe. En effet, est-ce que ce ne sont pas les sculptures impressionnantes, les photographies imposantes ou les peintures dans lesquelles nous pouvons nous perdre qui créent la vie ? Les travaux au néon du photographe et artiste new-yorkais de renommée internationale David Drebin fascinent rien que par leurs messages provocants. Drebin est connu pour ses photographies qui ont pour thème les femmes et leurs nostalgies, les fantasmes et l'aura érotique. Inaccessibles et irrésistibles à la fois, elles font de leur observateur involontairement un voyeur. Il prend alors part aux nostalgies, aux rêves et aux espoirs – il ressent alors de la proximité, de l'érotisme, de la mélancolie ou de la solitude. Ses installations de néon sont comme la réponse correspondante. « Shut up and kiss me », « Don't Ever Call me Again », « It's All Lies Darling » – alors que les photographies visualisent les nostalgies des femmes, les inscriptions y apportent une réponse. David Drebin est né en 1970 au Canada et a grandi à Toronto. Après des études à la Parsons School of Design 1996, le monde de l'art a vite remarqué ses photographies. Sa première exposition individuelle a eu lieu en 2005 dans la galerie berlinoise « Camera Work ». Ses albums « Dreamscapes », « The Morning After », « Beautiful Disasters », « Chasing Paradise » et « Love & Lights » sont parus chez teNeues. David Drebin raconte des histoires – en mots et en images.

Bright red, yellow, blue, or purple—New York City-based artist David Drebin's neon light installations reveal the secret thoughts of their models and femmes fatales.

Leuchtendes Rot, Gelb, Blau oder Violett: Der in New York lebende Künstler David Drebin enthüllt mit seinen Neon-Installationen die heimlichen Gedanken der Modelle und Femmes fatales.

Roue, jaune, bleu ou violet fluo. L'artiste David Drebin, qui habite à New York, révèle avec ses installations de néons les pensées secrètes des modèles et des femmes fatales.

4 Questions for ...
DAVID DREBIN

How did you come up with the idea for the neon works?

"A picture tells a thousand words and the Neons make us think about a thousand pictures. It is the reverse of making Photographs."

"A picture tells a thousand words."

Is there any special inspiration which drove you?

"I'm inspired by making people think...and laugh... and think."

How do you decide on the quotes? Does each quote have an interesting story behind it?

"The Neons come spontaneously from conversations and are rarely planned. They just happen and then a light goes off in my mind and I think 'let's make that a Neon'."

Do the Neons tie into your concept for photography or are they a different type of storytelling?

"All my art forms are related. Common themes are "Love and Lust" and how they are so often intertwined with fantasy and expectations..."

Wie sind Sie auf die Idee mit den Neon-Arbeiten gekommen?

„Ein Bild sagt mehr als tausend Worte und die Neonbilder lassen uns an tausend Bilder denken. Es ist genau umgekehrt wie beim Fotografieren."

Gab es einen bestimmten Anlass, der Sie dazu inspiriert hat?

„Die Inspiration war, Leute zum Nachdenken zu bringen… zum Lachen…zum Nachdenken."

„Ein Bild sagt mehr als tausend Worte."

Nach welchen Kriterien wählen Sie die Sprüche aus? Steckt hinter jedem Spruch eine interessante Geschichte?

„Die Neonbilder entstehen spontan in einer Unterhaltung und sind selten geplant. Es passiert einfach so und dann denke ich einfach: ‚Lass uns doch ein Neonbild machen'."

Passen die Neonbilder zu Ihrer Vorstellung von Fotografie oder ist das eine andere Art, eine Geschichte zu erzählen?

„Alle meine Kunstwerke sind miteinander verbunden. Ich beschäftige mich gerne mit den Themen ‚Lust und Liebe' und damit, dass sie so oft mit der Fantasie und Erwartungen verknüpft sind…"

Comment l'idée des néons vous est-elle venue ?

« Une image raconte mille choses, et les néons nous font penser à mille images. Tout le contraire de la photographie. »

Quelle a été votre source d'inspiration ?

« Le fait de faire réfléchir les gens … et rire … et réfléchir. »

« Une image raconte mille choses. »

Comment choisissez-vous les citations ?
Ont-elles une histoire ?

« Les néons naissent spontanément à partir de conversations. Ils sont rarement planifiés. Simplement, une lumière s'allume dans mon esprit et je me dis ‹ faisons un néon ›. »

Les néons sont-ils liés à votre conception de la photographie ou correspondent-ils à une forme de narration différente ?

« Toutes les formes d'art que je pratique sont liées. Par des thèmes communs comme ‹ l'amour et le désir ›, et leurs rapports si fréquents à l'imaginaire et aux attentes … »

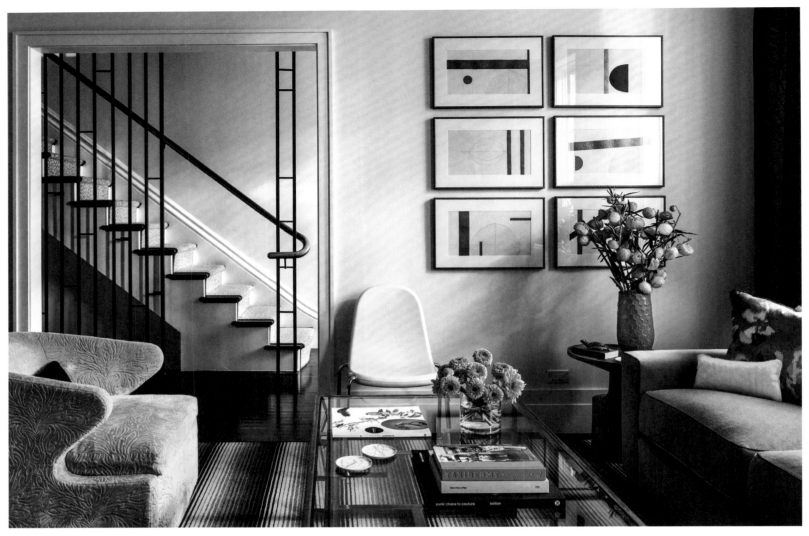

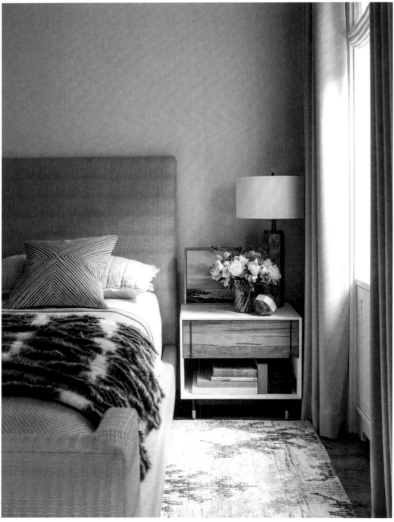

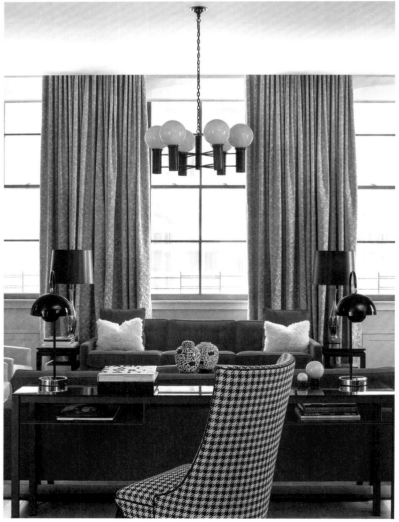

FEARINS | WELCH
Interior Design
Brooklyn, United States

"I like it when clients have an eye for detail and contribute their own aesthetics."
„Ich mag es, wenn Kunden ein Auge für Details haben und ihre eigene Ästhetik ins Spiel bringen."
« J'aime lorsque les clients ont le sens du détails et intègre leur propre esthétique. »

After growing up on a farm in the rural tobacco country of southern Virginia, Ward Welch is sure it was the grand Victorian architecture so prevalent in the area that inspired him to study architecture at the University of Virginia. He began his career in an architecture firm in Pennsylvania, and after a decade relocated to New York to establish CWB Architects in 1999 with two colleagues. With more than 20 employees, Welch and his partners provide a link between the sensitive renovation of historic buildings and the contemporary architectural vernacular. Ward Welch knows two things from experience—first, you need more than an attractive exterior, and second, to achieve its full potential, good architecture requires a coherent interior design concept. To that end, CWB offered in-house interior design services, but in 2015, with a growing number of non-architecture clients, he and Erin Fearins established Fearins | Welch Interior Design. From eastern Tennessee, she shares with Welch a history of design grounded in the rural

South, drawing on a tradition that has always been characterized by elegance, emphasizing that "our interior design style aims to be comfortable, inviting and eccentric, but also charming." In a Brooklyn brownstone (top left) graphic elements and carefully placed color accents create a youthful look. The staircase's geometric lines provide the theme for the living room. Fearins | Welch designs are intended to tell a story.

Aufgewachsen ist er auf einer Farm im ländlich geprägten Tabakland im südlichen Virginia – Ward Welch ist sich sicher, dass es die großartige viktorianische Architektur der Gegend war, die ihn letztlich dazu inspirierte an der University of Virginia Architektur zu studieren. Seine Karriere startete Ward Welch zunächst in einem Architekturbüro in Pennsylvania, bevor er 1999 nach New York ging, um dort zusammen mit zwei Kollegen CWB Architects zu gründen. Mit mehr als 20 Angestellten schlagen Welch und seine Partner einen Bogen zwischen einfühlsamer Renovierung historischer Gebäude und zeitgenössischer Architektur, die mit ihrer Umgebung korrespondiert. Ward Welch weiß aus Erfahrung: „Es braucht mehr als nur eine attraktive Hülle. Um das Potenzial eines Gebäudes auszuschöpfen, ist ein

stimmiges Interior-Konzept unabdingbar." Gerade deshalb hat CWB stets auf eigene Interior Designer gesetzt. Aufgrund steigender Nachfrage gründete Ward Welch zusammen mit Erin Fearins 2015 das gleichnamige Interior-Design-Büro „Fearins | Welch Interior Design". Erin Fearins, die aus Tennessee stammt, teilt mit Ward Welch die traditionellen, südlich geprägten historischen Wurzeln: „Unsere Interior-Sprache ist stets komfortabel, einladend, charmant und zugleich exzentrisch!" In einem Haus in Brooklyn (links oben) sorgen grafische Elemente und bewusst gesetzte Farbakzente für den jugendlichen Charakter. Die geometrischen Linien des Treppenhauses wurden zum Leitmotiv im Wohnzimmer. Fearins | Welch möchten mit ihrer Einrichtung Geschichten erzählen.

Il a grandi dans une ferme dans un paysage rural marqué par les champs de tabac au sud de la Virginie – Ward Welch est sûr que c'est la magnifique architecture victorienne de la région qui l'a inspiré à étudié l'architecture à l'University of Virginia. Ward Welch a démarré sa carrière dans un bureau d'architectes en Pennsylvanie avant de se rendre en 1999 à New York et de fonder avec deux collègues CWB Architects. Avec plus de vingt salariés, Welch et ses partenaires forment le lien entre la rénovation respectueuse de bâtiments historiques et l'architecture contemporaine en harmonie avec son environnement. Ward Welch le sait par expérience : « Une enveloppe attrayante ne suffit pas. Pour exploiter le potentiel d'un bâtiment, un concept d'intérieur harmonieux est indispensable. » C'est pour cette raison que CWB a toujours misé sur ses propres architectes d'intérieur. En raison de la demande croissante, Ward Welch a fondé avec Erin Fearins le bureau d'*interior design* du même nom « Fearins | Welch Interior Design ». Erin Fearins, qui vient du Tennessee, partage avec Ward Welch des racines historiques et traditionnelles marquées par le sud : « Notre langage de décoration est toujours confortable, accueillant, charmant et excentrique à la fois ! » Dans une maison de Brooklyn (en haut à gauche), des éléments graphiques et des contrastes colorés ciblés apportent un caractère frais. Les lignes géométriques de la cage d'escalier sont reprises dans le séjour. Fearins | Welch souhaitent raconter des histoires avec leur décoration d'intérieur.

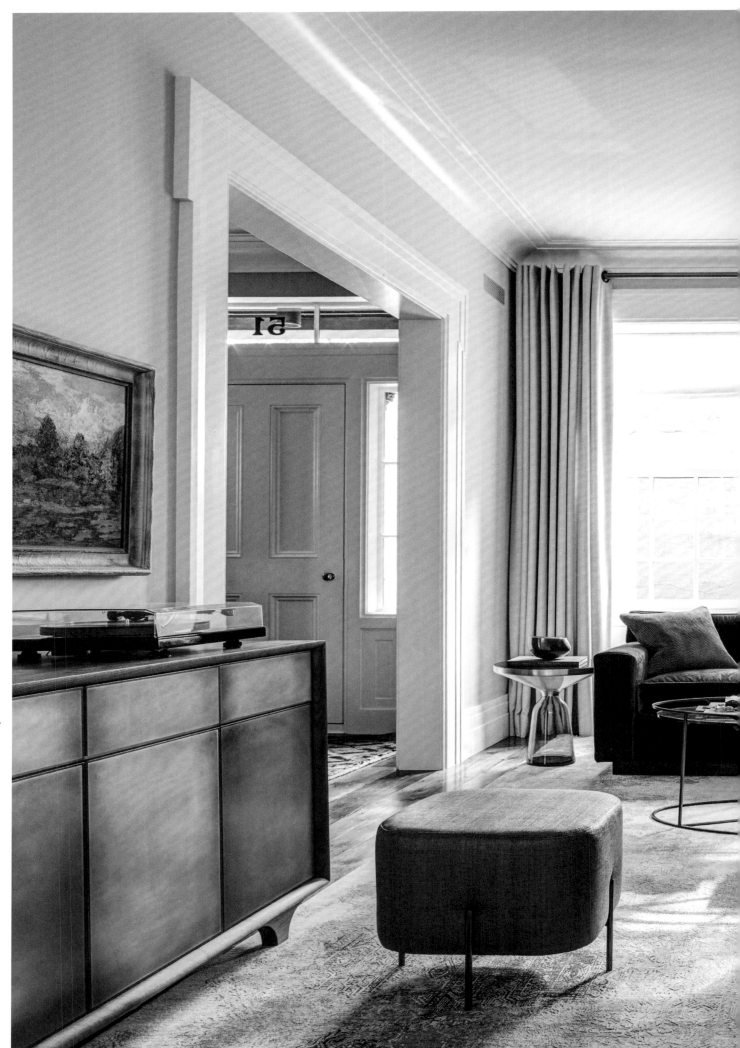

The colors of Greece—in a Brooklyn brownstone's living room a Lindsey Adelman chandelier hangs above a brass table by Donghia. Ward Welch rescued the fireplace mantelpiece from an adjoining house.

Die Farben Griechenlands: Im Wohnzimmer des typischen „Brooklyn Brownstone" schwebt ein Lindsey-Adelman-Leuchter über dem Messingtisch von Donghia. Die Kaminumrandung rettete Ward Welch aus dem Nachbarhaus.

Les couleurs de la Grèce : Dans le séjour du « Brooklyn Brownstone » typique, un luminaire Lindsey Adelman flotte au-dessus de la table en laiton de Donghia. Ward Welch a sauvé le tour de la cheminée dans une maison voisine.

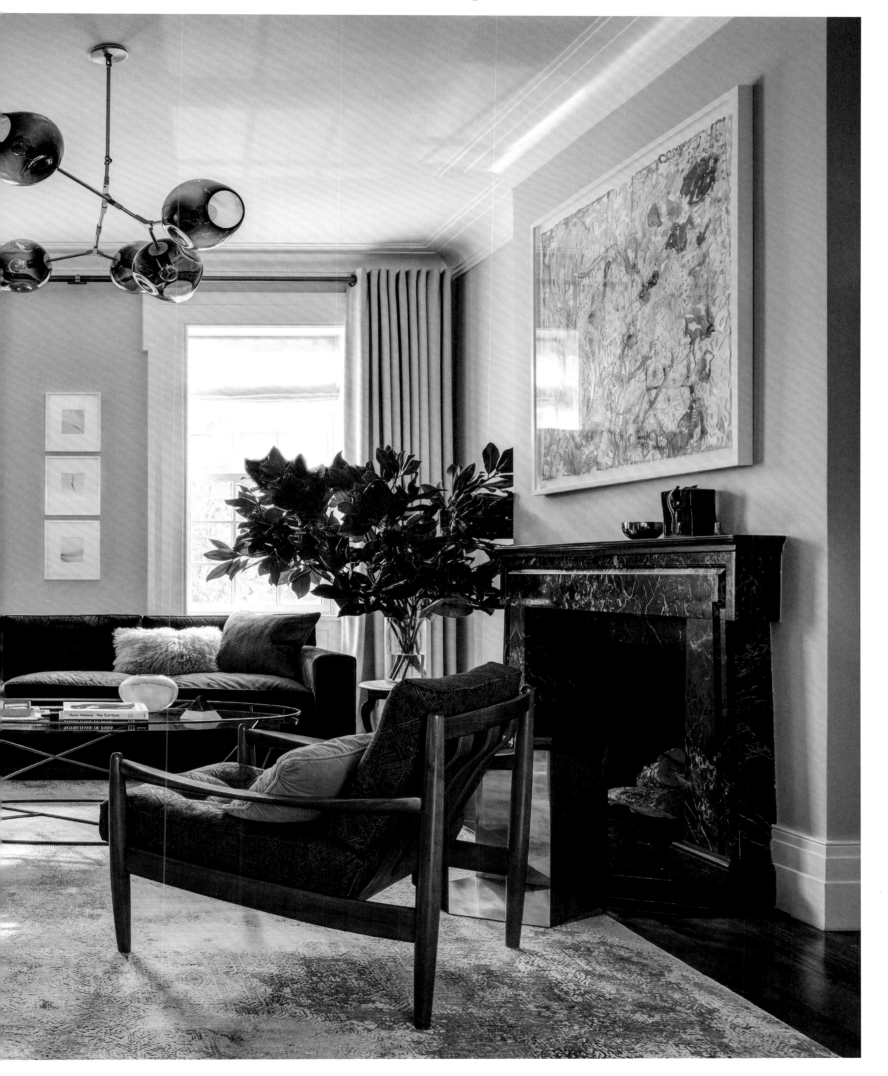

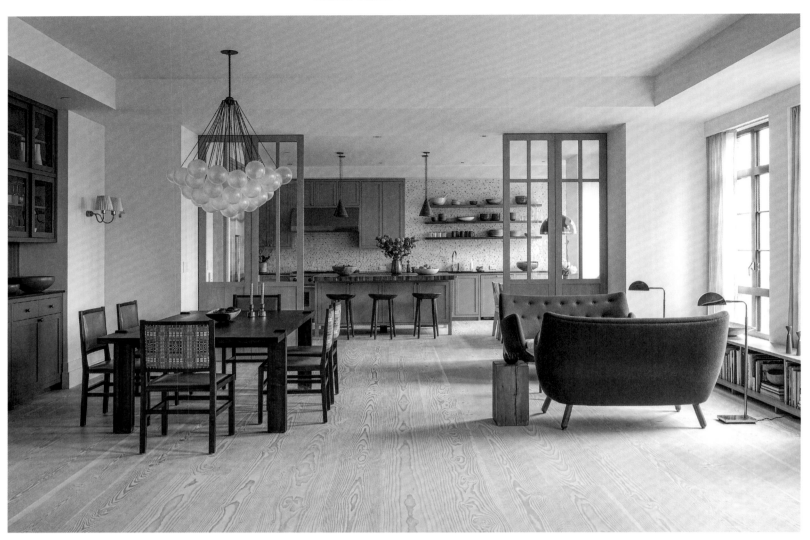

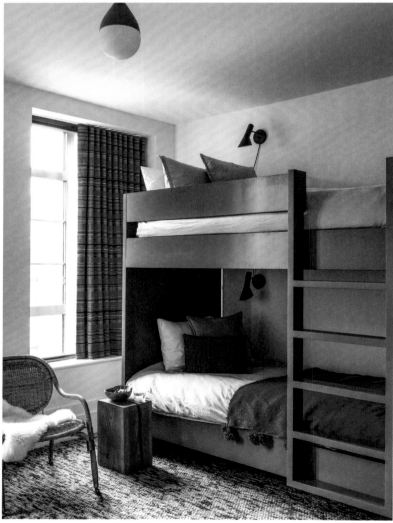

STUDIO SHAMSHIRI
Los Angeles, United States

"We feel a responsibility to produce designs that are sustainable and allow healthy lives."
„Wir fühlen uns einem Design verpflichtet, das nachhaltig ist und gesundes Leben ermöglicht."
« Nous nous sentons obligés d'utiliser un design qui est durable et permet de vivre sainement. »

If you were looking for a connection between interior design and Hollywood, Pamela Shamshiri would be the person to go to. Born in Iran, she grew up in Los Angeles and, after graduating from college, initially worked as a movie set designer. Following this, she founded "Commune", a successful design studio employing a staff of 40, with her brother Ramin and two other partners. In 2016 the brother-sister team decided to invest in a joint creative future, establishing "Studio Shamshiri", that draws on the experience they have gained working as art directors and set designers. This experience gives the private residences, commercial properties, and hotels that they design a look that is both authentic and natural while also providing a narrative. Careful use of resources is a key concern for Pamela and Ramin, who say "Wherever possible we use products that were manufactured in an environment-friendly way!" Commissioned by a New York couple to create a relaxed Californian vibe within the scope of renovation of a 5,200-square-foot (480-square-meter) penthouse at the former St. Vincent's Hospital in West Village, their design involved opening up rooms and building alcoves to create a clear but warm and modern environment. They chose light Douglas fir for the floor, while the mustard yellow kitchen was built by BBDW—a New York manufacturer known for its timeless craftsmanship. In keeping with Pamela and Ramin Shamshiri's style.

Sucht man nach Gemeinsamkeiten zwischen Interior Design und Hollywood – bei Pamela Shamshiri würde man fündig werden. Die gebürtige Iranerin wuchs in Los Angeles auf und arbeitete nach ihren Universitätsabschlüssen zunächst als Set-Designerin beim Film. Nachdem sie zusammen mit ihrem Bruder Ramin und zwei weiteren Partnern „Commune", ein erfolgreiches Designstudio mit 40 Kreativen, geführt hatte, beschlossen die beiden, künftig zu zweit kreativ zu sein und gründeten 2016 „Studio Shamshiri". Pamela und Ramin schöpfen aus einem Erfahrungsschatz, der durch die Arbeit als Art-Direktoren und Set-Designer gewachsen ist. Wohnhäuser, gewerbliche Objekte und Hotels, die sie gestalten, bekommen auf diese Weise einen Look, der authentisch und selbstverständlich wirkt, gleichzeitig Geschichten zu erzählen weiß. Der sparsame Umgang mit Ressourcen spielt für Pamela und Ramin eine erhebliche Rolle: „Wir setzen nach Möglichkeit Produkte ein, die umweltfreundlich hergestellt wurden!" Für ein New Yorker Paar, das im ehemaligen St. Vincent Hospital im West Village ein 480-Quadratmeter-Penthouse kaufte und sich ein lässig-kalifornisches Wohnfeeling wünschte, öffneten sie Räume und schufen Nischen, um eine klare, gleichzeitig warme und moderne Atmosphäre zu gestalten. Für den Boden wählten sie helle Douglastanne, die gelbe Küche fertigte BBDW – eine New Yorker Manufaktur, die für ihr zeitloses Handwerk bekannt ist. Ganz im Sinne von Pamela und Ramin Shamshiri.

Si l'on recherche des points communs entre la décoration d'intérieur et Hollywood – on en trouve forcément chez Pamela Shamshiri. Cette Iranienne de naissance a grandi à Los Angeles. Après ses études, elle a commencé à travailler en tant que décoratrice de plateau pour les films. Après avoir géré avec son frère Ramin et deux autres partenaires « Commune », un studio de design à succès avec quarante créateurs, ils ont décidé de mettre leur créativité à profit à deux à l'avenir et ont fondé en 2016 le « Studio Shamshiri ». Pamela et Ramin puisent dans leur expérience acquise en tant que directeurs artistiques et décorateurs de plateaux. De cette manière, les immeubles, les biens commerciaux et les hôtels qu'ils aménagent revêtent un look à la fois authentique et évident qui sait également raconter des histoires. Pour Pamela et Ramin, la gestion économe des ressources joue un rôle considérable : « Si possible, nous utilisons des produits qui ont été fabriqués de manière écologique ! » Pour un couple de New-Yorkais qui a acheté dans l'ancien St. Vincent Hospital à West Village un penthouse de 480 m² et souhaitait un intérieur à l'ambiance décontractée à la californienne, ils ont ouvert des pièces et ont créé des niches afin de créer une ambiance claire, à la fois chaude et moderne. Pour le sol, ils ont choisi du sapin clair de Douglas, la cuisine jaune a été fabriquée par BBDW – une manufacture new-yorkaise connue pour son artisanat intemporel. Parfaitement dans l'esprit de Pamela et Ramin Shamshiri.

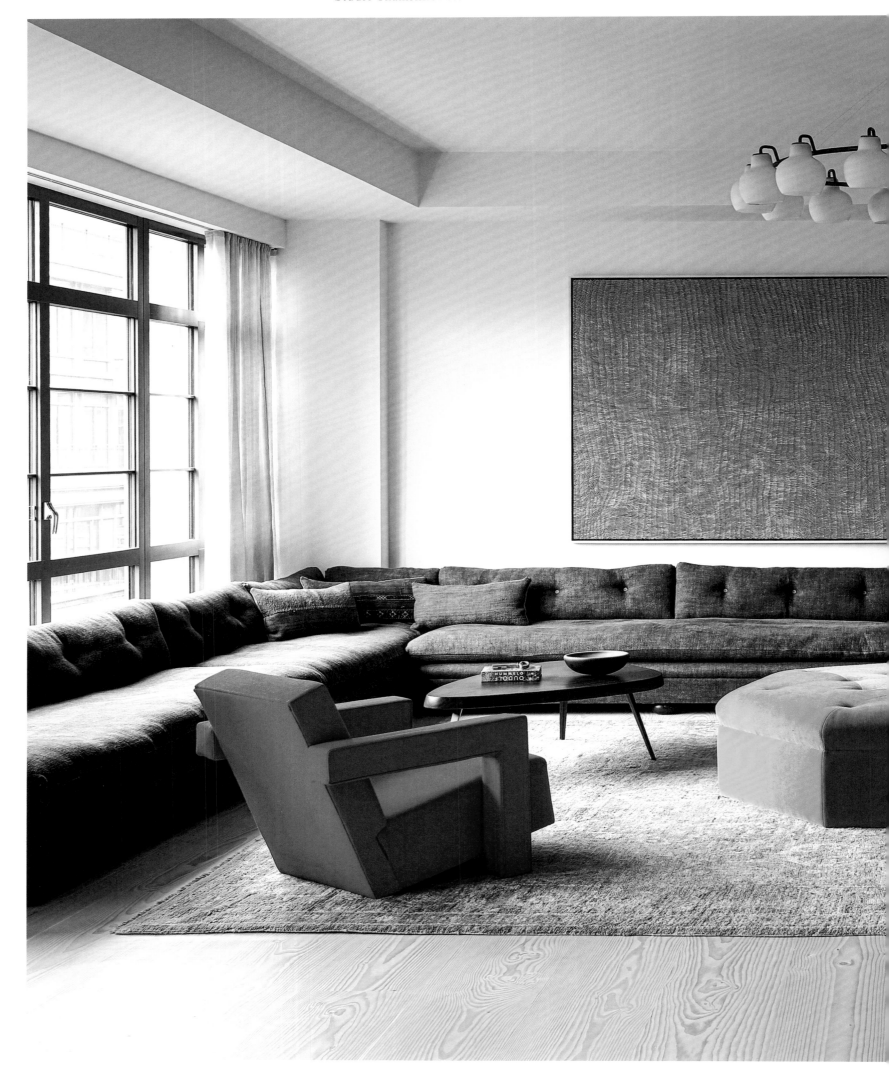

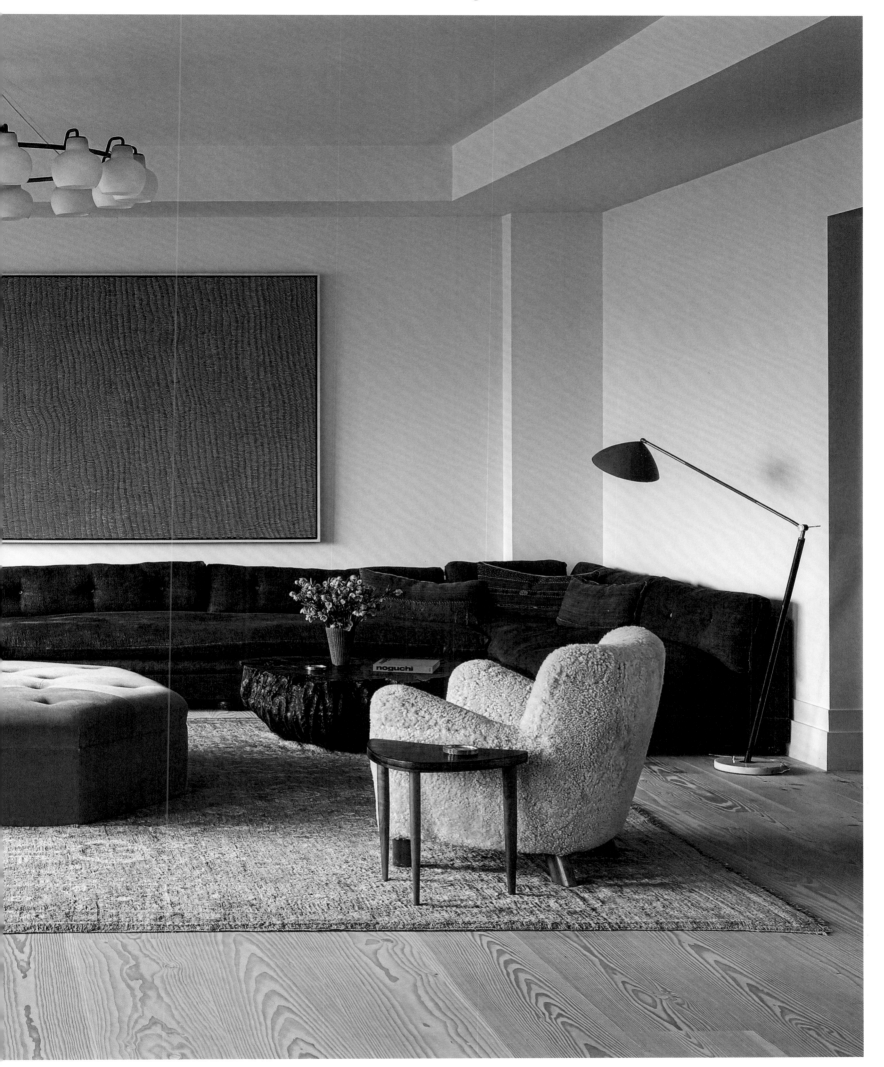

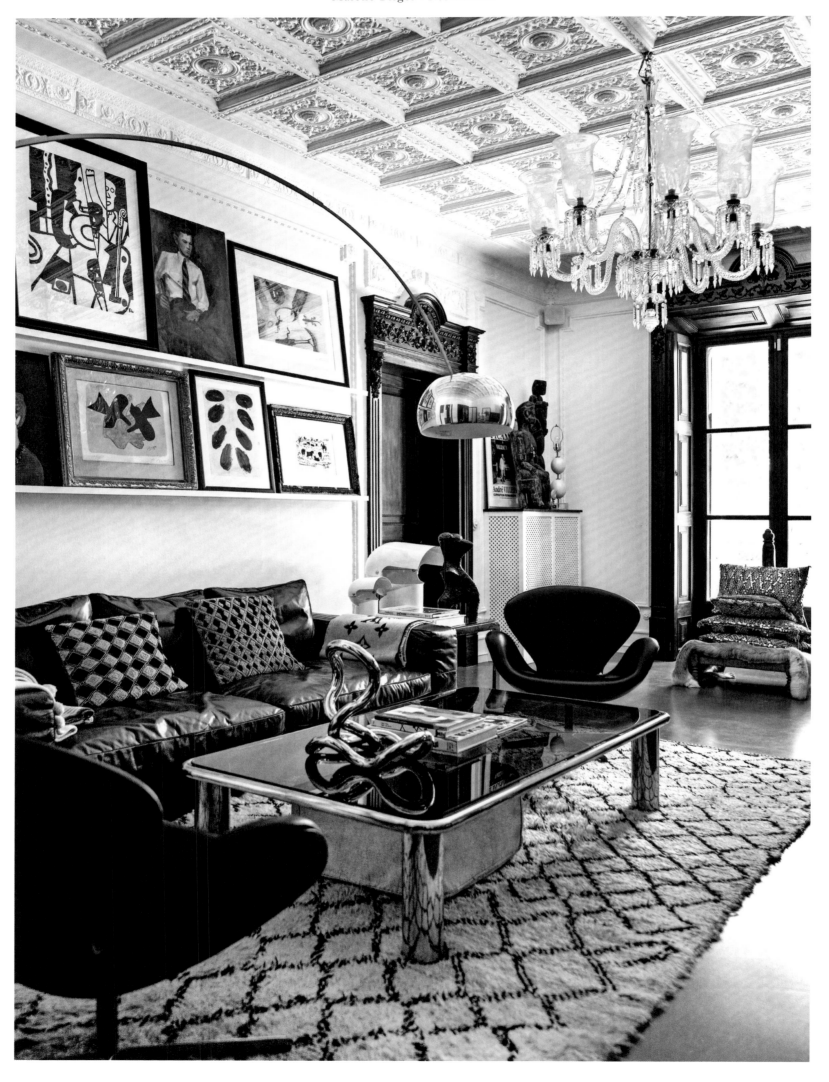

MALENE BIRGER
Lake Como, Italy

"Color has always been integral to my fashion designs. That's why I prefer monochrome interiors."
„In meiner Mode war Farbe stets gegenwärtig. Deshalb bevorzuge ich beim Einrichten schwarz-weiß."
« La couleur est omniprésente dans mes créations. Pour l'aménagement d'intérieur je préfère le noir et blanc. »

Creativity knows no boundaries—a leitmotif that seems perfect for designer Malene Birger. Her fashion labels "Day Birger et Mikkelsen" and "By Malene Birger" were successfully sold in more than 40 countries around the world. More than enough reason for the Dane to turn to new challenges—interior design and art. "We all spend so much time in our homes. I love creating an atmosphere that is warm and cozy but also interesting," she explains. Anyone who has moved over 20 times in less than 20 years knows what counts when furnishing a home. Malene Birger has lived in Stockholm, London, Mallorca, and is now living in Italy, but she was particularly fond of Mallorca. "Mallorca is warm and full of palm trees —my favorite kind of tree," she enthuses. The apartment (left) was love at first sight. Located in a historic building dating from 1890 and with a view of Palma's cathedral, nothing had been changed for 30 years. So, a real find. Malene Birger, who launched her first BIRGER1962 DÉCOR collection, in 2014, has furnished the apartment with numerous items collected on her travels. She intuitively combines modern design with Arabian furniture and artifacts, mostly in black, white, and brown tones. And since the designer herself knows no boundaries, her dream is to design a small boutique hotel. With the distinctive cosmopolitan look that is Malene Birger.

Kreativität kennt keine Grenzen: ein Leitmotiv, das für die Designerin Malene Birger maßgeschneidert scheint. Ihre beiden Modelabel „Day Birger et Mikkelsen" und „By Malene Birger" wurden erfolgreich in über 40 Ländern der Welt verkauft: Für die Dänin war das Grund genug, sich neuen Aufgaben zu widmen – dem Interior Design und der Kunst. „Wir alle verbringen so viel Zeit in unserem Zuhause. Ich habe Freude daran, eine warme, wohnliche und zugleich interessante Atmosphäre zu schaffen", erklärt sie. Wer mehr als zwanzig Mal in 20 Jahren umgezogen ist, weiß, worauf es beim Einrichten ankommt. Malene Birger hat in Stockholm, London und auf Mallorca gelebt, derzeit wohnt sie in Italien. Doch die Baleareninsel hat einen besonderen Platz in ihrem Herzen: „Mallorca ist warm und voller Palmen –

meinen Lieblingsbäumen", schwärmt sie. Die Wohnung (links) war Liebe auf den ersten Blick. Sie liegt in einem historischen Gebäude von 1890 mit Blick auf die Kathedrale von Palma und war seit 30 Jahren nicht verändert worden, ein echter Glücksfall also. Malene Birger, die 2014 mit „Birger1962 DÉCOR" ihre erste Interior-Kollektion präsentierte, hat die Wohnung mit zahlreichen Fundstücken ihrer Reisen eingerichtet. Sie bringt intuitiv modernes Design, arabische Möbel und Kunstgegenstände zusammen, bevorzugt in den Farben Schwarz, Weiß und Braun. Und weil die Kreative selbst keine Grenzen kennt, träumt sie davon, ein kleines Boutique-Hotel zu gestalten. Im unverkennbar kosmopolitischen Malene Birger-Look.

La créativité ne connaît pas de limite : un leitmotiv qui semble crée pour Malene Birger Ses deux labels de mode « Day Birger et Mikkelsen » et « By Malene Birger » se sont vendus avec succès dans plus de quarante pays : Pour la Danoise, c'était une raison suffisante de pour relever de nouveaux défis – dans l'interior design et dans l'art. « Nous passons tous beaucoup de temps chez nous. J'aime créer une atmosphère chaleureuse, agréable et intéressante à la fois », souligne-t-elle. Lorsque l'on a déménagé vingt fois en 20 ans, on connaît les critères importants pour l'aménagement de l'intérieur. Malene Birger a vécu à Stockholm, Londres et Majorque. Elle vit actuellement à Italie. Les Îles Baléares occupent une place spéciale dans son cœur : « À Majorque, il fait chaud et il y a de nombreux palmiers – mes arbres préférés », s'enthousiasme-t-elle. Elle a eu le coup de foudre pour l'appartement (à gauche). Il est situé dans un bâtiment historique de 1890 avec vue sur la cathédrale de Palma et n'avait pas changé depuis 30 ans, un véritable coup de chance. Malene Birger qui a présenté en 2014 sa première collection de décoration d'intérieur « Birger1962 DÉCOR», a aménagé l'appartement avec de nombreuses pièces ramenées de ses voyages. Elle assemble de manière innée un design moderne, des meubles et des objets d'art arabes, elles privilégient les couleurs noir, blanc et marron. Parce que la créativité ne connaît pas de limite, elle rêve d'aménager un petit hôtel-boutique. Dans le look cosmopolite unique de Malene Birger.

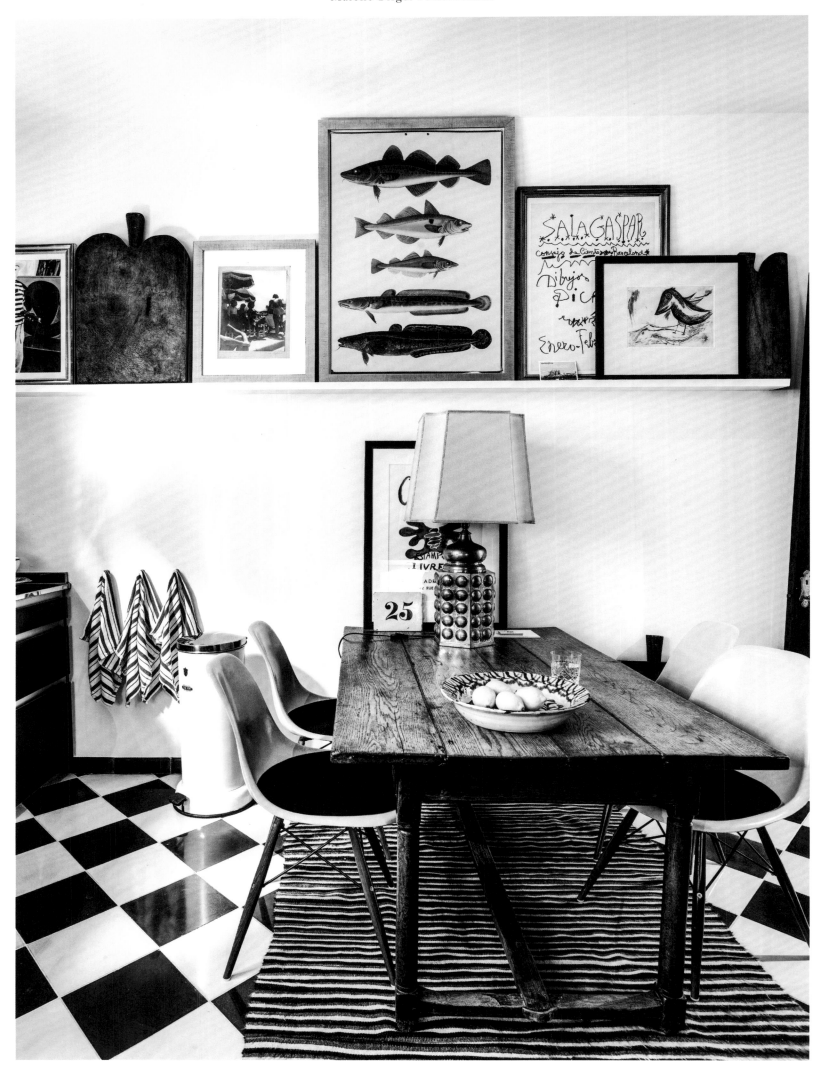

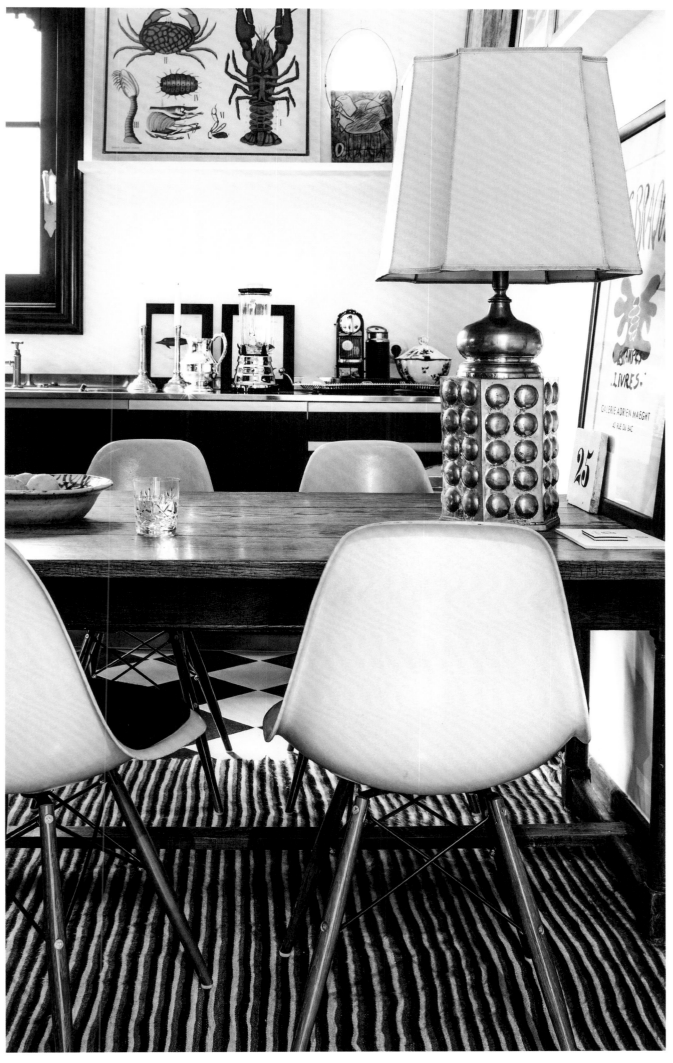

Malene Birger choose
Mallorcan handmade tiles
for the kitchen. Many
of the paintings are her
own work, often created
using twigs, pine needles,
and pine cones instead
of brushes.

In der Küche entschied
sich Malene Birger für mal-
lorquinische Fliesen. Viele
der Bilder hat die Kreative
selbst gemalt, oft benutzt
sie anstatt Pinseln Zweige,
Piniennadeln und Zapfen.

Dans la cuisine, Malene
Birger a opté pour des
céramiques majorquines.
La créatrice a peint la
majorité des tableaux,
souvent, elle utilise des
branches, des aiguilles de
pin et des pommes de pin
plutôt que des pinceaux.

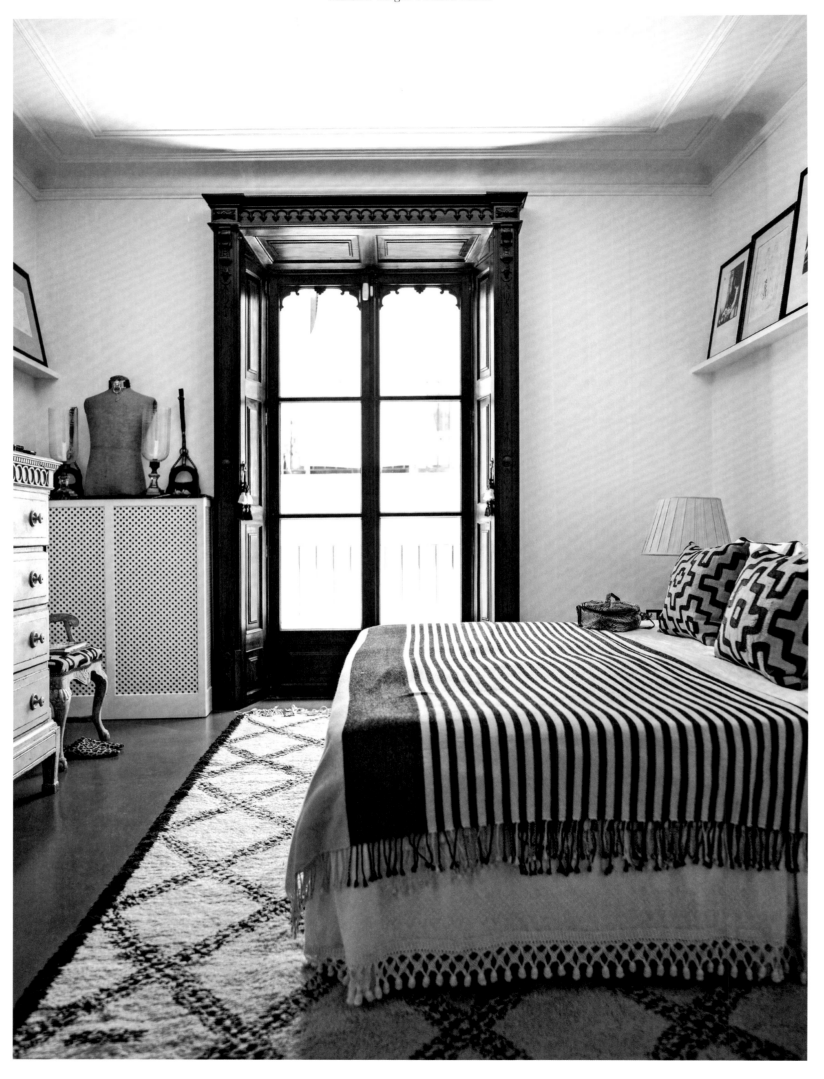

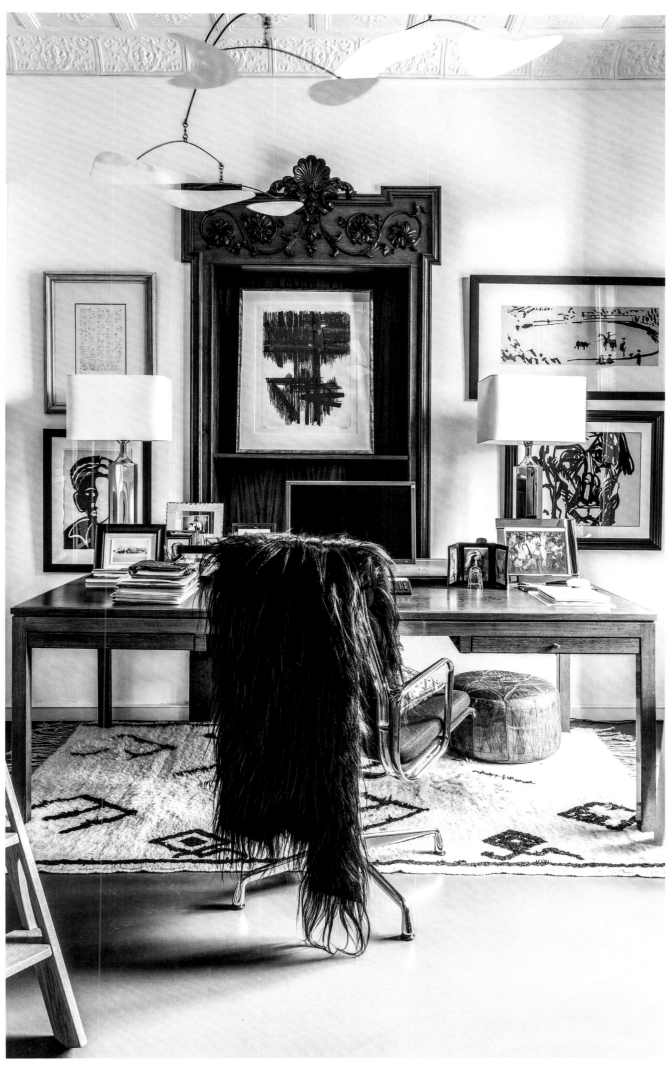

Impressive—the delicate carvings on the door frames, made of Cuban mahogany, are one of the apartment's highlights. Moroccan Berber rugs and African fabrics are the perfect match.

Imposant: die filigranen Schnitzereien der Türrahmen aus kubanischem Mahagoni sind echte Schmuckstücke der Wohnung. Dazu passen marokkanische Berberteppiche und afrikanische Stoffe.

Imposantes : les sculptures filigranes des cadres des portes en acajou cubain sont de véritables bijoux dans l'appartement. Les tapis berbères marocains et les tissus africains s'harmonisent parfaitement avec elles.

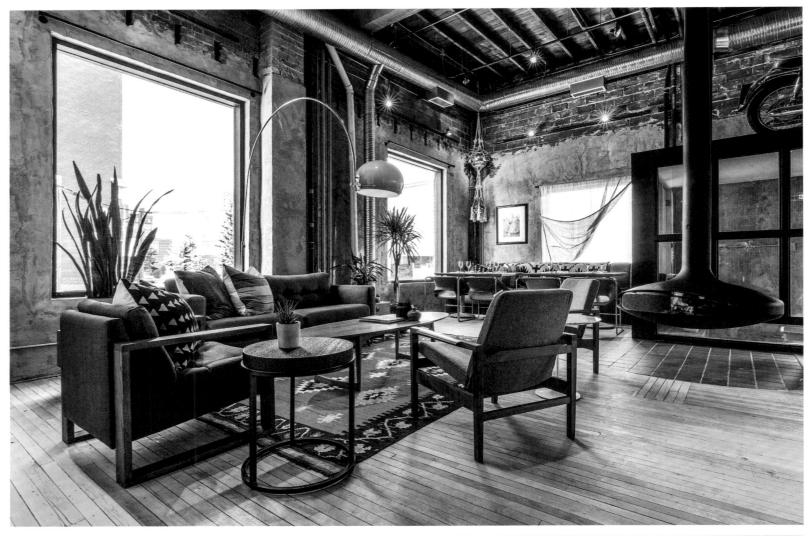

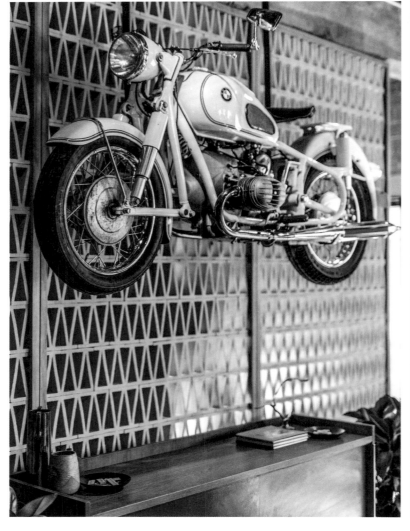

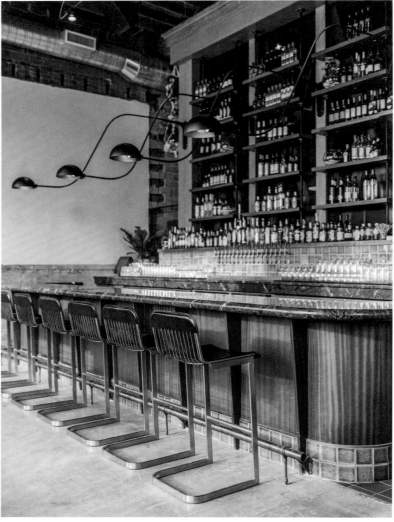

FRANK
Architecture & Interiors
Calgary, Canada

"Most of our work is in hospitality, focusing on atmospheres, moods, and visions."
„In unserer Arbeit geht es meist um Gastfreundschaft. Um Atmosphäre, Stimmung und Visionen."
« Dans notre travail, la convivialité est souvent le maître mot. L'atmosphère, l'ambiance et les visions. »

In this case, the name does not say it all—because behind FRANK are strong women. Kate Allen, Kelly Morrison, and Kristen Lien founded their architectural and interior design practice in 2009 and since then have realized over 100 projects in and around Canada together with their team. Although the company sometimes also handles residential projects, their first love is the planning of gastronomy projects and hotels. "That kind of design allows us to create visions and work with moods. We can indulge ourselves, creating spaces that encapsulate and enchant guests in equal measure." The process always begins with the space and an idea, explains Kate Allen. As was the case with the Bridgette Bar (left), located in a 1930's industrial building in Calgary's hot 10th Avenue neighborhood and completed by FRANK in 2016. The design concept combines the 1950's rock look with 70's boho style. The restaurant's visual center is the open kitchen, complete with a wood fire grill. Art objects and oddball items such as a vintage BMW motorcycle are displayed on the walls. Leather upholstered stools have brass frames and could easily pass for rockabilly originals, while the bar counter is made from green marble. The lounge is composed of vintage furniture oriented around a cozy fireplace. "The Bridgette Bar's motto," explains Kate Allen, "could be 'come as you are—and stay a while'!" An invitation that design-loving guests will surely be only too happy to follow.

Der Name ist nicht Programm – denn hinter FRANK steht geballte Frauenpower. Kate Allen, Kelly Morrison und Kristen Lien gründeten 2009 ihr Architektur- und Interior-Design-Büro, mit ihrem Team haben sie seither mehr als 100 Projekte in und um Kanada realisiert. Obwohl auch private Häuser im Portfolio stehen, schlagen ihre Herzen eindeutig für die Planung von Gastronomieprojekten und Hotels: „Hier können wir Visionen schaffen und mit Stimmungen arbeiten. Wir können schwelgen und Räume kreieren, die Gäste umhüllen und gleichermaßen verzaubern." Am Anfang, so Kate Allen, stehe immer die Immobilie und eine Idee. So war es auch bei der Bridgette Bar (links), die im angesagten Viertel 10th Avenue in Calgary in einem Industriegebäude aus den 1930er-Jahren liegt und von FRANK

2016 fertiggestellt wurde. Das Einrichtungskonzept bringt den rockigen Look der 50er-Jahre mit dem Bohemian Style der Siebziger zusammen. Die offene Küche mit ihrem Holzofengrill ist das optische Zentrum im Restaurant. An den Wänden hängen Kunstobjekte und Kuriositäten, beispielsweise ein Motorrad-Oldtimer von BMW. Der Bartresen trägt grünen Marmor, die lederbezogenen Stühle wurden aus Messing gefertigt und könnten Originale aus der Rockabilly-Ära sein. In der Lounge gruppieren sich Vintage-Möbel um einen gemütlichen Feuerplatz. „Das Motto der Bridgette Bar", erklärt Kate Allen, „könnte lauten: komm' wie du bist – und bleibe!" Eine Aufforderung, der man als designinteressierter Gast nur allzu gerne nachkommt.

Le nom n'est pas représentatif. En effet, plusieurs femmes se cachent derrière FRANK. Kate Allen, Kelly Morrison et Kristen Lien ont fondé leur bureau d'architecture et d'*interior design* en 2009 à Calgary. Depuis, elles ont réalisé avec leur équipe plus de cent projets au Canada et dans les pays voisins. Bien que des logements privés fassent également partie de leur portfolio, elles se passionnent clairement pour la planification des projets gastronomiques et des hôtels : « Ici, nous pouvons créer des Visions et travailler avec des ambiances. Nous pouvons nous épanouir et créer des espaces qui enveloppent les hôtes et les ravissent à la fois. » Selon Kate Allen, il y a toujours un bien immobilier et une idée au début. Cela a été également le cas pour le Bridgette Bar (à gauche) qui se trouve dans le quartier tendance de la 10e avenue à Calgary dans un bâtiment industriel des années 30 et a été réalisé par FRANK en 2016. Le concept d'aménagement réunit le look rock des années 50 et le style bohémien des années soixante-dix. La cuisine ouverte et son four au feu de bois sont les pièces centrales du restaurant. Sur les murs, des objets d'art et des curiosités sont accrochés, par exemple une moto de collection de BMW. Le comptoir est recouvert de marbre vert, les chaises recouverts de cuir ont été faites de laiton et pourraient être des pièces originales de l'époque Rockabilly. Dans le lounge, des meubles vintage se regroupent autour d'un âtre confortable. « Le thème du Bridgette Bar », explique Kate Allen, « pourrait être « viens comme tu es, et reste ! » Une demande que l'on est ravi de satisfaire lorsque l'on est passionné de design.

3 Questions for …
FRANK
Architecture & Interiors

Where does FRANK Architecture & Interiors draw inspiration from? How does your firm maintain creativity?

"Each project has an overarching concept, developed early in the design process. Our goal is to help facilitate a unique and meaningful experience through concept-driven design that links the interior to the cuisine, music, and beverage program. By establishing a conceptual thread that links all aspects of the project, we aim to offer a cohesive and considered experience where each element complements and even elevates the next. With restaurant design, we have the opportunity to provide a memorable experience that punctuates everyday life."

Do you prefer to design interiors for older buildings with classic architecture or newer, modern or contemporary buildings?

"We love working in older buildings. Although they have their renovation challenges, they offer unique character that frames the design discussion and the context for us to respond to. There is an interesting dialogue created when a new intervention meets a space with rich history."

"We love working in older buildings."

The Bridgette Bar assimilates a lot of raw, industrial elements into the overall interior design. Exposed brick, unfinished wood beams, and unpolished concrete mesh comfortably alongside more elegant veneers. What was your decision-making process in choosing which original, more 'rugged' materials to retain in the new, sophisticated design for the space?

"It was important to us that the interior feels as though it had evolved over time. This organic layering of textures establishes a sense of rootedness, history, and charm. The concept for Bridgette Bar is unpretentious and encourages guests to 'come as you are' and even stay awhile. The exposed brick and wood beams support this attitude by celebrating the rawness and beauty of the existing building. We felt that layering the masculine architecture of the existing building with feminine textiles and details would create an interesting contrast while adding warmth and curiosity to the space."

Woher nimmt FRANK Architecture & Interiors seine Ideen? Wie erhält man sich in Ihrer Firma die Kreativität?

„Jedem Projekt liegt ein übergreifendes Konzept zugrunde, das frühzeitig im Planungsprozess entwickelt wird. Wir wollen ein sinnvolles Erlebnis durch eine konzeptbasierte Planung ermöglichen, bei der die Küche, die Musik und das Getränkeangebot zur Einrichtung passen. Indem wir einen roten Faden erstellen, der alle Aspekte des Projekts einbezieht, möchten wir ein kohärentes und in sich schlüssiges Erlebnis bieten, bei dem jedes Element das nächste ergänzt bzw. aufwertet. Mit der Planung von Restaurants haben wir die Möglichkeit, ein unvergessliches Erlebnis zu schaffen, das sich vom Alltäglichen abhebt."

„Wir arbeiten gerne mit Altbauten."

Planen Sie lieber Einrichtungen für Altbauten in klassischer Bauweise oder neuere, moderne oder zeitgenössische Gebäude?

„Wir arbeiten gerne mit Altbauten. Das ist zwar sehr anspruchsvoll bei der Sanierung, aber dafür sind sie von einmaliger Bauart, an der sich die Planungsvorgaben und der Kontext, in dem wir uns bewegen, orientieren. Es entsteht ein spannender Dialog, wenn neue Baumaßnahmen an Gebäuden mit reicher Vergangenheit auszuführen sind."

In der Bridgette Bar finden sich viele rohe Industrieelemente in der Raumgestaltung wieder. Unverputzte Ziegelwände, raue Holzbalken und Sichtbeton vermischen sich nahtlos mit eleganten Verblendungen. Wie verlief bei Ihnen der Entscheidungsprozess, als es galt abzuwägen, welche der 'robusten' Werkstoffe bei der hochwertigen Neugestaltung erhalten bleiben sollten?

„Für uns war es wichtig, dass die Raumgestaltung sich anfühlt, als ob sie sich mit der Zeit entwickelt habe. Der organische Aufbau von Schichten ruft ein Gefühl von Verwurzelung, Geschichte und Charme hervor. Das Konzept für die Bridgette Bar ist unprätentiös und lädt die Gäste ein, in zwanglosem Outfit zu kommen und sich wohl zu fühlen. Die unverputzten Ziegel und Holzbalken tragen dazu bei, indem sie die Rauheit und Schönheit des Gebäudes unterstreichen. Wir fanden, dass die Kombination aus maskuliner Architektur und femininen Textilien und Details einen interessanten Kontrast bilden würde, der dem Raum Wärme und etwas Kurioses verleiht."

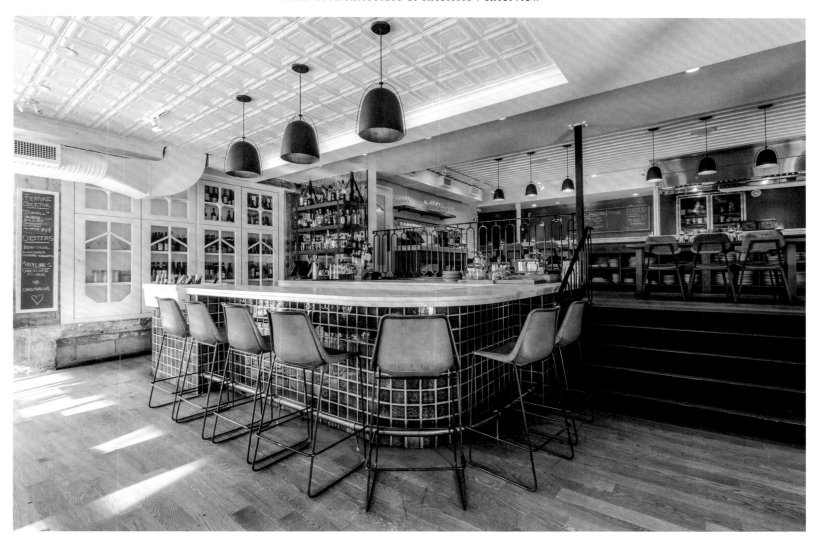

« Nous adorons travailler dans des édifices anciens. »

D'où vient l'inspiration de FRANK Architecture & Interiors ? Comment nourrissez-vous votre créativité ?

« Chaque projet repose sur un concept global, mis en place au début du processus de création. Notre objectif est d'offrir une expérience unique et significative au travers d'un design reliant conceptuellement la cuisine, la musique et la carte des boissons. Grâce à ce concept qui nous permet de proposer une expérience cohérente et réfléchie, chaque élément complète, voire sublime le suivant. Concevoir des restaurants, c'est, pour nous, offrir des moments mémorables qui ponctuent la vie quotidienne. »

Préférez-vous créer dans le cadre d'une architecture ancienne, classique, ou dans des bâtiments plus récents, modernes ou contemporains ?

« Nous adorons travailler dans des édifices anciens. Même si la rénovation apporte son lot de défis, ils possèdent un caractère unique qui détermine nos échanges sur le design et le cadre auquel nous réagissons. Un dialogue intéressant se met alors en place entre les interventions nouvelles et l'espace riche de son histoire. »

L'architecture intérieure du Bridgette Bar intègre de nombreux éléments bruts, industriels. Briques mises à nues, poutres en bois non traitées ou béton non ciré se mêlent avec aisance à des revêtements plus élégants. Selon quels critères avez-vous choisi les matériaux originaux, plutôt « rudes », incorporés au réagencement raffiné de l'espace ?

« Pour nous, il était important que l'intérieur donne l'impression d'avoir évolué au fil du temps. Cette superposition organique de textures crée une sensation d'enracinement, d'histoire, de charme. Dépourvu de prétention, le concept du Bridgette Bar invite les hôtes à venir « comme ils sont » et à rester là un moment. En célébrant l'aspect brut et la beauté de l'édifice, les briques et poutres de bois favorisent cette attitude. Nous pensions qu'associer cette architecture masculine à des tissus et des détails féminins, créeraient un contraste intéressant qui rendrait l'espace tout à la fois chaleureux et surprenant. »

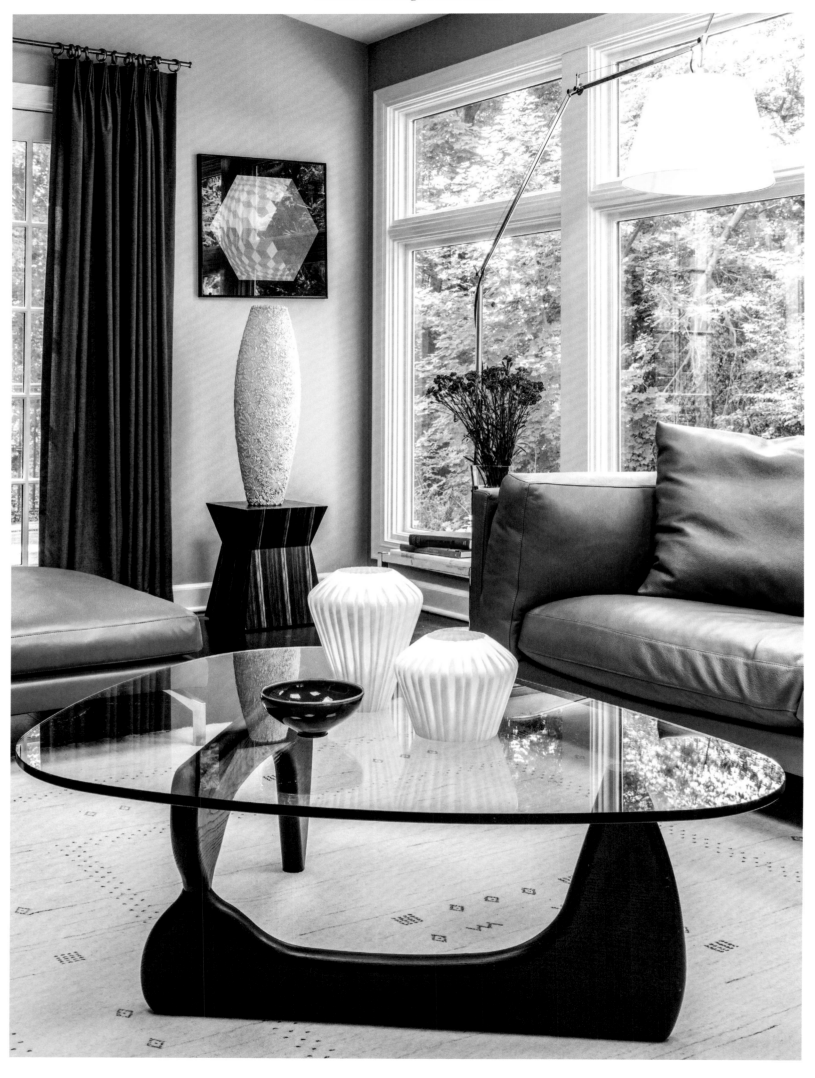

MOLITOR XU DESIGN
New York, United States

"My style is a mélange of Asian and Western cultural elements."
„Mein Stil ist eine Melange aus asiatischen und westlichen Kultureinflüssen."
« Mon style est un mélange d'influences asiatiques et occidentales. »

Hong Molitor-Xu was born in Shanghai, studied civil engineering in Germany, and worked and lived in Hong Kong for many years—all prior to moving to New York in 2007. Molitor-Xu was fascinated by design from an early age, so attending the New York School of Interior Design right after arriving was a logical consequence. At the same time, she started as an intern with the eminent New York interior designer Jamie Drake, and was soon responsible for a number of her large scaled projects as a valuable member of the prominent firm. Now, she has a firm of her own: "I don't feel committed to any particular era or style," she explains. Molitor-Xu draws her inspirations from her rich experience of having lived and worked in different cultures around the world. Because of her roots, she is often asked about Feng Shui. "It is effective," she says, "the place where you naturally feel most at home also has the best Feng Shui." Given her background she is not limited to the Asian elements, but rather combines them with European and Western influences. Her work is inspired more by sound proportions, a creative approach to fabrics and materials and strong architectural elements with elegant silhouettes. She describes her own home (left) as a cultural mélange. In the living room, Asia meets Art Deco. The painting, by a contemporary artist, was brought by Molitor-Xu from China to her chosen home in New York.

Die New Yorker Interior Designerin Hong Molitor-Xu wurde in Shanghai geboren, studierte in Deutschland Bauwesen und arbeitete in Hong Kongs Finanzzentrum – bevor sie 2007 nach New York ging. Schon früh begeisterte sich Hong Molitor-Xu für Design. Der Schritt, 2009 die New York School of Interior Design zu besuchen, war daher nur konsequent. Gleichzeitig fing die Kreative als Praktikantin bei dem angesehenen New Yorker Interior Designer Jamie Drake an und verantwortete schon bald selbst diverse Projekte. Heute betreibt sie ihr eigenes Büro: „Ich fühle mich nicht zu einer speziellen Zeit oder einem Stil hingezogen", erklärt Molitor-Xu. Als Inspiration dienen vielmehr ihre zahlreichen Erfahrungen, die sie in anderen Kulturkreisen rund um den Globus sammeln konnte. Aufgrund ihrer Wurzeln wird sie dabei häufig auf die Harmonielehre Feng-Shui

angesprochen: „Sie ist äußerst wirksam, denn der Ort, an dem man sich geborgen und zu Hause fühlt, hat gleichzeitig auch das beste Feng-Shui." Als versierte Weltenbummlerin beschränkt sich die Designerin jedoch nicht auf asiatische Einflüsse, sondern weiß diese mit westlichen Stilelementen zu kombinieren. Es sind gute Proportionen, der spielerische Umgang mit Textilien und Materialien, starke architektonische Elemente mit anmutigen Silhouetten, die ihre Arbeit besonders inspirieren. Ihr eigenes Zuhause (links) bezeichnet sie als kulturelle Melange: Im Wohnzimmer trifft Asien auf Art déco, das Gemälde eines zeitgenössischen Malers brachte sie aus China in ihre Wahlheimat New York.

La décoratrice d'intérieur new-yorkaise Hong Molitor-Xu est née à Shanghai, a étudié l'architecture en Allemagne et a travaillé dans le centre financier de Hong Kong, avant de déménager à New York en 2007. Très tôt, Hong Molitor-Xu s'est passionnée pour le design. Suivre des cours à la New York School of Interior Design en 2009 n'était ainsi que la suite logique. La créatrice a commencé comme stagiaire du designer new-yorkais en vogue Jamie Drake et a réalisé très vite de nombreux projets. Aujourd'hui, elle possède sa propre agence : « Je n'ai pas l'impression d'appartenir à une époque précise et je ne suis pas attirée par un seul style », explique Molitor-Xu. Ses nombreuses expériences collectées dans d'autres cercles culturels autour du globe lui servent d'inspiration. En raison de ses origines, elle s'inspire souvent de l'art de l'harmonie feng-shui : « Il est très efficace. En effet, le lieu où l'on se sent bien et chez soi est le meilleur feng-shui ». En tant que voyageuse cosmopolite avertie, la designeuse ne se limite cependant pas aux influences asiatiques. Elle sait les combiner à des éléments de style occidentaux. Ce sont les bonnes proportions, l'emploi ludique des textiles et matériaux, des éléments architecturaux forts avec des silhouettes agréables qui inspirent son travail. Elle qualifie son propre intérieur (à gauche) de mélange culture : Dans le séjour, l'Asie est combinée à l'Art déco. Elle a ramené de Chine à New York un tableau d'un peintre contemporain.

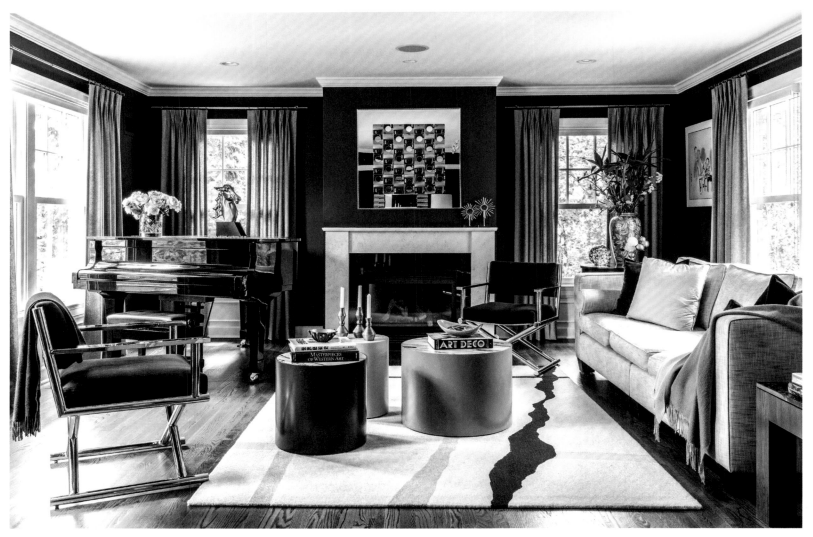

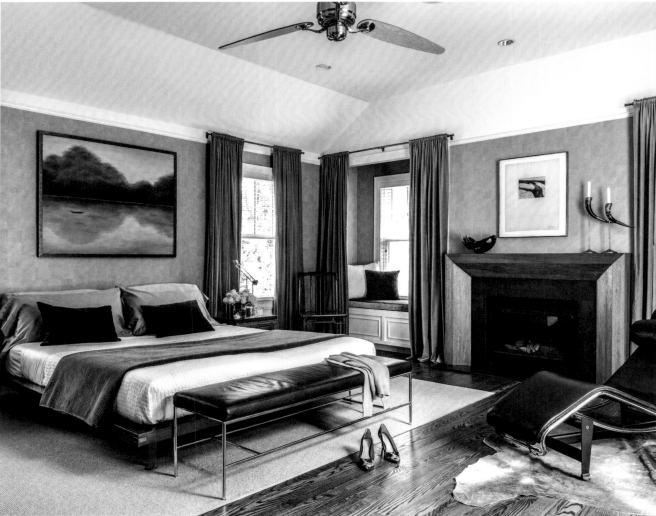

The New York interior designer interprets the dialogue between colors, textures and materials in a highly individual way. In her own house, she marries Art Deco with the Far East.

Die New Yorker Interior Designerin interpretiert den Dialog von Farben, Texturen und Materialien ganz individuell. In ihrem eigenen Haus vereint sie Art déco und Fernost.

La décoratrice d'intérieur new-yorkaise interprète de manière très personnelle le dialogue des couleurs, textures et matières. Elle a allié Art déco et Orient chez elle.

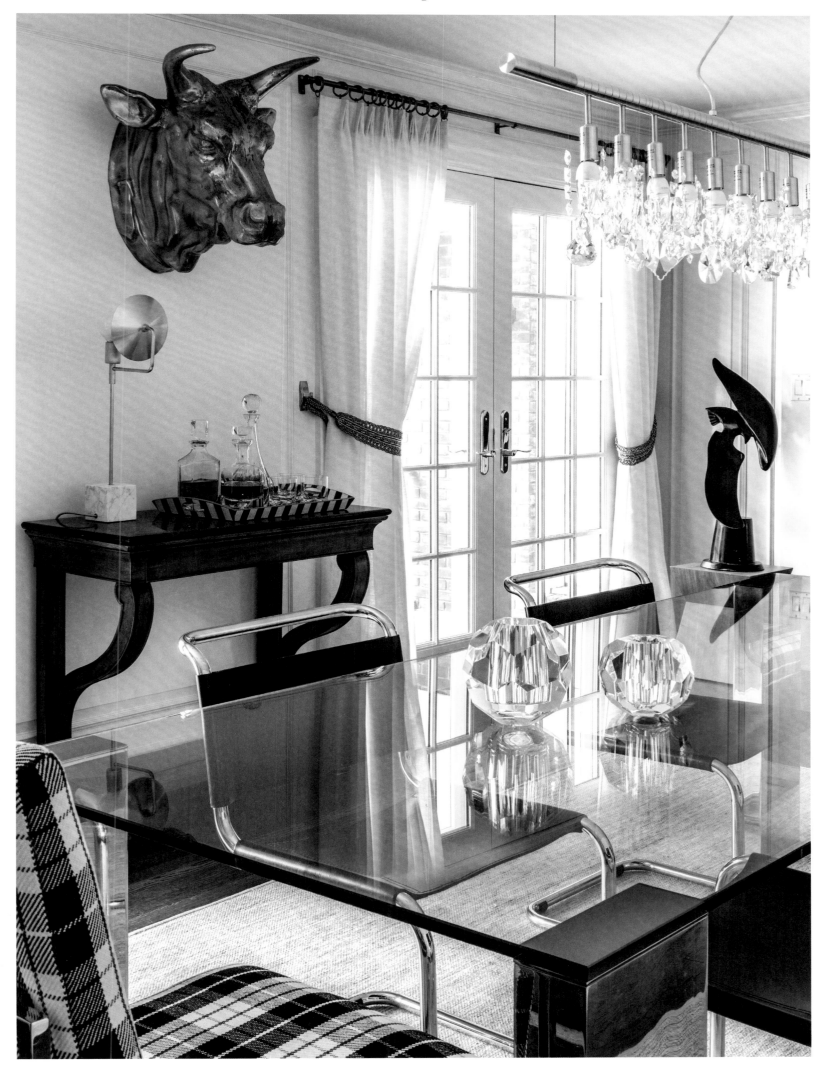

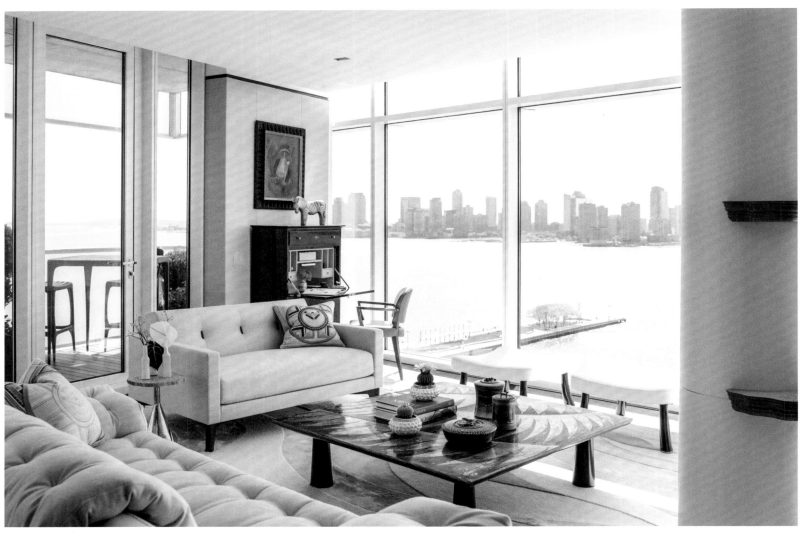

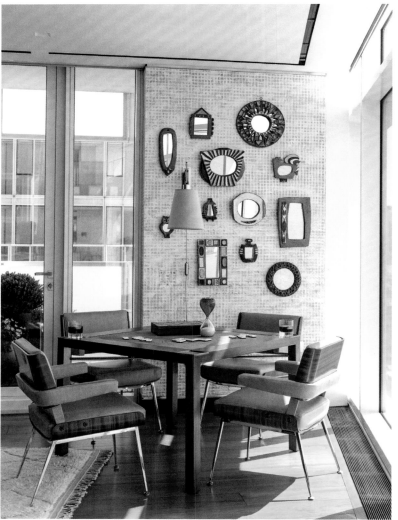

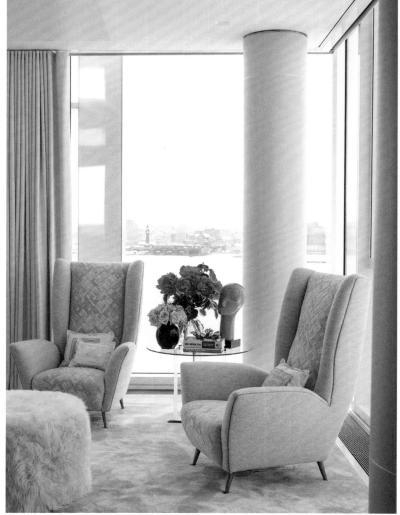

PHILLIP THOMAS
New York City, United States

"For me, it is extremely important to have a warm relationship with clients."
„Es ist mir extrem wichtig, zu meinen Kunden eine herzliche Beziehung aufzubauen."
« Pour moi, il est extrêmement important d'établir une relation sincère avec mes clients. »

There are projects and then there are *projects*. Sometimes the brief is to decorate a small apartment, using spectacular colors or unusual materials to give it a special twist. And sometimes the property's location is, in itself, so fantastic that the best solution is to focus on detail. The latter was the case for an apartment in a waterside glass skyscraper in the West Village, NYC designed by star architect Richard Meier. "The owners gave us a brief that we dubbed 'tree house on the Hudson'," laughs interior designer Phillip Thomas. "They wanted a luxurious retreat, a comfortable place that would entertain them." Thomas, who studied Fine Arts at the New York School of Interior Design and set up his own firm in 2011, places great value on unusual materials. He is passionate about detail, always striving to create concepts that are tailored to the client. In the apartment on the Hudson

River, for example, Thomas had the supporting pillars covered in fine leather, while a cabinetmaker built the drawers in the bar area to fit the bottle dimensions of the client's favorite wines. The result? Mid-century furniture combined with contemporary pieces plus accessories that complement each other without detracting from the spectacular river views provided by the floor-to-ceiling windows.

Es gibt Projekte und es gibt *Projekte*. Manchmal geht es um ein kleines Apartment, das mit spektakulären Farben oder außergewöhnlichen Materialien den Twist bekommt. Und manchmal ist das Objekt allein aufgrund seiner Lage so besonders, dass Interior Design besser im Detail punkten sollte. So war es bei einem Apartment, das in einem New Yorker Glas-Tower im West Village direkt am Wasser liegt. Das Gebäude wurde von Stararchitekt Richard Meier erbaut. „Der Besitzer wünschte sich ein Wohnfeeling, das wir intern als ‚Baumhaus am Hudson' bezeichneten", lacht Interior Designer Phillip Thomas: „Wir sollten einen luxuriösen Rückzugsort kreieren, einen komfortablen Platz, an dem er sich unterhalten fühlte." Phillip Thomas, der an der New Yorker School of Interior Design Kunst studierte und 2011 sein eigenes Studio eröffnete, legt Wert auf außergewöhnliche Materialien. Seine Leidenschaft gilt den Details – sie müssen für den Kunden stets maßgeschneidert sein. Im Apartment am Hudson River ließ Thomas beispielsweise die tragenden Säulen mit feinem Leder verkleiden, die Schubläden im Barbereich fertigte ein Kunstschreiner entsprechend der Maße der Lieblingsweinflaschen des Klienten an. Das Ergebnis: Möbel aus der Mitte des letzten Jahrhunderts, die Thomas mit zeitgenössischen kombinierte sowie Accessoires, die sich ergänzen, ohne von der spektakulären Aussicht aus den bodentiefen Panoramafenstern auf das Wasser abzulenken.

Il y a des projets et des *projets*. Parfois, il s'agit d'un petit appartement que l'on transforme avec des couleurs spectaculaires ou des matériaux inhabituels. Parfois, le bien immobilier est si original rien que par sa situation que l'*interior design* doit plutôt marquer des points dans les détails. Cela était le cas dans un appartement situé dans une tour en verre de New York, dans West Village, directement au bord de l'eau. Le bâtiment a été construit par l'architecte star Richard Meier. « Le propriétaire voulait une ambiance confortable que l'on a qualifiée en interne de « cabane dans les arbres près de l'Hudson » », s'amuse l'architecte d'intérieur Phillip Thomas : « Nous devions créer un lieu de retraite luxueux, un endroit confortable dans lequel on se sentait à l'aise. » Phillip Thomas, qui a étudié l'art à la New York School of Interior Design et a ouvert son propre studio en 2011 accord de l'importance aux matériaux originaux. Il se passionne pour les détails – ils doivent toujours être sur mesure pour le client. Dans l'appartement près de l'Hudson, Thomas a par exemple revêtu les colonnes porteuses de cuir fin, les tiroirs de l'espace barbier ont été fabriqués par un ébéniste en respect des dimensions des bouteilles de vin préférées du client. Le résultat : Des meubles du milieu du siècle que Thomas a combiné avec des meubles contemporains et des accessoires qui se complètent sans détourner l'attention de la vue spectaculaire sur l'eau livrée par les fenêtres panoramiques faisant toute la hauteur de la pièce.

PHILIP GORRIVAN DESIGN

New York City, United States

"I love small rooms. They give one the opportunity to create something really special."
„Ich liebe kleine Räume. Denn sie geben dir die Möglichkeit, etwas ganz Besonderes zu kreieren."
« J'aime les petites pièces. En effet, elles me donnent la possibilité de créer quelque chose d'original. »

Philip Gorrivan is a man of many facets. This is no surprise considering his childhood in Maine, an explosive mix of a father who was a traditional Mainer and a French Moroccan mother. "She used to wear this fantastic Moroccan jewelry and none of the neighbors knew what to make of her," remembers Philip with a smile. To her it seemed natural to mix the traditional with French and Moroccan elements, although she also loved the modern. If you ask the American designer to describe his own signature style, born out of these contrasts, he'll tell you that it is a "combination of exotic eclecticism and classic elegance." In 2001, Philip Gorrivan opened a Manhattan-based design firm and his philosophy goes far beyond decorating—instead, his goal is to create a unique, authentic narrative. "Interiors should always be vivid yet refined," and he uses color, exciting textures, objets d'art, and standalone pieces of furniture to achieve this.

"I particularly like antiques that range from the 18th century to French modern." At the country home in Connecticut that Philip Gorrivan has decorated for himself, his wife, and their two children (right), colonial furniture has been combined with contemporary pieces, creating an atmosphere that is a blend of the rural and the mid-century. The large dining table by Jean-Michel Frank is a particular highlight.

Philip Gorrivan trägt viele Facetten in sich. Aus gutem Grund, denn er wuchs in Portland, Maine in einer explosiven Mischung auf – mit einem konservativen, in der Region tief verwurzelten Vater und einer marokkanischen Mutter mit französischem Lebensstil. „Sie trug diesen großartigen marokkanischen Schmuck und keiner unserer Nachbarn wusste, wie er sie einordnen sollte", erzählt Philip amüsiert. Sie mixte wie selbstverständlich das Traditionelle mit französischen und marokkanischen Elementen, liebte aber ebenso die Moderne. Fragt man den Amerikaner nach seiner eigenen Handschrift, die diesen Gegensätzen entsprungen ist, beschreibt er sie als eine „Kombination aus exotischem Eklektizismus und klassischer Eleganz". 2001 eröffnete Philip Gorrivan in Manhattan eine Designfirma. Seine Philosophie geht weit über

das Einrichten hinaus: Er möchte einzigartige und zugleich authentische Geschichten erzählen. Räume sollen stets lebendig, aber gleichzeitig auch feinsinnig gestaltet werden. Als Werkzeuge dienen ihm Farben, spannende Texturen, Kunstobjekte und Solitäre als Möbel: „Besonders mag ich Antiquitäten, die zwischen dem 18. Jahrhundert und der Französischen Moderne angesiedelt sind!" In seinem Landhaus in Connecticut, das Philip Gorrivan für sich, seine Frau und die beiden Kinder eingerichtet hat (rechts), treffen Kolonialmöbel auf moderne Stücke und erzeugen eine Stimmung zwischen ländlich und Mid-Century. Ein Highlight: der große Esstisch von Jean-Michel Frank.

Philip Gorrivan a de nombreuses facettes. Et à raison. En effet, il a grandi à Portland, Maine dans un mélange explosif – avec un père conservateur, fortement attaché à la région et une mère marocaine au style de vie francais. « Elle portait ces bijoux marocains magnifiques et nos voisins ne savaient pas que penser d'elle », raconte Philip, amusé. Bien évidemment, elle mélangeait le style traditionnel et des éléments francais et marocains mais aimait également la modernité. Si l'on demande au créateur américain quel est son style propre, issu de ces contrastes, il le décrit comme une « combinaison d'éclectisme exotique et d'élégance classique ». En 2001, Philip Gorrivan a ouvert une entreprise de design à Manhattan. Sa philosophie va bien au-delà de l'aménagement d'intérieur : il veut raconter des histoires uniques et authentiques à la fois. Les espaces doivent toujours être aménagés de manière vivante et raffinée à la fois. Couleurs, textures captivantes, objets d'art lui servent d'outils et des éléments solitaires de meubles : « J'aime particulièrement les antiquités entre le XVIIIe siècle et l'époque moderne française ! » Dans sa maison de campagne du Connecticut, que Philip Gorrivan a aménagé pour lui, sa femme et leurs deux enfants (à droite), des meubles coloniaux sont combinés à des pièces modernes et créent une ambiance entre un style rural et mid-century. Un élément phare : la grande table de salle à manger de Jean-Michel Frank.

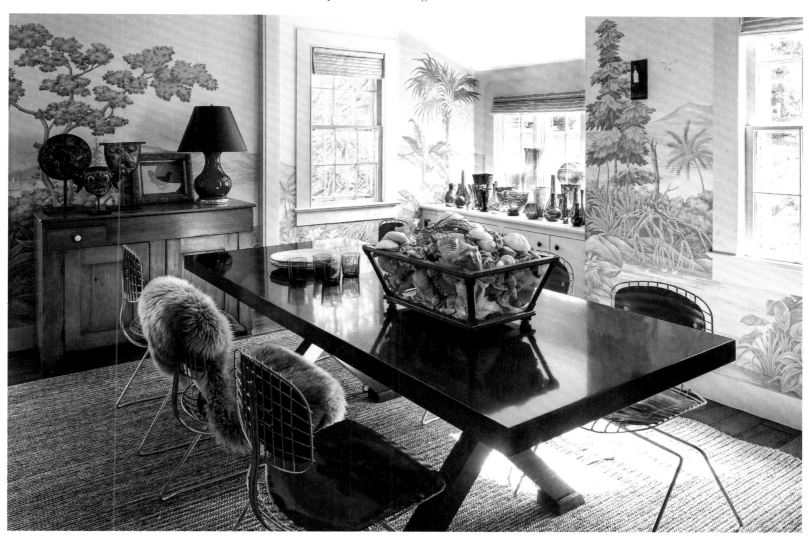

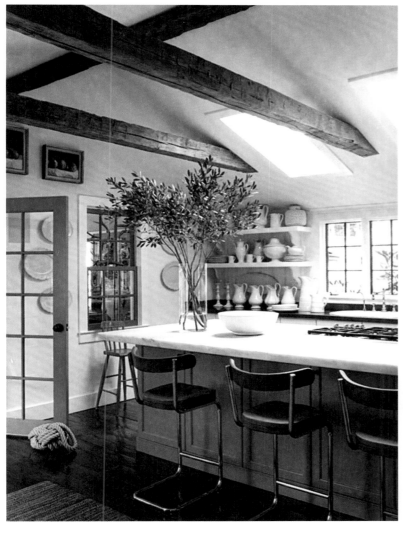

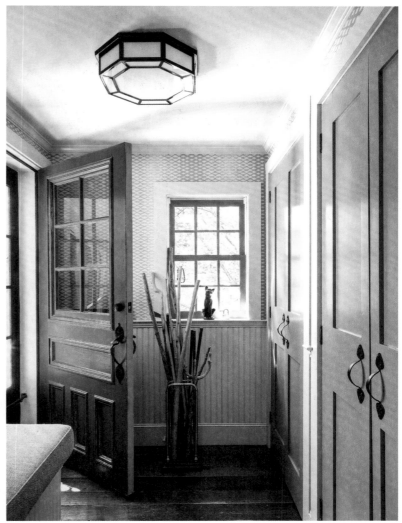

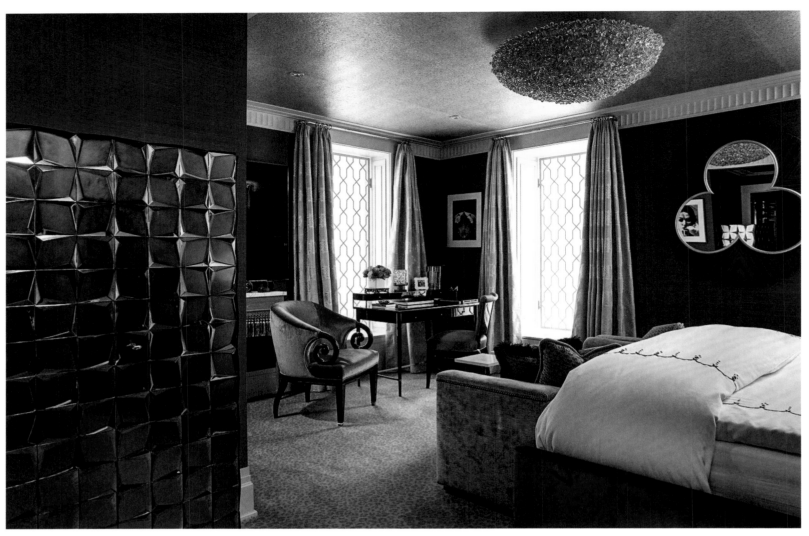

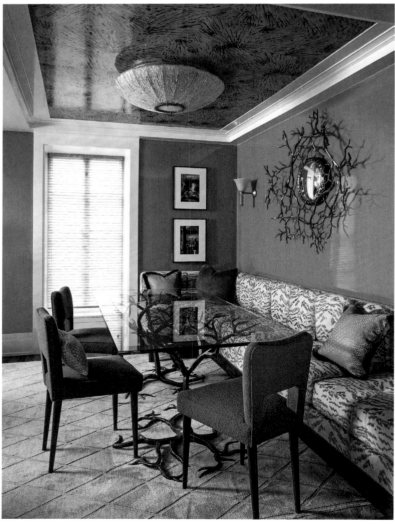

Color is the central element of Philip Gorrivan's interiors—at a pied-à-terre in Manhattan the walls have a reddish brown faux tortoise covering (left). For the living room the designer selected wallpaper in a petrol shade.

Raumbilder durch Farbe: In einem Pied-à-terre in Manhattan leuchten die Wände in braunrotem Schildkrötenimitat (links). Im Wohnzimmer wählte Philip Gorrivan eine Tapete in Petrol.

Des motifs haut en couleurs : dans un pied-à-terre à Manhattan, les murs s'éclairent dans une imitation tortue marron-rouge (à gauche). Dans le séjour, Philip Gorrivan a choisi une tapisserie couleur pétrole.

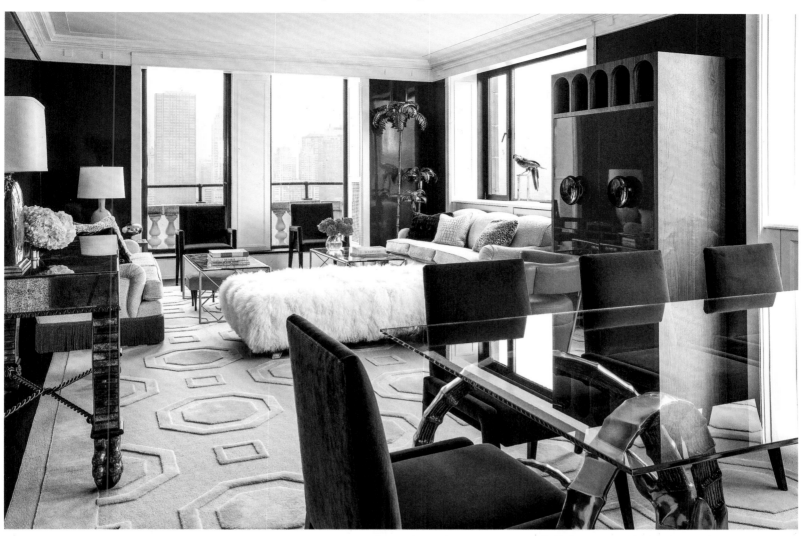

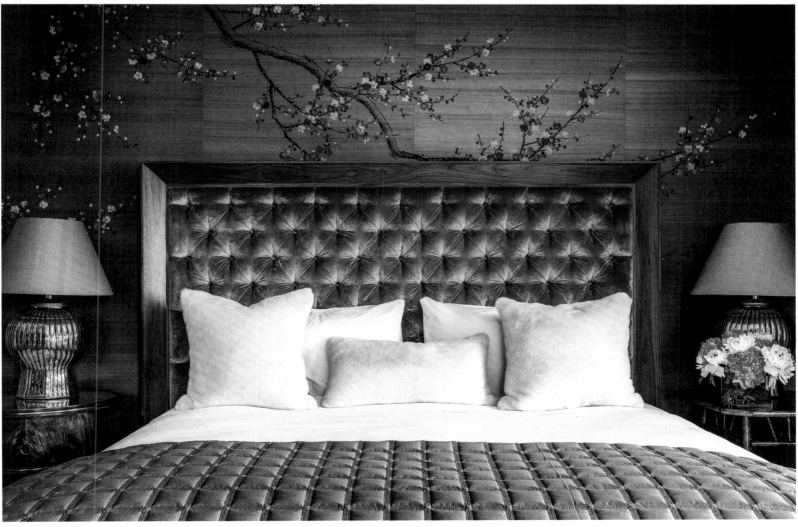

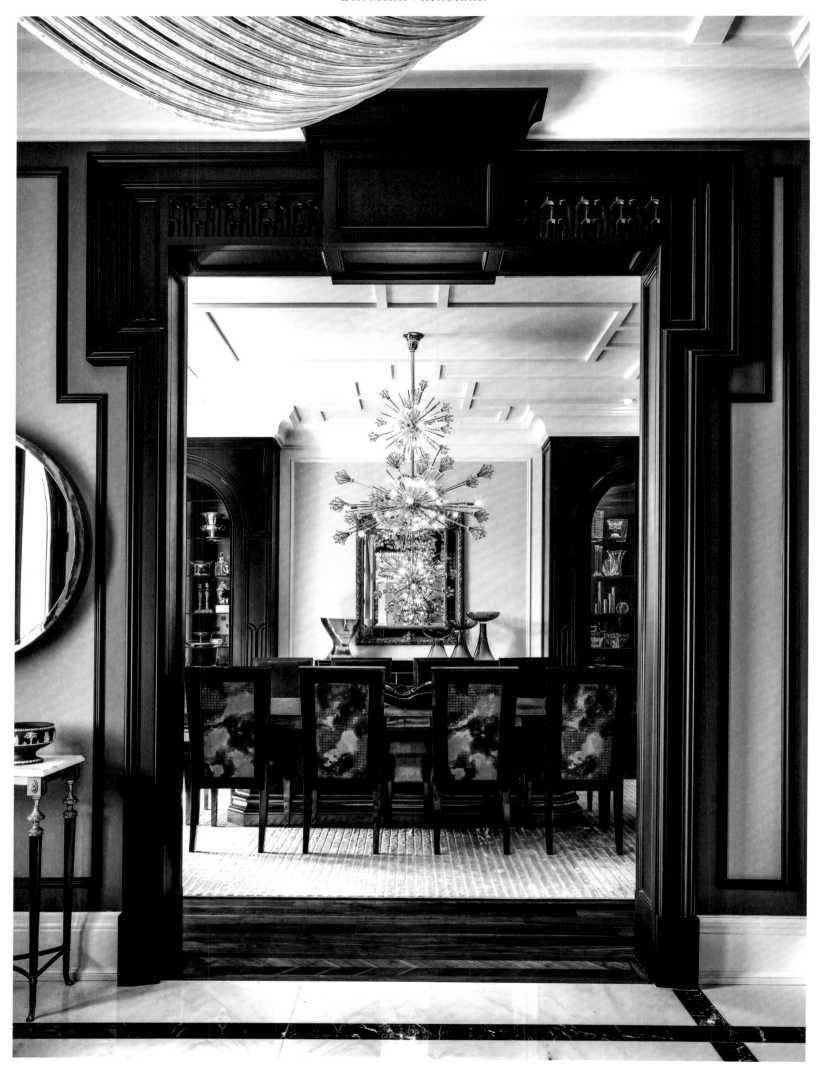

LORI MORRIS

Toronto, Canada

"I don't like to follow trends; I would rather seek to initiate them."
„Ich möchte keinen Trends folgen, sondern versuche lieber Trends zu initiieren."
« Je ne veux pas suivre de tendance, je préfère les initier. »

Lori Morris describes herself as bold, confident and, in terms of her work as an interior designer, insatiable. Knowing no boundaries is, according to her, a contradiction in itself. "My personal style," she explained smiling, "is what I'd call sophisticated rocker chic." The Canadian is an avid fashion lover and draws inspiration from the likes of Dolce & Gabbana because both create a fusion of glamour and joie de vivre. Lori Morris grew up in the west of Toronto and discovered her passion for fabrics, patterns and exclusive materials at an early age. "I designed my own room when I was ten and from that moment onward I knew what my career was going to be." After studying at the International Academy of Merchandising and Design in Toronto, she founded Lori Morris Designs (LMD) in 1987. Her design team has since expanded to encompass over 35 staff. Together they have designed the interiors of villas and homes in San Francisco, Miami, and Toronto. Lori Morris has no desire to focus on one particular style. Something her designs do all have in common is a blend of elegance and warmth. In north Toronto she outfitted a newly built villa (left) in art deco style, integrating black-lacquered door arches and a custom-crafted walnut table enthroned on a solid plinth. Above the table hangs a 24-carat-gold-plated, three-tier Sputnik chandelier like some kind of futuristic satellite. This is the point where you know what Lori Morris means by rocker chic.

Sie beschreibt sich selbst als kühn, souverän und, was ihre Arbeit als Interior Designerin betrifft, unersättlich. Kennt keine Grenzen, sagt, sie sei ein Widerspruch in sich selbst: „Meinen persönlichen Stil", erzählt Lori Morris lachend, „würde ich mondänen Rocker-Chic nennen." Die Kanadierin liebt Mode. Lässt sich gerne von Dolce & Gabbana inspirieren – weil beide Modeikonen Glamour mit Lebensfreude paaren. Aufgewachsen ist Lori Morris westlich von Toronto. Schon früh entdeckte sie ihre Passion für Stoffe, Muster oder feine Materialien: „Im Alter von zehn Jahren habe ich mein Zimmer entworfen und von diesem Moment an stand mein Berufswunsch fest." Nach ihrem Studium an der International Academy of Merchandising and Design

in Toronto gründete sie 1987 Lori Morris Designs (LMD). Inzwischen ist ihr Designteam auf über 35 Mitarbeiter angewachsen. Gemeinsam haben sie Villen und Häuser in San Francisco, Miami oder Toronto eingerichtet. Lori Morris möchte sich auf keinen Stil festlegen lassen. Was ihre Entwürfe eint, ist die Mischung aus Eleganz und Wärme. Eine neu erbaute Villa im Norden Torontos (links) gestaltete sie im Art-déco-Stil. Mit schwarz lackierten Torbögen und einem auf Maß gefertigten Walnusstisch, der auf einem massiven Sockel thront. Darüber schwebt eine mit 24 Karat vergoldete dreistöckige Sputnik-Leuchte wie ein futuristischer Satellit. Spätestens jetzt weiß man, was Lori Morris mit Rocker-Chic meint.

Elle se décrit elle-même comme effrontée, souveraine et insatiable dans son travail de décoratrice d'intérieur. Elle ne connaît pas de limite et dit d'elle-même qu'elle est un paradoxe : « Mon style personnel », raconte Lori Morris en souriant, « je le décrirais comme chic-roc mondain ». La Canadienne aime la mode. Elle s'inspire volontiers de Dolce & Gabbana – parce qu'ils savent allier glamour et joie de vivre. Lori Morris a grandi à l'ouest de Toronto. Ella découvert très tôt sa passion pour les tissus, les motifs et les matériaux raffinés : « À l'âge de dix ans, j'ai aménagé ma chambre. À partir de ce moment-là, j'avais trouvé ma vocation. » Après des études à l'International Academy of Merchandising and Design à Toronto, elle a fondé en 1987 Lori Morris Designs (LMD). Son équipe de design comprend désormais 35 collaborateurs. Ensemble, ils ont aménagé des villas et appartements à San Francisco, Miami ou Toronto. Lori Morris ne veut pas se cantonner à un style. Le point commun de ces réalisations est un mélange d'élégance et de chaleur. Elle a aménagé une nouvelle villa construite dans le nord de Toronto (à gauche) dans le style Art déco. Avec des arches noir verni et une table sur mesure en bois de noyer qui trône sur un socle massif. Au-dessus, une lampe Sputnik à trois étages dorée à l'or 24 carats flotte tel un satellite futuriste. Un bel exemple de ce que Lori Morris entend par chic-roc.

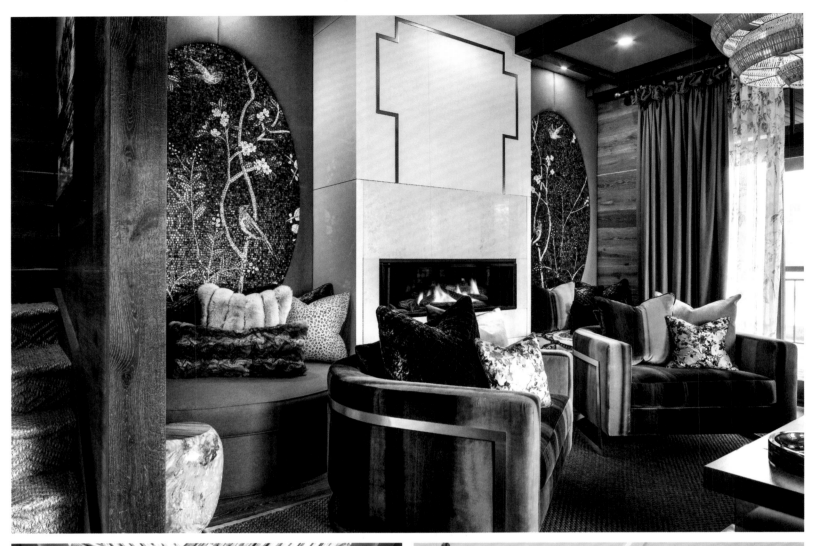

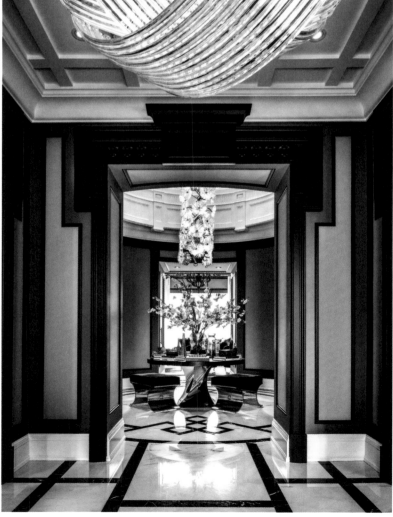

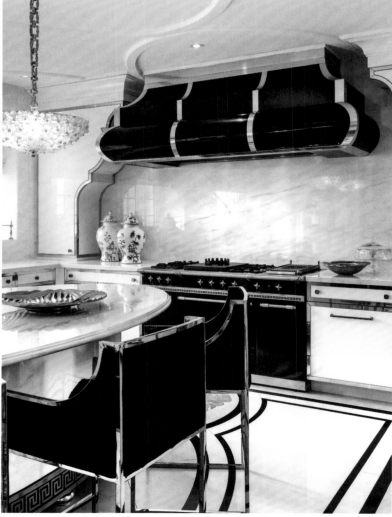

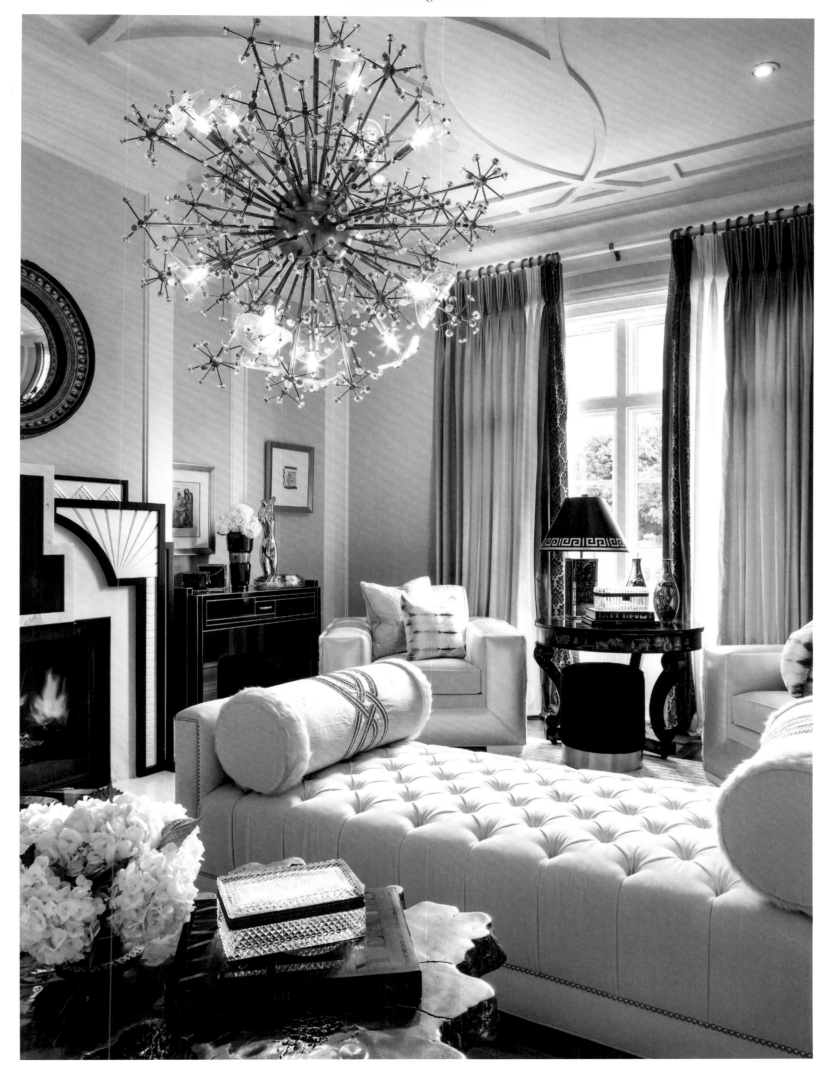

HBA
Dubai, United Arab Emirates

"Guests arriving at a hotel should be surprised by its unique atmosphere."
„Gäste, die ein Hotel betreten, sollen mit einer einzigartigen Atmosphäre überrascht werden."
« Les clients qui entrent dans un hôtel doivent être surpris par une ambiance unique. »

Paris, Los Angeles, Shanghai—David T'Kint has lived on virtually every continent on the planet and knows from his own experience what travelers want. Born in Belgium, David T'Kint has been managing the Dubai office of Hirsch Bedner Associates (HBA), an international interior design firm specializing in the hospitality sectors with 22 offices worldwide, since 2014. "Creativity can only succeed if it is combined with passion. This applies not only to our work but how we approach it. Our focus is on finding out what our clients really want." In the case of the Raffles Jakarta Hotel in Indonesia the client, successful businessman Pak Ciputra, provided a clear brief—the luxury hotel should reflect the colorful spirit of Indonesian artist Hendra Gunawan. Working closely with the client, David T'Kint and his team commissioned large-scale art installations on the walls and ceilings that reproduce original works by Gunawan. Explosions of intense color are framed by a backdrop of elegant gold tones and juxtaposed with classic upholstery, oversized chaise longues, and high-end materials such as onyx marble. In the "Writers Bar" (right) HBA Dubai has showcased a legend from Gunawan's early Indonesian childhood. Tall, tree-like lamps fashioned from crystal glass chains resemble Javan waterfalls, while the design of the custom-made blue carpet includes highly life-like tropical fish.

Paris, Los Angeles, Shanghai: David T'Kint hat auf beinahe allen Kontinenten der Welt gelebt und weiß aus eigener Erfahrung, was Reisende wünschen. Der gebürtige Belgier führt seit 2014 die Dependance Dubai von Hirsch Bedner Associates (HBA), einem internationalen, auf Gastronomie und Hotellerie spezialisierten Interior-Design-Büro mit weltweit 22 Standorten. „Kreativität kann ohne Passion nicht erfolgreich sein. Das gilt nicht nur für unsere Arbeit, sondern auch für unsere Herangehensweise. Herauszufinden, was unsere Kunden wirklich wollen, darauf liegt unser Fokus." Beim Raffles Jakarta Hotel in Indonesien stand der konkrete Wunsch des Auftraggebers Pak Ciputra, einem erfolgreichen Unternehmer, im Vordergrund: Das Luxushotel sollte die Farbenwelt des indonesischen Künstlers Hendra Gunawan spiegeln. David T'Kint und sein Team ließen in enger Zusammenarbeit mit dem Auftraggeber großflächige Kunstinstallationen an Wänden und Decken von Originalgemälden reproduzieren. Um Gunawans explosiver Farbkraft einen Rahmen zu geben, banden sie diese in elegante Goldtöne ein, schufen Gegensätze mit klassischen Polstermöbeln, überdimensionierten Chaiselongues und hochwertigen Materialien wie Onyxmarmor. In der „Writers Bar" (rechts) visualisierte HBA Dubai eine Sage aus Gunawans früher indonesischer Kindheit. Raumhohe Leuchten aus Kristallglasketten erinnern an die Wasserfälle Javas, auf blauen, maßgefertigten Teppichböden schwimmen scheinbar lebendige tropische Fische.

Paris, Los Angeles, Shanghai: David T'Kint a vécu sur presque tous les continents du monde et sait par expérience ce que souhaitent les voyageurs. Ce Belge de naissance dirige depuis 2014 le Dependance Dubai d'Hirsch Bedner Associates (HBA) une agence d'architecture d'intérieur internationale spécialisée dans la gastronomie et l'hôtellerie avec 22 sites dans le monde entier. « La créativité ne peut pas fonctionner sans passion. Cela ne s'applique pas seulement à notre travail mais également à notre approche. Découvrir ce que nos clients veulent vraiment, c'est sur cela que nous nous concentrons. » Dans l'hôtel Raffles de Jakarta en Indonésie, l'envie concrète du donneur d'ordres Pak Ciputra, un entrepreneur accompli, était au premier plan : l'hôtel de luxe devait refléter l'univers de couleurs de l'artiste indonésien Hendra Gunawan. En étroite collaboration avec le donneur d'ordres, David T'Kint et son équipe ont fait reproduire de grandes installations de peintures originales sur les murs et les plafonds. Afin d'apporter un cadre aux couleurs explosives de Gunawan, ils les ont encadrés dans des tons dorés élégants, ils ont créé des contrastes avec des meubles capitonnés classiques, des chaises longues surdimensionnées et des matériaux de qualité comme le marbre-onyx. Dans le « Writers Bar » (à droite), HBA Dubai a visualisé une légende issue de l'enfance de Gunawan en Indonésie. Des lampes à hauteur de pièce, faites de chaînes de cristal, rappellent les cascades de Java, sur des tapis bleus sur mesure nagent des poissons tropicaux semblant vivants.

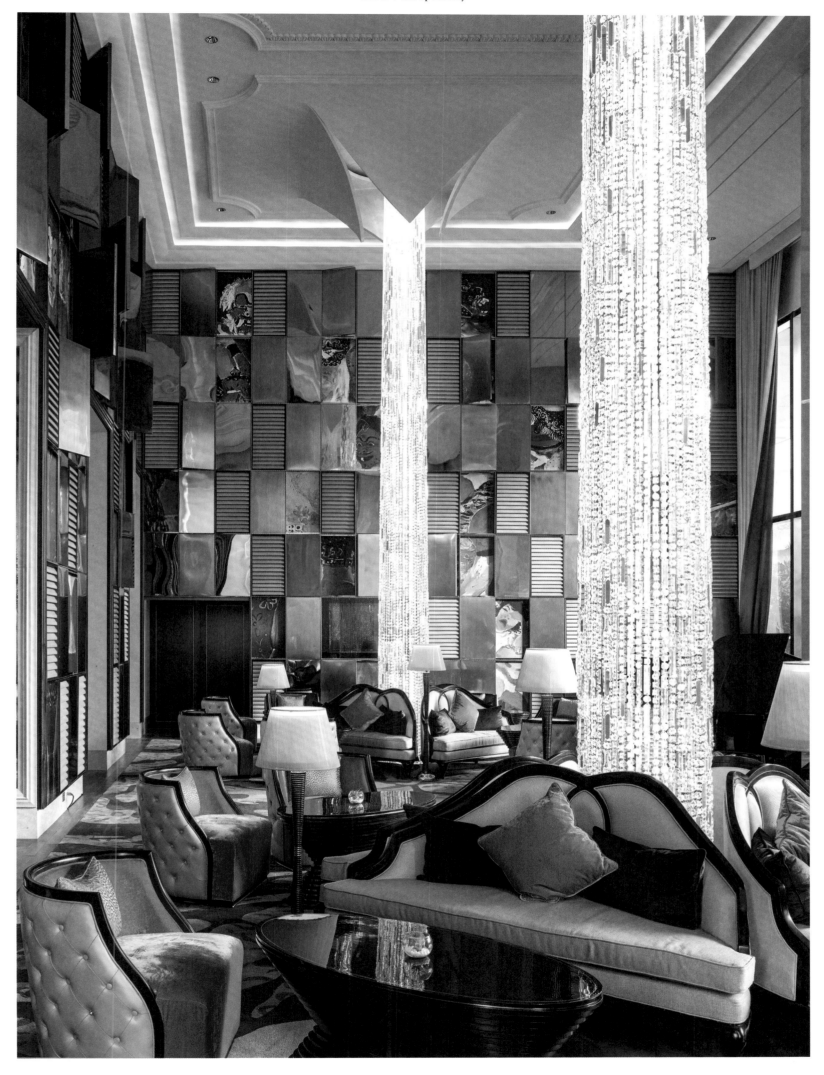

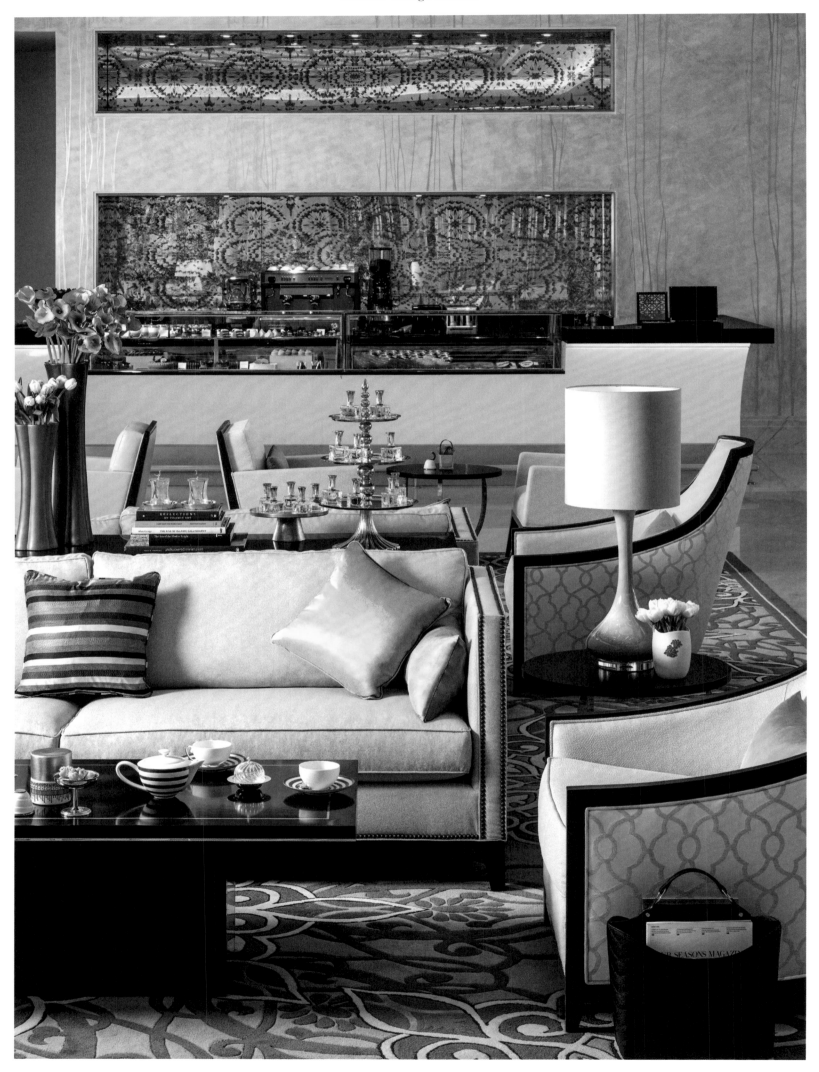

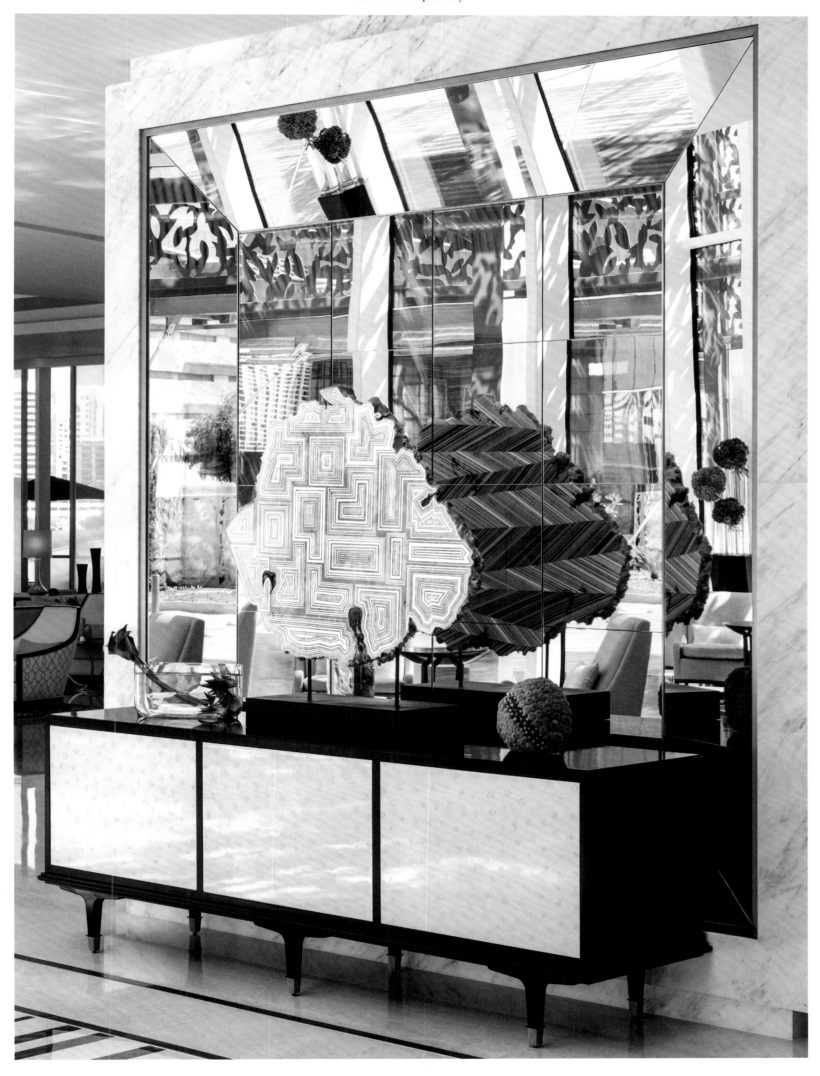

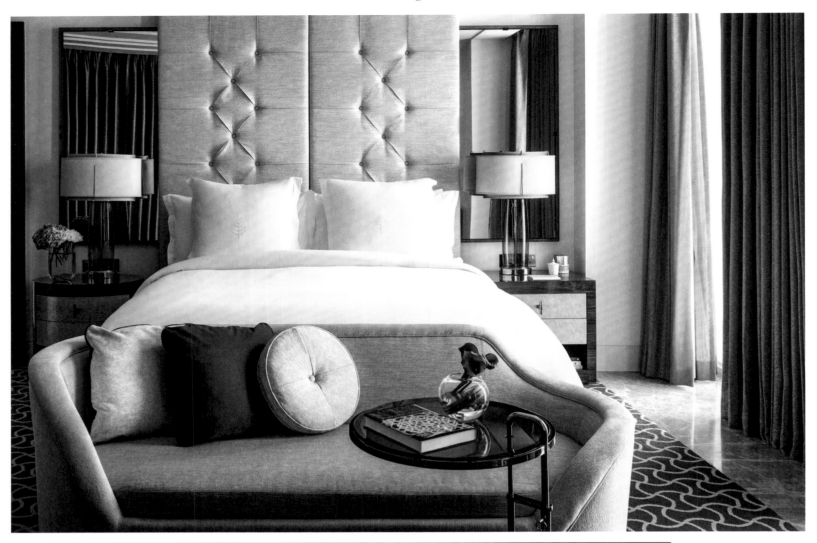

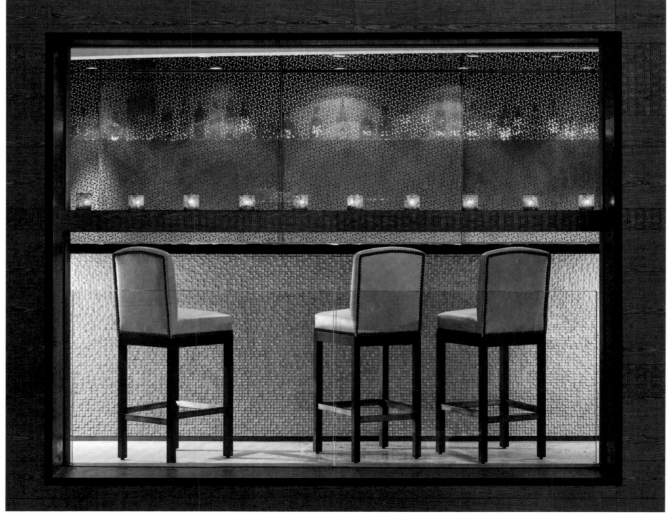

At the Four Seasons Hotel Abu Dhabi (previous double page and top left) opulent details harmonize with classic elements. Lebanon's rich culture is referenced throughout the Kempinski Beirut hotel (right).

Im Four Seasons Hotel Abu Dhabi (vorherige Doppelseite und oben links) korrespondieren opulente Details mit klassischen Elementen. Das Kempinski Beirut zitiert die reiche Kultur Libanons im gesamten Hotel (rechts).

Dans l'Hôtel Four Seasons d'Abu Dhabi (double page précédente et en haut à gauches), des détails opulents sont associés à des éléments classiques. Le Kempinski de Beyrouth évoque la richesse culturelle libanaise dans l'ensemble de l'hôtel (à droite).

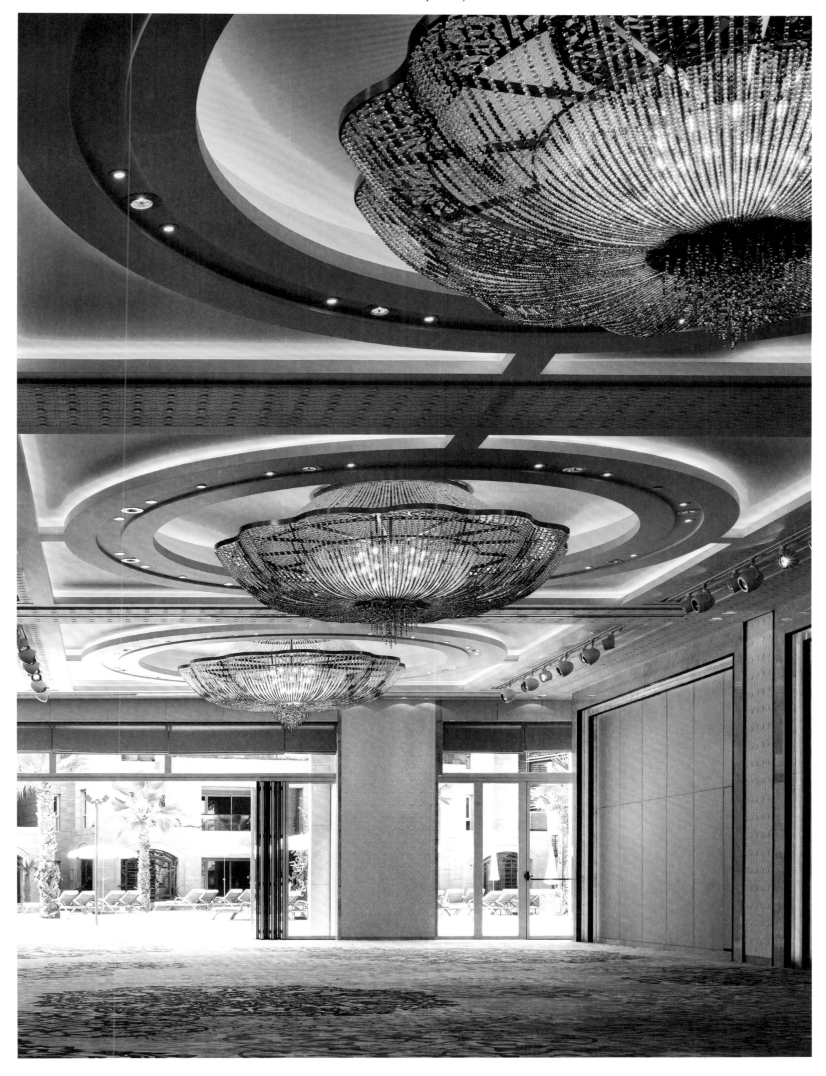

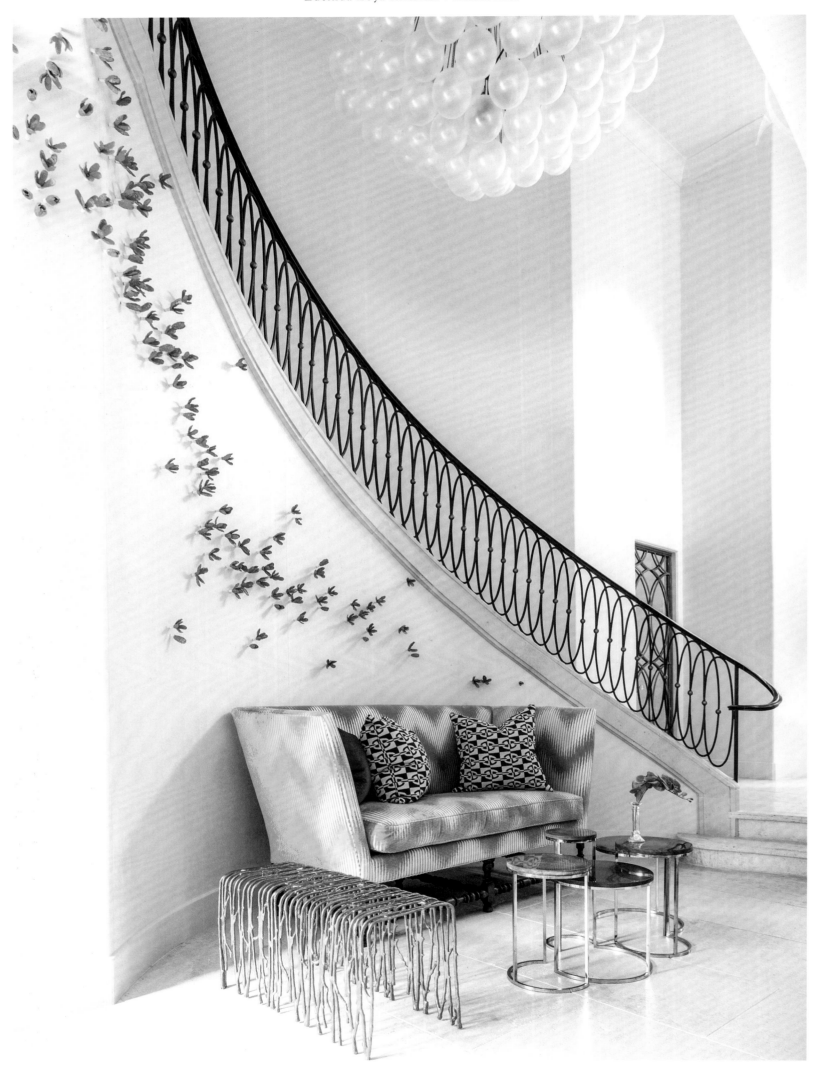

LUCINDA LOYA INTERIORS

Houston, United States

"I integrate something white into every space—to provide the eye with a point of reference for the other colors."
„Ich integriere in jeden Raum etwas Weißes – damit das Auge einen Bezugspunkt zu den Farben hat."
« J'intègre un peu de blanc dans chaque pièce – afin que l'œil est un point de référence pour les couleurs. »

How do you define a unique and vibrant interior design aesthetic? You could describe it as clever but timeless, and bursting with energy. Or you could just look at the interiors designed by Lucinda Loya. "I always approach my projects with the clients' lifestyle in consideration, with an open mind and when possible a dash of humor," explains the designer, who is well-known for the explosive interior and fashion style that led to American *Vogue* including her on their *Vogue* 100 list, citing her trend setting fashion sense, and professional achievements. Based in Texas, with an office in Houston, she describes herself as being passionate about her work—no matter the size of a project. What she likes best is putting an artistic twist on her client's ideas to come up with a result that is not only original but, above all, looks sophisticated and surprising. For the entryway of a villa (left) she decided to give center stage to a Bradley Sabin piece comprising light red ceramic flowers, while the walls and floors remain in a low-key white. In Louisville, Kentucky Loya purchased a mansion dating from 1875, transforming it into a spacious seven-bedroom residence for her family and guests, who are always welcome. Full of enthusiasm—Louisville is her hometown—she created interiors that are bursting with colors and patterns. If any house deserves to be described as fabulously flamboyant, it's this one.

Wie definiert man eine einzigartige Interior-Design-Ästhetik? Man könnte sie als raffiniert, aber zugleich auch zeitlos und energiegeladen beschreiben. Oder man sieht sich Räume der Interior Designerin Lucinda Loya an. „Ich gehe stets mit Offenheit und Humor an meine Projekte heran und berücksichtige die Lebensweise meiner Kunden", erklärt die Kreative, die für einen explosiven Wohn- und Modestil gleichermaßen bekannt ist und 2010 in der amerikanischen *Vogue* 100 Liste für ihr trendweisendes Modegespür ausgezeichnet wurde. Die Texanerin, deren Büro in Houston liegt, sagt über sich selbst, sie sei passioniert – egal, wie umfangreich ein Projekt angelegt ist. Am meisten Spaß habe sie daran, den Vorstellungen ihrer Kunden einen künstlerischen Twist zu geben, damit am Ende das Ergebnis nicht nur außergewöhnlich, sondern vor allem auch elegant und überraschend aussieht. Für die Eingangshalle einer Villa (links) entschied sie sich, dem Kunstwerk von Bradley Sabin aus hellroten Keramikblüten optisch den Vortritt zu lassen, Wände und Boden hielt sie bewusst zurückhaltend weiß. In Louisville, Kentucky kaufte Lucinda Loya ein Herrenhaus von 1875 und verwandelte es in ein großzügiges Anwesen mit sieben Schlafzimmern für ihre Familie und stets willkommene Gäste. Voller Enthusiasmus (Louisville ist ihre Heimatstadt) schuf sie ein Interior voll bunter Farben und Muster. Wenn ein Ort die Beschreibung einzigartig und flamboyant verdient, dann dieser.

Comment définit-on une esthétique unique de décoration d'intérieur ? On peut la qualifier de raffinée et également atemporelle et dynamique à la fois. Ou alors on admire les pièces aménagées par la décoratrice d'intérieur Lucinda Loya. « J'aborde toujours mes projets avec une ouverture d'esprit et de l'humour et je tiens toujours compte du mode de vie de mes clients », déclare la créatrice connue pour un style d'intérieur et de mode explosif et qui est entrée en 2010 dans la liste américaine *Vogue* 100 pour son sens branché de la mode. La Texane, dont le bureau se trouve à Houston, dit d'elle-même qu'elle est passionnée – quelle que soit l'ampleur du projet. Elle aime par dessus tout apporter une touche artistique aux idées de ses clients afin que le résultat soit non seulement exceptionnel mais également élégant et visuellement surprenant. Pour le hall d'entrée d'une villa (à gauche), elle a choisi de mettre en exergue l'œuvre d'art de Bradley Sabin en fleurs de céramique rouge clair et de laisser volontairement les murs et le sol en retrait en blanc. À Louisville, Kentucky, Lucinda Loya a acheté un manoir de 1875 et la transformé en une grande demeure avec sept chambres pour sa famille et ses invités. Pleine d'enthousiasme (Louisville est sa ville d'origine), elle a créé un intérieur haut en couleurs et en motifs. Si un lieu mérite d'être qualifié d'unique et de flamboyant, c'est bien celui-ci.

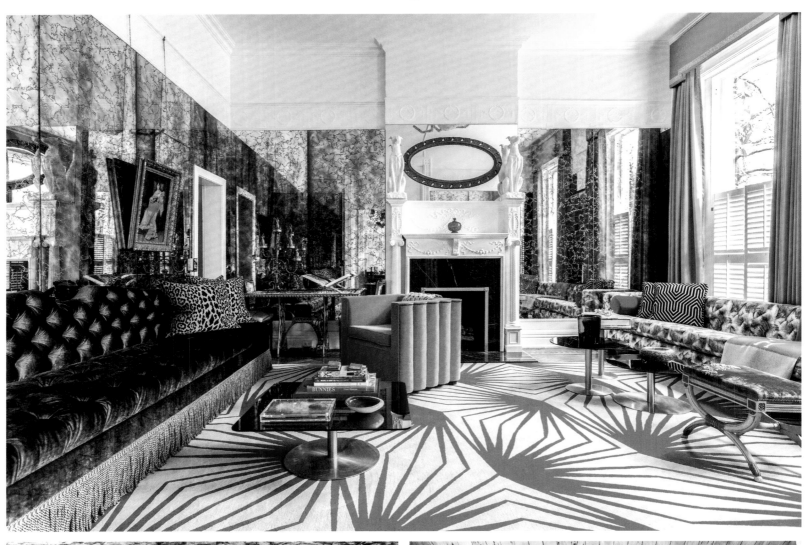

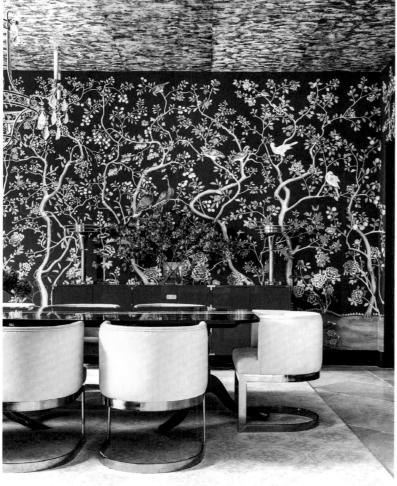

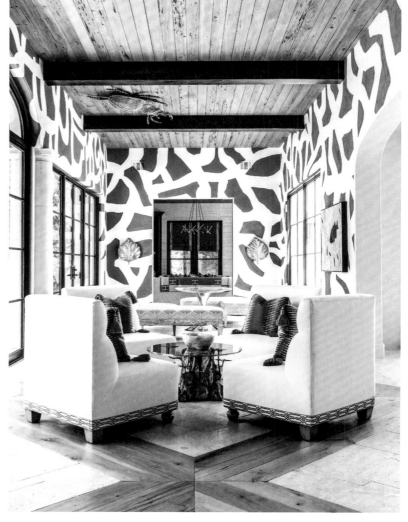

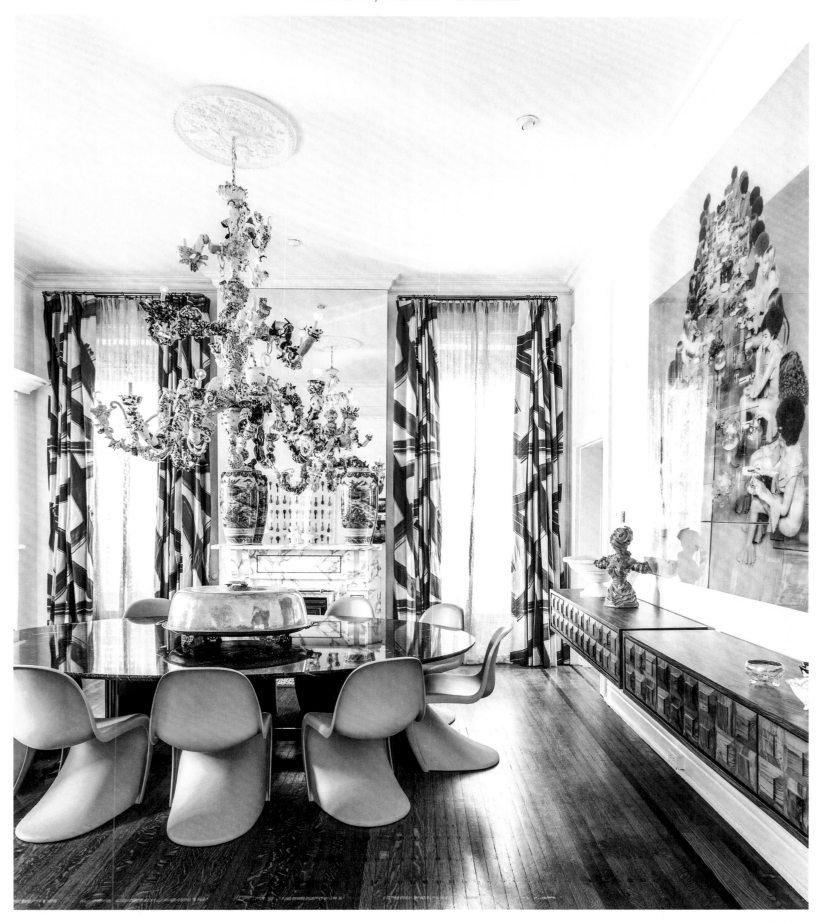

In Kentucky (left page, top image) Lucinda Loya transformed a mansion into a colorful stage set. The brightly patterned rug is from The Rug Company.

In Kentucky (linke Seite oben) verwandelte Lucinda Loya eine Villa in ein farbenfrohes Bühnenbild. Der gemusterte Teppich stammt von The Rug Company.

Dans le Kentucky (en haut à gauche), Lucinda Loya a transformé une villa en un décor haut en couleurs. Le tapis à motif est signé The Rug Company.

A ceramic chandelier (above) created by New York artist Francesca DiMattio illuminates the light and bright dining room. Lucinda Loya grouped pistachio green Panton chairs around a marble table.

Im Esszimmer (oben) illuminiert ein Keramik-leuchter der New Yorker Künstlerin Francesca DiMattio den lichten Raum. Lucinda Loya gruppierte Panton Chairs in Pistaziengrün um den Marmortisch.

Dans la salle à manger (haut), une lampe en céramique de l'artiste new-yorkaise Francesca DiMattio éclaire la pièce lumineuse. Lucinda Loya a rassemblé des Panton Chairs vert pistache autour de la table en marbre.

113

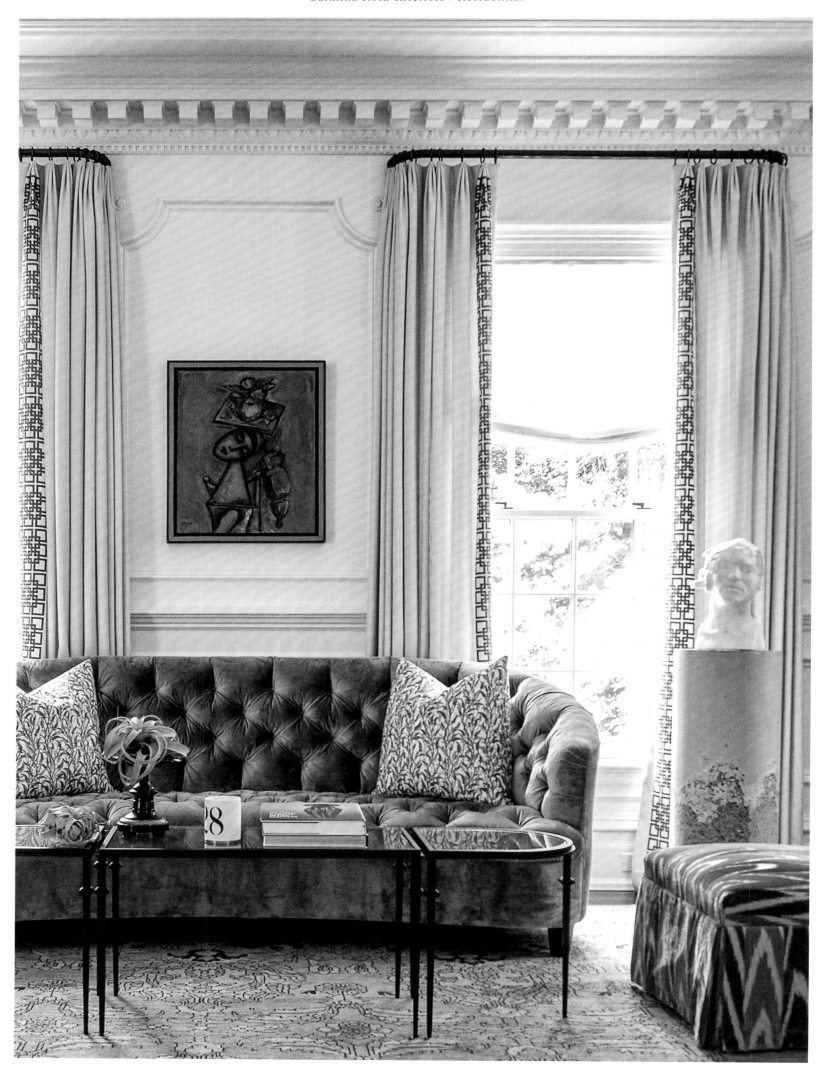

CARMIÑA ROTH INTERIORS

Greenwich, United States

"The creative process for an interior design brief is like a journey."
„Der Schaffensprozess einer Inneneinrichtung ist wie eine kreative Reise."
« Le processus de réalisation d'un aménagement d'intérieur est comme un voyage créatif. »

Carmiña Roth's passion for interior design began at the tender age of eight years, when she started to change her room around. Born in Puerto Rico, she grew up in North Carolina, studied architecture and art history in France and Italy, and received a law degree from Yale with a focus on art law. After graduating, Carmiña Roth worked in finance for many years, channeling her creativity renovating apartments in New York City and homes in the Hamptons for friends and acquaintances. In 2006, she finally got up the courage to take the leap and set up her own interior design firm in Greenwich, Connecticut. The designer now has an impressive roster of clients, many of them repeat ones, throughout New England, New York City and beyond. Carmiña Roth places value on being personally involved in all stages of the design process. An attentive ear and a keen eye for each project's special aspects allow her to develop concepts that are tailored to each client. When redecorating a villa in Greenwich, she responded to the client's wishes, creating an elegant look that is simultaneously warm and vibrant. High-quality materials, fine antiques, and contemporary art are showcased against a backdrop of unobtrusive colors, while pink accents provide a contrast. "We carefully selected every item," explains the interior designer, "to be authentic, interesting, and meaningful."

Ihre Leidenschaft für Interior Design begann im zarten Alter von acht Jahren. Damals fing Carmiña Roth an, ihr Zimmer umzugestalten. Die gebürtige Puerto Ricanerin wuchs in North Carolina auf, studierte Architektur und Kunstgeschichte in Frankreich und Italien sowie Jura in Yale mit dem Schwerpunkt Kunstrecht. Zunächst arbeitete Carmiña Roth viele Jahre in der Finanzwelt und richtete als kreativen Ausgleich New Yorker Apartments und Häuser in den Hamptons für Freunde und Bekannte ein. 2006 wagte sie den Sprung in die Selbstständigkeit und gründete ihr eigenes Studio in Greenwich, Connecticut. Inzwischen kann die Kreative ein beeindruckendes Kundenportfolio vorweisen – für viele hat sie mehrere Projekte in Neuengland, New York City und darüber hinaus realisiert. Carmiña Roth legt Wert darauf, bei jedem einzelnen Schritt persönlich involviert zu sein. Aufmerksam zuhören können und einen klaren Blick für die Besonderheiten eines Objekts entwickeln – auf diese Weise schaffe sie es, für ihre Auftraggeber die richtige Hülle zu schneidern. Einer Villa in Greenwich verlieh sie, entsprechend dem Wunsch der Klienten, einen eleganten Look, der gleichzeitig warm und lebendig wirkt. Hochwertige Materialien, feine Antiquitäten und zeitgenössische Kunst kommen durch zurückhaltende Farben gut zur Geltung, Akzente in Pink wählte sie bewusst als Kontrast. „Jeden Gegenstand", erklärt die Interior Designerin, „haben wir danach ausgewählt, dass er echt, interessant und bedeutsam ist."

Sa passion pour l'*interior design* a commencé à l'âge tendre de huit ans. C'est à cette époque que Carmiña Roth a commencé a aménagé sa chambre. La Portoricaine de naissance a grandi en Caroline du Nord, a étudié l'architecture et l'Histoire de l'art en France et en Italie et le droit à Yale avec une spécialité en droit de l'art. Carmiña Roth a commencé par travailler pendant de nombreuses années dans la finance et aménageait des appartements new yorkais et des maisons dans les Hamptons pour ses amis et ses connaissances afin de satisfaire son côté créatif. En 2006, elle a osé sauter le pas vers l'indépendance et a ouvert son propre studio à Greenwich, Connecticut. Depuis, la décoratrice possède un portefeuille impressionnant de clients. Elle a réalisé plusieurs projets en Nouvelle-Angleterre, à New York et au-delà pour bon nombre d'entre eux. Carmiña Roth aime être impliquée personnellement dans toutes les étapes. Pouvoir écouter attentivement et développer une idée claire des particularités d'un objet – de cette manière, elle réussi à créer le bon espace pour ses clients. Sur demande des clients, elle a conféré à une villa à Greenwich un look élégant, qui est à la fois chaleureux et vivant. Des matériaux de grande qualité, des antiquités raffinées et de l'art contemporain sont mis en valeur par des couleurs discrètes, elle a choisi volontairement les accents rose fuchsia pour former des contrastes. « Nous avons choisi chaque objet », explique la décoratrice d'intérieur, « parce qu'il était authentique, intéressant et avait du sens. »

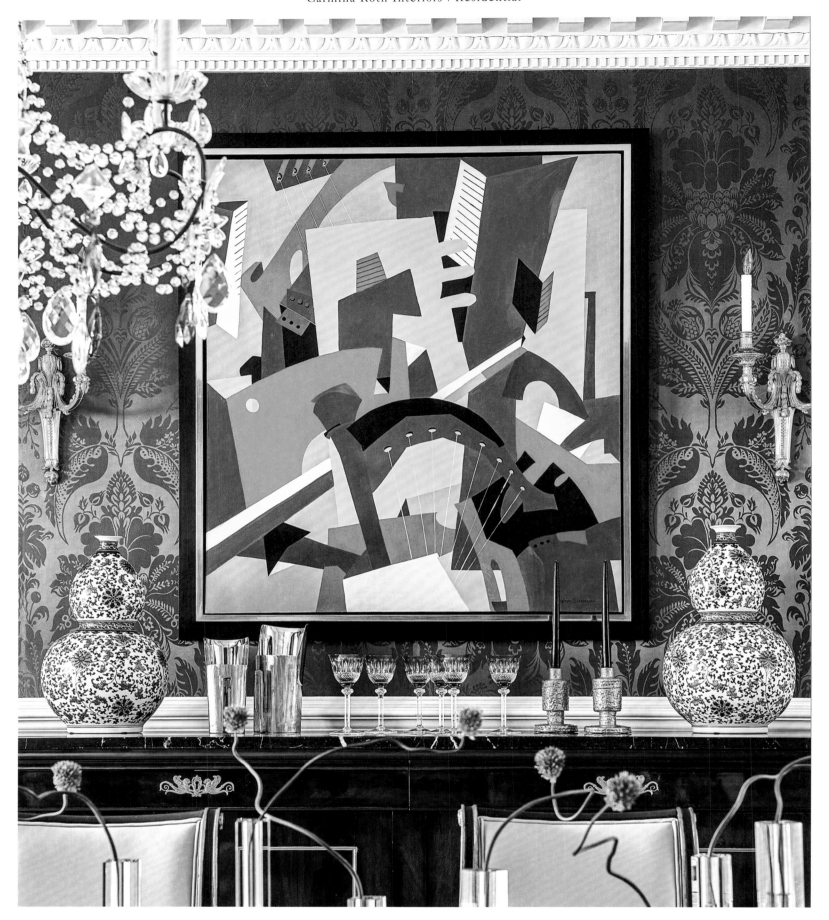

Elegant and vibrant—
the walls in the dining
room are decorated with
silk wallpaper from de
Gournay (above). In the
music room, Carmiña Roth
hung a piece by American
painter Caio Fonseca.

Elegant und lebendig:
die Wände im Esszimmer
tragen eine Seidentapete
von de Gournay (oben).
Im Musikzimmer platzierte
Carmiña Roth ein Kunst-
werk von dem amerikani-
schen Maler Caio Fonseca.

Élégants et vivants :
les murs de la salle à
manger sont recouverts
d'une tapisserie en soie de
Gournay (en haut). Dans
la salle de musique,
Carmiña Roth a placé une
œuvre d'art du peintre
américain Caio Fonseca.

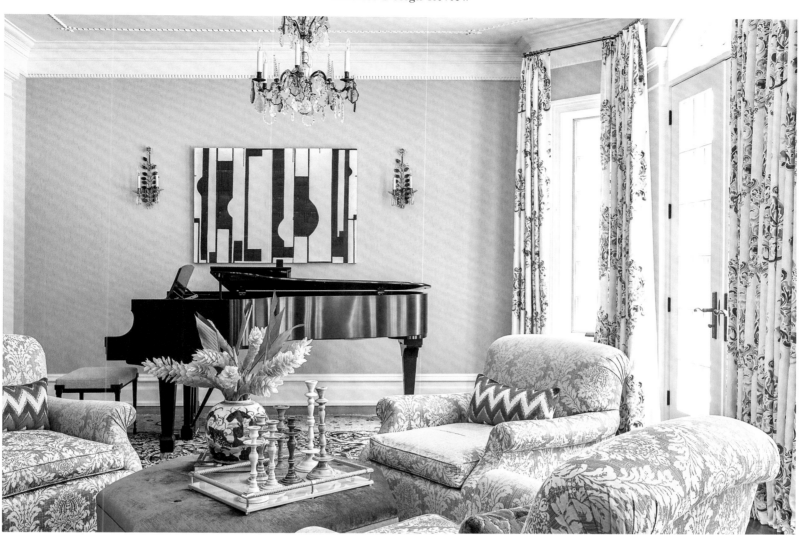

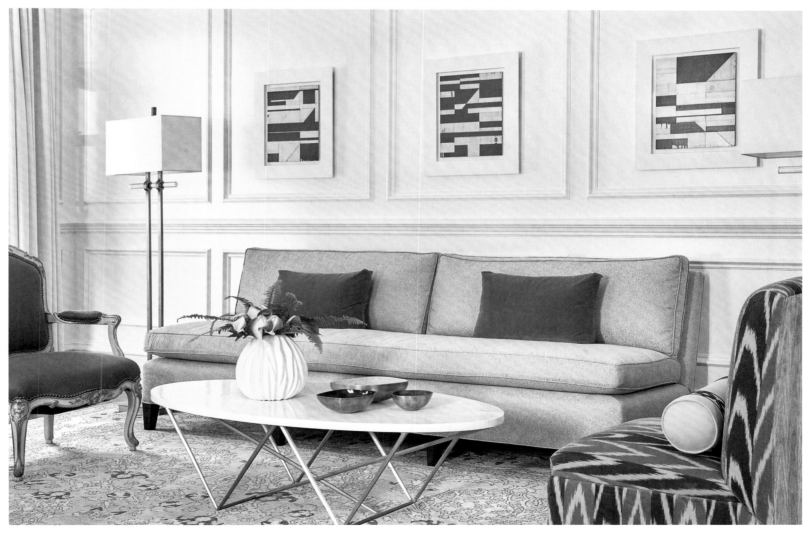

ANGUS MCCAFFREY
San Francisco, United States

"Every room should be decorated in a way that makes you smile."
„Jeder Raum sollte so gestaltet werden, dass er einen zum Lächeln bringt."
« Chaque pièce doit être aménagée de sorte à donner le sourire. »

Working as a team and gaining mutual creative inspiration is a positive experience that Martha Angus and Katie McCaffrey have been enjoying for over 13 years now. For McCaffrey, who was responsible for all projects while working as a design director with Martha Angus Inc., taking the step into partnership was a logical progression. The two designers set up Angus McCaffrey, which is now based north of San Francisco. "We bounce ideas off each other," enthuses Katie. Parallel to this, she explains, it allows Martha to spend more time traveling and searching for unusual design objects, while Katie supervises the projects. Both women can draw on many years of experience—Martha has been designing homes for clients like Ralph Lauren and the Lauder family for over 40 years, while Katie's expertise in the industry and in the field of furniture design has been honed for more than two decades. Together Angus McCaffrey transformed a pied-à-terre in San Francisco into a colorful, elegantly casual home. The clients, a family scattered around the Bay area, uses the residence as a meeting place and wanted something lively to act as a contrast to their more conservatively decorated main home —a stroke of luck. The interior design duo envisaged the living room (right) as a timeless, sophisticated space that would be ideal for both lively parties and as a quiet space to relax. The Francophile owners discovered the sunburst mirror at a Paris flea market and it complements the cosmopolitan look perfectly.

Im Team arbeiten, sich gegenseitig kreativ inspirieren – damit haben Martha Angus und Katie McCaffrey seit über 13 Jahren gute Erfahrungen gemacht. Für Katie McCaffrey, die zunächst bei Martha Angus als Design Direktorin für sämtliche Aufträge zuständig war, schien der Schritt zur Gemeinsamkeit nur konsequent. Die beiden gründeten nördlich von San Francisco Angus McCaffrey: „Wir spielen uns gegenseitig die Bälle zu", schwärmt Katie. Gleichzeitig, erzählt sie, könne Martha sich nun mehr den Reisen und der Suche nach außergewöhnlichen Designobjekten widmen, während sie selbst die Projekte am Laufen halte. Beide schöpfen aus einem langjährigen Erfahrungsschatz: Martha, die seit mehr als 40 Jahren Häuser für Kunden wie Ralph Lauren und die Lauder Familie eingerichtet hat, während Katie seit mehr als zwei Jahrzehnten in der Interior-Branche und

im Bereich Möbeldesign tätig ist. Ein Pied-à-terre in San Francisco verwandelte Angus McCaffrey in ein farbenfrohes, elegantlässiges Domizil. Die Auftraggeber, eine Familie, die in der Gegend um die Bucht von San Francisco verstreut lebt und das Domizil als Treffpunkt nutzt, wünschten sich etwas Lebendiges als Kontrast zu ihrem eher zurückhaltend gestalteten Erstwohnsitz – ein Glücksfall. Das Wohnzimmer (rechts) stellten sich die beiden Interior Designer zeitlos und raffiniert vor, ideal für quirlige Partys, ideal aber auch als Lounge zum Relaxen. Den Sunburst-Spiegel fanden die frankophilen Besitzer auf einem Pariser Flohmarkt. Er passt perfekt zum kosmopolitischen Look.

Travailler en équipe, s'inspirer réciproquement avec créativité – cette recette réussit à Martha Angus et Katie McCaffrey depuis plus de 13 ans. Pour McCaffrey, qui était tout d'abord responsable de l'ensemble des projets en tant que directrice du design chez Martha Angus, cette collaboration était la suite logique. Les deux femmes ont fondé Angus McCaffrey au nord de San Francisco : « Nous nous soutenons mutuellement », s'enthousiasme Katie. De plus, raconte-t-elle, Martha peut désormais consacrer plus de temps aux voyages et à la recherche d'objets exceptionnels de design pendant qu'elle se charge du déroulement des projets en cours. Les deux femmes possèdent une grande expérience : Martha, qui, depuis plus de 40 ans, aménage des maisons pour des clients tels que Ralph Lauren et la famille Lauder et Katie qui travaille depuis plus de vingt ans dans l'architecture d'intérieur et le design de meubles. Angus McCaffrey a transformé un pied-à-terre à San Francisco en un logement haut en couleur, à la fois élégant et décontracté. Les donneurs d'ordres, une famille qui vit éparpillée dans la région autour de la baie de San Francisco et utilise le domicile comme point de rencontre, souhaitait quelque chose de vivant en contraste avec son domicile principal plutôt discret – un coup de chance. Le séjour (à droite) a été aménagé de manière atemporelle et raffinée par les deux décoratifs d'intérieur. Il est parfait pour les soirées animées ou comme lounge pour se détendre. Les propriétaires francophiles ont trouvé le miroir Sunburst sur un marché aux puces à Paris. Il s'harmonise parfaitement avec le style cosmopolite.

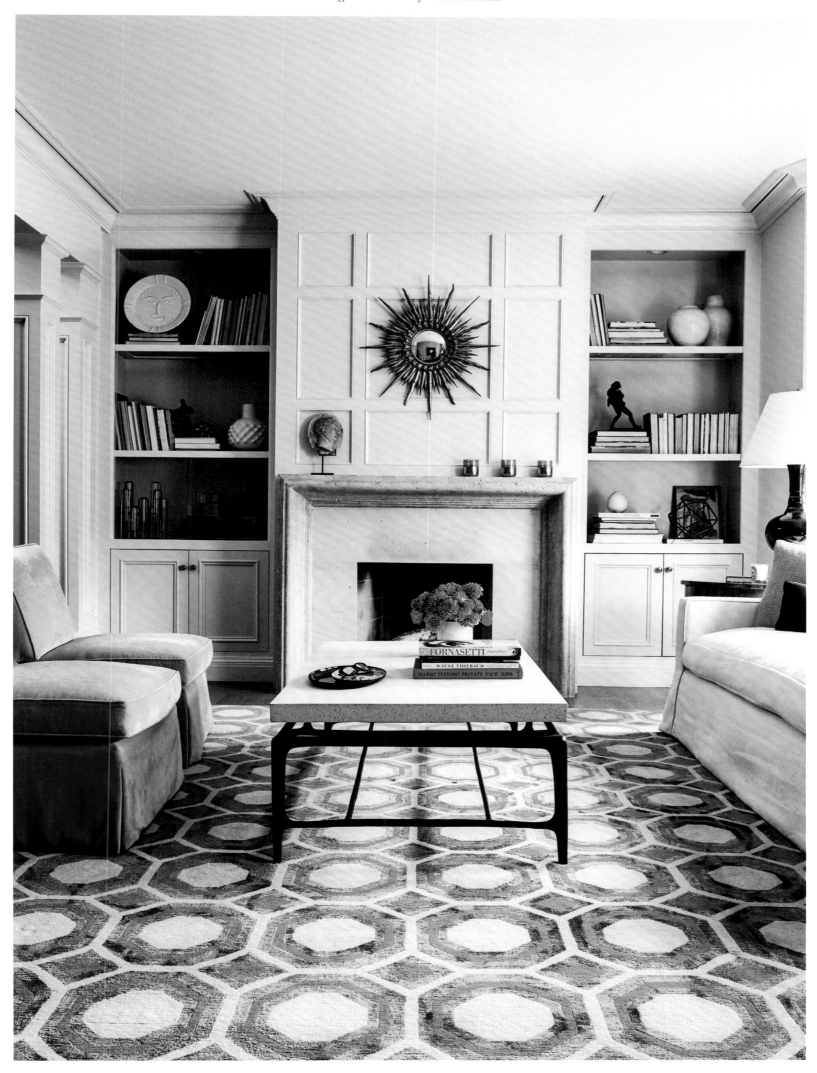

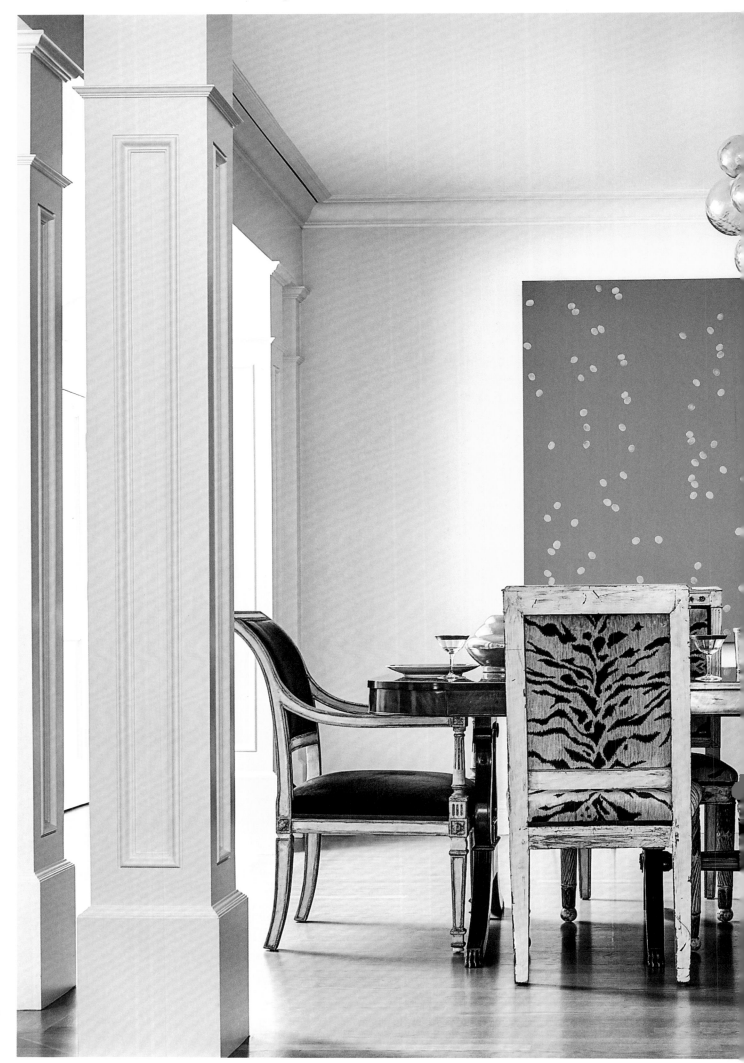

The antique Empire chairs in the pied-à-terre's dining room are upholstered in tiger-look silk velvet, providing a touch of extravagance. The chandelier over the dining table is from Oly Studio, San Francisco.

Im Esszimmer des Pied-à-terre sorgen die antiken Empire-Stühle, bezogen mit einem Seidensamt in Tiger-Optik, für Extravaganz. Über dem Esstisch: ein Leuchter von Oly Studio, San Francisco.

Dans la salle à manger du pied-à-terre, les chaises Empire antiques, recouvertes d'un velours satiné imprimé tigre, apportent une touche d'extravagance. Au-dessus de la table : une lampe d'Oly Studio, San Francisco.

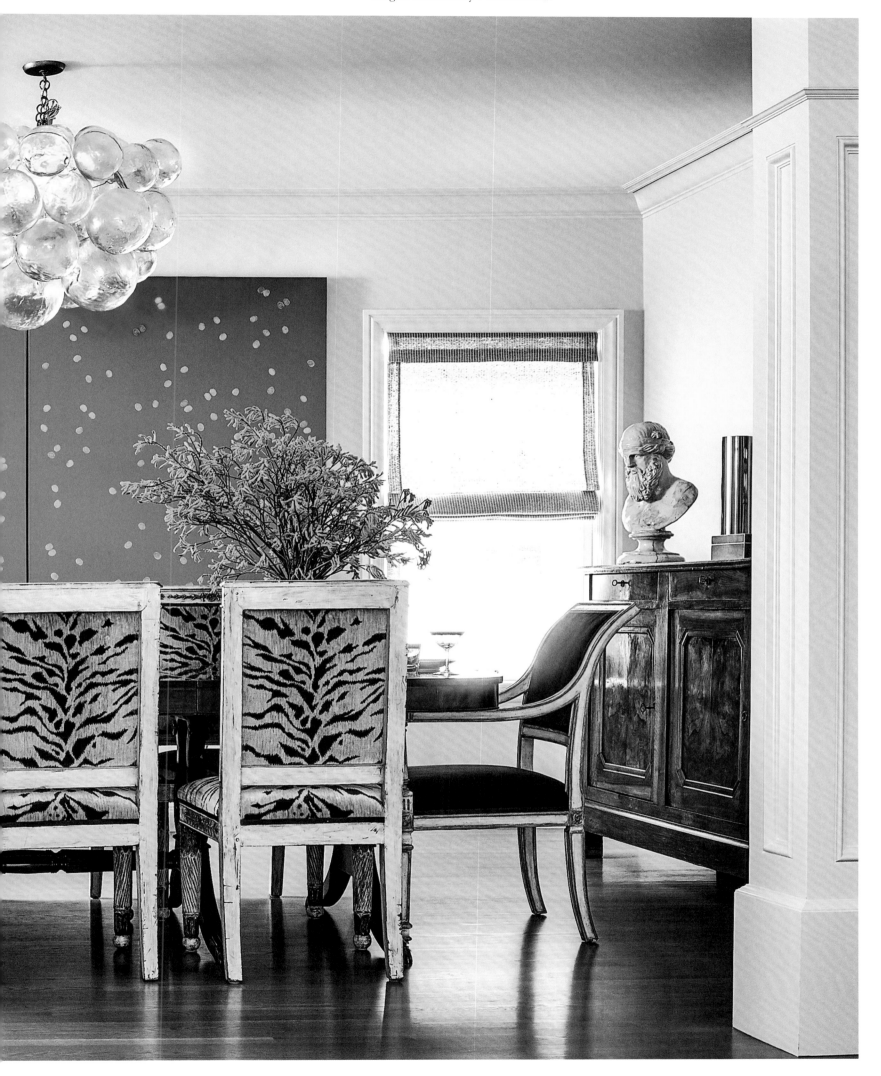

MARIE-CAROLINE WILLMS
Madrid, Spain

"I like interiors that are authentic and not too perfect. Good design must be timeless."
„Ich mag Einrichtungen, die wirklich sind und nicht zu perfekt. Gutes Interior muss zeitlos sein."
« J'aime les décorations qui sont vraies et imparfaites. Un bon intérieur doit être atemporel. »

"Do you like breakfast in bed?" "How often do you invite friends over for dinner?" "What is your favorite time of day?" When Marie-Caroline Willms begins a new project, the first thing she does is ask her clients about their typical daily routine, believing that this information is key to achieving good spatial planning. The German-born designer brought an apartment in Madrid's Barrio de Las Letras neighborhood back to life for a young couple. The location is fantastic and, in the early 19th century, the area's impressive buildings were home to many famous writers. "When I first saw the photos," recalls Marie-Caroline Willms, "my attention was drawn to the beautiful floors with their original cement tiles." Since the existing layout didn't work for the young family, the interior designer had a number of walls removed. Now, the dark hallways have been swapped for generous spaces and lots of light. The kitchen was moved from the rear of the apartment and integrated into the central living area. Due to the tight budget the existing furniture had to be retained, however Marie-Caroline Willms combined it with new pieces sourced from auctions. "My style resembles a photo collage of the client's life—there's room for heirlooms, old things, contemporary objects, bespoke pieces, and fun items," explains the designer. In the living room old mirrors frame the fireplace—a boho touch that is perfect for the apartment and the building.

„Frühstücken Sie gerne im Bett?", „Wie oft laden Sie Freunde zum Essen ein?", „Welche Tageszeit ist Ihnen die liebste?" – wenn Marie-Caroline Willms ein neues Projekt angeht, fragt sie zunächst nach dem typischen Tagesablauf ihrer Klienten. Erst wenn man den verstanden hat, ist sich die Interior Designerin sicher, kann man die Aufteilung der Räume sinnvoll planen. Für ein junges Paar hat die gebürtige Deutsche eine Wohnung in Madrids Viertel Barrio de Las Letras aus dem Dornröschenschlaf erweckt. Die Lage ist ein Glücksfall, viele bekannte Literaten haben hier in imposanten Häusern des beginnenden 19. Jahrhunderts gelebt: „Als ich die ersten Bilder sah", erinnert sich Marie-Caroline Willms, „fiel mir der wunderschöne Boden mit den original erhaltenen Zementfliesen auf." Die ursprüngliche Aufteilung entsprach nicht den Bedürfnissen einer jungen Familie. Die Interior Designerin

ließ Wände entfernen – anstatt dunkler Korridore zogen Großzügigkeit und Licht ein. Die Küche holte sie aus dem hintersten Winkel nach vorne und integrierte sie zentral in den Wohnbereich. Da das Budget eng bemessen war, versuchte Marie-Caroline Willms bereits vorhandene Möbel mit neuen Fundstücken, die sie auf Auktionen fand, zu kombinieren. „Mein Stil ist mit der Fotocollage eines Lebens vergleichbar: Geerbtes hat darin genauso Platz wie Altes, Modernes, Maßangefertigtes, Verrücktes", betont die Kreative. Im Wohnzimmer flankieren alte Spiegel den Kamin. Ein Touch Bohemian steht der Wohnung und dem Gebäude gut.

« Vous aimez prendre votre petit-déjeuner au lit ? » « À quelle fréquence invitez-vous des amis à manger ? » « Quel moment de la journée aimez-vous le plus ? » – lorsque Marie-Caroline Willms commence un nouveau projet, elle commence par demander à ses clients de quelle manière une journée typique se déroule. La décoratrice d'intérieur est persuadé qu'il est nécessaire de savoir cela pour planifier de manière pertinente la répartition des pièces. Dans le quartier de Barrio de Las Letras à Madrid, la décoratrice d'origine allemande a réveillé pour un jeune couple un appartement de son sommeil profond. L'emplacement est une heureuse coïncidence. De nombreux écrivains connus ont vécu ici dans des maisons imposantes du début du XIXe siècle : « Lorsque j'ai vu les premières photos », se souvient Marie-Caroline Willms, « j'ai remarqué le magnifique sol avec ses carrelages d'origine en ciment. » La répartition initiale ne correspondait pas aux besoins d'une jeune famille. La décoratrice d'intérieur a fait retirer des murs, générosité et lumière ont remplacé les corridors sombres. Elle a ramené la cuisine sur le devant et l'a intégré centralement à la pièce à vivre. Étant donné que le budget était serré, Marie-Caroline Willms a essayé de combiner les meubles déjà présents avec des nouvelles trouvailles collectées lors de ventes aux enchères. « Mon style est comparable au collage photo d'une vie : Les vieux objets ont leur place tout comme l'ancien, le moderne, le sur mesure, le fou » souligne la créatrice. Des vieux miroirs entourent la cheminée dans le séjour. L'appartement et le bâtiment sont magnifiques avec leur touche bohème.

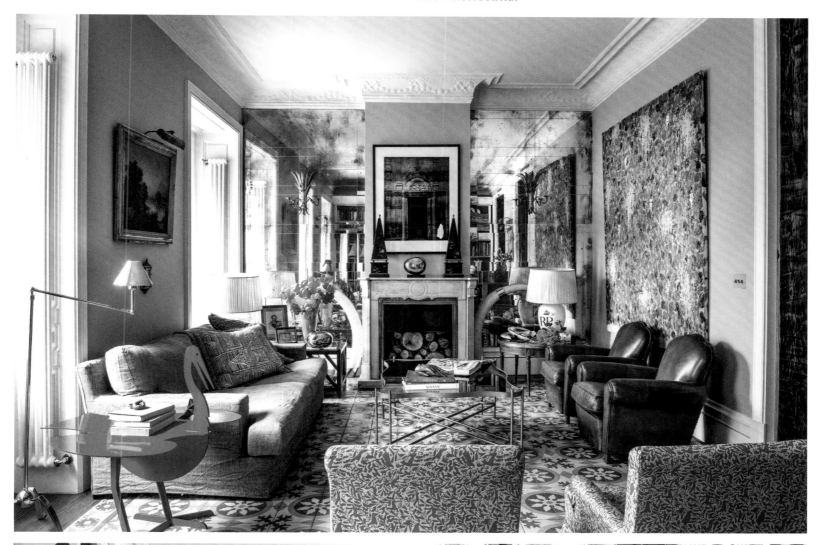

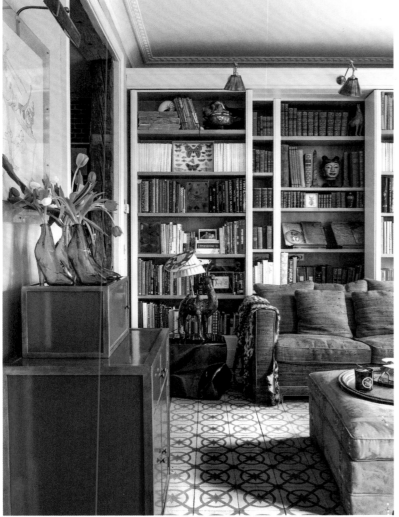

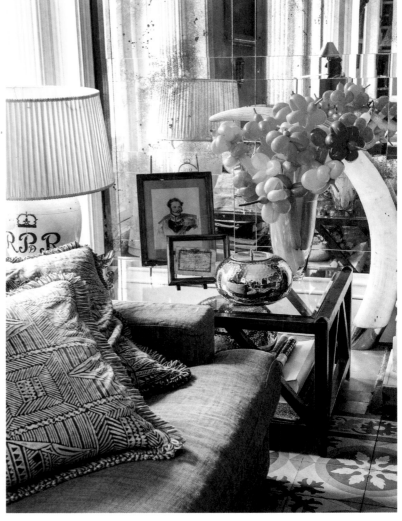

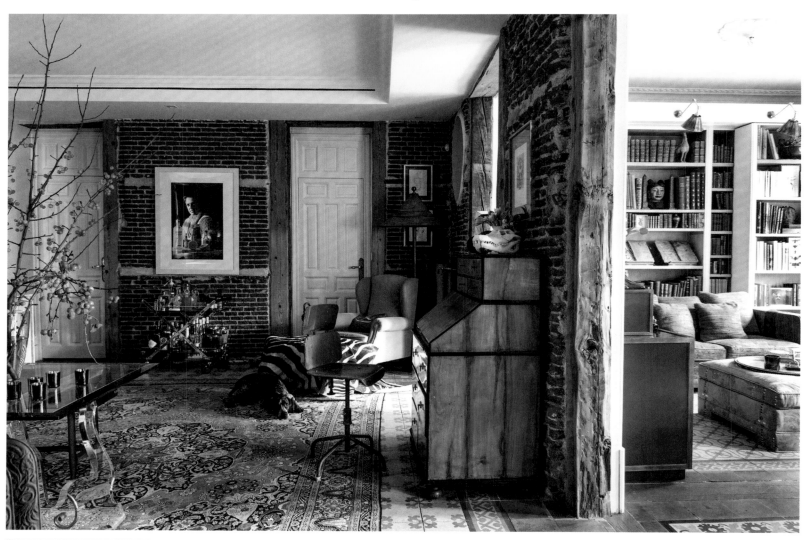

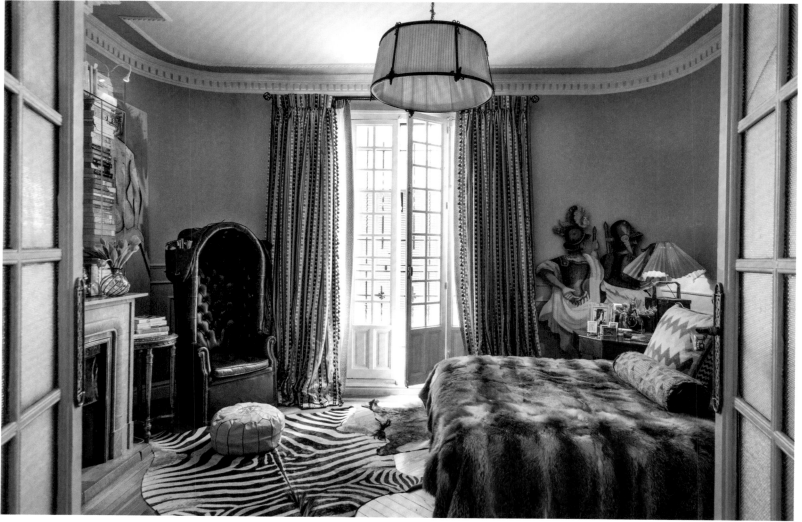

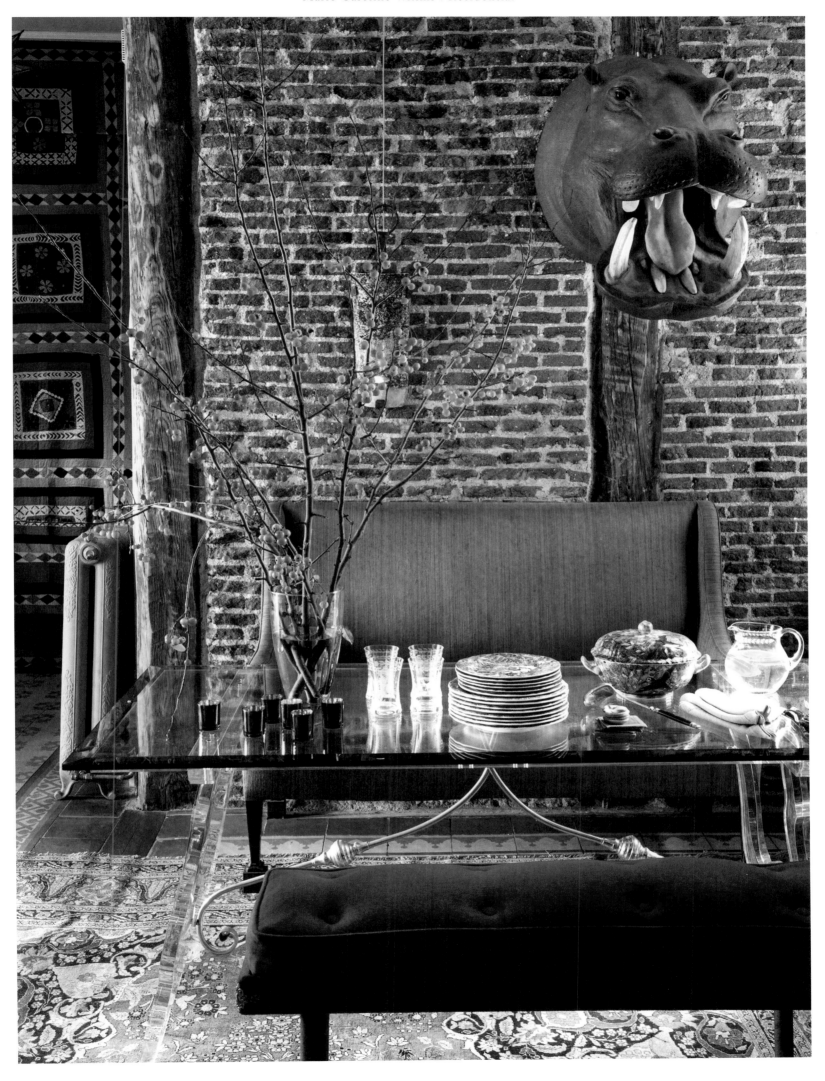

HARRY HEISSMANN

New York City, United States

"Interior design needs a touch of humor and surprising details to generate interest."
„Interior Design braucht eine Prise Humor und überraschende Details, die für Spannung sorgen."
« L'*interior design* a besoin d'une touche d'humour et de détails surprenants qui passionnent. »

If a client asked Harry Heissmann to furnish a match box, he wouldn't hesitate for a second, saying "My philosophy is based on four key elements—what the client wants; the location; comfort; and practicality!" Heissmann was born in Germany and studied interior design at the Academy of Arts in Munich before moving to New York in 1995 where he caught the eye of Albert Hadley, who hired him in 2000 and dubbed his desk 'the magic shop.' Hadley, who advised such illustrious clients as Jackie Kennedy and was subsequently inducted into the Interior Design Hall of Fame, remains Heissmann's role model and source of inspiration to this day. "For my clients I move effortlessly from traditional to contemporary and everything that is in-between!" The best example of this is an almost 300-square-meter (3,230-square-foot) penthouse in Chelsea, decorated by Heissmann for a couple. Located directly next to the High Line, an elevated

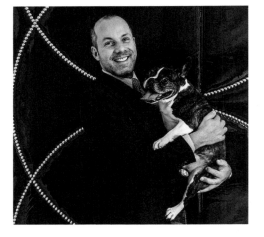

public park created on a former railroad spur, the property provides views of passers-by from the living room and patio. The clients wanted a daybed in the living room—and Heissmann had it upholstered in a glamorous digitally printed fabric sourced from Studio Four (right). The disco ball, also a key request by the clients, dates from the 1930s, when it provided bling at a popular Harlem club. The highlight is, however, undoubtedly the monster fireplace, inspired by the 16th-century Parco dei Mostri—Park of Monsters—near Rome.

Wenn ein Bauherr Harry Heissmann bitten würde, für ihn eine Zündholzschachtel einzurichten – er würde keine Sekunde zögern: „Meine Philosophie basiert auf den Schlüsselbegriffen Kundenwunsch, Lage, Komfort und Machbarkeit!" Harry Heissmann, der in Deutschland geboren wurde und in München an der Kunstakademie Interior Design studierte, ging 1995 nach New York City, wo er von Albert Hadley, der Heissmanns Schreibtisch den Spitznamen „Zauberladen" gab, entdeckt und 2000 engagiert wurde. Hadley, der sogar Jackie Kennedy beriet und später in die Interior Design Hall of Fame aufgenommen wurde, ist Heissmann bis heute Vorbild und Inspirationsquelle. „Für meine Kunden bewege ich mich mühelos zwischen traditionell, zeitgenössisch und allem, was dazwischen angesiedelt ist!" Bestes Beispiel dafür

ist ein fast 300 Quadratmeter großes Penthouse in Chelsea, das Heissmann für ein Paar einrichten durfte. Da es direkt an der High Line, einer Parkanlage entlang einer ehemaligen Hochbahntrasse, liegt, kann man vom Wohnzimmer und der Terrasse aus die New Yorker beim Lustwandeln beobachten. Für den Salon wünschten sich die Auftraggeber ein Daybed – Harry Heissmann ließ es mit einem glamourösen digital bedruckten Stoff von Studio Four beziehen (rechts). Die Discokugel, ebenfalls ein inniger Wunsch der Kunden, sorgte in den Dreißigerjahren in einem angesagten Club in Harlem für Stimmung. Das Highlight aber ist der Monsterkamin: Harry Heissmann wurde im mittelitalienischen Parco dei Mostri, dem Park der Ungeheuer, dazu inspiriert.

Si un maître d'ouvrage demandait à Harry Heissmann d'aménager une boîte d'allumettes pour lui, il n'hésiterait pas une seconde : « Ma philosophie repose sur les termes-clés : souhait du client, emplacement, confort et faisabilité ! » Harry Heissmann qui est né en Allemagne et a étudié l'architecture d'intérieur à la Kunstakademie de Munich a déménagé en 1995 à New York où il a été découvert et engagé en 2000 par Albert Hadley, qui a décrit le bureau de Heissmann comme un « magasin de magie ». Hadley, qui a même conseillé Jackie Kennedy, a été intégré plus tard au Interior Design Hall of Fame, reste aujourd'hui encore le modèle et la source d'inspiration de Heissmann. « Pour mes clients, je me déplace insatiablement entre le traditionnel, le contemporain et tout ce qu'il y a entre les deux. » Un penthouse de près de 300 m² à Chelsea, que Heissmann a aménagé pour un couple, en est le meilleur exemple. Étant donné qu'il est situé directement près de High Line, un parc situé le long d'une ancienne ligné ferroviaire aérienne, il est possible d'observer les promeneurs new yorkais directement depuis le séjour et la terrasse. Pour le salon, le donneur d'ordres voulait un daybed. Harry Heissmann l'a fait recouvrir d'un tissu glamour à imprimé digital de Studio Four (à droite). La boule disco était également une demande du client. Elle mettait l'ambiance dans les années 30 dans un club tendance de Harlem. L'élément-phare est la cheminée monstre : Harry Heissmann a été inspirée par le Parco dei Mostri, le Parc des Monstres, situé au centre de l'Italie.

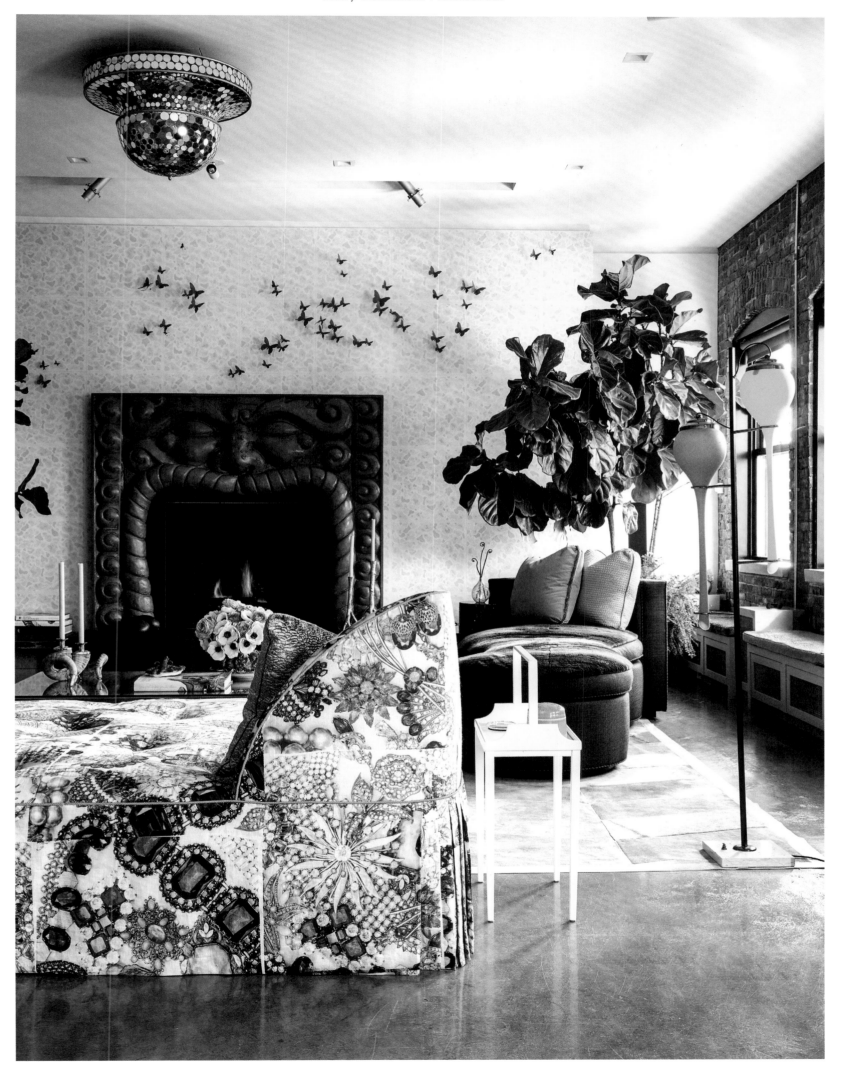

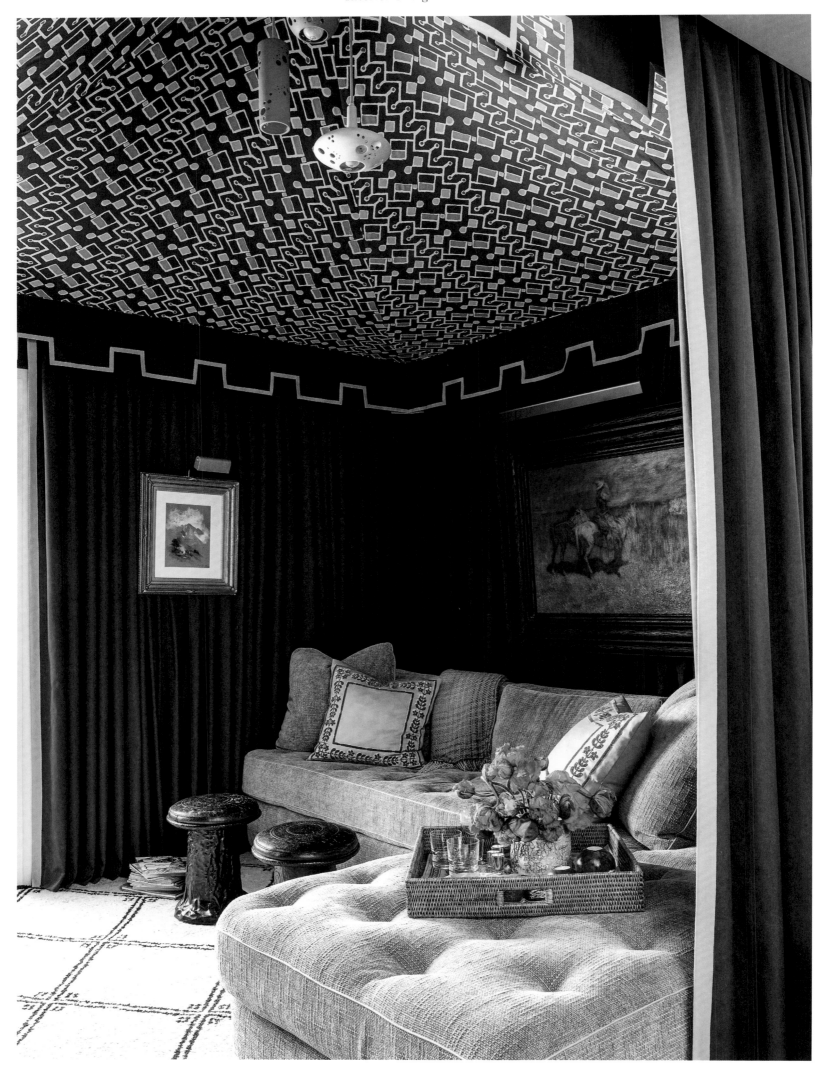

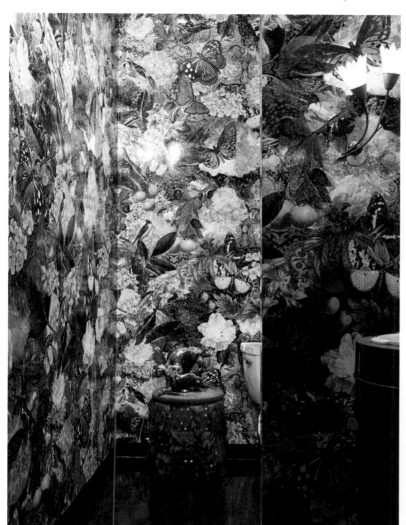

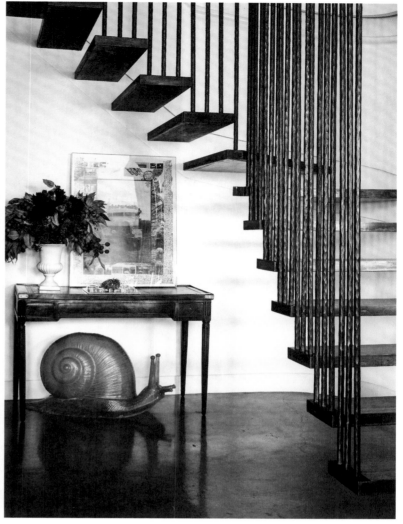

Harry Heissmann likes to call the penthouse his "High Line Fantasy." The TV room is designed to resemble a Bedouin tent, while the powder room surprises guests with holographic wallpaper incorporating a bright tropical theme.

Harry Heissmann nennt das Penthouse gerne „High Line Fantasy": den Fernsehraum gestaltete er als Beduinenzelt, im Badezimmer überrascht die holografische Tapete mit buntem Tropenmotiv.

Harry Heissmann aime appeler le penthouse « High Line Fantasy » : il a aménagé la salle de télévision comme une tente de bédouins. Dans la salle de bains, la tapisserie holographique surprend avec ses motifs tropicaux multicolores.

ATELIER DURANTE
New York City, United States

"Interior design should include color concepts, with each room leading into the next."
„Einrichtung hat mit Farbkonzeption zu tun. Jeder Raum leitet zum nächsten über."
« L'aménagement d'intérieur ressemble à la conception des couleurs. Chaque pièce conduit vers la suivante. »

It sounds like an obscure riddle but is actually surprisingly logical. Colors have always been important to New York-based interior designer Pamela Durante. "I combine them so no tone dominates; instead the result is a harmonious whole." She believes this should apply to the interaction between rooms. If the color scheme for a salon comprises warm red, curry and beige, Durante will link it to an adjacent room by selecting a soft gold for the latter. Prior to founding Atelier Durante in 1994, Durante built an extensive background in the luxury hotel industry, notably with hotelier Ian Schrager, where she was project manager on furniture, furnishings, and equipment for the Royalton and Paramount. What she enjoys most is putting together carefully selected pieces for interiors that have an eclectic mix with a French twist. Durante is a faculty member of the New York School of Interior Design, where she teaches future colleagues. Durante has a passion for textiles, and has been commissioned to create a hospitality fabric line entitled, "Pam's Intoxicating Fabric Collection" with seven different colorways, such as Claret, Chambord, and London Gin, and 10 different patterns, such as Walk the Line, Buzzed, and Last Call (all right). She uses her signature style to create attractive collages for clients. The designer believes the final look should be well-balanced and, true to this, prefers orchestras not soloists.

Es klingt wie ein undurchsichtiges Rätsel, birgt aber eine überraschend schlüssige Erklärung. Farben haben für die New Yorker Interior Designerin Pamela Durante von jeher eine große Rolle gespielt: „Ich stelle sie so zusammen, dass am Ende keine heraussticht – und sich alles harmonisch zu einem Ganzen fügt", erklärt sie. Wichtig sei für sie, dass dies auch für die einzelnen Räume untereinander gelte. Wenn der Salon warme Rot-, Curry- und Beigetöne trägt, wählt Durante für das angrenzende Esszimmer einen zarten Goldton als verbindendes Element. Bevor sie 1994 mit Atelier Durante ihr eigenes Studio gründete, war Pamela Durante in der Luxushotellerie tätig und übernahm für die New Yorker Hotellegende Ian Schrager die Gestaltung des Royalton sowie der Paramount Hotels. Am liebsten kombiniert sie ausgesuchte Einzelstücke, schafft Raumerlebnisse mit einem modernen französischen Twist und gibt ihr Wissen auch gerne weiter: Als Mitglied der New York School of Interior Design unterrichtet sie angehende Kollegen. Neben der Begeisterung für Farben sind es vor allem Stoffe, die ihr Herz höher schlagen lassen. Beide Leidenschaften vereint sie in ihrer eigenen Textilkollektion: Farben wie „Claret" oder „Chambord" treffen auf imposante Muster wie „London Gin" und „Buzzed". Am liebsten kombiniert die Kreative verschiedenste Texturen und Dessins und erstellt daraus für ihre Kunden anschauliche Collagen. Ihr Leitmotiv gilt auch hier: Am Ende sollte die Wirkung ausgewogen sein. Anstatt Solisten bevorzugt Pamela Durante das Orchester.

Cela ressemble à une devinette mystérieuse. Pourtant, l'explication est étonnamment cohérente. Pour la décoratrice d'intérieur new-yorkaise Pamela Durante, les couleurs ont toujours joué un grand rôle : « Je les assemble de sorte à ce qu'aucune ne se démarque et qu'elles forment ensemble un tout harmonieux », explique-t-elle. Pour elle, il est important que cela fonctionne également entre les différentes pièces. Si le salon est recouvert de tons chauds rouge, curry et beige, Durante choisit un ton doré tendre comme élément de liaison pour la salle à manger attenante. Avant d'ouvrir son propre studio avec l'Atelier Durante en 1994, Pamela Durante a travaillé dans l'hôtellerie de luxe et a été chargée d'aménager le Royalton et les Paramount Hotels pour la légende de l'hôtellerie new-yorkaise Ian Shrager. Elle combine volontiers des éléments individuels sélectionnés, elle crée des pièces étonnante avec une touche française moderne et elle aime transmettre ses connaissances : En tant que membre de la New York School of Interior Design, elle enseigne à ses futurs collègues. En plus de son enthousiasme pour les couleurs, elle voue également une véritable passion aux tissus. Elle a réuni ses deux passions dans sa propre collection de textiles : des couleurs comme « Claret » ou « Chambord » sont combinés à des motifs imposants comme « London Gin » et « Buzzed ». Les créateurs combinent les textures et motifs les plus variés et créent ensuite des collages originaux pour leurs clients. Son leitmotiv est valable ici aussi : l'effet final doit être équilibré. Plutôt que les solistes, Pamela Durante privilégie l'orchestre.

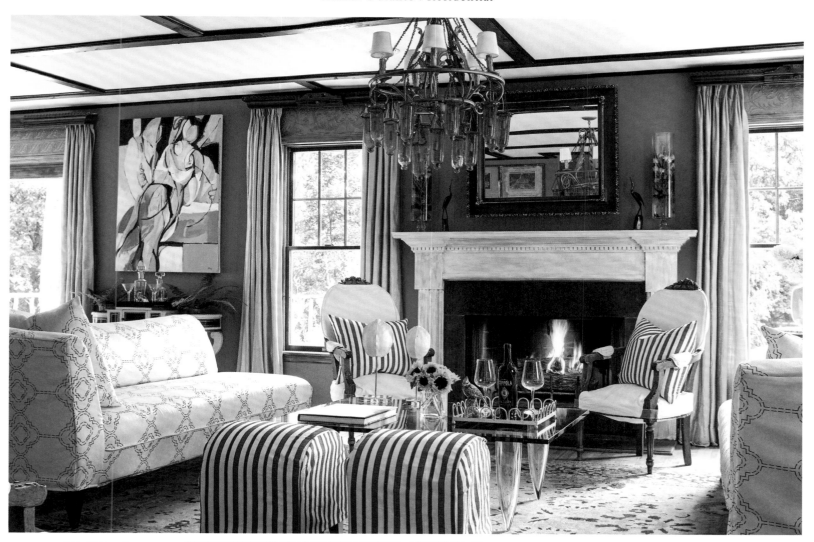

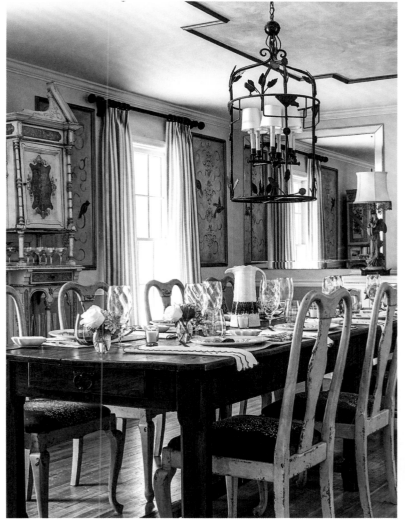

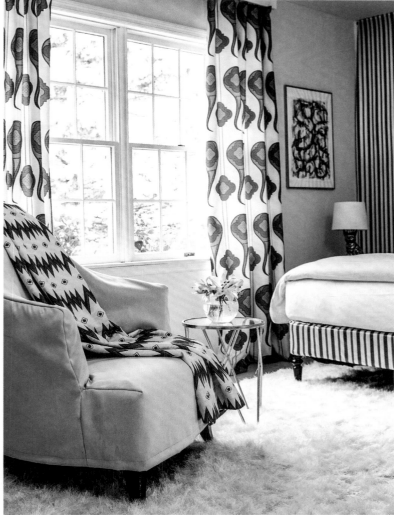

INSON DUBOIS WOOD

New York City, United States

"An interior designer is always also a philosopher, poet, story-teller, confidante, and friend."
„Ein Interior Designer ist stets auch Philosoph, Poet, Geschichtenerzähler, Vertrauter und Freund."
« Un *interior designer* est toujours un philosophe, un poète, un conteur, un confident et un ami. »

People have dreams and visions—particularly when it comes to decorating their living spaces. Interior designers can help to realize them. For Inson Dubois Wood this task involves a whole lot more: "Designers must create thought images and settings in order to gain their clients' trust before they can draw even one line on paper!" With a French mother and a Thai father, the architect is a true cosmopolitan who spent his childhood summers and winters in Europe or Asia, depending on the season. Born in Connecticut he studied at the prestigious Cornell University and Harvard's Graduate School of Design before gaining experience working on projects around the world for Juan Pablo Molyneux and David Easton, both interior design legends. Inson Dubois Wood appears to move effortlessly between traditional, contemporary, and modern design styles and is known for his elegant interiors, that are a blend of richness, interesting textures, and impeccable proportions. His subtle feel for colors, lifted by strong accents, allows him to create rooms that are often reminiscent of theater sets. A vacation home was transformed into an homage to the Venetian carnival (right). Antiques, Rodin sculptures, futuristic furniture, and French art déco have all been brought together to form a playful whole that is in keeping with the opulent, red-painted ceiling with its tendrils of leaves in gold.

Menschen haben Träume und Visionen – besonders, wenn es die Einrichtung ihrer Wohnräume betrifft. Interior Designer helfen dabei, diese zu verwirklichen. Für Inson Dubois Wood bedeutet diese Aufgabe weitaus mehr: „Designer müssen Gedankenbilder, Szenerie kreieren – um auf diese Weise Vertrauen zu schaffen, noch bevor eine einzige Linie gezeichnet wird!" Der Architekt ist Kosmopolit: Mit einer französischen Mutter und einem thailändischen Vater verbrachte er als Kind die Sommer- und Wintermonate je nach Jahreszeit in Europa oder Asien. Geboren in Connecticut studierte er an der renommierten Cornell University sowie der Harvard Graduate School of Design, bevor er bei Juan Pablo Molyneux und David Easton, beides Interior-Design-Legenden, Erfahrungen mit weltweiten Projekten sammelte. Mühelos bewegt sich Inson Dubois Wood zwischen traditionellen, zeitgenössischen und modernen Stilrichtungen. Er ist bekannt für seine eleganten Interiors, die eine Mischung aus Reichtum, interessanter Textur und tadellosen Proportionen vereint. Sein subtiles Gespür für Farben, die er mit kräftigen Akzenten durchbricht, lässt Räume entstehen, die oftmals Bühnenbildern gleichen. Ein Ferienhaus verwandelte er in eine Kulisse, die den venezianischen Karneval zitiert (rechts). Antiquitäten, Rodin-Skulpturen, futuristische Möbel und französisches Art déco bringt er scheinbar spielerisch zusammen – passend zum opulenten, rot lackierten Deckengemälde mit Blätterranken in Gold.

Les gens ont des rêves et des visions, notamment lorsqu'il s'agit d'aménager leur intérieur. Les *interior designer* aident à leur concrétisation. Pour Inson Dubois Wood, cette tâche signifie bien plus : « Les designers doivent penser, créer des scènes et créer une relation de confiance avant même de signer quoi que ce soit ! » L'architecte est cosmopolite : Avec une mère française et un père thaïlandais, il a passé, enfant, ses étés et ses hivers en Europe ou en Asie, en fonction de la saison. Né dans le Connecticut, il a étudié à la célèbre Cornell University et à la Harvard's Graduate School of Design avant de se faire ses premières expériences chez Juan Pablo Molyneux et David Easton, deux légendes de la décoration d'intérieur, avec des projets dans les monde entier. Inson Dubois Wood évolue insatiablement entre des styles traditionnels, contemporains et modernes. Il est connu pour ses intérieurs élégants qui allient un mélange de richesse, de texture intéressante et de proportions parfaites. Son sens subtil des couleurs qu'il jonche de contrastes puissantes permet de réaliser des pièces ressemblant souvent à des décors de théâtre. Il a transformé une maison secondaire en un lieu rappelant le carnaval de Venise (à droite). Il combine avec aisance les antiquités, les sculptures de Rodin, les meubles futuristes et l'Art déco francais, en harmonie avec les fresques rouge verni du plafond avec des bordures faites de feuilles couleur or.

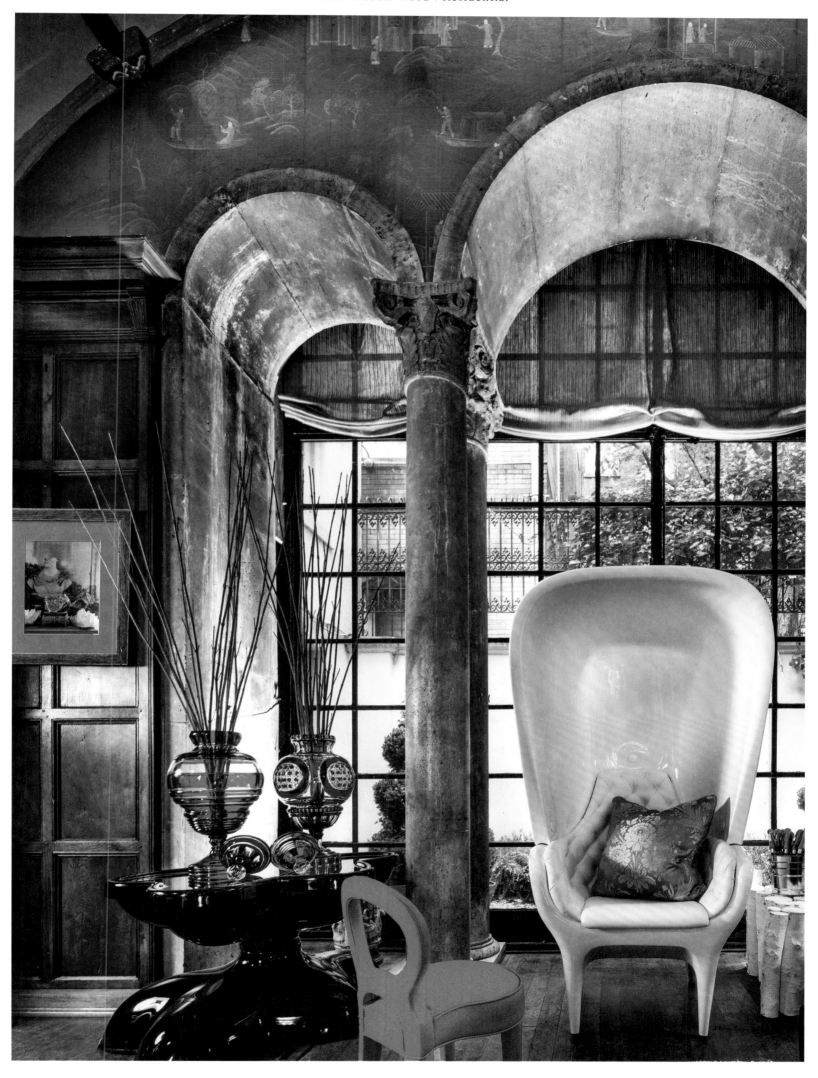

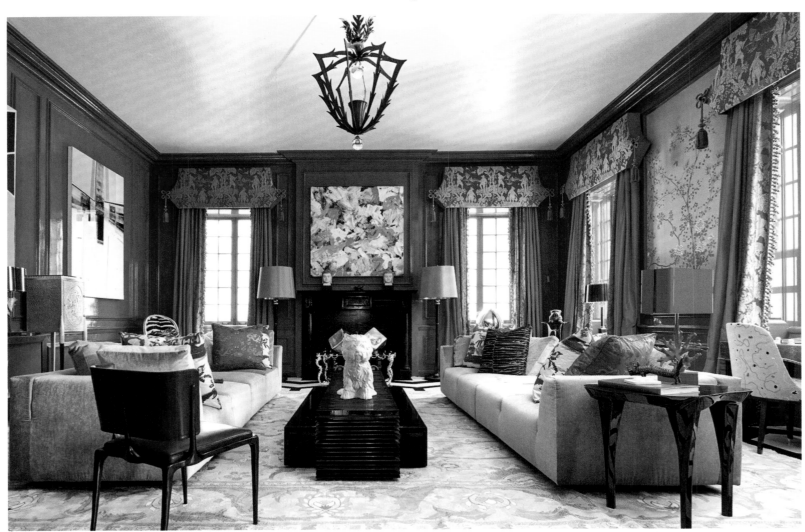

Chinese New Year was the inspiration for the living room of this Upper East Side townhouse (this page). The design for an apartment overlooking Central Park (right) is modeled on a Parisian artist's atelier as well as an 18th-century farmhouse in Provence.

Das chinesische Neujahrsfest stand Pate für das Wohnzimmer eines Ferienhauses (diese Seite). Ein Apartment mit Blick auf den Central Park (rechts) erinnert an ein Künstleratelier in Paris.

La fête du Nouvel An chinois a servi d'inspiration au séjour d'une maison de campagne (sur cette page). Un appartement avec vue sur Central Park (à droite) rappelle un atelier d'artiste à Paris.

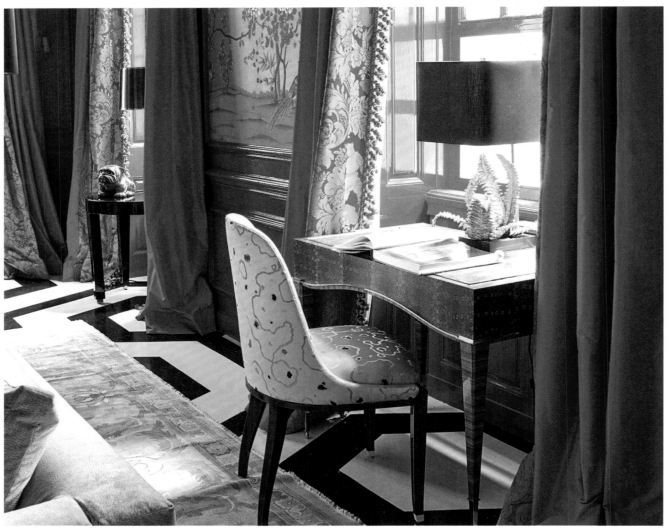

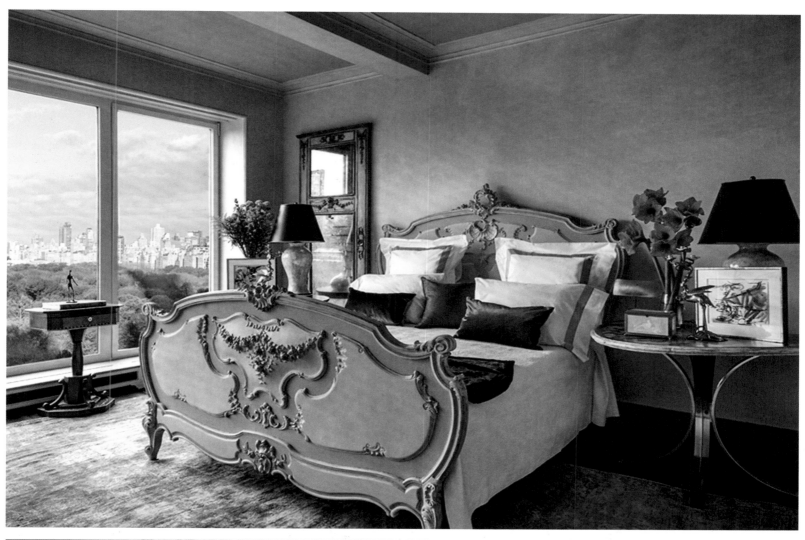

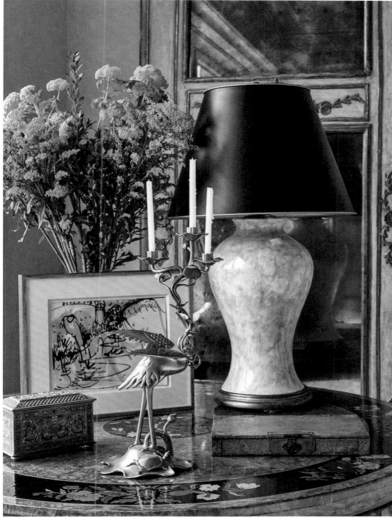

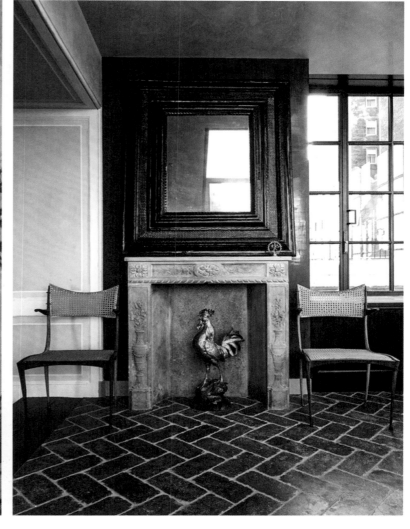

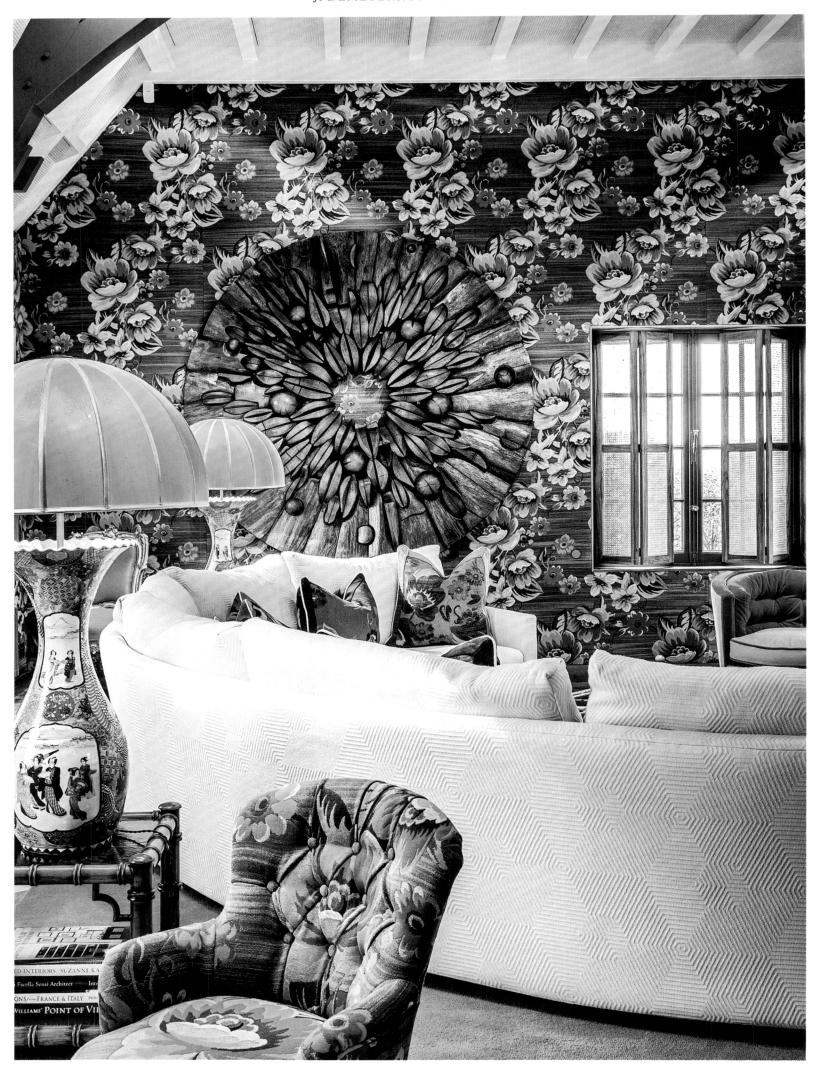

JPDEMEYER&CO

Bruges, Belgium

"Not loving colors is like not liking the sun or a blue sky."

„Keine Farben zu lieben, ist wie die Sonne oder den blauen Himmel nicht zu mögen."

« Ne pas aimer les couleurs est comme ne pas aimer le soleil ou le ciel bleu. »

Belgian interior designer Jean-Philippe Demeyer is gifted with a vivid imagination. Just like a composer, he creates blends of antique furniture with vintage pieces and new, custom-made pieces. This should not come as a surprise, since the inventive interior designer began his career as an antiques dealer. "If it was up to me," says Demeyer laughing, "I would buy a truckload of treasures every day." Since they, however, are hard to come by and he loves things with a twist, Demeyer and his partners Frank ver Elst and Jean-Paul Dewever have local manufacturers produce their own designs for lamps, small items of furniture or cushions. Demeyer, who likes to express emotions through his designs, also has a weakness for English country style—believing that Brits are able to combine objects in an understated way, without being too serious. For the well-known florist Johan Gryp, who lives and works south of Bruges, Jean-Philippe Demeyer created rooms full of imagination. The brief was for the private area to blend into a harmonious whole with the studio and flower store, just like an English garden full of flowers. Demeyer wanted to create a setting that references Johan Gryp's love of blossoms. In the saloon of another project (left), luxuriant flowers cover the entire wall—Demeyer had the tapestry specially made to measure. The effect? Crazy, flamboyant, and, above all, full of zest for life!

Der belgische Interior Designer Jean-Philippe Demeyer verfügt über eine lebhafte Fantasie. Wie ein Kompositeur mischt er kunterbunt antike Möbel mit Vintage-Stücken und neuen maßgefertigten Objekten. Kein Wunder: seine Karriere begann der originelle Inneneinrichter als Antiquitätenhändler. „Wenn es nach mir ginge", erzählt Demeyer lachend, „würde ich am liebsten jeden Tag einen Container voll Pretiosen kaufen." Weil die jedoch rar gesät sind und er eine Vorliebe für das Ausgefallene hat, lassen Demeyer und seine beiden Partner Frank ver Elst und Jean-Paul Dewever Lampen, kleine Möbel oder Kissen von lokalen Manufakturen nach eigenen Entwürfen fertigen. Demeyer, der in seinen Designs gerne Emotionen zum Ausdruck bringt, hat ein Faible für den echten englischen Landhausstil – die Briten, findet er, kombinieren Dinge miteinander völlig unaufgeregt und ohne übertriebene Ernsthaftigkeit. Für den bekannten Floristen Johan Gryp, der südlich von Brügge lebt und arbeitet, schuf Jean-Philippe Demeyer Räume voll Imagination. Der private Bereich sollte mit dem Atelier und Blumenladen sowie dem englisch angelegten Garten voller Blumen eine Einheit bilden. Demeyer wollte Kulissen schaffen, die Johan Gryps Liebe zu Blüten zitieren. Im Salon eines anderen Objekts (links) ranken üppige Blumen über die gesamte Wand – Demeyer ließ den Gobelinstoff dafür maßanfertigen. Die Wirkung: verrückt, flamboyant und vor allem lebensfroh!

L'architecte d'intérieur belge Jean-Philippe Demeyer possède une imagination débordante. Tel un compositeur, il mélange les meubles antiques avec des pièces vintage et des nouveaux objets fabriqués sur mesure. Ce n'est pas étonnant : le décorateur d'intérieur original a commencé sa carrière comme antiquaire. « Si ce n'était que moi », raconte Demeyer avec le sourire, « j'achèterais chaque jour un conteneur d'objets précieux. » Parce qu'ils sont rare et qu'il aime ce qui est extravagant, Demeyer et ses deux partenaires Frank ver Elst et Jean-Paul Dewever font fabriquer des lampes, des petits meubles ou des coussins par des fabricants locaux. Demeyer qui exprime volontiers des émotions dans ses designs, a un faible pour le style authentique anglais de maison de campagne. Selon lui, les Britanniques combinent des choses ensemble toute en douceur et sans sérieux exagéré. Pour le célèbre fleuriste Johan Gryp qui vit et travaille au sud de Bruges, Jean-Philippe Demeyer a créé des pièces pleines d'imagination. L'espace privé devait former une unité avec l'atelier et au magasin ainsi qu'avec le jardin anglais attenant plein de fleurs. Demeyer voulait créer des coulisses reflétant l'amour de Johan Gryp pour les fleurs. Dans le salon d'un autre bien immobilier (à gauche) des fleurs luxuriantes arborent l'ensemble du mur – Demeyer a fait fabriquer sur mesure le tissu de gobelin. L'effet : fou, flamboyant et surtout plein de vie !

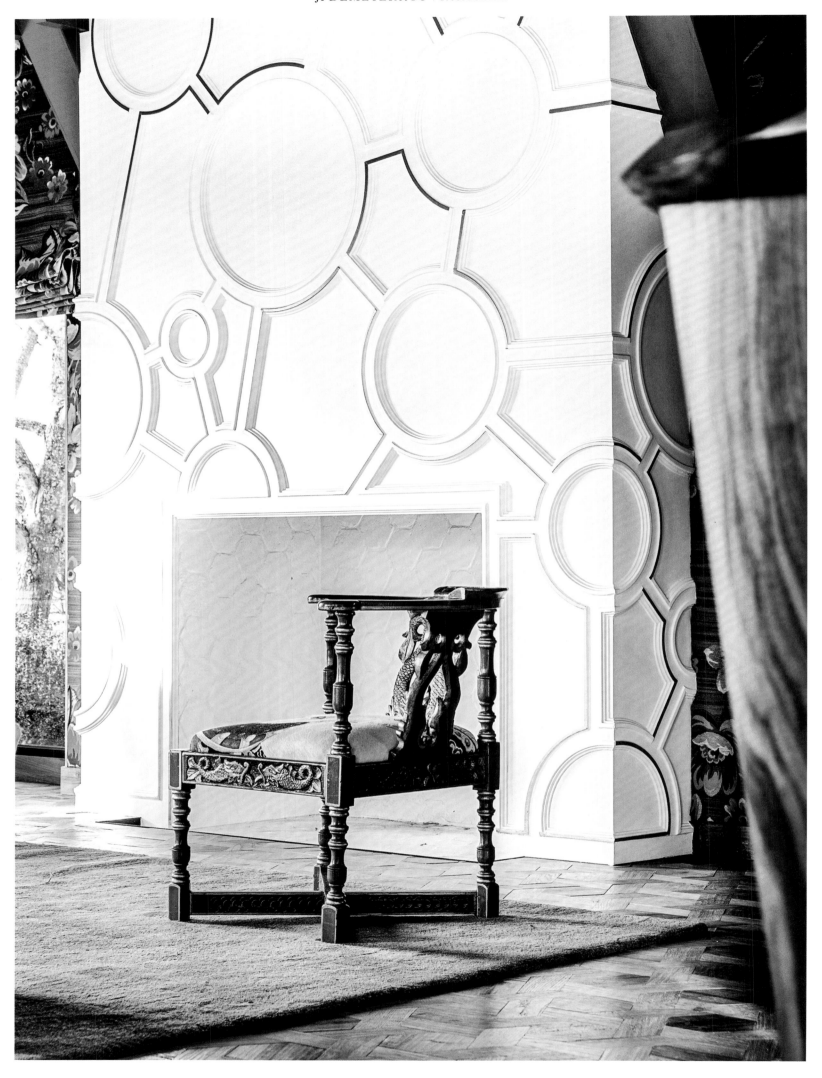

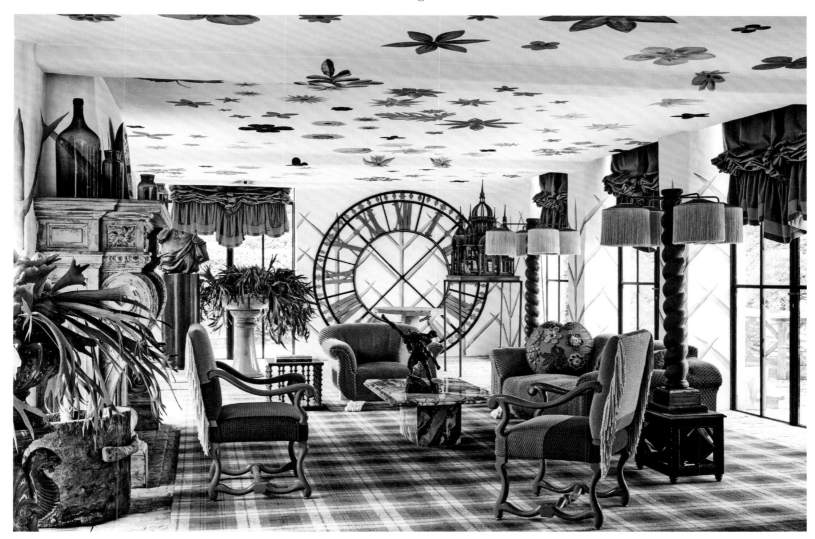

The florist's living room, a blend of orangery, glasshouse, and cottage, has a low ceiling. To distract attention from this, Jean-Philippe Demeyer had it painted with strong flower motifs.

Das Wohnzimmer des Floristen, eine Mischung aus Orangerie, Glashaus und Cottage, hat niedrige Decken. Um optisch davon abzulenken, ließ Jean-Philippe Demeyer sie mit starken Blüten bemalen.

Le séjour du fleuriste, un mélange d'orangerie, de verrière et de cottage, a des plafonds bas. Pour détourner le regard de ceux-ci, Jean-Philippe Demeyer les a peints avec des fleurs imposantes.

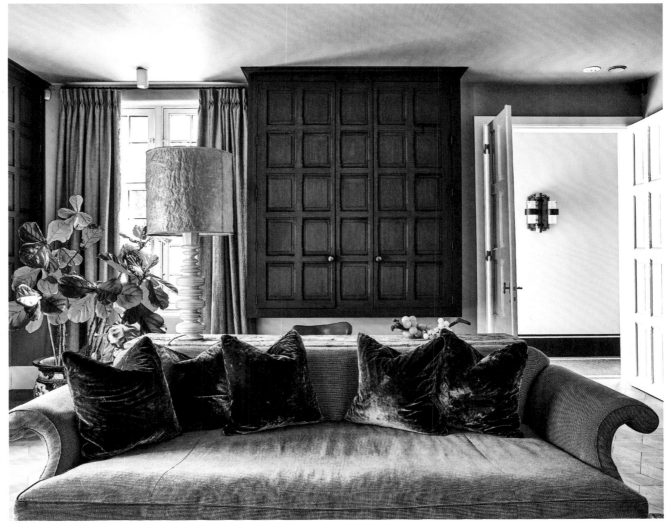

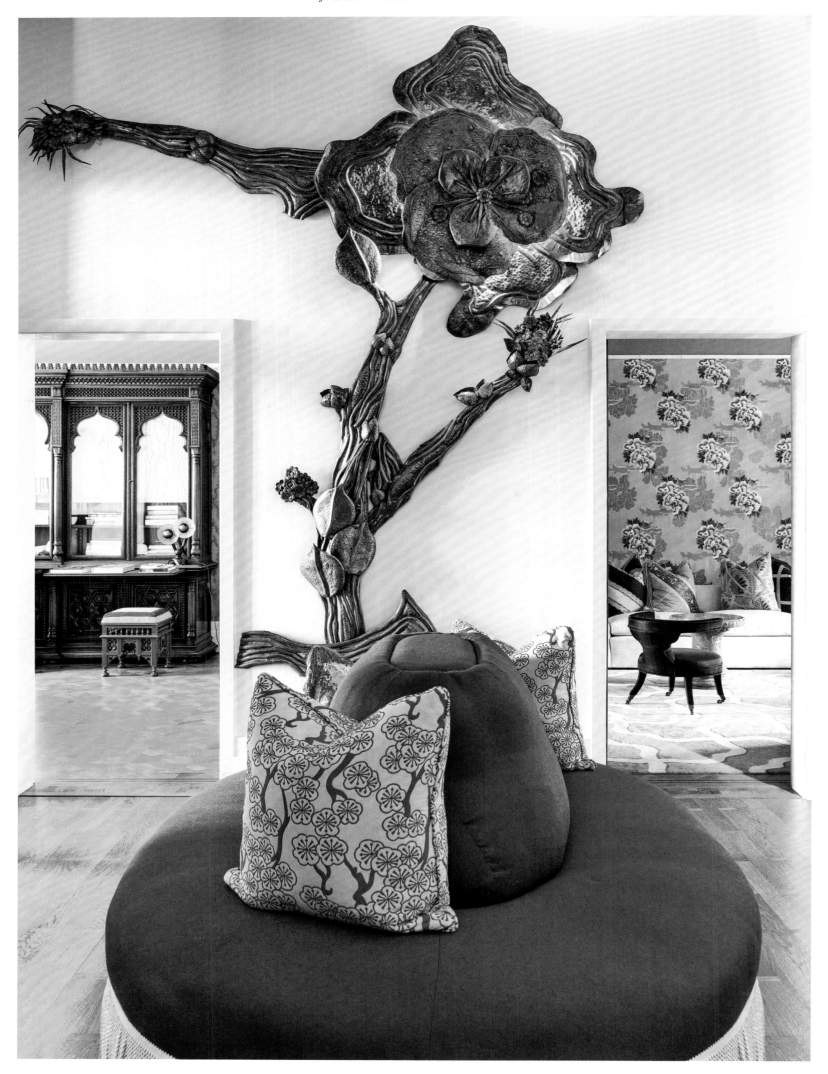

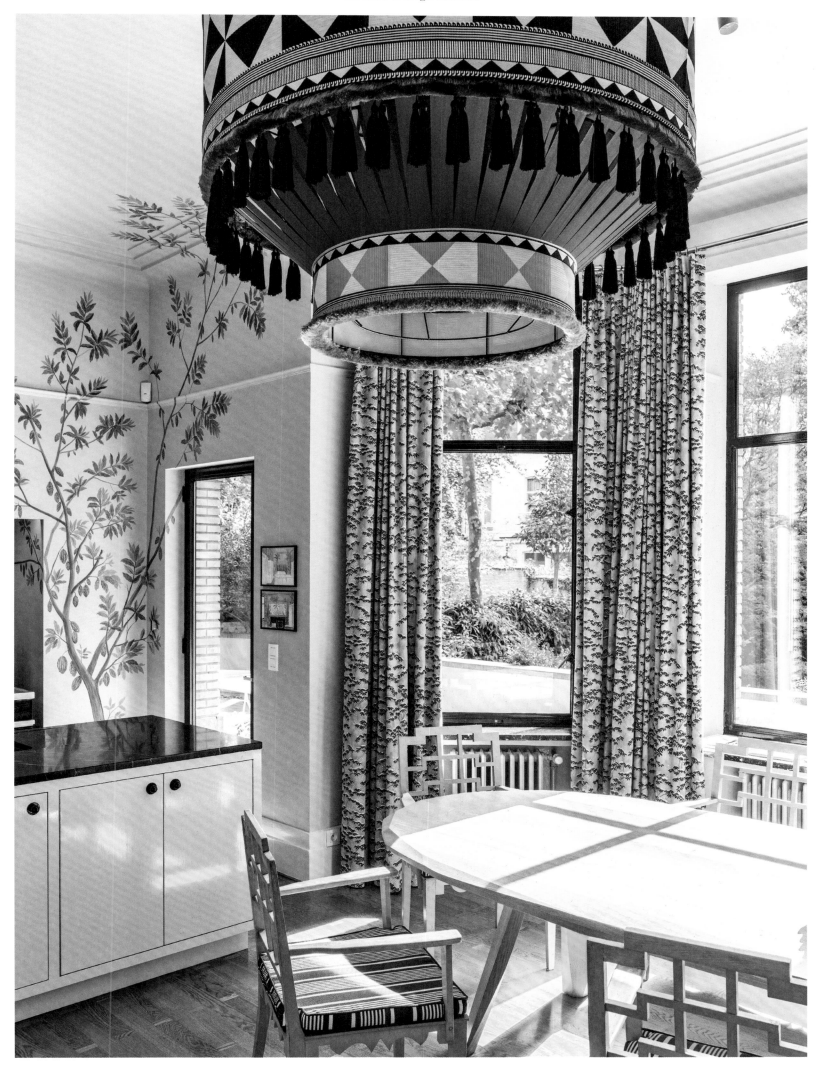

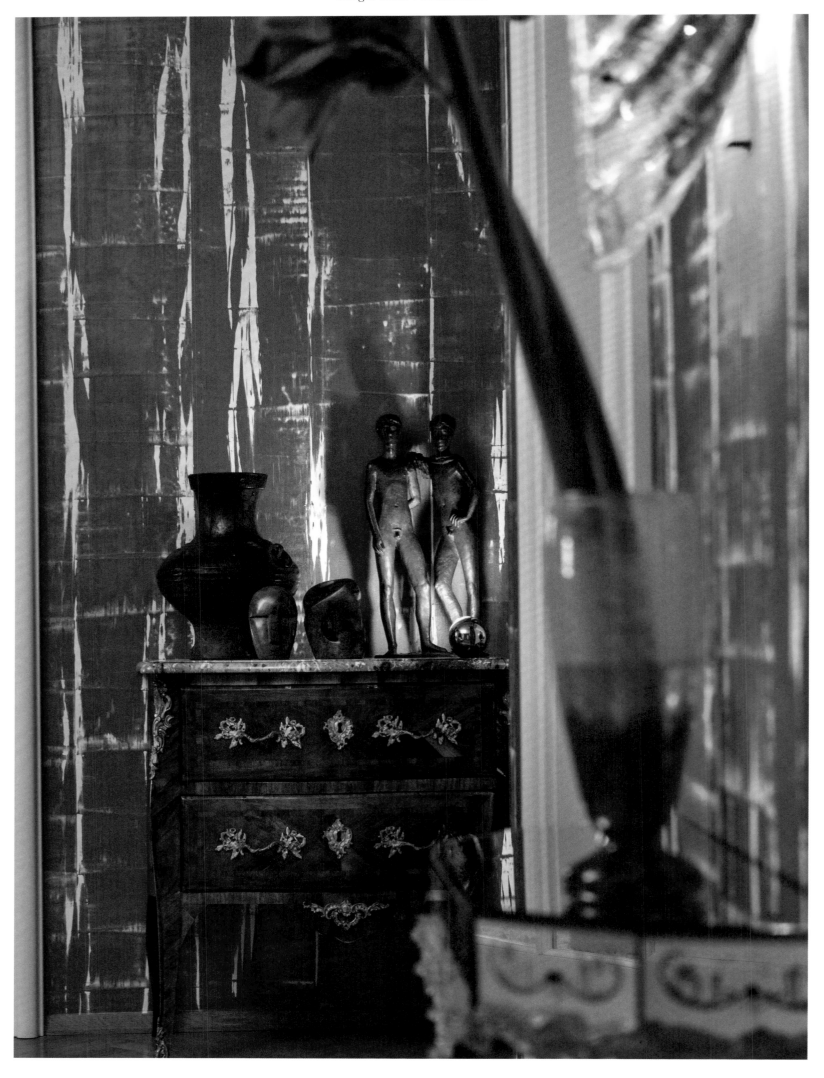

HOLGER KAUS
Rottach-Egern, Germany

"Primarily, I want to create a genuine home for my clients."
„Für meine Kunden möchte ich in erster Linie ein echtes Zuhause schaffen."
« Je souhaite créer en premier lieu un intérieur authentique pour mes clients. »

Holger Kaus himself calls rural Rottach-Egern on Lake Tegernsee home; though his explorations to antique dealers and art auctions take him all over the world. Holger Kaus loves his work, which in his case was a calling from the very outset. A native of Frankfurt, he discovered his passion for interior design at an early age. "Even while still at school, I created houses for my friends on paper," revealed the internationally renowned interior designer with a glint in his eye. And his style? It's certainly not one that follows any particular pattern. "I don't really feel the need to put my mark on a project. Of far greater importance for me is to nurture the cultural aspects of the place and the people living it," emphasized the Bavarian-by-choice. A focal point for Holger Kaus is homeliness. Customers that engage him can look forward to an extremely snug home. He experiments with colors and selected fabrics with virtuosity, sometimes testing the more unusual combinations within his own four walls. Kaus, who studied design history as well as interior design and landscape gardening in London, consequently creates the context for exceptional artistic objects, such as the 1950s drinks cabinet stemming from the "Vereinigten Werkstätten" in Munich, with its engraved mirror interior and vellum-covered doors, or a precious Louis IV commode, which he bought at a Pierre Bergé auction in Paris (left). For a North African client, he generously opened up all the rooms towards the kitchen—in line with tradition and hospitality within the country.

Er selbst lebt auf dem Land in Rottach-Egern am Tegernsee. Doch seine Entdeckungsreisen zu Antiquitätenhändlern und auf Kunstauktionen führen ihn um die ganze Welt. Holger Kaus liebt seinen Beruf, der in seinem Fall von Anfang an Berufung war. Die Leidenschaft fürs Einrichten entdeckte der gebürtige Frankfurter früh: „Schon in der Schulbank habe ich auf dem Papier Häuser für meine Freunde gestaltet", erzählt der international renommierte Inneneinrichter mit einem Augenzwinkern. Sein Stil? Jedenfalls keiner, über den sich eine Schablone legen lässt. „Ich habe nicht das Bedürfnis, einem Projekt meinen Stempel aufzudrücken. Viel wichtiger ist mir, die Kultur des Ortes und seiner Bewohner zuzulassen", betont der Wahlbayer. Im Zentrum stehe für Holger Kaus die Behaglichkeit. Kunden, die ihn beauftragen, dürfen ein gemütliches Zuhause erwarten. Virtuos experimentiert er mit Farben und ausgesuchten Stoffen, ungewöhnliche Kombinationen probiert er schon mal in den eigenen Wänden aus. Kaus, der in London Designgeschichte sowie Innen- und Gartenarchitektur studierte, schafft so den Rahmen für besondere Kunstobjekte: einen Barschrank der Vereinigten Werkstätten Münchens aus den Fünfzigern, dessen geschnitzte Holztüren außen mit Schweinehäuten bezogen sind, oder eine wertvolle Louis IV-Kommode, die er bei Pierre Bergé in Paris ersteigerte (links). Für eine nordafrikanische Kundin öffnete er alle Räume großzügig zur Küche hin – entsprechend der Tradition und Gastfreundschaft des Landes.

Lui-même vit à la campagne, à Rottach-Egern, près du Tegernsee. Cependant, ses voyages d'exploration chez les antiquaires et dans les ventes aux enchères d'art l'ont amené à découvrir le monde entier. Holger Kaus aime son métier. Dans son cas, il s'agissait dès le départ d'une vocation. Ce natif de Francfort a découvert très tôt sa passion pour l'aménagement d'intérieur : « Sur les bancs de l'école, je construisais déjà des maisons en papier pour mes amis », raconte l'*interior designer* de renommée internationale avec un clin d'œil. Son style ? En aucun cas, un sur lequel on peut coller une étiquette. « Je n'ai pas le besoin de mettre ma patte sur un projet. Il m'importe plutôt de laisser de la place à la culture du lieu et de ses résidents », souligne ce Bavarois de cœur. Le bien-être est le critère essentiel pour Holger Kaus. Les clients qui font appel à lui peuvent être sûrs que leur intérieur sera confortable. Il expérimente avec brio les couleurs et des tissus sélectionnés, il commence par tester dans son propre intérieur des combinaisons originales. Kaus, qui a étudié l'histoire du design, l'architecture d'intérieur et le paysagisme à Londres, crée ainsi le cadre accueillant des objets artistiques particuliers : une armoire de bar des Ateliers réunis de Munich datant des années 50, dont l'aménagement intérieur est composé de miroirs gravés et l'extérieur montre des portes recouvertes de parchemins ou encore une commande Louis IV précieuse qu'il a achetée aux enchères chez Pierre Bergé à Paris (à gauche). Pour une cliente d'Afrique du Nord, il a ouvert largement toutes les pièces sur la cuisine – en respect de la tradition et de l'esprit de convivialité du pays.

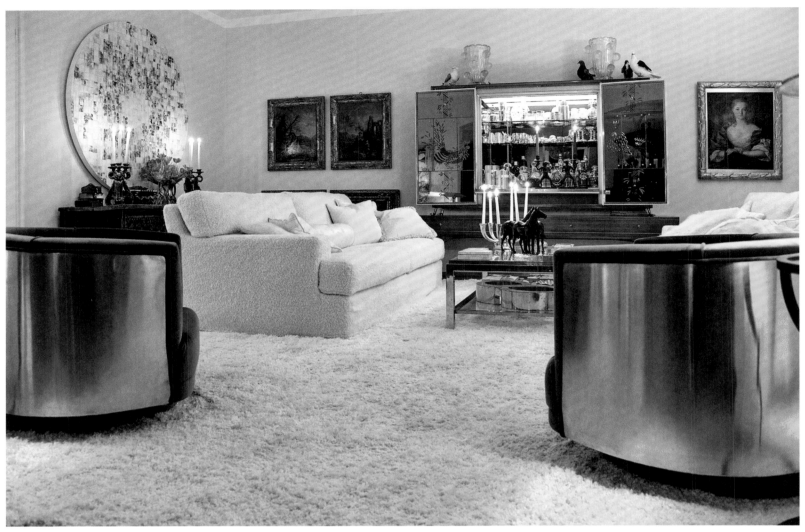

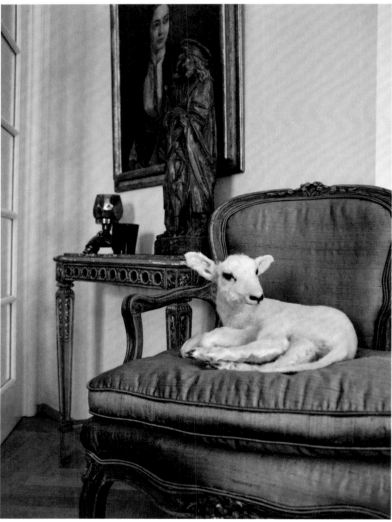

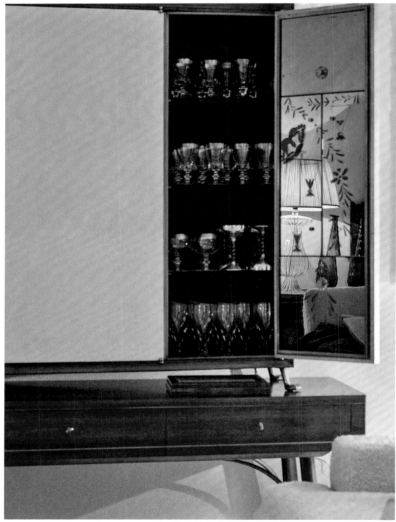

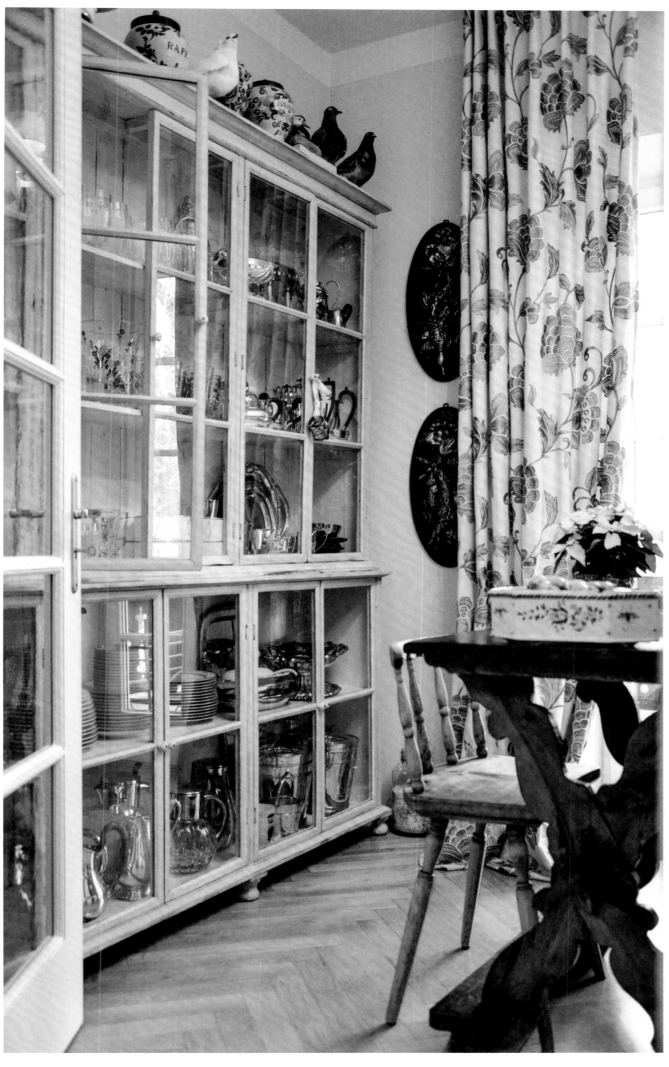

A penchant to mingle different eras: Holger Kaus is a virtuoso when it comes to salvaging exceptional treasures. The interior designer bought the 1920 display cabinet (left) at an auction in Bologna.

Am liebsten die Epochen mischen: Holger Kaus ist ein Virtuose, wenn es darum geht, besondere Schätze zu bergen. Den Vitrinenschrank (links) von 1920 ersteigerte der Interior Designer in Bologna.

Il aime par dessus tout mélanger les époques : Holger Kaus est un virtuose pour dénicher les trésors originaux. L'*interior design*er a acquis la vitrine (gauche) de 1920 aux enchères à Bologne.

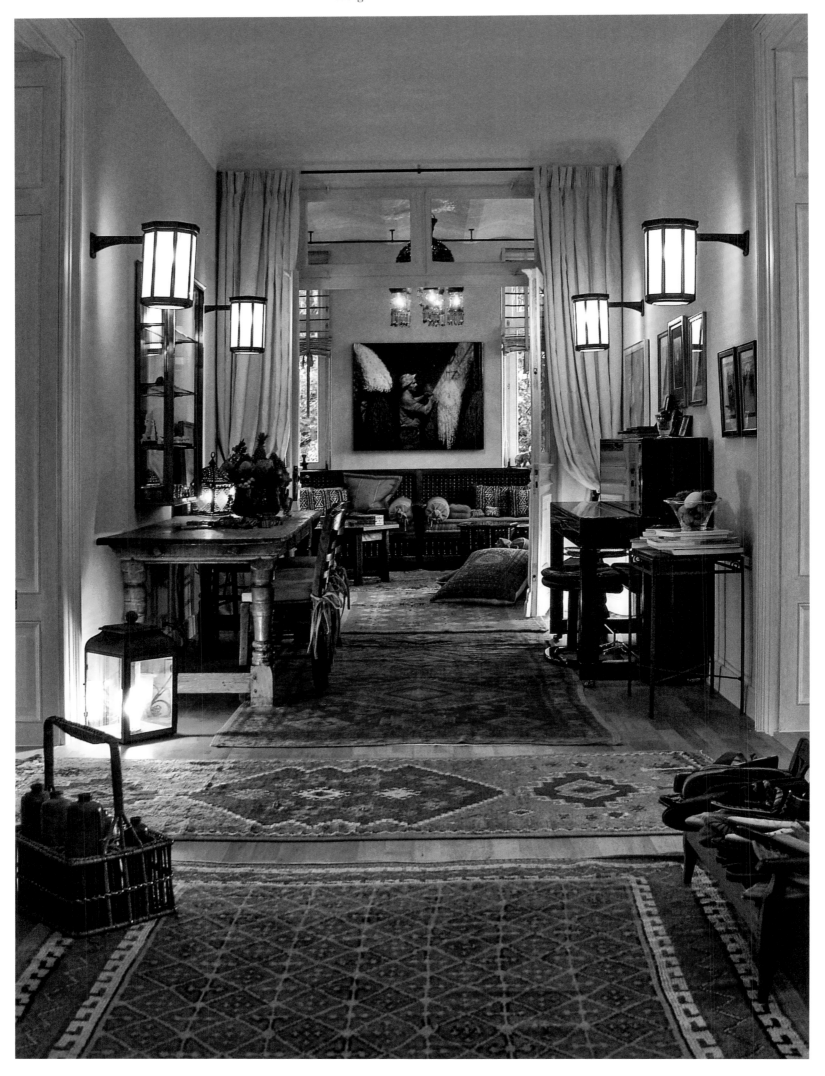

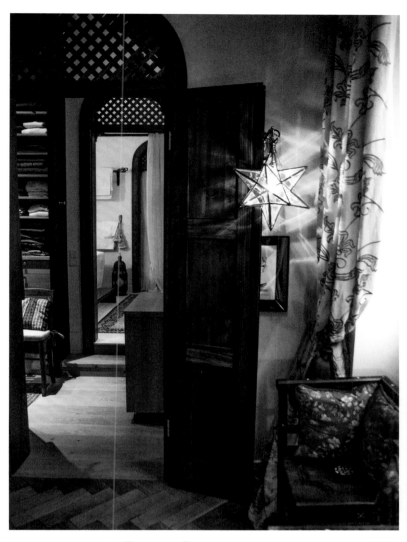

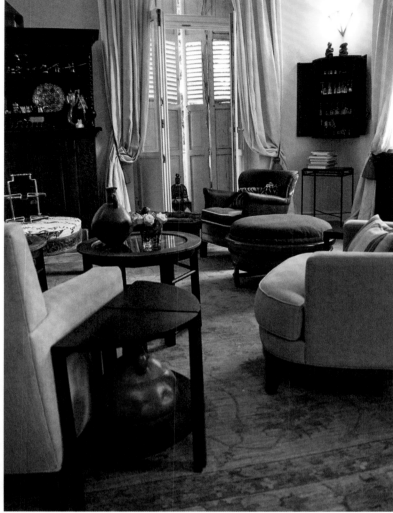

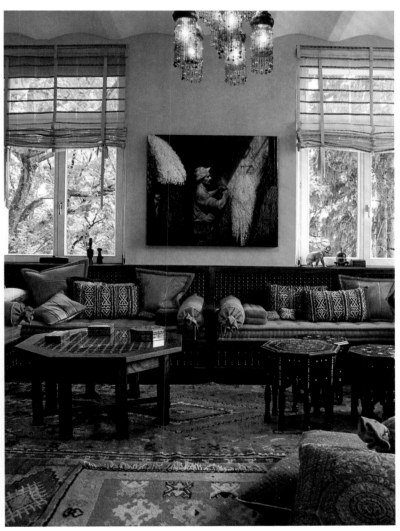

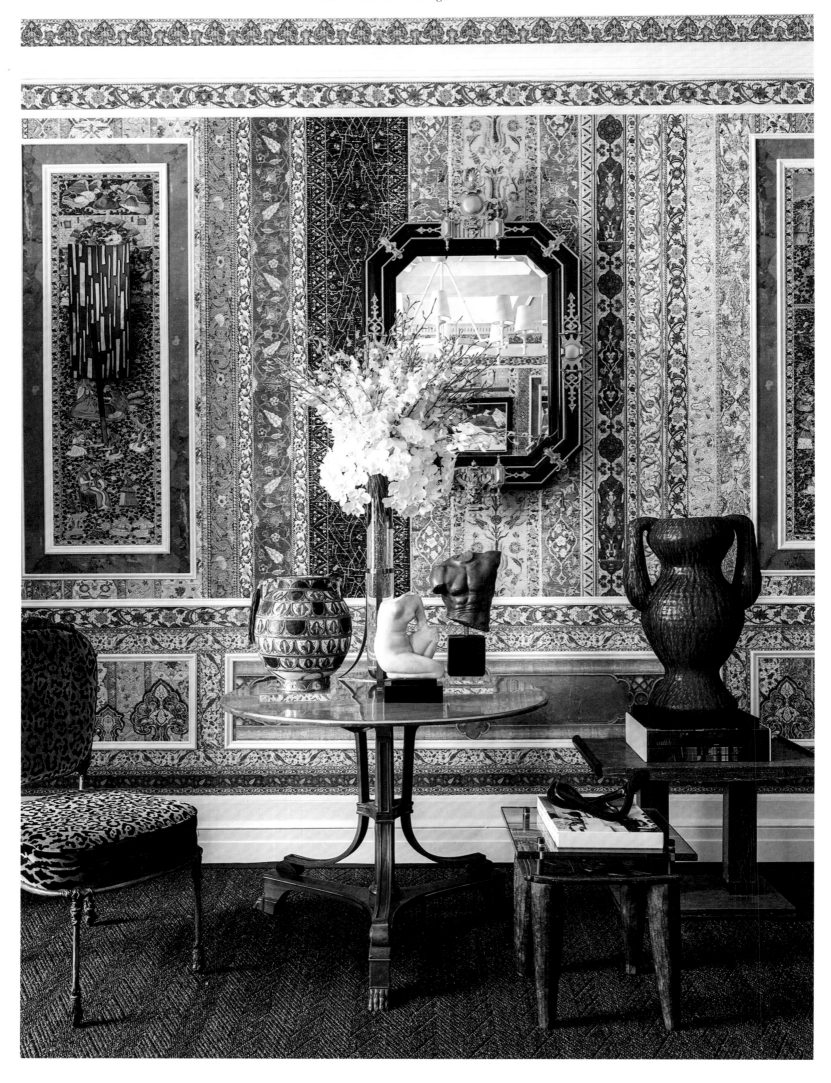

RICHARD MISHAAN DESIGN
New York City, United States

"Fashion and interiors are not that different and yet sometimes they are worlds apart."
„Mode und Interior sind einerseits nicht sehr verschieden, andererseits weit voneinander entfernt."
« La mode et l'architecture d'intérieur ne sont d'un côté pas si différents et d'un autre côté très éloignés. »

Richard Mishaan is celebrating his company's 25th anniversary, a quarter century during which there has been much to reflect on. After attending Columbia University, Mishaan worked in fashion, eventually designing men's and women's collections under his own label. In 1993, he went back to his first love: interior architecture and design. Mishaan opened an office on Fifth Avenue, starting with residential projects but was quickly invited to design retail and hospitality projects for companies such as Sony Corporation and Starwood Hotels. He was then presented with the opportunity to design furniture for Donghia, marking the beginning of years now designing furniture, lighting, textiles, and accessories for some of the world's best firms. Mishaan was born in Bogota, Colombia at a time of political unrest, forcing his family to move from the place they loved and leaving them heartbroken in the process. Because Colombia's rich culture has informed so much of who he is, Mishaan decided years later to buy a home in Cartagena, affording him time in the country of his birth. He is now renowned for an impressive style of interiors based on his vast design know-how and his roots. For last year's Kips Bay Decorator Show House, Mishaan transformed the living space in a 19th-century residence (left) into a modern-day interpretation of Italian architecture and set design legend Renzo Mongiardino. The highlight: wallpaper from Iksel Decorative Arts sporting a design discovered on vintage wood paneling in a Syrian mansion.

Richard Mishaan, dessen Designbüro in diesem Jahr sein 25-jähriges Jubiläum feiert, kann auf eine ereignisreiche Karriere zurückblicken: Nach seinem Studium an der Columbia University arbeitete der Kreative für ein Modeunternehmen, bevor er sich mit seinem eigenen Label selbstständig machte. 1993 verlegte er den Fokus wieder auf seine beiden anderen großen Leidenschaften: Architektur und Design. Er eröffnete sein eigenes Studio auf der Fifth Avenue und realisierte zunächst Privathäuser, doch schnell folgten Aufträge von namhaften Unternehmen und Hotels wie Sony oder Starwood Hotels. Für Donghia entwarf er anschließend Möbel, mittlerweile designt er auch Lampen, Teppiche und Stoffe. Mishaan wurde in Bogota, Kolumbien in eine Familie hineingeboren, die aufgrund der politischen Unruhen nach Südflorida fliehen musste. Seine Herkunft trägt er noch heute im Herzen und so kaufte er Jahre später ein Haus in Cartagena, um mehr Zeit in seiner alten Heimat verbringen zu können. Mishaan ist bekannt für einen imposanten Einrichtungsstil, der aus seiner jahrelangen Expertise sowie seiner kulturellen Vergangenheit schöpft. Für das Kips Bay Decorator Show House 2017, ein jährlich stattfindendes Charity-Projekt, verwandelte Mishaan einen Wohnraum in einem Gebäude aus dem 19. Jahrhundert (links) in eine moderne Neuinterpretation, die den Stil der italienischen Architektur- und Bühnenbildlegende Renzo Mongiardino zitiert. Das Highlight: eine Tapete von Iksel Decorative Arts, deren Dessin Mishaan auf alten Holzpaneelen eines syrischen Herrenhauses fand.

Richard Mishaan, dont l'agence de design fête cette année son 25ème anniversaire possède une carrière riche en événements : après des études à la Columbia University, le créateur a travaillé pour une entreprise de mode avant de se lancer avec son propre label. En 1993, il s'est concentré sur ses deux autres passions : l'architecture et le design. Il a ouvert son propre studio sur la Fifth Avenue et a commencé par réaliser des maisons privées. Ensuite, des projets d'entreprises et hôtels der renom comme Sony ou Starwood Hotels ont rapidement suivi. Pour Donghia, il a ensuite dessiné des meubles. Désormais, il crée également des lampes, des tapis et des tissus. Mishaan est nommé à Bogota, Colombie, dans une famille qui a dû fuir en Floride du Sud en raison des troubles politiques. Ses racines lui tiennent aujourd'hui encore à cœur et ainsi, des années plus tard, il a acheté une maison à Carthagène des Indes afin de pouvoir passer plus de temps dans son pays d'origine. Mishaan est connu pour son style d'aménagement imposant qu'il puise dans ses nombreuses années d'expertise et son passé culturel. Pour le Kips Bay Decorator Show House 2017, un projet caritatif qui a lieu chaque année, Mishaan a transformé un espace de vie dans un bâtiment du XIXe siècle (à gauche) en une réinterprétation moderne qui rappelle le style de la légende italienne de l'architecture et de la décoration scénique Renzo Mongiardino. Le point fort : une tapisserie d'Iksel Decorative Arts dont Mishaan a trouvé le dessin sur de vieux panneaux de bois d'un manoir syrien.

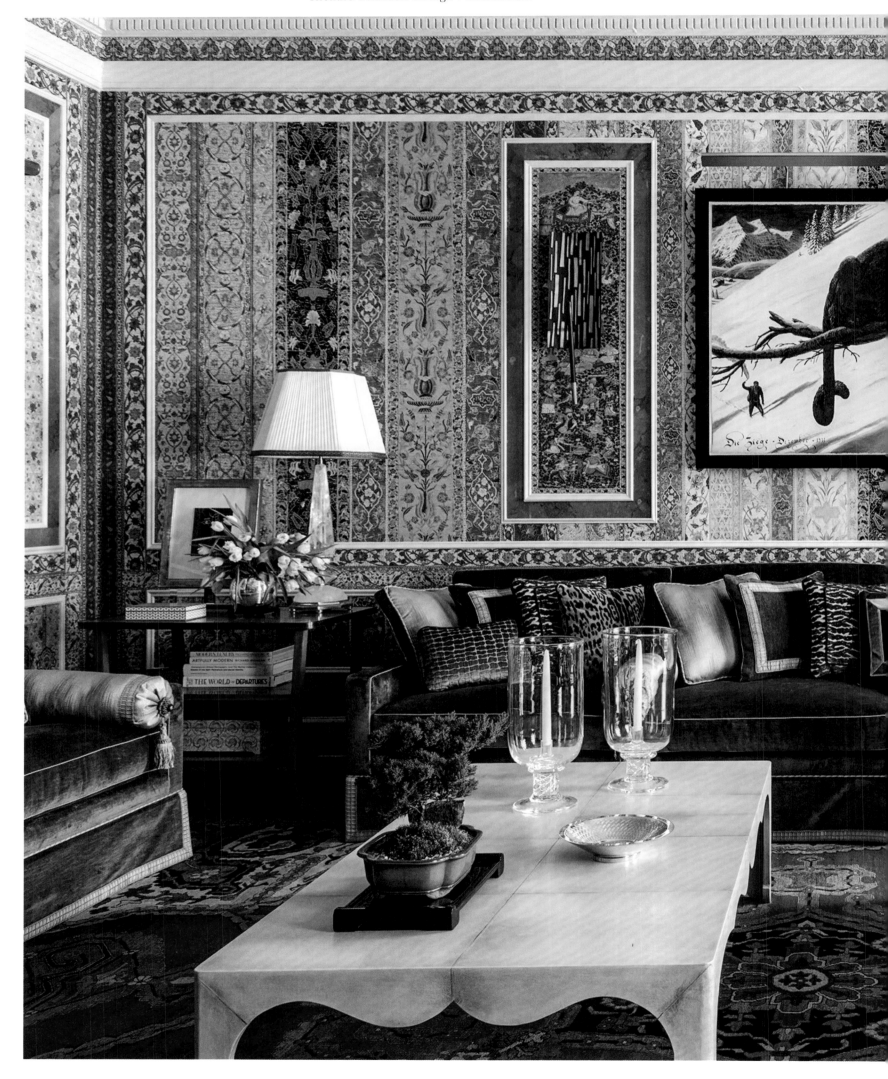

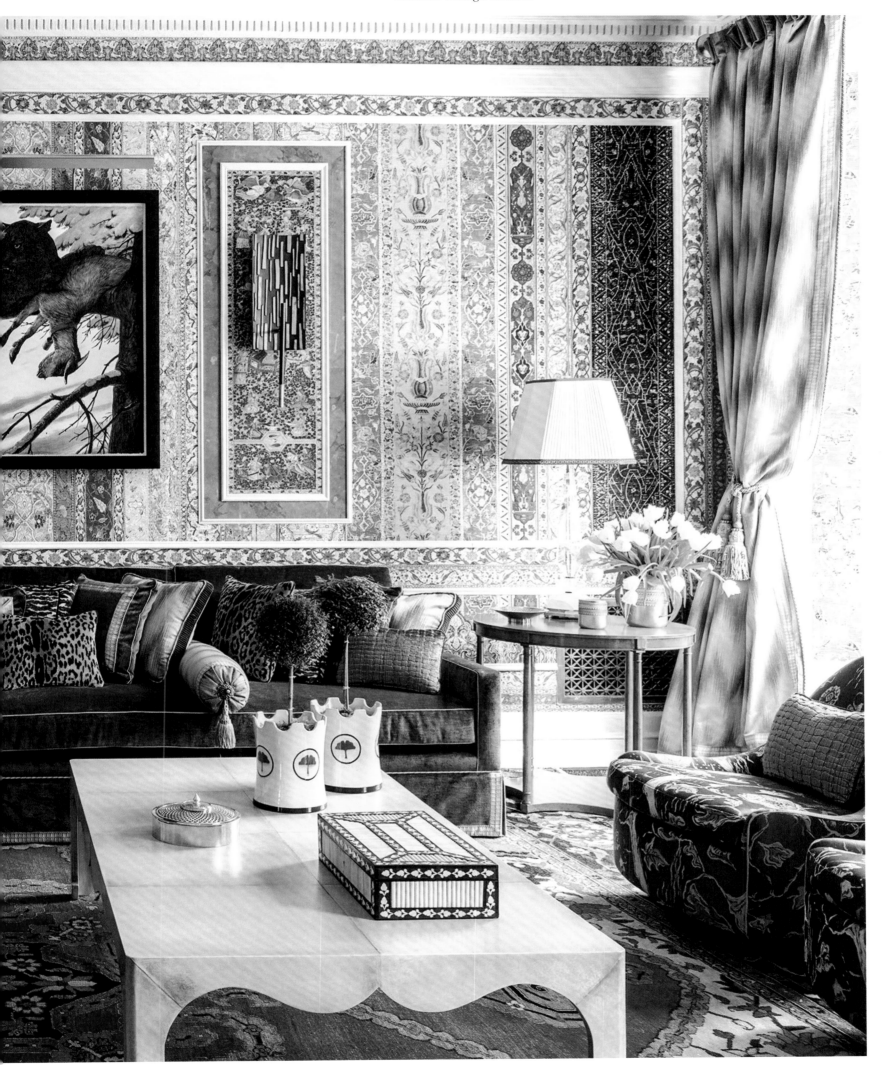

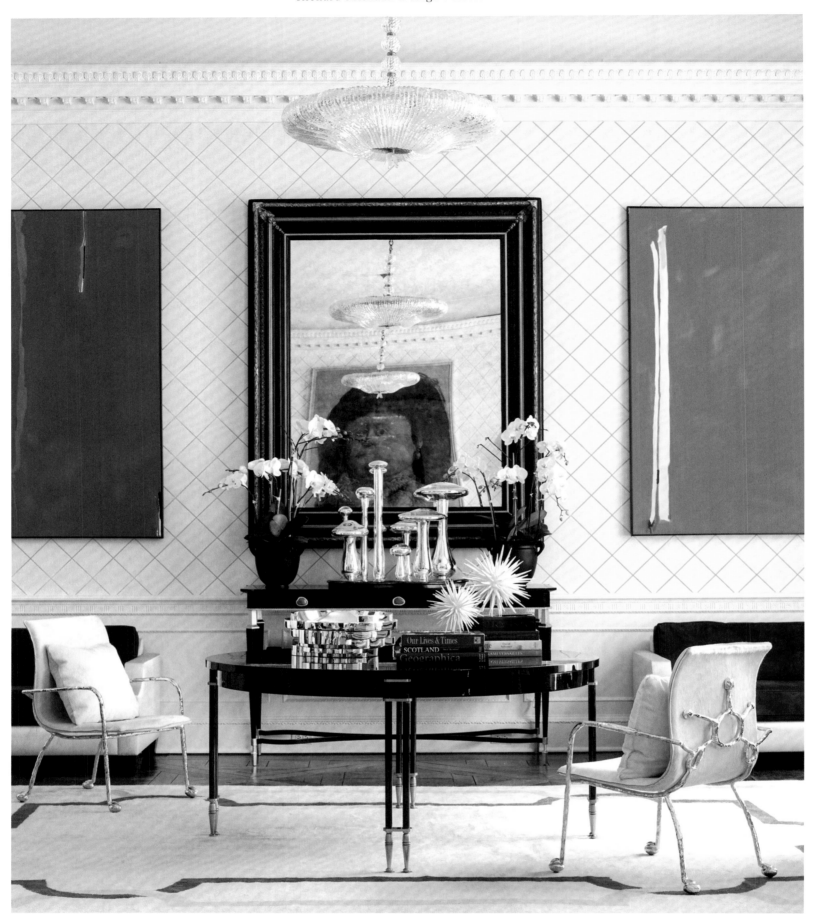

For the Kips Bay Decorator Show House 2011, Richard Mishaan married grandeur with Bohemian chic.

Für das Kips Bay Decorator Show House 2011, eine Wohltätigkeitsveranstaltung bei der Interior Designer Räume gestalten, kombinierte Richard Mishaan Grandezza mit Bohemian-Chic.

Pour le Kips Bay Decorator Show House 2011, un événement caritatif au cours duquel les interior designers aménagent des espaces, Richard Mishaan a combiné grandezza et chic bohémien.

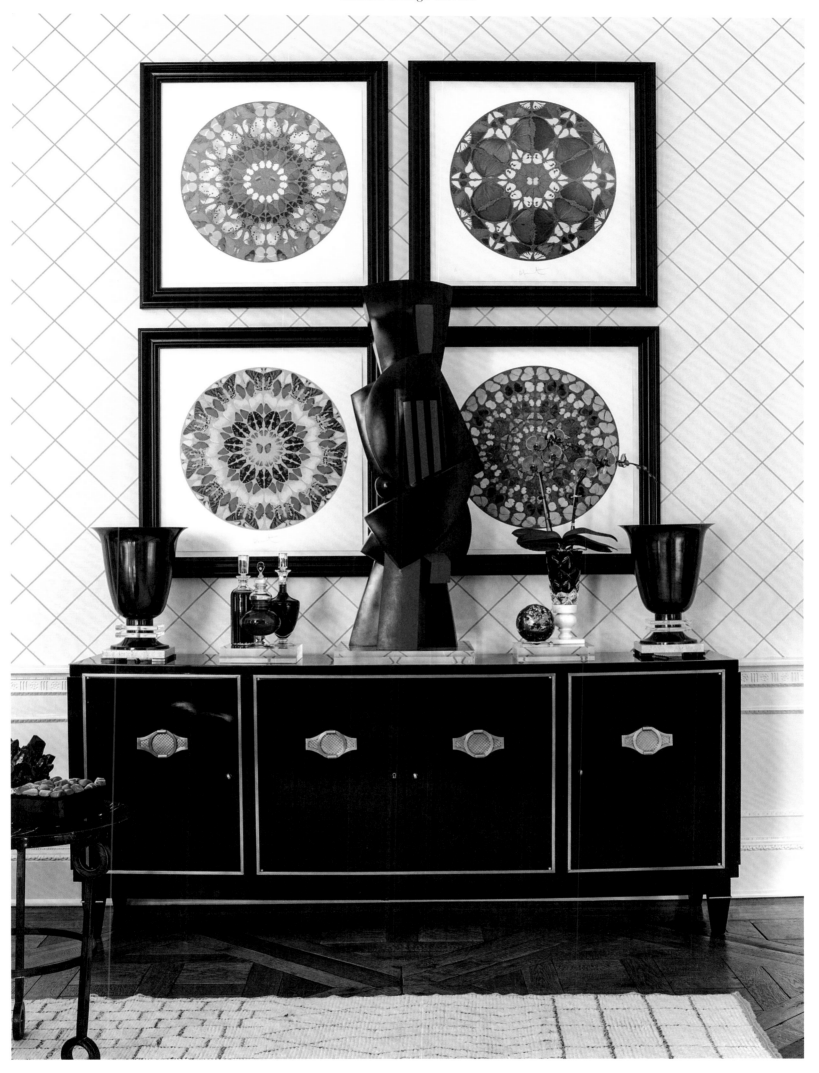

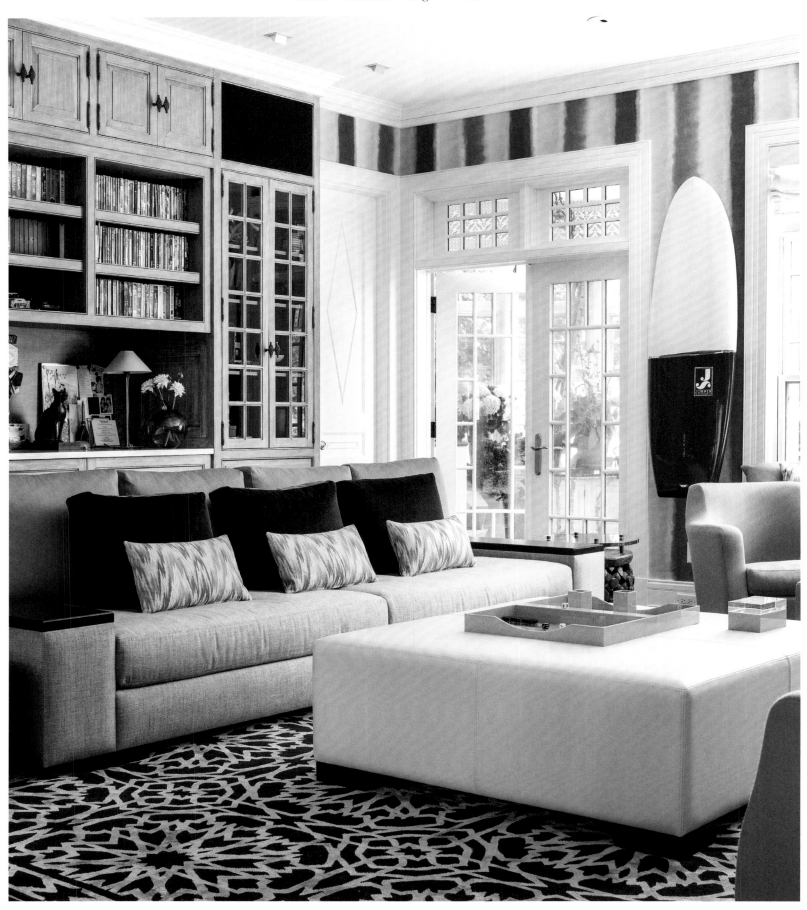

15 years on, Richard Mishaan furnished his summer house in the Hamptons with a contemporary yet tailored look: the family room and dining niche radiate in blue and white—down to the backgammon board and other accessories.

Nach 15 Jahren schenkte Richard Mishaan seinem Sommerhaus in den Hamptons einen komplett neuen Look: Wohn- und Esszimmer strahlen in Weiß-Blau – einschließlich des Backgammonbretts.

Après 15 ans, Richard Mishaan a offert à sa maison d'été dans les Hamptons un look entièrement nouveau. Le séjour et la salle à manger rayonnent un blanc et bleu – tout comme le plateau de backgammon.

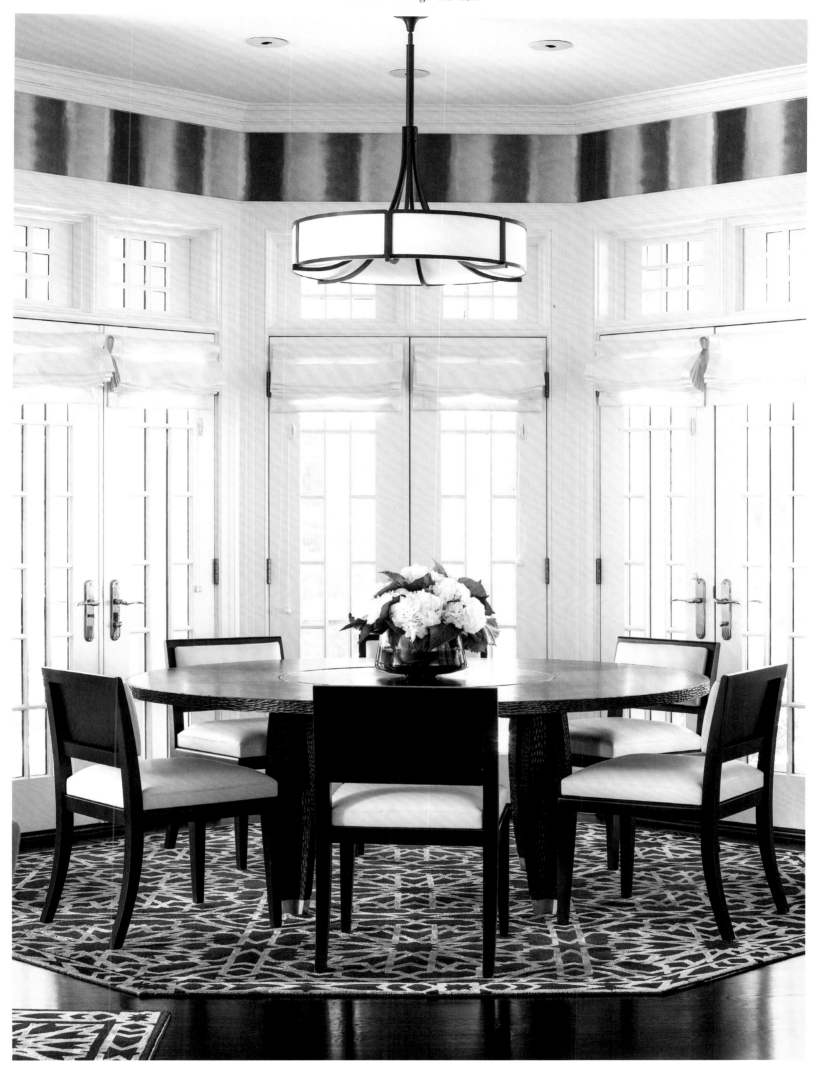

TAYLOR HOWES
London, United Kingdom

"Interior design must be transcendently defining in its style but practical in its nature."
„Interior Design muss auf überragende Weise stilprägend, gleichzeitig aber auch praktisch sein."
« L'*interior design* doit avoir un style marqué mais être également pratique. »

Her philosophy is simple and likeable—"Our clients come to us because they value fine art and interiors, our established bespoke approach and as they are often time tight." What initially appears euphemistic can actually be described as the secret to Karen Howes' success. For over 25 years, the Brit and her team at Taylor Howes have been decorating private homes, hotels and restaurants, bespoke developments, yachts and private jets, across Europe, the Middle East, and the US. "Interior design has been a passion since childhood." Karen Howes spent her youth honing and developing an understanding of fine arts, interior design and perhaps more importantly reading people, which have aided her in growing Taylor Howes. The team at Taylor Howes is established in the industry for their passion for interpreting wishes into reality. In one North London project Taylor Howes,

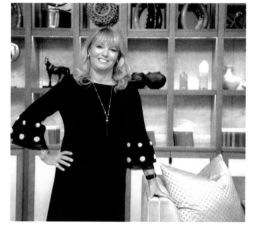

for example, converted a large traditional townhouse into a light-filled mega-mansion fit for both entertaining and relaxed family time, a particular request of the client. This project saw the private areas converted into relaxed "Hamptons style" spaces and the entertaining areas, such as the dining room, into more glamorous and formal rooms. This particular property's highlight is the pool, which has turquoise mosaic tiles on its bottom and stylized fish and lotus leaves at the ends, creating a relaxingly potent mix.

Ihr Denkansatz ist simpel und sympathisch: „Unsere Kunden", sagt sie, „kommen zu uns, weil sie Kunst, Einrichtung sowie unsere maßgeschneiderten Ansätze sehr schätzen und oft wenig Zeit haben." Was auf den ersten Blick euphemistisch klingt, könnte man als Karen Howes Erfolgsgeheimnis interpretieren. Seit über 25 Jahren richten die Britin und ihr Team Privathäuser, Hotels, Restaurants, maßgefertigte Immobilien, Yachten und Privatjets in Europa, dem Mittleren Osten sowie den USA ein. „Interior Design ist seit jungen Jahren meine Passion", erklärt Karen Howes, die ihre Jugend damit verbrachte, ihr Verständnis für Kunst und Inneneinrichtung zu schulen und sich eine gute Menschenkenntnis anzueignen. Heute, sagt sie, seien es genau diese Fertigkeiten, die für das Wachstum von Taylor Howes

maßgeblich verantwortlich sind. Mit viel Leidenschaft setzen Karen und ihr Team Kundenwünsche in die Realität um, so wie im Falle eines Objekts im Londoner Norden: Hier wurde ein traditionelles Townhouse in eine lichtdurchflutete Villa verwandelt, die für repräsentative Zwecke, aber auch als familiärer Rückzugsort verwendet wird – ein großes Anliegen der Besitzer. Der private genutzte Teil wurde mit einem entspannten „Hamptons-Feeling" versehen, die offiziellen Räume wie das Esszimmer sollten einen glamourösen Touch bekommen. Das Highlight: der Poolbereich mit Mosaiksteinen in Türkis, die mit stilisierten Fischen und Seerosenblättern an der Stirnseite für einen beeindruckenden Mix sorgen.

Son approche est simple et sympathique : « Nos clients », dit-elle, « font appel à nous parce qu'ils apprécient l'art, la décoration et nos approches sur mesure et ont souvent peu de temps ». Ce qui semble un euphémisme au premier abord pourrait être qualifié comme secret de la réussite de Karen Howes. Depuis plus de 25 ans, la Britannique et son équipe aménagent des maisons privées, des restaurants, des biens immobiliers sur mesure, des yachts et des jets privés en Europe, au Moyen-Orient et aux États-Unis. « L'*interior design* est ma passion depuis mon plus jeune âge », explique Karen Howes qui a passé son enfance à se former à l'art et à l'aménagement d'intérieur et à développer ses connaissances humaines. Aujourd'hui, dit-elle, ce sont ces compétences qui contribuent essentiellement à la croissance de Taylor Howes. Karen et son équipe concrétisent avec beaucoup de passion les envies des clients, comme par exemple pour un bien immobilier dans le nord de Londres : ici, une maison de ville traditionnelle a été transformée en villa baignée de lumière qui est utilisée à des fins de représentation ainsi que comme lieu de retraite familiale – il s'agissait d'un souhait ardent des propriétaires. La partie à usage privé a été aménagée dans un style « Hamptons » décontracté, les salles officielles comme la salle à manger devaient avoir une touche glamour. L'élément-phare : l'espace de piscine avec des pierres mosaïques en turquoise qui forment, avec des poissons stylisés et des pétales de nénuphars sur la partie frontale, un mélange impressionnant.

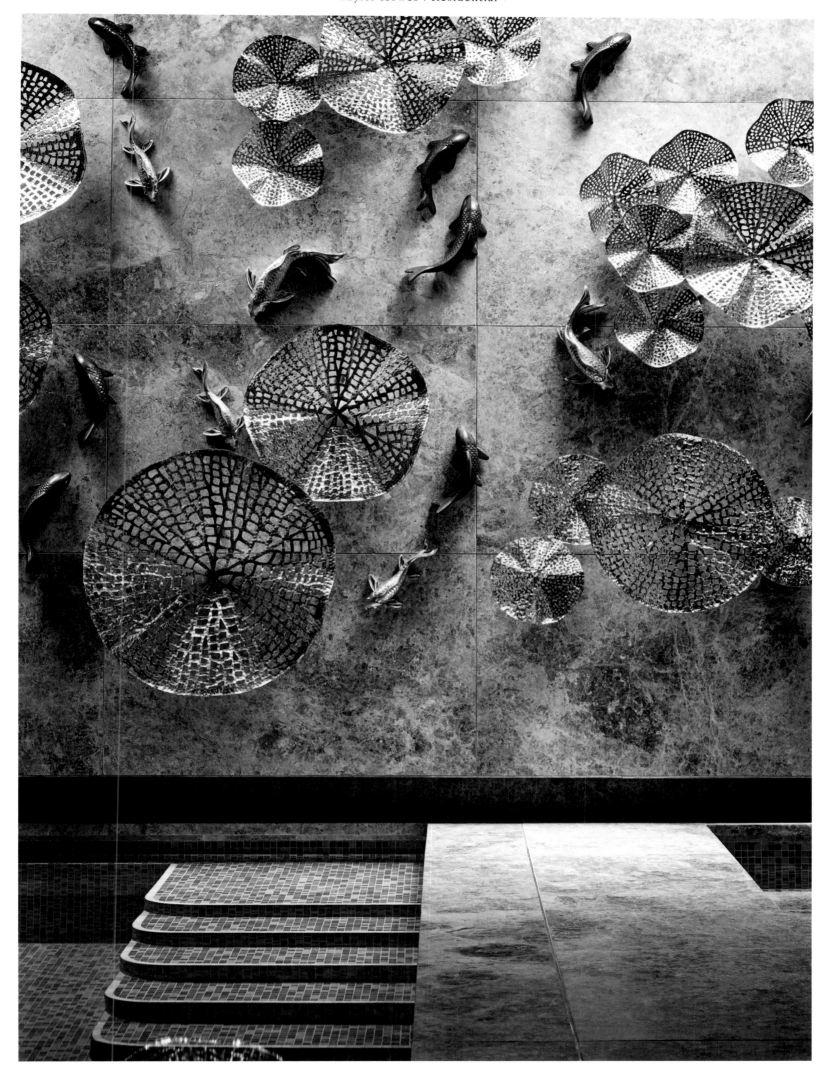

Hamptons flair in the family rooms, extravagance in the entertaining areas. Karen Howes of Taylor Howes, interior design group, achieved this balancing act at a villa in North London.

Hamptons-Feeling in den Familienzimmern, Extravaganz in den repräsentativen Räumen: für eine Villa im Norden Londons schaffte Karen Howes von der gleichnamigen Interior-Firma den Spagat.

Ambiance Hamptons dans les pièces familiales, extravagance dans les pièces représentatives : pour une villa au nord de Londres, Karen Howes de l'entreprise d'aménagement d'intérieur du même nom, a réussi ce tour de force.

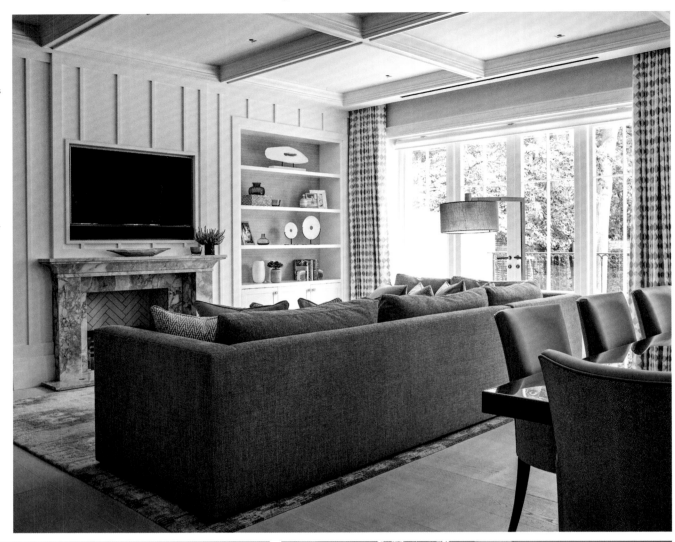

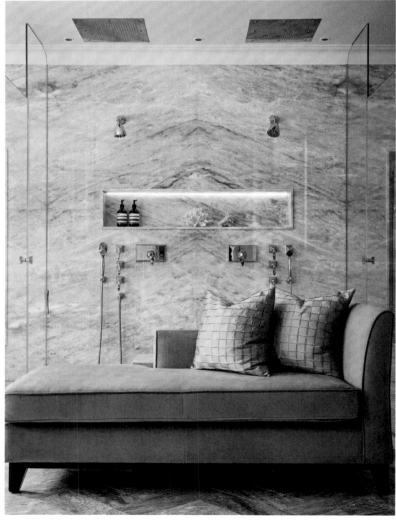

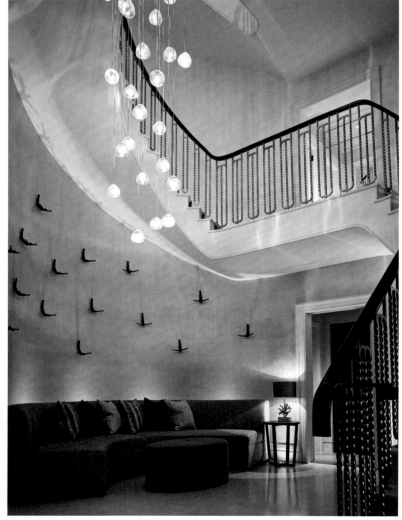

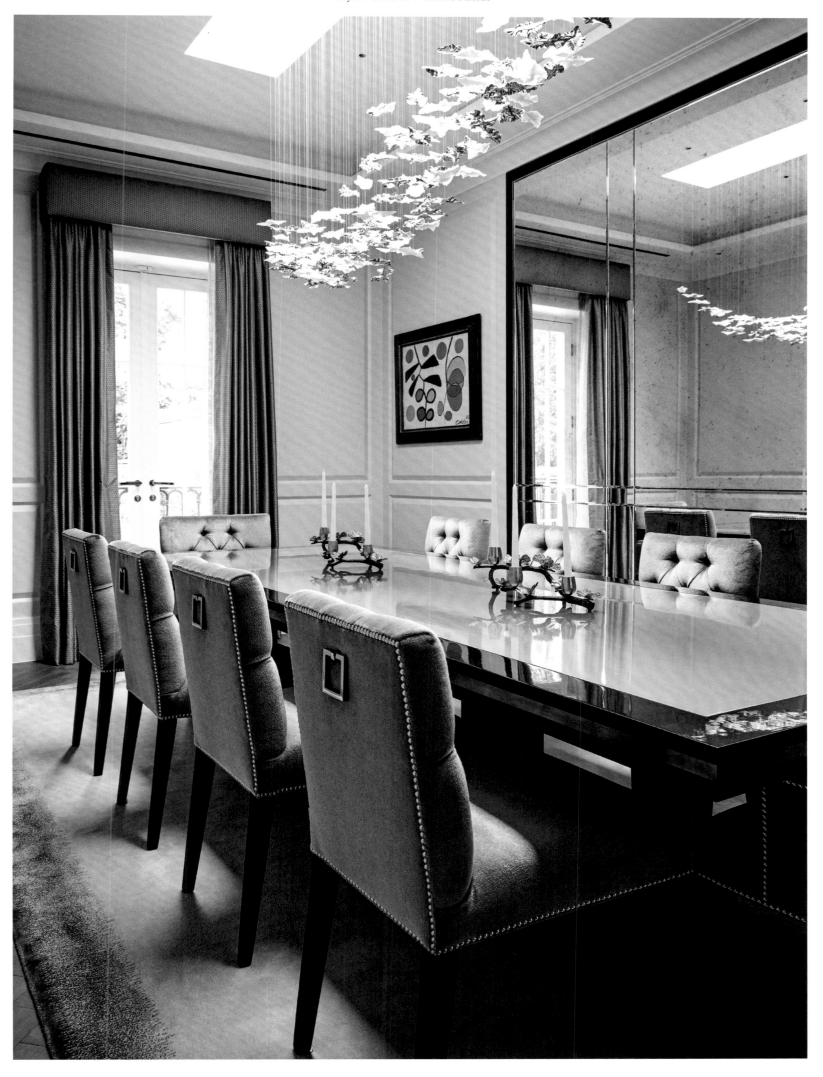

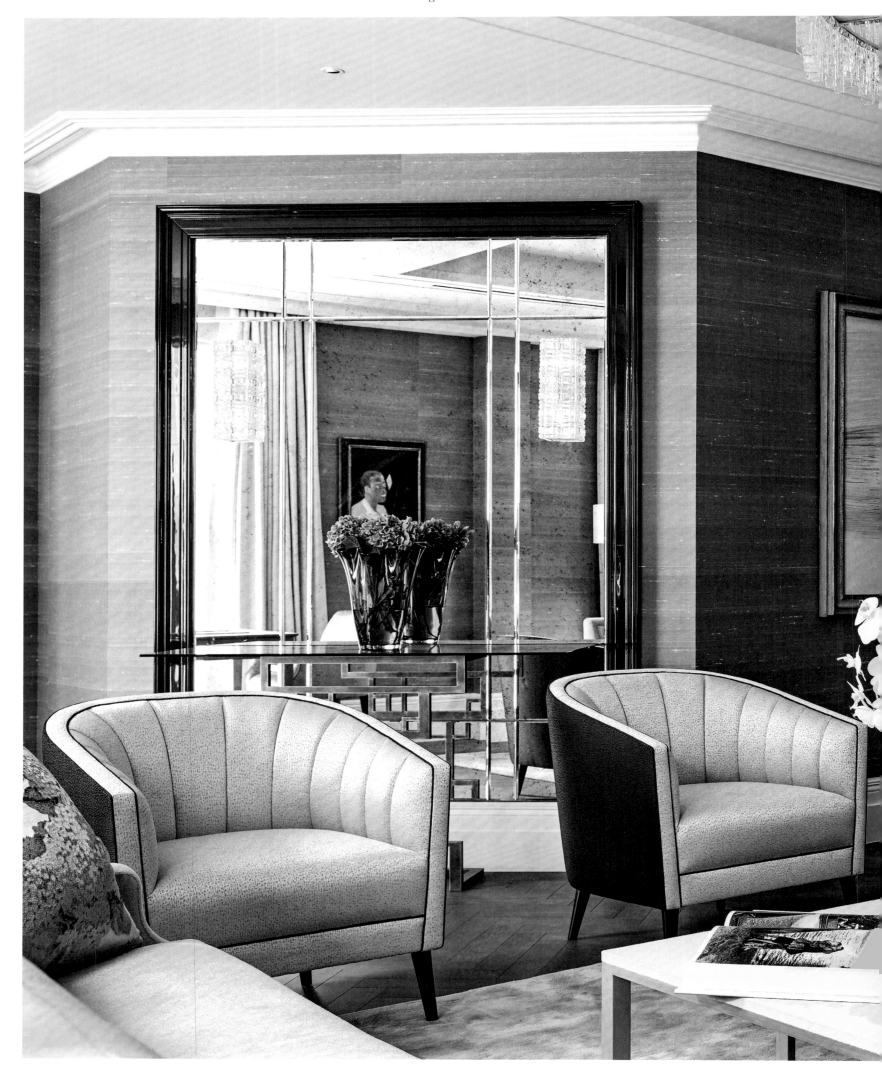

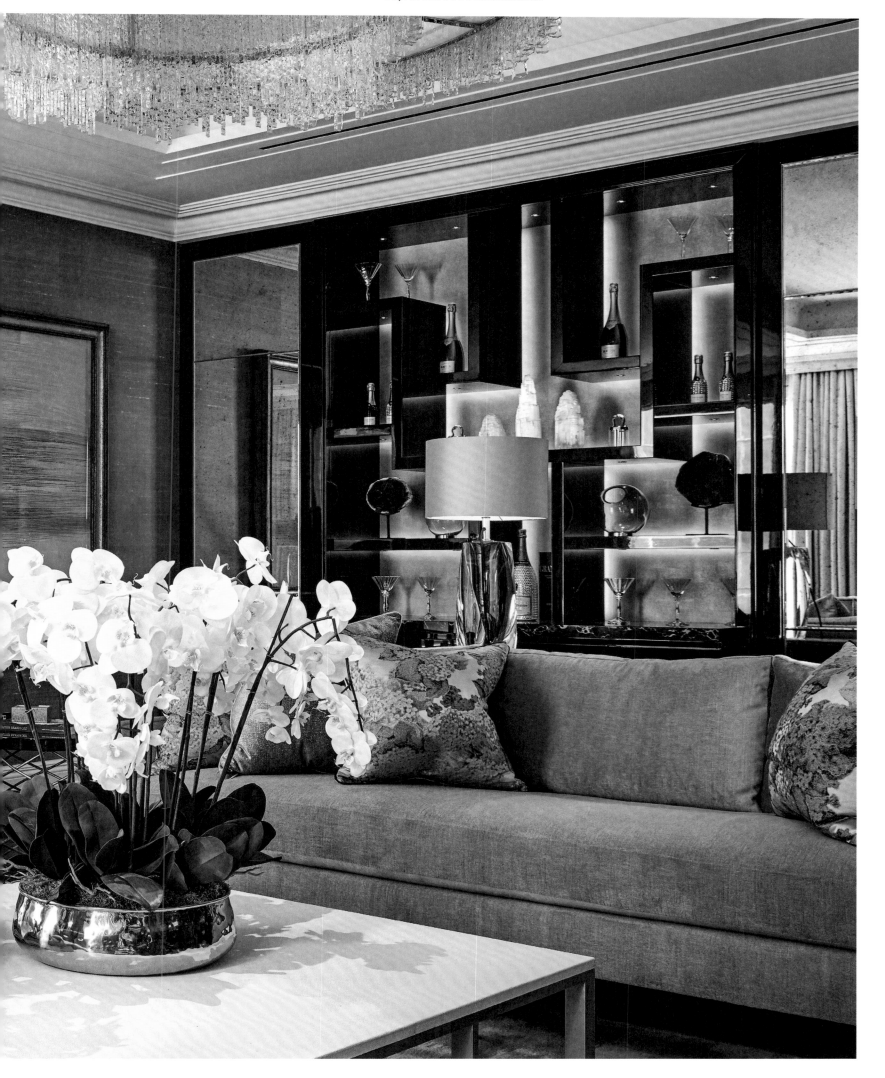

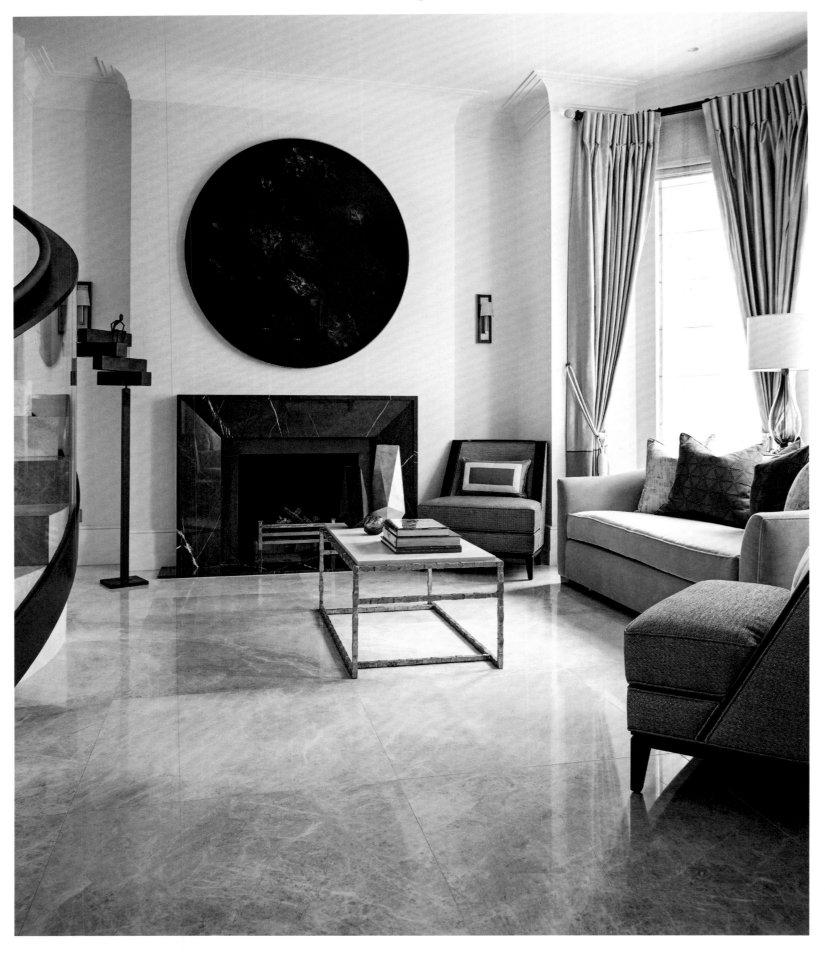

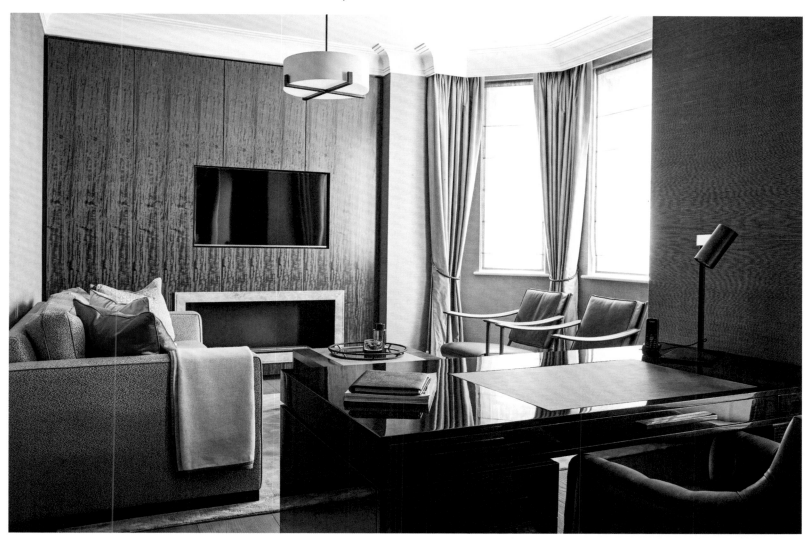

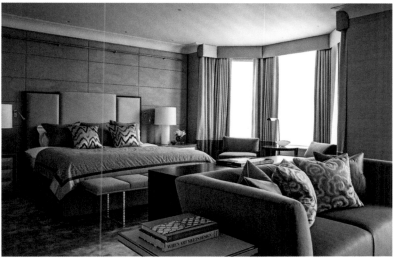

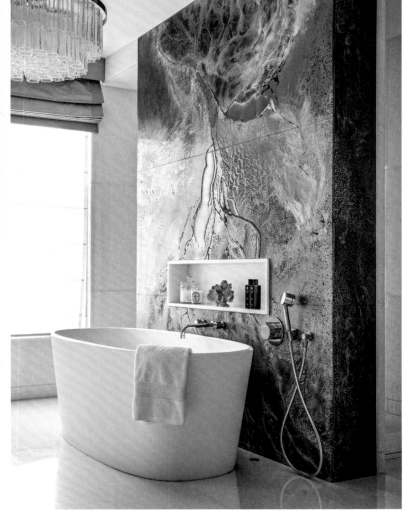

Taylor Howes decorated
a family's residence in
an elegant contemporary
style. Predominantly earth
and grey tones have been
used for the living room,
and entertaining area; the
master bathroom includes
a Murano glass chandelier
as a striking centerpiece.

Die Residenz einer
Familie gestaltete Taylor
Howes zeitgenössisch-
elegant. Im repräsentativen
Wohnzimmer überwiegen
Erd- und Grautöne, im
Masterbad fungiert ein
Muranoglas-Leuchter
als Centerpiece.

Taylor Howes a réalisé
la résidence d'une famille
dans un style contempo-
rain élégant. Dans le salon
représentatif, les tons
de terre et gris dominent,
dans la salle de bain
principale, un spot en
verre de Murano attire
toute l'attention.

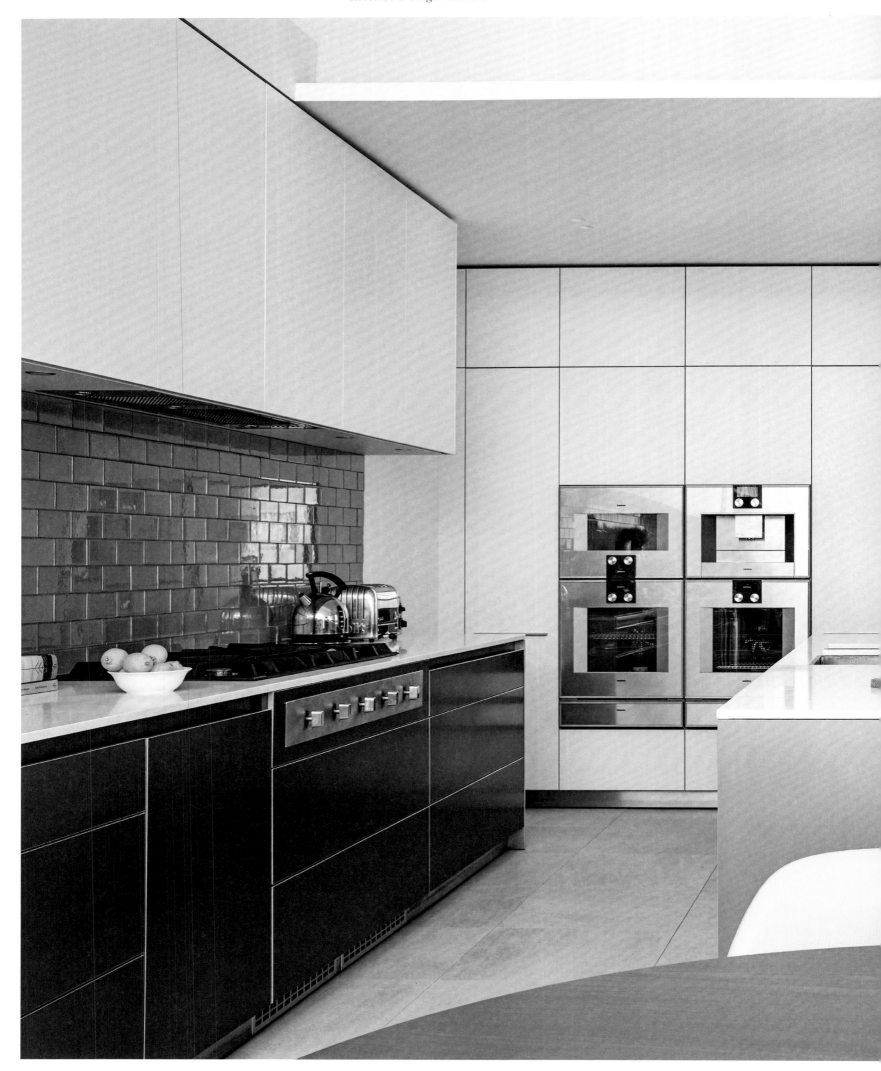

GAGGENAU

Munich, Germany

"We believe that appealing aesthetics belong in all areas of life—including in the kitchen."
„Anspruchsvolle Ästhetik gehört für uns in alle Lebensbereiche – auch in die Küche."
« Une esthétique exigeante est importante dans tous les domaines de vie, selon nous. Même dans la cuisine. »

What have refrigerators got to do with interior design? Actually, quite a lot. Primarily, they bring colors, fabrics, furniture and objects to the fore and impress in terms of technical quality and avant-garde aesthetic appeal. Gaggenau is dedicated to preserving its manufacturing tradition. Founded in 1683 in the Black Forest, the company history tells of a hammer mill and nail forge that developed over the centuries into a luxury brand of kitchen appliances that is synonymous with innovation, functionality, design and global recognition. The Gaggenau Vario refrigerators 400 series encompasses refrigerators, freezers, fridge-freezer combinations and wine cabinets. Individual components can be freely combined to create an in-column refrigeration set-up. Handleless doors, customized fronts and the stainless steel and glass doors of the wine cabinets transform kitchens into emotional spaces. "The new series from Gaggenau represents the quintessence of finesse within the luxury household appliance segment," affirmed Sven Baacke, head of design at Gaggenau. Opening the doors reveals an interior design in stainless steel and anodized aluminum elements in dark anthracite. Inspired by the vintage casks used for maturing fine wines, the bottle trays are crafted from prime oak. And the absolute highlight: a simple press opens the handleless door as if by magic. The kitchen consequently becomes the heart and soul of the house.

Was haben Kühlschränke mit Interior Design zu tun? Eine ganze Menge. Im besten Falle lassen sie Farben, Textilien, Möbeln und Objekten den Vortritt und überzeugen mit technischer Qualität und avantgardistischer Ästhetik. Gaggenau fühlt sich der Tradition der Manufaktur verpflichtet. Die Geschichte der 1683 im Schwarzwald gegründeten Firma erzählt von einer Hammer- und Nagelschmiede, aus der sich im Laufe der Jahrhunderte eine Luxusmarke für Küchengeräte entwickelt hat, die für Innovation, Funktionalität, Design und weltweite Anerkennung steht. Die Gaggenau Vario Kühlgeräte-Serie 400 umfasst Kühl-schränke, Gefrierschränke, Kühl-Gefrier-Kombinationen sowie Weinklimaschränke. Die einzelnen Elemente können frei miteinander zu einer Kühlwand kombiniert werden.

Grifflose Türen, individuelle Fronten sowie die Edelstahl- oder Glastüren der Weinklimaschränke machen aus Küchen Erlebniswelten: „Die neue Serie von Gaggenau repräsentiert die Quintessenz der Raffinesse im Luxus-Hausgerätesegment", betont Sven Baacke, Chefdesigner von Gaggenau. Die Ausstattung hinter den Türen ist aus Edelstahl und eloxierten Aluminiumelementen in dunklem Anthrazit gefertigt. Inspiriert von der Optik alter Fässer, die für die Reifung feiner Weine verwendet werden, sind die Flaschenablagen aus edlem Eichenholz. Und das Beste: durch einfaches Drücken öffnet sich die grifflose Tür wie von Zauberhand. Die Küche ist hier Herz und Seele des Hauses.

Quel est le point commun entre les réfrigérateurs et *l'interior design* ? Il y en a beaucoup. Dans le meilleur des cas, ils laissent la priorité aux couleurs, aux textiles, aux meubles et aux objets et convainquent par leur qualité technique et leur esthétique d'avant-garde. Gaggenau respecte la tradition de la manufacture. L'histoire de l'entreprise fondée en 1683 dans la Forêt noire raconte une forge de marteaux et de clous qui est devenue au fil des siècles une marque de luxe pour les appareils de cuisine qui est reconnue dans le monde entier pour son innovation, sa fonctionnalité, son design. La série de Gaggenau réfrigérateurs Vario 400 comprend des réfrigérateurs, des congélateurs, des combinaisons de réfrigérateurs et congélateurs et des caves à vin climatisées. Les différents éléments peuvent être combinés entre eux pour former un meuble réfrigérant. Les portes sans poignée, les faces individuelles et les portes en inox ou en verre des caves à vin climatisées transforment les cuisines en univers de découverte : « La nouvelle série de Gaggenau représente la quintessence du raffinement dans le segment des appareils électroménagers de luxe », souligne Sven Baacke, designer en chef de Gaggenau. L'équipement qui se cache derrière les portes est fait d'inox et d'éléments en aluminium anodisé en anthracite foncé. Inspiré des fûts anciens utilisés pour le vieillissement des vins raffinés, les tablettes de bouteille sont en bois de chêne noble. Le mieux : en appuyant simplement, la porte sans poignée s'ouvre comme par magie. La cuisine est le cœur et l'âme de la maison.

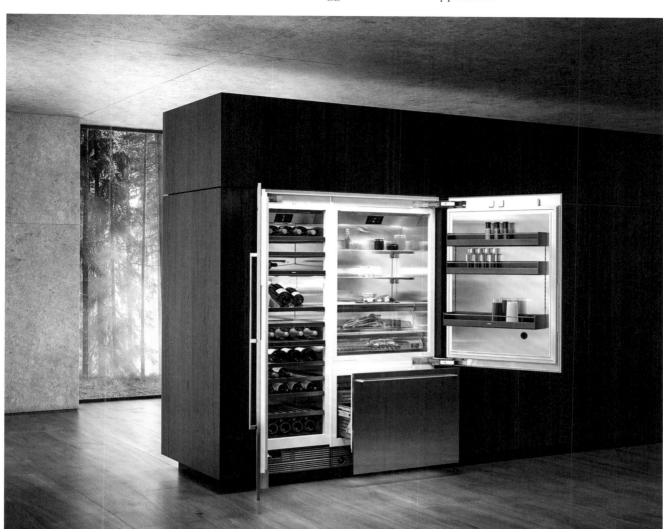

Stainless steel and anodized aluminum: Gaggenau Vario refrigerators 400 series modules can be freely combined, are technically superlative and transform kitchens into emotional spaces.

Edelstahl und eloxiertes Aluminium: die Module der Gaggenau Vario Kühlgeräte-Serie 400 lassen sich individuell kombinieren, überzeugen technisch und verwandeln Küchen in Erlebniswelten.

Inox et aluminium anodisé : les modules de la série de Gaggenau réfrigérateurs Vario 400 peuvent être combinés individuellement, ils convainquent sur le plan technique et transforme les cuisines en univers de découverte.

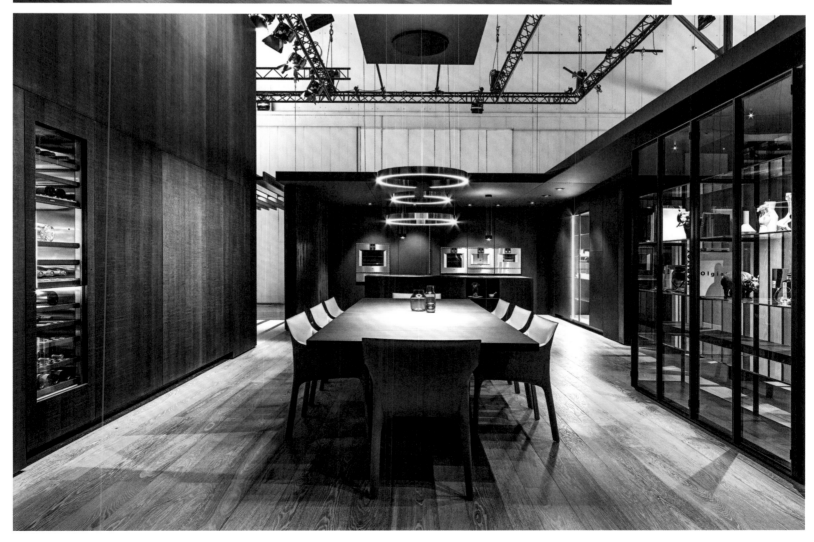

MANG MAURITZ
Munich, Germany

"Architecture reveals perspectives. Design perfects the sense of space."
„Architektur eröffnet Perspektiven. Design vollendet das Raumgefühl."
« L'architecture ouvre des perspectives. Le design parfait l'ambiance d'une pièce. »

Ask Stefan Mauritz and Thomas Mang about their aspirations, and they will quote Oscar Wilde— "I'm always satisfied with the best." It is not unknown for the Munich-based architects to make provocative proposals for a new project so that they can discover what the client really wants. "We try to present the whole spectrum of options that are available. This allows us to identify personal needs more precisely." Both of them (Stefan Mauritz has worked, among others, for Rolls-Royce; Thomas Mang with star architect Helmut Jahn) have been fascinated by the idea of a holistic approach for years now. Mang, who is responsible for interior design, and Mauritz, who handles classic architectural issues for the duo, cooperate closely during all phases of a construction project, working hand in hand from the initial stage of planning. For a Munich apartment they used old tree trunks sourced from Lake Constance to create archaic-looking couch tables that harmonize with the wide, rough oak floorboards. These discreet elements are designed to draw attention to the extravagantly patterned, cobalt blue Cole & Son wallpaper. Mang Mauritz decorated an urban residence with meticulously lacquered doors and high-end wood paneling. The ebony dining table is combined with chairs in a dramatic hot pink. The owners have homes around the world, and this was the starting point for Thomas Mang and Stefan Mauritz' design concept, that they describe as "Metropolitan Style".

Fragt man Stefan Mauritz und Thomas Mang nach ihrem Anspruch, zitieren sie gerne Oscar Wilde: „Ich bin immer mit dem Besten zufrieden." Um herauszufinden, was sich ein Kunde wirklich wünscht, gehen die beiden Münchener Architekten schon mal mit provokanten Vorschlägen an ein neues Projekt heran. „Wir versuchen das gesamte Spektrum an Möglichkeiten aufzuzeigen. So lassen sich die Koordinaten der persönlichen Bedürfnisse präzise bestimmen." Seit Jahren (Stefan Mauritz arbeitete unter anderem für Rolls-Royce, Thomas Mang mit Stararchitekt Helmut Jahn) sind die beiden von der Idee ganzheitlicher Ansätze fasziniert. Über alle Bauphasen stehen Mang, der für die Innenarchitektur verantwortlich zeichnet, und Mauritz, der für das Duo die klassische Architektur betreut, in engem Austausch,

lassen ihre Aktivitäten vom ersten Schritt der Planung an Hand in Hand gehen. In einem Münchener Apartment inszenierten sie uralte Baumstämme vom Bodensee als archaisch anmutende Couchtische. Sie harmonieren mit den breiten, rohen Eichendielen und lassen der extravagant gemusterten Tapete von Cole & Son in Kobaltblau optisch den Vortritt. Eine Townvilla stattete Mang Mauritz mit aufwendig lackierten Türen und edler Holzvertäfelung aus und gruppierte um den Esstisch aus Ebenholz Sessel in dramatischem Pink. Die Besitzer sind auf der ganzen Welt zu Hause: Thomas Mang und Stefan Mauritz fanden, dass sich dies in der Umsetzung niederschlagen sollte und beschreiben die Einrichtung als „Metropolitan Style".

Lorsque l'on demande à Stefan Mauritz et à Thomas Mang quelle est leur ambition, ils citent volontiers Oscar Wilde : « Je me contente du meilleur ». Afin de découvrir ce que souhaite vraiment un client, les deux architectes munichois abordent un nouveau projet avec des propositions provocantes. « Nous essayons de montrer toute l'étendue des possibilités. Ainsi, les coordonnées des besoins précis peuvent être déterminées précisément. » Depuis des années (Stefan Mauritz a notamment travaillé pour Rolls-Royce, Thomas Mang avec l'architecture star Helmut Jahn), les deux hommes sont fascinés par l'idée d'approches complètes. Pendant toutes les phases de la construction, Mang, responsable de l'architecture d'intérieur et Mauritz, responsable de l'architecture classique au sein du duo, échangent continuellement et accomplissent leurs activités main dans la main dès la première étape de la planification. Dans un appartement munichois, ils ont mis en scène des troncs d'arbre du Lac de Constance sous forme de tables basses à l'aspect archaïque. Elles s'harmonisent avec les larges lattes du plancher en chêne brut et mettent au premier plan les papiers peints aux motifs extravagants de Cole & Sohn en bleu cobalt. Mang Mauritz a équipé une villa urbaine de porte aux peintures complexes et de panneaux de bois noble et ont regroupé autour de la table de la salle à manger en bois d'ébène des fauteuils d'un fuchsia dramatique. Les propriétaires aiment parcourir le monde : Thomas Mang et Stefan Mauritz étaient d'avis que cela devait se ressentir dans la mise en œuvre et ont décrit l'aménagement choisi comme un « metropolitan style ».

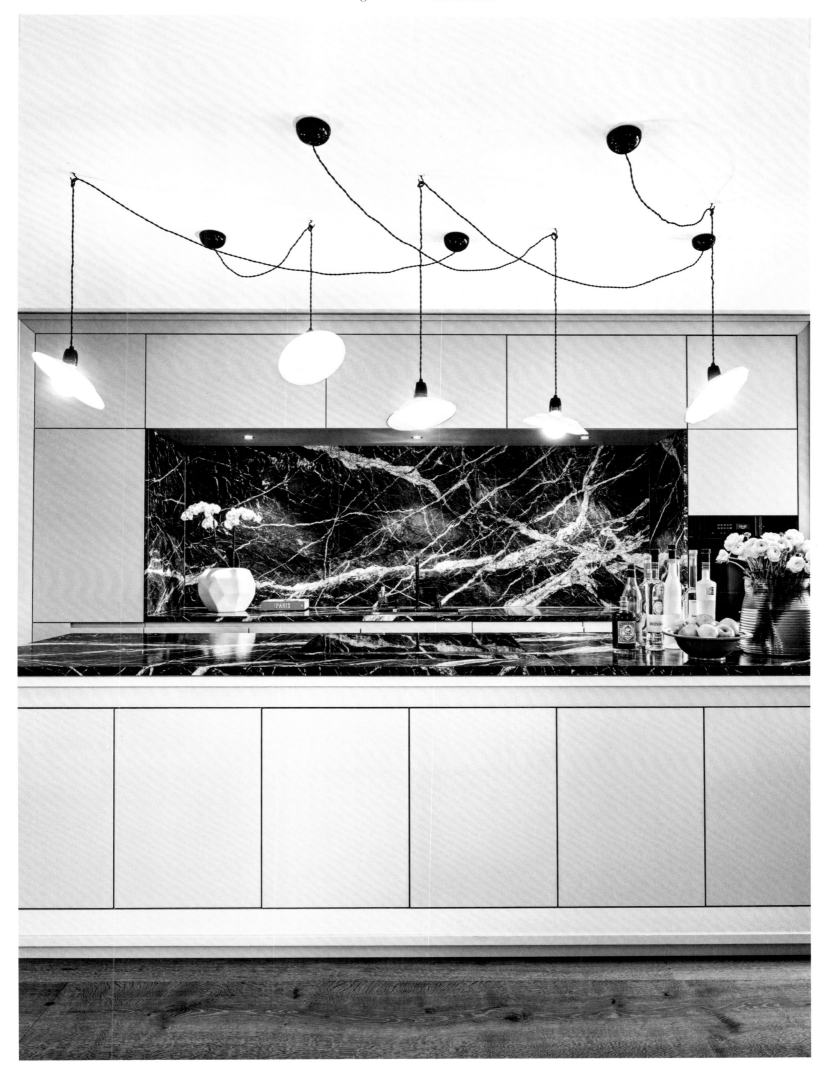

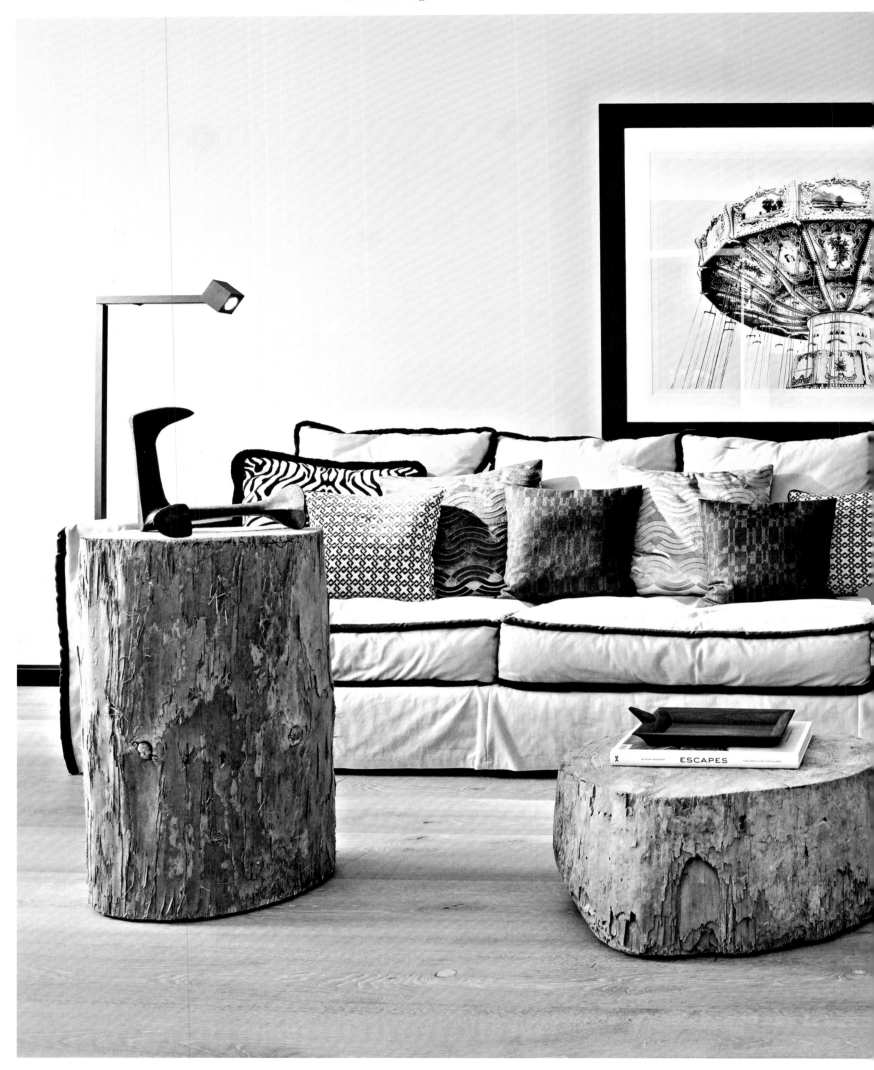

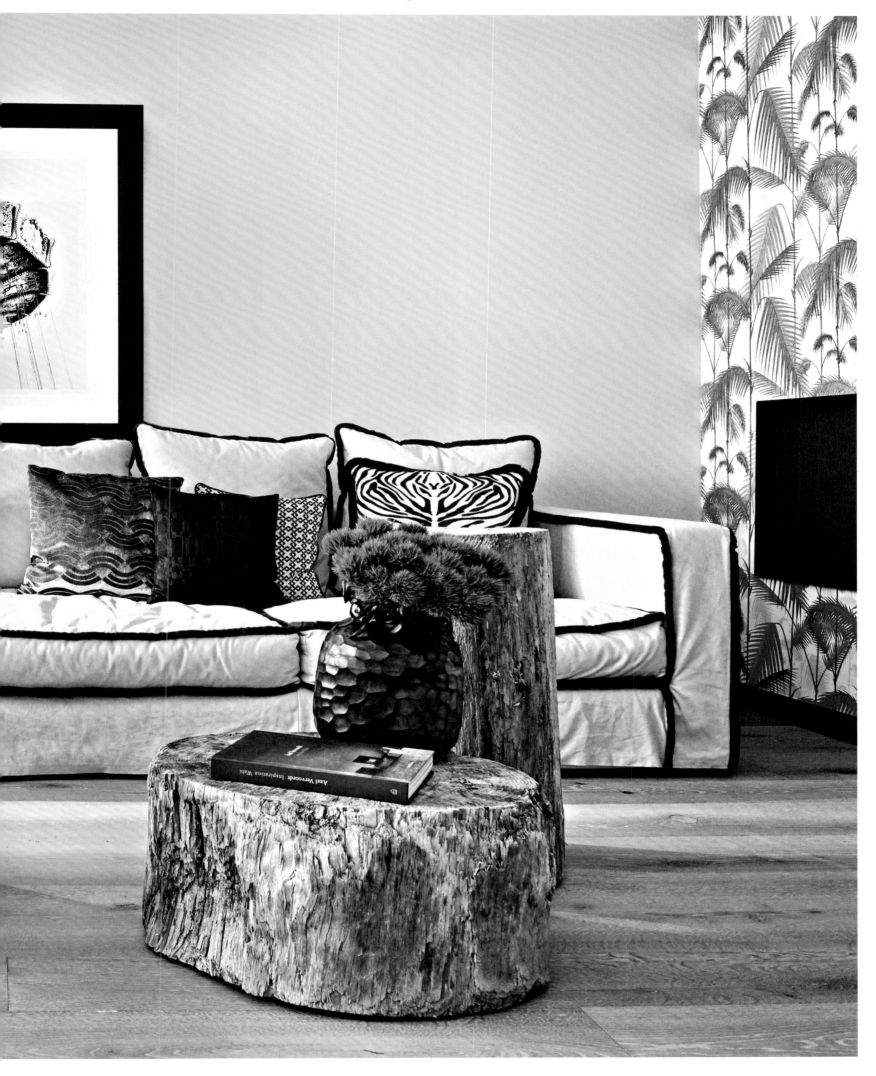

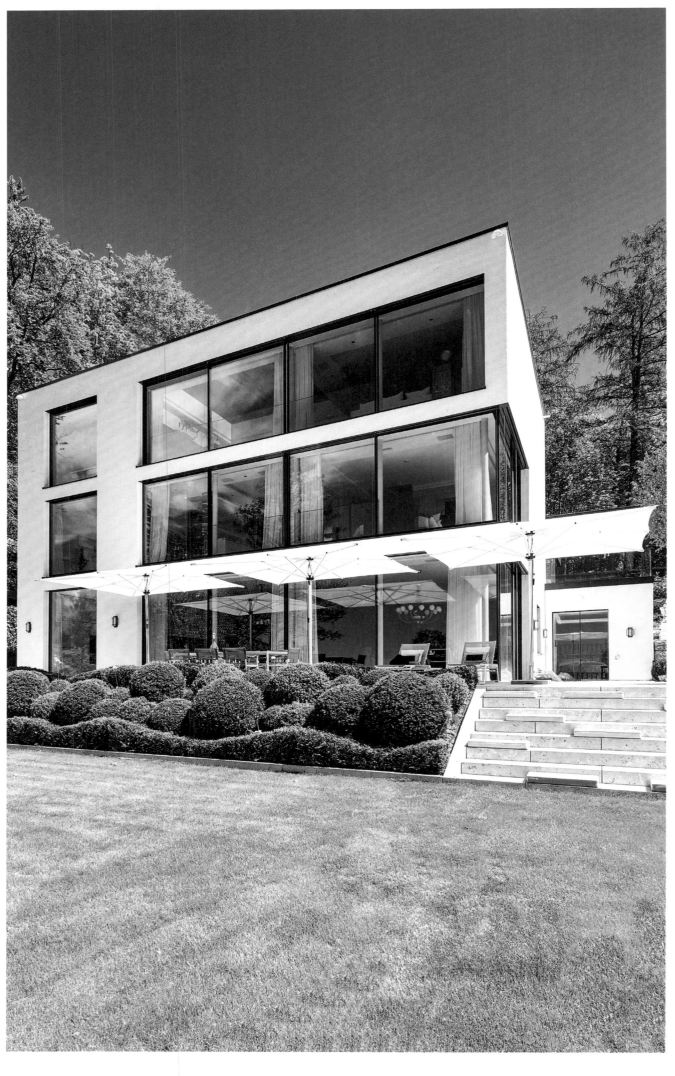

Architects Mang Mauritz designed a villa on the shores of a lake in Upper Bavaria, Germany so that all the rooms look out onto the lake. Sky-Frame sliding doors make the sky, water and interior appear to blend into one.

Bei einer Villa an einem oberbayerischen See richteten die Architekten Mang Mauritz alle Räume in Richtung See aus. Sky-Frame-Fenster lassen Himmel, Wasser und Interior optisch verschmelzen.

Dans une villa située au bord d'un lac de Haute-Bavière, les architectes Mang Mauritz ont orienté toutes les pièces en direction du lac. Des fenêtres sky frame permettent au ciel, à l'eau et à l'intérieur de fusionner visuellement.

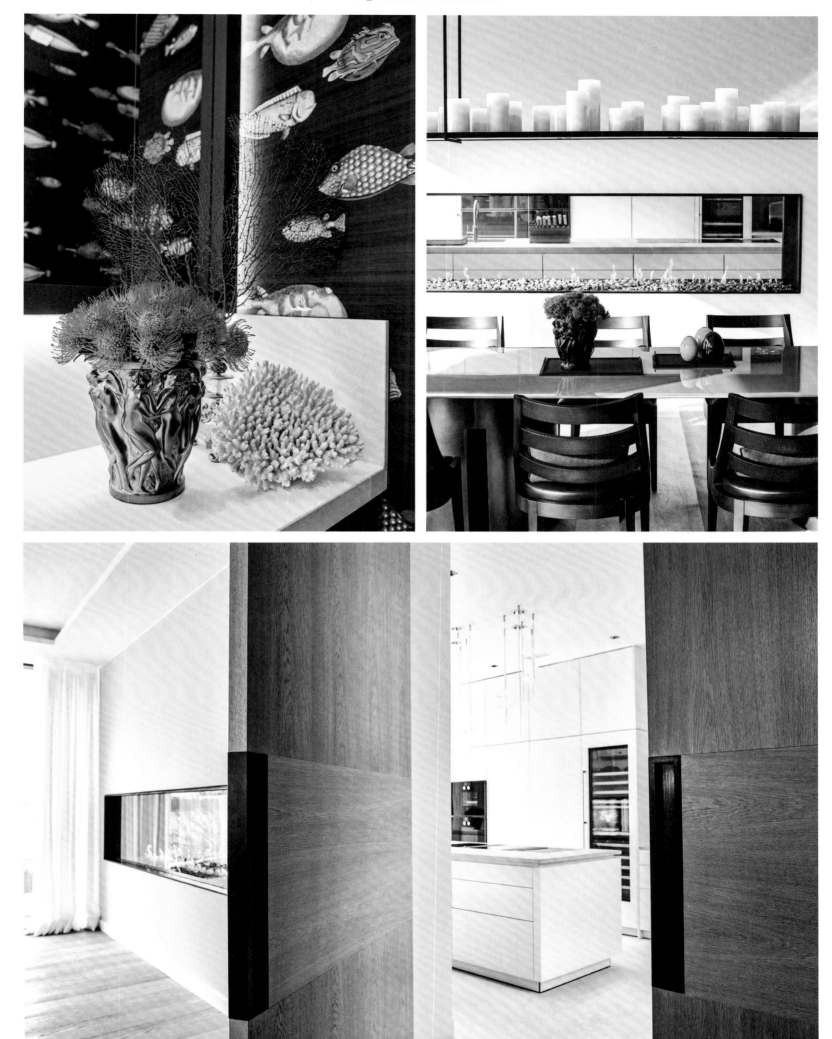

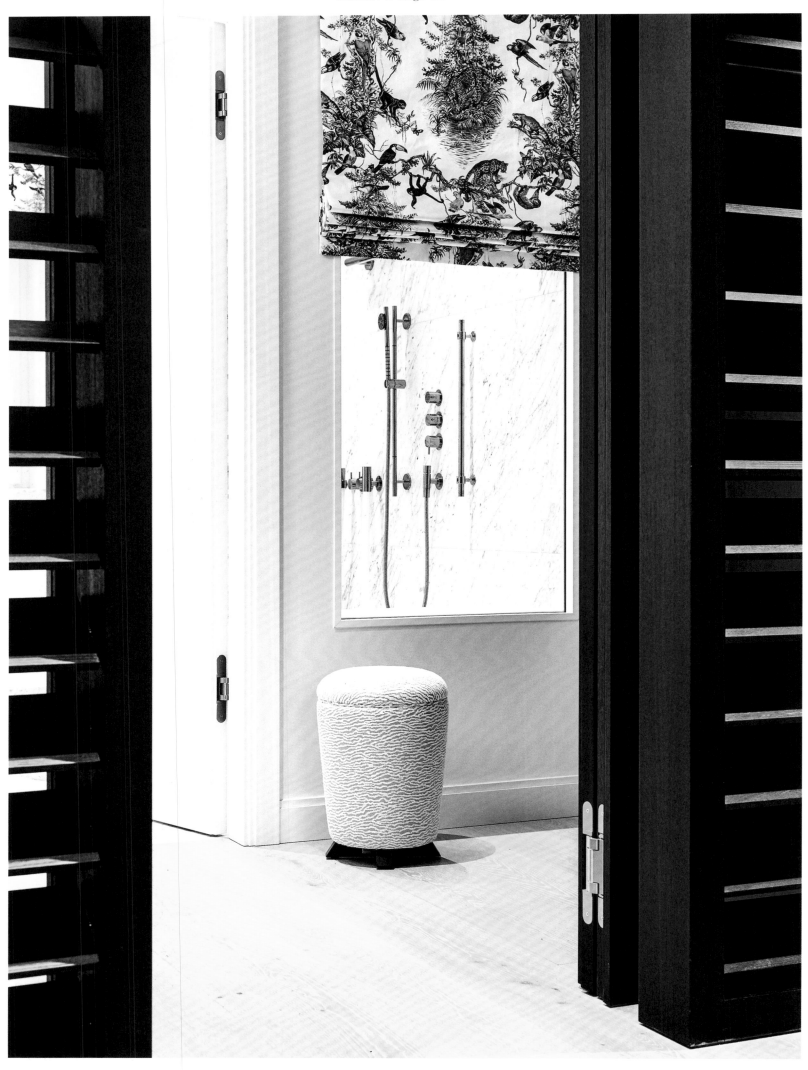

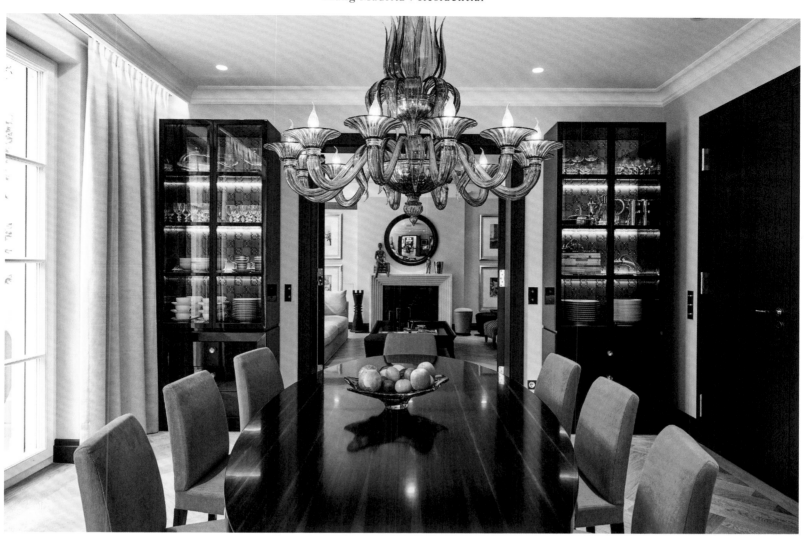

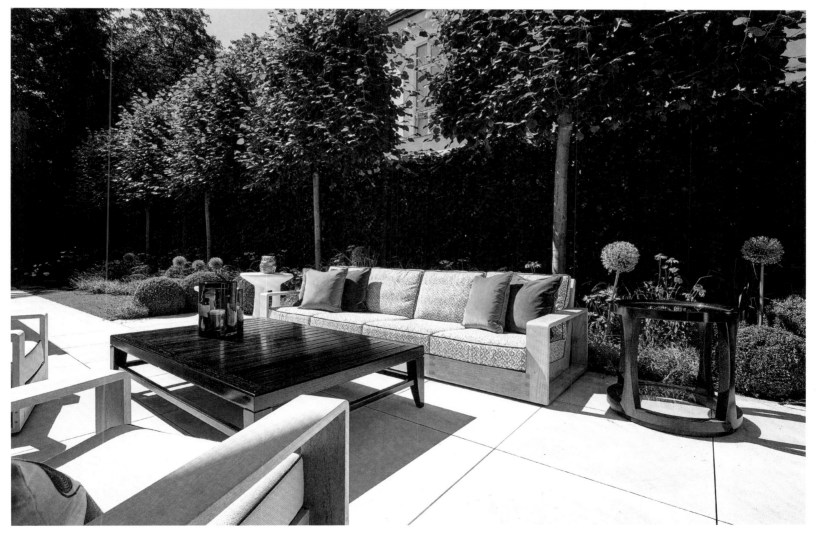

5 Questions for ...
MANG MAURITZ

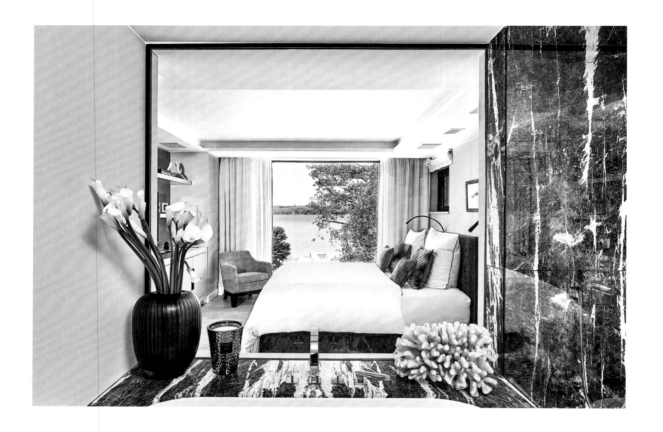

How would you describe your style and design aesthetic?

"Our style is holistic and defined by talking to our clients so that we can understand how their lives function. After that, our goal is to come up with smart planning that allows us to merge architecture and design concepts for perfect interiors from the get go."

"We are interested in the combination and composition of diverse, natural elements."

How much are you influenced by design trends? How do you select colors and textiles?

"We focus on coherence. On integration into the immediate environment, whether this is nature or the neighborhood's architecture, and our use of materials is based on this. Right now we are seeing that our clients want to experience their surroundings in a tactile way. They are asking us to include texture such as leather, wood, or textiles in our designs. We are interested in the combination and composition of diverse, natural elements."

Are there any specific manufacturers that you work with often?

"We have partnerships with companies such as Promemoria and Donghia, Hermès, Jim Thompson, and many others. We also cooperate with a Hong Kong-based expert for our light planning and have many pieces and design accessories custom-made by specialists."

An historic property or a new-build – which do you prefer to design?

"Utilizing and re-interpreting existing structures or having a clean slate for a design—both are attractive and both require the close collaboration of architecture and design."

How do you achieve that in practice?

"We have an ongoing dialog. We include our clients in the process. We are also becoming increasingly successful at convincing people that it doesn't make sense to buy an expensive piece of ready-built real estate and then have to remodel it to fit their needs. Instead, they should have a holistic philosophy from the outset."

Wie würden Sie Ihren Stil, Ihre Designästhetik beschreiben?

„Unser Stil ist ganzheitlich. Wir definieren ihn über die Gespräche, die wir mit unseren Kunden führen, um deren Tagesablauf zu verstehen. Dann geht es darum, klug zu planen und Architektur vom ersten Entwurf an mit den Ideen für das perfekte Interior Design zu verschmelzen."

Wie sehr beeinflussen Designtrends Ihre Arbeit? Wie wählen Sie Farben und Textilien?

„Es geht um Stimmigkeit. Um die Integration ins direkte Umfeld; sei es die Natur oder die Architektur in der Nachbarschaft, an der sich der Einsatz unserer Materialien orientiert. Derzeit beobachten wir, dass unsere Kunden ihren Lebensraum auf haptische Weise erfahren möchten, sie möchten Strukturen wie Leder, Holz oder Stofflichkeit erfassen. Uns interessiert die Kombination und Komposition verschiedener natürlicher Elemente."

Arbeiten Sie mit bestimmten Herstellern besonders häufig zusammen?

„Wir pflegen Partnerschaften mit Unternehmen wie Promemoria und Donghia, Hermès, Jim Thompson und vielen weiteren. Für die Lichtplanung kooperieren wir mit einem Experten aus Hongkong, außerdem lassen wir viele Stücke und Designaccessoires von Spezialisten einzelanfertigen."

Historisches Objekt oder Neubau: Was gestalten Sie lieber?

„Bestehende Strukturen zu nutzen und neu zu interpretieren oder einen Entwurf auf dem weißen Papier entstehen lassen: Beides hat seinen Reiz und bedarf einer engen Abstimmung zwischen Architektur und Design."

„Uns interessiert die Kombination und Komposition verschiedener, natürlicher Elemente."

Wie realisieren Sie das in der Praxis?

„Wir tauschen uns kontinuierlich aus. Beziehen unsere Kunden mit ein. Und überzeugen immer mehr Menschen davon, keine teuer erworbene, fertige Immobilie im Nachhinein auf persönliche Bedürfnisse anzupassen – sondern von Anfang an einer ganzheitlichen Philosophie zu folgen."

Comment décririez-vous votre style, votre esthétique d'aménagement ?

« Notre style est complet. Nous le définissons à travers les entretiens que nous avons avec nos clients afin de comprendre le déroulement de leurs journées. Ensuite, il s'agit de planifier intelligemment et de fusionner l'architecture dès la première ébauche avec les idées de l'interior design parfait. »

« Nous nous intéressons pour la combinaison et la composition de différents éléments naturels. »

À quel point les tendances de l'aménagement influencent-elles votre travail ? Comment choisissez-vous les couleurs et les textiles ?

« Tout est question d'harmonie. D'intégration dans l'environnement direct ; que ce soit la nature ou l'architecture voisine. Nous choisissons nos matériaux en fonction de lui. Actuellement, nous constatons que nos clients souhaitent découvrir leur espace de vie par le toucher, avec des structures comme le cuir, le bois ou les tissus. Nous nous intéressons pour la combinaison et la composition de différents éléments naturels ».

Travaillez-vous fréquemment avec certains fabricants ?

« Nous collaborons avec des entreprises comme Promemoria et Donghia, Hermès, Jim Thompson et bien d'autres. Pour l'éclairage, nous collaborons avec un expert de Hong Kong. De plus, nous faisons fabriquer individuellement par les spécialistes de nombreuses pièces et accessoires design. »

Bâtiment historique ou nouvelle construction :
Que préférez-vous aménager ?

« Utiliser les structures existantes et les réinterpréter ou faire naître une ébauche sur une feuille blanche : Les deux ont leur attrait et requièrent une collaboration étroite entre l'architecture et le design. »

Comment réalisez-vous cela en pratique ?

« Nous ne cessons d'échanger. Nous incluons nos clients. Et nous convainquons de plus en plus de personnes de ne pas adapter ultérieurement à ses besoins un bien immobilier prêt, acheté pour une somme importante – mais de suivre. une philosophie complète dès le départ. »

GWDESIGN
Los Angeles, United States

"We want to combine sophisticated materials and structures in a contemporary, multi-facetted way."
„Wir möchten raffinierte Materialien und Strukturen zeitgemäß und facettenreich zusammenbringen."
« Nous souhaitons assemblés de manière moderne et multi-facettes des matériaux et structures raffinés. »

How does it feel to sit by a pool with a view that takes in palms, downtown Los Angeles, and the Pacific all at the same time? Dominic Gasparoly and Khalid Watson of GWdesign provide a light-hearted answer to the question, "This West Hollywood gem boasts a view that is so good it would make even an "Angry Bird" mellow!" The villa, designed by architect Khalid Watson and furnished by his partner Dominic Gasparoly, is located on sought-after Sunset Plaza Drive in the hills above the city. Visitors entering the property, which is reminiscent of Le Corbusier, from its rear angular side feel as if they have been catapulted straight from the ground into the clouds. Floor-to-ceiling windows draw the eye out to the pool deck. GWdesign's concept for the over 500-square-meter (5,380-square-foot) living space is all about contrasts—white stone in the kitchen, natural light oak plank flooring, a black waxed steel frame showcasing the fireplace and TV area in the living room. Interior designer Dominic Gasparoly and architect Khalid Watson, who have been running their architectural practice in New York and Los Angeles for 15 years now, describe themselves as devotees of modernism—however, with intentional breaks in style and a sophisticated, surprising mix of materials. They enjoy planning projects that span the whole spectrum—architecture and interior design combined with their own furniture designs. With obvious success, as demonstrated by their "Best Furniture Collection Award" from New York's Guggenheim Museum. "Our objective is to create unique but sensual spatial experiences!"

Wie fühlt es sich an, am Pool zu sitzen mit Blick auf Palmen, Downtown Los Angeles und den Pazifik gleichermaßen? Dominic Gasparoly und Khalid Watson von GWdesign beantworten die Frage augenzwinkernd: „Dieses Juwel in West Hollywood prahlt mit einer Aussicht, dass selbst ein Angry Bird gute Laune bekäme!" Die Lage der Villa, die von dem Architekten Khalid Watson geplant und seinem Partner Dominic Gasparoly eingerichtet wurde, liegt am begehrten Sunset Plaza Drive in den Hügeln oberhalb Los Angeles. Betritt man das Anwesen, dessen Baustil an Le Corbusier erinnert, von seiner rückwärtigen kantigen Seite, fühlt man sich wie vom Erdboden direkt in die Wolken katapultiert. Bodentiefe Fenster schicken den Blick nach draußen zum Pooldeck. Auf über 500 Quadratmetern Wohnfläche setzt GWdesign

bewusst auf Kontraste: weißer Stein in der Küche, naturhelle Eichendielen am Boden, ein schwarz gewachster Stahlrahmen, der im Wohnzimmer Kamin und TV-Bereich rahmt. Interior Designer Dominic Gasparoly und Architekt Khalid Watson, die seit 15 Jahren in New York und Los Angeles ihr Architekturbüro betreiben, sehen sich dem Modernismus verschrieben – allerdings mit gewollten Brüchen und einer raffinierten und überraschenden Mischung an Materialien. Ihre Projekte planen sie am liebsten in der gesamten Bandbreite: Architektur, Interior Design, eigene Möbelentwürfe. Dafür haben sie den „Best Furniture Collection Award" vom New Yorker Guggenheim Museum erhalten: „Was wir wollen, sind einzigartige und zugleich sinnliche Raumerlebnisse schaffen!"

Qu'est-ce que cela fait d'être assis au bord de la piscine, la vue sur des palmiers avec Los Angeles et le Pacifique en contrebas ? Dominic Gasparoly et Khalid Watson de GWdesign ont répondu à la question avec un clin d'œil : « Ce joyau de West Hollywood frime avec une vue qui mettrait même un « Angry Bird » de bonne humeur ! » L'emplacement de la villa qui a été planifié par l'architecte Khalid Watson et a été aménagée par son partenaire Dominic Gasparoly est situé près du célèbre Sunset Plaza Drive sur les collines surplombant la ville. Lorsque l'on pénètre dans la propriété dont le style rappelle Le Corbusier par sa partie arrière rectangulaire, on a l'impression d'être catapulté du sol directement dans les nuages. Des fenêtres de plain-pied donnent vue directement sur la terrasse extérieure avec piscine. Sur plus de 500 m² de surface habitable, GWdesign mise volontairement sur les contrastes : de la pierre blanche dans la cuisine, des planchers en chêne clair naturel au sol, un cadre en acier ciré noir qui entoure dans le séjour la cheminée et l'espace télévision. L'*interior designer* Dominic Gasparoly et l'architecte Khalid Watson qui possèdent un cabinet d'architectes depuis 15 ans à New York et Los Angeles se vouent au modernisme – toutefois avec des ruptures volontaires et un mélange raffiné et surprenant des matières. Ils aiment planifier leurs projets en intégralité : Architecture et décoration d'intérieur alliées à la conception de meubles. Pour cela, ils ont reçu le prix « Best Furniture Collection Award » du Musée Guggenheim de New York : « Nous voulons créer des espaces uniques et sensuels à la fois ! »

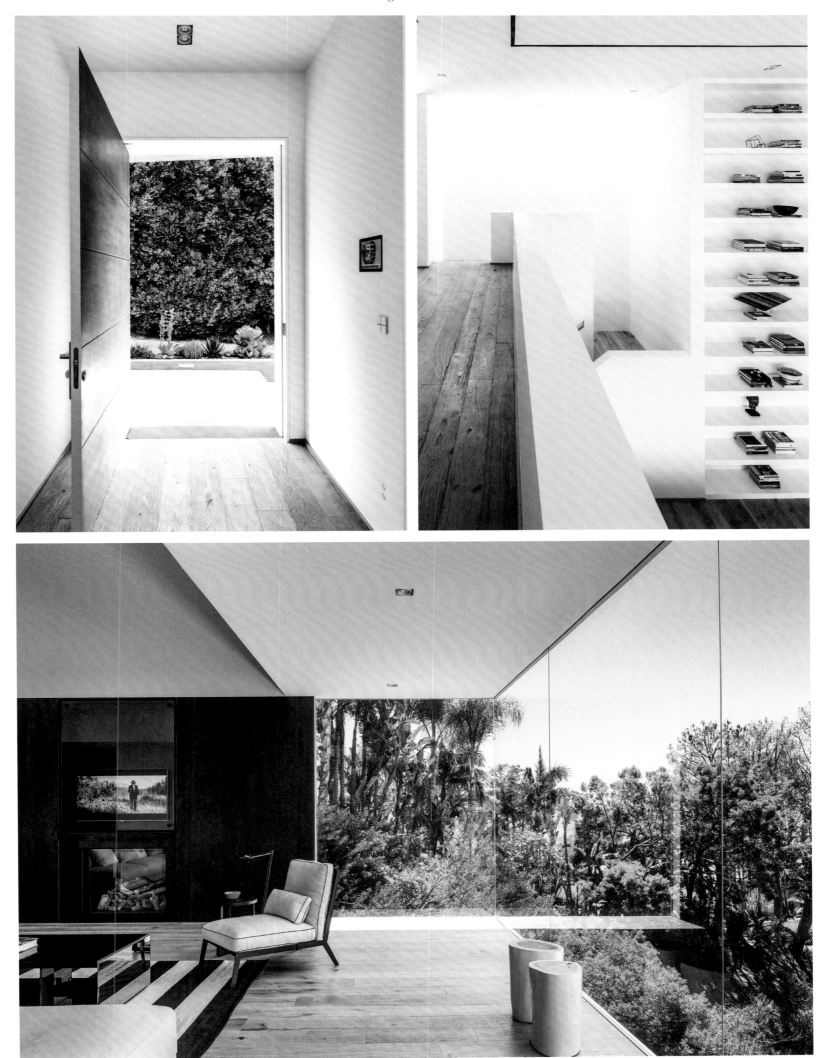

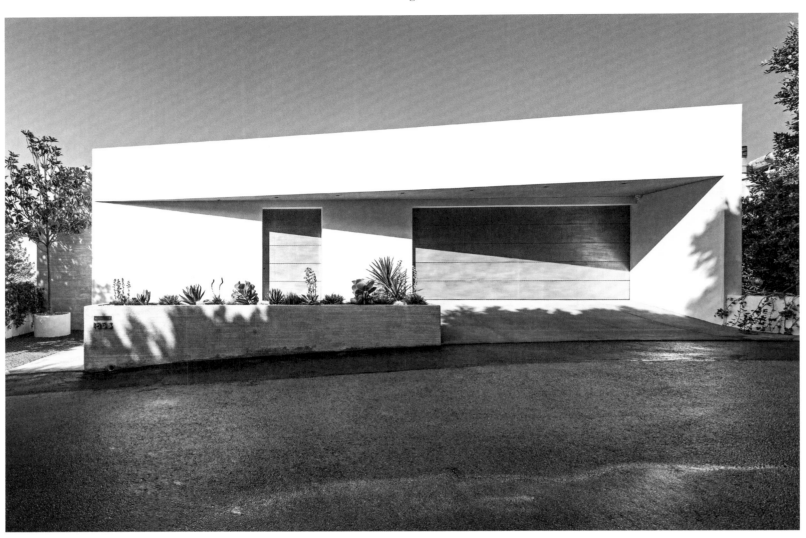

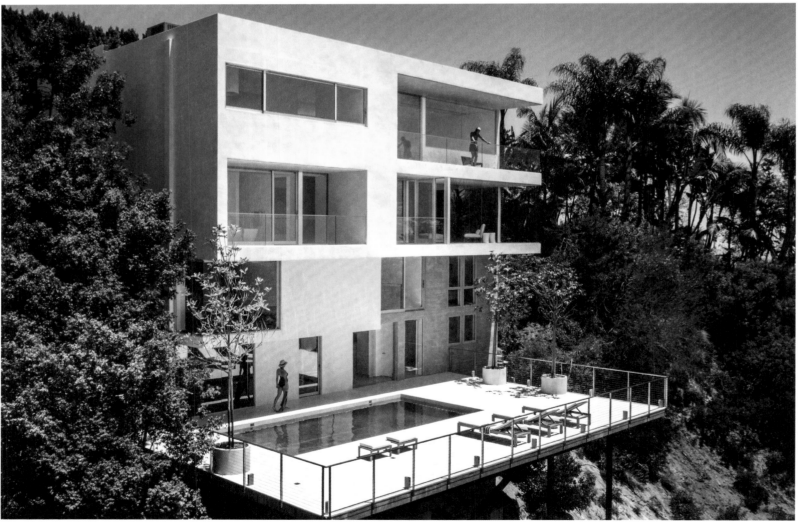

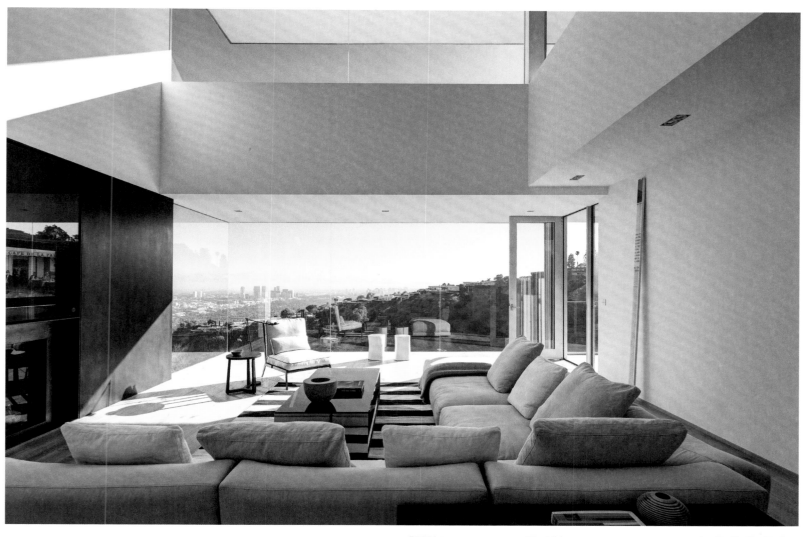

Three levels with spectacular views of Los Angeles and Malibu—the façade references Mondrian, the pared-back architecture Le Corbusier.

Drei Ebenen mit spektakulärem Ausblick auf Los Angeles und Malibu: Die Fensterfronten erinnern an Mondrian, der reduzierte Baustil an Le Corbusier.

Trois niveaux avec une vue spectaculaire sur Los Angeles et Malibu : Les faces des fenêtres rappellent Mondrian, le style architecture minimaliste Le Corbusier.

ULRIKE KRAGES
Hamburg, Germany

"For me, beauty, poetry, and aesthetics are integral to a healthy environment."
„Schöngeist, Poesie und Ästhetik bilden für mich eine gesunde Umgebung."
« Culture, poésie et esthétique forment pour moi un environnement sain. »

Ulrike Krages founded an architectural planning office in 2001. Today it has become five companies, each in a different business segment. The Urban Comfort group develops holistic architectural and interior design projects, designs its own products with licensing partners, and is a passionate promoter of "healthy" living. Ulrike Krage's activities are so wide-ranging that calling her a multi-talent seems inadequate. The native of Germany's East Frisia region is also surprisingly down-to-earth. Even now, her concept of living is still influenced by the tranquility and nature of her childhood, forming the basis for her all-embracing creativity. The designer's work focuses on the holistic approach and, together with her team of architects, designers, psychologists, and lighting designers, she

develops unusual and unconventional ideas. Ulrike Krages believes that a room requires a "warm belly" and must engage with its surroundings. Urban Comfort's kitchens demonstrate just how detailed its planning is. Transparent tableware cabinets can be moved around, functioning as room dividers. And since Ulrike Krages is always forward-thinking, a further product has recently been added to the range. Pieces of sea glass, found when walking on the shore, were the inspiration for a new collection of wallcoverings.

2001 startete Ulrike Krages mit einem Planungsbüro für Architektur. Mittlerweile hat sich daraus eine Firmengruppe mit fünf einzelnen Geschäftsbereichen entwickelt. Mit Urban Comfort entwickelt sie ganzheitliche Architektur- und Wohnprojekte, designt hauseigene Produkte mit Lizenzpartnern und engagiert sich mit Leidenschaft für „gesundes" Wohnen. Ulrike Krages Aufgabenspektrum umfasst derart viele Bereiche, dass die Bezeichnung Multitalent fast untertrieben klingt. Dabei ist die gebürtige Ostfriesin erstaunlich bodenständig. Die Stille und Natur ihrer Kindheit prägten nachhaltig ihr Lebenskonzept und bilden bis heute die Basis für ihre umfassende Kreativität. Bei ihrer Arbeit steht für die Designerin stets der gesamtheitliche Ansatz im Vordergrund. Mit ihrem Team, das aus Architekten, Designern,

Psychologen und Lichtplanern besteht, entwickelt sie ungewöhnliche und unkonventionelle Ideen. Ein Raum, sagt sie, verlange nach einem „warmen Bauch" und dem Gespür für seine Umgebung. Wie sehr die Planung von Urban Comfort ins Detail geht, sieht man ihren Küchen an. Transparente Geschirrvitrinen lassen sich verschieben und werden zum Raumteiler. Und weil Ulrike Krages stets nach vorne denkt, ist kürzlich ein weiteres Produkt hinzugekommen. Bei einem Strandspaziergang fand sie vom Meer geschliffene Glassteine und entwickelte daraus eine eigene Wandbelagskollektion.

Ulrike Krages a lancé son bureau d'études pour l'architecture en 2001. Il est devenu depuis un groupe d'entreprises avec cinq divisions commerciales différentes. Avec Urban Comfort, elle développe des projets complets d'architecture et de logements, elle dessine ses propres produits avec des partenaires sous licence et s'engage avec passion en faveur d'un « habitat sain ». L'éventail de tâches d'Ulrike Krages comprend tellement de domaines que le terme de multitalents semble être un euphémisme. Étonnamment, cette native de Frise orientale a cependant gardé les pieds sur terre. Le calme et la nature de son enfance ont marqué durablement son concept de vie et sont aujourd'hui encore à la base de sa créativité. Dans son travail, la designer accorde la priorité à une approche complète. Avec son équipé composée d'architectes, de designers, de psychologues et de planificateurs d'éclairage, elle développe des idées inhabituelles et non conventionnelles. Selon elle, un espace requiert un « noyau chaud » et une harmonie avec son environnement ambiant. On peut voir dans ses cuisines à quel point la planification d'Urban Comfort concerne les moindres détails. Des vaisseliers transparents peuvent être glissés pour devenir des séparateurs d'espace. De plus, comme Ulrike Krages ne cesse de penser plus loin, elle a aouté un nouveau produit récemment à sa gamme. Lors d'une promenade sur la plage, elle a trouvé des briques de verre polies par la mer et en a fait sa propre collection de revêtements muraux.

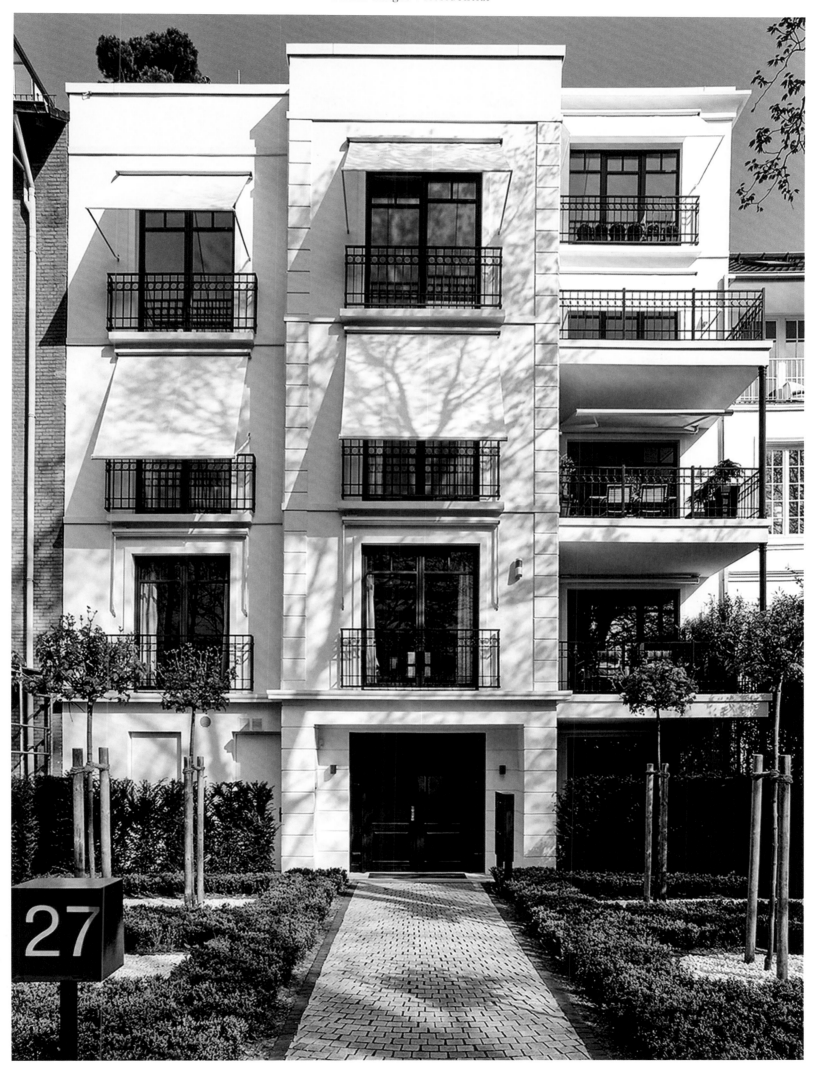

The Urban Comfort group comprises five companies. UK² Urban Architecture realizes new buildings and further developments such as these town houses in Hamburg, Germany, built in the classical style.

Die Urban Comfort Unternehmensgruppe besteht aus fünf Geschäftsbereichen: UK² Urban Architecture realisiert Neu- und Ausbauten wie dieses Hamburger Stadthausensemble im klassischen Stil.

Le groupe d'entreprise Urban Comfort comprend cinq divisions commerciales : UK² Urban Architecture réalise des bâtiments nouveaux et des agrandissements, comme ici, le Stadthausensemble de Hambourg dans un style classique.

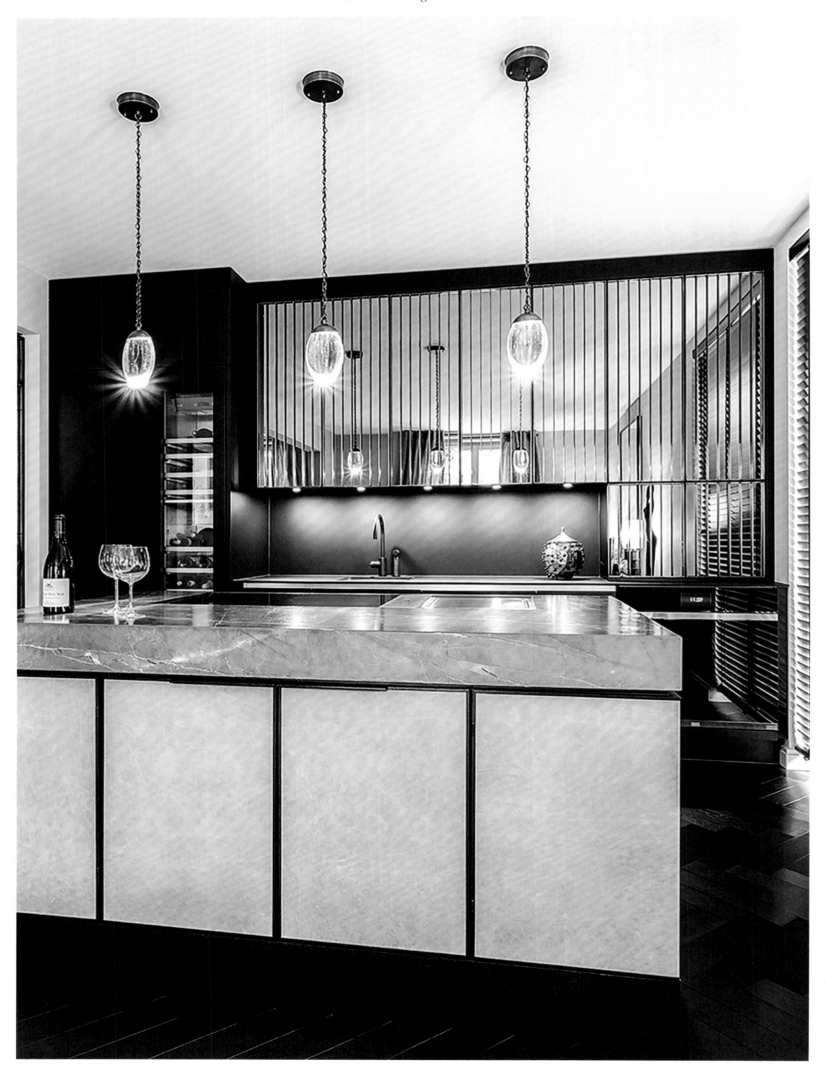

UK⁴ Urban Kitchen plans kitchens that are simultaneously carefully crafted and sensuous. In an apartment in an old building (below) the central block's fronts mirror the flames from the fireplace opposite.

UK⁴ Urban Kitchen plant Küchen, die handwerklich ausgefeilt und gleichzeitig sinnlich sind. In einem Altbau (unten) spiegeln die Fronten am Mittelblock das Feuer im Kamin gegenüber.

UK⁴ Urban Kitchen planifie des cuisines à l'artisanat travaillé et sensuelles à la fois. Dans un bâtiment ancien (en bas), les faces de l'îlot médian reflètent le feu dans la cheminée.

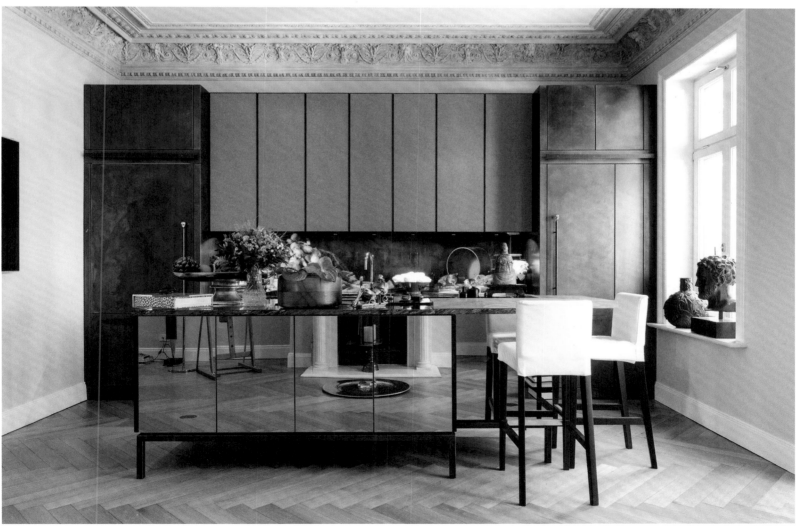

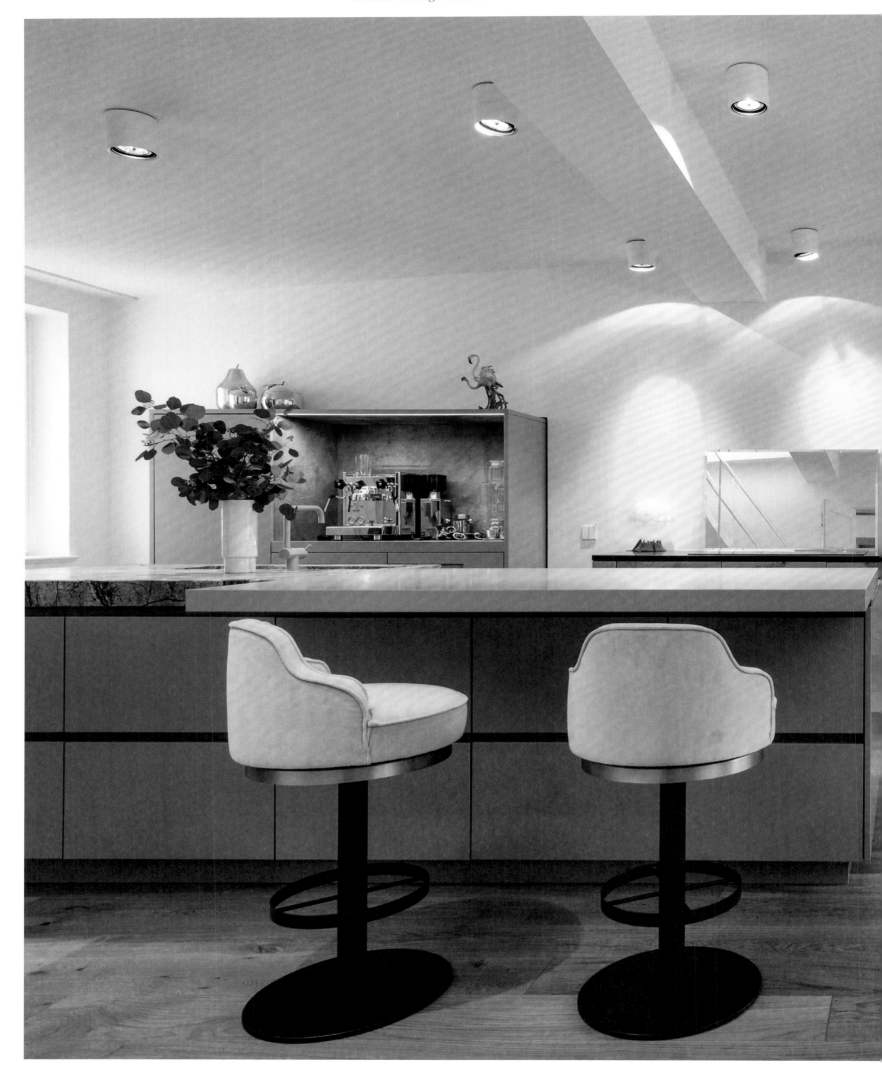

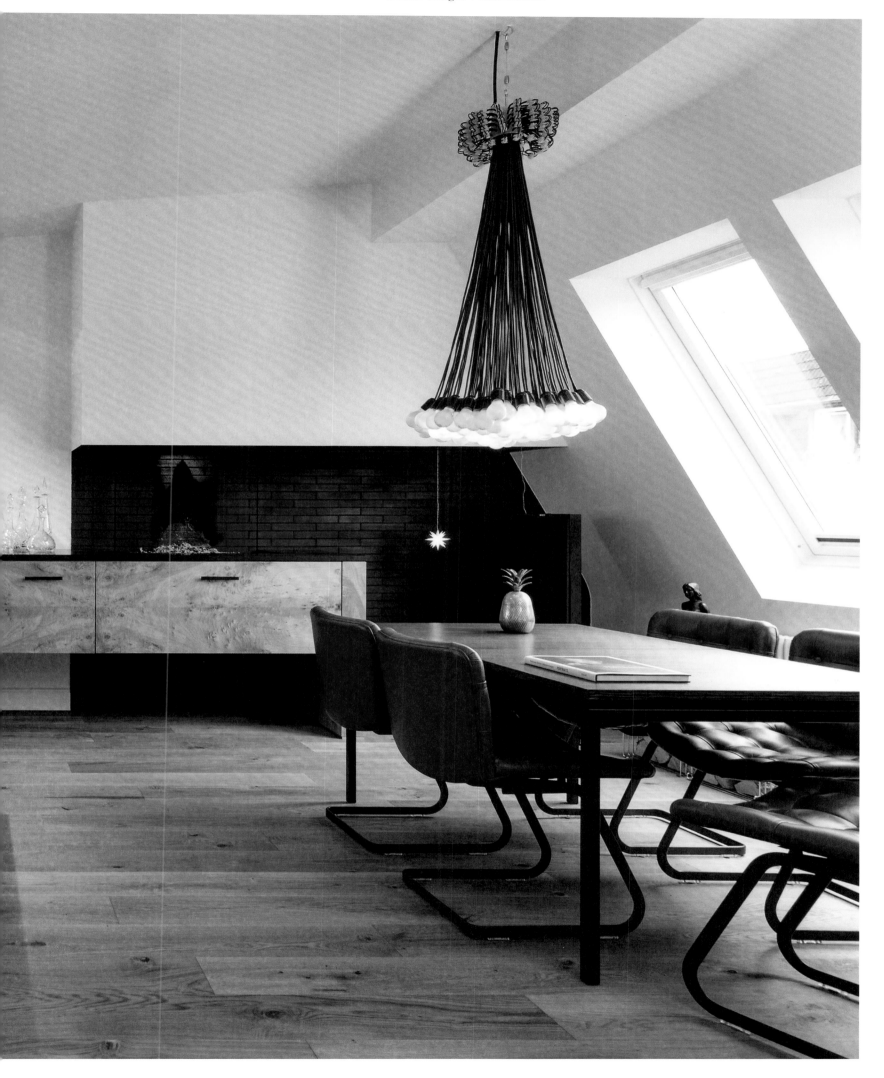

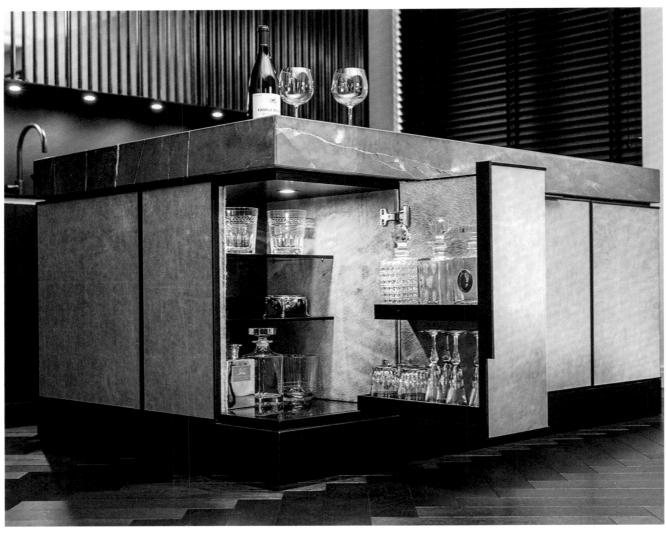

Ulrike Krages develops interior design concepts for clients; her style is a mix of cozy, contemporary, antique, and colorful. She says "My goal is to combine pieces that don't seem to match when you first see them."

Ulrike Krages entwickelt Wohnkonzepte für andere, sie selbst liebt die Mischung aus behaglich, modern, antik und bunt: „Was auf den ersten Blick nicht passend scheint, möchte ich miteinander verbinden."

Ulrike Krages développe des concepts de logements pour les autres, elle aime le mélange de confort, modernité, antiquité et couleurs : « J'aime combiner ce qui semble ne pas aller ensemble au premier regard. »

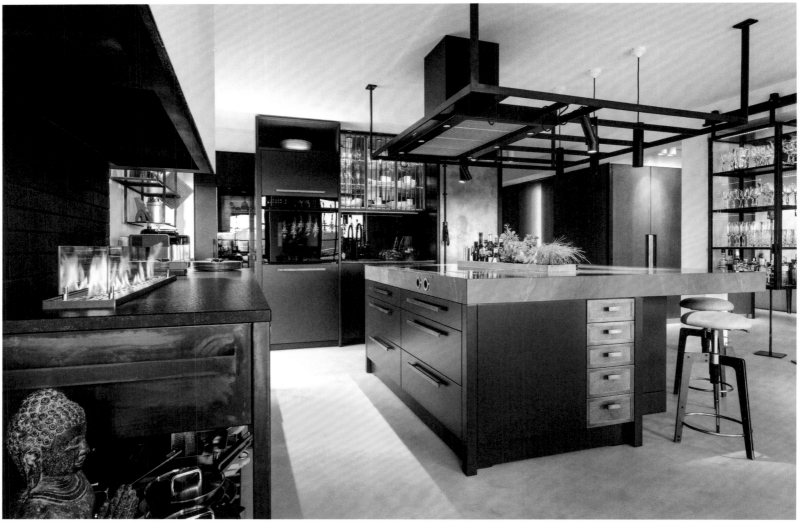

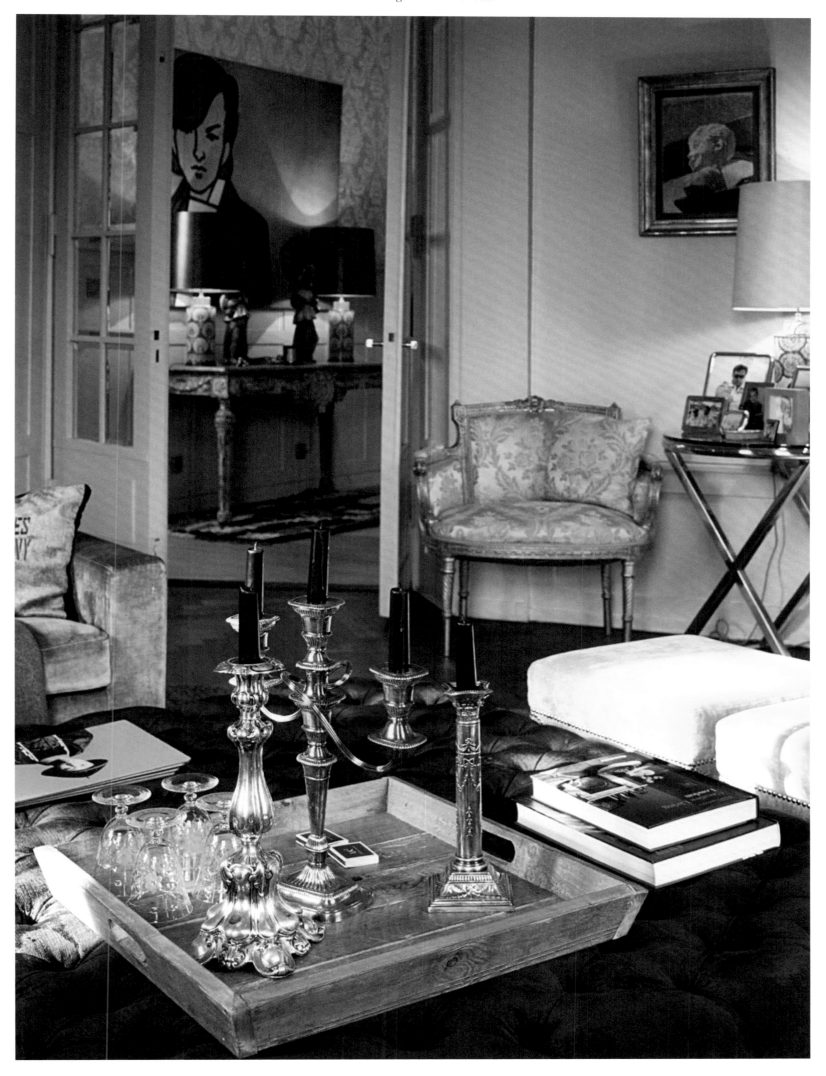

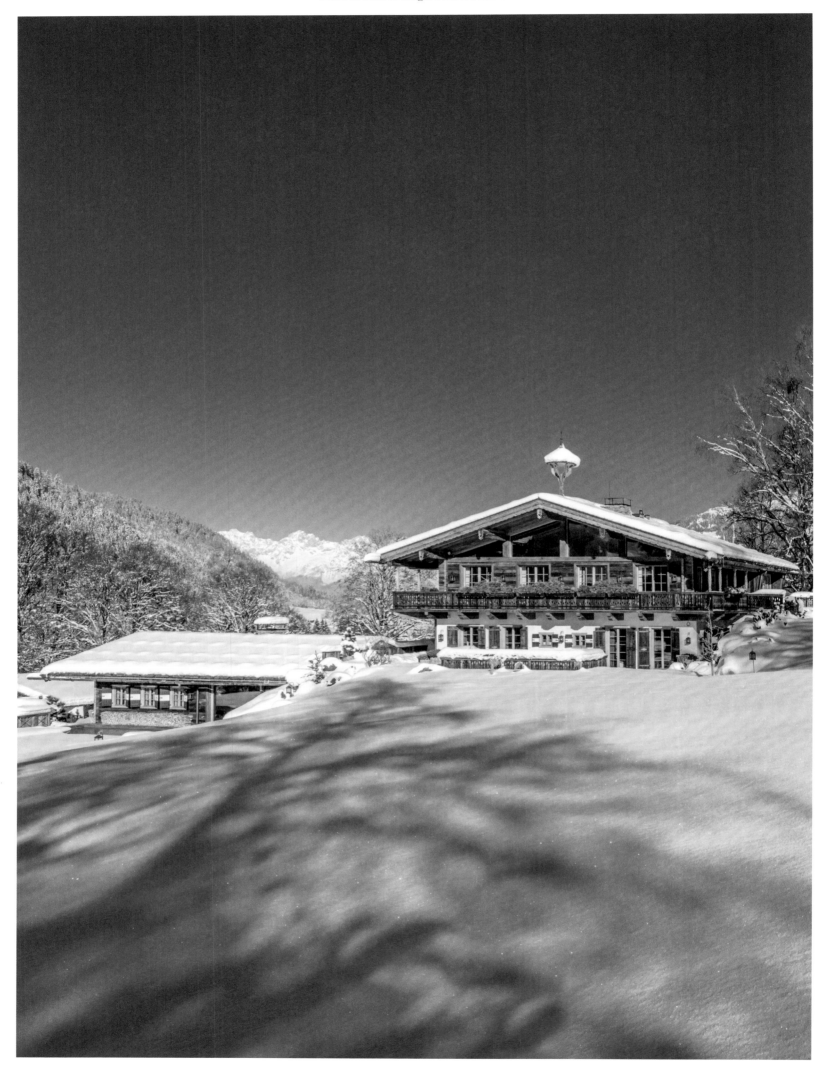

HILD HOME DESIGN
Vienna, Austria

"Our luxurious single-family houses should be spacious but still cozy."
„Unsere luxuriösen Einfamilienhäuser sollen trotz Großzügigkeit behaglich sein."
« Nos maisons individuelles luxueuses doivent être confortables malgré leurs dimensions généreuses. »

Early in the morning when the first rays of sun paint the craggy peaks of the Kaiser Mountains in Tyrol dark pink and make the old beams at Chalet Raya creak, despite the winter temperatures your first impulse is to walk barefoot across the wooden floor. Underfloor heating throughout the property means that you can, while still enjoying the real fires. What at first glance appears to be a renovated historic property, is, in reality, a luxury home newly constructed using centuries-old wood from disused farm buildings. Hild Home Design came up with the successful concept 15 years ago and builds homes in Vienna, on Lake Wörther; and on the island of Capri. The chalets near Kitzbühel look as if they have always been there, however, offer the comfort of modern luxury hotels, with indoor pools; comfortable English boxspring beds; hand-carved balcony railings; gyms; and guest suites. Inside they feel like supersized mountain chalets. Hild Home Design has furnished almost 1,000 square meters (10,763 square feet) of living space. The walls are painted in earthy colors or covered with traditional

loden fabric; the closets in the dressing room are upholstered with soft buckskin. The wooden floors are covered with handwoven rugs from India, while the light fittings were sourced from Porta Romana, a factory near London, England. Outside, the visitor can enjoy the 7,000-square-meter (75,347-square-foot) plot with a garden that looks out to the Wilder Kaiser mountain and provides a dramatic natural spectacle in the evenings.

Früh morgens, wenn die ersten Sonnenstrahlen die zackigen Gipfel des Tiroler Kaisergebirges dunkelrosa malen und die alten Holzbalken des Chalets Raya zum Knacken bringen, möchte man trotz winterlicher Temperaturen auf den Dielen barfuß laufen. Das kann man auch, denn trotz Kamine wurde überall Fußbodenheizung verlegt. Was auf den ersten Blick wie restauriert aussieht, ist in Wahrheit ein Luxusanwesen, neu errichtet aus jahrhundertealten Hölzern abgetragener Bauernhöfe. Hild Home Design hat sich das erfolgreiche Konzept vor 15 Jahren ausgedacht und baut Anwesen am Wörthersee und auf Capri mit Blick aufs Wasser. Die Chalets bei Kitzbühel sehen aus, als hätten sie immer hier gestanden und bieten dennoch den Komfort moderner Luxushotels: mit Indoor-Pools, komfortablen Boxspringbetten

aus England, handgeschnitzten Balkongeländern, Fitnessräumen und extra Apartments für Gäste. Innen fühlt man sich wie in einer überdimensionalen Berghütte. Fast 1.000 Quadratmeter Wohnfläche wurden von Hild Home Design gestaltet: die Wände mit erdigen Farben gestrichen oder mit Loden bespannt, die Schränke im Ankleidezimmer mit weichem Hirschleder bezogen. Auf den Dielen finden sich handgewebte Teppiche aus Indien, die Leuchten kommen von Porta Romana, einer Manufaktur südlich von London. Draußen schwingt der Blick über das 7.000 Quadratmeter große Grundstück und den angelegten Garten zum Wilden Kaiser hinüber. Dort vollzieht sich auch abends ein spektakuläres Naturschauspiel.

Au petit matin, lorsque les premiers rayons du soleil colorent en rose foncé les cimes déchiquetées du massif de l'Empereur au Tyrol et font craquer les vieilles poutres en bois du chalet Raya, on aimerait marcher pieds nus sur le plancher malgré les températures hivernales. Cela est possible, en effet, un chauffage par le sol a été posé partout en plus de la cheminée. Ce qui semble restauré au premier regard est en réalité un complexe de luxe, construit à partir des bois centenaires de fermes désaffectées. Hild Home Design a mis au point ce concept à succès il y a quinze ans et construit des complexes à Vienne, au Wörthersee et à Capri. Les chalets près de Kitzbühel semblent avoir toujours été présents et offrent néanmoins le confort des hôtels modernes de luxe : des piscines intérieures, des lits Boxspring confortables d'Angleterre, des balustrades de balcon sculptées à la main, des salles de sport et des appartements supplémentaires pour les invités. À l'intérieur, on a l'impression d'être dans un chalet de montagne surdimensionné. Près de 1000 mètres carrés de surface habitable ont été aménagés par Hild Home Design : les murs ont été peints avec des couleurs terreuses ou recouverts de tissu Loden, les armoires sont revêtues de peau de daim souple dans le dressing. Sur les parquets, on trouve des tapis tissés à la main venus d'Inde, les lampes viennent de Porta Romana, une manufacture au sud de Londres. À l'extérieur, on peut admirer le terrain de 7000 m² et le jardin attenant au Wilder Kaiser. Le soir également, on peut assister au spectacle grandiose de la nature.

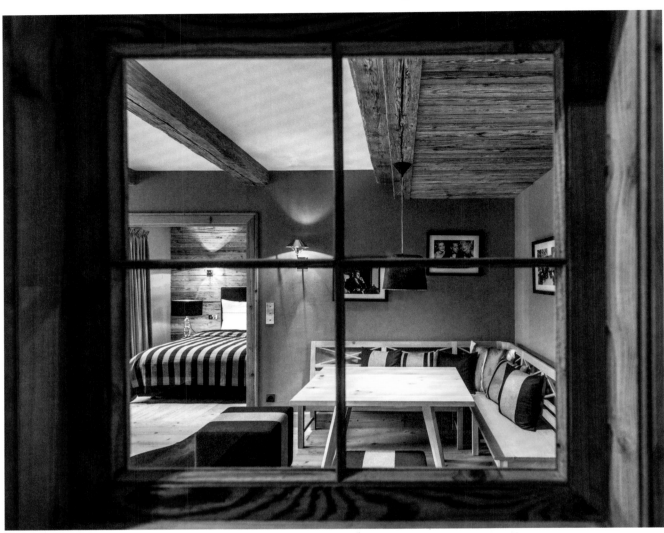

Loden fabric from Tyrol and buckskin have been used at Chalet Raya in Jochberg. The indoor pool with hydro-flow system overlooks the heated outdoor pool and, in winter, snow-covered pine trees.

Im Chalet Raya in Jochberg wurden Lodenstoffe aus Tirol und Hirschleder verarbeitet. Vom Indoor-Pool mit Gegenstromanlage blickt man im Winter auf den beheizten Außenpool und schneebedeckte Tannen.

Dans le chalet Raya à Jochberg, des tissus Loden du Tyrol et de la peau de daim ont été travaillés. Depuis la piscine intérieure avec installation à contre-courant, on peut admirer l'hiver la piscine extérieure chauffée et les sapins enneigés.

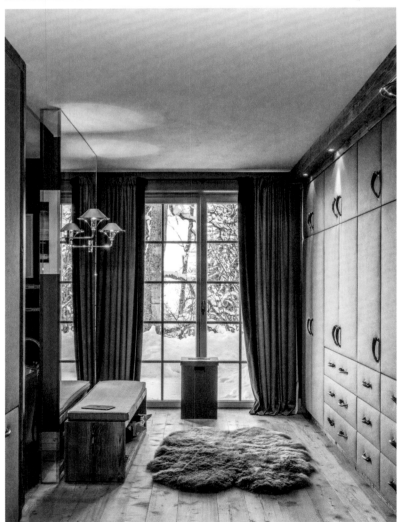

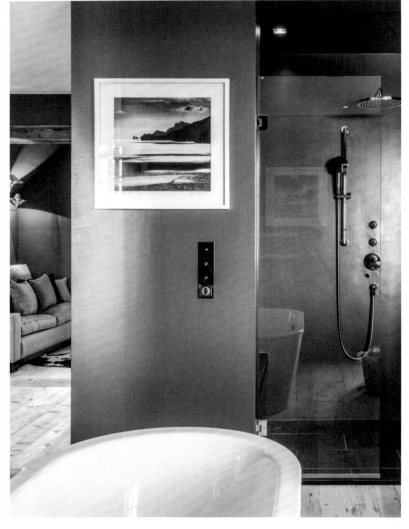

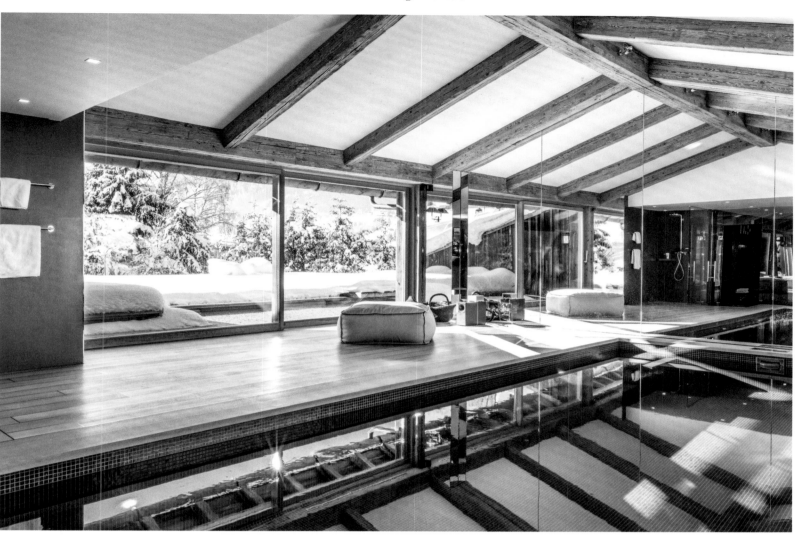

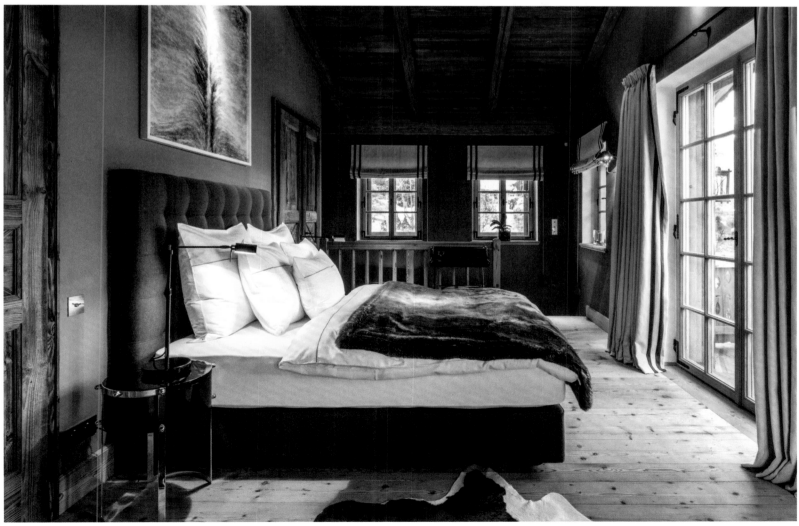

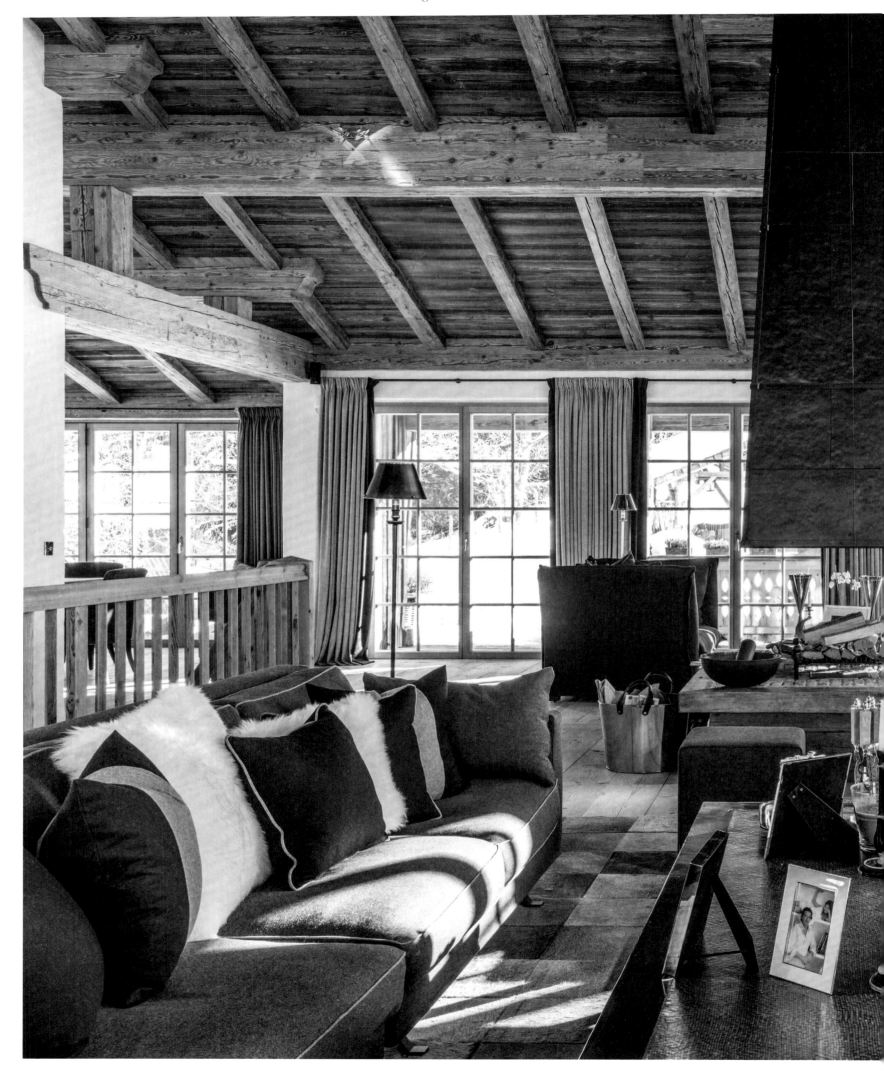

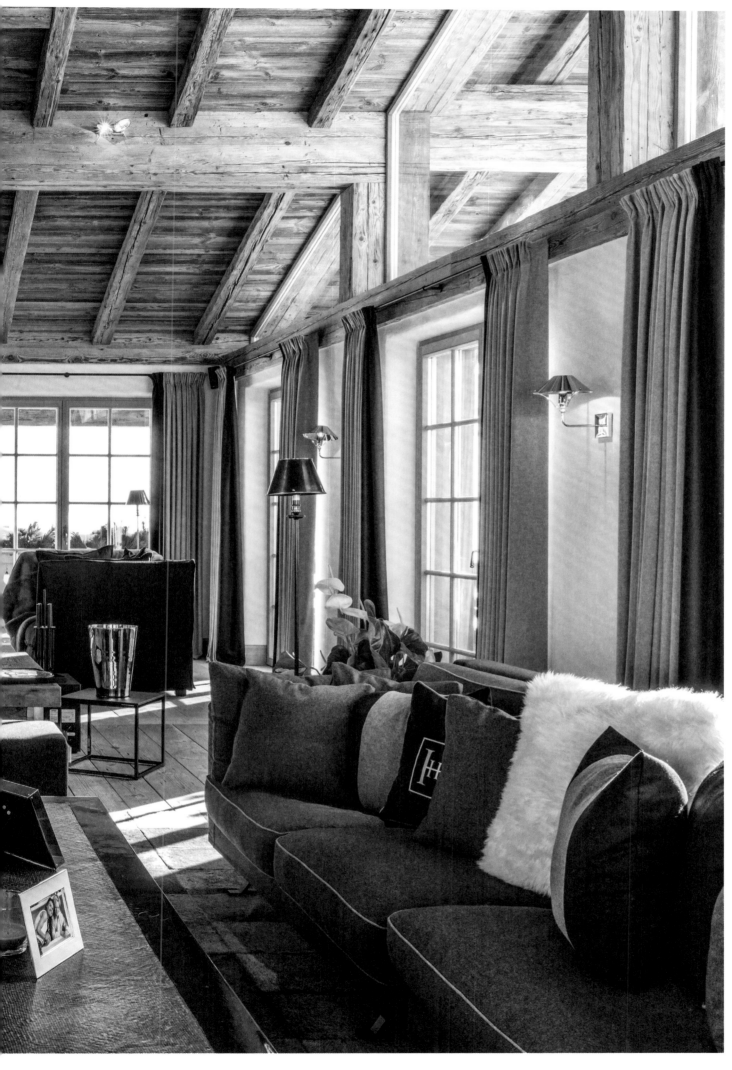

In the cozy living
room with exposed roof
beams, the open fireplace
dominates, ensuring a
romantic Alpine feel. It
leads to the dining room,
library, and spacious
kitchen-diner.

**Im behaglichen Wohn-
zimmer** mit Sicht-
dachstuhl dominiert eine
offene Feuerstelle und
sorgt für Hüttenroman-
tik. Daran angrenzend:
Speisezimmer, Bibliothek
sowie die großzügige
Wohnküche.

Dans le salon confortable
avec toit panoramique,
un foyer ouvert domine et
recrée l'ambiance roman-
tique des chalets. Juste
à côté : salle à manger,
bibliothèque et la grande
cuisine américaine.

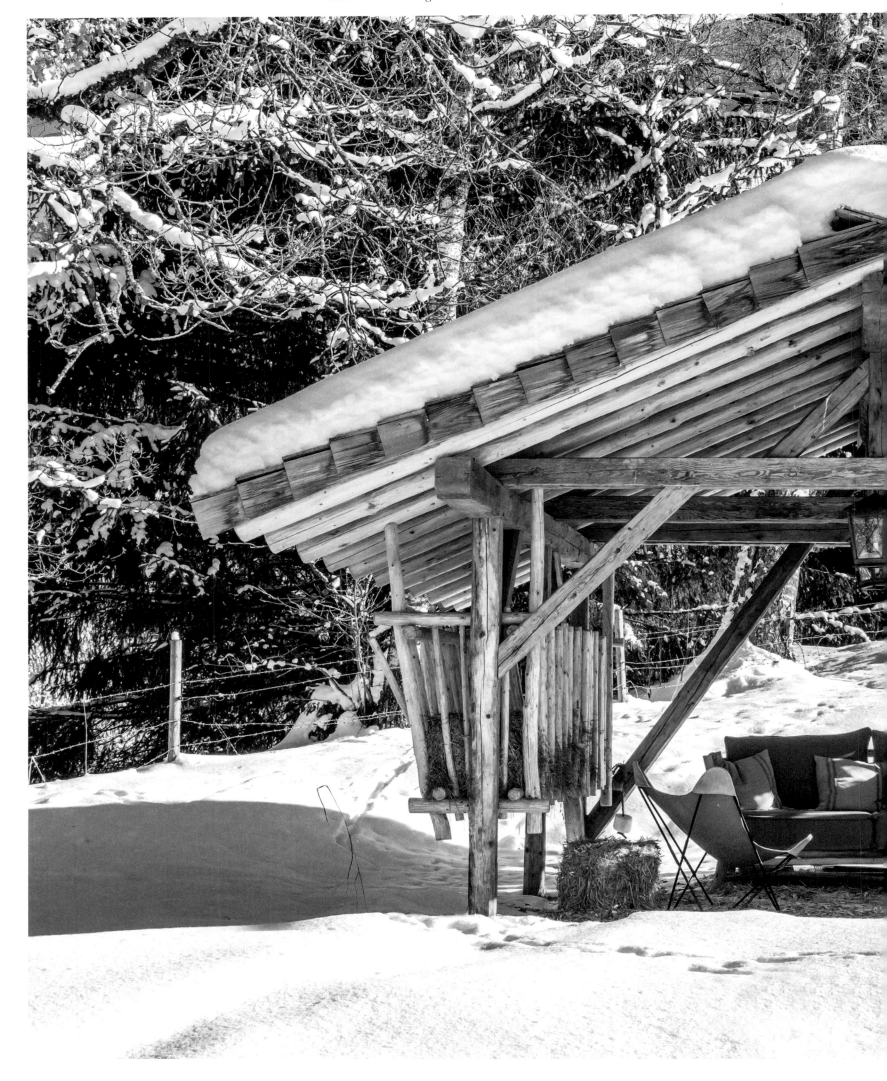

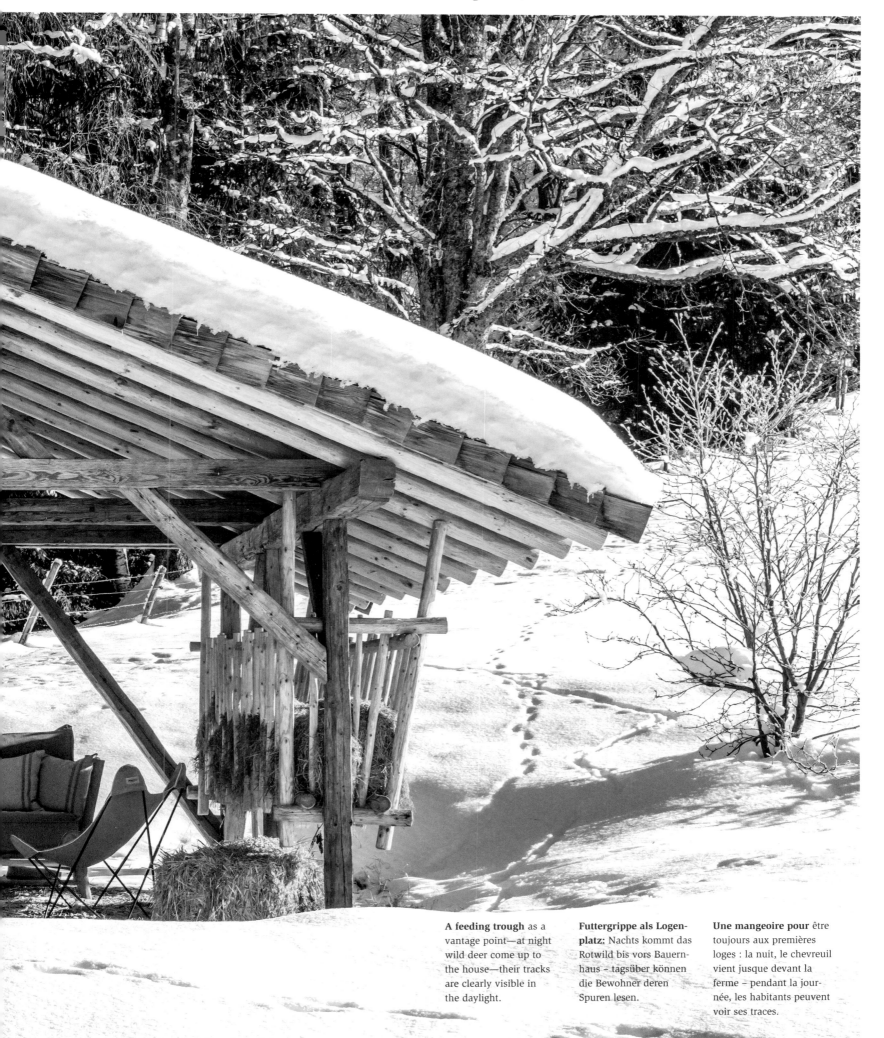

A feeding trough as a vantage point—at night wild deer come up to the house—their tracks are clearly visible in the daylight.

Futtergrippe als Logenplatz: Nachts kommt das Rotwild bis vors Bauernhaus – tagsüber können die Bewohner deren Spuren lesen.

Une mangeoire pour être toujours aux premières loges : la nuit, le chevreuil vient jusque devant la ferme – pendant la journée, les habitants peuvent voir ses traces.

FRESO HOME
Munich, Germany

"Fabrics are my absolute passion. I know which ones will be appropriate at the very first encounter."
„Stoffe sind meine absolute Passion. Schon beim ersten Treffen weiß ich, welche geeignet sind."
« Les tissus sont ma passion absolue. Dès le premier regard, je sais lesquels seront les plus adaptés. »

If passion and work could be interwoven, then the outcome would be by and large harmonious. To continue with the metaphor, this is especially true with regard to Maria Brandis, who runs the Freso Home interior studio in the center of Munich. Fabrics and color have always been a central focus for the art historian, who after completing her studies embarked on practical training at Sotheby's in Munich and London and learned trompe l'oeil painting in Madrid. "No other material can so quickly orchestrate or completely transform a space," said the Vienna-born entrepreneur passionately. When she arrived back in Germany from Madrid in 1994, Maria Brandis opened her first shop as the only Munich-based franchisee of Spanish interior label KA International. 2004 then ultimately saw the opening of Freso Home over two floors in a central location between the public square Maximiliansplatz and the Old Botanical Gardens. Clients seeking out Maria Brandis can expect a lot of time, individuality and an abundance of inspiration: "We hold around 700 fabric catalogs, in addition to custom-made furniture and exclusive home accessories such as cushions and lamps." She has many of these individually made, while an in-house sewing studio processes the select fabrics. To provide her customers with a notion of her designs, Maria Brandis creates mood boards for them (below right), with the emphasis naturally being on fabrics.

Wenn sich Leidenschaft mit dem Beruf verweben lässt, ist das Ergebnis meistens stimmig. Ganz besonders trifft dies, wollte man bei der Metapher bleiben, für Maria Brandis zu, die im Herzen Münchens ihr Interior-Atelier Freso Home betreibt. Stoffe und Farben haben für die Kunsthistorikerin, die nach ihrem Studium bei Sotheby's in München und London volontierte und „Trompe l'oeil"-Malerei in Madrid erlernte, stets eine ganz zentrale Rolle gespielt: „Mit keinem anderen Material lassen sich Räume im Handumdrehen inszenieren oder komplett verändern", schwärmt die gebürtige Wienerin. Nachdem sie 1994 aus Madrid zurück nach Deutschland gekommen war, eröffnete sie als einzige Münchener Franchise-Nehmerin für KA International, ein spanisches

Interior-Label, ihren ersten eigenen Shop. 2004 folgte schließlich Freso Home auf zwei Etagen, zentral in der Stadt gelegen zwischen Maximiliansplatz und Altem Botanischen Garten. Wer zu Maria Brandis kommt, den erwarten Zeit, Individualität und jede Menge Inspiration: „Wir haben über 700 Stoffbücher hier, außerdem nach Maß angefertigte Möbel sowie besondere Wohnaccessoires, beispielsweise Kissen und Leuchten." Vieles davon lässt sie individuell anfertigen, ein eigenes Nähatelier verarbeitet die feinen Textilien. Damit aber ihre Kunden ein Gefühl für Maria Brandis Entwürfe bekommen, stellt sie Moodboards (rechts unten) für sie zusammen: Stoffe stehen dabei erwartungsgemäß im Fokus.

Lorsque passion et profession se rejoignent, le résultat est le plus souvent harmonieux. Si l'on poursuit la métaphore, cela est particulièrement pertinent pour Maria Brandis qui possède son atelier d'architecture d'intérieur Freso Home au cœur de Munich. Pour l'historienne de l'art qui a œuvré après ses études chez Sotheby's à Munich et à Londres et a appris la peinture trompe l'œil à Madrid, les tissus et couleurs ont toujours joué un rôle central. « Aucune autre matière ne permet de mettre en scène ou de transformer intégralement des pièces en un tournemain », s'extasie la Viennoise de naissance. Après être retournée de Madrid en Allemagne en 1994, elle a ouvert sa première boutique, en tant que seule franchisée munichoise de KA International, une marque de décoration espagnole. En 2004, elle a ensuite ouvert Freso Home sur deux étages, une agence située au centre-ville entre Maximiliansplatz et Alten Botanischen Garten. Quiconque se rend chez Maria Brandis sera accueilli par du temps, de l'individualité et une grande inspiration : « Ici, nous avons plus de 700 livrets de tissus ainsi que des meubles fabriqués sur mesure et notamment des accessoires d'intérieur, par exemple des coussins et des lampes. » Elle fait fabriquer beaucoup d'entre eux individuellement, son atelier de couture se charge des textiles fins. Afin que ses clients se rendent compte du travail de Maria Brandis, elle assemble pour eux des moodboards (en bas à droite) : comme on peut s'y attendre, les tissus y occupent une place de choix.

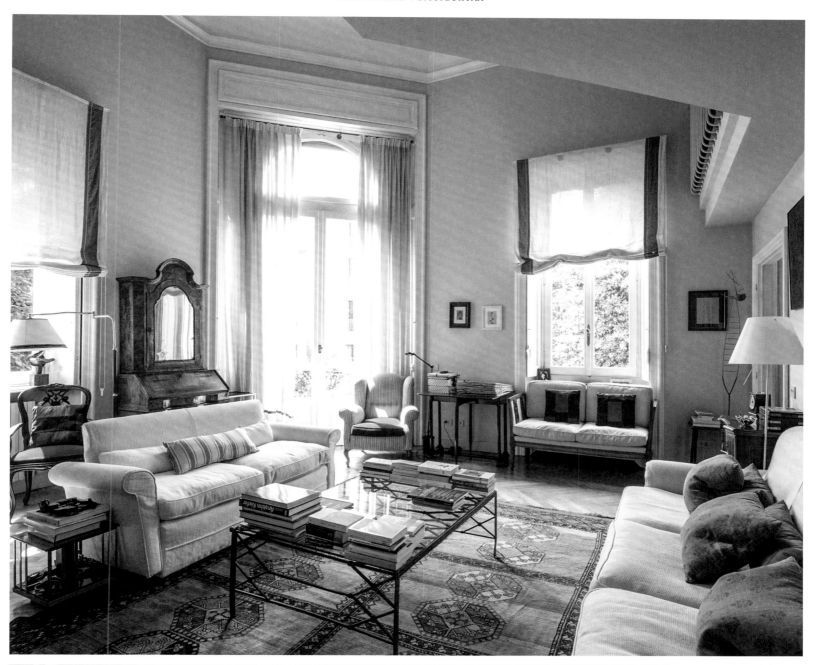

Maria Brandis exhibits a great deal of sensitivity when providing advice on interior furnishings and design. For a salon with high ceilings, the art historian chose subtle colors and natural fabrics from C&C Milano.

Mit viel Gespür berät Maria Brandis in puncto Einrichtung und Interior Design. Für einen Salon mit hohen Decken setzte die Kunsthistorikerin auf sanfte Farben und Naturstoffe von C&C Milano.

Maria Brandis conseille dans le domaine de la décoration et l'interior design avec beaucoup de subtilité. Pour un salon avec des plafonds élevés, l'historienne de l'art a misé sur les couleurs douces et les tissus naturels de C&C Milano.

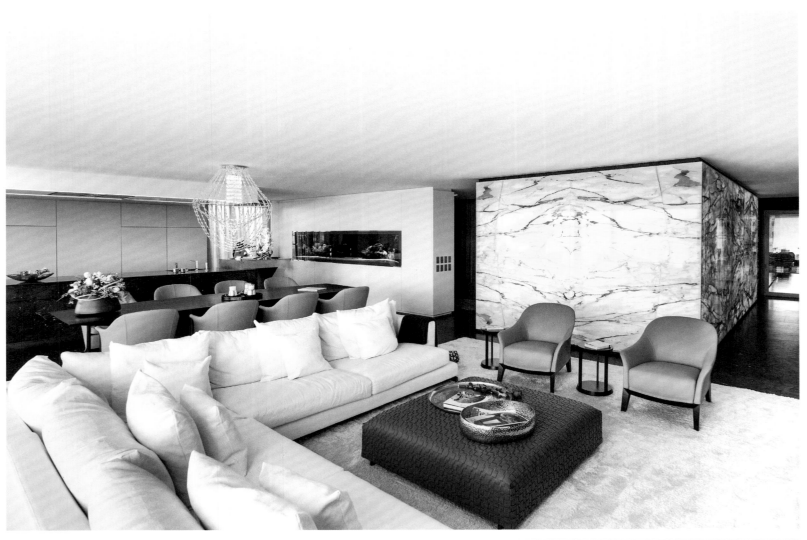

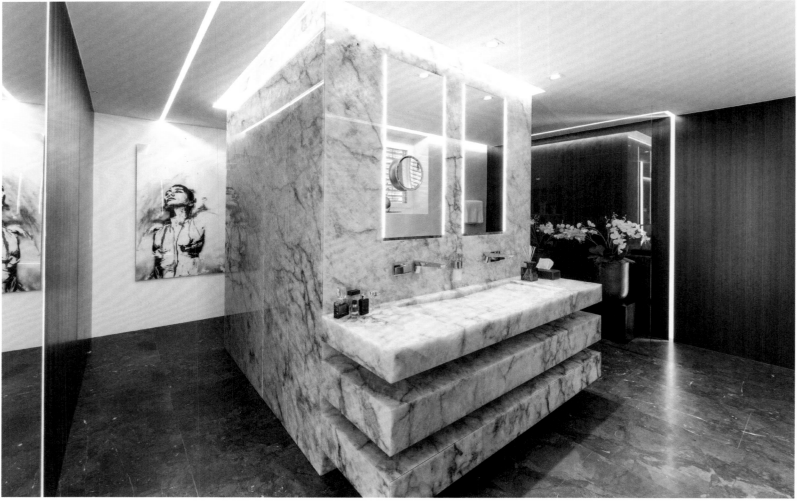

WIDMER WOHNEN

Gossau, Switzerland

"We like to use organic materials and always look for sustainable producers."
„Wir bevorzugen biologische Materialien und achten stets auf nachhaltige Produktion."
« Nous privilégions les matériaux biologiques et veillons toujours à une production durable. »

There is a secret to Widmer Wohnen's success and Dany Widmer is happy to share it: to create individualized interiors that reflect the client's personality, you need one crucial thing—time. Before the Swiss interior designer gets down to specifics such as room layouts; light concepts; or materials, he tries to find out what the client's vision for their home is so that the final result fits like a made-to-measure suit. "To start off, I develop creative solutions that, and this is very important to me, are unique!" Dany, who runs the business together with his brother Remo Widmer, filters the key facts out of discussions, using them to come up with an overall concept that is considered down to the smallest detail and stylish while also cozy. He carefully selects the furniture, accessories, lamps, and textiles, and is happiest when he can follow the transformation of properties from the bare brickwork to the day the client moves in. For a dream plot on a lake (left), whose owner works with natural stone, Dany Widmer came up with an interior that includes over twenty different kinds of stone. The furnishings have been kept classic and low-key to ensure that the overall look is not overloaded. An old farmhouse (p. 208/209) was brought up to the latest technical standards—while the design, that includes old spruce wood, honors the building's history. The concept for the bar was more adventurous—three huge decorative Swiss brackets reference the surrounding landscape and its traditions.

Es gibt ein Geheimnis für den Erfolg von Widmer Wohnen und Dany Widmer verrät es gerne: Um individuelle Wohnwelten zu bauen, in denen sich ein Kunde wiederfindet, braucht es im Vorfeld vor allem eines – und das ist Zeit. Noch bevor der Schweizer Einrichter an konkrete Details wie Raumaufteilung, Lichtgestaltung oder Materialität geht, möchte er herausfinden, wie ein Zuhause gestaltet werden muss, sodass es wie ein Maßanzug sitzt. „Erst danach entwickle ich kreative Lösungen, die, und das ist mir wichtig, kein zweites Mal zum Einsatz kommen!" Dany, der das Geschäft zusammen mit seinem Bruder Remo Widmer führt, filtert aus den Gesprächen die Essenz heraus und entwickelt daraus ein Gesamtkonzept, das bis ins Detail durchdacht, stilvoll und gleichzeitig wohnlich ist. Möbel, Accessoires, Lampen und Textilien wählt der Interior Designer mit Bedacht, begleitet Objekte am liebsten vom Rohbau bis zum Einzug. Für eine Traumimmobilie am See (links), deren Besitzer mit Natursteinen arbeitet, realisierte Dany Widmer ein Interieur mit über 20 verschiedenen Steinsorten. Damit das Gesamtbild trotzdem nicht überladen wirkt, bleibt die Einrichtung klassisch und klar im Hintergrund. Ein altes Bauernhaus (S. 208/209) wurde technisch auf den allerneuesten Stand gebracht – optisch dagegen mit gehacktem Fichtenaltholz seiner Geschichte entsprechend gewürdigt. Für die Bar durfte es dann doch etwas ausgefallener werden: drei riesige Schweizer Schmuckschellen zitieren Landschaft und Brauchtum ringsum.

Il existe un secret à la réussite de Widmer Wohnen et Dany Widmer le révèle volontiers : pour réaliser des univers d'aménagement individuels auxquels un client s'identifie, une chose est essentielle au préalable – le temps. Bien avant que le décorateur suisse ne se penche sur les détails concrets comme la répartition spatiale, l'aménagement de l'éclairage ou les matériaux, il souhaite découvrir comment aménager un intérieur pour qu'il tombe comme un costume sur mesure. « Ce n'est qu'ensuite que je développe des solutions créatives qui, et cela est important pour moi, ne seront pas utilisées une seconde fois ! » Dany, qui gère l'entreprise avec son frère Remo Widmer filtre l'essence des entretiens et développe sur cette base un concept général qui est sophistiqué dans les moindres détails, stylé et agréable à vivre à la fois. L'*interior designer* sélectionne les meubles, les accessoires, les lampes et les textiles avec soin, il aime accompagner les logements du gros œuvre à l'emménagement. Pour un bien immobilier de rêve au bord d'un lac (à gauche) dont le propriétaire travaille avec des pierres naturelles, Dany Widmer a réalisé un intérieur avec plus de vingt sortes de pierres différentes. Pour que l'effet total ne soit cependant pas trop surchargé, l'aménagement reste classique et organisé en arrière-plan. Une ancienne ferme (p. 208/209) a été techniquement remise au goût du jour – sur le plan visuel, on a rendu cependant hommage à son histoire avec du vieux bois d'épicéa haché. Pour le bar, l'originalité était cependant de mise ; trois immenses grelots suisses rappellent le paysage et la tradition locale.

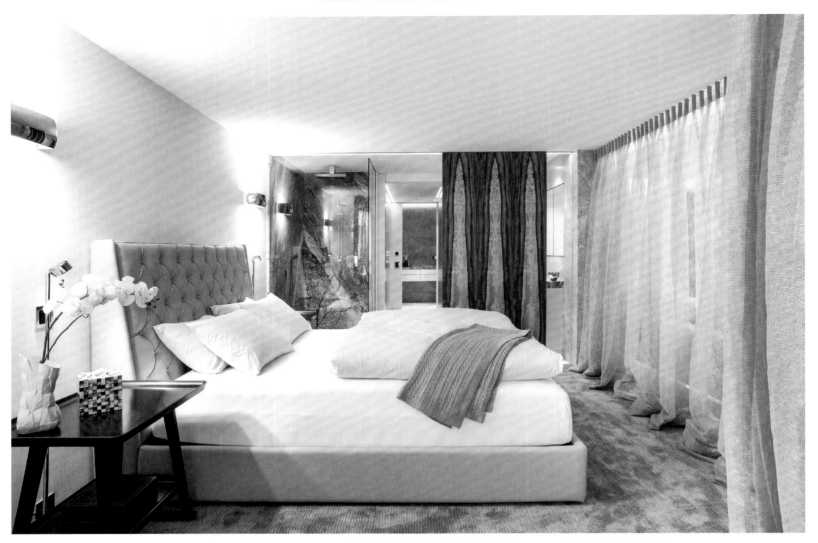

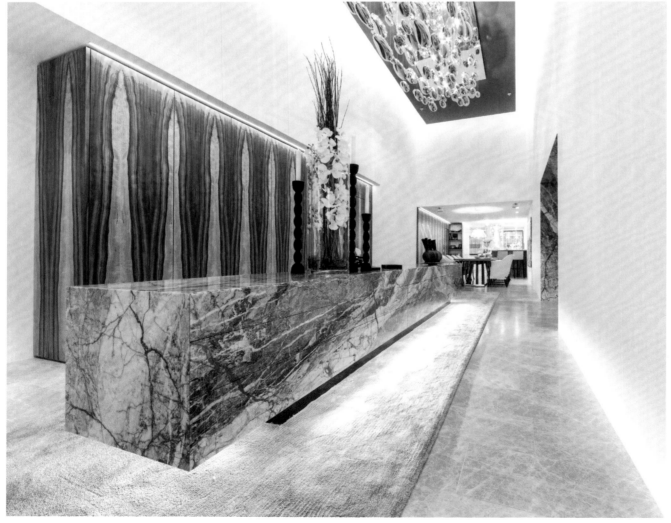

A city apartment that is used both privately and for entertaining required a careful balancing act—to emphasize the over 5-meter (16-foot) ceilings, Dany Widmer decided to use warm smoked cherry wood panels.

Spagat für eine Stadtwohnung, die privat und repräsentativ genutzt wird: Um die Raumhöhe von über fünf Metern aufzufangen, entschied sich Dany Widmer für warme Holzpaneelen aus geräucherter Kirsche.

Grand écart pour un appartement de ville qui est utilisé à titre privé et représentatif : pour atténuer les plus de cinq mètres de hauteur des pièces, Dany Widmer a opté pour des panneaux de bois de cerisier fumé.

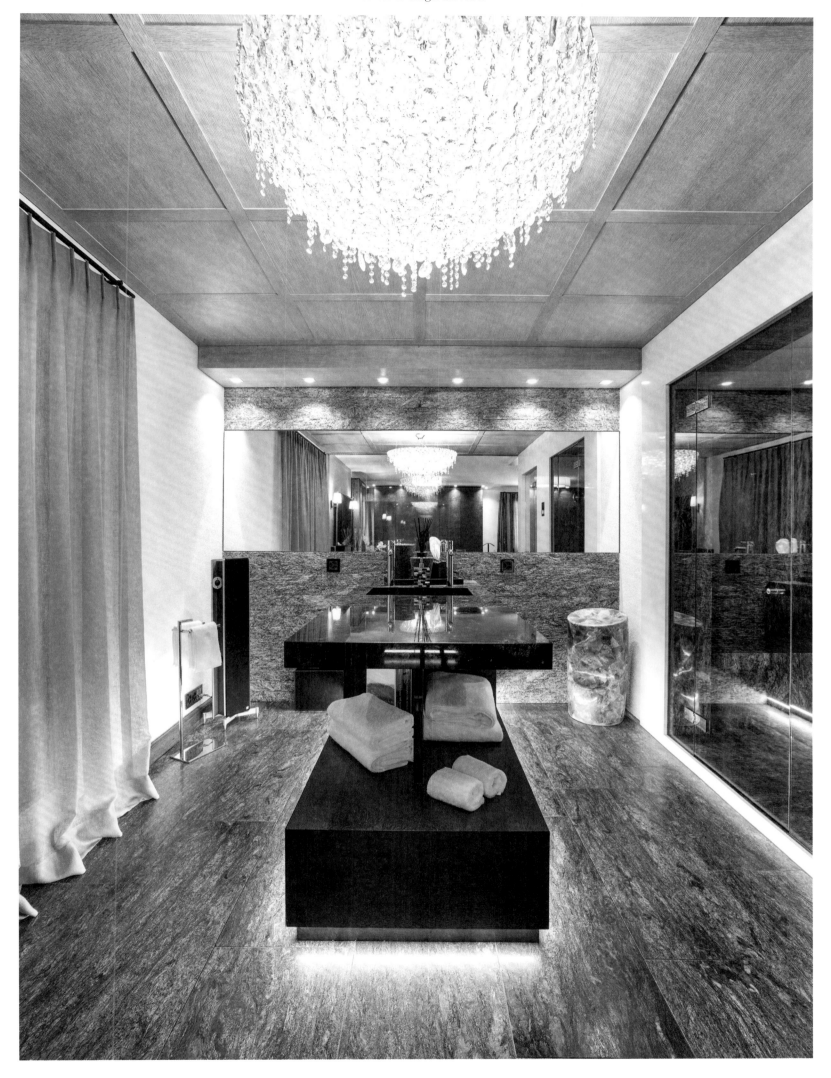

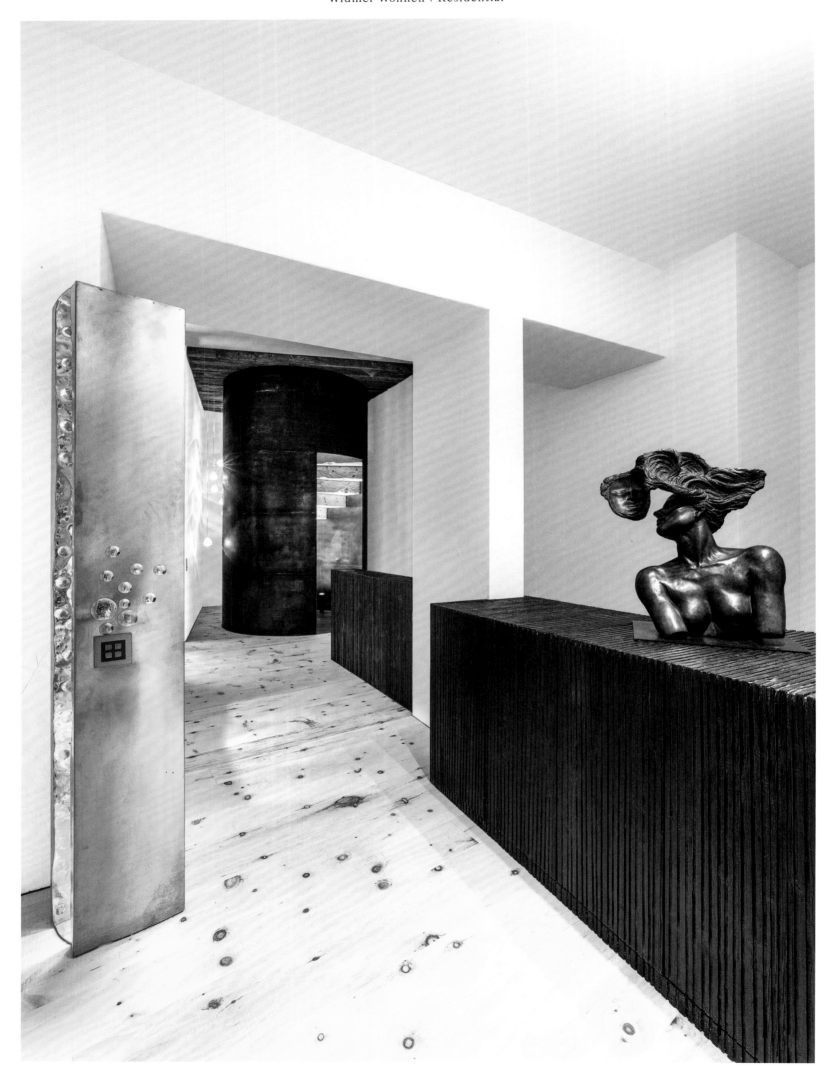

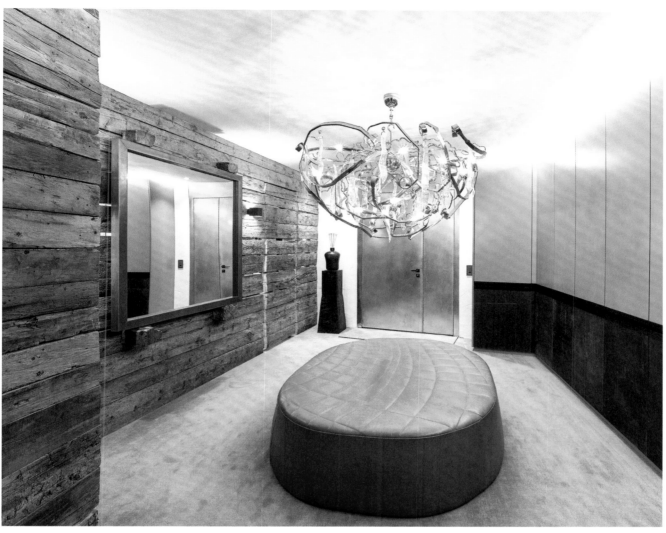

The Widmers also use their private vacation home as a showroom. Wood from stone pines, sourced from various European regions, has been used in a variety of ways throughout the house.

Das private Ferienan-wesen der Widmers wird auch als Showroom genutzt. Im gesamten Haus wurde Arvenholz aus verschiedenen Teilen Europas beschafft, unterschiedlich bearbeitet und verbaut.

La villa privée de vacances des Widmer est également utilisée en tant que showroom. Dans l'ensemble de la maison, du bois d'arolle venu de différentes parties de l'Europe a été utilisé, travaillé différemment et installé.

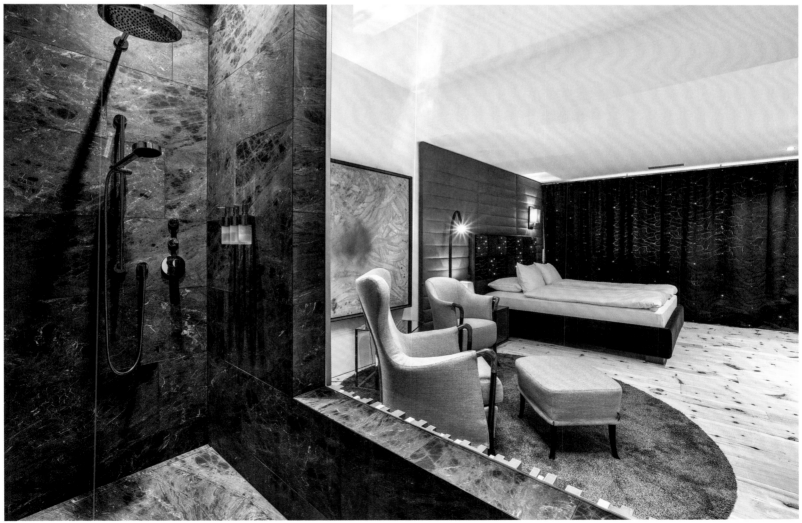

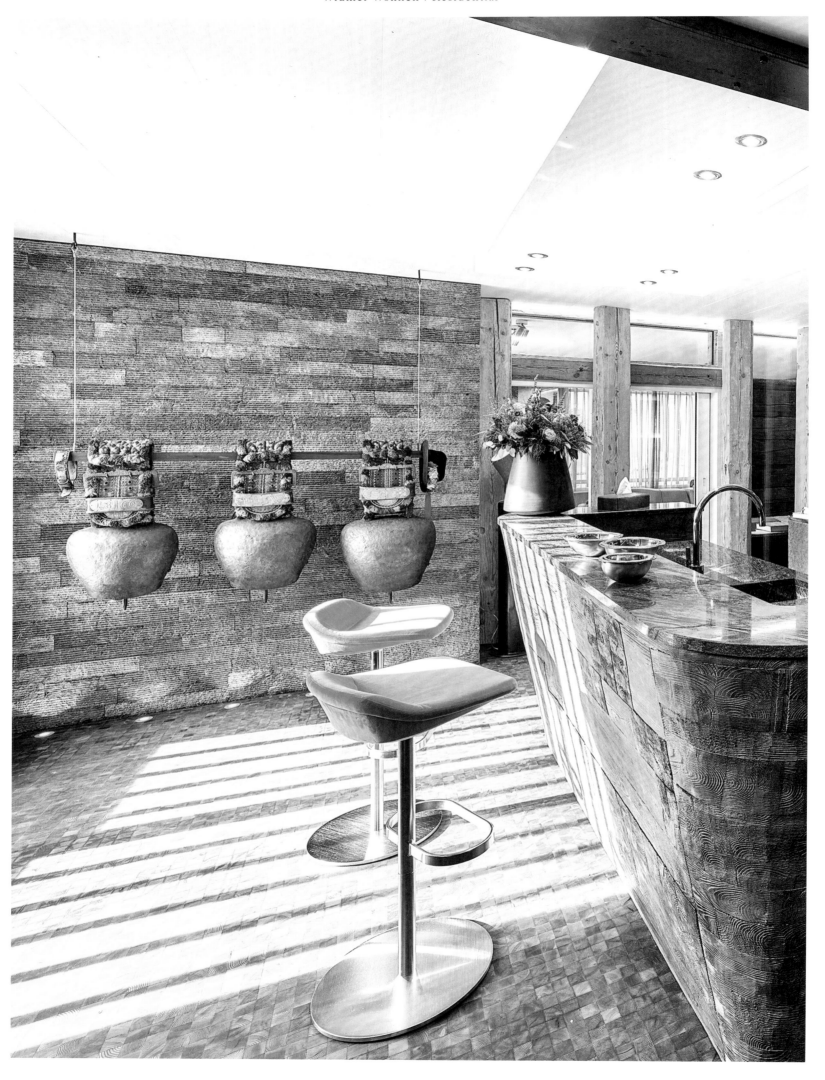

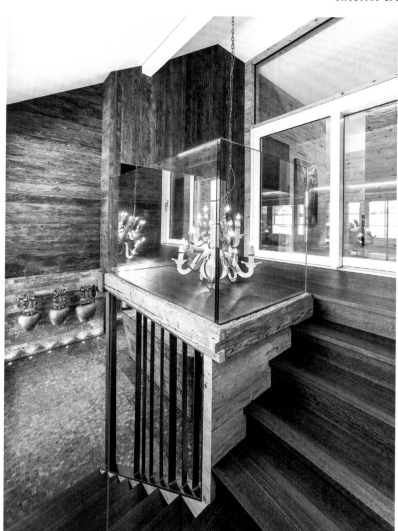
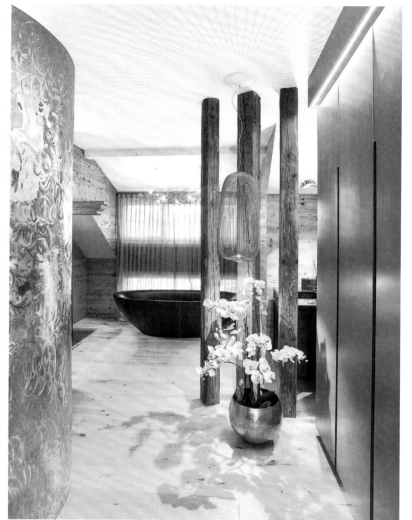
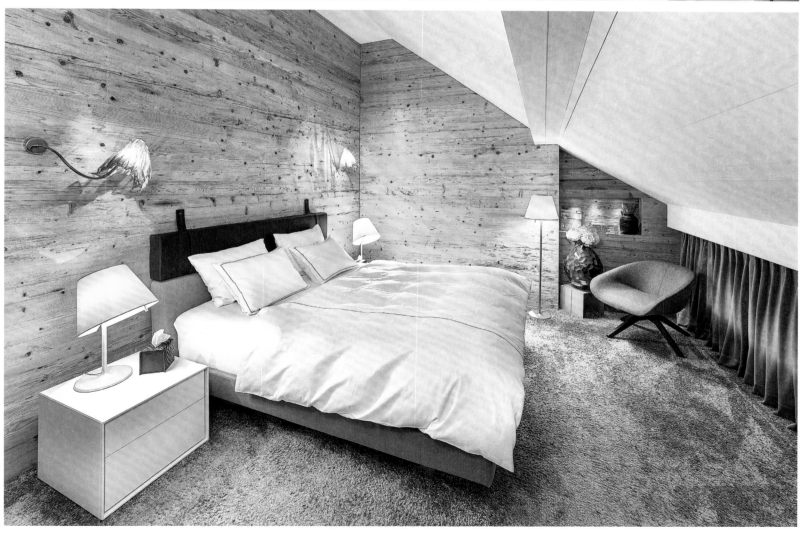

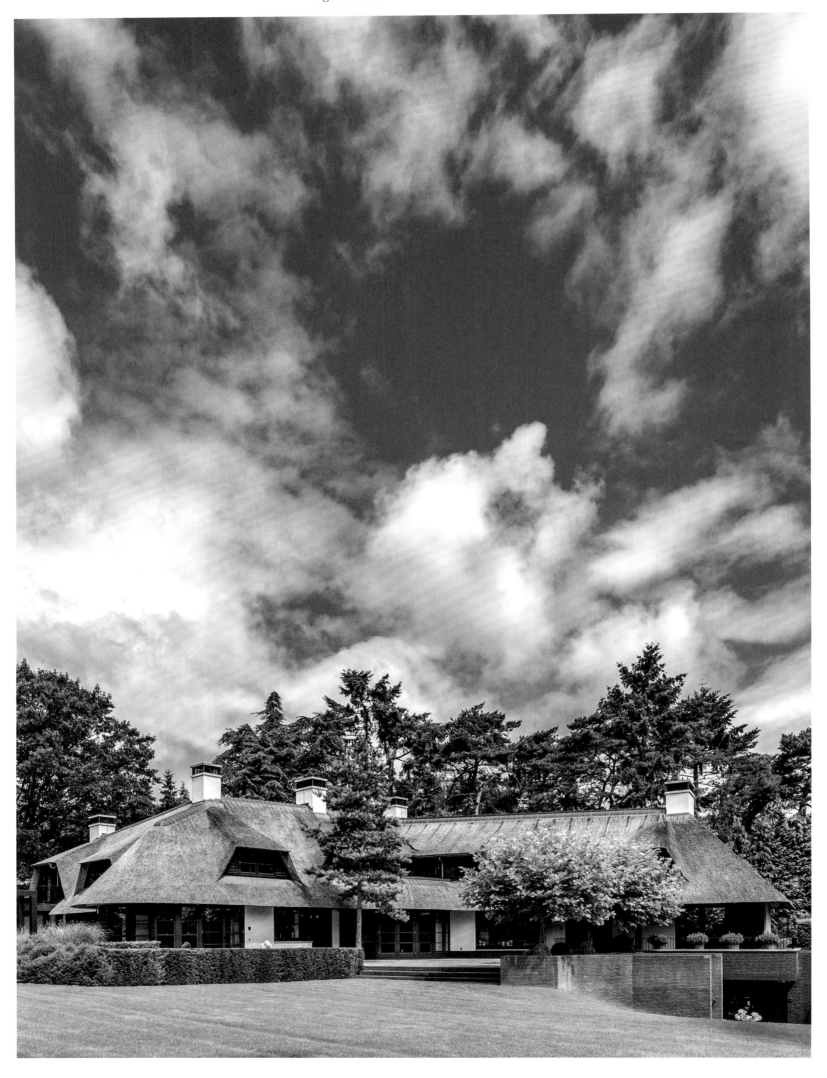

IGNACE MEUWISSEN
Moscow, Russia

"Our name stands for exceptional high-end properties around the world."
„Unser Name steht für absolute High-End-Immobilien auf der ganzen Welt."
« Notre nom est synonyme de biens immobiliers haut de gamme dans le monde entier. »

Picturesque thatched farmhouses and green meadows that roll gently to the horizon—who wouldn't want to live here? Laren in North Holland, just 30 kilometers from Amsterdam, the Dutch capital, has always been popular with artists and wealthy city dwellers. Ignace Meuwissen is also aware of the idyllic area's merits. Born in Belgium, he has gained an international reputation for representing unique off-market luxury real estate and is renowned as an influential advisor for a wealthy Russian-speaking clientele. For over 20 years now, Meuwissen has been identifying and selling residential gems such as palazzi in the heart of Venice, penthouses in Portofino, and villas in Beverly Hills. Since 2017, Ignace Meuwissen has been successfully holding the record of selling the most expensive property in Paris in the city's history, a 1,200-square-meter (13,000-square-foot) penthouse for 65 million euro, and the most expensive sale in 2018 world-wide. In Laren, he discovered a spacious rural residence that is now available for purchase after four years of extensive renovation work. The 1,500-square-meter (16,145-square-foot) prop-

erty comes with two guesthouses and a large outdoor pool, has four bedrooms and bathrooms, and a luxury spa with gym, hammam, sauna, hot tub, and relaxation area. Its security systems have been brought up to the latest standards and include a high-security alarm system, biometric access control, and a surveillance system. The residence is being offered with tasteful furnishings; the garden has been lovingly designed by landscape architects. And should the new owners find this idyll too quiet, then they can enjoy their own in-house nightclub.

Pittoreske, reetgedeckte Bauernhäuser, grüne Wiesen, die sanft bis zum Horizont schwingen – wer möchte da nicht leben? Laren in Nordholland stand bei Künstlern und wohlhabenden Amsterdamern schon immer hoch im Kurs: Die holländische Hauptstadt ist nur 30 Kilometer entfernt. Auch Ignace Meuwissen weiß um die Vorzüge der Gegend. Der gebürtige Belgier gilt als renommierter Berater für eine wohlhabende russischsprachige Klientel und hat sich weltweit einen Namen gemacht, der für einzigartige Off-Market-Luxusimmobilien steht. Meuwissen findet und kauft seit über 20 Jahren Wohnjuwelen – sei es ein Palazzo mitten in Venedig, ein Penthouse in Portofino oder eine Villa in Beverly Hills. Seit 2017 hält er zudem den Rekord für die teuerste verkaufte Immobilie in ganz Paris, ein 1.200 Quadratmeter großes Penthouse im Wert von 65 Millionen Euro. 2018 folgte der Verkauf des weltweit teuersten

Objekts. In Laren hat er eine großzügige Villa im Grünen entdeckt, die nun zum Verkauf angeboten wird. Vier Jahre dauerte die Renovierung des Anwesens, das außerdem über zwei Gästehäuser und einen Außenpool verfügt. Auf 1.500 Quadratmetern Wohnfläche verteilen sich vier Schlafzimmer und Bäder sowie ein Luxus-Spa mit Fitnessraum – dazu gehören ein Hamam, eine Sauna, ein Jacuzzi sowie ein Loungebereich. Sicherheitstechnisch wurde das Anwesen auf den neuesten Stand gebracht: ein High-Security-Alarmsystem gehört ebenso dazu wie eine biometrische Zugangskontrolle und ein Kamerasystem. Das Domizil wird geschmackvoll möbliert angeboten, der Garten wurde von Landschaftsarchitekten kunstvoll angelegt. Und wem die Idylle doch einmal zu ruhig erscheint: Das Haus hält sogar eine eigene Diskothek bereit.

Des bâtiments fermiers pittoresques, au toit de chaume, des prés verts qui flottent doucement jusqu'à l'horizon – qui n'aimerait pas vivre ici ? Laren, dans le nord de la Hollande, a toujours été appréciée des artistes et des habitants aisés d'Amsterdam : La capitale hollandaise est seulement située à 30 km. Ignace Meuwissen connait les avantages de la région. Ce Belge d'origine est un conseiller renommé pour une clientèle russophone aisée. Il s'est fait un nom dans le monde entier pour les biens immobiliers off-market uniques. Meuwissen trouve et achète depuis plus de 20 ans des bijoux immobiliers – que ce soit un palazzo au cœur de Venise, un penthouse à Portofino ou une villa à Beverly Hills. Depuis 2017, il détient de plus le record du bien immobilier vendu le plus cher de tout Paris, un pentouse de 1.200 m² d'une valeur de 65 millions d'euros. En 2018, la vente du bien immobilier le plus cher au monde a suivi. À Laren, il a découvert une généreuse villa dans la nature qui est désormais proposée à la vente. La rénovation de la résidence, qui possède également deux maisons d'hôtes et une piscine extérieure, a duré quatre ans. Sur 1.500 m² de surface habitable sont répartis quatre chambres et salles de bain et un spa de luxe avec salle de sport ; dont un hammam, un sauna, un jacuzzi et un espace lougne. Sur le plan de la sécurité, la technologie employée dans la résidence est ultramoderne : un système d'alarme high security est notamment présent ainsi qu'un contrôle biométrique d'accès et un système de caméra. Le domicile est proposé avec un mobilier de goût, le jardin a été aménagé de manière créative par des paysagistes. Et pour ceux qui trouvent l'ensemble trop calme : la résidence comprend également une discothèque.

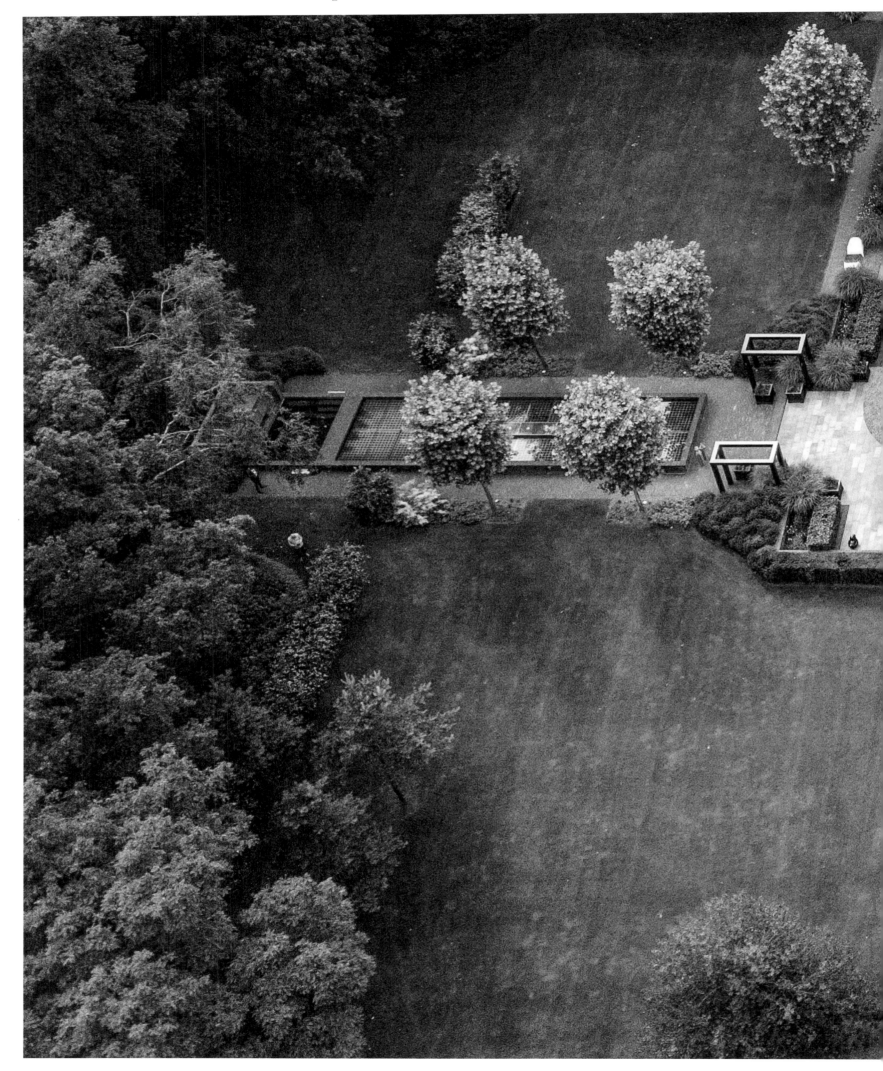

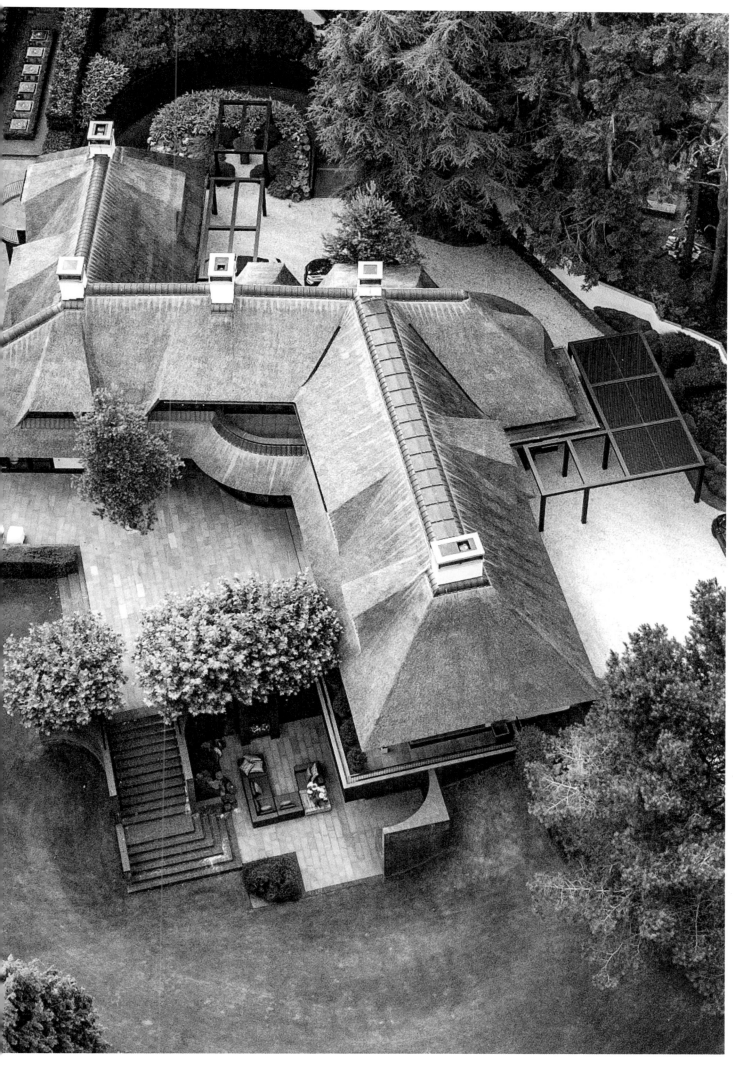

Ignace Meuwissen, the specialist for international luxury properties, appreciates Laren's location close to Amsterdam. The spacious villa has an outdoor pool and two guesthouses.

Ignace Meuwissen, der auf weltweite Luxusanwesen spezialisiert ist, schätzt die Lage von Laren nahe Amsterdam: Die großzügige Villa verfügt über einen Außenpool und zwei Gästehäuser.

Ignace Meuwissen qui s'est spécialisé dans les résidences de luxe dans le monde entier apprécie la localisation de Laren près d´Amsterdam : La villa généreuse possède une piscine extérieure et deux maisons d'hôtes.

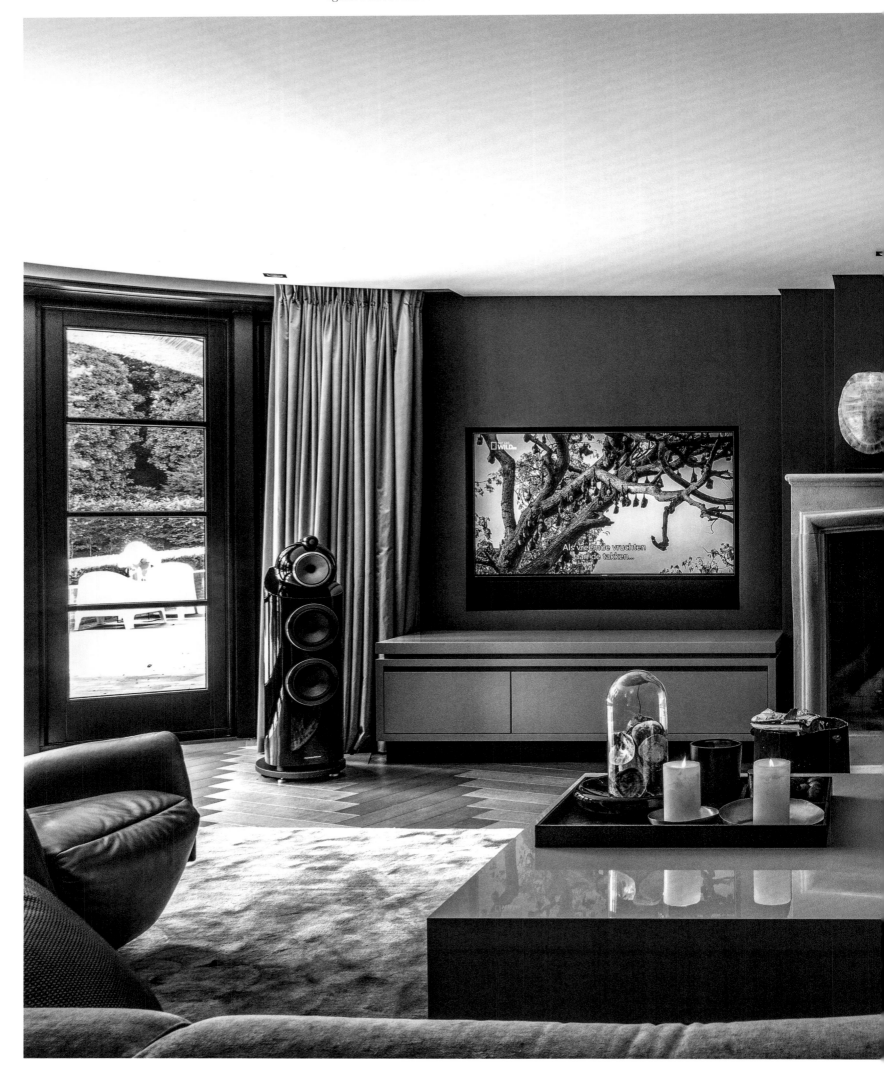

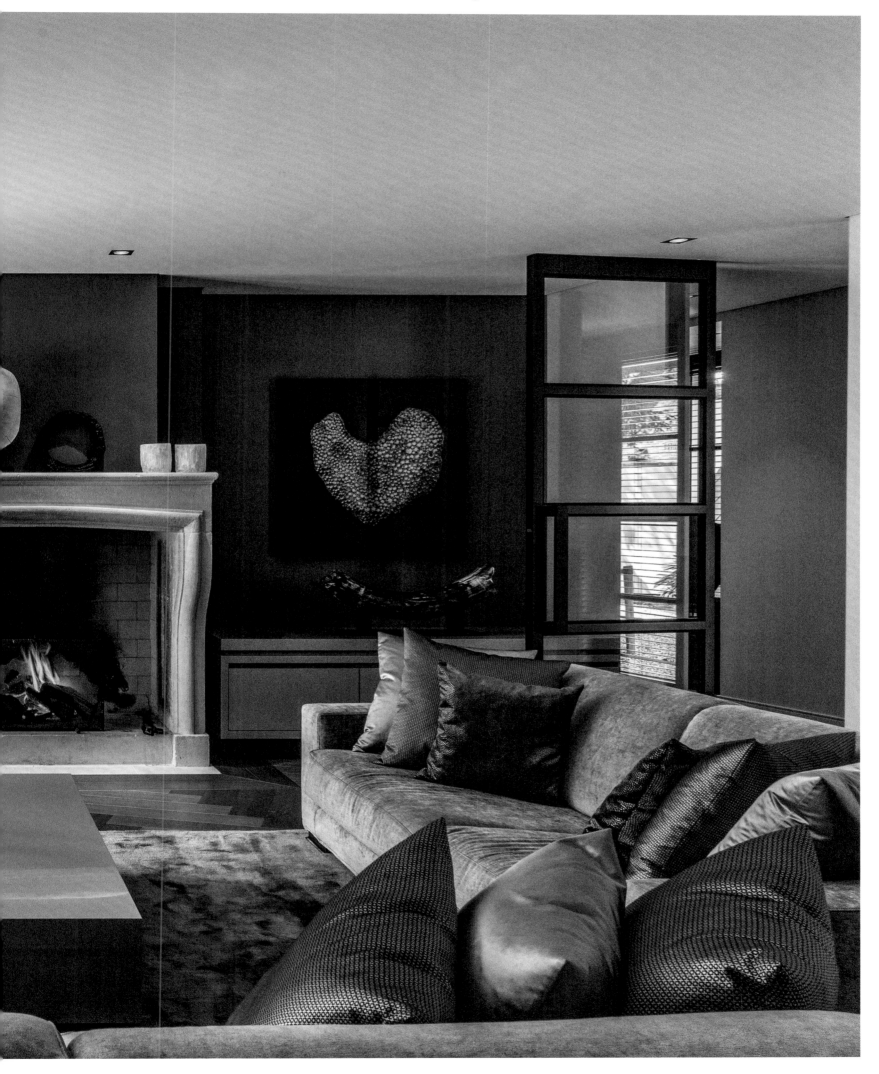

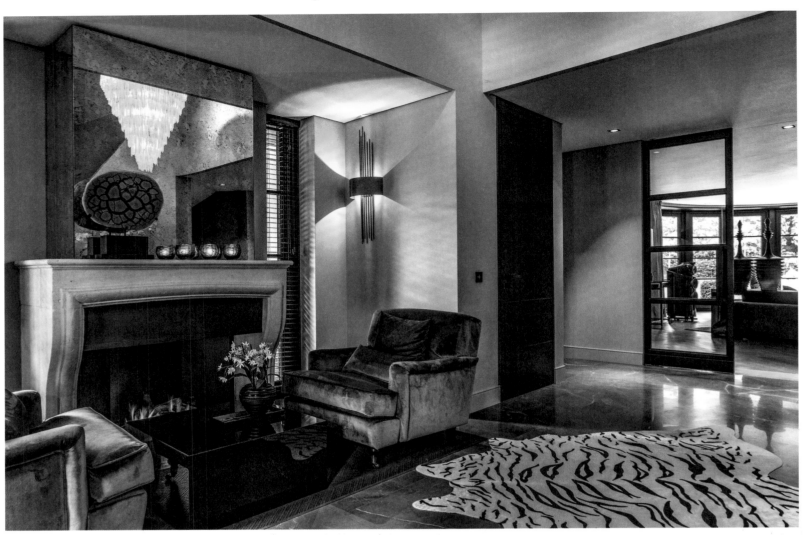

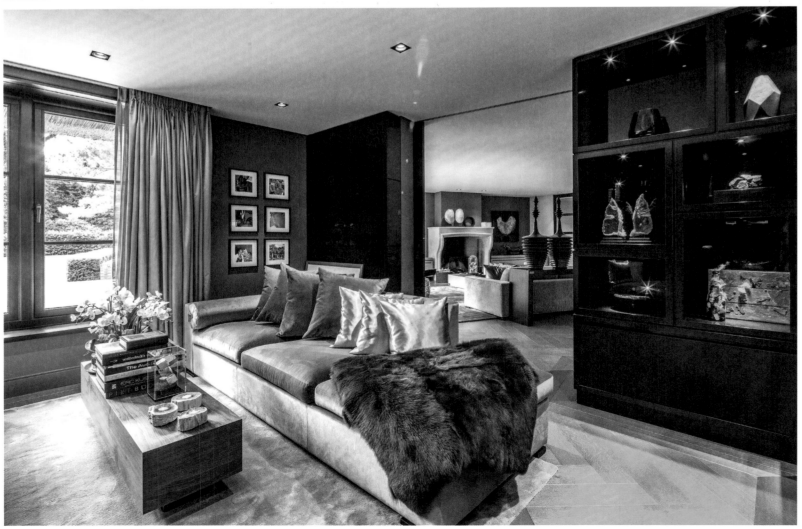

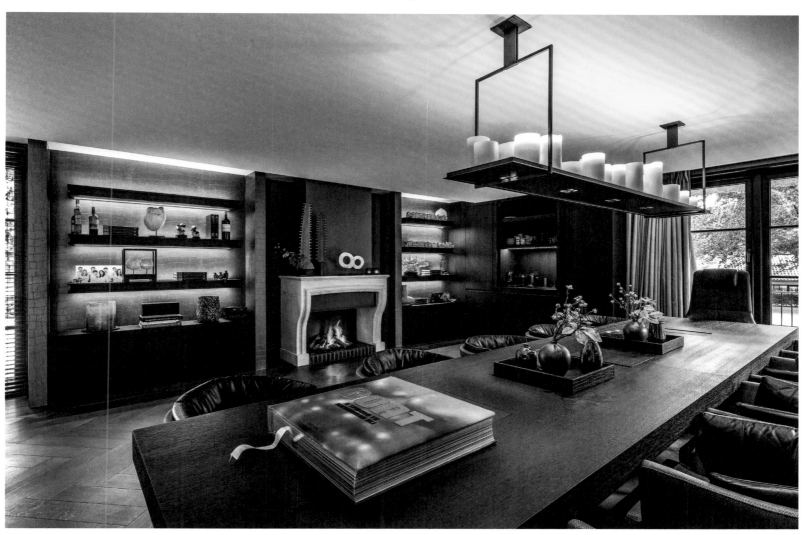

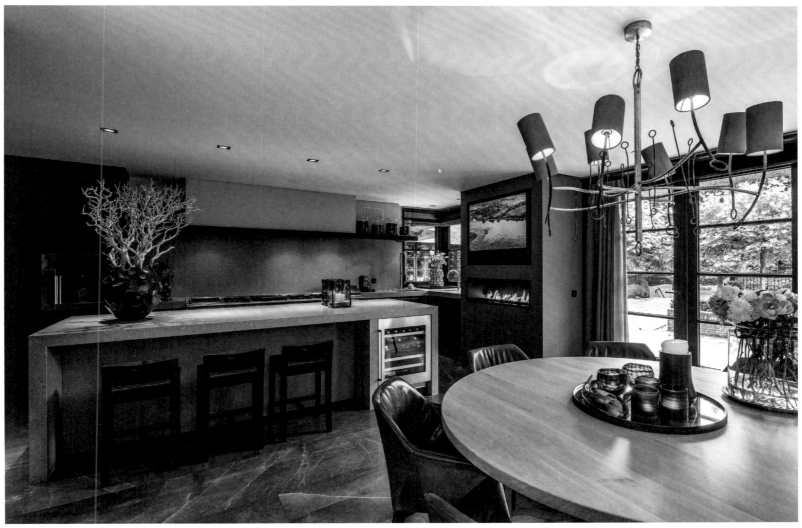

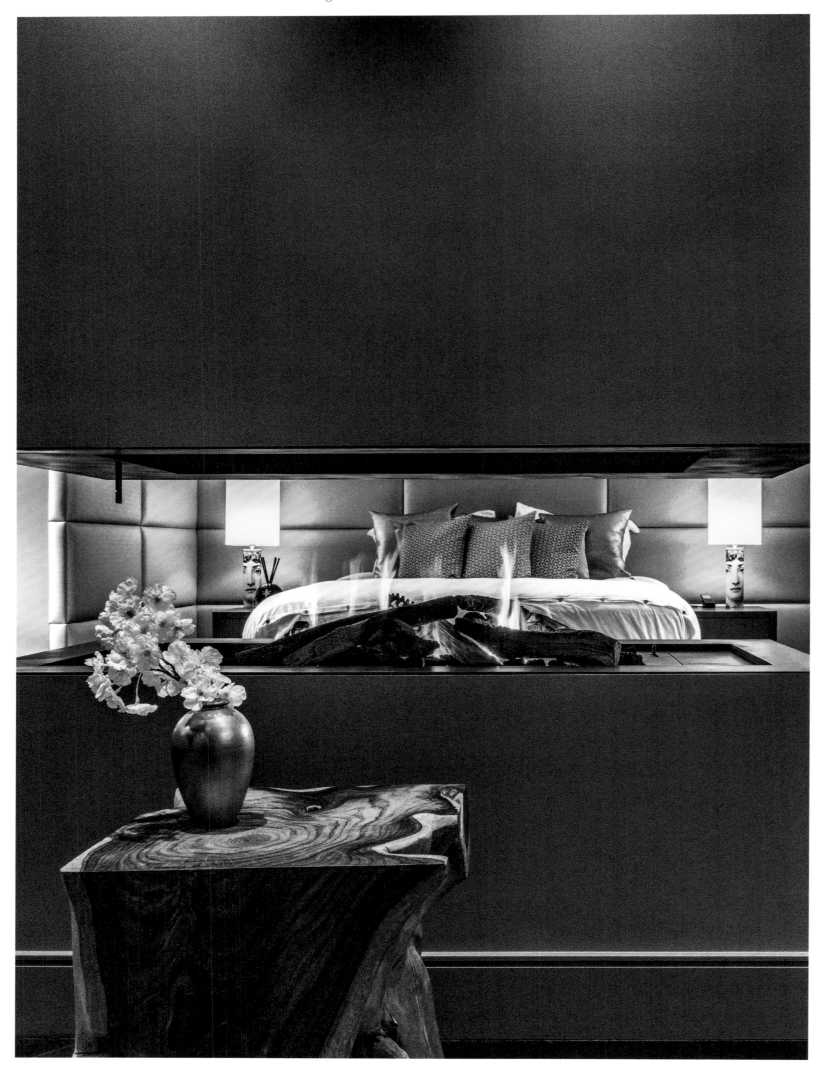

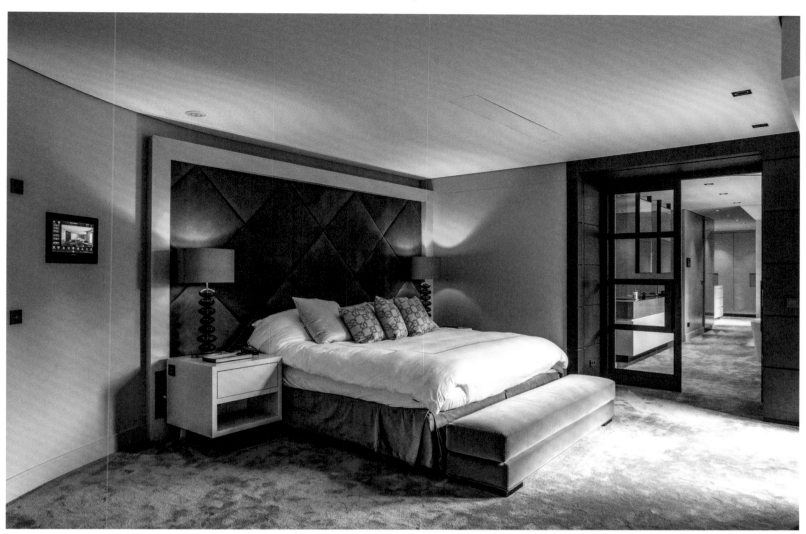

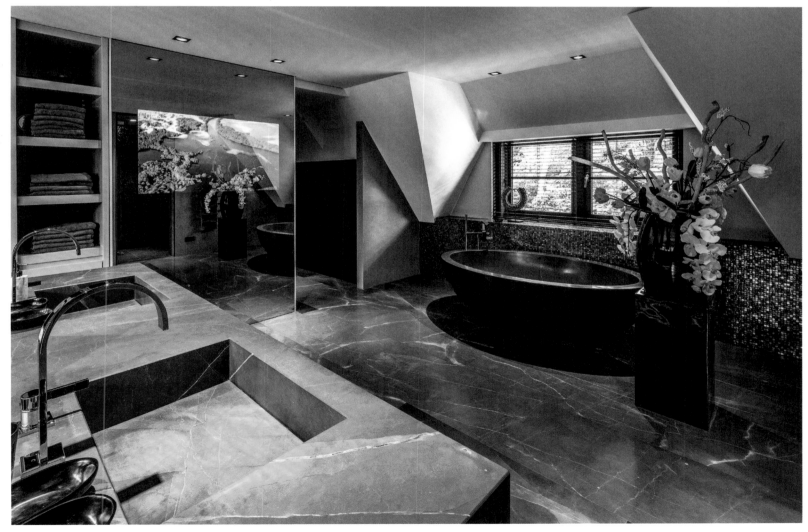

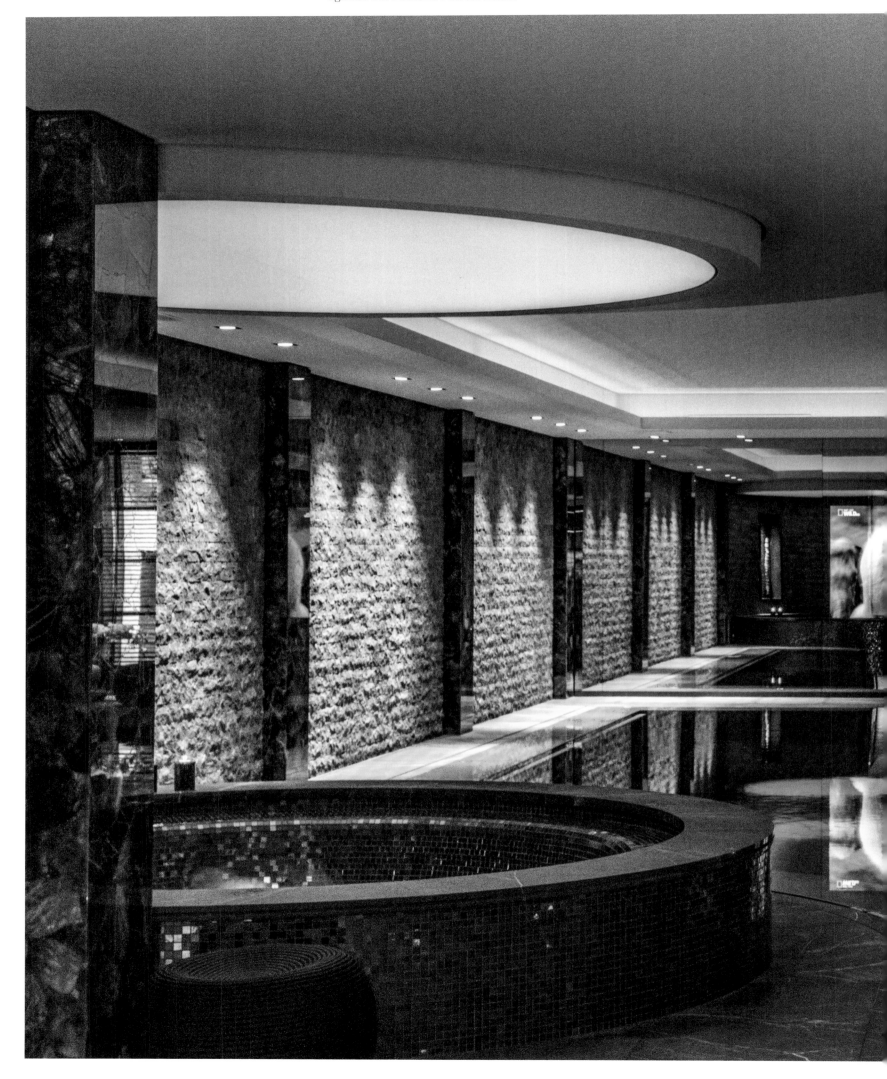

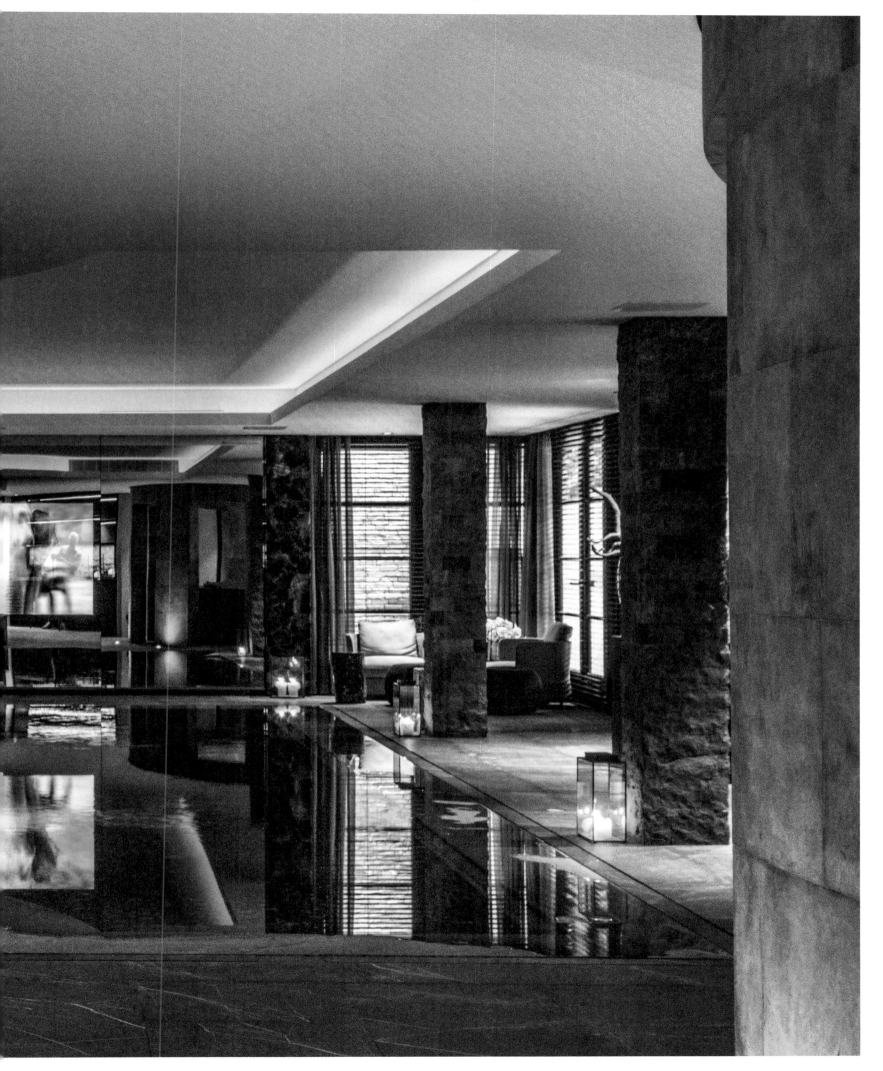

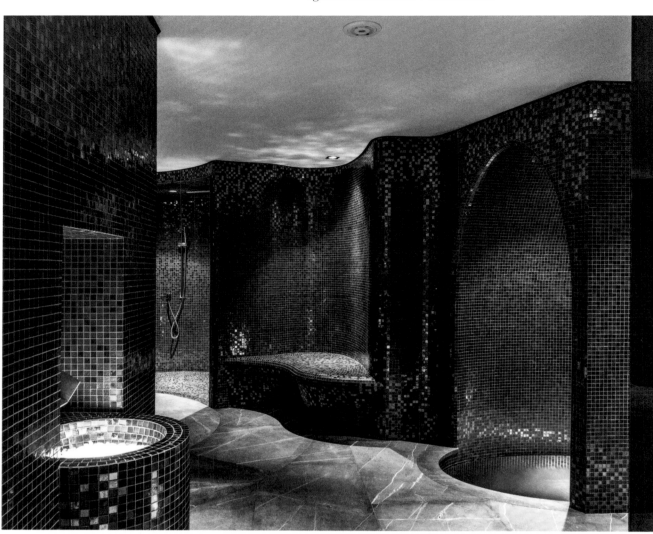

Crazy and cool
—the Dutch villa's occupants can choose whether to spend long winter evenings in their spa, in-house night club with bar, or home movie theater.

Crazy und cool: Lange Winterabende lassen sich in der niederländischen Villa wahlweise im Spa, der eigenen Diskothek mit Barbereich oder im hauseigenen Kinoraum verbringen.

Crazy et cool : dans la villa néerlandaise, on peut passer les longues soirées d'hiver dans le spa, la discothèque interne avec bar ou dans la salle de cinéma.

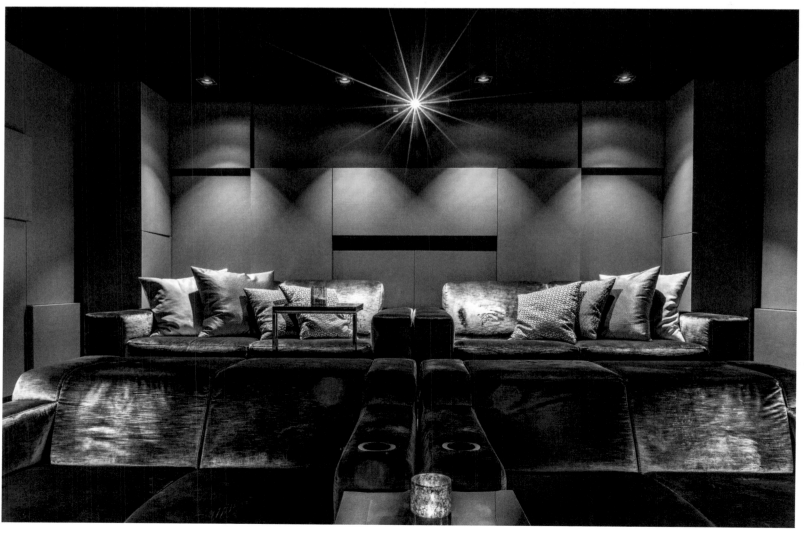

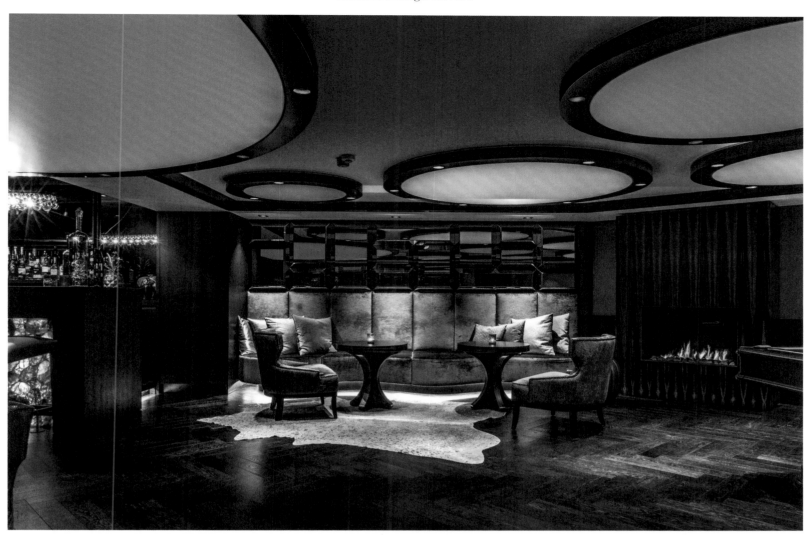

SCHEER ARCHITEKT
Munich, Germany

"The exciting thing about our profession is the complexity of the challenges."
„Das Spannende an unserem Beruf ist die Komplexität der Anforderungen."
« La complexité des exigences est ce qui rend notre métier passionnant. »

How does it feel to take part in a classic car road trip around the Kleinwalsertal valley in Austria? To find out the answer Rose Birnbeck-Scheer and Wilhelm Scheer rented an old MG and joined a bunch of other old vehicles to rattle up steep mountain roads and back down again. Why? They were looking for inspiration for a brief. The client, who is crazy about automobiles, wanted the design for his home to reflect this passion. "We always try to immerse ourselves in the topic and the client's inner world. We take this as the starting point for developing the overall concept from the first draft to the realization," explains Wilhelm Scheer, who set up his Munich, Germany-based architecture firm in 1985. Scheer Architekt describe their philosophy as classically influenced. Their goal is to combine the diverse aspects of the technical, building regulations, financial, human, and design areas with their own creativity and determination to achieve a complete success that appears effortless. The auto-loving client was given a villa with a showroom for his beloved vehicles that he christened CArt (a creation derived from 'car' and 'art'). Highlights of the building are the cantilevered steel stairs in the lobby and the ceiling structure in the integrated showroom. A diagonal grid of reinforced concrete beams supported by just four pillars was chosen to bear the high loads of the overarching construction. The owner's classic cars now not only have plenty of room but also look amazing.

Wie fühlt es sich an, mit einem Oldtimer an einer Rallye durchs österreichische Kleinwalsertal teilzunehmen? Um das herauszufinden, mieteten sich Rose Birnbeck-Scheer und Wilhelm Scheer einen alten MG und knatterten in Begleitung edler Karossen steile Bergstraßen hinauf und wieder hinunter. Der Grund: Sie sollten sich für einen Bauherrn, der verrückt nach Autos ist und seine Villa entsprechend geplant haben wollte, für dessen Leidenschaft Inspiration holen. „Wir versuchen stets, das Thema und die Welt des Auftraggebers im Innersten zu antizipieren und darauf das ganze Konzept vom Entwurf bis zur Ausführung zu entwickeln", sagt Wilhelm Scheer, der seit 1985 ein Architekturbüro in München betreibt. Scheer Architekt sehen sich in ihrer Grundhaltung klassisch geprägt. Ihr Ziel: sie möchten die Vielfalt

der Anforderungen auf technischer, baurechtlicher, finanzieller, menschlicher und gestalterischer Ebene mit der eigenen Kreativität und Zielstrebigkeit zu einem selbstverständlich wirkenden Gesamterfolg bringen. Der autoaffine Bauherr erhielt eine Villa mit Showroom für seine Autolieblinge, dem er den Namen CArt (eine Kreation aus Car und Art) gab. Highlights sind die in der Eingangshalle des Hauses schwebende Stahltreppe sowie die Deckenstruktur des hauseigenen Showrooms. Um die hohen Lasten in eine weitgespannte Konstruktion zu übertragen, wurde ein diagonales Raster von Stahlbetonunterzügen über nur vier Stützen gewählt. Die Oldtimer des Bauherrn haben nicht nur ausreichend Platz – sondern sehen richtig gut aus.

Que ressent-on lorsque l'on participe avec une voiture de collection à un rallye à travers la Kleinwalsertal en Autriche ? Pour le découvrir, Rose Birnbeck-Scheer et Wilhelm Scheer ont loué une vieille MG et dévalé les versants abrupts des montagnes en compagnie d'élégantes voitures. La raison : ils voulaient trouver de l'inspiration pour un maître d'ouvrage féru de voitures qui voulait aménager sa villa en conséquence et découvrir sa passion. « Nous essayons toujours d'anticiper le thème et l'univers du donneur d'ordres en son essence et de développer sur cette base tout le concept, de l'ébauche à l'exécution », a déclaré Wilhelm Scheer, qui possède un cabinet d'architectes à Munich depuis 1985. Scheer Architekt est marqué par un style classique. Son objectif : harmoniser la diversité des exigences sur le plan technique, du droit de la construction, financier, humain et créatif à sa propre créativité et à sa détermination pour obtenir un résultat réussi semblant évident. Le maître d'ouvrage amateur d'automobile a obtenu une villa avec showroom pour ses voitures préférées auquel il a donné le nom de CArt (une création entre Car et Art). Les éléments phares sont l'escalier en acier flottant dans le hall d'entrée de la maison et la structure de plafond du showroom. Afin de transférer les charges importantes à une structure très étendue, une trame diagonale de poutres en béton armé sur seulement quatre piliers a été choisie. Les voitures de collection du maître d'ouvrage n'ont pas seulement suffisamment de place, elles sont également mises en valeur.

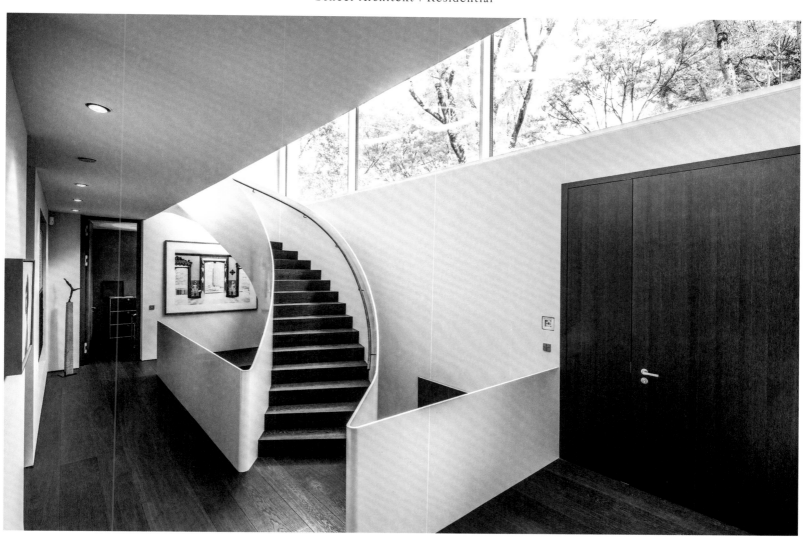

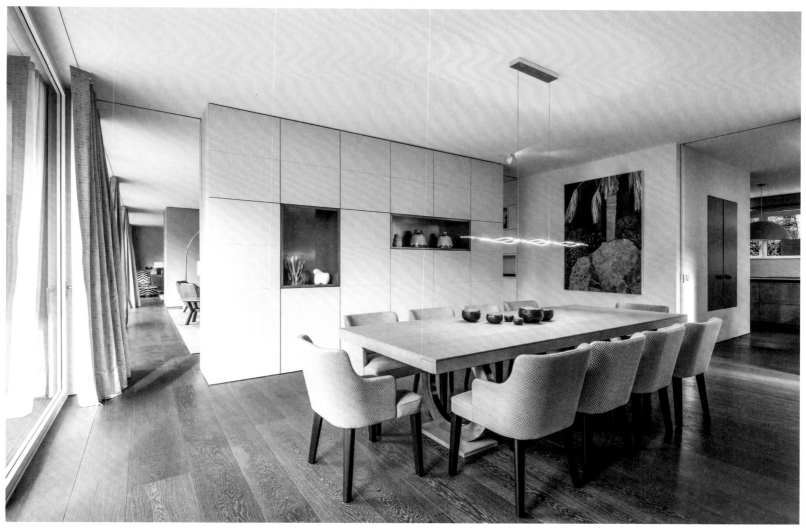

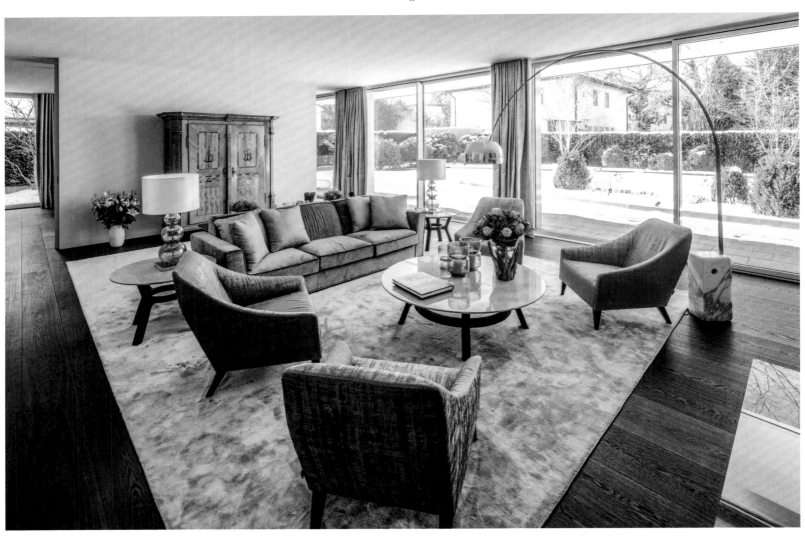

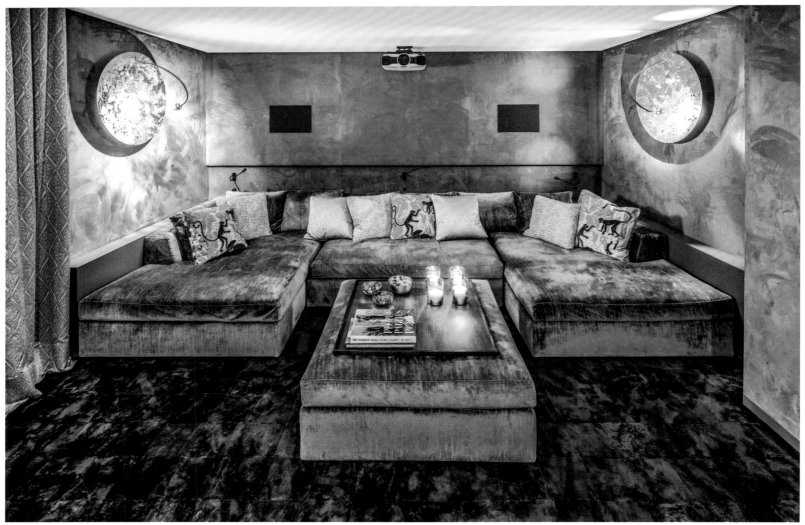

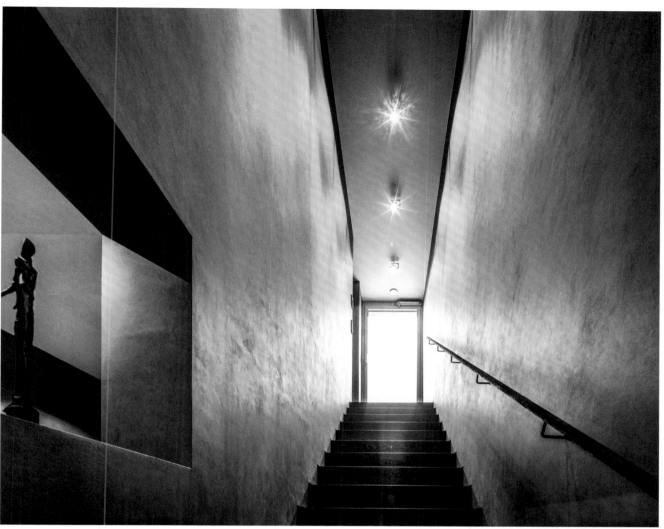

Scheer Architekt
designed the imposing
residence in Munich,
Germany to be a family
home with communal and
private rooms. The stairs
(left) lead to the spa area.

Das anspruchsvolle
Stadtpalais in München
planten Scheer Architekt
als privaten Familiensitz
mit Gemeinschafts- und
Individualräumen. Die
Treppe (links) führt zum
Wellnessbereich.

Scheer Architekt a
planifié le palais citadin
à Munich en tant que do-
micile familial privé avec
des espaces communs et
individuels. L'escalier
(à gauche) conduit à
l'espace bien-être.

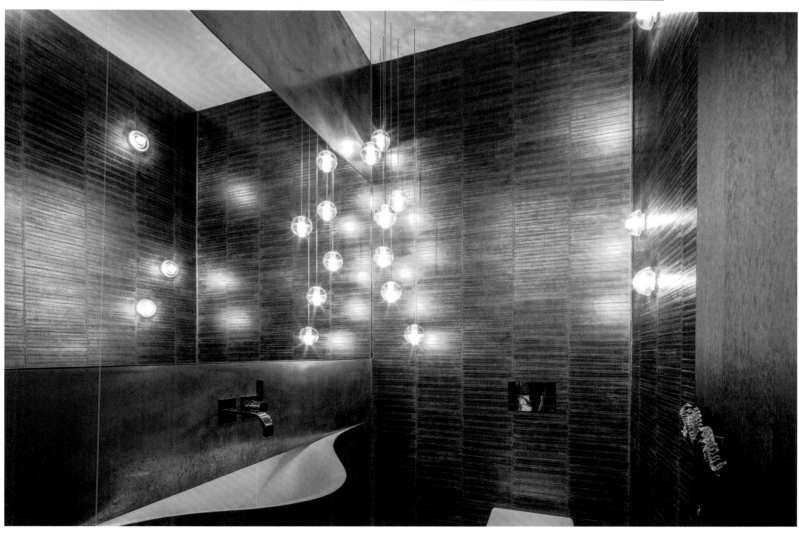

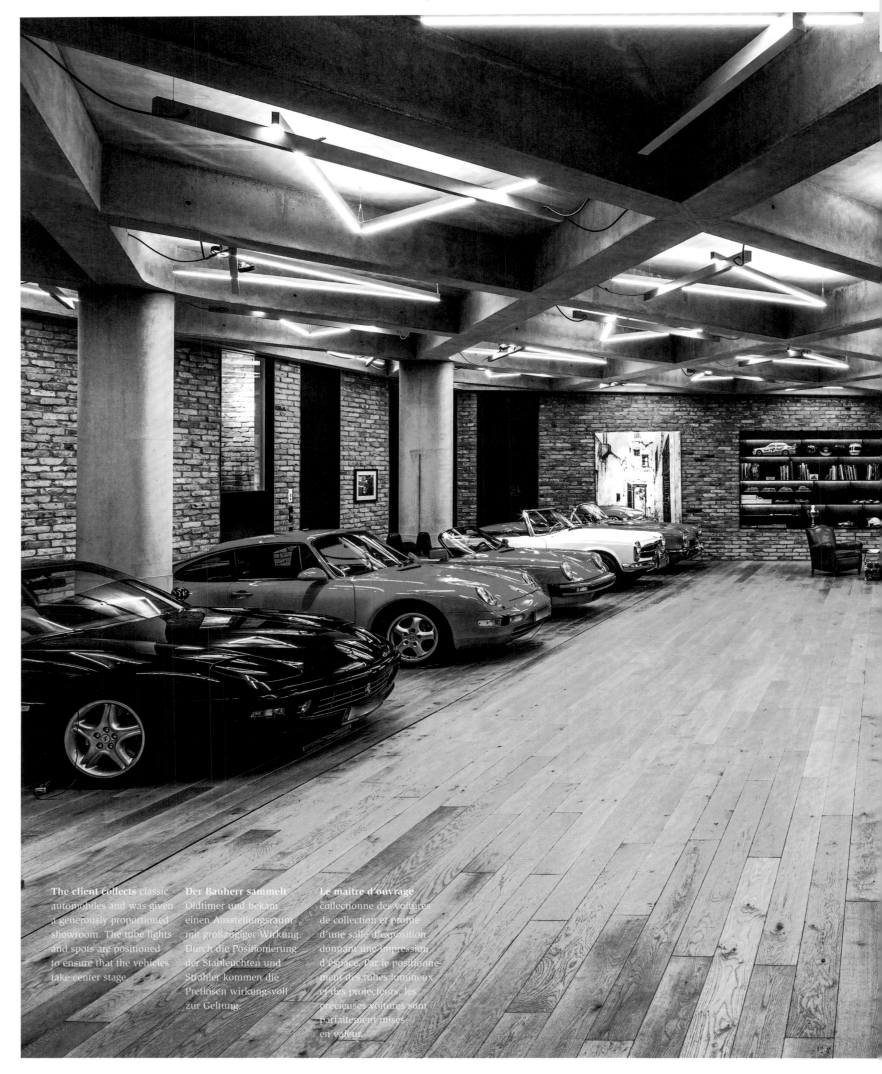

The client collects classic automobiles and was given a generously proportioned showroom. The tube lights and spots are positioned to ensure that the vehicles take center stage.

Der Bauherr sammelt Oldtimer und bekam einen Ausstellungsraum mit großzügiger Wirkung. Durch die Positionierung der Stableuchten und Strahler kommen die Pretiosen wirkungsvoll zur Geltung.

Le maître d'ouvrage collectionne des voitures de collection et profite d'une salle d'exposition donnant une impression d'espace. Par le positionnement des tubes lumineux et des projecteurs, les précieuses voitures sont parfaitement mises en valeur.

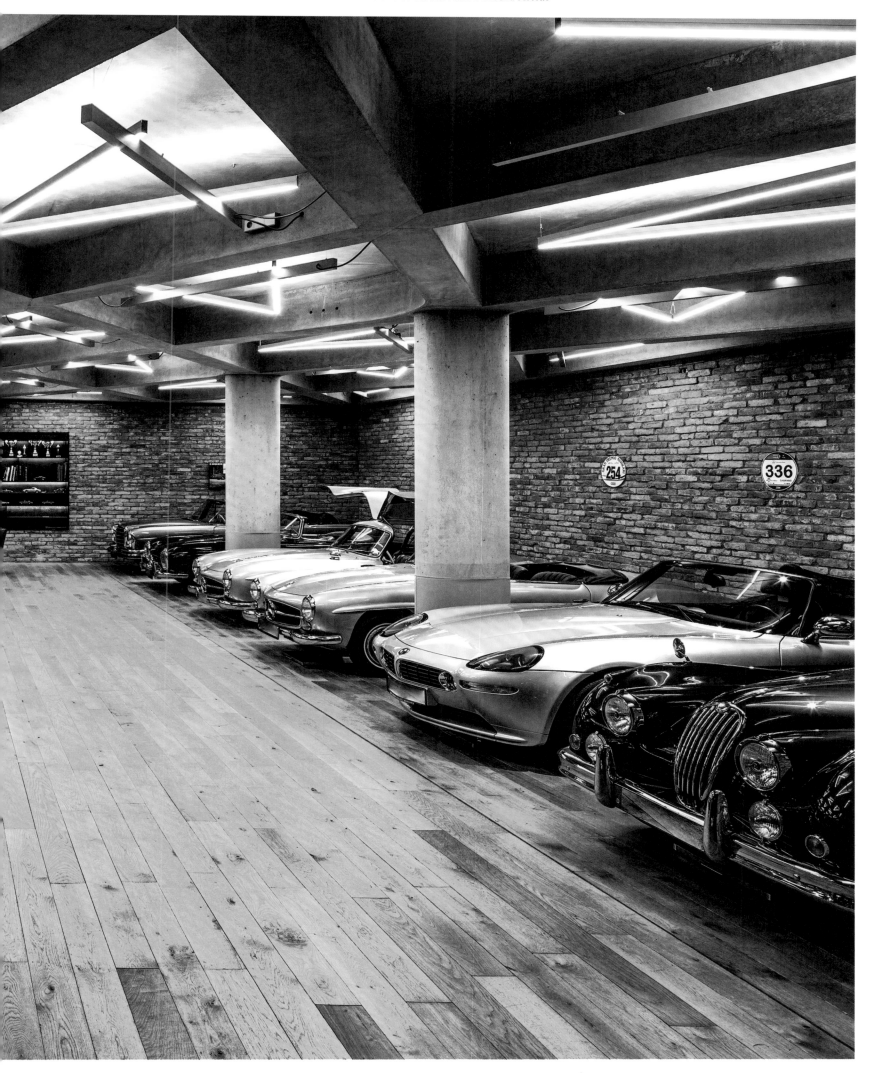

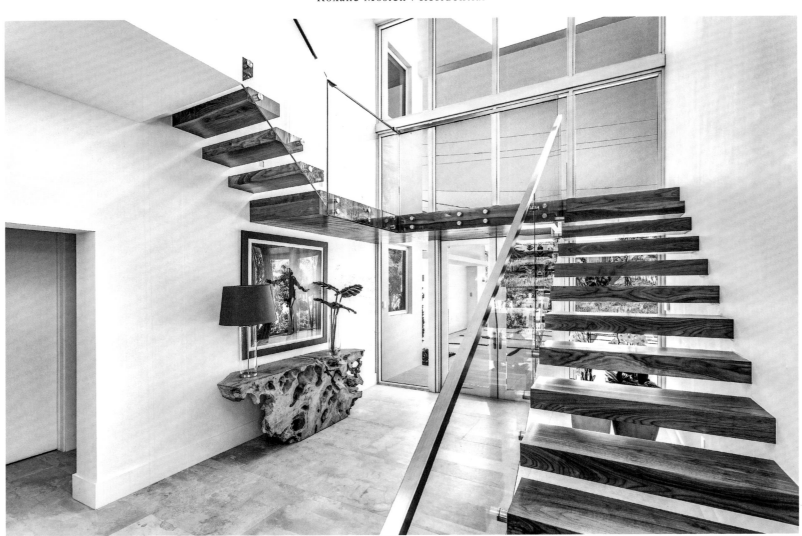

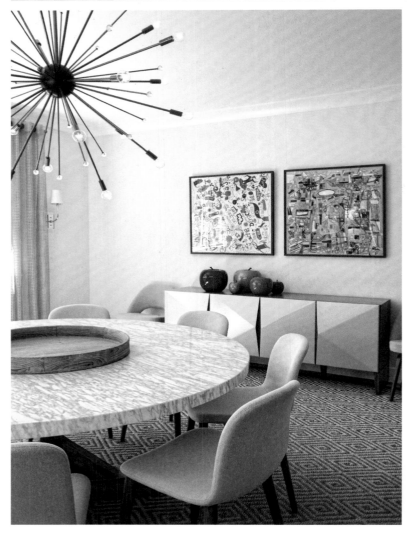

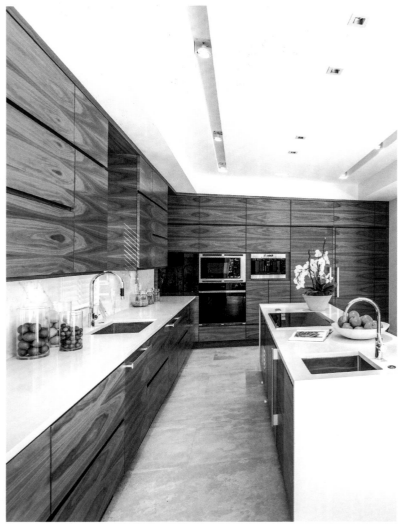

ROXANE MOSLEH

Bridgehampton, United States

"Interior design involves creating with color, orchestrating light, and applying the right amount of technology."
„Interior Design bedeutet Licht inszenieren, Technologien richtig einsetzen, aus Farben schöpfen."
« L'*interior design* signifie mettre en scène la lumière, bien utiliser les technologies, créer à partir de couleurs. »

As a designer, the sources for one's vision can be as varied as the greens of the Amazon. With interior design, Roxane Mosleh considers Italy—with its landscape, light, architecture, and people—the ultimate locale, in every way. Mosleh owned and operated Missoni Home, the first and only U.S. mono-brand retail operation for the Missoni fashion dynasty and, thus, traveled regularly to the country she has such passion for. Mosleh regularly quotes renowned architect Alvar Aalto: "Every one of my buildings begin with an Italian journey." Mosleh studied interior design at SUNY FIT and has represented brands such as Missoni Home, Arclinea and Knoll. She was raised by a Persian father and a French mother who filled their lives with color and elaborate textiles, teaching them to value the beauty of design and architecture. "They introduced me to the traditional and the contemporary, and to combine one with the other," explains the American, whose firm works on both interiors and construction projects out of Bridgehampton, New York. Mosleh was tasked with overseeing a conversion in Miami Beach and redesigning it for resale, opting to make it a modern retreat that blended optically, inside and out. She created a generous entrance using steel, walnut and glass, while the floor, which has the appearance of cast concrete, is actually made up of large-scale ceramic tiles that—as you would expect—hail from Italy.

Inspirationsquellen sind so unterschiedlich wie Grüntöne am Amazonas. Wenn es jedoch um Interior Design geht, steht Italien mit seiner Landschaft, seinem Licht, der Architektur und den Menschen weit oben. Bei Roxane Mosleh kommt hinzu, dass sie für die Modedynastie Missoni den US-Vertrieb leitete und regelmäßig an den Stiefel reiste. Dabei wandelte sie stets auf den Spuren des renommierten Designers und Architekten Alvar Aalto: „Jedes meiner Gebäude beginnt mit einer Italienreise!" Roxane Mosleh, die an der SUNY FIT in New York City Interior Design studierte und neben Missoni und Arclinea auch Knoll vertrat, wuchs, umgeben von Farben und Textilien, mit einem französischen Vater und einer persischen Mutter auf: „Von ihnen lernte ich Tradition und Moderne gleichermaßen wertzuschätzen und das eine mit dem anderen zu kombinieren", erzählt die Amerikanerin, die in Bridgehampton, New York ihr Büro betreibt und als Consultant Einrichtungs- und Bauprojekte berät. In Miami Beach sollte Roxane Mosleh einen Umbau begleiten und für den Verkauf gestalten. Da das Gebäude eher einem Neubau entsprach, entschied sie sich, einen modernen Zufluchtsort zu entwerfen, der Innen und Außen optisch miteinander verschmelzen lässt. Den Eingang konzipierte sie großzügig und offen mit Materialien wie Stahl, Walnussholz und Glas. Der Fußboden erinnert an Gussbeton, besteht aber in Wahrheit aus Keramikfliesen. Und die kommen – wie könnte es anders sein – aus Italien.

Les sources d'inspiration sont aussi variées que les tons de vert de l'Amazonie. Cependant, dans le domaine de la décoration d'intérieur, l'Italie est au premier plan avec son paysage, sa lumière, son architecture et ses habitants. L'autre avantage de Roxane Mosleh est qu'elle a dirigé le département commercial américain pour la dynastie de la mode Missoni et qu'elle se rendait régulièrement dans la Botte. Dans ce cadre, elle n'a cessé de suivre les traces du designer et architecte renommé Alvar Aalto : « Chacun de mes bâtiments commence par un voyage en Italie ! » Roxane Mosleh, qui a étudié l'architecture d'intérieur à New York au SUNY FIT et, outre Missoni et Arclinea, a grandi entourée de couleurs et de textiles, avec un père francais et une mère perse. « Ils m'ont appris à apprécier tant la tradition que la modernité et à les combiner ensemble », raconte l'Américaine qui possède son agence à Bridgehampton, New York et intervient dans des projets de décoration et de construction comme consultante. À Miami Beach, Roxane Mosleh devait accompagner la modification d'un bâtiment et l'aménager pour la vente. Étant donné que le bâtiment correspondait plutôt à une construction neuve, elle a décidé de créer un lieu de retraite moderne qui fusionne visuellement l'intérieur et l'extérieur. Elle a conçu une entrée généreuse et ouverte avec des matériaux comme l'acier, le bois de noyer et le verre. Le sol rappelle du béton coulé mais est composé en réalité de carreaux de céramique. Ils viennent d'Italie, bien évidemment.

JENNIFER POST DESIGN
New York City, United States

"I'm a purist. I create living areas for people who implicitly appreciate space and light."
„Ich bin Purist. Kreiere Wohnräume für Menschen, die bedingungslos Raum und Licht schätzen."
« Je suis une puriste. Je crée des lieux de vie pour les personnes qui apprécient l'espace et la lumière. »

Jennifer Post likes things light and clear-cut. The New York-based interior designer embraces an aesthetic that embodies freedom, one without undue constraint. "I prefer to design for ambitious people who love elegance but at the same time favor a minimalist lifestyle." Post is the mastermind and driving force behind award-winning architecture and design firm, Jennifer Post Design. For over 20 years, she has been at the forefront of creating elegantly modern, contemporary homes with a sophistication sought after by an elite clientele. Post has always been fascinated by diverse architecture and design. After an intermediate stint as a film set designer, she opened her first design studio in Southampton, New York—quickly followed by her first major contract at The Gramercy Park Hotel in Manhattan. A commission

at New York's famous One57 skyscraper (right) further placed her in the spotlight. "The project was exciting—the views from this building cannot be beaten," she says, smiling. No doubt, that also includes the iconic Essex House logo situated at eye level directly outside. Post's ability to edit living spaces to the most essential, uncluttered luxuries has earned her and her firm a world-class reputation amongst the industry's leading architects and designers.

Jennifer Post mag es gerne licht und klar: „Ich entwerfe am liebsten frei und ganz ohne Zwänge. Für Menschen, die anspruchsvoll sind, Eleganz lieben und gleichzeitig gerne minimalistisch leben!" Als führender Kopf von Jennifer Post Design, einem mehrfach prämierten Architektur- und Interior-Design-Büro, arbeitet sie seit 20 Jahren an der vordersten Front der Kreativbranche und gestaltet elegant-moderne Interieurs für einen elitären Kundenkreis. Früh schon war sie von den Themen Architektur und Design fasziniert. Nach einer Zwischenstation als Bühnenbildnerin beim Film eröffnete sie ihr erstes Designstudio in Southampton, New York – kurze Zeit später folgte der erste

Großauftrag für das Gramercy Park Hotel in Manhattan. Ein Projekt in New Yorks berühmtem One57-Wolkenkratzer (rechts) rückte die Kreative noch weiter ins Rampenlicht: „Dieser Auftrag war besonders spannend, denn der Ausblick ist einfach atemberaubend", erklärt sie lachend. Dazu gehört auch das Essex-House-Kultlogo, das sich auf Augenhöhe befindet. Jennifer Post besitzt die besondere Gabe, Lebensräume in essenzielle Luxusoasen zu verwandeln, die nie überladen wirken. Einer der Gründe, warum sie und ihr Team einen Weltklasse-Ruf genießen und zu den führenden Designgrößen der Branche zählen.

Jennifer Post aime ce qui est simple et clair : « J'aime créer librement, sans aucune contrainte. Pour les personnes qui sont exigeantes, aiment l'élégance et aiment également vivre de manière minimaliste ! » En tant que directrice de Jennifer Post Design, une agence d'architecture et d'*interior design* maintes fois primée, elle travaille depuis 20 ans sur le devant de la scène créative et aménage des intérieurs à la fois élégants et modernes pour un cercle de clients privilégiés. Elle a été très tôt fascinée par l'architecture et le design. Après une carrière intermédiaire comme scénographe de films, elle a ouvert sa première agence de design à Southampton, New York. Peu de temps après, elle recevait son premier grand contrat pour le Gramercy Park Hotel à Manhattan. Un projet dans le célèbre gratte-ciel newyorkais One57 (à droite) a placé la créatrice sous les feux de la rampe. « Ce projet a été particulièrement passionnant. En effet, la vue est à couper le souffle », explique-t-elle en riant. On peut notamment admirer à hauteur des yeux le logo culte Essex House. Jennifer Post possède le don particulier de transformer des espaces de vie en oasis puristes de luxe qui ne sont jamais surchargés. C'est l'une des raisons pour lesquelles elle et son équipe jouissent d'une renommée mondiale et font partie des plus grands noms du design du pays.

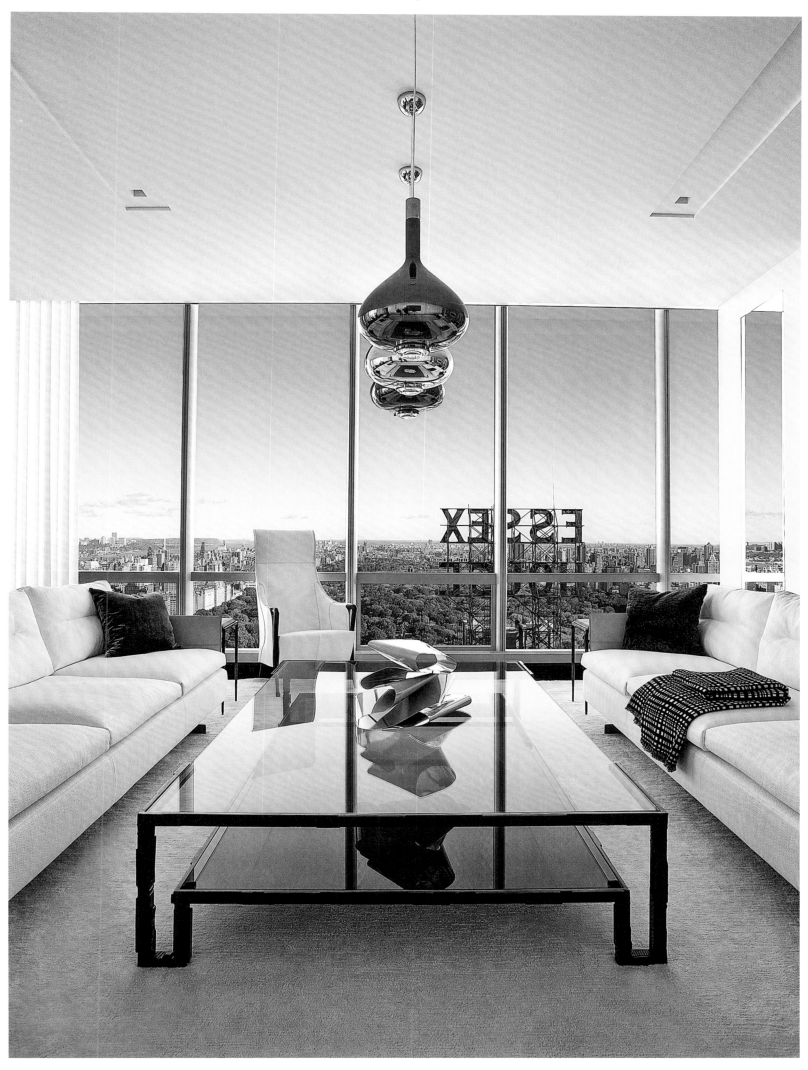

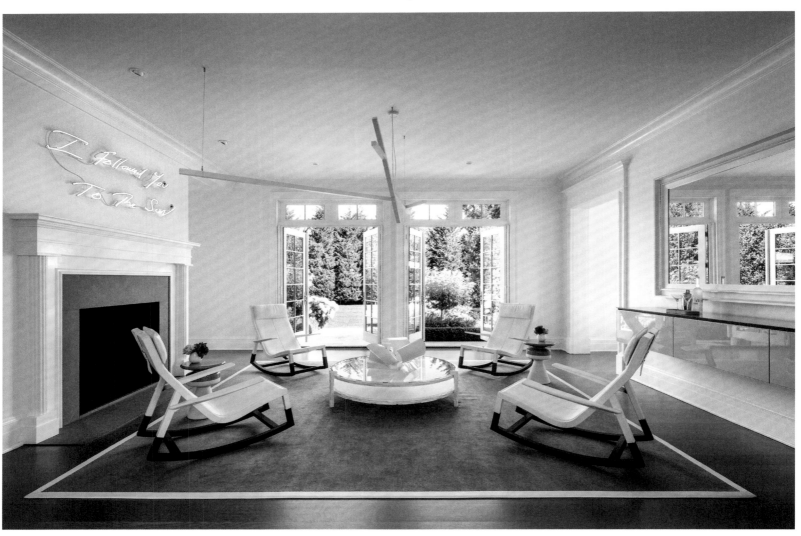

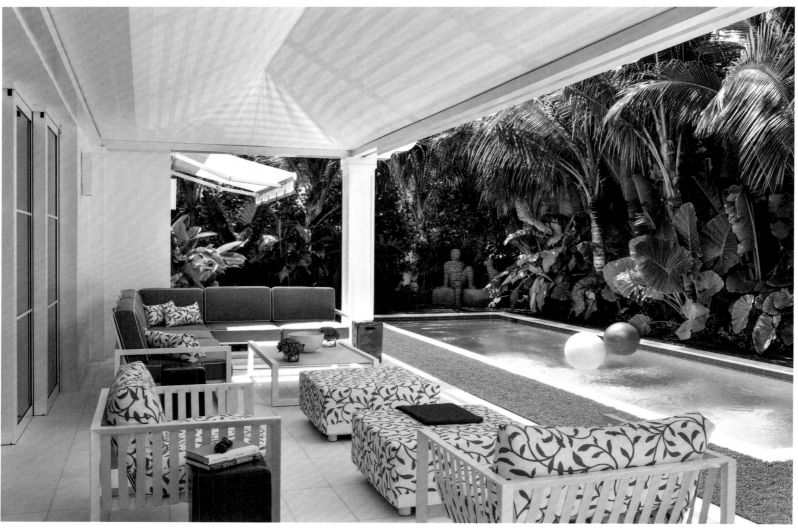

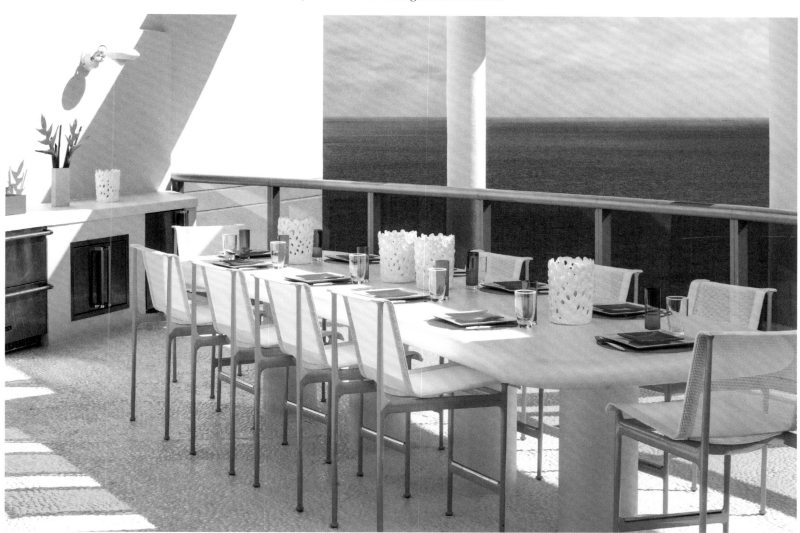

In the lounge of a beach house in Southampton (above left), Jennifer Post placed a white, Poltrona Frau leather rocker on a tailor-made, sea blue Pashmina carpet.

In die Lounge eines Ferienhauses in Southampton (links oben) setzte Jennifer Post weiße lederbezogene Schaukel-stühle von Poltrona Frau auf einen maß-gefertigten meerblauen Pashmina-Teppich.

Dans le lounge d'une maison de vacances à Southampton (en haut à gauche), Jennifer Post a utilisé des chaises à bas-cule blanches, recouvertes de cuir de Poltrona Frau sur un tapis pashmina bleu océan sur mesure.

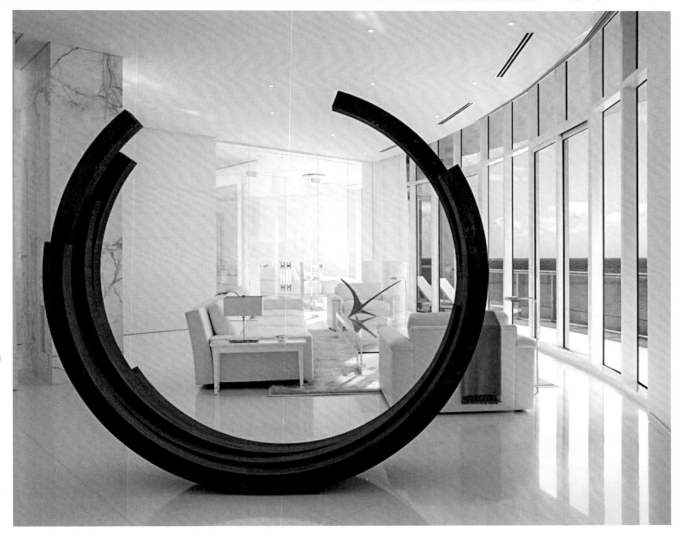

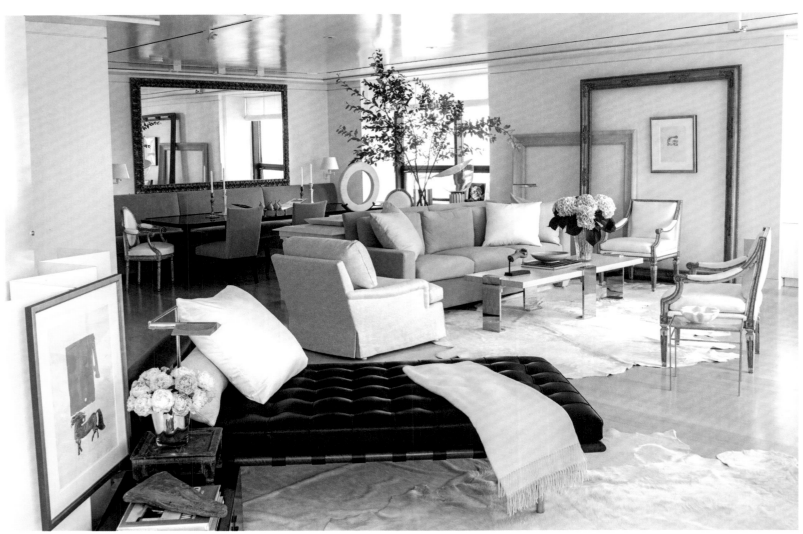

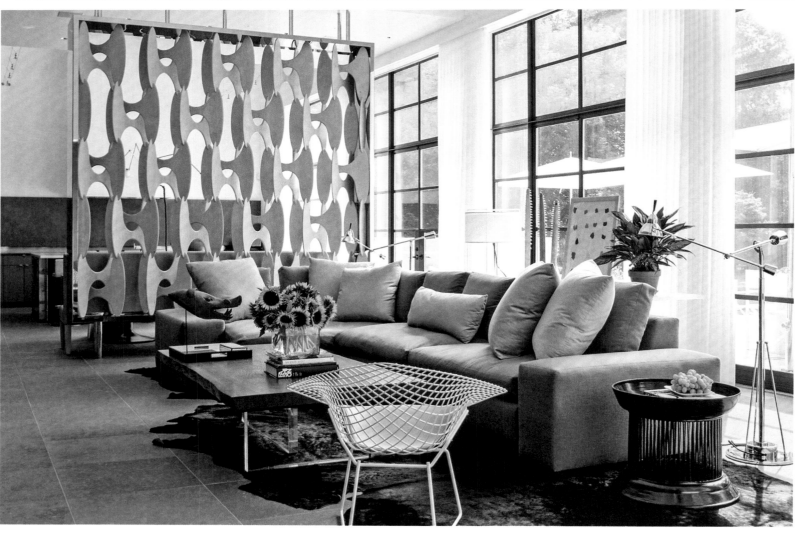

VICENTE WOLF
Associates
New York City, United States

"I am inspired by travel. It trains the eye and generates creativity."
„Was mich inspiriert, sind Reisen. Sie trainieren das Auge und generieren Kreativität."
« Ce sont les voyages qui m'inspirent. Ils entraînent l'œil et génèrent de la créativité. »

Describing him as an interior designer is like trying to describe an entire jigsaw puzzle by looking at a single piece. Vicente Wolf, who has had his own firm in New York City for over 35 years now, is also a furniture designer, a photographer, an art collector, a book author, a passionate traveler, and an expert at combining all these roles. The designer is known far beyond New York's city limits for his clear, restrained, and elegant aesthetic that the native of Cuba likes to blend with a touch of the exotic. "Successful creativity," he believes, "is best achieved when you leave your comfort zone." Which is why every year Vicente Wolf travels to destinations that are as exotic and remote as possible— for example Iran or Borneo. When there, he sources objects and furniture that can be used to create eye-catching displays for his clients. Oftentimes, his own photographs, taken on these trips, are highly sought-after objects. Wolf is convinced that it is this passion that makes his interior design work so focused. "Seeing the world through a lens has sharpened my interior design perception. The way I see floor plans is far more differentiated, forcing me to come up with completely new ideas." In a home, (below left) a Miro-inspired screen becomes an interesting room divider separating the dining area from the living room.

Ihn auf seine Arbeit als Interior Designer festzulegen – es wäre, als würde man nur ein Puzzleteil betrachten. Denn Vicente Wolf, der seit über 35 Jahren in New York City sein Büro betreibt, ist auch Möbeldesigner, Fotograf, Kunstsammler, Buchautor, passionierter Reisender und weiß das eine mit dem anderen zu verknüpfen. Weit über die Grenzen New Yorks ist Vicente Wolf bekannt für seine klare, zurückhaltende und gleichzeitig elegante Ästhetik, die der gebürtige Kubaner gerne mit einem Hauch Exotik mixt: „Erfolgreich kreativ zu sein", ist er sich sicher, „geht am besten, indem man sich aus seiner Komfortzone herausbewegt." Jedes Jahr bereist der Interior Designer deshalb Orte, die möglichst exotisch und abgelegen sind, beispielsweise Iran oder Borneo. Von dort bringt er Gegenstände und Möbel mit, um sie bei seinen Klienten als Blickfang zu arrangieren. Nicht selten sind seine eigenen Fotografien, die während dieser Reisen entstehen, begehrte Objekte. Wolf ist überzeugt, dass es genau diese Leidenschaft ist, die ihn als Interior Designer fokussierter vorgehen lässt: „Die Welt durchs Objektiv wahrzunehmen hat mein Gespür für Interior Design sensibilisiert. Ich nehme Grundrisse wesentlich differenzierter wahr und werde dadurch gezwungen, völlig neue Ideen zu entwickeln." In einem Zuhause (links unten) wird ein Miro inspirierter Screen zum interessanten Raumteiler, der den Essbereich vom Wohnzimmer trennt.

Le cantonner à son travail d'*interior design*er reviendrait à contempler une seule pièce d'un puzzle. En effet, Vicente Wolf, qui possède son bureau à New York depuis plus de 35 ans, est également designer de meubles, photographe, collecteur d'art, auteur de livres, voyageur passionné et sait allier toutes ces casquettes ensemble. Bien au-delà des frontières de New York, Vicente Wolf est connu pour son esthétique claire, discrète et élégante que le Cubain de naissance aime mélanger avec une touche d'exotisme : « Réussir grâce à sa créativité », assure-t-il, « fonctionne lorsque l'on sort de sa zone de confort. » Chaque année, l'*Interior Designer* se rend pour cette raison dans des endroits si possible exotiques et reculés, par exemple en Iran ou à Bornéo. Il ramène des objets et des meubles afin de les mettre en valeur chez ses clients. Il n'est pas rare que ses photographies réalisées pendant ces voyages deviennent des objets prisés. Wolf est convaincu que c'est précisément cette passion qui lui permet de travailler de manière plus engagée en tant qu'*interior designer* : « Percevoir le monde à travers un objectif a développé mon sens de la décoration d'intérieur. Je perçois les plans de manière plus différenciée et je suis ainsi contraint de développer des idées entièrement nouvelles. » Dans un logement (en bas à gauche), un écran d'inspiration Miro devient un séparateur de pièce intéressant qui délimite le coin repas et le séjour.

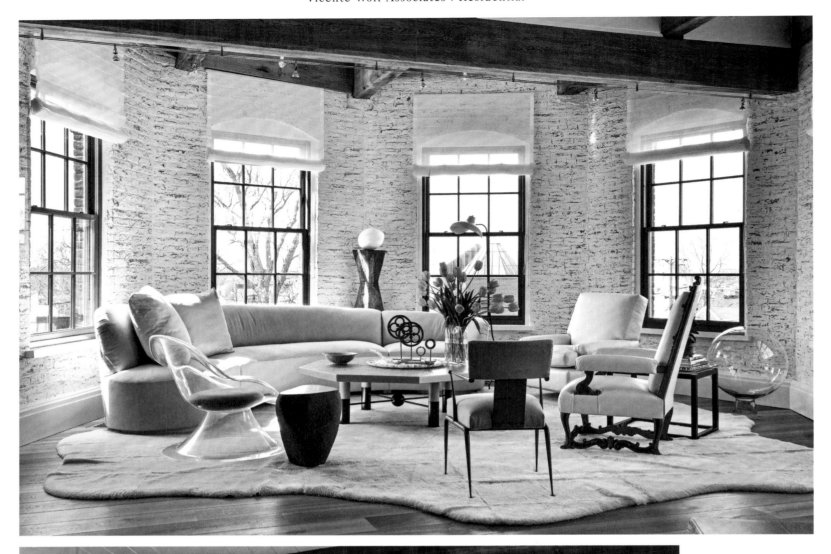

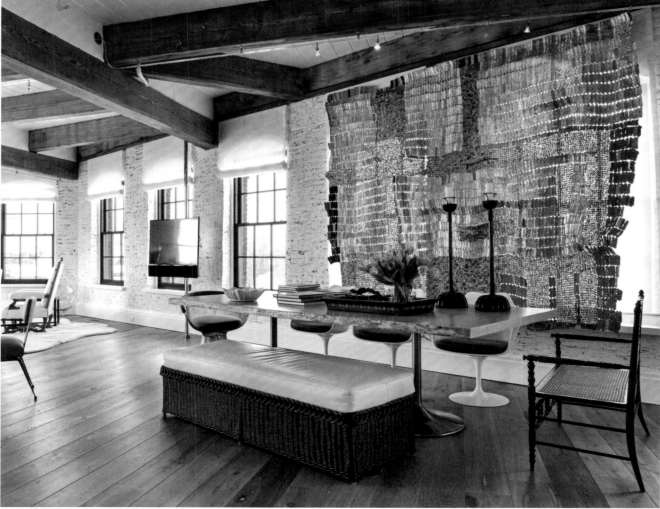

A watch factory (left) was transformed into a loft. Vicente Wolf combined a Vladimir Kagan sofa with antiques, Saarinen Tulip chairs, and a tapestry by African artist El Anatsui.

Eine Uhrenfabrik (links) wurde zum Loft. Vicente Wolf kombinierte ein Sofa von Vladimir Kagan mit Antiquitäten, den Saarinen Tulip-Stühlen und einer Tapisserie des afrikanischen Künstlers El Anatsui.

Une manufacture horlogère (à gauche) a été transformée en loft. Vicente Wolf a combiné a un canapé de Vladimir Kagan avec des antiquités, des chaises tulipes Saarinen et une tapisserie de l'artiste africain El Anatsui.

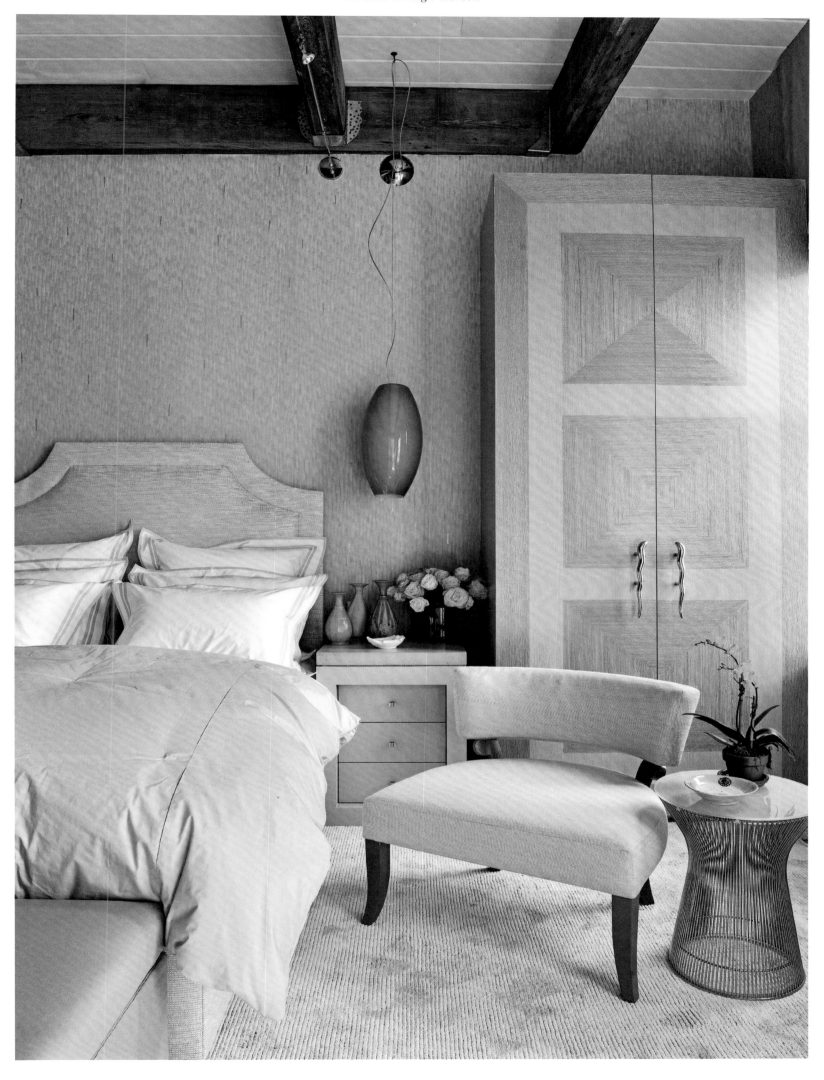

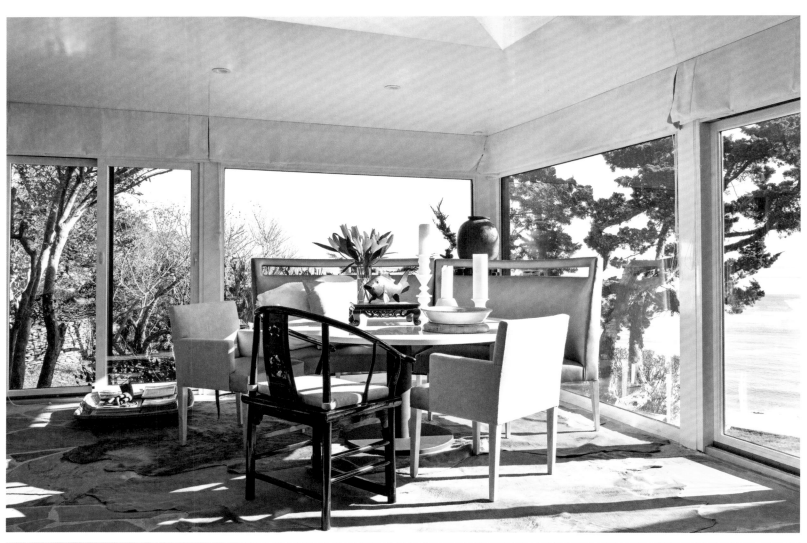

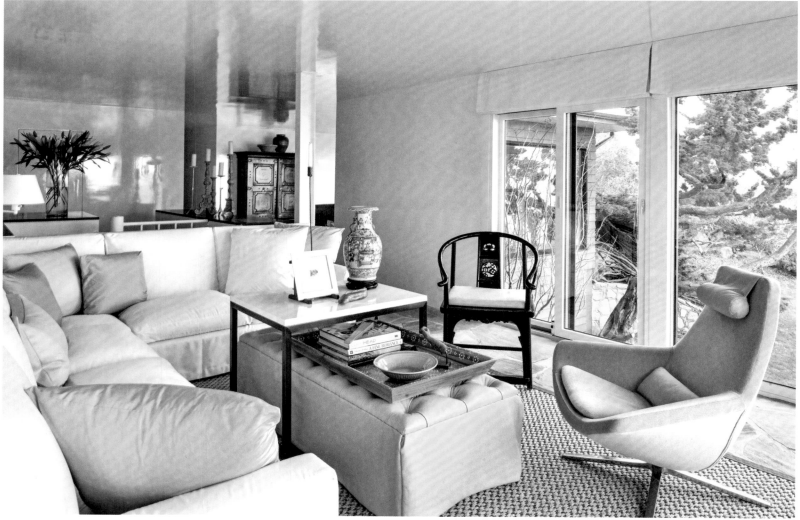

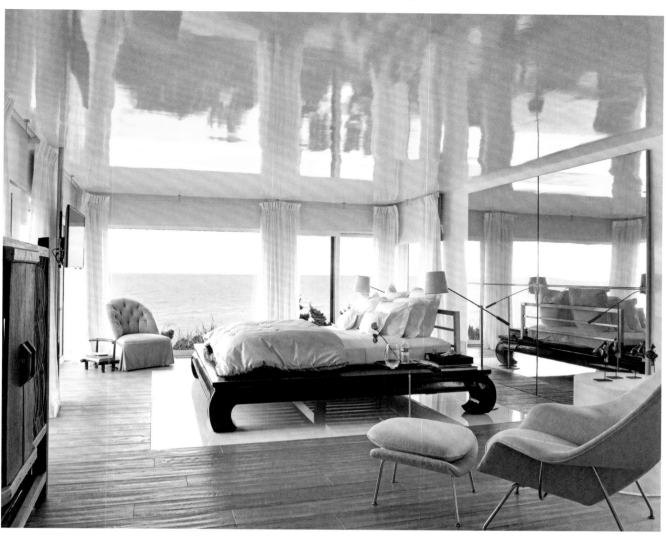

Vicente Wolf designed the dining room furniture to be subtle enough to give precedence to the panoramic view (top left of the page). For a Bali-based client he had a native-style bed made to function as the room's eye-catcher (left).

Die Esszimmermöbel entwarf Vicente Wolf zierlich genug, um dem Panorama den Vortritt zu lassen (linke Seite oben). Für einen Kunden auf Bali fertigte er stilgerecht ein Bett als Blickfang im Raum (diese Seite links).

Vicente Wolf a dessiné les meubles de la salle à manger de manière suffisamment gracieuse pour laisser la priorité au panorama (page de gauche, en haut). Pour un client de Bali, il a réalisé un lit stylisé en tant qu'élément-phare de la pièce (cette page à gauche).

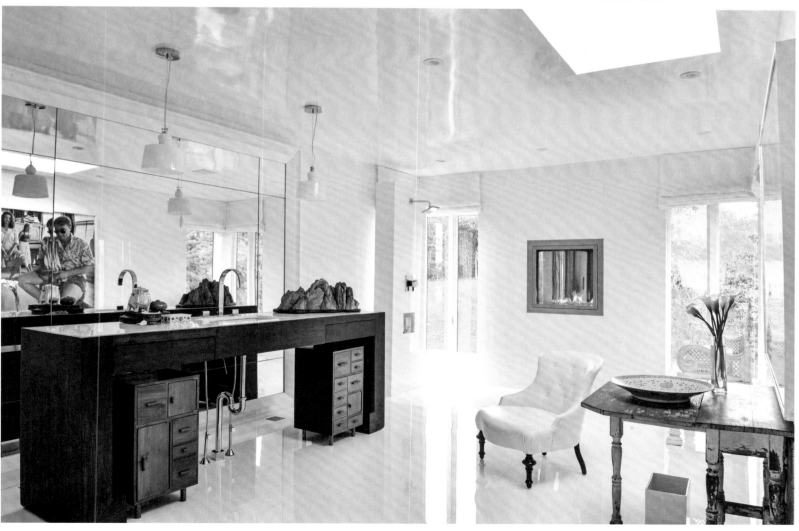

JAYNE DESIGN STUDIO
New York City, United States

"I have always been attracted to history and to objects linked with it."
„Ich fühle mich von der Vergangenheit und Objekten, die daraus hervorgegangen sind, angezogen."
« Je me sens attiré par le passé et les objets qui en découlent. »

If you look at Thomas Jayne's career, two things spring to mind: either the Californian has numerous parallel lives or he has an inherent gift for using his time extremely well. Jayne studied at the University of Oregon School of Architecture and Allied Arts before completing his Master of Arts in American and European History within the scope of a Winterthur Museum scholarship in Delaware. A further scholarship at the Metropolitan Museum of Art was followed by two years at Christie's, where he appraised European and American objects for auction catalogs. To delve into the world of interior design he worked for influential American design studios Parish-Hadley and Kevin McNamara. Thomas Jayne opted for self-employment in 1990, and his name has become synonymous with a profound knowledge of the subject ever since. But that's not all; he understands better than most how to put historical buildings into a clear and contemporary context: "I like old things, but I want them to look fresh and meet present-day expectations." Jayne experiments with color and creates juxtapositions that astound at first glance, but are surprisingly compatible within the overall appearance. Thomas Jayne designed a holiday home for a family in Oyster Bay, Long Island (right) as a multi-generation house. The owners wanted a harmonious blend of the traditional and the contemporary. Thomas Jayne and his team were the perfect choice.

Wer sich mit Thomas Jaynes Vita befasst, dem kommen zwei Dinge in den Sinn: entweder verfügt der Kalifornier über mehrere Parallelleben oder er hat die Gabe, seine Zeit extrem gut zu nutzen. Jayne studierte an der University of Oregon School of Architecture and Allied Arts bevor er den Master of Arts in Amerikanischer und Europäischer Geschichte im Rahmen eines Stipendiums am Winterthur Museum in Delaware absolvierte. Es folgte ein weiteres Stipendium am Metropolitan Museum of Art sowie zwei Jahre bei Christie's, wo er für Auktionskataloge europäische und amerikanische Objekte begutachtete. Um in die Welt des Interior Designs einzutauchen, arbeitete er bei den namhaften amerikanischen Designern Parish-Hadley sowie Kevin McNamara. 1990 machte Jayne sich selbstständig – seither bürgt sein Name nicht nur für profunde Sachkenntnis. Er versteht es wie kaum ein anderer, historische Bauwerke in einen zeitgenössischen und lichten Kontext einzubinden: „Ich liebe das Alte – aber möchte, dass es frisch aussieht und in die heutige Zeit passt." Jayne experimentiert gerne mit Farben, schafft Gegensätze, die auf den ersten Blick erstaunen, in der Gesamtoptik aber überraschend gut zusammenpassen. Ein Ferienanwesen in Oyster Bay, Long Island (rechts) gestaltete Thomas Jayne für eine Familie als Mehrgenerationenhaus. Die Besitzer wünschten sich eine harmonische Mischung aus Tradition und Gegenwart. Thomas Jayne und sein Team waren die ideale Besetzung.

Si l'on étudie le curriculum de Thomas Jayne, on remarque deux choses : soit le Californien a vécu plusieurs vies en parallèle, soit il a le don d'exploiter son temps de manière optimale. Jayne a étudié à l'University of Oregon School of Architecture and Allied Arts avant d'obtenir un Master of Arts en Histoire américaine et Histoire européenne dans le cadre d'une bourse au Winterthur Museum dans le Delaware. S'en est suivi une autre bourse au Metropolitan Museum of Art et deux ans chez Christie's où il a expertisé des objets européens et américains pour des catalogues de ventes aux enchères. Afin de plonger de l'univers de l'*interior design*, il a travaillé pour les designers américains de renom Parish-Hadley et Kevin McNamara. En 1990, Jayne s'est mis à son compte. Désormais, son nom est notamment synonyme d'une expertise profonde. Il est également l'un des seuls á réussir á intégrer des bâtiments historiques dans un contexte contemporain et simple : « J'aime l'ancien mais je veux qu'il semble frais et soit adapté à l'époque actuelle ». Jayne aime expérimenter avec les couleurs, créer des contrastes qui étonnent au premier regard, mais sont étonnamment harmonieux dans le concept général. Thomas Jayne a aménagé une résidence de vacances à Oyster Bay, Long Island (à droite) pour une famille qui voulait en faire une maison réunissant les générations. Les propriétaires souhaitaient un mélange harmonieux de tradition et de passé. Thomas Jayne et son équipe étaient les partenaires parfaits pour cela.

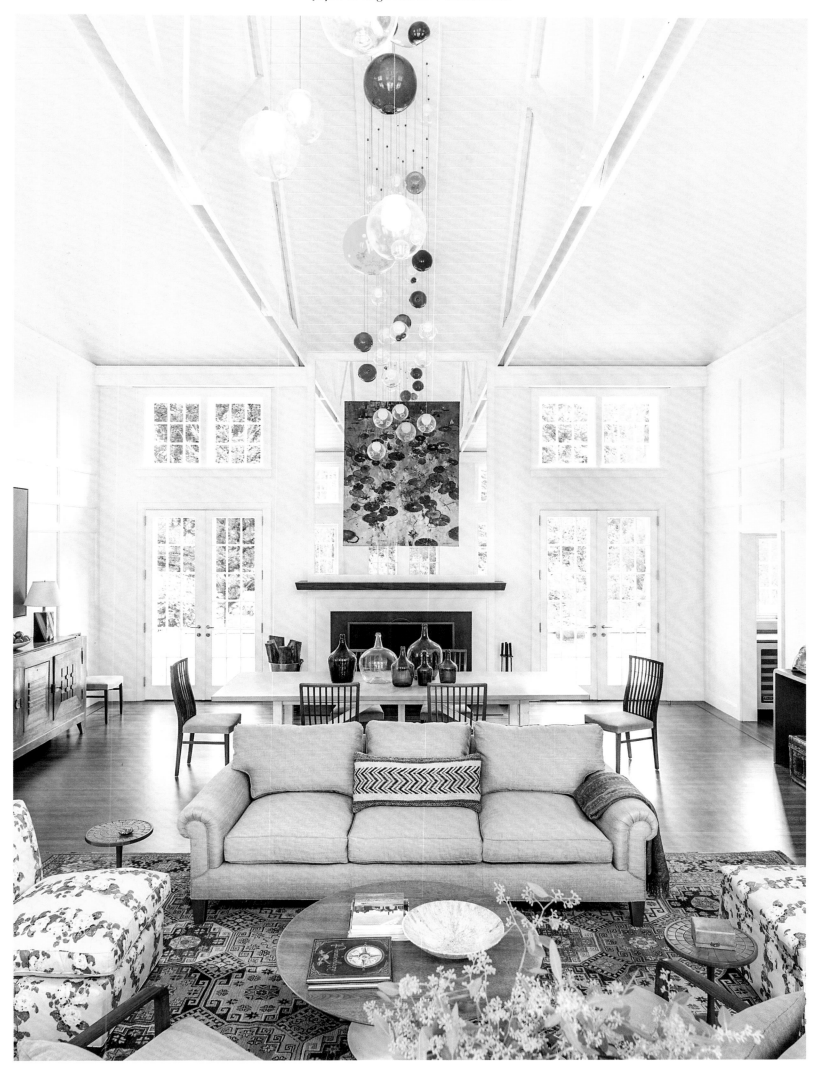

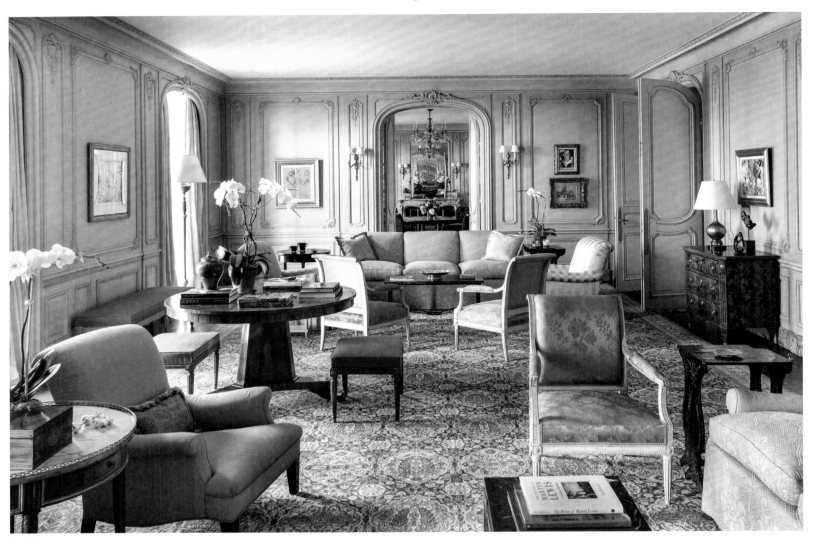

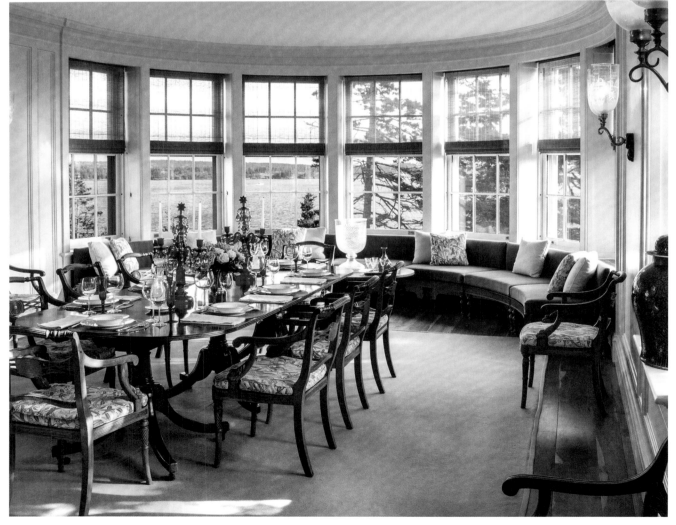

Thomas Jayne evoked the colorful sky and sea environment in the dining room of a villa in Maine with vistas over the water (left): he had the neo-classic chairs coated blue and green.

Im Esszimmer einer Villa in Maine mit Aussicht aufs Wasser (links) zitierte Thomas Jayne die Far-benwelt von Himmel und Meer: die neoklassizisti-schen Stühle ließ er blau und grün lackieren.

Dans la salle à manger d'une villa du Maine avec vue sur l'eau (à gauche), Thomas Jayne a cité l'uni-vers de couleurs du ciel et de la mer : il fait peindre les chaises de style néo-classique en bleu et vert.

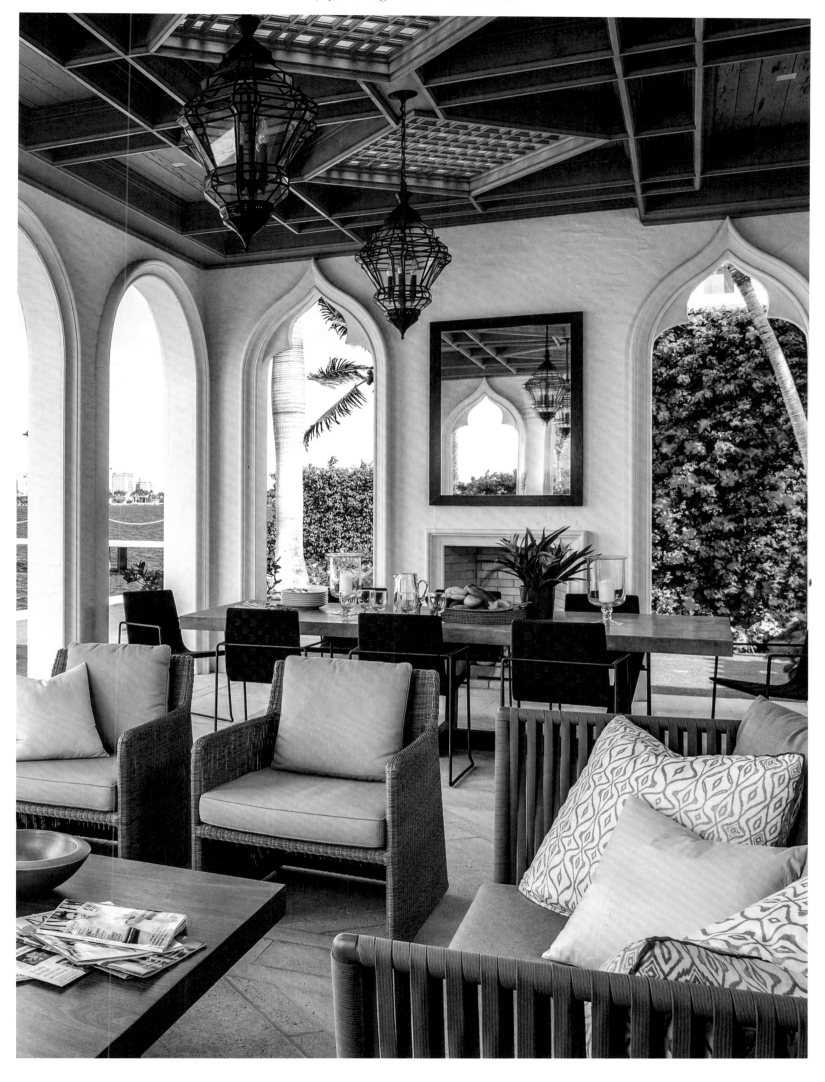

ROBERT COUTURIER
New York City, United States

"A successful project should sincerely reflect the client's sentiments."
„Ein erfolgreiches Projekt sollte die Empfindungen des Klienten direkt widerspiegeln.“
« Un projet réussi doit refléter directement le ressenti du client. »

Sometimes it's all in the name. That is definitely the case when it comes to New York interior decorator and designer Robert Couturier. Born in Paris, Couturier spent much of his childhood with his charismatic grandmother, who owned a glamorous house designed by Jean-Michel Frank in the 16th arrondissement. "When your past has that kind of start," Couturier is certain, "then the basis to spawn new creative processes is a good one." After studying interior decorating and design at the École Camondo in Paris, in 1978 the Frenchman moved to New York City, where he opened his own office nine years later. A pivotal moment was when the billionaire Sir James Goldsmith commissioned the interior designer to revamp his 5,500-square-meter (59,201-square-foot) estate La Loma on the Pacific coast of Mexico. Only 32 years old, for Couturier this was paramount to being knighted—ultimately, Goldsmith could afford to engage any interior designer in the

world. The way Couturier tackles a project is exceptional and full of passion and esprit. Decoration not only has to meet the needs of people, but also the architecture and environment. A prime example is the splendid country estate in Hampshire, England, built in 1900 by Edwin Lutyens (right). Robert Couturier, who had already designed houses in New York, Gstaad and London for the owner, decided against using further antiques and instead favored contemporary furniture. He firmly believes that "this would wake up the ancient walls!"

Ein Name kann Verheißung sein. Bei dem New Yorker Innenarchitekt und Designer Robert Couturier ist das definitiv der Fall. Geboren in Paris verbrachte Couturier viele Jahre seiner Kindheit bei der charismatischen Großmutter, die ein glamouröses Haus im 16. Arrondissement besaß, entworfen von Jean-Michel Frank: „Wenn man mit einer solchen Vergangenheit startet, ist die Basis für neue Schaffensprozesse eine gute“, ist sich Couturier sicher. Nach einem Studium der Innenarchitektur und des Interior Designs an der École Camondo in Paris zog es den Franzosen 1978 nach New York City, wo er neun Jahre später sein eigenes Büro eröffnete. Ausschlaggebend war ein Auftrag des Milliardärs Sir James Goldsmith, für den der Interior Designer das Anwesen La Loma mit über 5.500 Quadratmetern an der Pazifikküste

Mexikos gestalten durfte: für den erst 32-Jährigen so etwas wie ein Ritterschlag – denn Goldsmith hätte sich jeden Interior Designer der Welt leisten können. Die Art, wie Couturier an Projekte herangeht, ist einzigartig, voller Leidenschaft und Esprit: Dekoration solle nicht nur den Menschen, sondern auch der Architektur und Umgebung gerecht werden. Bestes Beispiel: ein großartiges Country-Anwesen in Hampshire, England, erbaut 1900 von Edwin Lutyens (rechts). Robert Couturier, der für die Besitzer bereits Häuser in New York, Gstaad und London gestaltete, entschied sich gegen weitere Antiquitäten und für zeitgenössische Möbel. Er findet: „Sie wecken die alten Mauern auf!“

Un nom peut sonner comme une promesse. C'est totalement le cas de l'architecture d'intérieur et designer new-yorkais Robert Couturier. Né à Paris, Couturier a passé de nombreuses années de son enfant chez sa grand-mère charismatique qui possédait une maison glamour dans le 16e arrondissement, réalisée par Jean-Michel Frank : « Lorsque l'on démarre avec un tel passé, on a forcément une bonne base pour de nouveaux processus créatifs », assure Couturier. Après des études d'architecture intérieure et d'*interior design* à l'École Camondo à Paris, le Francais a déménagé à New York où il a ouvert son propre bureau neuf ans plus tard. Une commande du milliardaire Sir James Goldsmith pour laquelle le décorateur d'intérieur a aménagé la propriété La Loma avec plus de 5.500 m² sur la côte Pacifique du Mexique a été décisive : cela a été la consécration pour l'homme de 32 ans. En effet, Goldsmith aurait pu s'offrir n'importe quel *interior designer* dans le monde. La manière dont Couturier aborde ses projets est unique, elle est pleine de passion et d'esprit. La décoration doit être adaptée aux personnes ainsi qu'à l'architecture et à l'environnement. Le meilleur exemple : une magnifique propriété Country dans le Hampshire, Angleterre, construit en 1900 par Edwin Lutyens (à droite). Robert Couturier, qui a déjà aménagé des maisons à New York, Gstaad et Londres pour leurs propriétaires, a préféré des meubles contemporains à de nouvelles antiquités. Selon lui : « Ils réveillent les murs anciens ! »

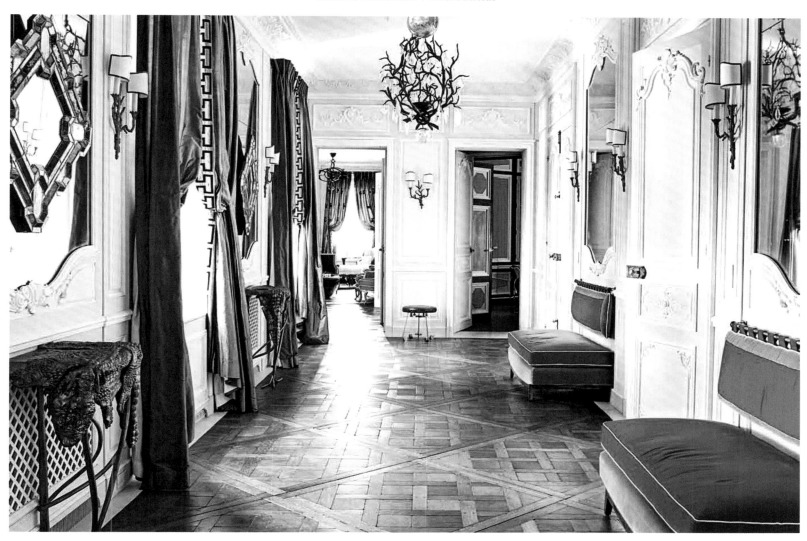

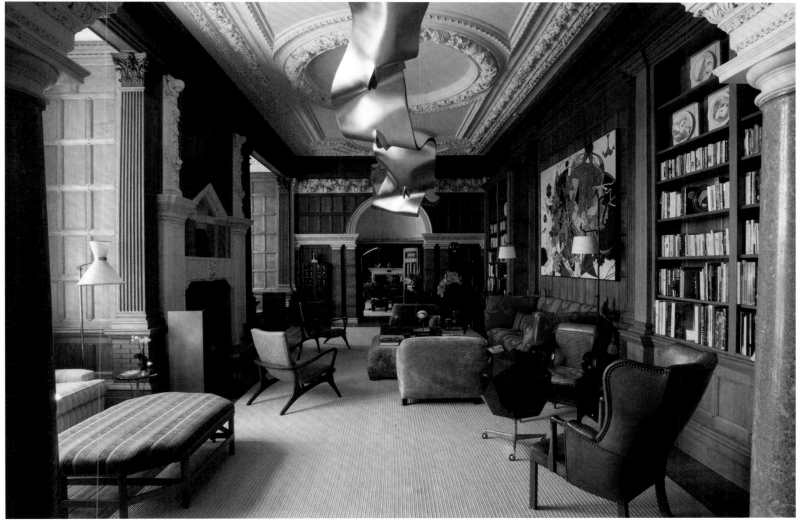

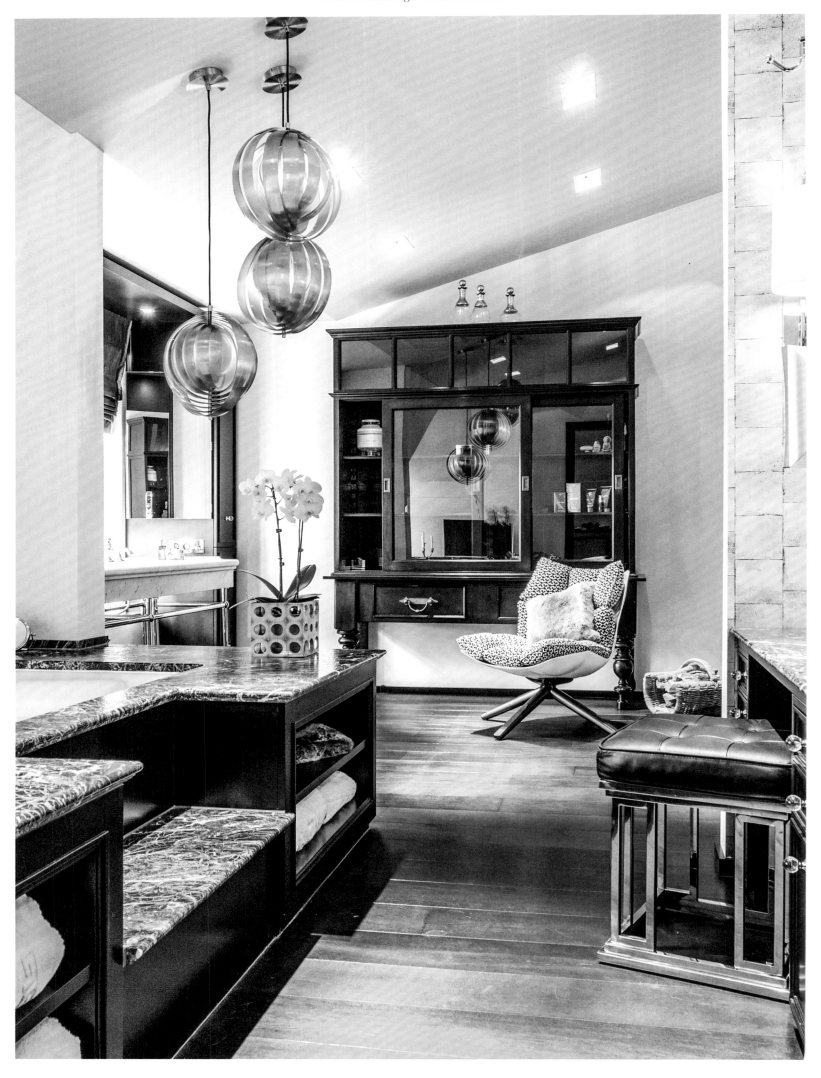

PETER BUCHBERGER
Munich, Germany

"Interior design should be timeless and have the potential to become a classic."
„Interior Design sollte zeitlos sein und das Potential haben, als Klassiker bestehen zu können."
« La décoration d'intérieur doit être atemporelle et avoir le potentiel d'exister en tant que classique. »

Peter Buchberger compares his work to the creative process experienced by an opera composer—not only because he loves music. The Munich-based interior designer, who has created concepts for prestigious hospitality companies such as Munich's Käfer-Restaurant as well as many villas and private projects, believes that both professions must find a way to combine signature style with the client's brief. Taking the history of the house and its surroundings into consideration is a must—"I would never dream of putting a minimalist Minotti sofa into a traditional Provençal house!" Despite this, the interior designer, who prefers to be described as a "compositeur", is a fan of clashes, believing that an interesting style mix can be stimulating. What matters most, he believes, is the quality of the furniture and objects, saying that "interior design should never try to be on-trend or artificial; it must have the potential to become a classic!" In a city villa in Munich (left) Peter Buchberger decided on an eclectic mix of design originals from the 1950s, 60s, and 70s. For the master bathroom he selected beautiful Moon lamps by Verner Panton, whose timeless designs he admires. They not only provide atmospheric lighting but also complement the colors of the reddish brown marble and warm wood flooring. The designer has also provided a touch of drama by grouping the lights together.

Er vergleicht seine Arbeit mit dem kreativen Prozess eines Opernkomponisten. Nicht nur, weil Peter Buchberger die Musik liebt. Der Münchener Interior Designer, der renommierte Gastronomiebetriebe wie das Münchener Käfer-Restaurant, aber auch zahlreiche Villen und Privatprojekte gestaltet hat, sagt, beide müssten einen Weg finden, die eigene Handschrift mit den Wünschen des Auftraggebers in Einklang zu bringen. Die Geschichte eines Hauses und seine Umgebung zu berücksichtigen, sei unerlässlich: „Ein minimalistisches Minotti-Sofa in ein ortstypisches Haus der Provence zu stellen, käme mir im Leben nicht in den Sinn!" Brüche indes mag der Interior Designer, der sich selbst lieber als „Komponist" verstanden wissen will, sehr. Er findet, dass Spannung gerade durch einen interessanten Stilmix entstehe. Ausschlaggebend ist für den Kreativen die Qualität der Möbel und Objekte: „Interior Design darf niemals modisch oder aufgesetzt sein, sondern muss das Potenzial zum Klassiker haben!", ist sich der Einrichter sicher. In einer Stadtvilla in München (links) entschied sich Peter Buchberger für eine eklektische Mischung mit Design-Originalen aus den Fünfziger-, Sechziger- und Siebzigerjahren. Für das Masterbad wählte er die formschönen Moon-Lamps von Verner Panton, dessen zeitlose Entwürfe er verehrt. Sie sorgen nicht nur für stimmungsvolles Licht, sondern passen farblich zum rotbraunen Marmor und den warmen Holzdielen. Ein bisschen Drama darf dennoch sein: Die Leuchten hat Peter Buchberger als Gruppe arrangiert.

Il compare son travail au processus créatif d'un compositeur d'opéra. Le fait que Peter Buchberger aime la musique n'est pas la seule raison à cela. L'*interior designer* de Munich, qui a aménagé des établissements gastronomiques de renom comme le restaurant munichois « Käfer » ainsi que de nombreuses villas et projets privés, est d'avis qu'il faut réussir à combiner de manière harmonieuse sa touche personnelle et les envies du client. Il est impératif de tenir compte de l'histoire d'une maison et de ses environs : « Il ne me viendrait jamais à l'idée d'installer un canapé minimaliste Minotti dans une maison typiquement provençale ! » Cependant, l'*interior designer*, qui préfère le titre de « compositeur », aime beaucoup les contrastes. Il trouve que ce sont justement les mélanges intéressants de styles qui sont passionnants. La qualité des meubles et des objets est décisive pour le décorateur : « L'*interior design* ne doit jamais être tendance ou surjoué, il doit avoir le potentiel nécessaire pour devenir classique ! » souligne le décorateur d'intérieur. Dans une maison de ville à Munich (à gauche), Peter Buchberger a opté pour un mélange éclectique contenant des éléments design originaux des années 50, 60 et 70. Pour la salle de bain principale, il a choisi les moon lamps esthétiques de Verner Panton dont il adore les créations atemporelles. Elles diffusent une lumière d'ambiance et sont assorties au marbre brun rougeâtre et aux couleurs chaudes du plancher en bois. Néanmoins, car l'on peut quand même s'autoriser une touche théâtrale : Peter Buchberger a regroupé les lampes entre elles.

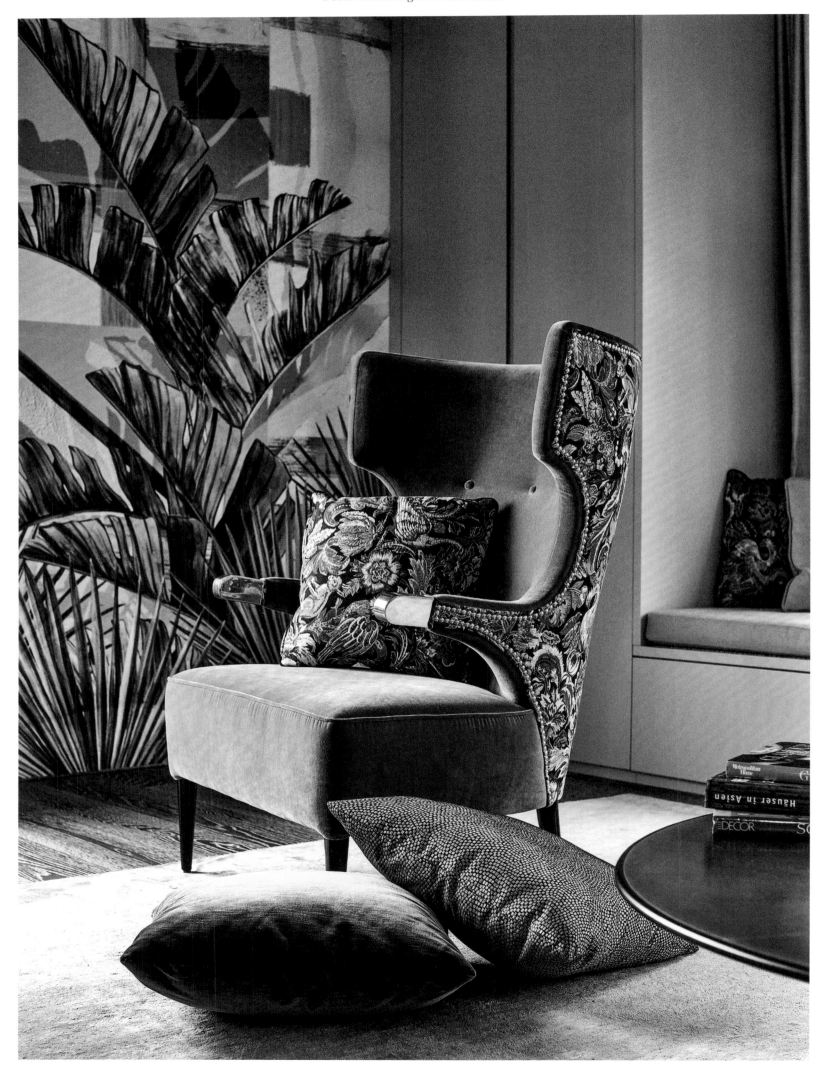

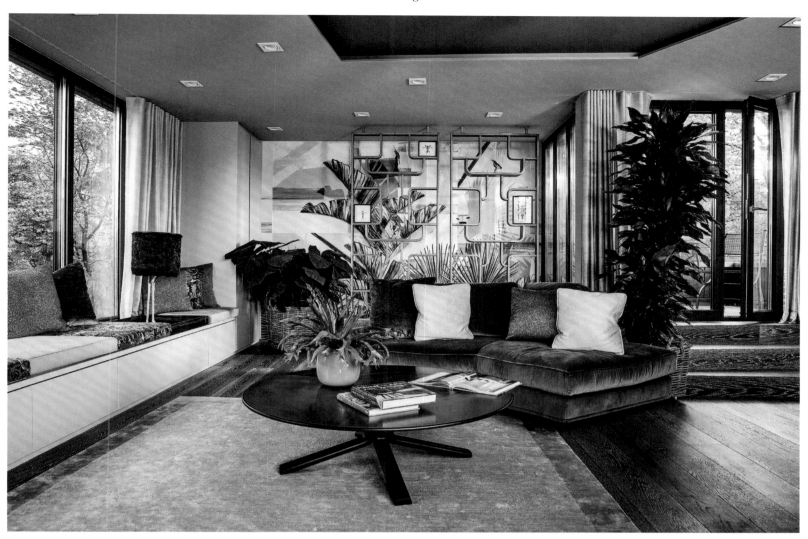

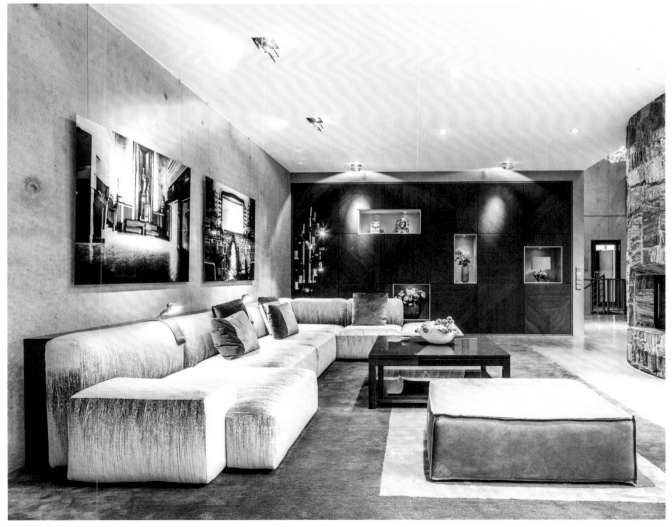

The mix makes the look interesting—at a Munich architect's villa, Peter Buchberger combined eye-catching hero pieces with warm background colors and carefully chosen fabrics.

Der Mix macht den Look interessant: Für eine Münchener Architekten-Villa kombinierte Peter Buchberger auffällige Solitäre mit warmen Hintergrundtönen und ausgesuchten Stoffen.

C'est le mélange qui rend le style intéressant : pour la villa d'un architecte munichois, Peter Buchberger a combiné des touches individuelles marquantes à des tons chauds en arrière-plan et des tissus choisis.

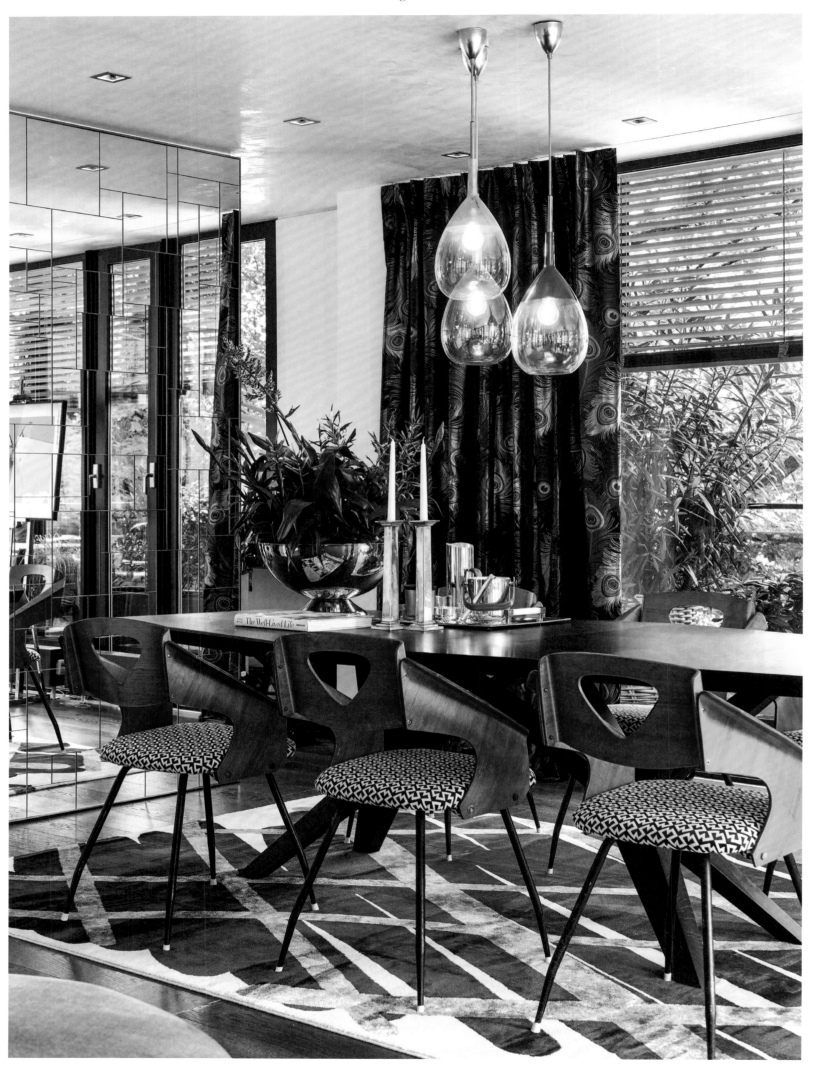

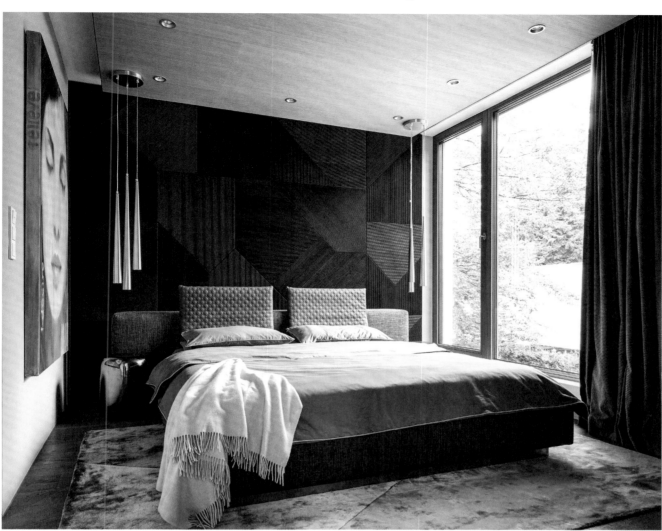

Colors are always a key feature—never too loud or harsh but still a clear statement. In the case of a classic modernist-style villa, Peter Buchberger took his inspiration from fall colors.

Farben spielen eine immanente Rolle: niemals schrill und laut, trotzdem klar in der Aussage. Bei einer Villa im Stil der klassischen Moderne ließ sich Peter Buchberger vom Herbst inspirieren.

Les couleurs jouent un rôle fondamental : elles ne doivent jamais être perçantes ni agressives mais livrer quand même un message clair. Dans une villa de style moderne classique, Peter Buchberger s'est inspiré de l'automne.

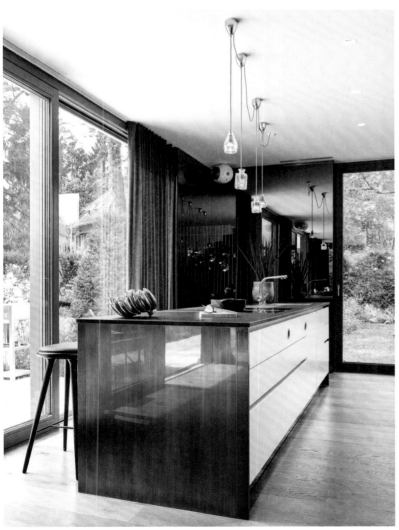

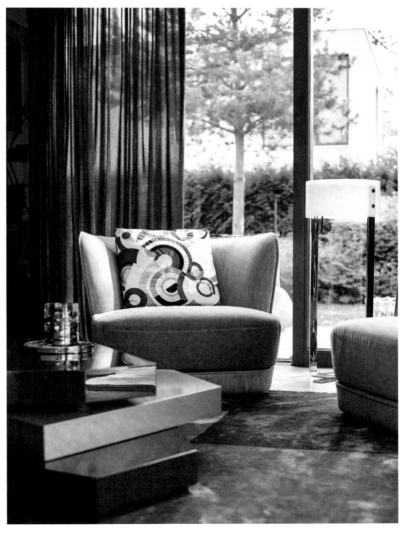

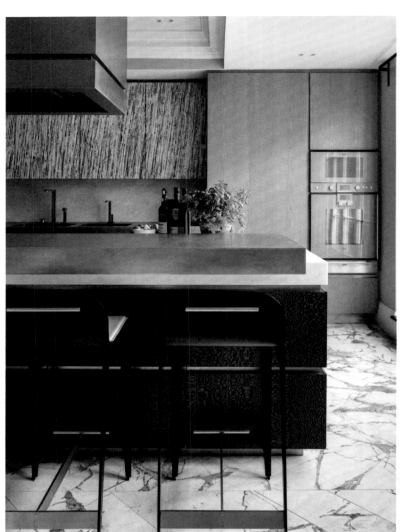

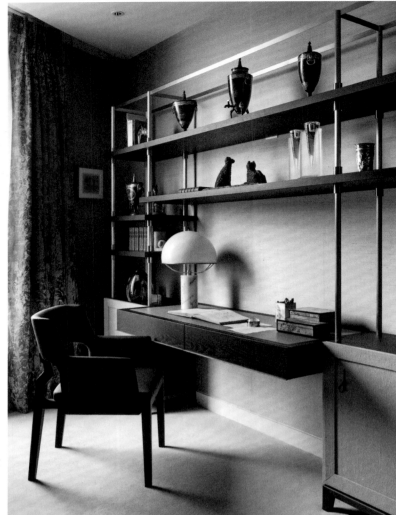

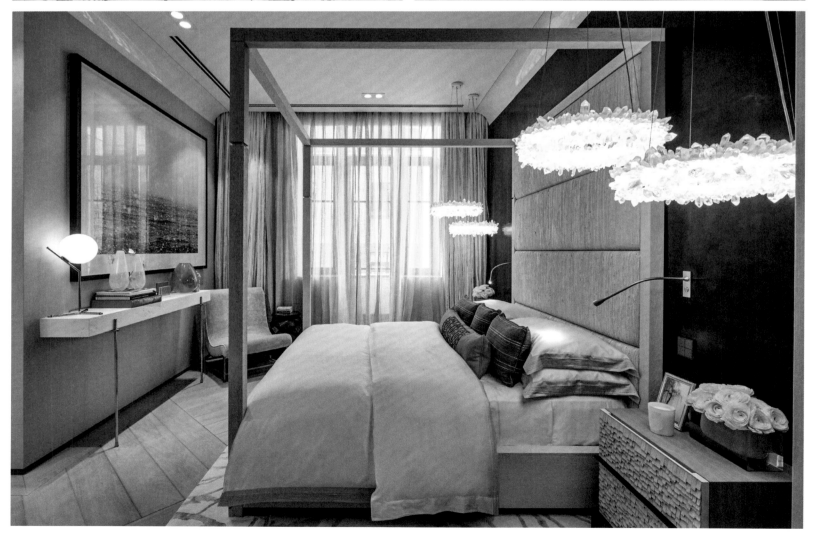

FIONA BARRATT INTERIORS

London, United Kingdom

"My aim is to create fluid and elegant spaces that enhance, not dictate, the way you live."
„Ich möchte fließende und elegante Räume schaffen, die das Leben bereichern und nicht diktieren."
« Je souhaite créer des espaces fluides et élégants qui enrichissent la vie et ne la dictent pas. »

Anyone who jets from London to Beirut, Moscow, or Hong Kong to furnish a villa; a commercial space; or a large apartment, must be good at what they do. British interior designer Fiona Barratt-Campbell, a graduate of the Parsons School of Design in New York City, creates interiors that she herself describes as a blend of timelessness, luxury, and intelligence. "Design practically runs in my DNA," she explains. Sir Lawrie Barratt, Fiona's grandfather and mentor, founded one of England's biggest construction firms in 1958—and was her source of inspiration and motivation. Although the designer spends her days surrounded by luxury, her roots are extremely down-to-earth and shaped by the rugged landscape of her childhood home Northumberland. She still works with local craftsmen there, who produce the furniture she designs and sells under her label FBC London. For Hallington Hall (top left), a country house with nine bedrooms; a huge kitchen; and three reception rooms located in her home region, she created closets, doors, and bookcases. In central Moscow, the designer transformed a 300-square-meter (3,200-square-foot) apartment into a cosmopolitan but simultaneously individual home (below) using carefully selected artwork, silk rugs, and the 20th century antiques that she particularly likes.

Wer von London nach Beirut, Moskau oder Hong Kong gerufen wird, um eine Villa, ein Gewerbeobjekt oder ein großes Apartment einzurichten, dem eilt ein Ruf voraus. Die britische Interior Designerin Fiona Barratt-Campbell, die an der Parsons School of Design in New York studierte, erschafft Wohnräume, die sie selbst als eine Mischung aus zeitlos, luxuriös und intelligent bezeichnet: „Design wurde mir praktisch in die Wiege gelegt", erklärt sie. Sir Lawrie Barratt, Fionas Großvater und Mentor, gründete 1958 eine der größten Baufirmen Englands – er inspirierte seine Enkelin und spornte sie an. Obwohl die Kreative beruflich im Luxus schwelgt, sind ihre Wurzeln extrem bodenständig und von der rauen Landschaft Northumberlands, wo sie aufwuchs, geformt. Bis heute lässt sie von den Kunsthandwerkern dort ihre eigenen Möbelentwürfe, die unter ihrem Label FBC London angeboten werden, fertigen. Für Hallington Hall (links oben), ein herrschaftliches Anwesen in ihrer Heimat mit neun Schlafzimmern, einer riesigen Küche und drei Empfangsräumen, entwarf sie Garderoben, Türen und Bücherregale. Im Zentrum von Moskau verwandelte die Designerin ein 300 Quadratmeter großes Appartment in einen kosmopolitischen und gleichzeitig sehr individuellen Wohnsitz (unten): mit ausgesuchter Kunst, Seidenteppichen und Antiquitäten aus den Zwanzigern, die sie ganz besonders mag.

Ceux qui sont appelés de Londres à Beyrouth, Moscou ou Hong Kong pour aménager une villa, un bâtiment professionnel ou un grand appartement sont toujours précédés par sa réputation. L'architecte d'intérieur britannique Fiona Barratt-Campbell, qui a étudié à la Parsons School of Design à New York, crée des espaces de vie qu'elle qualifié elle-même comme un mélange d'atemporalité, de luxe et d'intelligence : « J'ai été pour ainsi dire bercé par le design », explique-t-elle. Sir Lawrie Barratt, le grand-père et mentor de Fiona a fondé en 1958 l'une des plus grandes entreprises de construction d'Angleterre – il a inspiré et encourage sa petite-fille. Bien que la créatrice baigne professionnellement dans le luxe, ses racines sont très modestes et ont été formées par le paysage abrupt du Northumberland où elle a grandi. Aujourd'hui encore, elle fait fabriquer les meubles qu'elle dessine et qui sont proposés sous le label FBC London par des artisans locaux. Pour Hallington Hall (en haut à gauche), un manoir de sa région avec neuf chambres, une cuisine immense et trois salles de réception, elle a dessiné des dressings, des portes et des bibliothèques. Au centre de Moscou, la designeuse a transformé un appartement de trois-cents mètres carrés en une résidence à la fois cosmopolite et très personnelle (en bas) : avec des œuvres d'art choisies, des tapis de soie et des antiquités des années 20 qu'elle apprécie particulièrement.

SOFÍA ASPE
Mexico City, Mexico

"I feel that a home that looks attractive but isn't really cozy has no value."
„Ein Zuhause, das nur attraktiv aussieht, aber nicht gemütlich wirkt, ist in meinen Augen wertlos."
« À mes yeux, un intérieur qui paraît attrayant sans être confortable ne vaut rien à mes yeux. »

French painter Paul Cézanne was convinced about its impact—one of his most famous quotes is "I don't think when I paint, I see color." This is certainly the case for Mexican interior designer Sofía Aspe, who says "Color can wake or motivate you; it can be fun or sexy. It can calm you and make you feel relaxed." She set up her office in Mexico City in 2011 and since then has completed numerous projects in Mexico and the US. And this even though the designer originally studied business and the culinary arts, initially only doing interiors for friends. They loved the outcome so much that she decided to turn her passion into a career. Sofía quickly landed major projects, such as a 1,500-square-meter (16,150-square-foot) villa in Las Lomas, Mexico City's upscale residential neighborhood. The master bedroom looks out onto Chapultepec Park and Sofía decided to reference this in the adjoining bathroom, commissioning hand-painted wallpaper with a palm motif from Ananbô. Where a dark closet previously blocked the view, she removed walls and positioned the freestanding bathtub in the center of the room. A weekend house on the Valle de Bravo lake demonstrates Sofía Aspe's talent for using contemporary art. Her love of color is expressed in a painting by Greek artist Jannis Varelas, expertly showcased in the evening by a huge Fisher Weisman Collection chandelier.

Der französische Maler Paul Cézanne war überzeugt von ihrer Wirkung: „Ich denke an nichts, wenn ich male, ich sehe Farbe", lautet einer seiner berühmtesten Sätze. Für die mexikanische Interior Designerin Sofía Aspe trifft er beispielhaft zu. „Farbe", sagt sie, „kann aufwecken, motivieren, lustig oder sexy sein. Sie kann dich beruhigen und dafür sorgen, dass du dich locker fühlst." 2011 eröffnete sie in Mexico City ihr Büro und hat seither zahlreiche Projekte in Mexiko und den USA realisiert. Dabei hatte die Kreative ursprünglich Business und Culinary Arts studiert, das Einrichten zunächst für Freunde übernommen. Die waren von ihren Kompositionen so begeistert, dass aus der Passion Beruf wurde. Es folgten schnell Großprojekte, beispielsweise eine 1.500-Quadratmeter-Villa in Las Lomas, Mexico Citys Nobelwohnviertel. Dort hat man vom Master-Bedroom Blick auf den Chapultepec Park. Um ihn zu zitieren, entschied sich Sofía im angrenzenden Badezimmer für eine handbemalte Tapete von Ananbô mit Palmenmotiv. Wo einst eine dunkle Kammer die Sicht versperrte, öffnete sie Wände und platzierte eine freistehende Badewanne mitten im Raum. Ein Wochenenddomizil am See Valle de Bravo zeigt Sofía Aspes Händchen für zeitgenössische Kunst. Ihre Vorliebe für Farben übernimmt dort ein Gemälde des griechischen Malers Jannis Varelas. Ein riesiger Leuchter von Fisher Weisman Collection setzt es auch abends gekonnt in Szene.

Le peintre francais Paul Cézanne était convaincu par son effet : « Je ne pense à rien lorsque je peins, je vois de la couleur » est l'une de ces célèbres citations. Elle s'applique parfaitement à la décoratrice d'intérieur mexicaine Sofía Aspe. « La couleur », dit-elle, « peut réveiller, motiver, être amusante ou sexy. Elle peut t'apaiser et te permettre d'être détendu. » En 2011, elle a ouvert son bureau à Mexico et a réalisé depuis de nombreux projets au Mexique et aux États-Unis. La créatrice avait étudié à l'origine l'économie d'entreprise et les Culinary Arts. Elle revêtait la casquette de décoratrice d'intérieur au départ pour ses amis seulement. Ils ont été si charmés par ses compositions qu'elle a fait de son métier une passion. Des grands projets ont rapidement suivis, par exemple une villa de 1.500 m² à Las Lomas, un quartier résidentiel huppé de Mexico. Depuis la master bedon, on a vu sur le parc Chapultepec. Il faut notamment souligner un papier peint à la main par Ananbô avec des motifs de palmiers que Sofía a choisi pour la salle de bains attenante. Là où une chambre sombre bloquait la vue à l'origine, elle a ouvert les murs et a placé une baignoire sur pieds au milieu de la pièce. Une maison de campagne au bord du lac Valle de Bravo témoigne du sens de Sofía Aspe pour l'art contemporain. Sa passion pour les couleurs y est incarnée par un tableau du peintre grec Jannis Varelas. Une lampe immense de Fisher Weisman Collection le met également savamment en scène le soir.

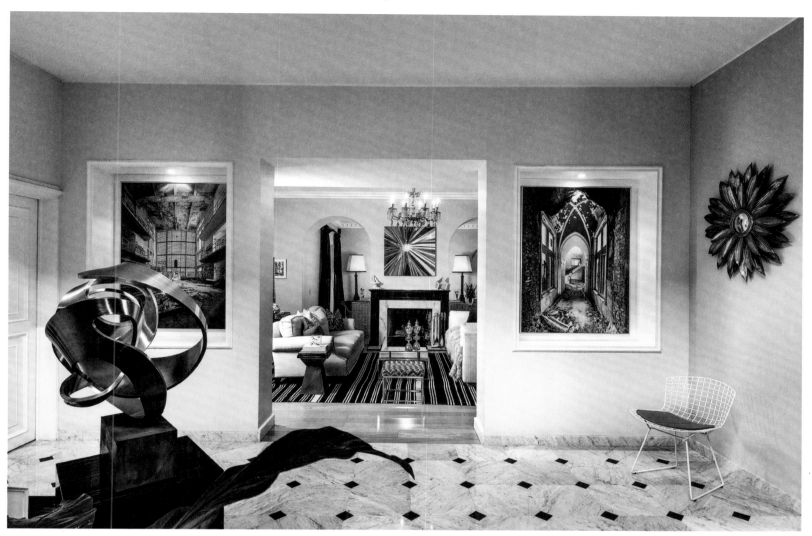

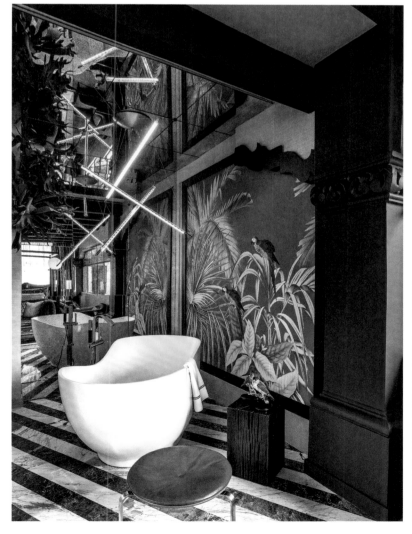

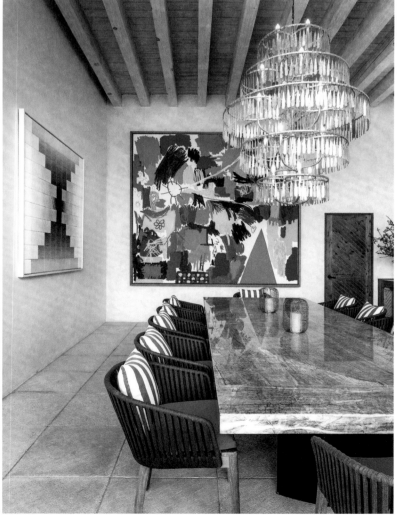

3 Questions for ...
SOFÍA ASPE

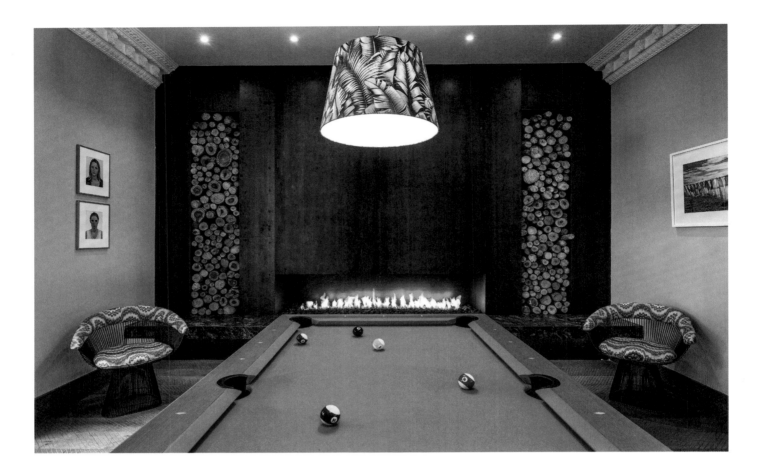

Your interiors are often punctuated with vibrant color. What role does color typically play in your designs and how is it incorporated into your design process?

"Color plays a fundamental role in great design. The use of color in a space can transmit emotions, and in doing so, create feelings and sensations for its inhabitants. I usually use lighter, more relaxing colors such as light beige, gray, blue, and lilac for bedrooms, and more vivid pantones for the rest of the project—especially in recreation and work spaces. Black and white can have enormous effects as well. When successfully applied, black adds drama, elegance, and mystery to a space. Color can be incorporated using paint, wallpaper, fabrics, natural stones and artwork. Art is a great way to add color—particularly to a monochromatic space or to a design for clients who favor lighter tones for walls and furniture."

Where do you draw inspiration from?

"I draw inspiration from many sources. Travel is one of the most important. It offers a glimpse into different cultures, and introduces one to new methods and ideas. I travel with eyes wide open in order to really observe and not just see. Whether from a marble floor in a church, a molding in a museum, a flower in a park, or the color of a door on the street—inspiration is everywhere when one is willing to absorb new ideas."

> ## "When successfully applied, black adds drama, elegance, and mystery to a space."

What do you tend to have in common with your clients?

"My clients hire me because we share an appreciation of some common design elements, such as a love of color, iconic mid-century pieces, antiques, but also contemporary furniture and art, and therefore, a preference for eclecticism. It's not a forced eclecticism; it's about having the freedom and knowledge to appreciate different eras, aesthetics, styles and values, and being able to mix them toghether in an orchestrated way."

Bei Ihrer Raumgestaltung setzen Sie oft Akzente mit leuchtenden Farben. Welche Rolle spielt die Farbe bei Ihren Entwürfen und wie ist sie in den Gestaltungsprozess eingebunden?

„Farbe spielt eine ganz wesentliche Rolle bei gelungener Gestaltung. Die Verwendung von Farbe in einem Raum kann Emotionen hervorrufen und bei den Bewohnern bestimmte Gefühle und Empfindungen auslösen. Normalerweise verwende ich für die Schlafräume hellere, entspannende Töne wie Hellbeige, -grau oder -blau sowie Flieder und in den anderen Räumen lebendigere Farbtöne – besonders in Arbeits- und Aufenthaltsräumen. Schwarz und Weiß können auch gut miteinander harmonieren. Richtig eingesetzt, verleiht Schwarz dem Raum etwas Dramatisches und Mystisches sowie Eleganz. Farbakzente kann man mit Wandfarben, Tapeten, Stoffen, Natursteinen und Kunstobjekten erzielen. Für Kunden, die bei Wänden und Möbeln hellere Töne favorisieren, bieten Kunstobjekte eine fantastische Möglichkeit, Farbe hineinzubringen, insbesondere in unifarbenen Räumen oder Einrichtungen."

Woher nehmen Sie die Inspirationen für Ihre Arbeit?

„Ich lasse mich durch vieles inspirieren. Reisen sind dabei fast die wichtigste Quelle. Man bekommt Einblicke in verschiedene Kulturen und lernt neue Methoden und Ideen kennen. Ich reise mit offenen Augen, um nicht nur zu sehen, sondern Eindrücke aufzunehmen. Das kann ein Marmorfußboden in einer Kirche sein, eine Form in einem Museum, eine Blume im Park oder eine bestimmte Farbe einer Haustür – Inspirationen finden sich überall, wenn man bereit für neue Ideen ist."

„Richtig eingesetzt, verleiht Schwarz dem Raum etwas Dramatisches und Mystisches sowie Eleganz."

Was verbindet Sie im Allgemeinen mit Ihren Kunden?

„Meine Kunden engagieren mich, da wir eine gemeinsame Vorliebe für bestimmte Gestaltungselemente haben wie etwa die Liebe zur Farbe, Kultobjekte aus der Mitte des letzten Jahrhunderts, Antiquitäten oder auch moderne Möbel und Kunstgegenstände, und demnach eine Vorliebe für Eklektizismus. Es geht nicht um erzwungenen Eklektizismus, sondern um die Freiheit und das Wissen, unterschiedliche Epochen, ästhetische Aspekte, Stile und Werte zu schätzen und sie bestmöglich miteinander in Einklang zu bringen."

Vos intérieurs sont souvent rythmés par des couleurs vives. Quel rôle jouent-elles précisément et comment sont-elles intégrées au processus de création ?

« Dans tout bon design, la couleur joue un rôle fondamental. Elle permet de véhiculer des émotions, et donc, de provoquer des sentiments ou des sensations. Je recours généralement à des tonalités claires et relaxantes, tels que le beige doux, le gris, le bleu ou le mauve, pour les chambres à coucher, préférant ailleurs un nuancier plus vif – surtout dans les pièces dédiées aux loisirs ou au travail. Le noir et le blanc produisent aussi des effets extraordinaires. Employé avec justesse, le noir instaure une forme de théâtralité, d'élégance ou de mystère. La couleur peut être introduite via la peinture, le papier peint, le tissu, la pierre naturelle. L'art constitue également une ressource remarquable – surtout dans un espace monochrome, ou lorsque les clients optent pour des murs et un mobilier aux teintes claires. »

Où puisez-vous votre inspiration ?

« Je m'inspire de nombreuses sources. Le voyage est l'une des plus importantes. En nous initiant à différentes cultures, il permet de découvrir de nouvelles méthodes ou idées. Je voyage les yeux grands ouverts, afin, non pas de voir, mais d'observer. Que ce soit le sol de marbre d'une église, un moulage dans un musée, une fleur dans un parc ou une porte colorée dans la rue – l'inspiration est partout dès lors que l'on sait accueillir de nouveaux concepts. »

« Employé avec justesse, le noir instaure une forme de théâtralité, d'élégance ou de mystère. »

Qu'avez-vous en commun avec vos clients ?

« Mes clients m'engagent parce que nous partageons un certain goût du design : l'amour de la couleur, des objets anciens ou emblématiques des années 1950, du mobilier et de l'art contemporains – en somme, une tendance à l'éclectisme qui n'a rien de contraint. L'idée est d'apprécier chaque époque, esthétique, style ou valeur avec assez de liberté et de culture pour les orchestrer ensemble. »

ROBERT PASSAL
New York City, United States

"Interior design is a very personal process through which one becomes part of the family."
„Interior Design ist ein sehr persönlicher Prozess, durch den man Teil der Familie wird."
« L'*interior design* est un processus très personnel avec lequel on devient un membre de la famille. »

How does an interior designer find out what a property owner really wants? Perhaps by progressing intuitively, making headway through dialogue. New York interior designer Robert Passal tends to go a step further. As a result, he's developed a questionnaire over the years that queries owners on far more than just their favorite colors: "Sailboat or cruise ship?" … "Mac or PC?" are just some of the designer's questions. "I really grill my clients to try and understand what they want, but can't put into words." Passal, who started developing his skills with New York's high-profile antique dealer John Rosselli, opened his own design studio in 2000. When *House & Garden* published an article on baseball legend Jorge Posada's Manhattan apartment in 2005—fully designed and outfitted by Passal—his name became a byword for consummate style and caused a rush of celebrities to knock on his door, including Alex Rodriguez, who employed Passal in multiple projects. Another was star coiffeur Guido Palau, who popped into the studio to consult on a birthday gift for fashion designer Alexander McQueen. Shortly afterwards he asked Passal to design his newly acquired New York duplex (top right). The outcome, which appeared in *Architectural Digest*, is a relaxing hideaway that the hairstylist is delighted with: "I've had a few big apartments in my lifetime," he said, "but I'm happiest in this one. I can hardly imagine ever moving out!"

Wie findet ein Interior Designer heraus, was ein Bauherr sich wirklich wünscht? Er kann intuitiv vorgehen, sich durch Gespräche annähern. Der New Yorker Interior Designer Robert Passal setzt noch eins drauf und hat aus diesem Grund über die Jahre einen Fragenkatalog entwickelt, der weit mehr als nur Lieblingsfarben auskundschaftet: „Segelboot oder Kreuzfahrtschiff?", „Mac oder PC?" will der Kreative darin wissen: „Ich fühle meinen Klienten auf den Zahn, versuche zu begreifen, was sie sich wünschen, aber nicht in Worte fassen können." Passal, der bei New Yorks prominentem Antiquitätenhändler John Rosselli lernte, eröffnete 2000 sein eigenes Designstudio. Als *House & Garden* 2005 das in Manhattan gelegene Apartment von Baseball-Legende Jorge Posada veröffentlichte, das Passal eingerichtet

hatte, wurde sein Name zum Synonym für guten Stil und zahlreiche Prominente wie Alex Rodriguez klopften an seine Studiotür. Ein weiterer Kunde: der Star-Coiffeur Guido Palau. Er kreuzte eines Tages bei ihm im Laden auf, um ein Geburtstagsgeschenk für Modedesigner Alexander McQueen zu kaufen. Kurz darauf bat er den Interior Designer, sein neues New Yorker Domizil einzurichten (oben rechts). Beide spielten sich die Bälle zu und so entstand ein relaxtes Refugium, das in der *Architectural Digest* vorgestellt wurde und über das der Figaro schwärmt: „Es gab in meinem Leben größere Apartments, aber in diesem bin ich am glücklichsten. Ich kann mir nicht vorstellen, jemals wieder auszuziehen!"

Comment un architecte d'intérieur découvre-t-il les souhaits profonds d'un maître d'ouvrage ? Il peut procéder de manière intuitive, apprendre en discutant. L'*interior design*er new yorkais Robert Passal va plus loin et a développé au fil des ans un catalogue de questions qui fait bien plus que s'enquérir des couleurs préférées : « Bateau à voile ou bateau de croisière ? », « Mac ou PC ? », telles sont les questions du créateur. « Je m'imprègne de nos clients, j'essaie de comprendre ce qu'ils souhaitent mais n'arrivent pas à exprimer. » Passal, qui a appris auprès du célèbre antiquaire new-yorkais John Rosselli, a ouvert en 2000 son propre studio de design. Lorsque *House & Garden* a publié en 2005 l'appartement de la légende du baseball Jorge Posada située à Manhattan, que Passal a aménagé, son nom est devenu synonyme d'un bon style et de nombreuses célébrités comme Alex Rodriguez sont venues frapper à la porte de son studio. Un autre client : le coiffeur star Guido Palau. Ils se sont croisés un jour en magasin pour acheter un cadeau d'anniversaire pour le designer de mode Alexander McQueen. Peu de temps après, il demandait au décorateur d'intérieur d'aménager son nouveau domicile newyorkais (en haut à droite). Les deux hommes se sont renvoyés la balle et un refuge décontracté a vu le jour qui a été présenté dans l'*Architectural Digest* et dont le Figaro a fait l'éloge : « J'ai eu des appartements plus grands dans ma vie mais c'est de celui-ci dont je suis le plus heureux. Je ne m'imagine pas déménager à nouveau ! »

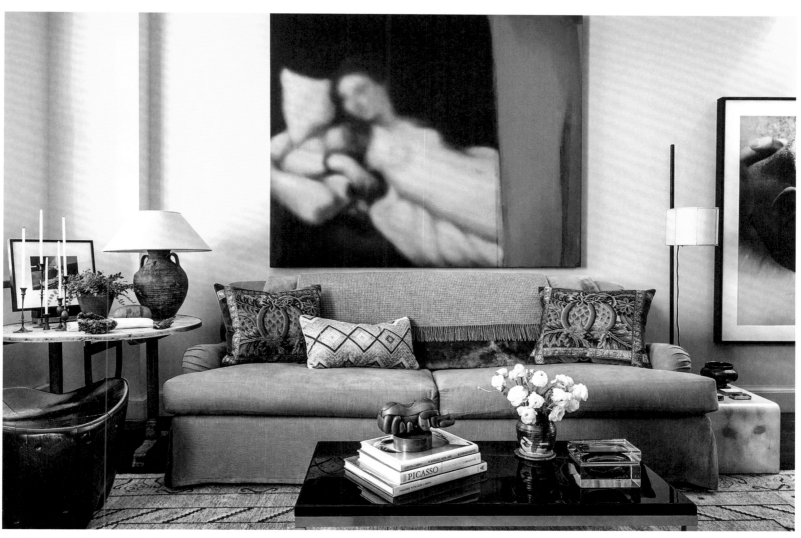

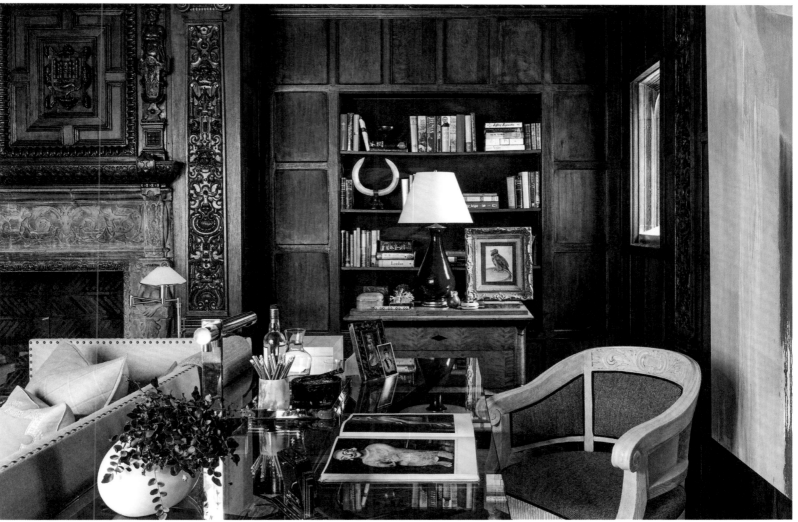

INGRAO
New York City, United States

"We speak different languages. Our design vernacular is not limited to one style or approach."
„Wir sprechen viele Sprachen. Unser Design-Vokabular ist nicht auf einen Stil oder einen Ansatz festgelegt."
« Nous parlons de nombreuses langues. Notre vocabulaire de design n'est pas fixé sur un style ou une approche. »

Anyone who realizes design projects in Manhattan, Paris, Aspen or Hong Kong must have a reputation that precedes them. For Ingrao, that challenge is never too big or too eccentric. An example being a residence spanning over 5,000 square meters (53,000 square feet) on Long Island that was built in French limestone and furnished with 18th-century antiques. Or the library of an apartment on the Upper East Side, for which the architect chose lacquered walls and an extravagant post-modernist bronze coffee table by Dutchman Marc d'Haenens (right). Anthony Ingrao and Randy Kemper, otherwise known as Ingrao, employ over 30 designers and architects. The design and architectural firm is New York City-based and was established in 1982. Their clients include actors Goldie Hawn, Kim Cattrall, former General Electric CEO Jack Welch, Howard Stern, and prominent New York stockbrokers and real estate moguls. "But the most impressive projects," says

Anthony Ingrao with a smile, "are the ones I'm not allowed to talk about!" He is, however, happy to discuss the Baccarat Hotel & Residences in New York. With over 60 apartments, the complex was realized to mark the 250th anniversary of the founding of the Baccarat French crystal house. For Ingrao the project was an opportunity to pay homage to the 'Grande Nation.'

Wer Designprojekte in Manhattan, Paris, Aspen und Hong Kong realisiert, dem eilt ein Ruf voraus. Bei Ingrao lautet dieser, dass man vor keinen Herausforderungen zurückschreckt – seien sie noch so ausgefallen. Ein über 5.000 Quadratmeter großes Anwesen auf Long Island ließ das Design- und Architekturstudio aus französischem Kalkstein bauen und stattete es großzügig mit Antiquitäten aus dem 18. Jahrhundert aus, bei der Bibliothek einer Residenz an der Upper East Side entschied man sich für lackierte Wände und einen extravaganten Coffee Table der Postmoderne aus Bronze des Niederländers Marc d'Haenens (rechts). Anthony Ingrao und Randy Kemper, besser bekannt als Ingrao, führen mittlerweile ein Team aus 30 Designern

und Architekten, gegründet wurde das New Yorker Büro 1982. Zu ihren Kunden zählen die Schauspielerinnen Goldie Hawn und Kim Cattrall, der frühere General Electric CEO Jack Welch, Howard Stern sowie bekannte New Yorker Börsenmakler und Immobilienmagnaten: „Die eindrucksvollsten Projekte", erzählt Anthony Ingrao schmunzelnd, „sind aber jene, über die ich nicht berichten darf!" Das Baccarat Hotel & Residences New York mit mehr als 60 Wohnungen hingegen nennt er gerne. Es wurde anlässlich des 250-jährigen Jubiläums der französischen Kristallmanufaktur Baccarat realisiert. Für Ingrao war es eine Reminiszenz an seinen langjährigen Aufenthalt in der Grande Nation.

Celui qui réalise des projets de design à Manhattan, Paris, Aspen et Hong Kong est précédé par sa réputation. La réputation d'Ingrao est que l'agence n'a peur d'aucun défi – aussi originaux soient-ils. L'agence de design et d'architecture a fait construire une propriété de 5.000 m² sur Long Island en calcaire et l'a aménagée généreusement avec des antiquités du XVIIIe siècle. Pour la bibliothèque d'une résidence de l'Upper East Side, elle a opté pour des murs vernis et une coffee table extravagante de l'époque postmoderne en bronze, signée par le Néerlandais Marc d'Haenens (à droite). Anthony Ingrao et Randy Kemper, plus connus sous le nom d'Ingrao, dirigent maintenant une équipe de 30 designers et architectes. L'agence new-yorkaise a été fondée en 1982. Parmi leurs clients, on retrouve les actrices Goldie Hawn et Kim Cattrall, l'ancien CEO de General Electric Jack Welch, Howard Stern et des célèbres courtiers en bourse et magnats de l'immobilier new-yorkais : « Les projets les plus impressionnants », raconte Anthony Ingrao en souriant, « sont ceux dont je ne peux pas parler ! » En revanche, il aime citer le Baccarat Hotel & Residences New York avec plus de 60 appartements. Il a été réalisé à l'occasion du 250ème anniversaire de la manufacture française de cristal Baccarat. Cela a rappelé à Ingrao son séjour prolongé en France.

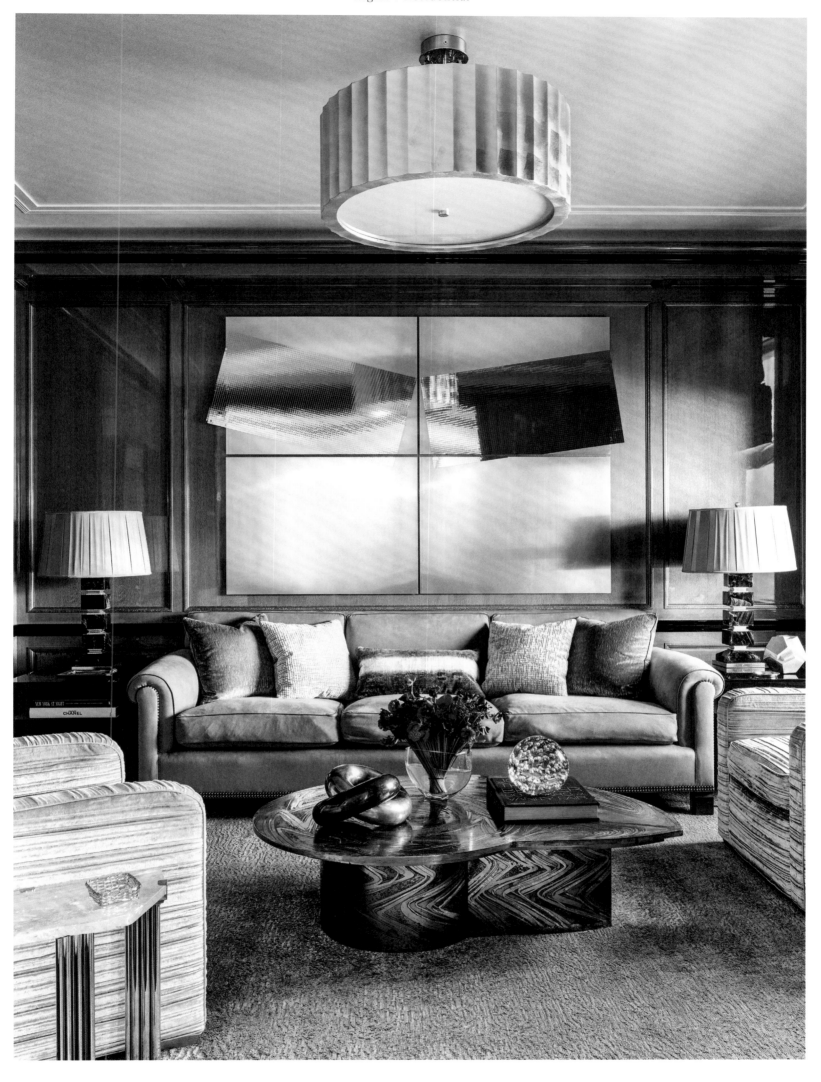

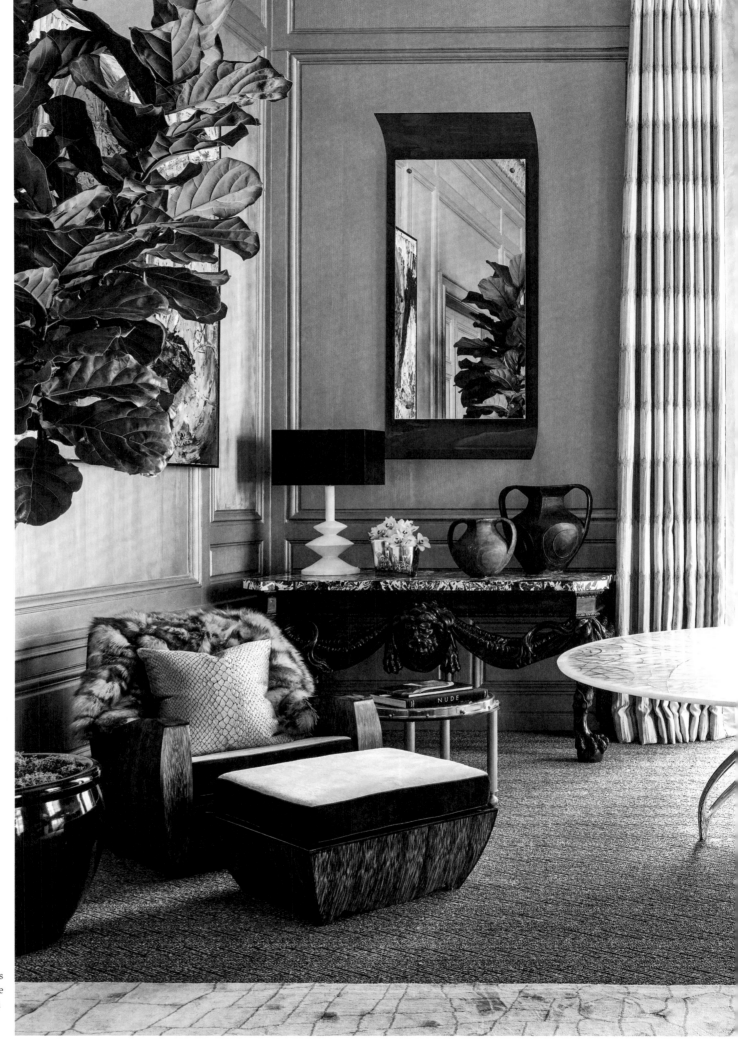

A historic, high ceilinged residence in Manhattan, Ingrao discovered the impressive 18th-century George II-style side tables with black and white marble tops.

Altbauresidenz in Manhattan mit hohen Decken: die beiden beeindruckenden Konsolen aus dem 18. Jahrhundert mit schwarzweißen Marmorplatten im Georg II.-Stil stöberte Ingrao persönlich auf.

Résidence ancienne à Manhattan avec des hauts plafonds : Ingrao a trouvé lui-même les deux consoles impressionnantes du XVIIIe siècle avec des plateaux en marbre noir et blanc dans le style Georges II.

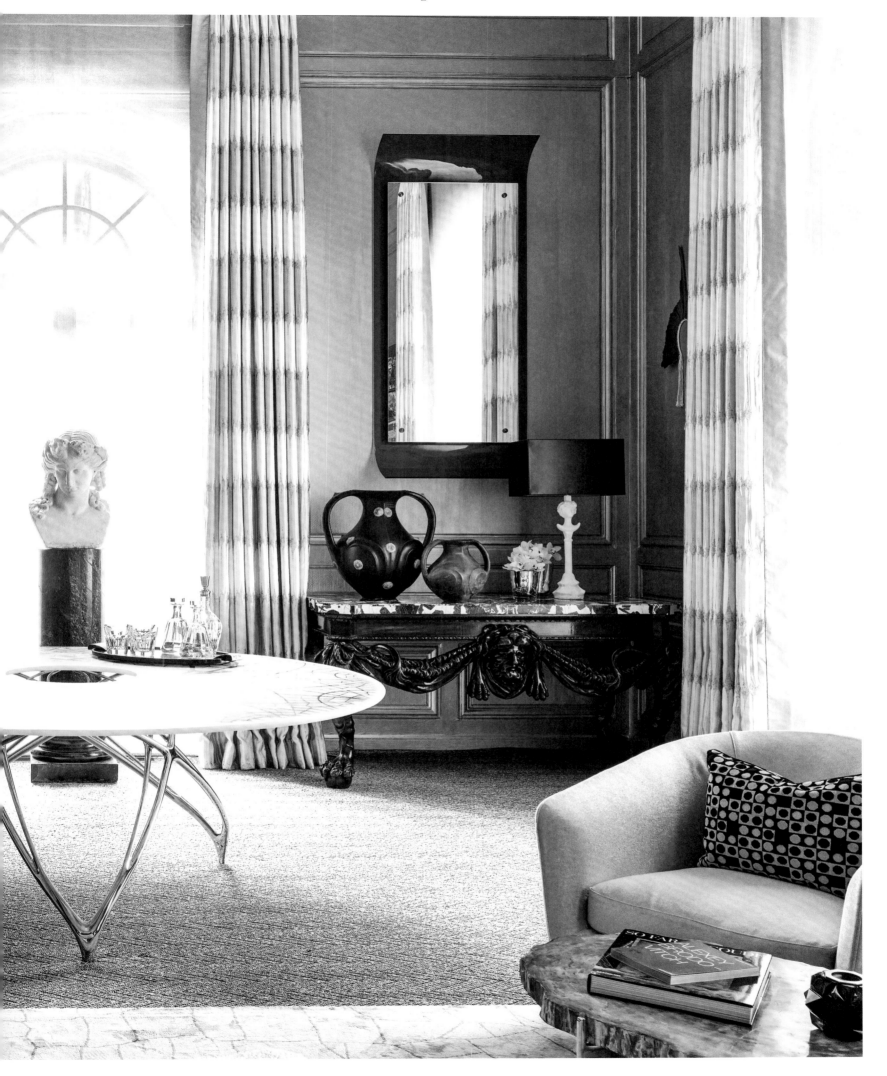

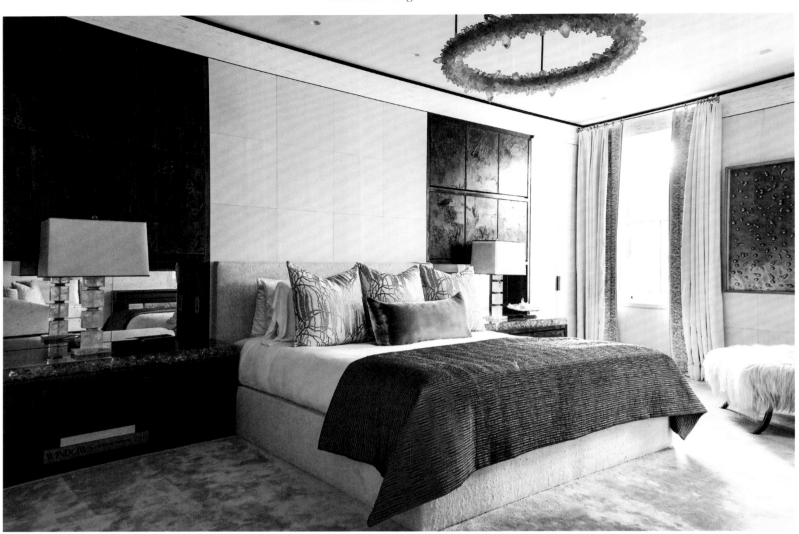

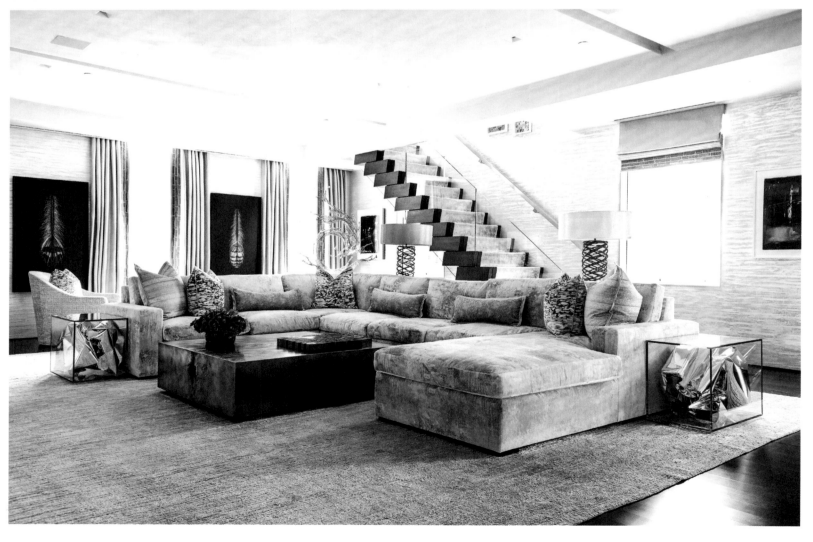

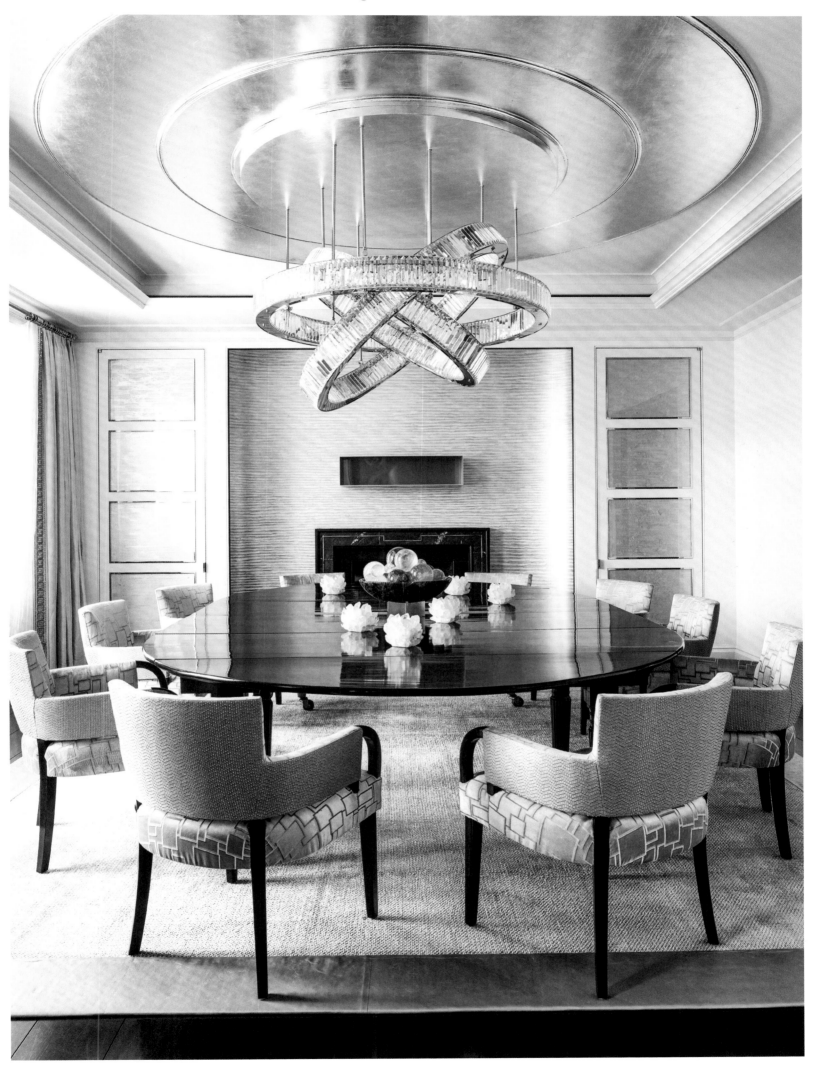

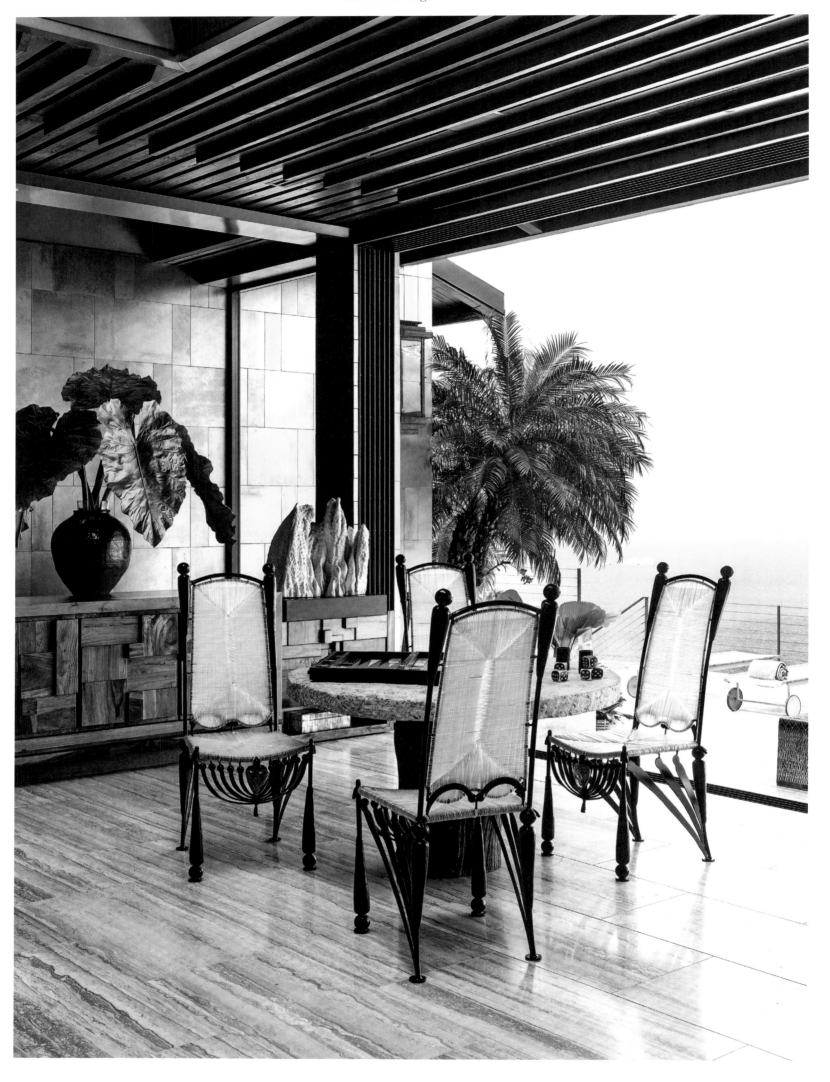

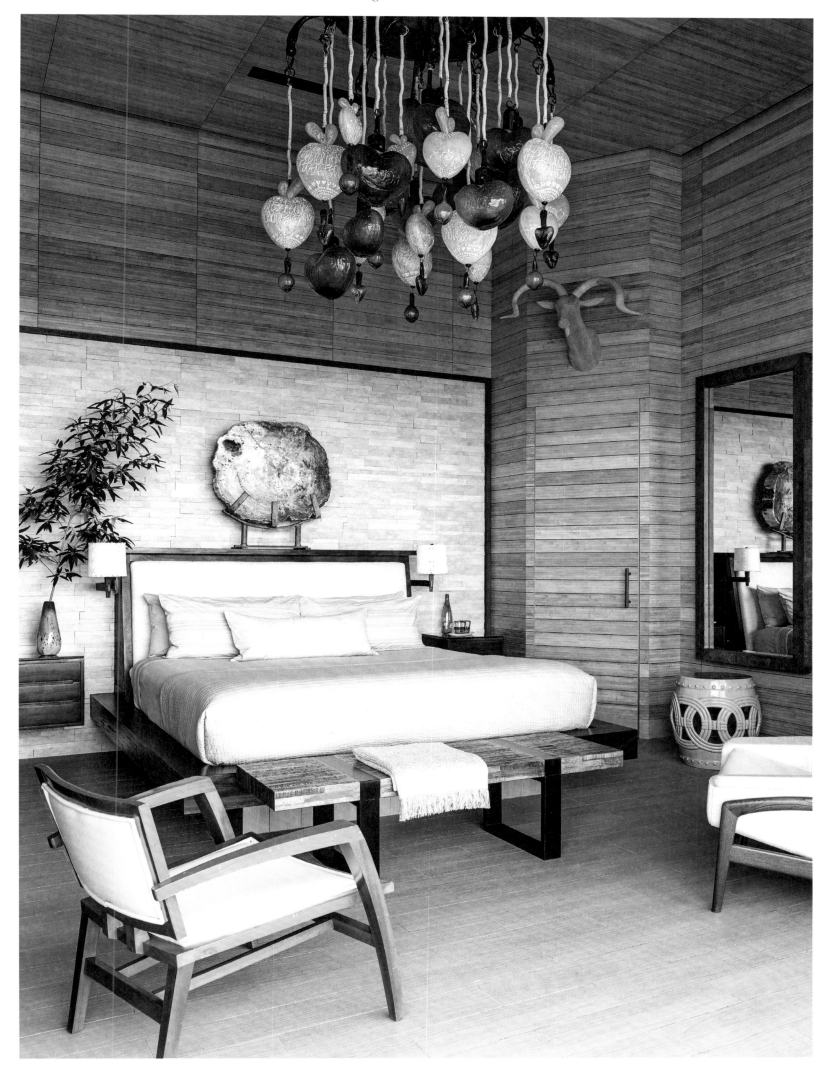

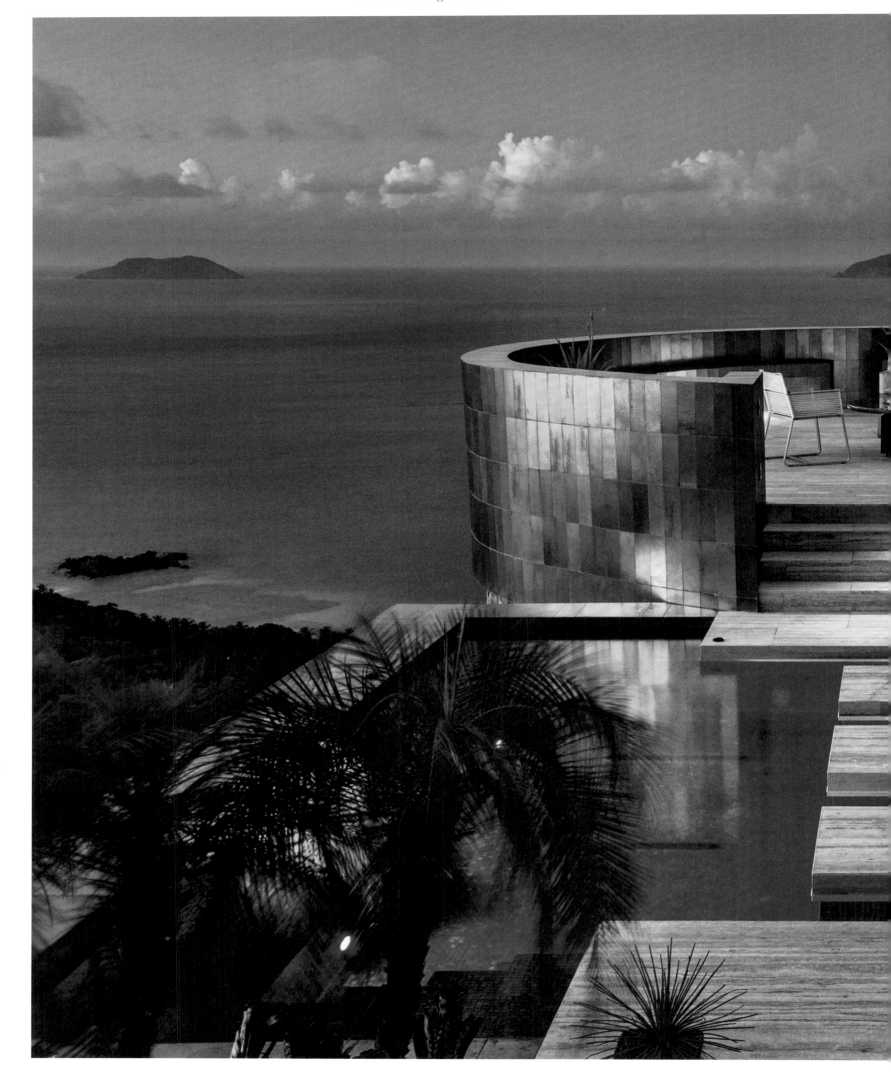

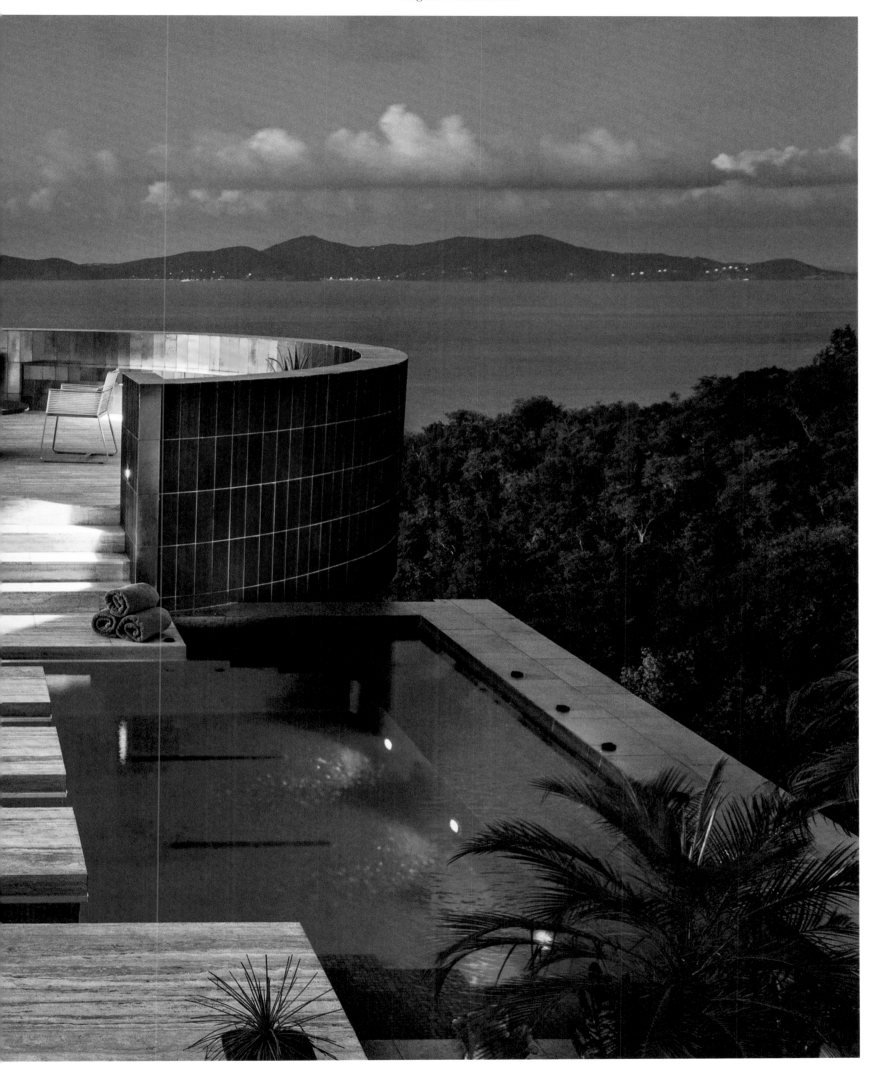

RIALTO LIVING
Palma de Mallorca, Spain

"Our style is unpretentious. We focus on good quality and an exciting mix of materials."
„Unser Stil ist unprätentiös. Wir setzen auf gute Qualität und spannenden Materialmix."
« Notre style est dénué de prétention. Nous misons sur la qualité et sur un mélange passionnant de matières ».

What do you get when a successful textile designer and a graphic designer open a concept store in a spectacular building in Palma de Mallorca? A must-see for anyone who is interested in carefully selected furniture, art, home accessories, fashion, books, textiles, and objets d'art and enjoys visiting good cafés. Swedish Klas Käll, one of the founders of the Gant fashion brand, and Barbara Bergman opened their "Rialto Living" store in an old movie theater on Calle San Felio over ten years ago. In 2014, they expanded into the adjoining historic "Can O'Ryan" palace, doubling the store's size to a total of 1,400 square meters (15,000 square feet). The couple's own flair plus a mix that they describe as "relaxed elegance" quickly gained them fans. In the meantime, they have also decorated numerous vacation homes on the sun-drenched island. Their signature style, designed to harmonize with the climate and outward-looking houses with large patios, provides a narrative for the landscape, ocean, and Mediterranean lifestyle. Furnishings include rattan chairs with blue and white cushions, while schemes are lifted using color accents such as green or orange. "Our absolute passion is textiles. You can achieve incredible transformations with them." Both designers are convinced that linen and cotton reflect the island's mentality. What they like best is mixing colors, textures, and patterns. The Rialto Living store also functions as a gallery for local and international artists and their works can be found in many of the villas decorated by Barbara and Klas.

Was kommt dabei heraus, wenn ein erfolgreicher Textildesigner und eine Grafik-Designerin einen Concept Store in einer spektakulären Kulisse Palmas eröffnen? Ein Mekka für alle, die sich für eine gute Mischung aus Möbeln, Kunst, Wohnaccessoires, Mode, Büchern, Stoffen, Café und die schönen Dinge des Lebens begeistern. Vor über zehn Jahren starteten die Schweden Klas Käll, Mitbegründer des Modelabels Gant, und Barbara Bergman ihren Laden „Rialto Living" in einem alten Kino auf der Calle San Felio. 2014 erweiterten sie mit dem angrenzenden historischen Palast „Can O'Ryan" auf insgesamt 1.400 Quadratmeter Fläche. Die Wahl-Mallorquiner überzeugten schnell mit ihrem persönlichen Stil und einer Mischung, die sie selbst als „entspannt elegant" bezeichnen. Inzwischen haben sie zahlreiche Ferienhäuser auf der sonnenverwöhnten Insel eingerichtet. Ihr Look, der zum Klima und den nach außen gewandten Häusern mit großzügigen Terrassen passt, erzählt von der Landschaft, dem Meer, dem mediterranen Lebensstil. Dazu passen Korbmöbel mit Kissen in Blau und Weiß, Farbakzente in Grün oder Orange sorgen für Lebendigkeit. „Unsere absolute Passion gilt Textilien. Mit ihnen kann man unglaubliche Veränderungen bewirken." Leinen und Baumwolle entsprechen dem Inselfeeling, sind sich beide sicher. Am liebsten mischen sie Farben, Strukturen und Muster. Und weil Rialto Living auch eine Galerie für einheimische und internationale Künstler beherbergt, finden sich deren Arbeiten in zahlreichen Fincas, die Barbara und Klas gestaltet haben.

Que se passe-t-il lorsqu'un designer textile à succès et une graphiste ouvrent un concept store dans un site spectaculaire de Palma ? Une Mecque pour tous ceux qui apprécient les savants mélanges de meubles, art, accessoires de décoration, mode, livres, tissus, café et des bonnes choses de la vie. Il y a plus de dix ans, le Suédois Klas Käll, cofondateur du label de mode Gant et Barbara Bergman ont ouvert leur magasin « Rialto Living » dans un ancien cinéma de la Calle San Felio. En 2014, ils l'ont élargi avec le palais historique voisin « Can O'Ryan » pour atteindre 1400 m² de surface totale. Ces Majorquins de cœur ont rapidement su convaincre par leur style personnel et un mélange qu'ils qualifient eux-mêmes de « décontracté et élégant ». Ils ont déjà aménagé de nombreuses maisons de vacances sur l'île ensoleillée. Leur look qui est adapté au climat et aux maisons orientées vers l'extérieur avec des terrasses généreuses raconte le paysage, la mer et le style de vie méditerranéen. Des meubles en osier avec des coussins en bleu et blanc sont parfaitement assortis à ce style et des contrastes colorés en vert ou orange apportent de la vie. « Les textiles sont notre passion absolue. Ils permettent de réaliser des changements incroyables. » Le lin et le coton correspondent à l'ambiance de l'île, ils en sont tous les deux convaincus. Ce qu'ils préfèrent est mélanger les couleurs, les structures et les motifs. Parce que Rialto Living abrite également une galerie pour les artistes locaux et internationaux, on retrouve leurs œuvres dans de nombreuses fincas aménagées par Barbara et Klas.

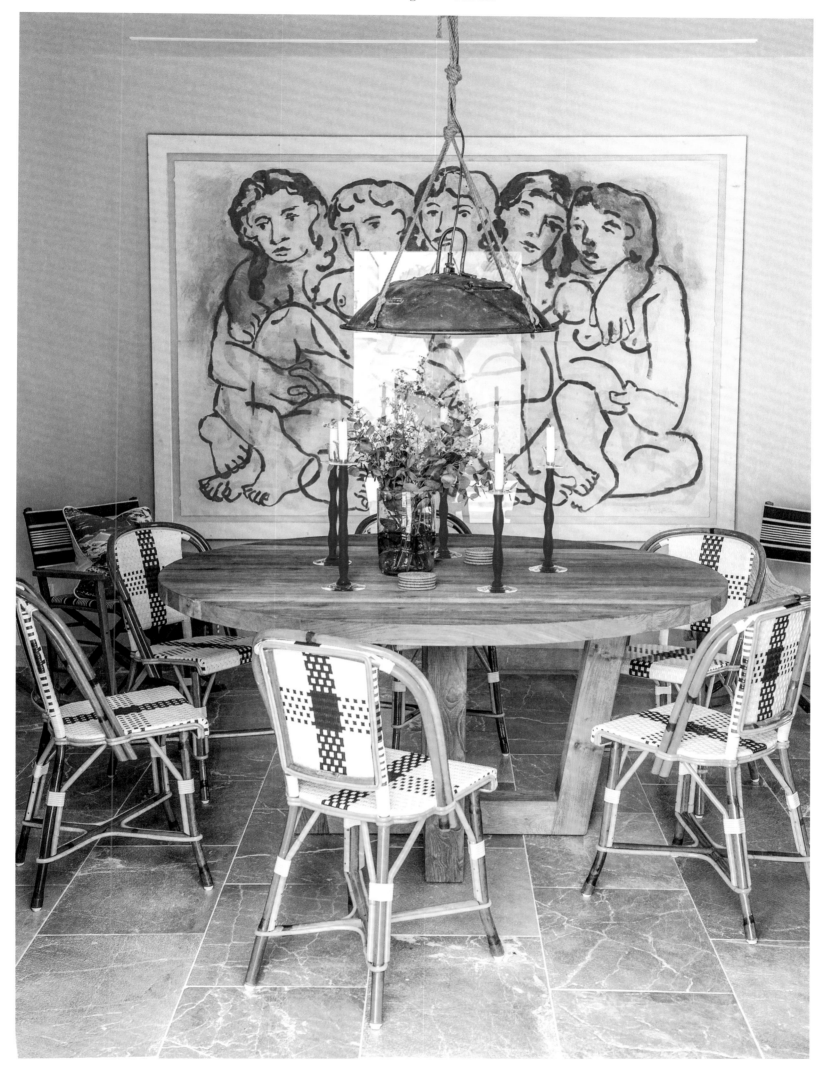

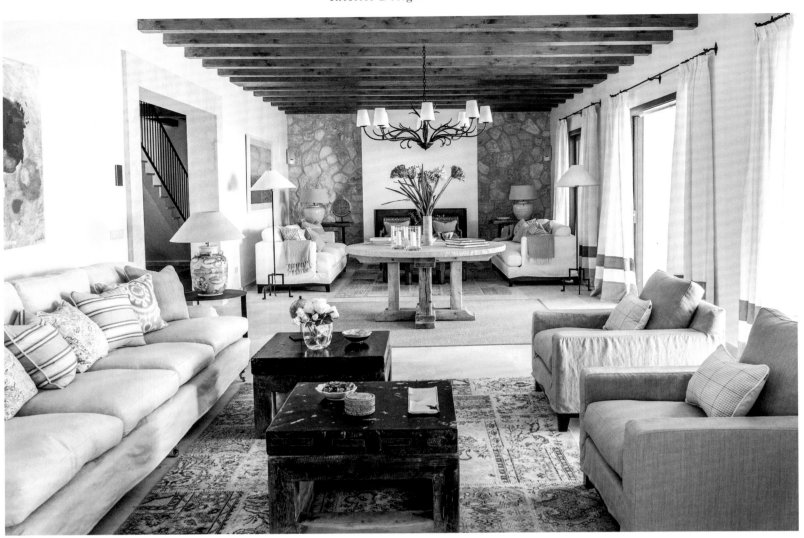

A range of linen fabrics in blue and beige blend with the finca's natural stonework (above). The painting by well-known Majorcan artist Joan Bennàssar inspired the furnishing and colors in the living room.

Verschiedene Leinenstoffe in Blau und Beige harmonieren mit dem Naturstein der Finca (oben). Das Bild des bekannten mallorquinischen Malers Joan Bennàssar inspirierte Einrichtung und Farbwelt im Wohnraum.

Divers tissus de lin en bleu et beige s'harmonisent avec la pierre naturelle de la finca (en haut). Le tableau du célèbre peintre majorquin Joan Bennàssar a inspiré l'aménagement et l'univers de couleurs du salon.

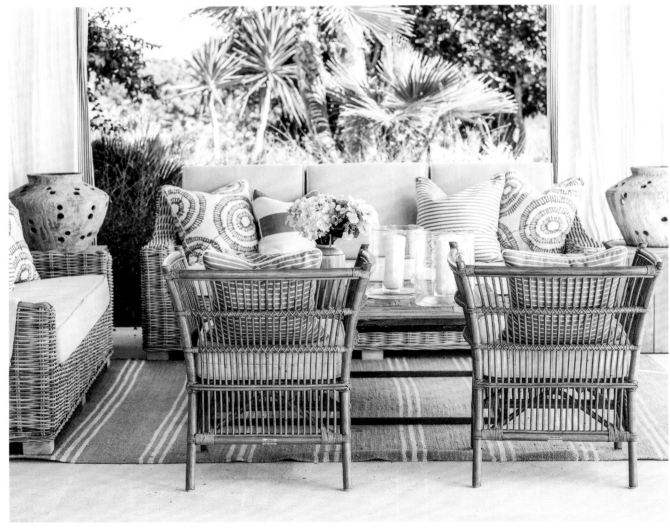

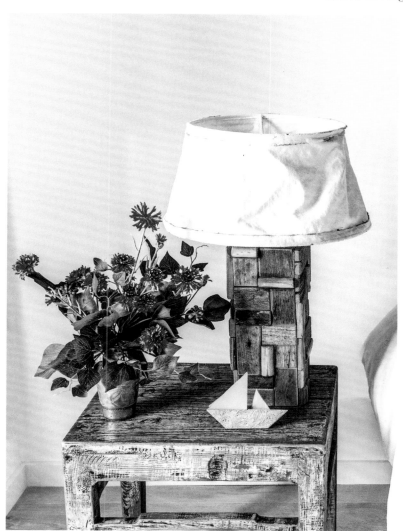

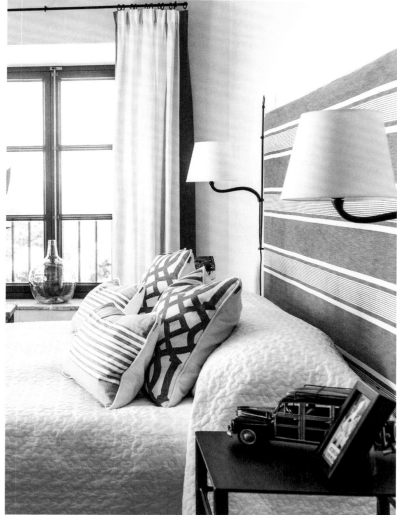

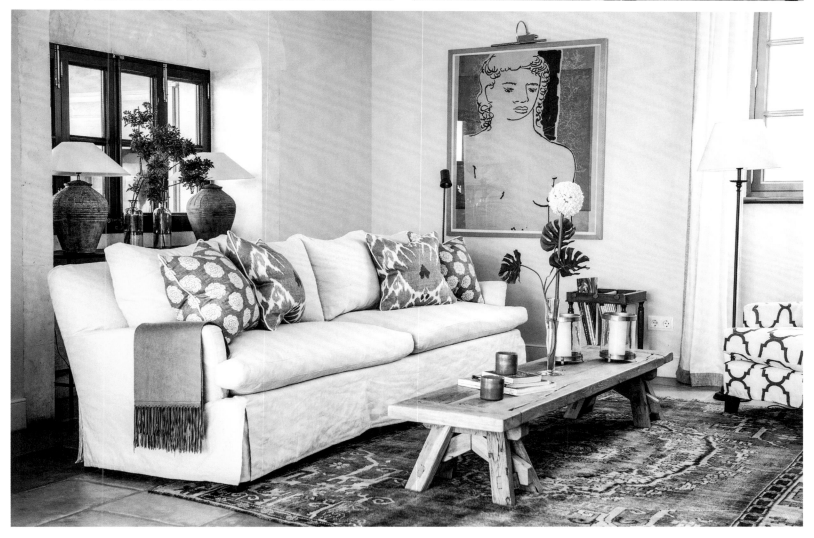

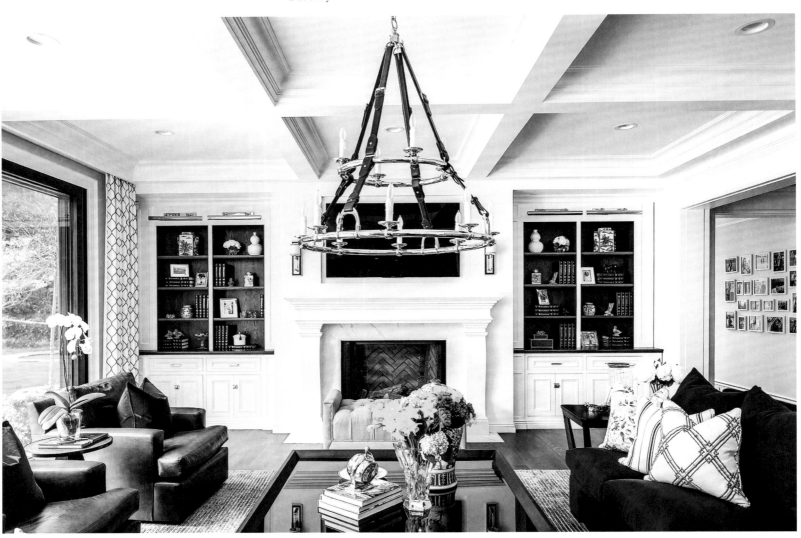

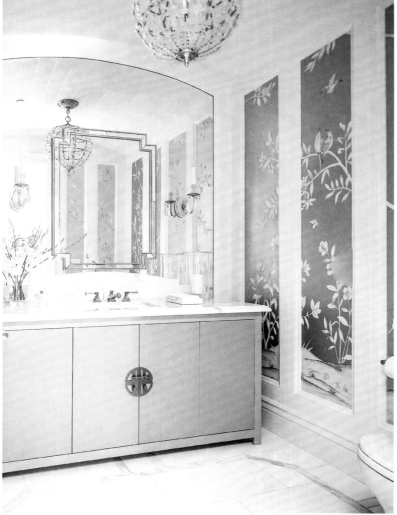

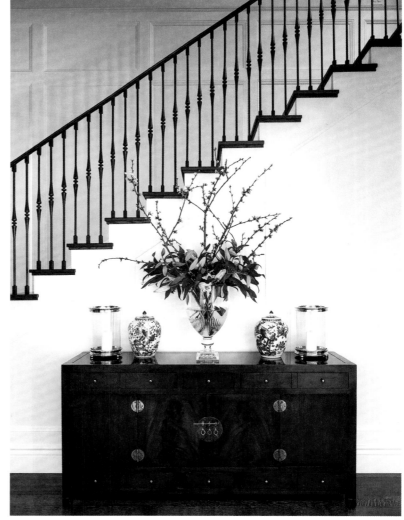

BARCLAY BUTERA
Interiors
Newport Beach, United States

"There should be history in every room, whether it be a piece of art, a vintage rug, or a family heirloom."
„In jedem Raum sollte Geschichte stecken. Sei es Kunst, ein antiker Teppich oder ein Erbstück."
« Chaque pièce doit raconter une histoire. Qu'il s'agisse d'art, d'un tapis antique ou d'un legs. »

Barclay Butera's work has an underlying principle—wherever possible the interior designer aims to win clients "for life." To achieve this goal, the Californian says it is essential that the first project is an immediate success. Butera, whose houses and objects are regularly featured in *The New York Times, The Wall Street Journal* and interiors magazines such as *Traditional Home,* founded his design firm in Newport Beach, California, in 1994 with two further showrooms in Park City, Utah, and Corona del Mar, California, having been added since then. "I draw my creativity from all the fantastic architecture between the East and West Coasts. In addition, I am also inspired by European and Far Eastern influences, haute couture runways, and trips to exotic countries," explains Butera, who describes his style as "classic with a fresh twist." Butera is a master when it comes to combining heirlooms with contemporary design and integrating art objects with daring patterns and textures. For a family home in Pasadena, California, the designer chose his signature blue on white palette for the entire project (left). Butera describes the effect as crisp coastal chic that's extremely soothing. The client wanted a mix of comfortable elegance with respect to their lifestyle and brought strong ideas to the table. Butera welcomes such clients, saying "then we can use our talents to create a spectacular space that brings their vision to life."

Es gibt einen Grundsatz in Barclay Buteras Arbeit: Am liebsten möchte der Interior Designer seine Kunden ein Leben lang begleiten. Damit dies gelinge, sagt der Kalifornier, müsse das erste Projekt auf Anhieb überzeugen. Butera, dessen Häuser und Objekte regelmäßig in der *New York Times,* dem *Wall Street Journal* und in Interior Magazinen wie *Traditional Home* veröffentlicht werden, gründete 1994 sein Designbüro in Newport Beach, Kalifornien – inzwischen kamen zwei weitere Showrooms in Park City, Utah und Corona del Mar, Kalifornien hinzu. „Meine Kreativität schöpfe ich aus all der großartigen Architektur zwischen Ost- und Westküste. Aber auch europäische und fernöstliche Einflüsse, die Laufstege der Haute Couture und meine Reisen in exotische Länder sind Inspirationsquellen", betont Butera, der seinen Stil als „klassisch mit einem frischen Twist" beschreibt. Barclay Butera versteht es, Erbstücke mit zeitgenössischem Design zusammenzubringen, Kunstobjekte mit kühnen Mustern und Texturen zu verweben. Für ein Familienanwesen in Pasadena, Kalifornien wählte der Interior Designer die Farben „Blau auf Weiß" als Leitmotiv (links). Butera beschreibt das Ergebnis als erfrischenden und gleichzeitig beruhigenden Küsten-Chic. Der Kunde wünschte sich eine Mischung aus Eleganz, Komfort und Lebensqualität und brachte konkrete Vorstellungen ins Spiel. Butera weiß das zu schätzen: „So können wir unser Talent nutzen und einen Lebensraum schaffen, der Visionen wahr werden lässt."

Le travail de Barclay Butera suit un principe : L'architecte d'intérieur aime avant tout accompagner ses clients pendant toute leur vie. D'après le Californien, pour réussir cela, le premier projet doit immédiatement convaincre. Butera, dont les maisons et les bâtiments sont régulièrement mentionnés dans le *New York Times,* le *Wall Street Journal* et des magazines de décoration comme *Traditional Home,* a fondé en 1994 son agence de design à Newport Beach, Californie. Depuis, il possède deux autres showrooms à Park City, Utah et Coronal del Mar, Californie. « Je puise ma créativité de toute l'architecture magnifique entre la côte Est et la côte Ouest. Les influences européennes et orientales, les podiums de Haute Couture et mes voyages dans les pays exotiques sont également des sources d'inspiration », souligne Butera qui décrit son style comme « classique avec une touche de fraîcheur ». Barclay Butera sait allier des pièces antiques avec un design contemporain, mélanger des objets d'art avec des motifs et textures osés. Pour une résidence familiale à Pasadena, Californie, l'*interior designer* a choisi les couleurs « bleu sur blanc » comme leitmotiv (à gauche). Butera décrit le résultat comme frais, avec le chic apaisant de la côte. Le client voulait un mélange d'élégance, de confort et de qualité de vie et avait des idées concrètes. Butera apprécie cela : « Ainsi, nous pouvons utiliser notre talent et créer un espace de vie qui permet de concrétiser ses visions. »

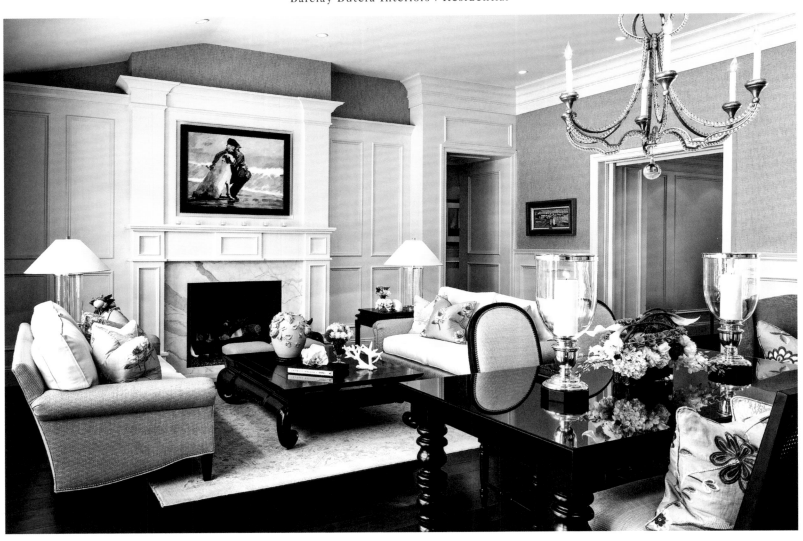

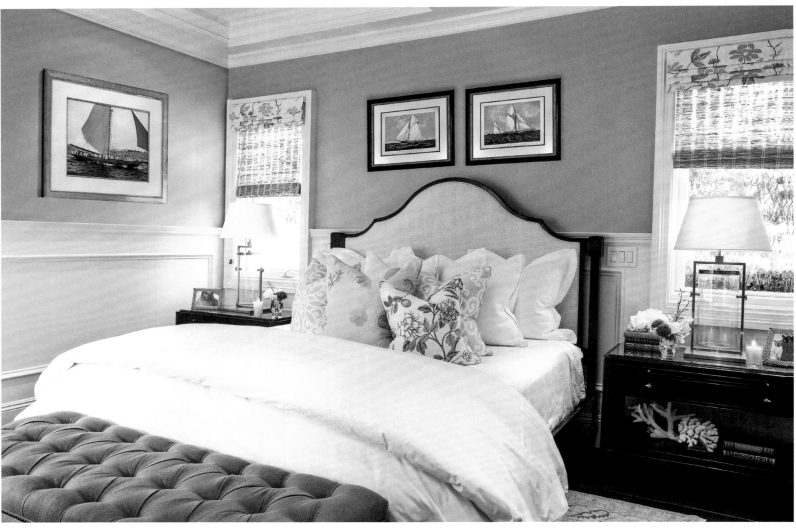

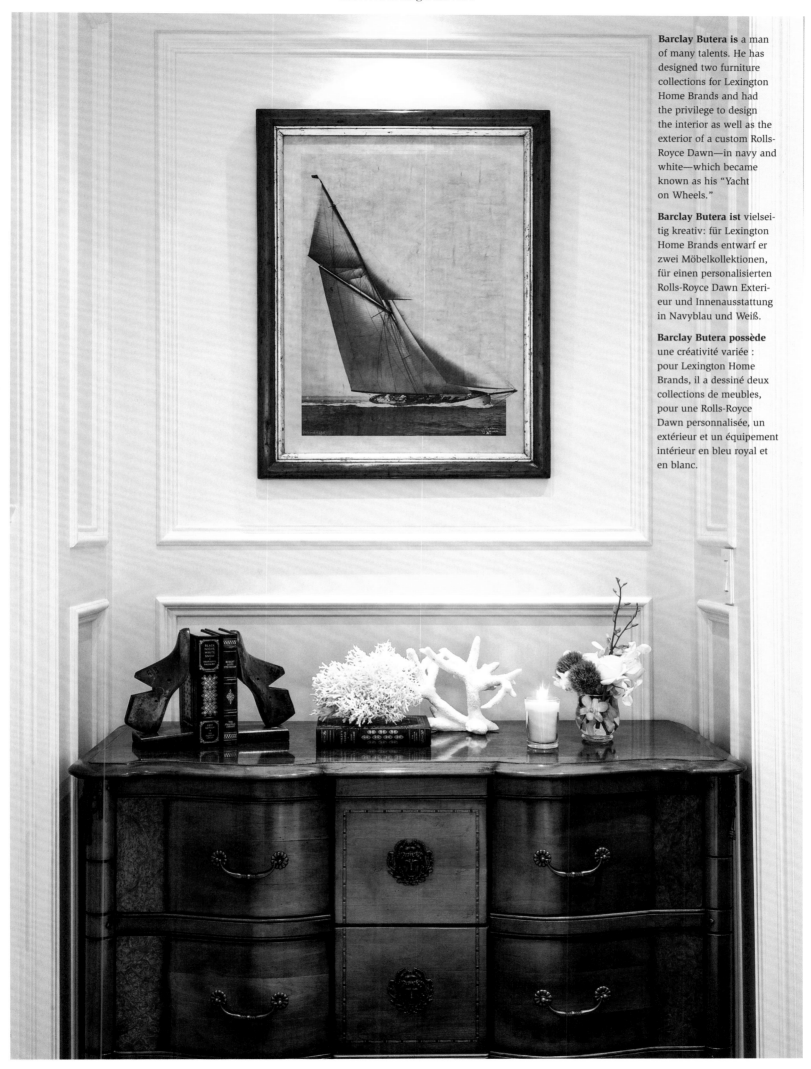

Barclay Butera is a man of many talents. He has designed two furniture collections for Lexington Home Brands and had the privilege to design the interior as well as the exterior of a custom Rolls-Royce Dawn—in navy and white—which became known as his "Yacht on Wheels."

Barclay Butera ist vielseitig kreativ: für Lexington Home Brands entwarf er zwei Möbelkollektionen, für einen personalisierten Rolls-Royce Dawn Exterieur und Innenausstattung in Navyblau und Weiß.

Barclay Butera possède une créativité variée : pour Lexington Home Brands, il a dessiné deux collections de meubles, pour une Rolls-Royce Dawn personnalisée, un extérieur et un équipement intérieur en bleu royal et en blanc.

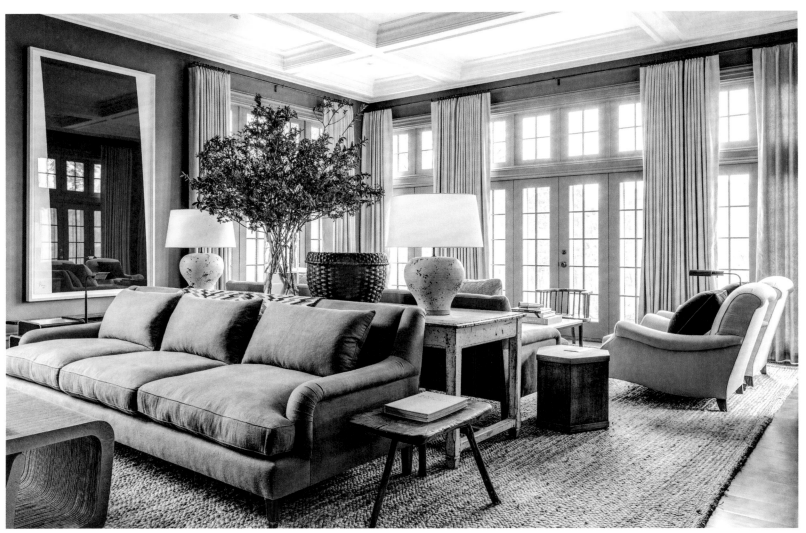

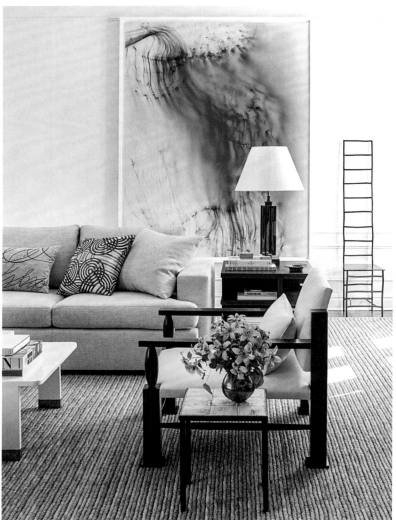

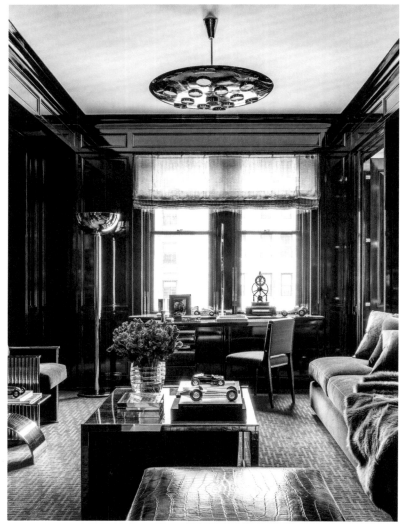

MARK CUNNINGHAM
New York City, United States

"I don't want to overload rooms. Better one detail too few than one too many."
„Ich möchte Räume nicht überladen. Lieber ein Detail weniger, als eines zu viel."
« Mieux vaut pas assez de détails que trop. Je n'aime pas surcharger les espaces ».

Anyone with an eye for simple luxury appreciates Mark Cunningham's discreet style, which focuses on materials and detail but also on comfort and simplicity. A reserved man himself, Mark's aversion to arrogance is evident in his projects. Whether an elegant apartment in Manhattan for a high-profile celebrity or a large country home for a family, Mark prioritizes the client's needs and well-being above all. The style he brings to every endeavor is edited and clean, yet refined, luxurious, curated and meticulous. In Connecticut, the designer created a relaxed haven (above left) for a fashion designer and her family; the living room pictured was designed around the fabric used on the couch. With a photograph by Wolfgang Tillmans as a backdrop (bottom left), Cunningham designed a space casual enough to live in for the home of a couple who are passionate art collectors, while showcasing their very impressive collection. Cunningham's love of interiors may be in his DNA: The New York City-based designer grew up under the wide skies of Arizona and Nevada and regularly accompanied his mother, who studied interior design, on her trips to San Francisco in search of unusual furniture and objects. Cunningham has no set approach but draws his inspiration from the space and from each specific client. If he has a unifying philosophy it would be, "Better one detail too few than one too many."

Er ist leise, niemals laut: Wer auf dezenten Luxus viel Wert legt, weiß Mark Cunninghams besonnenen Stil zu schätzen. Der New Yorker Designer setzt auf Materialen und Details, aber ebenso auf Komfort und Schlichtheit. Als Person eher zurückhaltend, mag Cunningham keine überheblichen Attitüden – und das sieht man seiner Arbeit auch an. Ob elegante Apartments in Manhattan für hochkarätige Prominente oder großzügige Landhäuser für Familien: Die Bedürfnisse und das Wohlbefinden seiner Kunden haben stets Priorität. Für eine Modedesignerin und ihre Familie schuf der Designer in Connecticut ein relaxtes Refugium (links oben); inspiriert vom Leinenbezug des Sofas, konzipierte er das ganze Wohnzimmer um den Stoff herum. Mit einer Fotografie von Wolfgang Tillmans als Hintergrundkulisse (links unten) designte er ein entspanntes Zuhause für zwei Kunstsammler

und ihre kuratierten Schätze. Cunninghams Liebe zum Interior Design mag in seiner DNA liegen: Aufgewachsen ist er in den Weiten Arizonas und Nevadas. Seine Mutter, die Interior Design studierte, nahm ihn regelmäßig zu ihren Streifzügen auf der Suche nach ausgefallenen Möbeln und Objekten nach San Francisco mit. Auch in seiner täglichen Arbeit lässt sich der Kreative gerne treiben – und von jedem Raum und jedem einzelnen Kunden immer wieder neu inspirieren. Doch wenn es eine Philosophie gibt, die sich wie ein roter Faden durch seine Entwürfe zieht, wäre es sicher: „Lieber ein Detail weniger, als eines zu viel."

Quiconque aime le luxe épuré saura apprécier le style discret de Mark Cunningham, centré sur les matières et les détails, autant que sur le confort et la simplicité. Homme réservé, Mark fuit l'arrogance, ce dont témoigne chacun de ses projets. Qu'il s'agisse de l'élégant appartement d'une célébrité médiatique à Manhattan, ou d'une grande maison de campagne destinée à accueillir une famille, Mark se fonde avant tout sur les besoins et le bien-être des propriétaires. Chacune de ses entreprises se caractérise par un style sobre et net, tout autant que raffiné, luxueux, précis et méticuleux. Pour une créatrice de mode et sa famille, il a su imaginer dans le Connecticut (ci-dessus à gauche) un havre décontracté dont le salon a été entièrement pensé en fonction du tissu utilisé pour le canapé. Pour un couple d'amateurs d'art passionnés, il a organisé autour d'une photographie de Wolfgang Tillmans placée en arrière-plan, un espace de vie confortable qui met cependant en valeur l'impressionnante collection des propriétaires (ci-dessous à gauche). Sans doute, les gênes ne sont-ils pas étrangers au goût de Mark Cunningham pour les intérieurs : installé à New York mais élevé sous les vastes cieux de l'Arizona et du Nevada, le styliste a régulièrement accompagné sa mère, formée en architecture intérieure, dans ses voyages à San Francisco pour y dénicher des meubles ou des objets insolites. Ne sachant jamais d'avance comment il procèdera, Cunningham s'inspire de l'espace et s'adapte à chaque client. S'il en avait une, la philosophie qui guide son travail serait : « mieux vaut pas assez de détails que trop ».

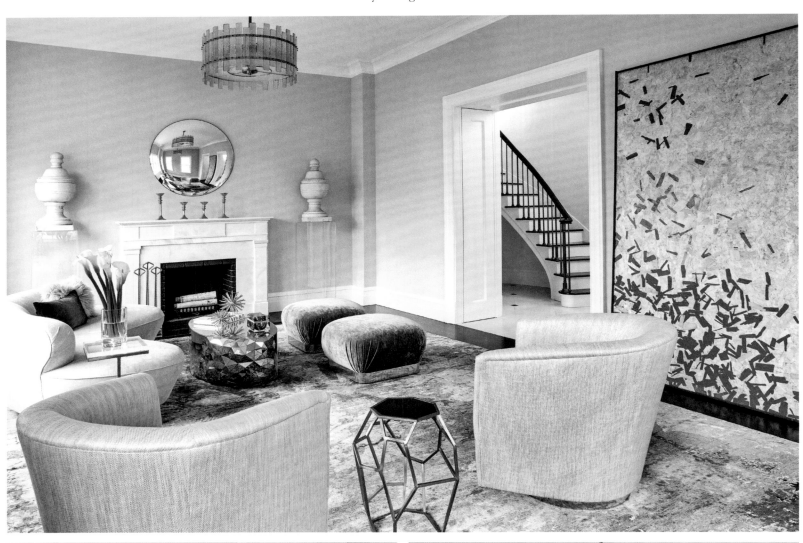

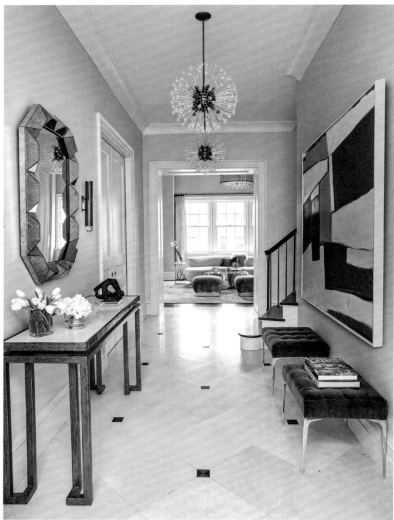

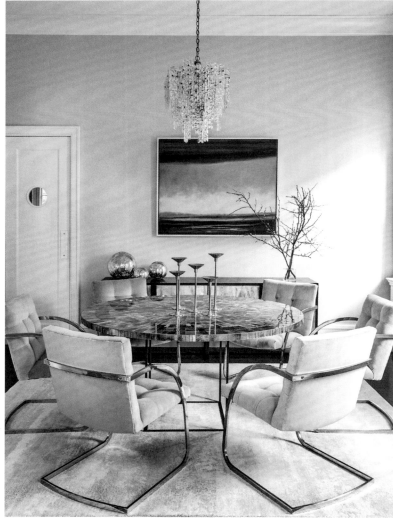

MELANIE ROY DESIGN
New York, United States

"My passion is for family homes. I find the mix of functional and beautiful exciting."
„Meine Passion gilt Familienhäusern. Die Mischung aus funktional und schön finde ich spannend."
« Je suis passionnée par les maisons familiales. Le mélange de fonctionnalité et d'esthétique me captive. »

Melanie Roy is not afraid of change. In her first life, the American designer worked in the television industry for 10 years successfully producing shows and winning awards. After the birth of her second child, however, she realized that she didn't relish the prospect of endless days at the studios separated from her children. "Design was always my passion; I was always going to antiques shows and art exhibitions." Melanie Roy attended the New York School of Interior Design and worked for several years at the prestigious interior design firm Cullman & Kravis. Leading to breathtakingly fast developments, Melanie Roy did not hesitate to start her own firm just a short time later. Versed in all periods and styles, she has a vast knowledge of art and focuses on interior design concepts that are family-friendly while still being elegant, sophisticated, and timeless. A family residence on Park Avenue in Manhattan (left) is made up of two apartments and a rooftop terrace that she connected to create a grand duplex penthouse. Melanie Roy describes its interior as "a fresh take on classic elegance." Inspired by the warm limestone in the entryway, she chose a color palette of naturals, taupes and light brown with hits of blue.

Melanie Roy hat keine Angst vor Veränderung. In ihrem ersten Leben war die Amerikanerin ins Fernsehgeschäft eingestiegen, hatte zehn Jahre erfolgreich Serien produziert und dafür Filmpreise bekommen. Doch nach der Geburt ihres zweiten Kindes schreckte sie die Aussicht auf endlose Arbeitstage in Fernsehstudios fern ihrer Kinder: „Design war immer meine Leidenschaft, ich versäumte kaum eine Antiquitätenmesse oder Kunstausstellung." Melanie Roy begann Kurse an der New Yorker School of Interior Design zu besuchen, lernte so die renommierten Einrichter Cullman & Kravis kennen und absolvierte dort ein Praktikum. Der Rest entwickelte sich in atemberaubender Geschwindigkeit – ohne zu zögern, eröffnete die Kreative kurze Zeit später ihr eigenes Studio. Versiert in allen Epochen und Stilrichtungen, verfügt Melanie Roy über eine umfangreiche Kunstexpertise; ihr Fokus liegt auf Einrichtungskonzepten, die einerseits familientauglich, andererseits elegant, ausgeklügelt und zeitlos sind. Ein Domizil an der Park Avenue in Lenox Hill, Manhattan (links), das sich ursprünglich aus zwei Apartments zusammensetzte, vereinte die Designerin. Melanie Roy beschreibt das Interior als „klassisch-elegant mit einem Frischekick". Inspiriert vom warmen Kalkstein im Entree wählte sie Farben in Natur, Taupe und hellem Braun, durchsetzt von Akzenten in Blau.

Melanie Roy n'a pas peur du changement. Au cours de sa première vie, l'Américaine a commencé dans le milieu de la télévision, elle a produit pendant dix ans des séries avec succès et a gagné pour cela des prix cinématographiques. Cependant, après la naissance de son deuxième enfant, la perspective de passer des journées de travail interminables dans les studios de télévision, loin de ses enfants, lui a fait peur : « Le design a toujours été ma passion, je ne manquais presque qu'aucun salon d'antiquités ou exposition d'art. » Melanie Roy a commencé à suivre des cours à la New York School of Interior Design, elle a y rencontré les célèbres décorateurs d'intérieur Cullman & Kravis et y a effectué un stage. Le reste s'est produit à toute vitesse – sans hésiter, elle a ouvert peu de temps après son propre studio. Chevronnée dans toutes les époques et tous les styles, Melanie Roy possède une expertise étendue dans l'art ; elle se concentre sur les concepts d'aménagement qui sont d'un côté, adaptés aux familles, d'un autre côté, élégants, sophistiquées et atemporels. Un domicile familial dans Park Avenue, Lenox Hill, Manhattan (gauche) est composé de deux appartements que la designeuse a réuni. Melanie Roy décrit son intérieur comme « classique, élégant avec une touche de fraîcheur. » Inspirée par le calcaire chaud dans l'entrée, elle a choisi des tons naturels, taupe et marron clair, rehaussés par des accents bleus.

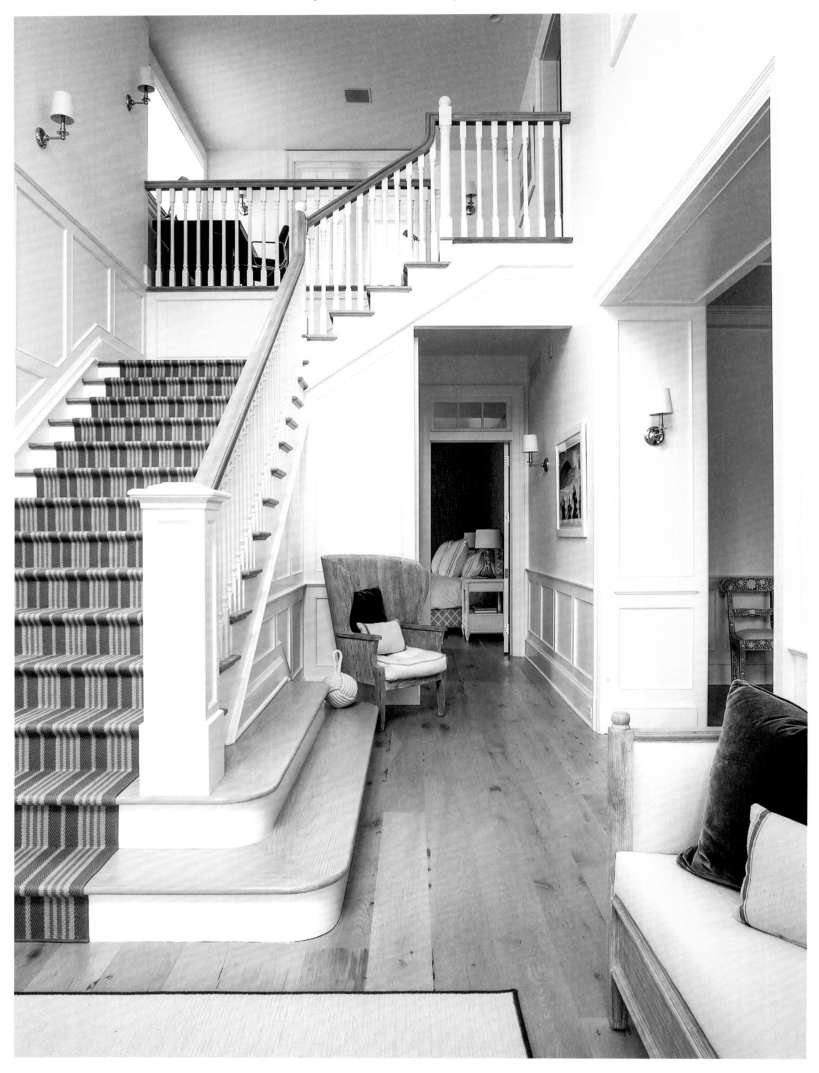

MABLEY HANDLER
Interior Design
The Hamptons, United States

"We design homes using color schemes that are based on the ocean, the wind, and salt water."
„Wir entwerfen Häuser in den Hamptons, deren Farbwelten von Meer, Wind und Salzwasser erzählen."
« Nous concevons des maisons dans les Hamptons dont les couleurs racontent la mer, le vent et l'eau salée. »

There is no interior design firm that captures the essence of the Hamptons better than Mabley Handler Interior Design. A love of the East End, and a commission in 2002 to design a Southampton Village house in the classic Hamptons style, motivated Jennifer Mabley, an accomplished interior designer, and husband Austin Handler, a successful graphic designer, to move from Manhattan to Water Mill. The couple founded their firm soon thereafter, one defined by a tailored but relaxed aesthetic. Over the last decade, they've become one of the leading design firms in the Hamptons. In the spring of 2017, Mabley Handler launched a lifestyle furniture collection with Kravet, and are presently planning another design studio in Palm Beach. Jennifer and Austin's work has been featured in numerous publications, on television, and in over a dozen designer showhouses in the Hamptons, Miami, and Palm Beach. This house (left) epitomizes casual East End elegance: The client wanted bespoke without formal, a classic East Hampton beach house that would blend with historic village residences, but once through the front door, present an abundance of open, comfortable living spaces. The couple understands how to use maritime colors and natural materials to marry the shingle-style homes nestled in the sweeping dunes with the landscape. The rooms are cozy, yet awash in a soothing ocean of aquas, blues, and soft grays.

Wenn es darum geht, die Essenz der Hamptons einzufangen, gehören Mabley Handler Interior Design zu den Vorreitern in Sachen Inneneinrichtung. Die große Liebe zur Region und der Auftrag einer Kundin im Jahre 2002 legten hierfür den Grundstein: Zusammen mit ihrem Ehemann Austin Handler, einem erfolgreichen Grafikdesigner, zog die Interior Designerin Jennifer Mabley von Manhattan nach Water Mill. Bald schon gründete das Paar sein eigenes Büro, dessen Ästhetik stets von einer entspannten Eleganz geprägt ist. In den vergangenen zehn Jahren wurde daraus eines der führenden Designstudios in den Hamptons und im Frühling 2017 folgte der Launch einer eigenen Möbelkollektion in Kooperation mit Kravet. Jennifer und Austins Entwürfe sind nicht nur häufig in den Medien, sondern auch in zahlreichen Musterhäusern in den Hamptons, Miami

und Palm Beach vertreten. Bei einem Anwesen in East Hampton (links) wünschten sich die Besitzer ein natürliches und zugleich stilvolles Ambiente – ein klassisches East Hampton Beachhouse, das äußerlich gut zu den historischen Häusern der Gegend passt und im Inneren lässigen Komfort und ein offenes Raumkonzept bereithält. Jennifer und Austin verstehen es, Landschaft und schindelgedeckte Ferienhäuser, die sich harmonisch in die geschwungenen Dünen schmiegen, durch maritime Farben und bodenständige Materialien zusammenzubringen. So entstanden Räumlichkeiten voller Behaglichkeit, durchzogen von sanften Türkis-, Blau- und Grautönen.

Nul autre cabinet d'architecture intérieure ne sait mieux que Mabley Handler Interior Design saisir l'esprit des Hamptons. L'amour qu'ils portent à Long Island, ainsi que la conception en 2002 d'une maison de Southampton Village dans le plus pur style des Hamptons, convainquent Jennifer Mabley, talentueuse architecte d'intérieur, et son mari, Austin Handler, graphiste reconnu, de quitter Manhattan pour Water Mill. Peu après, le couple fonde son propre cabinet, que caractérise une esthétique tout à la fois décontractée et personnalisée, et qui, au cours de la décennie suivante, s'imposera dans la région des Hamptons. Au printemps 2017, Mabley Handler lance une collection de meubles lifestyle chez Kravet, et envisage actuellement de créer un autre studio de design à Palm Beach. Présenté dans de nombreuses revues et à la télévision, le travail de Jennifer et Austin est également visible dans plus d'une douzaine de maisons-témoins dans les Hamptons, à Miami ou encore, Palm Beach. Cette maison (à gauche) incarne l'élégance informelle de Long Island : son propriétaire souhaitait une maison de bord de mer sobre quoique conçue sur mesure, capable de s'harmoniser avec les demeures classiques du village tout en offrant, une fois passée la porte d'entrée, de multiples espaces de vie ouverts et agréables. Mabley Handler sait exploiter les couleurs de la mer, aussi bien que les matériaux naturels, pour intégrer dans le paysage les maisons en bardeaux de style « shingle », nichées dans les vastes dunes. Les pièces sont tout à la fois confortables et immergées dans un océan apaisant de verts turquoise, bleus ou gris doux.

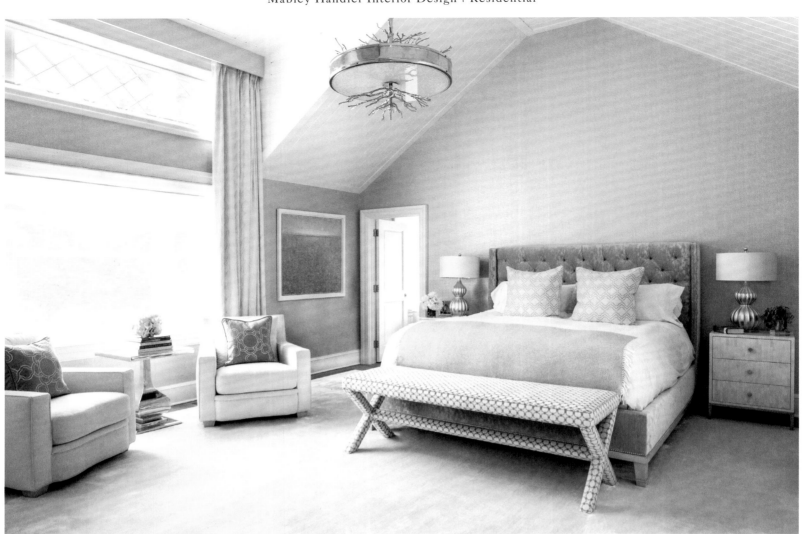

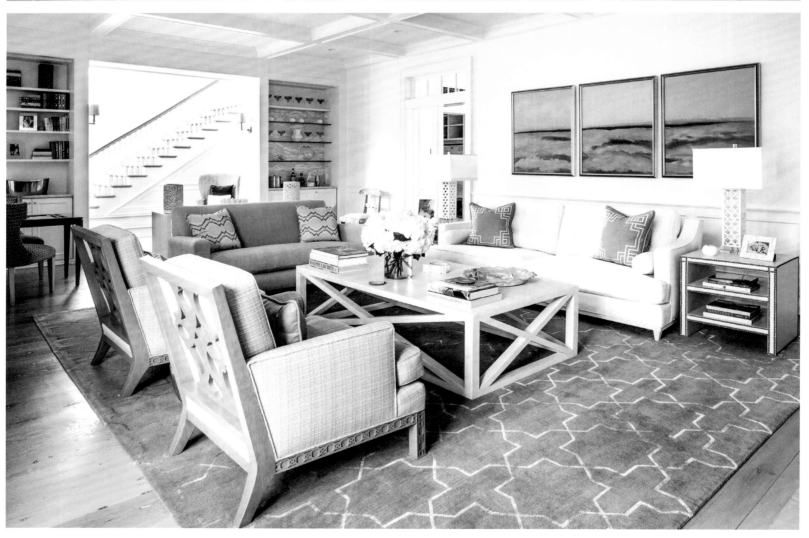

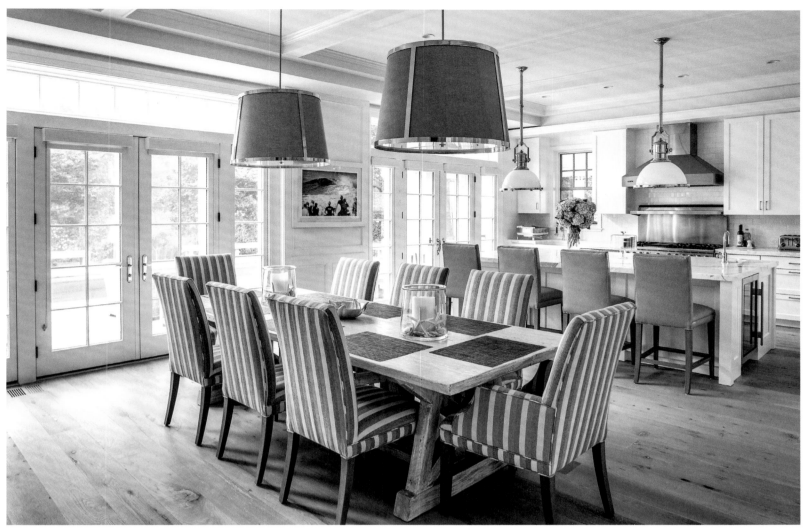

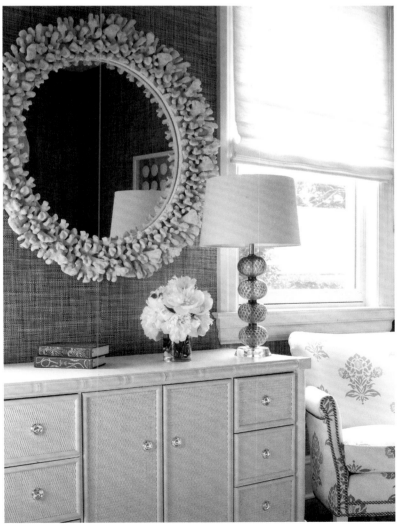

Hamptons style:
Jennifer Mabley and
Austin Handler's classically
elegant interiors mix wood
with linen fabrics and
cozy rugs in white, blue,
and beige.

Hamptons-Stil:
Jennifer Mabley und
Austin Handler mixen in
ihren klassisch-eleganten
Interiors Holz mit Leinen-
stoffen und wohnlichen
Teppichen in den Farben
Weiß, Blau und Sand.

**Atmosphère des
Hamptons :** Jennifer
Mabley et Austin Handler
mélangent dans leur inté-
rieur classique et élégant
du bois avec des tissus de
lin et des tapis d'intérieur
dans les tons blanc, bleu
et sable.

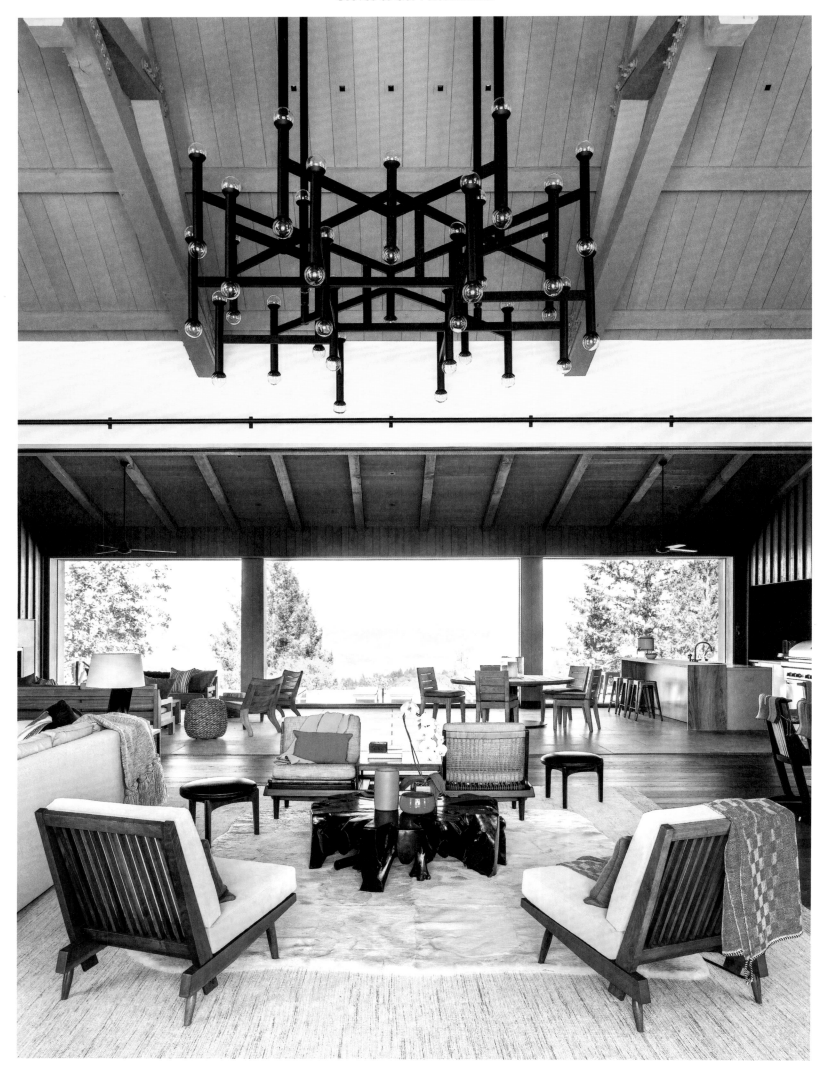

GROVES & CO.

New York City, United States

"Our aesthetic is fresh and modern. We have a penchant for luxury fabrics and elegant finishes."
„Unsere Ästhetik ist frisch und modern. Wir mögen luxuriöse Materialien und feine Oberflächen."
« Notre esthétique est fraîche et moderne. Nous aimons les matériaux luxueux et les surfaces raffinées. »

They have designed flagship stores for Tiffany, Giorgio Armani and Donna Karan; and furnished the private residences of fashion designers Michael Kors and Derek Lam. The characteristic style of Russell Groves and his team is always a modest overall concept marked by luxury materials in the details. Groves, who was raised in New York and studied architecture at the Rhode Island School of Design, firmly believes that good interior design captivates through exceptional combinations that are sophisticated and simultaneously elegant. Just what Russell Groves means by that is exemplified on the expansive estate of a 1,200-square-meter (13,000-square-foot) villa (left) perched like an aerie on an imposing mountain ridge in Napa Valley. Sizeable glazed areas open up spectacular vistas of the dramatic natural surroundings. The interior team invoked the environs and landscape with the appropriate materials: one example being the solid walnut bed in the master bedroom created by

legendary American artistic woodworker, George Nakashima. The massive, Jim Zivic petrified anthracite cocktail table is certainly an eye catcher, yet at the same time appears solitary. To meet the wishes of a young family with four children, Groves & Co. divided a New York penthouse on the Upper East Side into four different areas. In the lobby, the centerpiece of the two-floor luxury apartment, the aspect is dominated by a vast chrome stairway delightfully set against the vista of the New York City skyline.

Sie haben für Tiffany, Giorgio Armani oder Donna Karan die Flagship-Stores entworfen, für Modedesigner Michael Kors und Derek Lam deren Privatresidenzen eingerichtet: Der Stil von Russell Groves und seinem Team zeichnet sich immer durch ein zurückhaltendes Gesamtkonzept aus, das im Detail mit luxuriösen Materialien punktet. Groves, der in New York aufwuchs und an der Rhode Island School of Design Architektur studierte, ist sich sicher: „Gutes Interior Design überzeugt durch außergewöhnliche Kombinationen, die raffiniert und zugleich elegant sind." Was Russell Groves damit meint, zeigt sich im großzügigen Anwesen einer 1.200-Quadratmeter-Villa im Napa Valley (links): Wie ein Adlerhorst thront sie auf dem imposanten Gebirgsrücken.

Riesige Fensterflächen eröffnen spektakuläre Ausblicke auf die dramatische Natur ringsum. Das Interior-Team zitierte Umgebung und Landschaft mit adäquaten Materialien, beispielsweise einem Bett im Master-Schlafzimmer aus massivem Walnuss von der amerikanischen Kunsttischlerlegende George Nakashima. Der gewaltige Cocktail-Table aus versteinerter Kohle von Jim Zivic ist Blickfang und Solitär zugleich. Ein New Yorker Penthouse an der Upper East Side teilte Groves & Co. entsprechend den Wünschen einer jungen Familie mit Kindern in vier verschiedene Bereiche ein. Im Foyer, Zentrum der zweistöckigen Luxuswohnung, prägt eine gigantische Chromtreppe das Erscheinungsbild – passend zum Blick auf die Skyline von New York City.

Ils ont créé les flagshipstores pour Tiffany, Giorgio Armani ou encore Donna Karan, ils ont aménagé les résidences privés des stylistes Michael Kors et Derek Lam : Le style de Russell Groves et de son équipe se démarque par un concept général discret qui marque des points grâce à des détails composés de matériaux luxueux. Groves, qui a grandi à New York et a étudié l'architecture à la Rhode Island School of Design est sûr d'une chose : « Un bon aménagement intérieur convainc par des combinaisons exceptionnelles à la fois raffinées et élégantes. » Ce que Russell Groves veut dire par là est illustré par le grand domaine d'une villa de 1 200 m² à Napa Valley (à gauche). Tel un nid d'aigle, elle trône sur l'imposante crête montagneuse. Des immenses surfaces vitrées donnent une vue spectaculaire sur la nature majestueuse des environs. L'équipe de décoration d'intérieur a rendu hommage aux environs et au paysage avec des matériaux adéquats, comme par exemple, dans la chambre principale, un noyer massif de la légende américaine des tables artistiques George Nakashima. L'imposante table cocktail en charbon fossilisé de Jim Zivic attire tous les regards tout en occupant une place unique. Groves & Co. a divisé un penthouse new-yorkais dans l'Upper East Side en quatre espaces différents, en respect des envies d'une jeune famille avec enfant. Dans le foyer, le centre de cet appartement de luxe sur deux étages, un gigantesque escalier chromé marque l'esthétique – en harmonie avec la vue sur le skyline de New York.

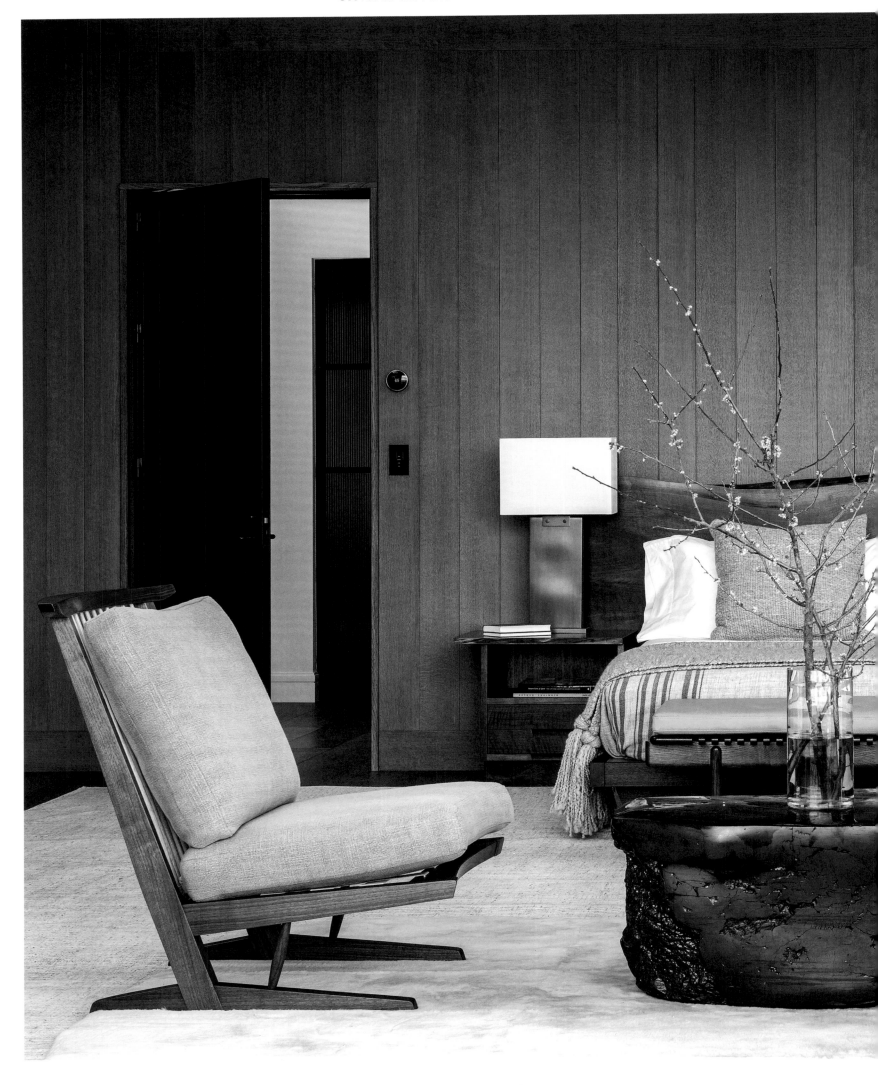

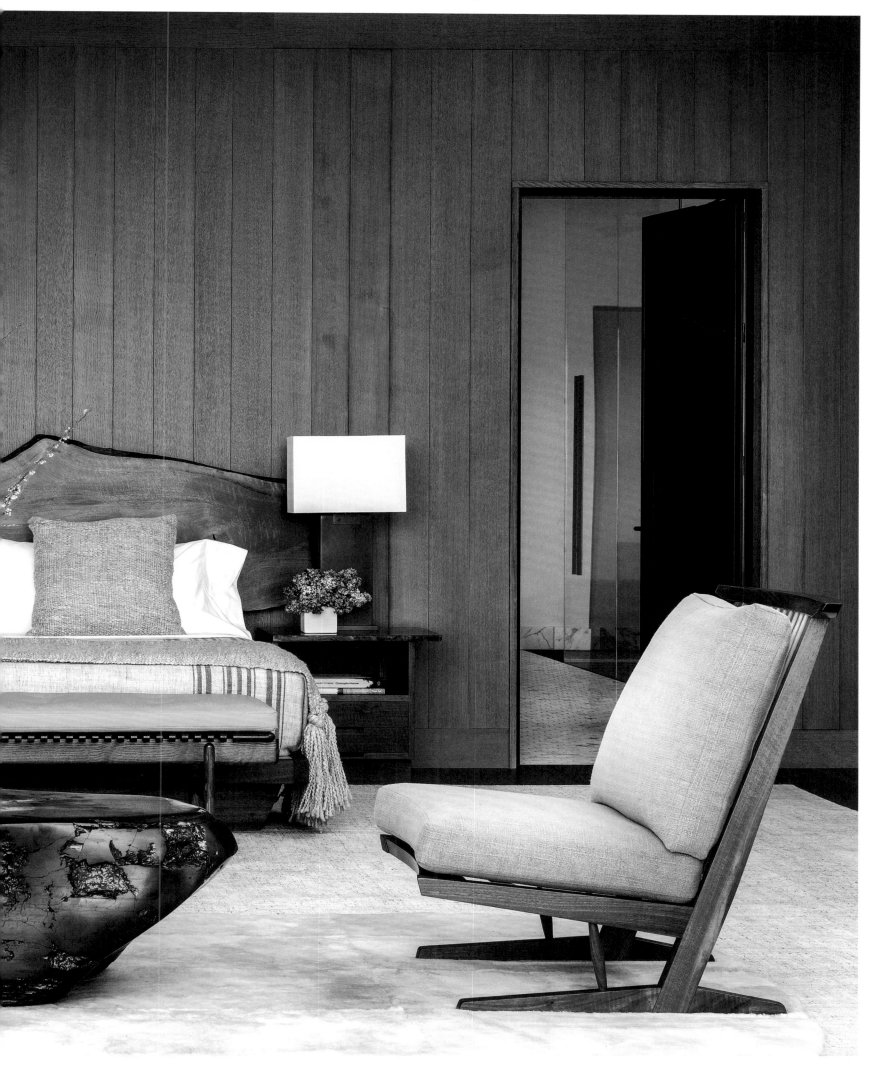

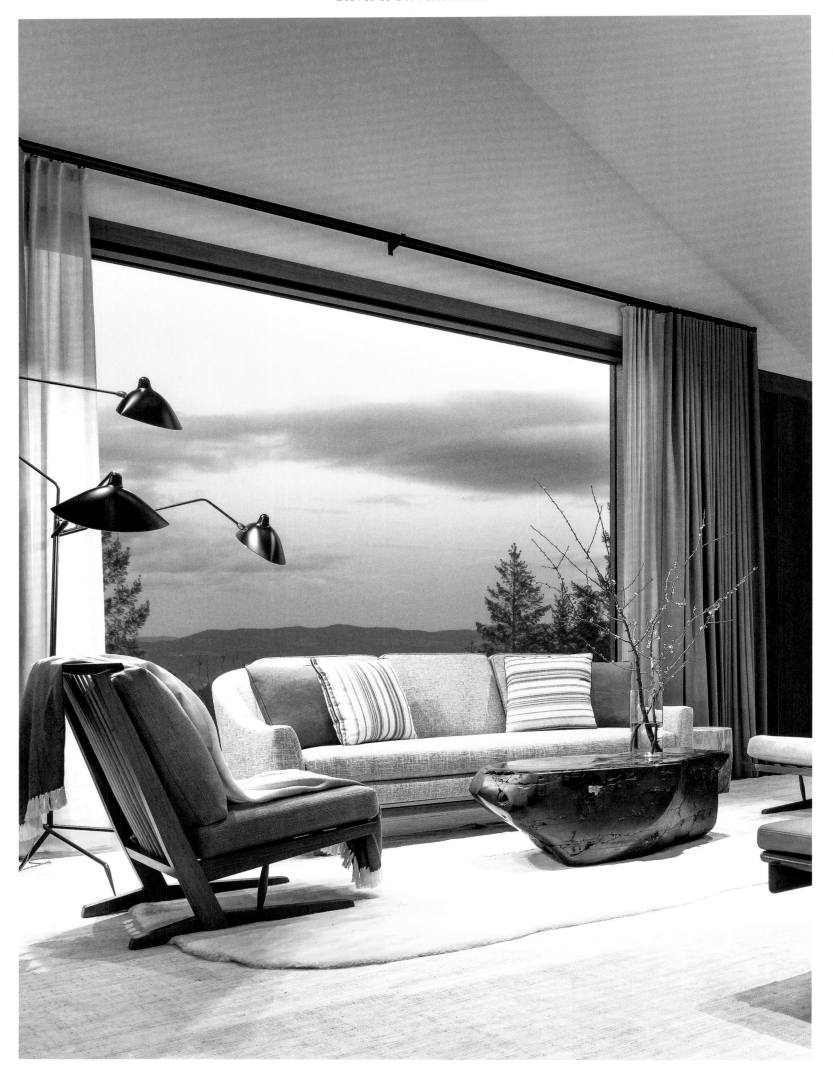

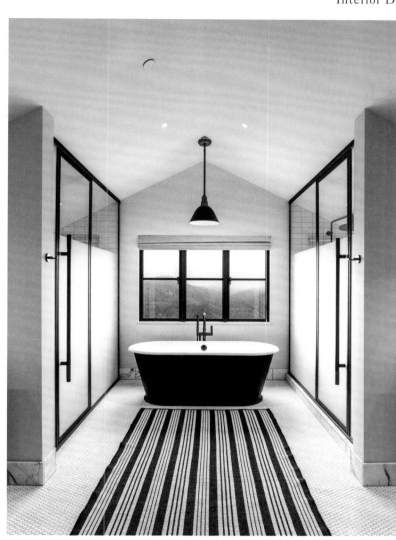

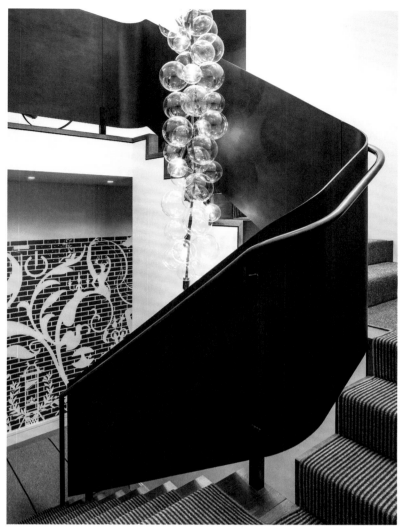

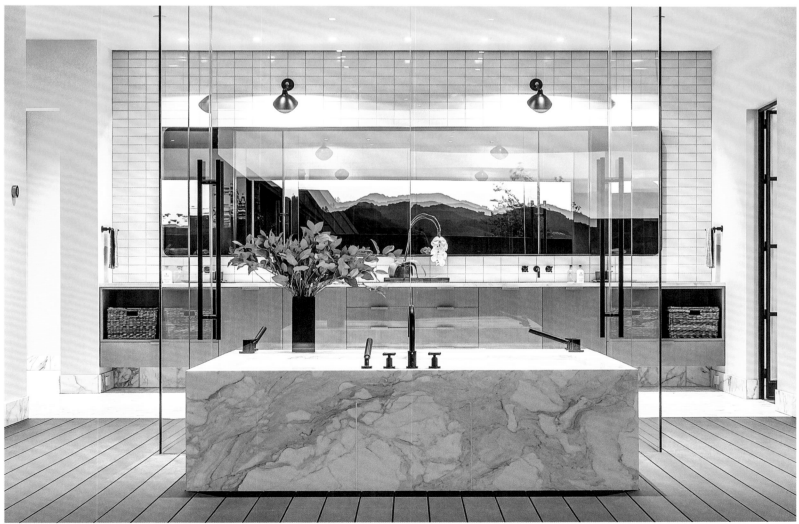

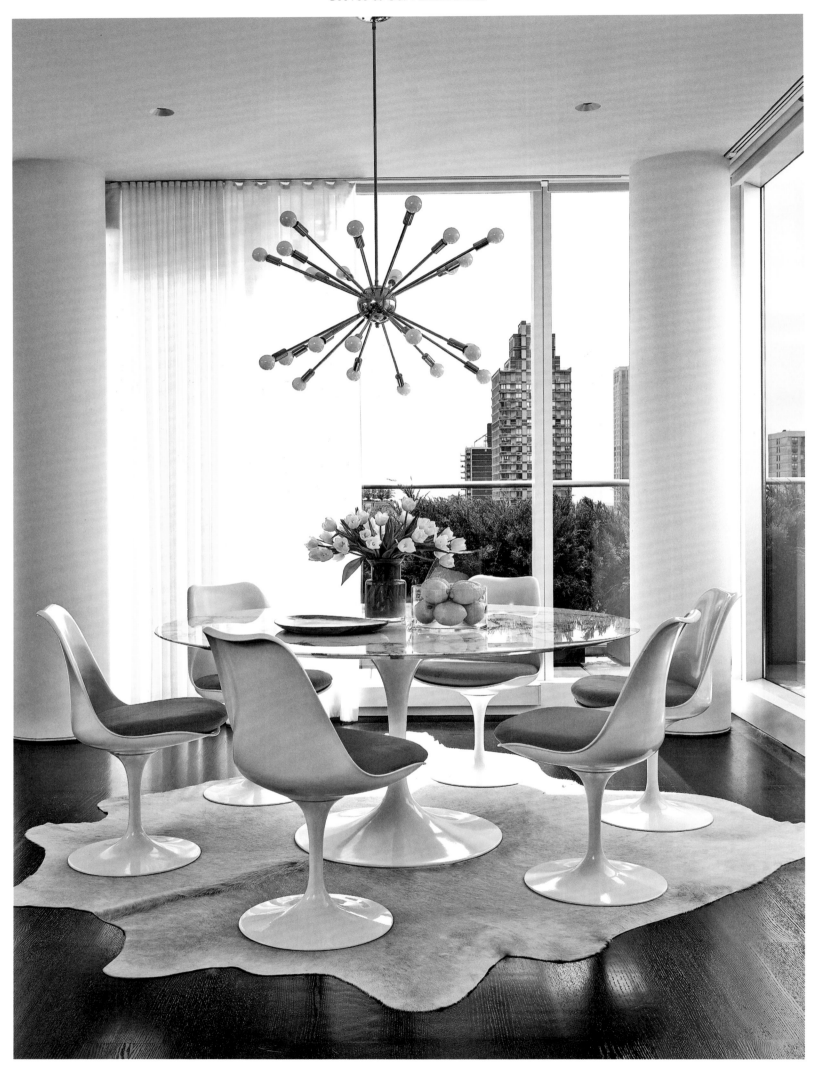

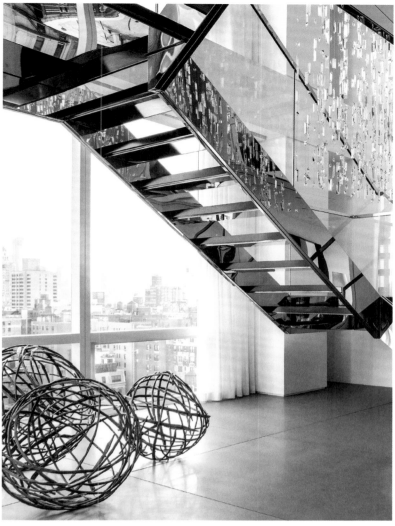

Penthouse with vista:
For the dining room, Groves & Co. chose Eero Saarinen table and chairs and a lamp designed by Lindsey Adelman. Dark wood, leather, wool and silk characterize the living room.

Penthouse mit Sicht:
Im Esszimmer wählten Groves & Co. Tisch und Stühle von Eero Saarinen sowie eine Leuchte von Lindsey Adelman. Dunkles Holz, Leder, Wolle und Seide prägen das Wohnzimmer.

Penthouse avec vue :
dans la salle à manger, Groves & Co. ont choisi une table et des chaises d'Eero Saarinen et une lampe de Lindsey Adelman. Bois foncé, cuir, laine et soie marquent le séjour.

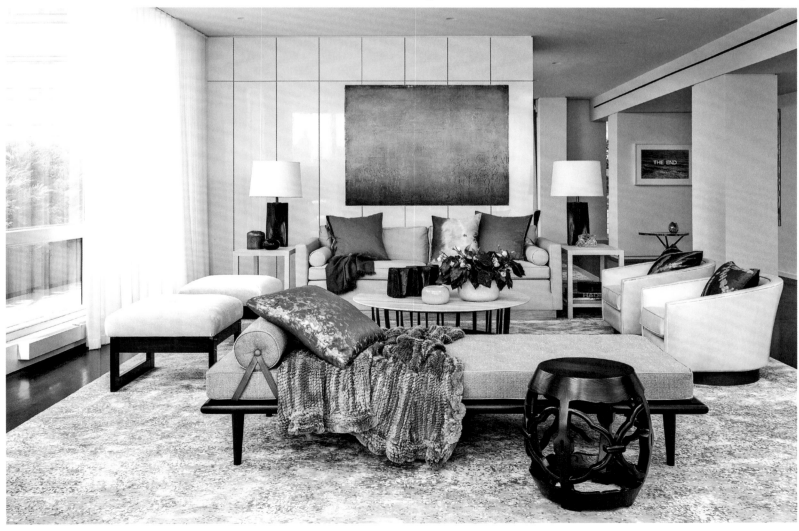

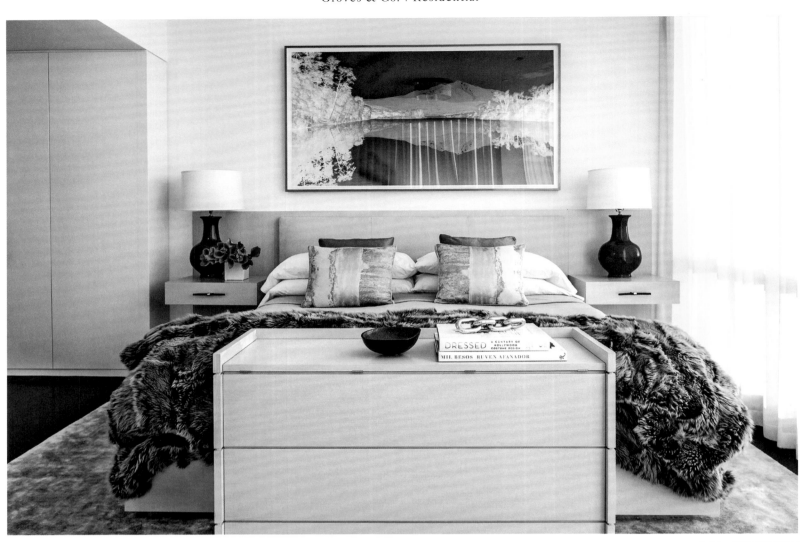

View in and out: A glass cube connects the two floors. From their studies, the kids can look down directly into the living room. The kitchen functions as an informal breakfast room.

Ein- und Ausblick: Ein Glaskubus verbindet beide Ebenen. Die Kinder können von ihren Studierzimmern direkt nach unten ins Wohnzimmer schauen. Die Küche fungiert als informeller Frühstücksraum.

Introspection et perspective : un cube en verre relie les deux niveaux. Les enfants peuvent regarder directement en bas dans le séjour depuis leurs salles d'études. La cuisine sert de salle informelle de petit-déjeuner.

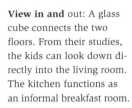
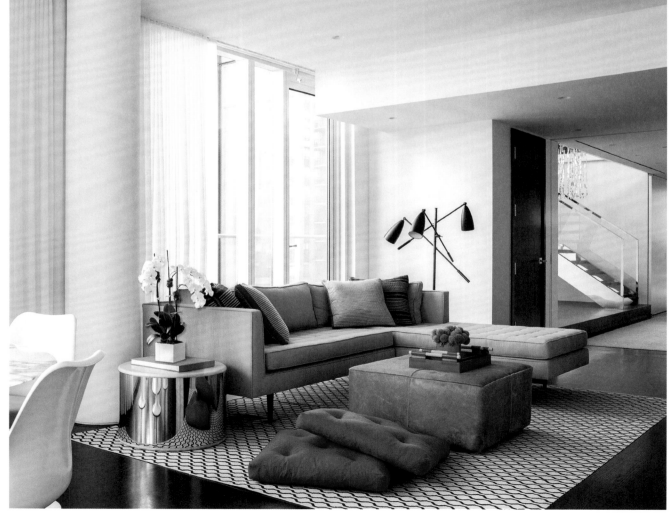

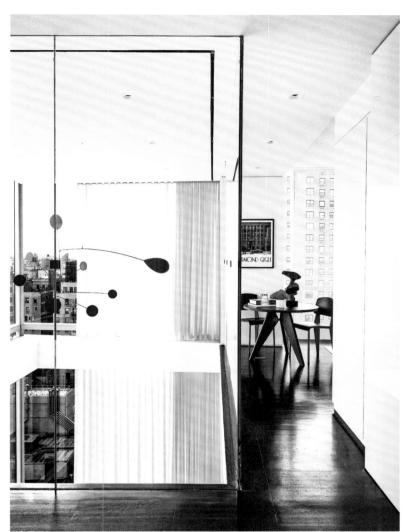

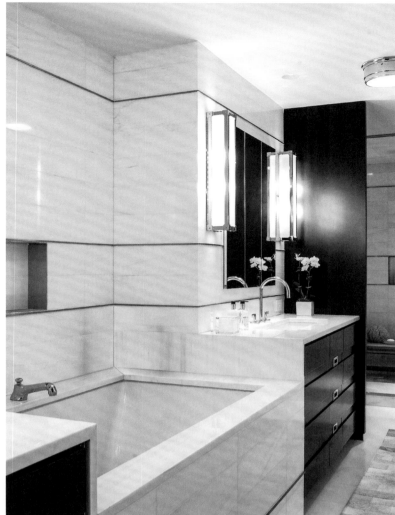

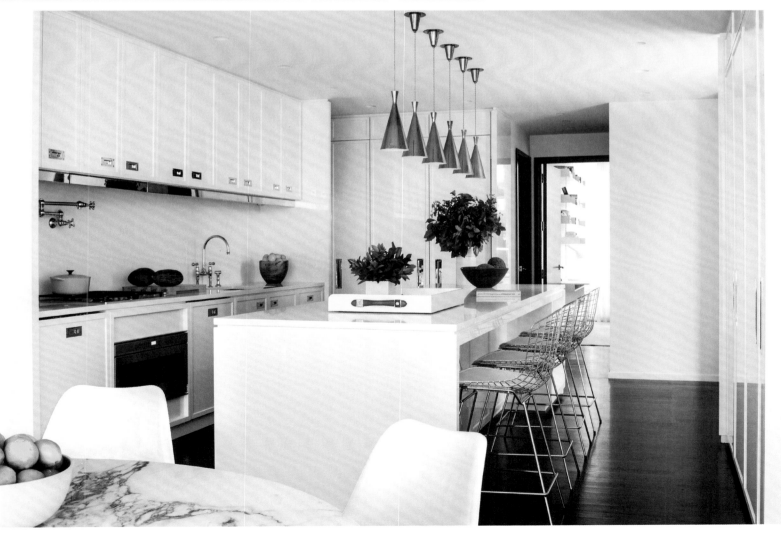

Index

pp. 136-141
JPDEMEYER&CO
Rooigem 3
8310 Sint-Kruis (Brugge), Belgium
www.jpdemeyer.com

pp. 142-147
Holger Kaus
Fürstenstr. 10a
83700 Rottach-Egern, Germany
www.holgerkaus.com

pp. 148-155
Richard Mishaan Design LLC
145 Hudson Street, Suite 5A
New York, NY 10013, USA
www.richardmishaan.com

pp. 156-165
Taylor Howes
49-51 Cheval Place
Knightsbridge, London SW7 1EW
United Kingdom
www.taylorhowes.co.uk

pp. 166-167
Gaggenau Hausgeräte GmbH
Carl-Wery-Str. 34
81739 Munich, Germany
www.gaggenau.com

pp. 168-177
Mang Mauritz Design GmbH
Pilotystraße 4
80538 Munich, Germany
www.mangmauritz.com

pp. 178-181
GWdesign
Los Angeles, CA, USA
New York, NY, USA
www.gwdesign.com

pp. 182-191
Urban Comfort by Ulrike Krages
Hansastr. 27a
20149 Hamburg, Germany
www.uk-urbancomfort.com

pp. 192-199
Hild Home Design GmbH
Gersthofer Straße 29-31
1180 Vienna, Austria
www.hildhomedesign.com

pp. 200-201
Freso Home
Ottostrasse 3-5, Kunstblock
80333 Munich, Germany
www.fresohome.de

pp. 202-209
Widmer Wohnen AG
St. Gallerstrasse 71
9200 Gossau (SG), Switzerland
www.widmer-wohnen.ch

pp. 210-223
Ignace Meuwissen
www.ignacemeuwissen.com

pp. 224-229
Scheer Architekt GmbH
Erich-Kästner-Str. 8-10
80796 Munich, Germany
www.scheerarch.de

pp. 230-231
Roxane Mosleh & Associates LLC
7 Trademans Path Unit 9
Bridgehampton, NY 11932, USA
www.roxanemosleh.com

pp. 232-235
Jennifer Post Design Inc.
25 East 67th Street at Madison
Avenue
New York, NY 10065, USA
www.jenniferpostdesign.com

pp. 236-241
Vicente Wolf Associates
333 W 39th Street, 10th Floor
New York, NY 10018, USA
www.vicentewolf.com

pp. 242-245
Jayne Design Studio
36 East 12th Street, Suite 702
New York, NY 10003, USA
www.jaynedesignstudio.com

pp. 246-247
Robert Couturier, Inc.
69 Mercer Street
New York, NY 10012, USA
www.robertcouturier.com

pp. 248-253
Raumkonzepte Peter Buchberger
Cuvilliesstrasse 8
81679 Munich, Germany
www.rkpb.de

pp. 254-255
Fiona Barratt Interiors
The Studio
12 Francis Street
London, SW1P 1QN, United Kingdom
www.fionabarrattinteriors.com

pp. 256-259, pp. 302-303
Sofía Aspe
Mexico City, Mexico
www.sofiaaspe.com

pp. 260-261
Robert Passal Interior Design
& Architecture
—
New York
333 Park Avenue South, Suite 4A
New York, NY 10010, USA
—
Miami
6580 Indian Creek Drive
Miami, FL 33141, USA
www.robertpassal.com

pp. 262-271
Ingrao Inc.
17 East 64th Street
New York, NY 10065, USA
www.ingraoinc.com

pp. 272-275
Rialto Living
Carrer de Sant Feliu 3
07012 Palma de Mallorca, Spain
www.rialtoliving.com

pp. 276-279
Barclay Butera Interiors
—
Newport Beach
1745 Westcliff Drive
Newport Beach, CA 92660, USA
—
Corona Del Mar
2824 East Coast HWY
Corona Del Mar, CA 92625, USA
—
Park City
255 Heber Avenue
Park City, UT 84060 USA
www.barclaybutera.com

pp. 280-281
Mark Cunningham
15 West 37th Street, 14th Floor
New York, NY 10018, USA
www.markcunninghaminc.com

pp. 282-283
Melanie Roy Design, LLC
New York, USA
www.melanieroydesign.com

pp. 284-287
Mabley Handler Interior Design
34 Head of Pond Rd
Water Mill, NY 11976, USA
www.mableyhandler.com

pp. 288-297
Groves & Co.
210 Eleventh Avenue No. 502
New York, NY 10001, USA
www.grovesandco.com

About the Author
Über die Autorin
A propos de l'auteur

© Mads Mogensen

Following practical training at the daily German newspaper *Süddeutsche Zeitung*, Tatjana Seel established the prestigious interior magazine *Deco Home* (publisher Winkler Medien Verlag). A freelance author since 1996, she researches, writes and produces reports, profiles and interviews on interior design and travel for numerous magazines, work that takes her all over Europe. To this day, she has never lost her passion for impressive architecture, dazzling interiors, interesting people and exceptional landscapes. Working as a journalist has enabled her to bring together all these aspects—for which she is eternally grateful. Tatjana's portrait was taken by the photographer Mads Mogensen during a photo shoot on Majorca. For the set he chose a Ligne Roset 'Fifty' armchair: A quirky coincidence given that the author has visited and profiled numerous designers for the French furniture company. Tatjana Seel lives with her family just south of Munich and close enough to the mountains to which she is profoundly connected.

Tatjana Seel entwickelte nach ihrem Volontariat bei der *Süddeutschen Zeitung* das renommierte Interior-Magazin *Deco Home* (Winkler Medien Verlag). Seit 1996 recherchiert, schreibt und produziert sie als freie Autorin Interior- und Reisereportagen, Porträts und Interviews für zahlreiche Magazine und ist dafür in ganz Europa unterwegs. Die Passion für gute Architektur, überraschende Interiors, interessante Menschen und besondere Landschaften begleitet sie bis heute. Ihr Beruf als Journalistin ermöglicht, all das miteinander zu verbinden, wofür sie dankbar ist. Während einer Fotoproduktion auf Mallorca entstand Tatjanas Porträt, das der Fotograf Mads Mogensen aufnahm. Als Set wählte er dafür den Sessel „Fifty" von Ligne Roset. Ein schöner Zufall – die Autorin hat für das französische Möbelunternehmen zahlreiche Designer besucht und porträtiert. Tatjana Seel lebt mit ihrer Familie südlich von München. Nah genug an den Bergen, mit denen sie sich tief verbunden fühlt.

Après s'être formée auprès du quotidien *Süddeutsche Zeitung*, Tatjana Seel fonde la prestigieuse revue *Deco Home* (édité par Winkler Medien Verlag). Auteur freelance depuis 1996, elle enquête, écrit, signe des reportages ou des portraits, réalise des entretiens sur la décoration et les voyages pour de nombreux magazines. Son travail de journaliste, qui l'amène à sillonner l'Europe, lui permet d'englober sa passion, toujours intacte, pour les architectures marquantes et les intérieurs surprenants, aussi bien que pour les personnalités singulières et les paysages exceptionnels – ce dont elle est infiniment reconnaissante. Réalisé à Majorque, le portrait de Tatjana est dû au photographe Mads Mogensen qui a choisi le fauteuil « Fifty » de Ligne Roset. Coïncidence insolite lorsque l'on sait que l'auteur a dressé le portrait de nombreux designers pour l'éditeur de mobilier français. Tatjana Seel vit avec sa famille au sud de Munich, non loin des montagnes auxquelles elle se sent profondément reliée.

Photo Credits

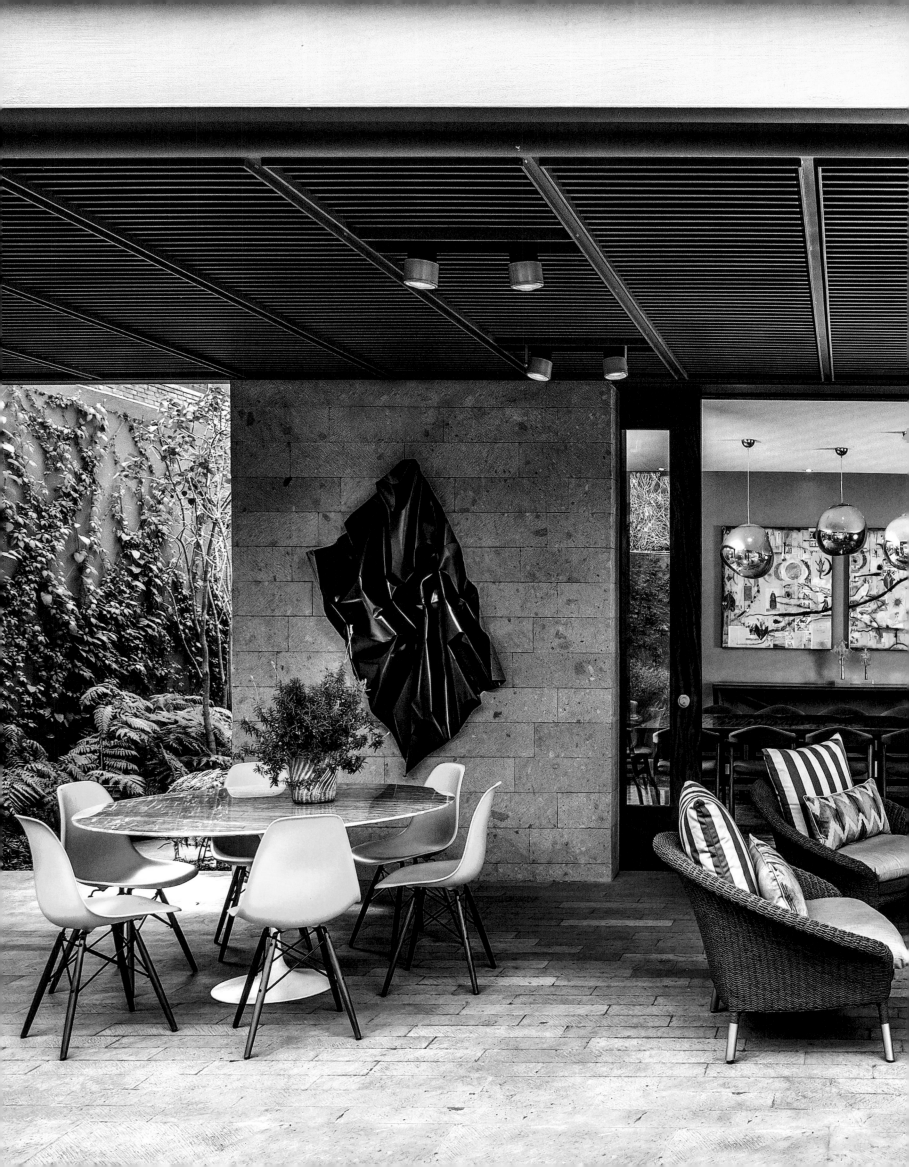

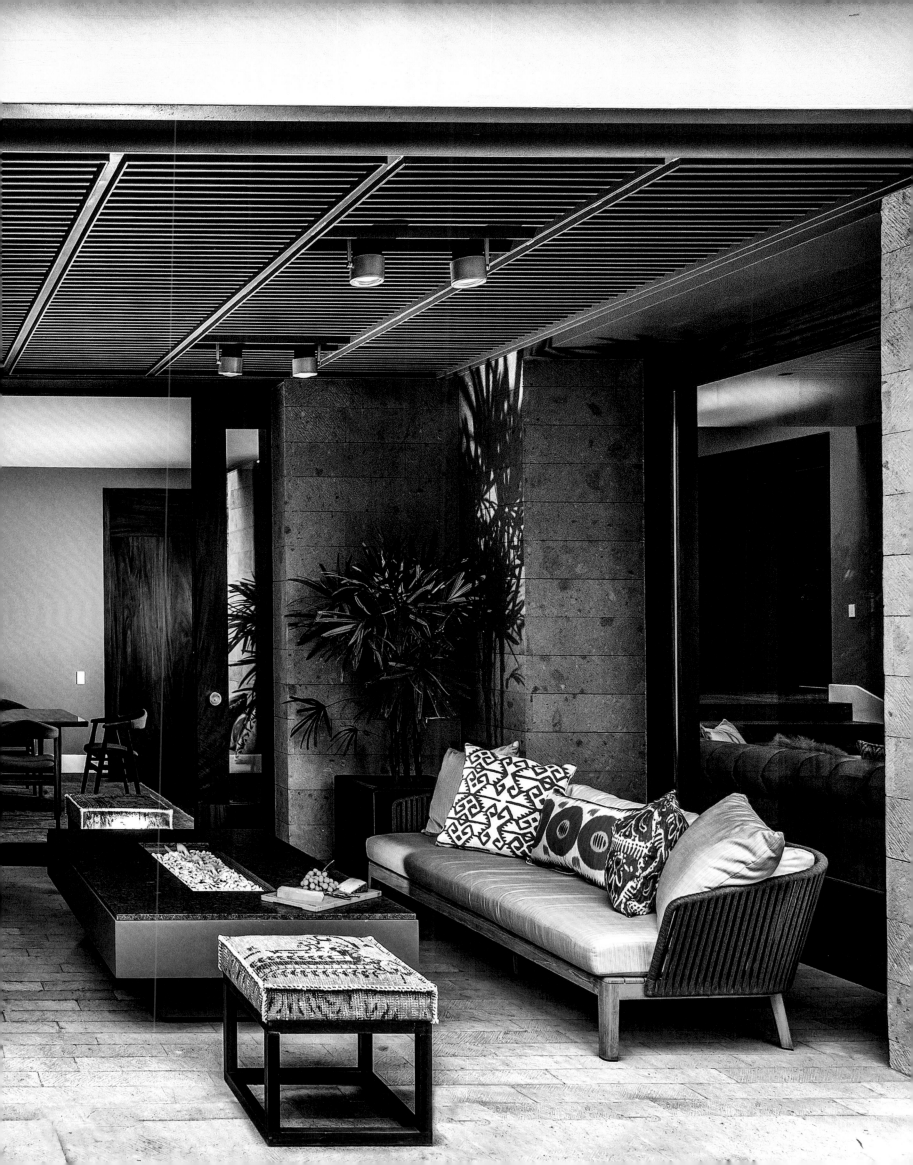

Imprint

Edited by Cindi Cook
Contributing editor: Marc Steinhauer
Translations by Deman Übersetzungen/Alison Fry (English),
Floriane Dollat (French), Anne Siebertz (German);
Alice Boucher (French)
Copy editing by Christina Reuter (German)
Proofreading by Deman Übersetzungen (English/French),
Christina Reuter (German)
Creative Director: Martin Graf
Design & Layout: Robin John Berwing, Stefan Gress
Editorial coordination by Christina Reuter
Production by Nele Jansen
Color separation by Robin Alexander Hopp

Cover photography by Tria Giovan/Carmiña Roth Interiors
Back cover photography by Zachary Balber/Roxane Mosleh

ISBN 978-3-96171-097-3

Library of Congress Number: 2017958244

Printed in Italy

Published by teNeues Publishing Group

teNeues Media GmbH & Co. KG
Am Selder 37, 47906 Kempen, Germany
Phone: +49-(0)2152-916-0
Fax: +49-(0)2152-916-111
e-mail: books@teneues.com

Press department: Andrea Rehn
Phone: +49-(0)2152-916-202
e-mail: arehn@teneues.com

Munich Office
Pilotystraße 4, 80538 Munich, Germany
Phone: +49-(0)89-443-8889-62
e-mail: bkellner@teneues.com

Berlin Office
Kohlfurter Straße 41–43, 10999 Berlin, Germany
Phone: +49-(0)30-4195-3526-23
e-mail: ajasper@teneues.com

teNeues Publishing Company
350 7th Avenue, Suite 301, New York, NY 10001, USA
Phone: +1-212-627-9090
Fax: +1-212-627-9511

teNeues Publishing UK Ltd.
12 Ferndene Road, London SE24 0AQ, UK
Phone: +44-(0)20-3542-8997

teNeues France S.A.R.L.
39, rue des Billets, 18250 Henrichemont, France
Phone: +33-(0)2-4826-9348
Fax: +33-(0)1-7072-3482

www.teneues.com

MIX
Paper from
responsible sources
FSC® C015829
FSC www.fsc.org

teNeues Publishing Group
Kempen
Berlin
London
Munich
New York
Paris

teNeues